THE WORLD FROM HERE **X**

THE WORLD FROM HERE X

TREASURES
OF THE GREAT LIBRARIES
OF LOS ANGELES

Edited by
Cynthia Burlingham
and
Bruce Whiteman

UCLA Grunwald
Center for the Graphic Arts
Hammer Museum
Los Angeles

Distributed by Getty Publications
Los Angeles

This catalogue was
published in conjunction with
**The World from Here: Treasures of the Great
Libraries of Los Angeles**
an exhibition held at the Hammer Museum,
Los Angeles, October 17, 2001,
to January 13, 2002.

This exhibition has been made possible
through the generous support of
**The Institute of Museum and Library Services,
The Ahmanson Foundation, The Ralph M. Parsons
Foundation,** and **The Getty Grant Program.**

Published by the
UCLA Grunwald Center for the Graphic Arts
and the **Armand Hammer Museum of Art
and Cultural Center,**
10899 Wilshire Boulevard,
Los Angeles, California 90024-4201.

Distributed by Getty Publications,
1200 Getty Center Drive, Suite 500,
Los Angeles, California 90049-1682,
www.getty.edu.

ISBN 0-89236-659-1

Editors
Karen Jacobson and **Lynne Kostman**
Designers
Lorraine Wild with **Amanda Washburn**
and **Robert Ruehlman**
Principal photographer
Paula Goldman
Proofreader
Dianne Woo
Indexer
Kathleen Preciado
Printed in Germany
by **Dr. Cantz'sche Druckerei**, Ostfildern

CONTENTS

FOREWORD

The World from Here celebrates the remarkable depth and diversity of special collections material in Los Angeles County by presenting works borrowed from some thirty local libraries. These "treasures" range all the way from the precious, expected monuments of classical and European civilization—such as works by Ptolemy, Copernicus, Galileo, Shakespeare, and Freud—to Japanese obstetrical manuals and annotated Hollywood film scripts. The subject matter can be as esoteric and otherworldly as an eighth-century Buddhist religious scroll or as quotidian as a nineteenth-century children's board game or the 1872 Los Angeles city directory. Likewise, the artifacts on display can be as official and politically momentous as the Spanish document founding Los Angeles as a city or the handsomely printed version of Columbus's letter to his royal patrons on the discovery of the New World, or as private as the erotic musings of a bold modern novelist or the scratchings of a world-famous composer on an opera manuscript. Blood, fish, pagodas, obelisks, worms, golf, babies, games, music, politics, poetry, scrolls, diaries, Bibles, and much, much more—the mind's plenty is here.

Such a heterodox assemblage reflects the sprawling, changing city in which these objects reside. Likewise, it is meant to challenge any simple preconception about the nature of "treasures" and to expose the cultural and political questions librarians must confront in assembling research materials to document the present and the past, the here and the there, the obvious and the esoteric, for the future. The very number of libraries contributing to this exhibition and participating in the related programming gives some hint of the feisty, individualist history of Los Angeles and the differing perspectives that contribute to our passionate, innate curiosity about the history of human and natural life.

Certainly, no such gathering of artifacts could have been conceivable without the knowledge, generosity, and close collaboration of a dedicated network of librarians across the county. Their meticulous knowledge and professional collegiality give the lie to the twin notions that this place is characterized by a casualness bordering on the slovenly or a disconnectedness bordering on isolationism. Likewise, the impression of these research collections as remote in terms of both access and subjects is turned upside down when we think of these manuscripts, books, and objects as intensely concentrated containers of human curiosity, imagination, and genius. These vessels of knowledge are ready to be released and revivified every time they are revisited. Libraries, often housed in stately buildings, ought, at least metaphorically, to flash with vivid bolts of energy, since they serve as transmitting stations from past to present to future. In regard to intellectual energy, California and Los Angeles have no shortage of either providers or users.

Nevertheless, for all this richness and cooperation, it takes a certain courage to move library collections out of their shadowed protection into the public arena of museum display. But the Hammer Museum and the Grunwald Center at UCLA had the advantage of having successfully organized two previous exhibitions of library materials: *Picturing Childhood: Illustrated Children's Books from University of California Collections* (1997) and *Oscar Wilde: From the Collection of the Clark Library, UCLA* (1999). Because of these exhibitions, Bruce Whiteman approached us with this ambitious project. In turn, he and Cynthia Burlingham of the Hammer Museum and Grunwald Center collaborated with an organizing team drawn from four major local libraries: the Huntington Library and the libraries of the Getty Research Institute, the University of Southern California, and the University of California, Los Angeles. The names of these committee members are listed in the catalogue, and we thank them for their imagination and dedication.

Finally, we wish to thank the generous funders of the exhibition: the Institute of Museum and Library Services, the Ahmanson Foundation, the Ralph M. Parsons Foundation, and the Getty Grant Program. They shared our vision of a lively, substantial exhibition that celebrates both our multifaceted community and the awesomely wide-ranging resources of human knowledge that are preserved here.

Ann Philbin
Director, Hammer Museum

David Stuart Rodes
Director, Grunwald Center for the Graphic Arts

8

Academy of Motion Picture Arts and Sciences, Margaret Herrick Library
Autry Museum of Western Heritage Research Center
Braille Institute Library Services
California Institute of the Arts Library
California State University, Long Beach, University Library, Special Collections
California State University, Northridge, University Library
Center for the Study of Political Graphics
Getty Research Institute, Library
The Huntington Library
Libraries of the Claremont Colleges, Denison Library, Scripps College
Libraries of the Claremont Colleges, Seeley G. Mudd Science Library,
 Pomona College
Libraries of the Claremont Colleges, Special Collections, Honnold/Mudd Library
Libraries of the Claremont Colleges, Sprague Library, Harvey Mudd College
Long Beach Public Library
Los Angeles Public Library
Loyola Marymount University, Charles Von der Ahe Library
Natural History Museum of Los Angeles County, Research Library
Natural History Museum of Los Angeles County, Seaver Center for Western
 History Research
Occidental College, Mary Norton Clapp Library, Special Collections Department
Otis College of Art and Design, Millard Sheets Library
Rancho Santa Ana Botanic Garden Library
Santa Monica Public Library
Southern California Library for Social Studies and Research
UCLA, Department of Special Collections, Charles E. Young Research Library
UCLA, The Elmer Belt Library of Vinciana, Arts Library
UCLA, History & Special Collections, Louise M. Darling Biomedical Library
UCLA, Music Library, Special Collections
UCLA, Richard C. Rudolph East Asian Library
UCLA, William Andrews Clark Memorial Library
University of Southern California, Archival Research Center,
 Doheny Memorial Library
University of Southern California, Cinema-Television Library
Western States Black Research and Educational Center

ORGANIZING COMMITTEE

Cynthia Burlingham
Hammer Museum and Grunwald Center for the Graphic Arts,
University of California, Los Angeles

Katharine E. S. Donahue
History and Special Collections, Louise M. Darling Biomedical Library,
University of California, Los Angeles

Bennett Gilbert
Antiquarian bookseller

Marcia Reed
Library, The Getty Research Institute

Marje Schuetze-Coburn
Special Collections, Doheny Memorial Library,
University of Southern California

Victoria Steele
Department of Special Collections, Charles E. Young Research Library,
University of California, Los Angeles

Stephen Tabor
The Huntington Library

Bruce Whiteman
William Andrews Clark Memorial Library,
University of California, Los Angeles

Wim de Wit
Special Collections and Visual Resources, Library,
The Getty Research Institute

David S. Zeidberg
The Huntington Library

Noriko Gamblin
Consultant

CURATORIAL SUBCOMMITTEE

Cynthia Burlingham
Noriko Gamblin
Bruce Whiteman
Wim de Wit

ACKNOWLEDGMENTS

The idea for this catalogue and exhibition originated with the members of *The World from Here* organizing committee, whose names are listed on page 9. Representing nine major special collections libraries across the city, they first met more than three years ago to initiate plans for an exhibition that would represent the extraordinary resources of our region's special collections libraries. We thank our fellow committee members for their interest in and commitment to helping to guide this project. We wish to recognize the extraordinary efforts of two members of the committee in particular. Wim de Wit contributed a significant amount of time and critical expertise to the curatorial committee and to the development of the exhibition checklist. The fund-raising acumen of Victoria Steele was also critical to the success of the project. We also wish to thank David Rodes and Ann Philbin for committing the staff and resources of the Grunwald Center and the Hammer Museum. In turn, the entire organizing committee joins us in thanking the following individuals and institutions.

The exhibition and catalogue have benefited from the generosity of several important funders. A National Leadership Grant from the Institute of Museum and Library Services was crucial in ensuring the realization of the project, and the Ahmanson Foundation guaranteed the publication of a comprehensive catalogue. The Ralph M. Parsons Foundation and the Getty Grant Program were generous in funding the interpretive installation and programs. We wish to thank the following individuals for their understanding and support of this unique project: Robert Erburu, Wendy Hoppe, Deborah Marrow, Jack Myers, and Lee Walcott.

The representatives of the thirty-two participating libraries deserve special acknowledgment for their generosity in lending important works from their collections. We thank them for their patience, flexibility, and enthusiasm and recognize that it was their loans that made this exhibition possible: Linda Mehr and Anne Coco, Margaret Herrick Library, Academy of Motion Picture Arts and Sciences; Kevin Mulroy, Marva Felchlin, and Laurie German, Autry Museum of Western Heritage Research Center; Henry C. Chang and Julie Ueno, Braille Institute Library Services; Coco Halverson, California Institute of the Arts Library; Irene Still Meyer, Special Collections, University Library, California State University, Long Beach; Tony Gardner, University Library, California State University, Northridge; Carol Wells and David Gabel, Center for the Study of Political Graphics; Judy Harvey-Sahak, Libraries of The Claremont Colleges (Denison Library, Scripps College; Seeley G. Mudd Science Library, Pomona College; Special Collections, Honnold/Mudd Library; and Sprague Library, Harvey Mudd College); Susan Allen, Mary Reinsch-Sackett and her staff, Margaret Honda, Beverly Faison, Jesse Rossa, Charles Merewether, Frances Terpak, and Nancy Perloff, Library, Getty Research Institute; Ruth Stewart, Long Beach Public Library; Daniel Dupill and Dan Strehl, Los Angeles Public Library; Errol Stevens, Charles Von der Ahe Library, Loyola Marymount University; Donald McNamee, Research Library, Natural History Museum of Los Angeles County; Jonathan Spaulding and Janet Fireman, Seaver Center for Western History Research, Natural History Museum of Los Angeles County; Michael Sutherland, Special Collections Department, Mary Norton Clapp Library, Occidental College; Sue Maberry, Millard Sheets Library, Otis College of Art and Design; Bea Beck, Rancho Santa Ana Botanic Garden Library; Cynni Murphy, Santa Monica Public Library; Sarah Cooper, Southern California Library for Social Studies and Research; Susan Rogers, Shelly Smith, Daniel Lewis, Alan H. Jutzi, and Mary Robertson, the Huntington Library; Daniel J. Slive, Anne Caiger, and Octavio Olvera, Department of Special Collections, Young Research Library, UCLA; Teresa Johnson, History & Special Collections, Louise M. Darling Biomedical Library, UCLA; Gordon Theil and Stephen Davison, UCLA Music Library Special Collections; Sarah Elman, Amy Tsiang, and Toshie Marra, Richard C. Rudolph East Asian Library, UCLA; Julie Graham, the Elmer Belt Library of Vinciana, Arts Library, UCLA; Jennifer Schaffner and Suzanne Tatian, William Andrews Clark Memorial Library, UCLA; John Ahouse, Archival Research Center, Doheny Memorial Library, University of Southern California; Ned Comstock and Steve Hanson, Cinema-Television Library, University of Southern California;

and Mayme Agnew Clayton, Western States Black Research and Educational Center. We would also like to thank Romaine Ahlstrom, formerly of the Los Angeles Public Library, and Kevin Salatino, formerly of the Library, Getty Research Institute.

We also recognize the members of *The World from Here* Scholars Advisory Committee—Ellen S. Dunlap, Anthony Grafton, Paul Holdengräber, Lynn A. Hunt, Peter Parshall, and Kevin Starr—and thank them for their good counsel and ideas.

We greatly appreciate the contributions of the staff of the UCLA Grunwald Center and the Hammer Museum. Particular recognition is due Claudine Dixon, Grunwald Center curatorial administrator, who has managed numerous aspects of the exhibition and catalogue with great professionalism and skill. Linda Duke, Hammer director of education, and Amanda Hogg, public programs coordinator, devised the educational programming, with the assistance of Graziella Zabatta, education assistant, and Janine Al-Janabi, youth programs coordinator. Other staff who have lent their skills and knowledge are Carolyn Peter, Grunwald Center assistant curator; Maura Seaman, exhibition assistant; Susan Lockhart, senior registrar; Grace Murakami, associate registrar; Mitch Browning, senior preparator; Andrew Breshears, preparator; Dana Turkovic, graphic designer; Maureen McGee, assistant conservator; Layna White, collections manager; Heidi Zeller, public information assistant; Mary Ann Sears, director of marketing and special events; Kim Miller, development associate; and David Blair, director of finance. We also recognize the contributions of former director of education Cindi Dale, former director of public information Terry Morello, and former director of development Arwen Duffy. At UCLA we thank university librarian Gloria Werner; Greg Barnes of the Office of Instructional Development; and Peter Reill, director of the Center for Seventeenth- and Eighteenth-Century Studies. It has been a pleasure to work with Rose Marshack in developing the exhibition Web site, as well as Sid Berger, director of the California Center for the Book at UCLA, and his staff, Natalie Cole, Justin Scott, and Aura Lippincott, who are assisting with technical matters to host the Web

site. We also extend our gratitude to Pamela Glintenkamp of Sandpail Productions for interpretive components; Ralph Hudson at Ironwood for fabrication of the installation; and Cynthia Wornham and the staff of Ruder Finn for their communications expertise.

The essayists and numerous catalogue entry authors have immeasurably enhanced our understanding of this material, and we thank them. Karen Jacobson's invaluable editorial skills, supported by Lynne Kostman's sensitive editing of the essays, have been greatly appreciated. The catalogue was designed by Lorraine Wild with the assistance of Amanda Washburn and Robert Ruehlman, and their intelligent and beautiful design sets a new standard for library exhibition catalogues. Paula Goldman's remarkable photographs contribute greatly to the presentation of the objects. Dianne Woo proofread the catalogue and copyedited the exhibition text with great care and efficiency. The index was prepared by Kathleen Preciado, who brought her customary speed and intelligence to the task. We are especially grateful to Mark Greenberg and Christopher Hudson of Getty Trust Publications for their enthusiasm for the project. The Getty's participation as distributor is allowing this volume to reach a larger audience.

The design of the exhibition was a particularly demanding and complicated venture, and we thank the design team of Tim Durfee, Iris Regn, and Louise Sandhaus. The interpretive context they created for the exhibition represents a noteworthy achievement in the field of exhibition design. The development and fabrication of the exhibition design were supervised by Gloria Gerace, and we are grateful for her good judgment and superb management skills.

Finally we reserve a special acknowledgment for *The World from Here* exhibition consultant Noriko Gamblin. Her dedication to this project over the last three years and her great professionalism in assuming a vast range of responsibilities have earned her the gratitude of all the participants in this project.

Cynthia Burlingham
Bruce Whiteman

When Flora Haines Loughead published a guide to the book collections of California in 1878, not a single accumulation of books of any appreciable size existed anywhere in Southern California. The 103 libraries in her survey—fourteen public libraries and eighty-nine private—were all in the Bay Area.[1] Although what would later become the Los Angeles Public Library had been formed by that time, the books then available for loan certainly did not amount to much of a "library" and thus evaded Mrs. Loughead's investigation. Los Angeles at that time had no real bookshops and would have no antiquarian booksellers for another quarter of a century. (Dawson's Book Shop was founded in 1905 by Ernest Dawson as the city's first store fully to specialize in rare books and manuscripts.)[2] Nicolas Barker is right to emphasize at the beginning of his essay in this catalogue that books are the oldest objects in daily use today in Los Angeles, but as recently as 125 years ago they were scarcely perceptible in the city at all. If there were then houses with rooms denominated libraries, they were probably like that in the house of William C. Ralston, one of the founders of the Bank of California, whose library the novelist Gertrude Atherton described as "a room rather small, handsomely furnished with laurel, and, as I remember, never a book."[3]

It is easy enough to emphasize the astounding development that bookish culture has made in Los Angeles in barely more than a century. From the fecund 1920s, when the Huntington and Clark Libraries were opened, and when the Los Angeles Public and UCLA Libraries both got permanent homes, to the 1990s, when the Getty Research Institute Library was completed, the number of books and other special collections materials that have come to the city and been added to publicly accessible collections is truly remarkable. Other great cities of the world have built their libraries over a period of centuries, and in many of them the early printed books in the collections were read by contemporary readers as new books. None of the books in the libraries of Los Angeles printed before 1800 were read in Los Angeles as new books, and the same applies undoubtedly to a substantial proportion of the books of the nineteenth century as well.

Like many of the great American libraries, those in Los Angeles benefited enormously from the golden age of

bibliophily in the United States, the period of two decades that runs from the Robert Hoe sales in 1911 and 1912 to the Kern sale in 1929, just months before the stock market crash. Those years saw a burgeoning of the cultural life of Los Angeles, a world that included not just bibliophiles but also printers, writers, and booksellers as well as artists, musicians, and others. A skein of people created a book culture in a very short period of time, and many of them can be spotted as the sellers or owners (even occasionally as the authors) of many of the books in *The World from Here*: Ernest Dawson, Alice Millard, and Jake Zeitlin among the booksellers; Grant Dahlstrom, Saul Marks, and Ward Ritchie among the printers; Phil Townsend Dana, Paul Jordan-Smith, and Lawrence Clark Powell among the writers about books; and William Andrews Clark Jr., Estelle Doheny, Henry Huntington, John I. Perkins, Sarah Bixby Smith, and others among the collectors.[4] Of course nationally known writers lived in Los Angeles as well—from popular writers like Zane Grey and Edgar Rice Burroughs, to middlebrow novelists like Hamlin Garland and Upton Sinclair, to noir specialists like Dashiell Hammett and Raymond Chandler. For all the popular identification of the city of angels with the film industry first and foremost, books and libraries have had and continue to have a powerful and ramified position in the cultural nexus of the place.

The World from Here attempts to explore the variety and richness of the rare books, manuscripts, and other special collections materials in the public collections of Los Angeles, city and county. The selection of objects is by no means definitive or exhaustive. Indeed a number of shows like this one could be done with 391 entirely different objects, and all of them would be equally convincing. Although some items in the exhibition are unique, many are not, and a similar show in any other large city would contain copies of dozens of the same items with equal validity and equal power, from the Nuremberg Chronicle to Darwin's *Origin of Species* to Ansel Adams's photograph *Moonrise over Hernandez, New Mexico*. The spatial trajectory and the historical process that brought a particular copy of a particular object to a Los Angeles collection, however, together constitute a unique enveloping story, a kind of special aura that to greater or lesser degree surrounds every object in *The World from Here*. The exhibition is not about Los Angeles in any direct way; one

Notes
1. Flora Haines Loughead, *The Libraries of California: Containing Descriptions of the Principal Private and Public Libraries throughout the State* (San Francisco: A. L. Bancroft, 1878).
2. Kevin Starr devotes some pages to the early antiquarian book trade in Los Angeles in his *Material Dreams: Southern California through the 1920s* (New York and Oxford: Oxford University Press, 1990). Dawson's is discussed on pp. 308–10.
3. Gertrude Atherton, *California: An Intimate History*, rev. ed. (New York: Boni & Liveright, 1927), 274.

4. See Starr, *Material Dreams*, especially chaps. 11 and 12, and Tyrus G. Harmsen, "Early Book Collectors of Southern California," in *A Bibliophile's Los Angeles: Essays for the International Association of Bibliophiles on the Occasion of Its XIVth Congress, 30 September–11 October 1985*, ed. John Bidwell (Los Angeles, 1985), 29–42.

might say rather that it is about the aggregate meaning of those 391 auras.

The choice of objects has been dictated by several factors. Only collections that are publicly accessible at no cost were asked to contribute, as it was felt that viewers of the exhibition should have the liberty to follow up objects of interest by visiting the participating institutions as readers. (This excluded certain institutions that charge for use, as well as most museum libraries, which are meant mainly or exclusively for curatorial consultation.) As much as possible, objects were chosen not only because they were rare or valuable but also because they represented real research strengths in the libraries from which they come. Isolated high spots were mostly avoided. Not all "great" books and manuscripts are visually interesting, and because *The World from Here* is a library exhibition being shown in a museum environment, visual interest helped when choices needed to be made between objects of otherwise equal intellectual importance or rarity. Many books were available in Los Angeles in multiple copies, and frequently the choice of which one to borrow was based not only on copy-specific features but also on the desire to represent fairly the smaller as well as the larger institutions. It must also be said that certain desirable objects were not made available for exhibition for a variety of reasons, and although their absence might be noticed by viewers knowledgeable about the rare book libraries of Los Angeles, the objects borrowed in their stead are none of them of the second or substitute class.

Despite the subtitle of the exhibition, *The World from Here* is in many ways not a conventional library treasure show. It would have been comparatively simple to have found copies of three hundred or so books selected from *Printing and the Mind of Man*; to have added some famous literary works, some manuscripts, and some photographs to that group; and to have been content to consider the resultant conglomeration an exhibition.[5] Certainly there are, inevitably, a number of objects in *The World from Here* that figure in various guides to the "great books." No exhibition of this type could have ignored the Caxton Chaucer or the Shakespeare First Folio or the Audubon *Birds of America*. But in every section of the show there are objects that have been included not for their treasure qualities as such, but because they are important locally or provoke

allusions to Los Angeles's cultural history—its meaning as a place where books and other objects are created, collected, and preserved. Objects of this sort are most densely collocated in section 1, which focuses on the "here" of the exhibition's title. They will be noticed in the other seven sections too, ranging from W. S. Merwin's *The Real World of Manuel Córdova* in section 2, to Susan King's *Support Living Artists!* in section 3, to the diary of a 1909 car trip in postcard form in section 7, to the John Cage manuscript in section 8. None of these items is a standard-issue treasure, but all of them are evocative objects that are intrinsically fascinating and that have a significant place in the cultural matrix that is the city of Los Angeles. They allow popular culture and contemporary culture to be infused into the exhibition, without reflecting or creating an adversarial view of Los Angeles book culture as a whole ("Disney against the metaphysicals," as Ezra Pound put it in "Canto CXVI").[6]

It is difficult, if not impossible, to speak of a unified or generalized Los Angeles. It is the city whose center is everywhere and whose circumference is nowhere. More than other megalopolises Los Angeles is a collection of things: of neighborhoods, of ethnicities, of geographies, of cities within a city. It is also a collection of books (if I may use "books" for a moment to represent all of the different kinds of objects exhibited in *The World from Here*). Scholars are used to consulting one book here and one book there, but librarians and curators tend to be parochial and to think of *their* collection as *the* collection. But the collection that is the collections of Los Angeles in the aggregate is how we need to think of the bibliothecal culture of the city, and at that level it is a truly astonishing "library." The members of the organizing committee who visited the many libraries that are participating in *The World from Here*, and who made the choices of what to include, have been astounded by the remarkable accumulation that Los Angeles's libraries represent. Comparisons are odious, and exact ones need not be proffered. But the tiny fraction of the important material in the city's special collections libraries that is gathered together in *The World from Here* is convincing evidence, I think, that Los Angeles is one of the great book cities of the world.

Bruce Whiteman

5. John Carter and Percy H. Muir, eds., *Printing and the Mind of Man: A Descriptive Catalogue Illustrating the Impact of Print on the Evolution of Western Civilization during Five Centuries* (London: Cassell and Company, 1967).

6. Ezra Pound, *The Cantos of Ezra Pound* (New York: New Directions, 1970), 796.

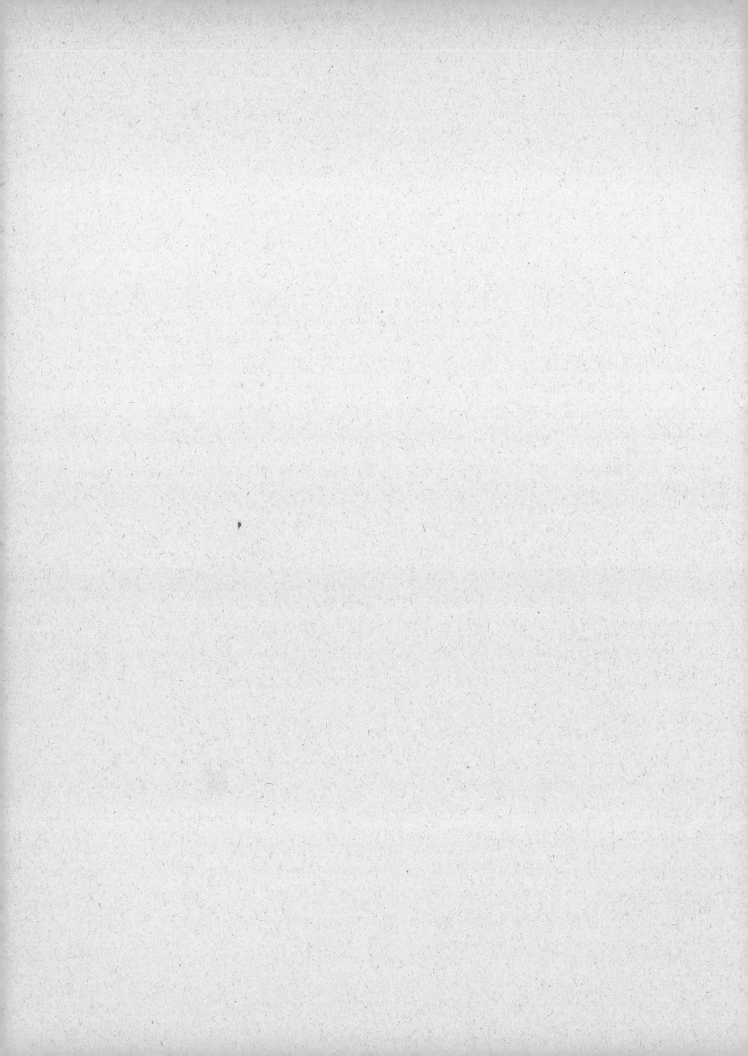

ANTHONY GRAFTON

LIBRARIES IN THE WEST
A MATTER OF TRADITION

Early in the 1920s the Anglo-Irish scholar Eliza Marian Butler arrived in Berlin, where she planned to study the papers of a German author of the Romantic period, Prince Pückler-Muskau. These were held in the Preussische Staatsbibliothek, which Ernst von Ihne had built for Kaiser Wilhelm just before World War I. This immense edifice had been completed in 1914 at the vast cost of twenty-five million marks. Its severe stone façade rivaled in size and grandeur those of the other grand official buildings that made Unter den Linden one of the stateliest avenues in any European capital. The kaiser had insisted on making the library's circular reading room the biggest in the world, even larger than that of the British Museum. Its extraordinary collections included not only German literary and musical manuscripts of the highest importance but also vast holdings of manuscripts and early printed books, which great historians such as Leopold von Ranke and Georg Voigt used to rewrite the history of Renaissance Italy. The Staatsbibliothek also housed great scholarly projects, above all the Monumenta Germaniae Historica, now in Munich.

In 1945 the Russian siege of Berlin reduced the reading room to an empty shell, pocked its façade with small craters and shell fragments, and destroyed or scattered large segments of its holdings. But even before this tragedy, the imposing library managed to cause problems for some of its users. The original heating system, for example, barely functioned. The great and venerable historian Gustav Droysen had to wrap his feet in a vast green and black blanket before he felt warm enough to work. And the handwritten card catalogue was far less sophisticated than the great comprehensive catalogues already being elaborated in London and Paris.

But Butler's experience was far worse than usual. "This," she wrote many years later,

was without exception the most hopeless and hideous institution I have ever come up against. Truculence, obstructionism and inefficiency were all snarled together with red tape in grisly Gordian knots. There was chaos in the catalogue-room, relentlessness in the reading-room, and insolence wherever you went. The officials must have come straight out of Kafka's Castle; their one object in life was to thwart you and to paralyse your efforts to circumvent them by disappearing into the canteen. The hours I wasted waiting for them to emerge from that fastness must have added up into days; and I was sometimes so limp when I got the books as hardly to be able to read them.[1]

Butler's mood did not improve when the unpublished letters she had hoped to find proved illegible. When she ventured into the canteen, she provoked fury among the library's employees by deciding to open a window. The whole experience did much to instill in Butler the dislike for German scholarship that would inspire her famous polemic, *The Tyranny of Greece over Germany* (1935).

When Butler retreated from the canteen into the courtyard, however, matters improved. A tall, dandified man, leaning on an ebony stick and wearing a monocle, politely inquired: "Illegibility aloft, hostility below?" She nodded. "It'll be easier upstairs tomorrow," he promised, and after warning her to "watch out for [his] e's and r's" and to stay out of the canteen, he vanished. The ghost's tip worked wonders. Butler cracked the prince's handwriting and produced a compulsively readable book from the letters she deciphered.[2] And one point of this story becomes immediately clear: great libraries are always enormous haunted houses, populated by ghosts. These range from those of the slaughtered cattle and sheep on whose skins thousands of medieval manuscripts were written, and which manifest themselves to the nose when a great collection's manuscript vault is opened in the morning, to those of the patrons, writers, and readers who have lived out their cramped lives—as a character in George Gissing's *New Grub Street* (1891) put it—like "hapless flies caught in a huge web," submerged in the peculiar miasma

of gloom, rivalry, and bile that the life of letters can generate.[3]

A second point is equally clear: libraries reflect the character of the larger communities they serve. Berlin, after all, was far from the only great modern city to place a vast central library in a prominent urban space. New York had done the same in 1898, employing the firm of Carrère and Hastings to replace the old Croton Reservoir at Fifth Avenue and Forty-second Street with a vast marble palace of the book. And its "great marble steps," "grand staircase," wooden paneling, vast halls, and glowing display cases full of incunabula and literary manuscripts made a powerful impression on readers like the young Alfred Kazin, who spent five years doing research there in the 1930s. The library's scale and dignity spoke eloquently of a nobler past. But its staff had none of the bureaucratic stiffness of their Prussian counterparts. They were as openhanded and easygoing as the Berlin librarians were hostile and aggressive. "Anything I had heard of and wanted to see," Kazin recalled, "the blessed place owned: first editions of American novels out of those germinal decades after the Civil War that led to my theme of the 'modern'; old catalogues from long-departed Chicago publishers who had been young men in the 1890s trying to support a little realism: yellowing, crumbling but intact sets of the old *Masses*."

Kazin, a freelance writer and occasional teacher of evening classes, had no impressive academic or literary credentials. But "no one behind the information desk ever asked me *why* I needed to look at the yellowing, crumbling, fast-fading material about insurgent young Chicago and San Francisco publishing houses in 1897." Far less did anyone suggest that the young man should content himself with "something more readily available." The whole society and culture of the American 1890s, the era of brownstones, long rustling skirts, and the literary rebellion that took shape across the country in little prairie towns and crowded urban newspaper offices—all of this revealed itself to Kazin effortlessly in room 315.[4]

Great libraries, in other words, are all haunted, but not by the same ghosts. They can be either utopia or dystopia for the scholar and writer: vast literary armories full of weapons ready to be used or vast, frustrating

1. E. M. Butler, *Paper Boats* (London: Collins, 1959), 96.
2. Ibid., 106.

3. George Gissing, *New Grub Street*, ed. Bernard Berganzi (Harmondsworth: Penguin, 1968), 138.
4. Alfred Kazin, *Starting Out in the Thirties* (Boston: Little, Brown, 1965), 133–37; idem, *New York Jew* (New York: Knopf, 1978), 4–8.

museums where the most glittering exhibits are kept safe behind glass, away from prying hands and eyes. They may, like the New York Public Library, reflect an open, receptive society, or like the Umweltbibliothek, which harbored much of the opposition in the former East Berlin, they may offer intellectual and moral resistance to a larger society that censors all publications and denies a hearing to unofficial or dissident views.

A single library can present both faces. To Butler, a foreigner and a woman, the Preussische Staatsbibliothek presented a spiky hedge of obstacles. But to young German historians like Felix Gilbert, who worked there in the same period, it offered something very different: a haven of repose and a place for quiet, daring conversations, a forum where one could securely discuss political questions that could no longer be raised in public with impunity. The courtyard and the famous rooms of the great editorial project, the Monumenta Germaniae Historica, provided space for reflection and discussion in the midst of Weimar and Germany's most politically and culturally contested city.[5] In short, any great library is experienced in very different ways—by its staff and its users, by regular and occasional visitors, by the diplomatic and the gruff.

Los Angeles, the imperial city of the American West, began to develop libraries on an imperial scale early in the twentieth century.[6] These libraries, though designed to serve large cultural imperatives, took shape for the most part as the brainchildren of individuals. Even the most imperial of all, the libraries of the University of California, Los Angeles, were chiefly shaped by the initiative of one great librarian, Lawrence Clark Powell. Other individuals, like the brilliant book dealer Jake Zeitlin and University of Southern California philosophy professor Ralph Tyler Flewelling, had a comparable impact, if on a smaller scale. Zeitlin, a scholar and printer as well as a bibliophile, did more than anyone else to form UCLA's great collections in the history of science and to develop the taste for fine printing that has enormously impacted private and public collecting in Southern California. And Flewelling managed to build from scratch one of the world's great collections on the history of philosophy. Evidently Los Angeles—a city that has grown explosively in the twentieth century and

that has enabled many individuals to acquire unprecedented levels of power and fortune—has nourished libraries with its own, profoundly local style.

Two stories of important Los Angeles book collections will stand here as representative of many others. Exemplars of new money on the grand scale, Henry Edwards Huntington, whose real estate investments and Big Red Cars did much to create the city of Los Angeles, and William Andrews Clark Jr., whose father had made a vast fortune from mines and smelters, set out to create outposts of English civilization in the American West. Both men collected grandly, Huntington by swallowing up whole libraries, Clark more selectively. Huntington, for example, bought the entire Bridgewater House library of Sir Tomas Egerton in one swoop. Both were aided, and sometimes hindered, by brilliant intermediaries.[7] Both built magnificent buildings designed to express the European cultural standing embodied by the books stored and displayed within them. And, finally, both built private libraries that became the seats of a new kind of scholarship.

From early on, Huntington saw his library not only as a set of books but also as the foundation for a scholarly enterprise. He moved his collection to his vast, 550-acre property in San Marino, where he lived in splendor in a mansion built in the style of Louis XVI. In 1923 he built a separate colonnaded mansion for the library. Huntington hired full-time research fellows to work in the library under the leadership of distinguished supervisors, who themselves had often been hired away from great universities. Others came for sabbatical leaves and shorter stays. The Huntington estate—with its vistas and statues, palm trees and Japanese gardens, and acres of rare cactus plants—provided a unique island for scholarly retirement and contemplation, and a base for the expenditure of massive scholarly energies.

At nearly the same time, Clark hired the brilliant architect Robert D. Farquhar to build a splendid brick villa richly decorated in Renaissance style to house his books. This complex, though smaller in scale than the Huntington, ranks among the handsomest libraries in the world. Robert Cowan, Clark's librarian, and Henry Raup Wagner of the Huntington compiled the first accurate bibliographies for the history of California under Spanish and then under American rule in the Clark and Huntington Libraries.[8]

5. See Horst Fuhrman, "Sind eben alles Menschen gewesen" (Munich: Beck, 1996); cf. F. Gilbert, "The Historical Seminar of the University of Berlin in the Twenties," in An Interrupted Past: German-Speaking Refugee Historians in the United States after 1933, ed. Hartmut Lehmann and James J. Sheehan (Cambridge: Cambridge University Press, 1991), 67–72.

6. Kevin Starr, The Rise of Los Angeles as an American Bibliographical Center (Sacramento: California State Library Foundation, 1989).

7. Among these was the book dealer A. S. W. Rosenbach, who at one auction at Sotheby's recognized that a modest pamphlet supposedly printed at Cambridge,

England, in 1668 had actually been printed at Cambridge, Massachusetts. Rosenbach bought the first volume of verse produced in New England for fifteen pounds and sold it again to Huntington at the same low price, charging only his normal 10 percent commission.

8. In addition to Starr, see John Edwin Pomfret, The Henry E. Huntington Library and Art Gallery from Its Beginnings to 1969 (San Marino, Calif.: Huntington Library, 1969); Donald C. Dickinson, Henry E. Huntington's Library of Libraries (San Marino, Calif.: Huntington Library, 1995); and the short but pointed account in Anthony Hobson, Great Libraries (New York: Putnam, 1970), 298–305.

Both collections, finally, outgrew the original goals of their creators. The Huntington, created to support the study of early modern and modern English literature, eventually included in its holdings everything from magnificent medieval manuscripts and early printed books from all over Europe to a set of photographs of the Dead Sea Scrolls, which transformed the study of early Christianity when they were finally made available to scholars. The Clark collection, which began by emphasizing British literature of the seventeenth and eighteenth centuries and the London of Oscar Wilde, became a comparably active center for students of European as well as English intellectual history.

At the start of the twenty-first century, these and other collections in Southern California—as the present exhibition demonstrates—amount to a splendid encyclopedia of human social and cultural history. Their holdings document the exploration of the world by travelers, the exploration of the cosmos by natural philosophers, and the exploration of the human body by artists and anatomists. They include Eastern and Western religious and literary classics in hundreds of languages and scripts; magnificent manuscripts on vellum; precious objects; incunabula on creamy rag paper, as fresh now as the day they were created; and pamphlets, newspapers, and ephemera on thin, brittle, yellowed newsprint. They offer information about all periods of human history and about hundreds of peoples who have no written history of their own. They nourish the intellectual life of scholars and citizens in Southern California, as well as visitors from every corner of the world. They also embody many of the forms that libraries have taken in the West. The Los Angeles collections, for all their up-to-date computer catalogues and security systems, however, reflect ancient traditions in the gathering and organization of knowledge.

Libraries go back, if not to the earliest centuries of recorded Western history, at least deep into the history of the ancient world. True, the cities of Mycenaean Greece, as archaeology revealed them in the nineteenth and twentieth centuries, had extensive archives listing royal possessions, but no scriptural texts or technical manuals have yet appeared to rival those preserved in the archives of older scribal cultures in Egypt and Mesopotamia. Written books

circulated freely enough in the Athens of the fifth century B.C. that prices became relatively low, and as early as the fourth century B.C. the plan for a substantial research library had crystallized.

In Athens, Aristotle, the Macedonian philosopher and student of Plato, created the first systematic research library as part of his larger institution, the Lyceum. He and his pupils preserved and studied the works of Plato, as well as Aristotle's own treatises and lectures. But these were only the core of what became a great collection. Convinced that the only way to master many problems—such as the nature of constitutions and their relation to the natures of peoples—was to collect information systematically, Aristotle set himself and his students to gather accounts of all known states before he composed his *Politics*. This apparently abstract and schematic treatise actually rests on the examination of no fewer than 158 constitutions: systematic efforts by Aristotle and his pupils to record the development of every city's institutions. The clear, simple categories of Aristotelian political thought crystallized only after the philosopher had made a massive scholarly effort, dredging through dozens of texts of very different kinds to master the whole range of forms of political experience.

In other fields as well, Aristotle's system clearly rested on a similarly massive effort to gather and sift through large amounts of literary evidence. To create a rigorous natural history, he interrogated fishermen, watched bees arriving at their hives, dissected starfish, and read everything that earlier philosophers had written about the cosmos and the earth. True, Aristotle was no modern historical scholar. When he set out to trace the development of opinion on an issue in metaphysics or natural philosophy, as he regularly did, he took more interest in setting off his own views effectively than in giving a full and precise historical account of what his predecessors had really thought and argued. His versions of the thoughts of others were often inflected by his own philosophical views and sometimes amounted to little more than doxographies, or lists of opinions. Only in exceptional cases did he himself identify the written sources upon which he drew. Accordingly, it is impossible to establish with precision the full scale of the collections Aristotle assembled. But he

and the institution he founded suggested for the first time that rational inquiry into many subjects must rest on research and that research must in turn rest on a systematic effort to collect and organize books of various types and origins. His model lies behind all later Western research libraries, and his systematic, taxonomic approach to the world lies behind all catalogues.[9]

The library that Aristotle had incorporated into the plan for his school became an institution in its own right in Alexandria, the Greek city founded in Egypt by Alexander's successors, the Ptolemies, late in the fourth century B.C. Here, as foreign rulers trying to prove themselves legitimate and powerful in an ancient country, the Ptolemies spent money lavishly to possess, in a brutally material sense, Greek culture in all its forms. In a temple precinct they established an enormous collection of books on papyrus rolls, supposedly almost five hundred thousand of them. They also appointed librarians, who carried out a whole series of tasks. The librarians acquired books for the library, both new texts by recognized writers and more reliable texts of well-known works such as the epics of Homer and the tragedies of Aeschylus, Sophocles, and Euripides. Their task often proved difficult and costly. To obtain the best possible texts of the Greek tragedians, the library paid an enormous deposit to borrow the official Athenian state copies. When it failed to return them, it forfeited ten talents to Athens. In other cases, including that of the Hebrew Bible, as one ancient account would have it, the library paid to have works in Near Eastern languages translated into Greek. Rich, glittering, and ambitious, the West's first great library represented a massive effort to create a publicly supported memory bank for a brand-new society—another function that libraries have served again and again, down to very recent times.[10]

The library's very success and the large scale on which it operated caused problems. Rival Greek-speaking dynasties, such as the Attalids of Pergamum in Asia Minor, founded collections of their own. Prices for rare books went up. Ingenious gentlemen began to forge texts, which they ascribed to prominent writers of the past and sold to competitive librarians. Moreover, the vast mass of material that the library contained raised new intellectual questions. The library continued to accumulate copies of even such

accessible works as Homer's epics, which it obtained not only by purchase but also by confiscating copies brought into Alexandria on ships. But these texts did not always agree with one another. Someone had to determine which texts were genuine and which manuscripts deserved credence. And someone had to explain textual references to recondite myths, obscure points of history and geography, and the like.

Callimachus, a poet as well as a scholar, carried out one of these tasks. Assembling *pinakes*, or lists of works ascribed to major authors, he used considerations of style and appropriateness to determine that certain works were "legitimate" and others "illegitimate," employing terms derived from Greek family law. Both he and other librarians, moreover, set about solving the multiple textual problems that confronted them. Using a system of symbols, which became more and more elaborate, they annotated Homer's epics, condemning many verses as inappropriate or spurious and then drawing up commentaries keyed to the text in which they gave reasons for their verdicts. The library, like its rivals, became a center for a new kind of literary scholarship and a new consciousness of history. Other texts as well became the objects of efforts at learned exegesis, emendation, and criticism.

At their full development, the Hellenistic libraries amounted to vast encyclopedias, richly equipped with works on history and geography as well as literature and philosophy. Callimachus himself drew on these materials, as did later Alexandrian poets, to produce learned, heavily allusive poetry—a poetry of the book, dependent on study of many sources and aimed at trained readers who could decipher carefully coded references. Following the example set by Herodotus and other historians, who had tried for centuries to collate and sort out divergent accounts of early Greek history, Hellenistic scholars began to create precise, systematic accounts of space and time in the Mediterranean world. Eratosthenes, also an Alexandrian librarian, devised a clever way of measuring the circumference of the world in the process of creating what he considered an accurate world map. He also tried to work out the chronology of the early history of Greece, the misty times that preceded the start of the Olympic Games in the eighth century B.C. By the second century

9. See in general Rudolf Pfeiffer, *Geschichte der klassischen Philologie*, 2d ed. (Munich: Beck, 1978), pt. 1, chap. 3. Pfeiffer, however, underplays the role of Aristotle in creating the tradition of scholarship. The best survey is now Lionel Casson, *Libraries in the Ancient World* (New Haven: Yale University Press, 2001).

10. For a fine general survey, see Christian Jacob, "Lire pour écrire: Navigations alexandrines," in *Le pouvoir des bibliothèques: La mémoire des livres en Occident*, ed. Marc Baratin and Christian Jacob (Paris: A. Michel, 1996), 47–83. For a more detailed account, see Pfeiffer, *Geschichte*, pt. 2.

A.D., when the great Alexandrian astronomer Claudius Ptolemy set out to compose a complete geography of the inhabited world, he could draw together an immense amount of information—from literary sources, travelers' accounts, histories, and military expeditions—on everything from the longitude and latitude of particular places to the nature of their inhabitants. His near-contemporary Galen, the greatest medical author of the ancient world, applied Alexandrian scholarly tools and collected variants in order to purify the works of the greatest earlier medical writer, Hippocrates. New models of scholarship, made possible by and largely created in the library, transformed the world of learning—not only in Greek cities but also in Rome, where by the first century A.D. Varro and other scholars applied similar techniques to the canon of Latin literature.

Alexandria, in other words, stands for one kind of public library: one that deploys vast resources to carry out immensely ambitious plans and, by doing so, creates not only a new deposit of traditions, a new artificial memory, but also the conditions that make new intellectual enterprises possible. In later centuries, Renaissance popes and Enlightenment philosophers, Victorian entrepreneurs and late twentieth-century masters of the Internet would devise similar projects, many of which were realized in stone and brick. For all their differences, the vast imperial libraries of the nineteenth century—the Bibliothèque Nationale in Paris, the British Museum in London, the Library of Congress in Washington, D.C.—made natural successors to the library of Alexandria. Like it, they promised their makers cultural prestige. Like it, they brought together unprecedented reserves of information. Like it, above all, they stimulated the creation of new methods for codifying and explicating the Babel of conflicting traditions that they amassed. The new, critical medieval scholarship of the nineteenth century, for example, could not have taken shape without the tremendous stores of material in Europe's national libraries. The vast resources of Los Angeles's collections, considered both cumulatively and individually, make the American metropolis on the Pacific Rim a natural successor to the first great multicultural entrepôt on the Mediterranean.

In their physical and institutional form, however, the great Los Angeles collections emulate a second model of the public library. This can be located most concretely in the Europe of the Renaissance and Reformation, though its roots also stretch back into the ancient and medieval worlds. Libraries began to grow substantially in the thirteenth century, and over the next two hundred years, mendicant orders, cities, and royal houses all built substantial collections of books. So did the papacy in its fourteenth-century period of captivity at Avignon. At this epoch, library reading rooms took on what remains their canonical shape with ranks of wooden tables to which manuscripts were chained.

At the same time, however, individual scholars like Francesco Petrarca, better known as Petrarch, began to insist that they needed to build or gain access to a new kind of collection. Even the best existing libraries could not satisfy their deepest intellectual needs. This realization was intimately connected with the rise of a new intellectual and literary movement, Renaissance humanism. The humanists, who rebelled against what they saw as the arid, abstract, and inhuman philosophy and theology of the late medieval universities, turned back to the Greek and Roman classics. There they found something that they believed the schools and universities of their time could not provide: books that not only offered profound statements about politics, history, and the human condition but did so in a language so eloquent that they affected their readers, making them wish to improve themselves.

Petrarch, the most influential of the early humanists, noted on the flyleaf of one of his favorite books that he had strong and distinctive literary tastes. In fact, he made a list of what he called "my special books; I have recourse to the others not as a deserter but as a spy."[11] And he made his library—the meticulously collected books whose margins he covered with a filigree of densely cross-referenced annotations—into a unique research instrument, one focused on the history, rhetoric, and poetry of ancient Rome. Petrarch also realized, as the Alexandrian scholars had, that many of the texts he most cherished were disfigured by gaps and scribal errors. He managed to bring together texts that had been dispersed in the Middle Ages: for example, he assembled in one manuscript most

11. Berthold L. Ullman, *Studies in the Italian Renaissance* (Rome: Edizioni di storia e letteratura, 1973); Carol Everhart Quillen, *Rereading the Renaissance* (Ann Arbor: University of Michigan Press, 1998); and, for the wider context, L. D. Reynolds and N. G. Wilson, *Scribes and Scholars*, 3d ed. (Oxford: Clarendon Press, 1991), chap. 4.

of the portions of texts by the Roman historian Livy that survive today. He also examined multiple manuscripts of a given text to recover better readings and began the process of assembling commentaries and reference works as well. What had begun as a search for poetic and moral inspiration grew naturally into something more complex: a search for exact knowledge about the ancient writers' lives and texts.

Within a generation, influential scholars were making similar efforts on a larger, even collective, scale. Petrarch's disciple Coluccio Salutati, for example, was chancellor of Florence as well as a student of the classics. He built up a great library of his own; he encouraged younger scholars to work with him; and he made clear that only public collections of the classic texts, based on carefully chosen and copied manuscripts, could put an end to the growing corruption of ancient sources caused by scribes who altered whatever they did not understand. "Let public libraries," he wrote, "be established, which should contain the full range of books. And let great experts be set in charge of them, men who can review their texts with the greatest care and who can expunge their discordant and variant readings with exemplary judgment."[12] Salutati's disciples, like the brilliant book hunter Poggio Bracciolini, sought out rare classical texts in the monastic collections of the Middle Ages, copying them when they had to and stealing them when they could. A network of informants, spies, and copyists grew up, which gave great scholars like Salutati immediate leads on new discoveries. And though Salutati's own books were dispersed by his heirs, his plans soon found realization.

In the fifteenth century, wealthy individuals and great families in Italy and northern Europe adopted the new fashion for classical learning. They too started to amass substantial collections and to make them available not to the public as a whole but to young men who came equipped with scholarly credentials. The first library in the new style was created by a private individual of relatively modest means. Niccolò Niccoli, a member of a wealthy Florentine family, spent his patrimony freely, eventually exhausting it, in order to build the richest collection he could of Latin texts. He exerted himself not only to obtain books but also to find the oldest and most accurate ones

available. Poggio, a brilliant writer of Latin who served the papacy for many years, worked as Niccoli's eyes abroad, using the opportunities travel offered to spy out unknown or little-known texts and buy or copy them. Niccoli made his house into a combined library and museum, where ancient gems and fragments of ancient sculptures flanked the books—a stylistic choice that would prove influential. Unlike most collectors at the time, Niccoli saw his books not merely as his own possessions to be jealously guarded but also as the property of the community of scholars— what came to be known as the "republic of letters." By the time Niccoli died, his library included some eight hundred books, two hundred of which were out on loan.[13]

The Medici family, close friends of Niccoli's who helped him financially, bought his library after his death and installed it in the Dominican convent of San Marco in a splendid space purpose-built for books by their architect, Michelozzi Michelozzo.[14] This and other libraries created in the middle of the fifteenth century from Rome to Cesena became the physical models of what a public library should be: a clean, well-lighted reading room equipped like medieval libraries with wooden benches and reading desks to which the books themselves were chained. Readers were still expected to stand by the desks and read the books in situ. Only unusually generous collections, like that of the Vatican, allowed some books to be taken home for study, wrapped in their chains to remind readers that they must someday be returned. And even the Vatican admitted readers into only two of its four rooms: the rest were the ancestors of modern special collections.

To some extent, in other words, these collections emulated existing models. Yet they were novel in many ways as well. In the first place, they were secular in orientation. Their creators, like Nicholas V and Cosimo and Lorenzo de' Medici, looked back to the Ptolemies with admiration and wonder. They liked to compare the size of their collections to that of the Alexandrian library. In practice, however, their aspirations were quite different. Trying to master a much longer past than the Ptolemies had been concerned with, they set out for the most part to collect only in certain selected areas—especially the Greek and Latin classics, as Petrarch had recommended long before, and the Bible. They took care to buy not only the best but

12. Berthold L. Ullman, *The Humanism of Coluccio Salutati* (Padua: Antenore, 1963), 101.
13. Berthold L. Ullman and Philip A. Stadter, *The Public Library of Renaissance Florence* (Padua: Antenore, 1972).
14. E. Garin, *La biblioteca di San Marco* (Florence: Nuova Italia, 1999).

also the most beautiful manuscripts they could, no longer scrolls but codices, written on parchment or paper in the revived Carolingian or newly created italic scripts, which they saw as especially attractive. Their collecting was sometimes an urgent enterprise: both Lorenzo de' Medici, who sent buying agents through the former Byzantine Empire, and Cardinal Bessarion, who left his massive library to the Venetian state, were trying to gather the fragments of the Greek heritage before these were permanently dispersed. But they also did their best to make their collections attractive, equipping them with windows for natural light; elegant frescoes, usually depicting great writers of the past; astronomical instruments and maps. Some great Renaissance libraries, like that of the Hapsburgs in Vienna, grew into museums on the grand scale, where fossils, gems, and works of art flanked and illuminated the books.[15]

In some courts, libraries became centers of a new kind of social life. In the Aragon of Alfonso I, for example, humanists assembled before the king in his library for "hours of the book," where they held one another's scholarship, Latinity, and morality up to bitter scorn. In Ferrara, the bastard ruler Leonello not only collected texts but also discussed them in detail with his learned courtiers—and ridiculed modern writers who tried to insinuate their inferior work into his collection. These libraries were, to a new extent, publicly accessible—at least for that small part of the public that could read, write, and speak classical Latin. Nicholas V claimed that he wished the Vatican Library he created to be used by "the whole Roman curia." By the end of the sixteenth century, as the Counter-Reformation took hold and religious wars bred bitterness and suspicion, readers were no longer allowed in the Vatican and many other great collections. In the early years, however, anyone who had a proper letter of introduction and adequate standing in the humanistic republic of letters could count on a friendly reception and the chance to see a rare text or a fine set of miniatures.

In the fifteenth and sixteenth centuries, such libraries developed throughout Europe as great collectors competed and cooperated. Standard plans developed. The cleric Tommaso Parentucelli—before he became Pope Nicholas V and built his own new library in Rome—

drew up a canon of great books that Malatesta Novello employed to build his small but select and lovely library at Cesena.[16] Some collections—like the royal, princely, and noble libraries that were growing rapidly in France and Burgundy—amounted to thousands of volumes and were lodged in castles. Sometimes these official collections were housed in splendid public buildings or, as at Leiden and Oxford, served great universities. Often, however, great collections continued to be private, owing their existence to and finding their lodgings in the private houses of learned noblemen like Jacques-Auguste de Thou or erudite gentlemen like John Selden or Robert Cotton.

Whether private or public, court-based or urban, these libraries fostered new kinds of sociability, as their Italian prototypes had. They became the stage for decorous—and indecorous—conversations about classical texts, political news, and much else. When Michel de Montaigne visited Rome in 1581, the central episode in his stay, as he recorded it in his travel diary, was his visit to the Vatican Library. He made clear that he was as struck by its decor and its objets d'art as by its extraordinary books:

On the 6th of March, I went to see the Vatican Library, which is laid out in five or six rooms in sequence. There are a great many books attached to desks, arranged in ranks; and there are many more in chests, which were opened for me. A vast quantity of manuscripts, including a Seneca and the Moralia of Plutarch. Among the notable things I saw there was the statue of Aelius Aristides with a bald head, a very thick beard, a great forehead, and a countenance expressing his gentle, majestic character: a book from China in barbaric writing, on leaves made from a substance much softer and more translucent than our paper.[17]

He also saw an ancient papyrus scroll, a manuscript of Saint Thomas Aquinas with corrections in the great theologian's own hand, the presentation manuscript of Henry VIII's book against Martin Luther, and the Codex Romanus of Virgil, written "in that long and narrow script that we see here [at Rome] in inscriptions from the time of the emperors." Evidently Montaigne enjoyed free access to the library's treasures and learned guidance to them—perhaps

15. See in general Anthony Grafton, *Commerce with the Classics* (Ann Arbor: University of Michigan Press, 1997), chap. 1.

16. Hobson, *Great Libraries*, 66–75.

17. Michel de Montaigne, *Journal de voyage*, ed. F. Rigolot (Paris: Presses universitaires de France, 1992), 111.

from his friend Marc-Antoine Muret, with whom he would discuss Jacques Amyot's French translation of Plutarch at dinner a few days later. Almost a century before Montaigne, young Italian scholars like Pietro Bembo and Pietro Crinito had had similar experiences in the Library of San Marco, where they sat respectfully as the brilliant, controversial polymath Pico della Mirandola discussed questions of theology and history with Angelo Poliziano and others. Almost a century after Montaigne, the *cabinet* of de Thou would be every erudite young man's first port of call in Paris. It was the perfect place to discuss such news as the rediscovery of Petronius's account of Trimalchio's dinner, a rediscovery that occurred around 1650 and sent shock waves across Europe's entire literary landscape. A whole world of learned friendship was created and sustained in these light new spaces, which, in modern terms, hung suspended somewhere between the public and the private sphere.

The new libraries promoted more than mannerly encounters among gentlemen. Many of them also became specialized scholarly instruments. There was, as Renaissance and Reformation scholars knew, ample precedent for this. The Romans of the late Republic and early Empire offered models for public and private libraries and for the ways that learned men should use them. All scholars knew Cicero's accounts of the discussions he held with his brother in the library in his country villa. In his *De finibus* they read his description of dropping into the library of the fabulously rich Lucullus only to find Cato already at work there. And in the *Noctes Atticae* of Aulus Gellius they found numerous descriptions of the libraries of imperial Rome— large and pleasant rooms filled with books where scholars met to discuss variant readings in the works of Virgil. It was, in short, from Rome more than from Alexandria that Renaissance patrons and scholars derived their notion of the atmosphere that a library should foster.

The ancient world offered other models as well. In the first centuries of its existence Christianity, a new religion, had needed to muster intellectual as well as liturgical and spiritual resources. In Caesarea, Herod's city in Palestine, a massive library grew up that specialized in study, editing, and commentary on the Christian classics. There Origen produced, and deposited, his *Hexapla*,

an edition of the Bible that juxtaposed six different texts in parallel columns. In the fourth century, Eusebius and the young scholars who worked with him used the library at Caesarea to draw up their histories of the world and the Christian church and their lives of Christian martyrs. Still later, Saint Jerome could once more use the books Origen had assembled as he set out to create a new Latin translation of and elaborate commentaries on the Old and New Testaments.

In the Reformation, Protestants and Catholics alike created libraries designed to prove that their version of Christianity, and only theirs, was historically valid. Matthias Flacius Ilyricus built up a substantial collection in Magdeburg, where he and his collaborators toiled to produce the first Protestant history of the Church and incurred suspicion that they had acquired their rare texts not only by purchase but also by adroit use of "Flacius's razor." Thomas Bodley endowed his library at Oxford in the hope of creating a Protestant research center on a much grander scale, a program matched by Cardinal Federico Borromeo, who turned the Biblioteca Ambrosiana at Milan into a Counter-Reformation counterpart to the Bodleian.[18]

The largest of these new libraries—like the magnificent Baroque information retrieval machine at Wolfenbüttel which Leibniz organized and where Lessing worked as librarian—harked back in some ways to Alexandria. For example, all of them developed their own systems of cataloguing, assembled collections of reference materials (including the catalogues of other libraries), and tried to ascertain whether the texts they contained were genuine or spurious. Unlike the Alexandrian library, however, they usually did not try to engorge the entire human memory bank. Instead, they confined themselves for the most part to subjects seemingly relevant to their creators' hopes (which were often loosely interpreted).

In many cases, they became not only passive collections but active centers of scholarly production, housing teams of scholars who devoted their entire lives to research and publication. This model would develop endlessly in later centuries—from the great Benedictine scholars of the seventeenth and early eighteenth centuries, who turned their order's libraries into one great series of linked research groups, to the great German-

18. Anthony Grafton, *The Footnote: A Curious History* (Cambridge: Harvard University Press, 1997).

Jewish art historian Aby Warburg, who made his personal collection of works on Renaissance art and culture the nucleus for a superb new research institute, which came into existence in Hamburg and still exists, albeit in much-altered form, in London. In their resolute idiosyncrasy, their willingness to subordinate the ideal of universal coverage to the desires and tastes of individuals, these libraries originally represented a different ideal (even though, over time, many of them lost their original identities as they were acquired by and dissolved into larger collections).

No form of library has been more productive in America than this second, specialized type. The Folger Shakespeare Library in Washington, D.C., the Newberry Library in Chicago, and the Philadelphia Athenaeum all embody in different ways the ideal of a single collection, limited but substantial in size, designed to foster both systematic research and scholarly discussion. For all their aggressive collecting policies and rapid expansion, the libraries of Los Angeles represent an agglomeration of small, specialized collections of this kind, more specialized in their original aim than in their final form. The splendid architectural settings in which they are housed and the forms of intellectual life that they support and promote, from conferences and seminars to informal conversations,

all hark back to the prototypes created on classical models in early modern Europe.

At the start of the twenty-first century, e-businesses around the world are sketching plans for electronic libraries at once more capacious and more systematically catalogued and organized than any collection of books could ever be. The bounds of all local collections threaten to burst, as electronic catalogues and resources extend individual libraries' ability to give access to books and manuscripts not physically in their possession. Even libraries' Web pages—which now contain hundreds, even thousands, of links and subsidiary pages—need custom search engines. The new collections taking shape are genuinely—as Erasmus said with a little exaggeration of the books printed in small format by Aldus Manutius—libraries without walls. *The World from Here* is especially valuable in this context. Using Los Angeles as a privileged example, it reveals—in the colors and textures, the lively detail, and the rich profusion of the books and images it brings together—the extent to which the physical library is a *Gesamtkunstwerk*. Revealing the riches of these coherent products of taste, knowledge, and individual enterprise, it challenges us to imagine virtual collections that can complement them.

NICOLAS BARKER

"AN INFINITY OF GOOD, SINGULAR, AND REMARKABLE BOOKS"

The oldest human artifacts in daily use in California are books. This is a paradox in a land that sometimes seems to have passed from the hunter-gatherer to digital imagery without the intervening stage of literacy. But history is made of paradox; without the paradoxical sense of nearness and distance in what we know of the past, it would have no meaning. The past is full of such surprises. I once walked through the Page Museum at the La Brea Tar Pits beside two elderly women who paused to admire (as I did) the last exhibit, the fiberglass block enclosing the prehistoric bones of thousands of dire wolves impacted in asphalt from the tar pit outside. We then passed out of the museum to see the tar pit itself with its life-size model mammoths. "All those dire wolves," murmured one of the women. "Mammoths, too," said the other. "And right on Wilshire," rejoined the first with sudden indignation. So the past creeps up on us to pounce when we least expect it, and our only defense is the books that put it in some sort of order, even—by their survival—giving us a tangible handle on it.

Los Angeles advanced from "pueblo" to "ciudad de los Angeles" only in 1835; it was then called "Los Angeles de la alta California" to distinguish it from its older, larger, and more famous Mexican namesake. It was not much bigger than the little huddle of old buildings that still survive around Olvera Street; the real wealth and grandeur of the region lay outside in the great farms and the homes of the *estancieros*, where a plate of gold pesos lay in the hall for the guest to add a thanks-offering or take his journey money, as occasion demanded. Where now is Mexican Los Angeles, where a handsome breviary was printed in 1770? And how to explain this extraordinary conurbation that fills and overflows Los Angeles County, a multiracial population

The title is from Gabriel Naudé, *Advis pour dresser une bibliothèque* (Paris: François Targa, 1627), 41: "comme il leur est facile de juger promptement par le grand nombre de ses volumes qu'il y en doit avoir une infinité de bons, signalez & remarquables."

that far exceeds the power of a dry land to feed it, a host of commercial and cultural institutions that reach out, far beyond the mountains and deserts surrounding it, to bestride the world? The growth of all this in 165 short years seems another paradox, rather like the Indian rope trick or a card castle that a puff will demolish. Only books, again, provide the hard evidence that it is real.

The growth has been slow. There were not many books in Southern California outside the missions before the middle of the nineteenth century; even in its second half, the documents (a promotional pamphlet for settlers, the modest first directory, local newspapers) hardly differentiate Los Angeles from many another growing town in the West. Yet the institutions that were to provide a home for books—documentation and foundation of the growth, in particular the cultural growth, that now took place at ever-increasing speed—were already coming into place. In 1865 St. Vincent's College was founded in downtown Los Angeles; it was the first institute of higher education in the area, and although the Vincentian fathers made it over in 1911 to the Society of Jesus, which later merged it with Marymount College to become Loyola Marymount University in 1973, its descent from that first beginning is unbroken. In 1872, the same year that the first city directory for Los Angeles was published, the Los Angeles Library Association was formed, to be followed by other public libraries outside the city limits: Santa Monica in 1890 and Long Beach in 1896, the latter the result of the gift of two hundred books from the Women's Christian Temperance Union. In 1880 private funds created the University of Southern California with premises on what is now Founders Park, four blocks north of the present Exposition Boulevard. It was followed by the establishment of a southern campus at the former Los Angeles Normal School on Vermont Avenue for the state-funded University of California in 1919. Thus, before the end of the century, church, state, municipal, and private funds had all been engaged in educational institutions, which were to become a permanent feature of the cultural landscape.

If immediate public utility stimulated all these foundations, the needs of history were not forgotten. New books were not easily come by, and many reached institutional homes secondhand, as gifts. More remarkable was the early interest in local history evinced by the foundation of the Historical Society of Southern California in 1883. Its collections passed to the Museum of History, Science, and Art on its creation in 1913—the future Los Angeles Natural History Museum, later augmented by the Seaver Center for Western History Research. The preservation not merely of books, photographs, and pamphlets but also of the family papers of early settlers, beginning with those of Antonio Del Valle and Antonio Francisco Coronel, municipal records of the alcaldes, private letters and diaries, even impressions of cattle brands on leather and brand registers (and later motion picture scripts), all became part of the preserved history of the region. The California Historical Society collection of photographs, going back to 1860, has similarly found a home in the University of Southern California.

All these initiatives, admirable though they were, would hardly have attracted interest from outside California, nor would they have led to any local interest in creating historic resources important on a world scale, without external impetus. This arrived, like the early settlers, by a number of different routes and from different and unpredictable quarters. Outside Philadelphia, public investment in culture and history, local or otherwise, was not so very much older than anywhere else in the country; even the New York Public Library was founded only in 1898. But already private fortunes were being amassed in steel and other metals, coal, transportation, and the manufacturing industries generally—wealth that found an outlet in collections of books and other objects, which, emulating long-standing tradition in Europe, were shaped by some notion of public display and usefulness. That tradition had been substantially disturbed by the French Revolution and the Napoleonic Wars that followed it, as well as the further upheaval occasioned by the suppression of monasteries in France, Germany, and the Low Countries. These events had freed millions of books from shelves that they had, in many cases, occupied for centuries. The conventional paths of the book trade proved quite unequal to this great surplus. The books circled round and round as if in some Dantean inferno, sometimes finding a brief resting place only to reappear in search of another home. Books that failed to find a place in the traditional classification system (theology, jurisprudence, belles lettres, and the

rest) were often destroyed. Others, by amalgamation, were sacrificed on the altar of the "perfect" book, an ideal form that had perhaps never actually existed. To a market where supply so far exceeded traditional demand as to threaten its accepted values, a new and original demand came as much-needed relief.

If White Kennett's *Bibliotheca Americana* (1713) had inaugurated interest in the bibliography of America a century earlier, it was not until the turn of the nineteenth century that its systematic accumulation began, nor did this spread beyond a few enthusiasts for another half-century. John Carter Brown and James Lenox and their lesser competitors generated a larger demand, enough to attract the attention of agents—Obadiah Rich, John Russell Smith, Henry Harrisse, and Henry Stevens of Vermont—who could mine the intractable but vast quantity of available books on their behalf. This pressure was, however, limited by the erratic nature of its access to the sources of supply: auction sales were sporadic and private sales unpredictable. Without some change, it was unlikely that the market would expand or systematic collection become possible.

Change came unexpectedly with the Civil War and its impact on Britain, the most obvious and accessible part of the market. If liberal opinion in Britain sided with the Union, economic interest, in particular a centuries-old dominance of the textile trades, favored the Confederacy and with it the supply of cotton. The defeat of the South spelled disaster to the Lancashire mills, and their downward trend spread to other parts of the hitherto growing industrial strength of Britain. The victorious North then had another and unexpected benefit. In the 1870s there were seven successive bad harvests in Britain. An already-weakened domestic agriculture could no longer deliver enough grain to sustain the country at the precise point when the Midwest could begin to furnish mass-produced grain at prices that crucially undercut the domestic product. For centuries, British wealth had been traditionally invested in land; now the land could no longer return revenue sufficient to support those who lived on it. For years the need to protect the great estates from division had been met by entail, the concentration of their assets in a single heir by whom they were inalienable. The owners of

these estates, unless protected by other assets (town or industrial property), now faced annual losses that they could not support, while the value of agricultural land itself fell.

The only cure was to break the principle of entail, and the series of measures known collectively as the Cairns Acts, introduced by Disraeli's lord chancellor, Earl Cairns, between 1879 and 1883, effectively brought this about. The owners of landed estates were not slow to take advantage of it. The Marlborough gems were sold en bloc in 1880 for ten thousand pounds, and the great library of Charles, third earl of Sunderland (1674–1722), which had descended to his Marlborough cousins, went in 1881–83 for more than fifty-six thousand pounds. The books of William Beckford, the greatest collector of his time, were sold by his grandson, the tenth duke of Hamilton, in 1882–83. The Thorolds sold the library of Syston Park in 1884, the collection made by Michael Wodhull a century earlier went in 1886, and so forth and so on. A new generation of American collectors, Charles B. Foote, Robert Hoe, John Pierpont Morgan, George Brinley, Henry W. Poor, Marshall C. Lefferts, and others saw and embraced these opportunities. What was more, their own tastes were influenced by the nature of what was offered. If they had hitherto been primarily interested in the history of their own hemisphere, with perhaps a conservative interest in the English Bible, the source of so many American traditions, they now took a more catholic view and began to collect English literature and history, following the tastes and the now available books of the British collectors who had preceded them. The First Folio of Shakespeare became as desirable as, and a good deal more accessible than, a Columbus letter. The climax came when the New York heiress Mrs. Abbie Pope outbid all others at the Osterley Park sale in 1887 to buy the only complete copy known of the first printing by William Caxton of Sir Thomas Malory's *Morte Darthur*.

It is no coincidence that the Grolier Club was founded in New York in 1884 to provide a social context for this new enthusiasm for book collecting, no longer the solitary occupation of a few but one shared by a whole group of collectors in close, if not always easy, alliance with the booksellers from and with whom their libraries were built up.

Collectors were not the only buyers, nor was Britain the sole supplier; both the Union Theological Seminary in New York and the University of Chicago made successful sorties to the continent of Europe to build up their institutional collections. But the concept of what we would now call a "literary heritage," embodied in a small but historic collection of primary texts, became a goal in itself to a new generation of private collectors. If, as increasingly happened, their treasures passed by gift or bequest to favored institutions, what was more natural than to build a suitable receptacle for them? The British Museum, the Bibliothèque Nationale, and the Library of Congress were all temples to a nation's books; lesser libraries, private or public, deserved the same monumental form. Not only were the books given a proper and safe home where others might admire and even touch them, but the task of building the library or raising the money for it also brought others into the fold to share the ideals of the collector.

If these developments in Britain and on the East Coast of America, enhanced by vastly improved communications, brought the two countries closer together in the last decades of the nineteenth and the first of the twentieth century, they left little mark in California. If British landowners in financial difficulties were tempted to sell libraries rather than other possessions (though pictures soon followed) by the knowledge that strong competition from America would increase prices, and if American booksellers now began to pay regular visits to Britain to buy books for their patrons or for their own stock, the market in the United States was limited to a circle of buyers and booksellers from Boston in the north to Washington in the south; it did not spread much farther west than Cincinnati. One man was to change this, Henry Edwards Huntington (1850–1929). A successful career in building and running railroads in alliance with his uncle, Collis Huntington, brought him west to San Francisco to run the Southern Pacific. In 1900 Collis died, leaving his estate to his widow, Arabella; his son, Archer; and his nephew. Huntington sold out his shares in Southern Pacific and began to look south, attracted as much by the beauty of the country as its commercial opportunities. He bought large tracts of unoccupied land from Huntington Beach to Santa Anita and began to build up the local railroads—the Huntington "Big

Red Cars" gave greater Los Angeles one of the best commuter networks in the world. Where Huntington built, others followed; the city expanded into the county. Wilshire Boulevard followed the line that led from downtown to the coast at Santa Monica. Land was cheap; flowers and trees of all sorts grew in the temperate climate; Spanish- and English-style houses spread, each with a generous garden.

Huntington himself bought six hundred acres under the San Gabriel Mountains, north of the city. In 1907 he began to build a house in a spacious garden that was to become his home and also to lay the foundations of the collection that filled first the house and then the ancillary library and art gallery that he added. In 1913 he married his uncle's widow, his close ally in business and an increasing influence on the taste that led him to become the dominant collector, especially of all things English, of his time. Huntington approached books as he did real estate, with a large vision. Not for him the acquisition of individual treasures, book by book; he preferred to buy whole libraries, as he did with that of E. D. Church in 1911, acquiring one of the main collections of Americana and English literature in the United States. But equally, he could dominate an entire sale, as he did at the dispersal of Robert Hoe's vast library in the same year, buying his copy of the Gutenberg Bible at a then-record price. Although he gave his main agent, the bookseller George D. Smith, generous commissions, he maintained a close watch on individual purchases, planning with businesslike care the series of duplicate sales that his large-scale acquisitions required.

But it was in Britain that his massive collecting had most effect. From the duke of Devonshire he got John Philip Kemble's famous collection, perhaps the largest ever made, of quarto plays by Shakespeare and his contemporaries. In 1917 he bought the Bridgewater Library en bloc, a collection going back to Sir Thomas Egerton, the patron of John Donne, and including the famous Ellesmere manuscript of Chaucer. All these paled by comparison with his purchases at the Britwell Court (1916–27) and Huth (1911–22) sales. Britwell Court held the library collected by William Miller (1797–1848), famous for its early English books, many of them acquired from the great sales of the Heber collection in the 1830s; Henry Huth (1815–78) was a banker of similar tastes whose collection complemented

Miller's. At these sales, George Smith carried all before him, and his undisguised joy (he did not share his patron's affection for all things English) at removing so many important books, some of them unique, from their native land stimulated public feeling and eventually legislation to prevent the export of other national treasures.

Huntington himself had another and different priority in mind. It was his ambition to create a world-class collection of pictures, decorative art, and books in handsome buildings set in a beautiful garden, for the benefit of a community that he had done so much to bring into being. In an interview for the *Los Angeles Examiner*, he said,

I shall build the library I have contemplated. These books of mine in value to the world of thought are a great responsibility; if seriously damaged, and, of course if destroyed, they could not be replaced and their loss would be irreparable. So I feel it to be my duty to give them a safe and proper home, for the owner of such things is really little more than a trustee and his responsibility is far greater than attaches to ownership of articles which there is some reason for regarding as purely personal.

The cost was immaterial. "I say money has nothing to do with it. True value can only be experienced in eons of time, by the march of centuries to come, and by the uplift of humanity."[1]

By the time of his death, he had seen this objective realized. It is not hard, even now, more than seventy years later, to feel the same sense of a miracle wrought that the first visitors to San Marino must have felt. Books, pictures, furniture, garden, all are so splendid that we can hardly believe that they are real and not an Arabian Nights dream; it would not altogether surprise the returning visitor to find that the djinn who brought it had taken it away, leaving only the San Gabriel chaparral behind. The unapproachable wealth of the Huntington, the grandeur of its setting, had thus a double legacy. It set a standard by which other institutions might measure their contents, their benefit to the public, less though it might be. It also encouraged others to do something different, not to try and emulate what could not be imitated, still less surpassed. The Huntington Library now embraces early printing from

all parts of Europe; English books, especially literary texts, of all periods; Americana, equally ancient and modern, with a large supporting reference collection. The Huntington contribution to this exhibition, infinitesimal in terms of all that it possesses, has provided a unique element in *The World from Here*. Its influence on other foundations, other libraries, in and beyond Southern California has been immense.

It was with similar idealism, if in an entirely different direction, that the group of colleges in Claremont, east of Los Angeles, came into being. It was originally the desire to build a Protestant utopia in the heart of the citrus groves that led to the foundation of Claremont and in turn to that of Pomona College in 1887. The undergraduate and graduate educational institutions and their associated libraries, which have grown up on or near this site, have been the result of almost continuous development since 1925, when Claremont University came into being, followed a year later by Scripps College. The libraries are partly shared, the central Honnold / Mudd Library serving all the component parts; the Sprague Library at Mudd College and the Mudd Library at Pomona specialize in the sciences, and the Ella Strong Denison Library at Scripps in the humanities. The collections are as various, including the Clary collection of books on Oxford (a role model for Claremont), the Philbrick drama, the Bodman Italian Renaissance and McCutcheon American hymnology collections, the Ida Macpherson collection on women and female suffrage, the William McPherson, Hanna and Mason Smith Western Americana collections, the Wagner collection on the history and cartography of the north Pacific, notable collections of the Brownings, Gertrude Stein (second only to Yale), Robert Burton, and Dryden, and the Carruthers aviation, Woodford geology, and Hoover science and metallurgy collections.

From these diverse sources have come equally diverse contributions to this exhibition, ranging from the beautiful 1476 Regiomontanus calendar to the Lou and Herbert Hoover copy of Agricola's *De re metallica*—a work translated and edited by the president—from the hand-colored gouaches of Sir William Hamilton's *Campi Phlegraei* to the extraordinary woven prayer book (1886–87) from the looms of Lyon. But the most remarkable contribution

1. James Thorpe, "The Founder and His Library," *Huntington Library Quarterly* 23 (August 1969): 304.

of all has come from the library of one of the most recent adjuncts to the Claremont system, the Rancho Santa Ana Botanic Garden. The original property for the garden was part of the Rancho Santa Ana, bought by John Bixby in 1875, which passed into the sole possession of his daughter Susanna Bixby Bryant in 1925. There, she was able to devote two hundred acres to the creation of a botanical garden in 1927. This was conceived on generous lines as a site for the growth and study of all indigenous Californian plants, with herbaria that would augment the families thus represented to give a complete account of each. The whole was supported by "a Botanical library which should be the cornerstone upon which the foundation of the whole institution will be laid."[2] Susanna Bixby had already acquired three thousand volumes, including a complete run of Curtis's *Botanical Magazine* and the copy of Pierre-Joseph Redouté's *Les roses* exhibited here, before her death in 1946. It was then decided to move both garden and library to Claremont, traditionally strong in botany and agriculture. The first planting on the new site began in 1951. The library finally moved to its own building in 1980; it now numbers seventy thousand items, books, periodicals, maps, nursery catalogues, and nonbook material, and includes the copy of John Sibthorp's *Flora Graeca* in the exhibition.

Only one other person can hold a candle to Huntington, either as collector or benefactor: William Andrews Clark Jr. (1877–1934). If Huntington was monumental, Clark, as both collector and benefactor, operated on a more human and practical, less titanic scale. Although born in Montana, whose copper provided the base of his wealth, he had moved to Los Angeles in 1907, the year that Huntington began to collect and build systematically. He cannot have ignored that great plan but remained very much his own man with different ways of collecting and different cultural priorities. He was perceptive as well as generous in his appreciation of the other, writing on his death: "It was upon a broad vision that the late Mr. Henry E. Huntington laid down and wrought out his vision to the last degree of perfection. To his superlative and unselfish philanthropy, not only . . . Los Angeles but also the entire world owes much." Unlike Huntington, Clark collected not

libraries but books. Refusing a Conrad collection offered by the Brick Row Bookshop in 1926, he wrote: "The particular disinclination I have to purchase the collection is that I find more pleasure in picking up the books . . . item by item. It gives me far more enjoyment and I can familiarize myself in this way more thoroughly with my books."[3] Although he began to collect on a systematic scale only in 1917, an invoice of 1911 shows that he was already buying first editions of Oscar Wilde, of whose works he amassed a matchless collection, including the entire manuscript part of the famous 1928 Dulau catalogue.

In chronological terms, Wilde came near the end of Clark's collecting scope. If it began with Chaucer, he had a more than respectable Shakespeare collection. He was wise enough, however, to see that he could never hope to achieve more than partial coverage and turned instead to the age of Dryden. Besides the poet's printed works (with some manuscripts), he added almost every English work of any importance between 1660 and 1720. Nor did he stop there: his collection was rich in the eighteenth century as a whole, and he took in later English (Charles Dickens and George Cruikshank a special enthusiasm) and American literature—Nathaniel Hawthorne, Herman Melville, Walt Whitman, and Edgar Allan Poe (*Tamerlane* was the most expensive book he ever bought). He had a discriminating love of modern fine printing with the Kelmscott and Doves Press complete; his sumptuous printed catalogues and other publications were entrusted to John Henry Nash, first of West Coast fine printers. The building that he created for his library is the prettiest in all Southern California, an eclectic mixture of Wren and Italy with murals by the young Allyn Cox. Hardly was it finished, when he gave his mind to its future. Perhaps more farsighted than Huntington, he realized that his objective, that the "library building and its contents [may be used] by students for research work," could best be achieved within an academic context.[4] So he made it over to the Regents of the University of California, and on commencement day in 1926, the Southern Campus, the future UCLA, was able to announce its first major gift, named in honor of his father, the Senator William Andrews Clark Memorial Library.

2. J. E. Pleasants, *History of Orange County, California* (Los Angeles: J. R. Finnell, 1931), vol. 1, 550.

3. William Andrews Clark to the Brick Row Bookshop, 27 March 1926, Box 2, Correspondence (General), Clark Library Archives to 1934, cited by William E. Conway

in "Books, Bricks, and Copper: Clark and His Library," in *William Andrews Clark, Jr.: His Cultural Legacy* (Los Angeles: William Andrews Clark Memorial Library, UCLA, 1985), 10.

4. *William Andrews Clark Memorial Library: Report of the First Decade, 1934–1944* (Berkeley and Los Angeles: University of California Press, 1946), vii.

If 1926 marked a climacteric in the progress both of Clark's library and the university, it was also the threshold of the "small renaissance, Southern California style," as Jake Zeitlin, its central figure, described it.[5] His first volume of poems, *For Whispers and Chants*, came out in 1927, but his bookshop (or rather series of bookshops) became a focus for a group of book collectors and other booksellers, printers, librarians, writers, academics, doctors, artists, and musicians, who sometimes thrived and sometimes starved in a city growing immeasurably, waxing and waning, with new industries (especially the motion picture industry), and new threats, from water shortage to the Depression. It was too loose a group to be called a club (although it spawned two, the Zamorano and the Rounce and Coffin Clubs), but those who met each other found themselves repeating the experience. Its common denominator was a love of books, and the friendships made, jobs found, and gifts (though none so grand as Clark's) given, grew out of this mold. It was very far from being a closed book, and it opened its pages to admit and welcome the refugees who came to Southern California from the war in Europe. (The fate of inhabitants of Japanese origin was another matter, which we can only now contemplate with the honesty it demands.) But the "small renaissance" was a real, not invented, phenomenon, and it gently pervaded a society that needed such cultural stimulus—in particular the libraries extant and to come, which it helped to reach a particular kind of fulfillment in what were not yet called "rare book rooms" or "special collections."

The postwar years that brought this about were like a new gold rush. To a government facing black-and-white confrontation with Russia, the issue was simple. The war had been won by the atomic bomb and nearly lost by Wernher von Braun's rockets: the common denominator was academic brainpower. So federal funds (not limited to physics, for who could tell where the next crucial invention would be?) were poured into universities, whence they spread to academic libraries and presses and to the book trade as a whole. Libraries began to grow faster and faster, and so did competition between libraries and their parent universities. Librarians as well as booksellers crossed the Atlantic (and the Pacific too) in search of "source materials," original manuscripts, and printed books that seemed

in danger of becoming genuinely rare, in order to feed departmental demands for what would enable them to steal a march on other universities. It could not last and it did not. If the postwar generation of students could hardly believe their luck, the next became disaffected with what struck them as crudely secular values: the years of "student unrest" followed. The great machine was slow to react, and it was not until the 1970s that it slowed down and went into reverse. Throughout the 1960s academic libraries grew by 10 percent each year, doubling in size, staff, and buildings in a decade; between 1970 and 1985 growth slowed to a total of 7 percent, less 0.5 percent per annum. For thirty years now they have learned to live by their wits or rather to find the funds needed to support necessary growth not from government but from private sources—in kind as well as cash. In this quest, "special collections" have come to be increasingly important, not just as bait for benefactors but as an outward and visible sign that the values that seemed lost forty years ago are still there.

The oldest such institutional collection (though not so named until 1963) was at the University of Southern California, which received its first gift of rare books in 1913. Besides the rare books and manuscripts collection as such, which ranges over an array of subjects and includes Audubon's *Birds of America* and the 1493 Rome printing of Columbus's letter, as well as the copy of *The Rake's Progress* given to USC by Igor Stravinsky, there are other "special" collections—on printing arts (centered on the collection of the late and much-lamented Richard Hoffman), on regional history (including the Hearst newspapers picture library and the papers of local politicians), and on American literature—and there is the Lion Feuchtwanger Memorial Library. The American Literature Collection of books and manuscripts was formally constituted in 1939 around the works of Ambrose Bierce, Sinclair Lewis, and William Dean Howells, to which was soon added the large archive of Hamlin Garland. It now stretches from Herman Melville, Jack London, and Henry James to Charles Bukowski and Lawrence Ferlinghetti, with extensive holdings of Kenneth Rexroth. Feuchtwanger's large library is accompanied by his own copies of his books and his extensive correspondence commemorating the exiles from

5. Jacob Zeitlin, "Small Renaissance, Southern California Style," *Papers of the Bibliographical Society of America* 50, no. 1 (1956): 17–27.

Nazi Germany. Beyond this again is the formidable concentration of records of the cinema industry, once the core of "Special Collections," now a department on its own, for which the university is chiefly famous.

The role that William Andrews Clark planned, with such remarkable foresight, for his library has finally been fulfilled, and it has now become the focus of UCLA's thriving Center for Seventeenth- and Eighteenth-Century Studies. Three years after receiving Clark's gift of 1926, the university moved to Westwood—then beyond the outer fringe of a Los Angeles that still saw La Brea as its limit. It has grown and changed immeasurably, its library growing and redoubling its rate of growth. Its remote location, with only the Los Angeles National Cemetery on its western perimeter, ceased to be remote; it was soon encompassed by the movie lots in Culver City on the south and the luxurious suburbs that followed them, Beverly Hills and Bel Air, on the east and north. The first campus buildings in the vernacular mixture of Italian Gothic and Spanish Colonial were overtaken by the postwar expansion; a new research library was built, and the original building became a student library, named after Lawrence Clark Powell, university librarian (1944–61), the architect of its growth. The workaday collection of 100,000 books in 1926 had grown slowly at first, but it reached the million mark in 1953, its second million by 1964, its third in 1971, reaching its present 7,500,000 by the end of the millennium. Its great size is its principal strength, but its special treasures, apart from the Clark Library, are scarcely less remarkable. Michael Sadleir's wonderful collection of Victorian novels, an early investment in children's books and (equally early) in local history material, were followed by the cream of the library of C. K. Ogden (bought by the University of California as a whole in 1957) and all Isaac Foot's books (1961). Its dominant feature since then has been the Ahmanson-Murphy collection of the Aldine Press (unrivaled save by Lord Spencer's collection at the John Rylands University Library of Manchester) and early Italian printing.

This last was inspired by the late Franklin D. Murphy, chancellor of the university (1960–68), whose later career cast a long warm light over almost every aspect of cultural life in and beyond Los Angeles. A doctor by upbringing and vocation, he also set up a fund for buying books on medical history for the Biomedical Library at UCLA, which now bears the name of a remarkable woman, Louise M. Darling, its founding librarian from 1947 to 1987. The university's long-established links with the medical faculty of Los Angeles were personified by Elmer Belt (1893–1980), professor of clinical surgery and collector of Leonardo da Vinci (his gift created the university's art library) and of Florence Nightingale and Silas Weir Mitchell, the Civil War physician (both given to the Biomedical Library). The Dickey collection on vertebrate zoology (with Mark Catesby's *Natural History of Carolina, Florida, and the Bahama Islands* [1731–43]) had already come to the university in 1940. These resources were amplified first by funds and then by the library (originally given to the Los Angeles County Medical Association) stemming from another Los Angeles physician, Walter Barlow. But the richest of all benefactions received by the Darling Library was that of John Benjamin in 1962, including William Harvey's classic *De motu cordis* (1628), Copernicus's *De revolutionibus orbium coelestium* (1543), Vesalius's *De humani corporis fabrica* (1543), and Isaac Newton's *Principia* (1687)—four books, any one of which would have elevated the library's Department of Special Collections (formally constituted in 1964) to more than special importance.

One of the Darling Biomedical Library's more unexpected resources is its collection of historic Japanese works on medicine. These are but a part of the still larger assembly of oriental works in the UCLA East Asian Library, which owes its inception to the prescient journey to China and Japan made by Richard C. Rudolph in 1947. He came back with ten thousand works, including the classic Chinese encyclopedias and reference books, and the collection has grown steadily ever since. Among its older works are some 250 Chinese books printed before 1796, Chinese civil documents, a collection of plays put on for the Mongol prince Ch'e, one of the earliest Japanese *emakimono* (picture scrolls), the seventeenth-century Buddhist *Lotus Sūtra* ornamental scroll, and, oldest of all, the *Muku jōkō kyō jishin'in darani* scroll, printed in Japan circa 770. Altogether, the collection forms a resource for study of East Asia of far more than local importance.

The Claremont Colleges, UCLA, and USC all range beyond the region. Occidental College, founded in 1887, is smaller and draws its students from nearer by, but it more than makes up for this in the loyalty it commands from its alumni. Its library collections include the work of the great Los Angeles printers Ward Ritchie, Saul Marks (each the subject of an individual collection), and Grant Dahlstrom, and its literary sources also have a strong local theme: the copies of Upton Sinclair's *Oil!* and Robinson Jeffers's *Granite and Cypress* come from collections of the two authors, both arguably the best of each. But the Occidental collection is of more than local significance, including medieval manuscripts and incunabula, among them the Aldine *editio princeps* of Aristotle (1495–98), the vast Guymon collection of detective fiction, Western and Latin Americana, books on railroads and aviation, collections of William Jennings Bryant and the Romantic poets. The California State University at Long Beach is also strong on Jeffers, and there are other traces of the friendship of its first director, Charles Boorkman, with Zeitlin, from the set of Diderot and D'Alembert's *Encyclopédie* to the Dorothy Ray Healey papers on the Communist party in Southern California, a medieval manuscript, Samuel Johnson's *Dictionary*, works by Samuel Taylor Coleridge and Virginia Woolf, as well as Ansel Adams and Edward Weston photographs and Breugel prints. The California State University at Northridge has contributed, as have the Santa Monica Public Library, with its early local photographs, and the Long Beach Public Library, which also preserves the papers of its former resident Marilyn Horne.

The California Institute of the Arts (CalArts), formed under the Disneys' aegis in 1961 by the merger of the Los Angeles Conservatory of Music (founded 1883) and the Chouinard Art Institute (1921), preserves the records of both, to which the David O. Selznick and Universal Studio collections have been added. The Western States Black Research and Educational Center has contributed the first published poetry by an African American woman, Phillis Wheatley. The Academy of Motion Picture Arts and Sciences exhibits remind us how moving pictures have rendered texts, sometimes the same texts as printed, over the last century, during which the Braille Institute has conveyed the same texts to the blind. The Autry Museum of Western Heritage now has a research center, which preserves not only the Gene Autry archive but also a surprising range of important relics of the old West, from *Prose and Poetry of the Live-Stock Industry of the United States* (1905) to the fifteen hundred posters of the Nudie's Rodeo Tailor and Western Equipment Collection; from it comes Richard Burton's *City of the Saints*, with its original drawings. The oldest repositories have surprising treasures too: the Seaver Center has not only a copy of Edward S. Curtis's *North American Indian* but also the original manuscript, and Amelia Earhart's diary of her first transatlantic flight as well; Loyola Marymount has the first illustrated Dante (1481), all four Shakespeare folios, the first editions of *Gulliver's Travels* and *Sense and Sensibility*, as well as the archive of Arthur Jacobs, producer of the *Planet of the Apes* film series.

But of all the variety offered by these repositories, none reflects the growth of Los Angeles from western city to world metropolis more than the Getty Research Institute. Created in 1983 and now united with the J. Paul Getty Museum in the new Getty Center complex—looking down the San Diego Freeway toward Sunset—it is the newest and inevitably least known (other than by reputation) of the great Los Angeles collections. A major part of it is dedicated to the documentation of works of art, from the beautiful drawings of Francesco di Giorgio Martini's *Edificij et machine* (c. 1475–80) to the multimedia extravaganzas of David Tudor, John Cage, and Robert Rauschenberg. The correspondence of artists and architects, notably Paul Signac, El Lissitzky, and Melchior Lechter, is matched with the archives of art dealers and historians. The ability of the Research Institute to absorb an enormous quantity of books of all periods has had a visible effect on the book trade over the last twenty years; the success of this endeavor is reflected here, notably in section 6 of the exhibition, "Ingenious Structures." Like Huntington, the Getty has been able to buy whole collections as well as individual items. It began with Theodore Besterman's collection of historic art books. Giovanni Muzio's architectural history collection was another foundation, and the De Belder Neoclassicism collection provided elegant form as well as content, while the archive of Jean Brown took the collection into the late twentieth century. The Alinari

archive has added enormously to its pictorial archive of works of art. But all these are only a few landmarks in a great and as yet not fully charted landscape. As visual imagery adds to or substitutes for the written and printed word, this record of all the manmade imagery of the past takes on a new significance.

The Ventura County Museum is not one of the most famous monuments of Southern California. It is simply a new town building, decent but not striking, in the old main street of Ventura. But it represents an entirely new concept in museology. Everything in it comes from the site on which it stands, excavated with all the care of modern archaeology. The site is an old one, so that the earliest fragments of pottery go back to the Chumash Indians. Each layer above provides evidence, in the relics of successive occupants, of continuing occupancy: first Spanish, then Mexican, then North American, and finally Chinese lived and worked, slept and cooked, using and wearing out tools and other utensils, breaking cups and plates, losing rings and keys and coins, abandoning other vestiges of the way that they lived. None of these objects would merit a second glance elsewhere; only here, and in relation with the other fragments, do they have a meaning. But the museum has an extra twist to give to the picture they present, for its five floors invert chronological order, with the Chumash at the top and the Chinese last, more or less where they were found, on the first floor. It is the world upside down. There is something to be gained from viewing this exhibition in the same way. Like the pieces at Ventura, the exhibits have a double meaning: they are what they were made to be, words or pictures given currency when they were written or printed; they are also, in combination, a window on the world in which they are now preserved and used. Through them we can imagine Keats giving away his *Poems* to John Gattie, but also the impact of *The Tramp* or *Oil!* as they were first seen or read here. But, again, we can turn the picture upside down, and through the first printing of a Japanese scroll, of Copernicus, of Newton's *Principia*, convert to Californian experience the newness of the theory of gravity, of the heliocentric universe, of a universal prayer. *The World from Here* is also a portrait of here, layered in the order that the world of books has imposed on it. If this is another paradox, it is also a handle on the past, and perhaps on the future too.

KENNETH A. BREISCH

"A SOURCE OF SURE AUTHORITY" LIBRARY BUILDING IN LOS ANGELES DURING THE TWENTIETH CENTURY

In little more than a century, Los Angeles collectors and institutions have commissioned a distinguished array of monuments to enshrine their books and manuscripts. During the first three decades of the twentieth century in particular, these libraries served to imbue a sprawling and largely uncultivated landscape with its own distinct cultural identity. Not surprisingly, perhaps, this florescence coincided with a rapid expansion of population and wealth, especially during the 1920s, when the city began to emerge as a major American metropolis. For the most part, the architecture of these early institutions was conservative and elite. The private libraries in particular were intended as erudite expressions of wealth and gentility; their more public counterparts, as monumental exemplars of the universal lessons believed to be derived from reading and education. In deliberate contrast to the contemporary gestures of the early "modernists," their style was heavily dependent upon the classical traditions of the eastern United States and Europe.

As library building continued into the third decade of the century, architects began to reinterpret this vocabulary in light of Southern California's unique character and history. In the half-dozen major buildings designed and erected during this period, a variety of interrelated design strategies were adapted in an attempt to establish a new regional dialect, as well as to express the meaning and function of the institutions themselves. It would not be until the great era of museum construction during the last two decades of the twentieth century that architecture would again have such a major impact on the public's perception of culture in Los Angeles, or play as significant a role in reshaping the way in which we perceive the city.

As in other areas of the country, Los Angeles generally followed the lead of the northeastern states when it came to the founding of libraries and the erection of buildings to house them. Like the libraries that preceded them in the East, the majority of public institutions in Los Angeles began as small, privately funded reading societies whose collections consisted of no more than several hundred or, at best, a few thousand volumes, housed in a room or basement of the town hall, post office, or upper floor of some commercial block. Construction of a building dedicated to the housing of books was never an assured outcome. The Los Angeles Library Association, for example, was formed in 1872 as a subscription library, which the city acquired in 1878 following the passage of legislation that allowed for the creation of a special library tax and the issuance of city bonds for the construction of a building. In spite of this statute, nearly five decades passed before the Los Angeles Public Library obtained permanent quarters. In the meantime, the collection was shuttled about the city, sharing space in the city hall, as well as several office and commercial buildings, before coming to rest in its current home in 1926.[1]

Other institutions in the region experienced similar, if somewhat less epic, odysseys. During the 1880s citizens in communities such as Pasadena, Santa Monica, Pomona, and San Pedro all formed private reading associations that would later become the bases for public libraries. Under the leadership of entrepreneur and civic booster Abbot Kinney, and funded with subscriptions and private donations, the Pasadena Library and Village Improvement society was incorporated in 1883.[2] The following year, it moved into a two-story, wood-frame structure, which the society erected to house a reading room and its collection of 329 books, as well as several fraternal societies that rented space on the upper story. Following a citywide referendum in 1890, this library was acquired by the City of Pasadena and moved into new, much more substantial quarters on Dayton Street (fig. 1). Until Andrew Carnegie began to bestow his largesse

on the region with a gift of fifteen thousand dollars for a public library building in Pomona in 1903, the Pasadena library would remain the only monumental structure specifically erected for library purposes in Los Angeles County.[3]

Constructed of quarry-faced ashlar masonry with round and pointed arches and a variety of picturesquely disposed turrets and gables, the new Pasadena library building was designed by the local architectural firm of Ridgeway and Stewart. Awkward and eclectic, the edifice nonetheless introduced contemporary Richardsonian Romanesque library forms to the West Coast, particularly as they had evolved in the Midwest during the previous decade.[4] The large windows, stair tower, and monumental porch were intended to mark this structure as a significant civic institution, even if its function as a library may not have been entirely distinguishable in its exterior elevations. Inside its purpose was more evident (fig. 2). Set under a broad, coved ceiling, which sprang from an elaborately ornamented cornice, books were displayed behind the librarian's desk on freestanding wooden shelves of a type common to smaller American public libraries of the era. Readers were seated in the center of the building at heavy wooden tables or in a special room set aside for female patrons.

Whereas the building cost twenty-five thousand dollars to erect, its books were initially valued at less than one-eighth of this amount. With further city support, however, this collection expanded rapidly, increasing from 3,000 to 12,800 volumes during the first eight years of the library's operation. In response to this growth, it was found necessary by the turn of the century to construct the first of several additions and to replace the earlier wooden shelving with more utilitarian two-story metal bookstacks (fig. 3). By 1927, when it was moved to a new building designed by Myron Hunt and H. C. Chambers, the Pasadena Public Library had long since outgrown these quarters as well.

1. Roger H. Woelfel, *Diamond Jubilee: Seventy-Five Years of Public Service: The Story of the Los Angeles County Public Library* (Glendale, Calif.: A. H. Clark Co., 1987). For the sources and early history of the public library movement in the United States and California, see Jesse H. Shera, *Foundations of the Public Library* (Chicago: University of Chicago Press, 1949); Sidney Ditzion, *Arsenals of a Democratic Culture: A Social History of the American Library Movement in New England and the Middle States, 1850–1900* (Chicago: American Library Association, 1947); Samuel S. Green, *The Public Library Movement in the United States, 1853–1893* (Boston: Boston Book Co., 1913); Rosemary Ruhig Du Mont, *Reform and Reaction: The Big City Public Library in American Life* (Westport, Conn.: Greenwood Press, 1977); Ray E. Held, *The Rise of the Public Library in California* (Chicago: American Library Association, 1973); idem, *Public Libraries in California, 1849–1878* (Berkeley: University of California Press, 1963); and California State Library, *Descriptive List of the Libraries of California* (Sacramento: W. W. Shannon, Supt. of State Printing, 1904). For the

growth of Los Angeles and its cultural institutions during the 1920s, see Kevin Starr, *Material Dreams: Southern California through the 1920s, Americans and the California Dream* (New York: Oxford University Press, 1990).
2. California State Library, *Descriptive List of the Libraries of California*, 49–52; Hiram Reid, *History of Pasadena* (Pasadena: Pasadena Historical Co., 1895), 201–10; John Windell Wood, *Pasadena, California, Historical and Personal: A Complete History of the Organization of the Indiana Colony* (Pasadena: J. W. Wood, 1917), 276–83; and *Los Angeles Times*, 13 January 1890 and 10 September 1890, Pasadena edition.
3. The Literary Association of San Pedro also erected a small library building in 1889. See *Library Journal* 13 (September– October 1888): 301; *Library Journal* 14 (conference number 1889), 172. The town of Redlands in San Bernardino County also opened a substantial building, the A. K. Smiley Public Library, in 1898 in the Mission Revival style. For this library, see California State Library, *Descriptive List of the Libraries of California*, 56–58.

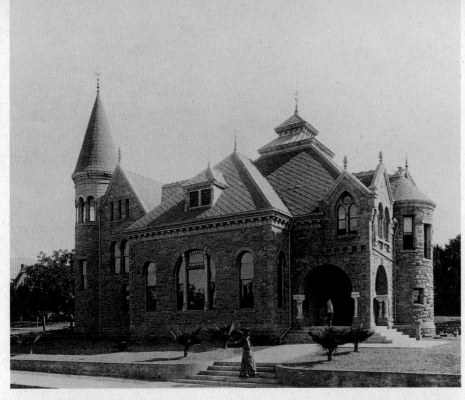

1 **Pasadena Public Library,**
designed by Ridgeway and Stewart, 1890.

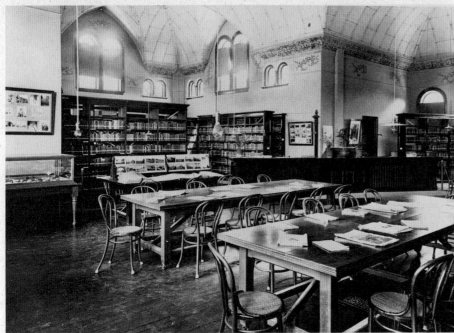

2 **Reading Room of the
Pasadena Public Library,**
designed by Ridgeway and Stewart, 1890.

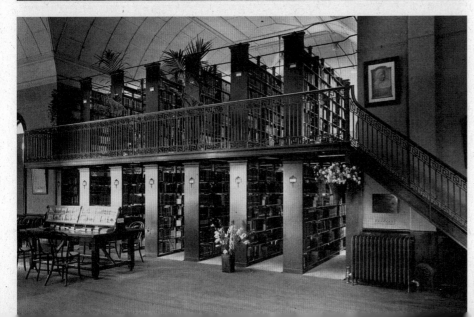

3 **Book Stack Addition to the
Pasadena Public Library,** 1900.

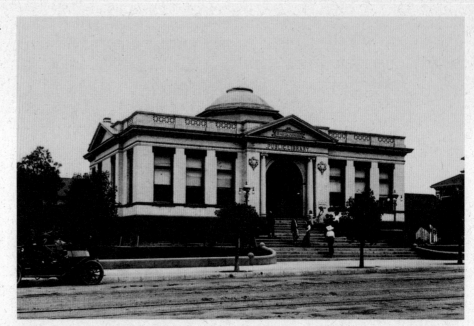

4 **Carnegie Public Library, Santa Monica**,
designed by Norman Marsh and Clarence H. Russell, 1904.

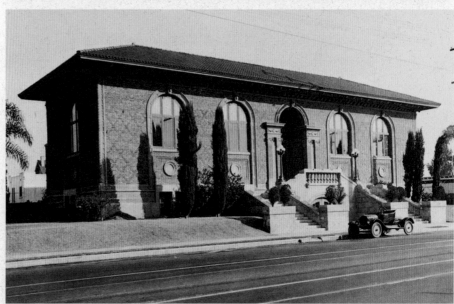

5 **Cahuenga Branch Library of the Los Angeles Public Library**, designed by Clarence H. Russell, 1916.

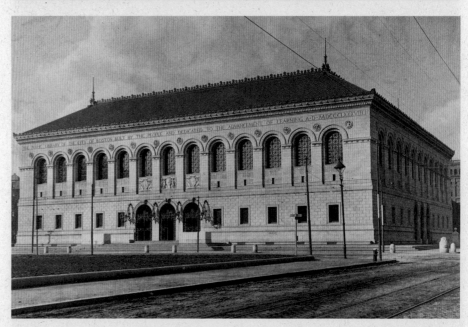

6 **Boston Public Library**,
designed by McKim, Mead and White, 1887–95.

As Abigail Van Slyck and others have noted, Andrew Carnegie's library building program, which began in earnest just as the Pasadena Library was undertaking its first expansion, significantly altered the nature of the American public library. Its impact was to be no less consequential in Los Angeles County, where Carnegie moneys were used to erect twenty-two library buildings during the first decades of the century, including six branches for the Los Angeles Public Library and the first library building at Pomona College in Claremont. The Santa Monica Public Library, which was completed in 1904 at a cost of $12,500, as well as all six of the Carnegie branches of the Los Angeles Public Library, are typical of these new landmarks (figs. 4, 5).[5]

In stark contrast to the picturesque animation of Ridgeway and Stewart's Pasadena building (see fig. 1), the Santa Monica Public Library—the first of these small Neoclassical edifices—was designed by Norman Marsh and Clarence H. Russell, who at the time were also laying out Abbot Kinney's "Venice of America" just to the south of Santa Monica.[6] As with the earlier library in Pasadena, the choice of style and plan for these new buildings continued to reflect national trends in library design and architectural taste, but now those of a decade and a half later. Classicism, especially of the sort disseminated through the influence of the prestigious Ecole des Beaux-Arts in Paris, had been widely popularized in this country by the success of the World's Columbian Exposition of 1893, as well as through the acclaim bestowed on individual buildings such as McKim, Mead and White's Boston Public Library, which opened two years later (fig. 6).[7]

By the first decade of the twentieth century, Beaux-Arts classicism had become the style of choice for America's new public monuments, especially public libraries. A 1902 edition of the *Architectural Review*, for example, reproduced designs for sixty-seven recently completed American library buildings, fifty-seven of which were in a classical idiom with only five exhibiting the influence of the earlier Romanesque Revival. While never specified by Carnegie or his corporation, the majority of the structures he endowed reflected this newly revived classical taste, wavering in style somewhere between the classicism of Greece and Rome and that of the Italian Renaissance.[8] Very much in line with the language of many of these buildings, the entry porch of the Santa Monica Public Library was flanked by Ionic columns and set beneath a broad entablature and pediment that proclaimed its purpose as a public library. Behind this small aedicular ensemble, a prominent dome hovered over the delivery desk, physically and figuratively marking the center of the institution. The Cahuenga Branch of the Los Angeles Public Library, which was designed by Clarence H. Russell and opened in 1916, was likewise entered through a prominent central porch marked with the classical orders. This building was now finished in an Italianate or Mediterranean style that is more closely related to the façade of McKim, Mead and White's Boston Public Library (cf. figs. 5, 6).

Easily recognized and understood by their working-class and middle-class constituencies, these small classical temples and palaces became synonymous with Carnegie and his philanthropy. They were also responsible for introducing a new academic language into the smaller towns and boroughs of America. In comparison to the picturesque character of much Victorian architecture, these buildings appeared more monumental and restrained, venerably historical, and, at the same time, sophisticated and progressive. This last quality was especially evident in the interior arrangements of these structures, particularly those erected during the later years of the Carnegie program under the direction of his personal secretary, James Bertram, who developed a set of design guidelines based on modern library planning principles similar to those approved by the American Library Association.[9]

4. For a general introduction to American library architecture during the nineteenth century, see Kenneth A. Breisch, "Small Public Libraries in America, 1850–1890: The Invention and Evolution of a Building Type" (Ph.D. diss., University of Michigan, 1982), and idem, *Henry Hobson Richardson and the Small Public Library in America: A Study in Typology* (Cambridge: MIT Press, 1997); Donald Oehlerts, "The Development of American Public Library Architecture from 1850 to 1940" (Ph.D. diss., Indiana University, 1974); Elizabeth Stone, *American Library Development, 1600–1899* (New York: H. W. Wilson Co., 1977); and John Boll, "Library Architecture 1800–1875: A Comparison of Theory and Buildings with an Emphasis on New England College Libraries" (Ph.D. diss., University of Illinois, 1961).
5. Beginning in 1899 Carnegie offered to erect a public library in any community that agreed to appropriate an annual sum equal to one-tenth of the cost of the structure for the continued support of the institution and the purchase of books. By 1917 Carnegie (after 1911, through the Carnegie Corporation) had endowed more than sixteen hundred library buildings in the United States at a cost of more than forty-one million dollars. See Abigail A. Van Slyck, *Free to All: Carnegie Libraries and American Culture, 1890–1920* (Chicago: University of Chicago Press, 1995); J. F. Wall, *Andrew Carnegie* (New York: Oxford University Press, 1970), 805–27; Theodore Jones, *Carnegie Libraries across America: A Public Legacy* (New York: John Wiley, 1997); George Bobinski, *Carnegie Libraries: Their History and Impact on American Public Library Development* (Chicago: American Library Association, 1969); Held, *The Rise of the Public Library in California*, 120–26; and Lucy Kortum, "The Carnegie Libraries of California" at http://www.carnegie-libraries.org/main.html.
6. Ellen Braby and Janet Hunt, *The Santa Monica Public Library, 1890–1990* (Santa Monica, Calif.: Santa Monica Public Library, 1990); Jeffrey Stanton, *Venice of America: Coney Island of the Pacific* (Los Angeles: Donahue Publishing, 1987).

As Anthony Grafton notes elsewhere in this cata- logue, during the years that Carnegie was building his public libraries, Henry Edwards Huntington and William Andrews Clark Jr. began amassing two of the great private libraries in the United States. By 1919, the year in which he signed a deed of trust that declared his intention to make his library available to the public, Huntington's col- lection included more than 600,000 books and 2.5 million manuscripts. The same year, he broke ground on a new building to house his archive (fig. 8). Overlooking the city of Los Angeles from his estate in San Marino, this edifice was designed by Pasadena architect Myron Hunt, who, along with Elmer Grey, had earlier designed the Huntingtons' palatial home, which stood just to the west of the new library.[10] In line with Hunt's Beaux-Arts training at Massachusetts Institute of Technology, Huntington's library took the form of a Hellenistic fortress with a great range of paired Ionic columns horizontally splayed across the façade. Two entryways—marking its dual function as library and art gallery—punctuated bracketing end pavil- ions, which were articulated with Doric pilasters. Directly behind the central freestanding screen of columns was the two-story reading room, which was encircled with book- cases. The plan of this structure was organized in the form of an E with three wings extended from the back of the main block. These housed workrooms for the staff, a vault for rare books and manuscripts, and exhibition space for the Huntingtons' art collections.

Following the Beaux-Arts method, Hunt's articulation of the Huntington Library borrowed from a variety of precedents to create typological and historical associations related to the program and function of the institution. George W. Kelham, for example, had employed a similar freestanding screen of Ionic columns, set between Doric end pavilions, on the entry façade of the San Francisco Public Library, which had opened in 1917. Kelham's south elevation, by contrast, was derived from Henri Labrouste's Bibliothèque Ste.-Geneviève in Paris (1844–50; fig. 7), a monument that served as a touchstone for almost all larger American library buildings of the later nineteenth and early twentieth centuries, including the Boston Public Library of McKim, Mead and White.[11] Although Hunt substituted an Ionic colonnade for Labrouste's arcade, his elevation like- wise owes a clear debt to the Bibliothèque, as it does per- haps to the great screen of paired Corinthian columns on the main façade of the Louvre, a gesture that may have been intended to signal the Huntington's function as a repository for art as well as books.

The classical demeanor of all these early library build- ings—large or small—was intended to reflect the same universal values of Western civilization that were believed to be embodied in the literary works they sheltered and that were proclaimed by their façades. Although the col- lections housed in the Carnegie libraries may have been relatively modest by comparison to those of Huntington, their "treasures," as well as their architectural forms, also

7. Arthur Drexler, ed., *The Architecture of the Ecole des Beaux-Arts* (New York: Museum of Modern Art, 1977); Robin Middleton, ed., *The Beaux-Arts and Nineteenth- Century French Architecture* (Cambridge: MIT Press, 1982); Reid Badger, *The Great American Fair: The World's Columbian Exposition and American Culture* (Chicago: N. Hall, 1979); David F. Burg, *Chicago's White City of 1893* (Lexington: University of Kentucky, 1976); and Robert W. Rydell, *All the World's a Fair: Visions of Empire at American International Expositions, 1876–1916* (Chicago: University of Chicago Press, 1984). For the Boston Public Library, see Leland M. Roth, *McKim, Mead and White: Architects* (New York: Harper and Row, 1983), 116–30. The rise in popularity of classi- cism was also closely related to the rise of the City Beautiful Movement in the United States during this period. See William H. Wilson, *The City Beautiful Movement* (Baltimore: Johns Hopkins University Press, 1989).
8. *Architectural Review* 9 (1902): 1–60; and Van Slyck, *Free to All*, 28. Among the few exceptions in Southern California are the libraries in Riverside and Inglewood, which were designed in the Mission Revival style; in Hollywood, as English Tudor; and in Eagle Rock, which quoted from the Spanish Colonial style. See Kortum, "The Carnegie Libraries of California."

9. Abigail A. Van Slyck, "'The Utmost Amount of Effectiv (sic) Accommodation': Andrew Carnegie and the Reform of the American Library," *Journal of the Society of Architectural Historians* 50 (1991): 373–83; Robert Wiebe, *The Search for Order, 1877–1920* (New York: Hill and Wang, 1967), 11–23; and Neil Harris, "Cultural Institutions and American Modernization," *Journal of Library History* 16 (1981): 35–44; and Dee Garrison, *Apostles of Culture: The Public Librarian and American Society, 1876–1920* (New York: Macmillan Information, 1979), 8–9. For the American Library Association's perspective on planning at this time, see Charles C. Soule, *How to Plan a Library Building for Library Work* (Boston: Boston Book Co., 1912).
10. Alson Clark, "Myron Hunt in Southern California," in *Myron Hunt, 1868–1952: The Search for a Regional Architecture*, vol. 4 of *California Architecture and Architects*, ed. David Gebhard (Los Angeles: Hennessey and Ingalls, 1984), 31–34; John Edwin Pomfret, *The Henry E. Huntington Library and Art Gallery, from Its Beginnings to 1969* (San Marino, Calif.: Huntington Library, 1969), 6–50; Robert O. Schad, *Henry Edwards Huntington: The Founder and the Library* (San Marino, Calif.: Henry E. Huntington Library and Art Gallery, 1937); James Thorpe, "The Founder and His Library," in *The Founding of the Henry E. Huntington Library and Art Gallery: Four Essays* (San Marino, Calif.: Huntington Library, 1969), 299–308; and Starr, *Material Dreams*, 334–36.

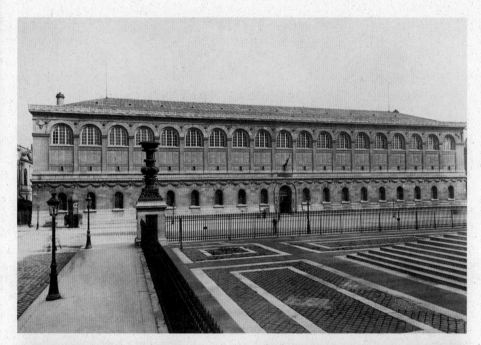

7 **Bibliothèque Ste.-Geneviève, Paris,** designed by Henri Labrouste, 1844–50.

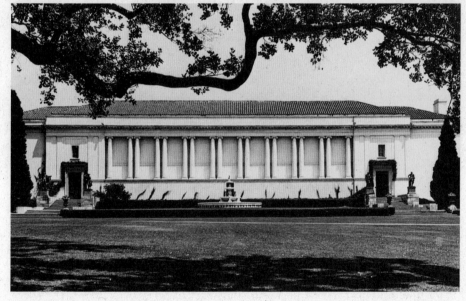

8 **Henry E. Huntington Library, San Marino,** designed by Myron Hunt of the firm Hunt and Chambers, 1919–25.

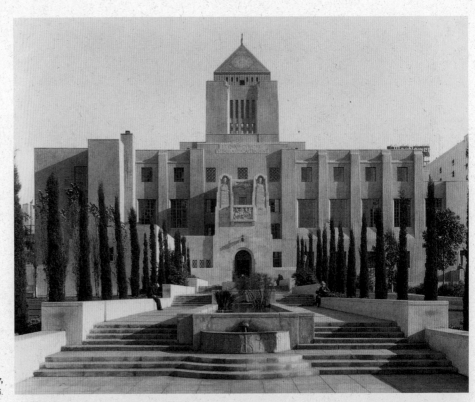

9, 10 **Los Angeles Public Library,**
designed by Bertram Goodhue and Carleton M. Winslow, 1922–26.

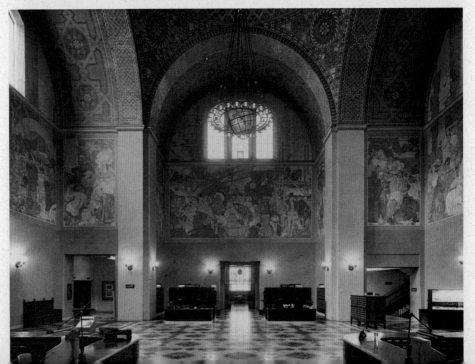

opened new and ever-widening vistas to their less wealthy patrons. As Abbot Kinney proclaimed at the opening of the Pasadena Public Library in 1890: "In a well-stocked library any working man, whether mainly by hand or mainly by mind, can look into the most distant places or remote times and so discover what has been done, what has been tried, what is good and what has failed in his special line. Thus in a library, however small we are in mental stature, we are still on the shoulders of and above giant intellects of the past. . . . We might compare books perhaps to railroads for the aid they give us in our mental journeys."[12]

Even as Henry Huntington's library was rising in San Marino, Bertram Grosvenor Goodhue appears to have begun developing his design for the Los Angeles Public Library. In the scheme that he ultimately evolved between 1921 and his death in 1924, however, he created a landmark that, in terms of cultural identity and recognition of place, is much more complex than its Hellenistic predecessor. Goodhue's first proposals for this library were still overtly classicist, but with references to the Spanish Colonial Revival style he had employed at the Panama-California Exposition held in San Diego in 1915. Here, in response to San Diego's Hispanic past, he had articulated his pavilions with late Spanish Renaissance and Baroque ornament. Originally inspired by a trip to Mexico in the 1890s, the elaborate Churrigueresque forms that Goodhue introduced at this exposition—at about the same time that Myron Hunt was experimenting with a similar language in his design for the First Congregational Church in

Riverside (1913)—were quickly taken up by architects and designers all across the region. It was, in fact, the great success of Goodhue's San Diego work, as well as his design for the campus of the California Institute of Technology in Pasadena, that recommended him to the Los Angeles Library Board. Budget constraints, however, delayed construction of this library building and ultimately forced the architect and the board to scale back their original ambitions.[13]

In the meantime, Goodhue won the commission for the Nebraska State Capitol, and it was here that he began to evolve the more geometric and abstract version of the Spanish Colonial Revival that he would ultimately employ in Los Angeles. In Nebraska, as well, Goodhue began a collaboration with poet and philosopher Hartley Burr Alexander and sculptor Lee Lawrie to produce a complex iconographic and sculptural program for this building. Goodhue worked out his designs in collaboration with these two men and the muralist Julian Ellsworth Garnsey, and his final conception for the Los Angeles Public Library combined architectural forms, sculpture, painting, and inscriptions that drew upon a wide range of artistic, architectural, and intellectual traditions, reaching well beyond the classical cultures of the West (fig. 9). "In part and in detail the building recalls numerous ancient styles," observed Goodhue's associate architect, Carleton Monroe Winslow, "for no building, particularly a Library, can disregard the accumulation of architectural experience of the past."[14]

11. Peter Booth Wiley, A Free Library in This City: The Illustrated History of the San Francisco Public Library (San Francisco: Weldon Owen, 1996), 121–34. For recent discussions of the Bibliothèque Ste.-Geneviève, see David Van Zanten, Designing Paris: The Architecture of Duban, Labrouste, Duc, and Vaudoyer (Cambridge: MIT Press), 83–98; Neil Levine, "The Romantic Idea of Architectural Legibility: Henri Labrouste and the Neo-Grec," in The Architecture of the Ecole des Beaux-Arts, ed. Arthur Drexler (New York: Museum of Modern Art, 1977), 325–416, and idem, "The Book and the Building: Hugo's Theory of Architecture and Labrouste's Bibliothèque Ste.-Geneviève," in The Beaux-Arts and Nineteenth-Century French Architecture, ed. Robin Middleton (Cambridge: MIT Press, 1982), 139–73.
12. Abbot Kinney at the opening of the Pasadena Public Library, Los Angeles Times, 10 September 1890, Pasadena edition, 1.
13. Everett R. Perry, "The New Library Building as the Librarian Sees It," in Handbook of the Central Building: Los Angeles Public Library (Los Angeles: Los Angeles Public Library, 1927), 26–27; Richard Oliver, Bertram Grosvenor Goodhue (New York: Architectural History Foundation; Cambridge: MIT Press, 1983), 109–19, 226–32; Charles Harris Whitaker, ed., Bertram Grosvenor Goodhue: Architect and Master of Many Arts (New York: Press of the American Institute of Architects, 1925), pls.

109–16, 230–32, 1574–80; David Gebhard, "The Spanish Colonial Revival in Southern California (1895–1930)," Journal of the Society of Architectural Historians 26 (May 1967): 136–37; Starr, Material Dreams, 191–211; Bertram G. Goodhue, The Architecture and the Gardens of the San Diego Exposition: A Pictorial Survey of the Aesthetic Features of the Panama-California International Exposition (San Francisco: P. Elder, 1916); Richard Oliver, "Bertram Goodhue," in Baxter Art Gallery, Caltech 1910–1950: An Urban Architecture for Southern California (Pasadena: Baxter Art Gallery, 1983), 17–26; Clark, "Myron Hunt in Southern California," 36–38; and Myron Hunt, "First Congregational Church," American Architect 105 (27 May 1914): 267–68.
14. Carleton Monroe Winslow, "General Description of the Building," Handbook of the Central Building: Los Angeles Public Library (Los Angeles: Los Angeles Public Library, 1927), 11. Although Goodhue died unexpectedly in 1924, his longtime associate, Carleton Monroe Winslow, was able to complete his vision. See also Oliver, Bertram Grosvenor Goodhue, 184–212; Whitaker, Bertram Grosvenor Goodhue, 214–25; Bertram Grosvenor Goodhue, "Plans, Interiors, Details," Architect 7 (1926–27): 595–605; and Faith H. Hyers, "Expansion of the Los Angeles Public Library," Library Journal 51 (February 1926): 121–24; and idem, "Significance of Los Angeles' New Library," Library Journal 51 (August 1926): 663–66.

As filtered through Goodhue's lens of abstraction (and impacted by a reduced budget), this "accumulation of architectural experience" can be perceived in manifold and ambiguous ways. His "modified" Spanish Colonial forms, for example, suggest a plethora of ancient Mediterranean and Near Eastern traditions. Articulated with classical pilasters and pylons that metamorphose into busts of ancient artists and philosophers, Goodhue's library sits like a great ziggurat in a lush garden. The central tower, its crowning pyramid sheathed in colorful mosaic tiles, recalls at once Iberian, Byzantine, and Egyptian sources, as well as the form of a modern American skyscraper.[15] Alexander's inscriptions, as well as Lawrie's sculptural figures, likewise borrow from Greece and Rome, the ancient Near East, Egypt, China, and India to create a veritable cathedral of knowledge, very much intended to be experienced as a kind of literary and philosophical journey through time and place. Extending the southeast and northwest axes of his plan—and conceived by Goodhue as integral to his project—exotic gardens with ponds and fountains similarly recalled a cultural continuity stretching back through Islamic Spain to the biblical Gardens of Babylon.[16]

While stylistically quite different from the Huntington, Goodhue's building also remains indebted to the idea of the Bibliothèque Ste.-Geneviève. As Labrouste explained in 1852, "the names of the principal authors and writers whose works" were preserved within his library had been inscribed across its front elevation in order to create a "monumental catalogue" that might serve as "the principal ornament of the facade, just as the books themselves are the most beautiful ornament of the interior."[17] In Los Angeles, Goodhue, with the assistance of Alexander

and Lawrie, integrated an even more ambitious iconographic program into the entire fabric of his building, combining this with what Winslow called a "modern expression of the plan and the manner of construction."[18] The architect's aspirations might be understood in light of David Van Zanten's description of Labrouste's ideal of "transparency" as a concept where "the whole work of architecture—its structure, its function, its philosophical nature—might be grasped by a glance at its exterior, as if one were conceptually seeing right through its walls."[19]

What Goodhue did reject from Labrouste was the impressive reading room, a type of grand space that had gained wide popularity in American library design by the 1920s. His Los Angeles scheme instead combined centralized bookstacks with fifteen departmental reading rooms organized by subject, each decorated under the direction of Julian Garnsey with different ornamental and mural schemes. The concept for this novel arrangement had been developed in consultation with the Library Board and its librarian, Everett R. Perry. Widely acclaimed at the time, this disposition was given extensive coverage by Joseph L. Wheeler and Alfred Morton Githens in their landmark publication of 1941, *The American Public Library Building: Its Planning and Design with Special Reference to Its Administration and Service.*[20]

At the core of this scheme, and rising up through the mass of the building, was a great central rotunda, which was located on the second floor of the building and acted as a point of convergence for corridors, elevators, and staircases that led to the primary reading rooms (figs. 10, 11). This is, noted Perry, "the first place you reach on entering the library and is your starting place and point of

15. The tower was intended to be used as an area of expansion of the bookstacks but never was. Goodhue seems to have derived its form from earlier proposals for the new Stirling Library at Yale and also ideas he had for a new type of American skyscraper. See Whitaker, *Bertram Grosvenor Goodhue*, pls. 196–97, 234–35; and also Hartley Burr Alexander, "Story of the Inscriptions," and Julian Ellsworth Garnsey, "Notes on Painted Decoration," in *Handbook of the Central Building: Los Angeles Public Library* (Los Angeles: Los Angeles Public Library, 1927), 17–25.

16. Henry Hobson Richardson and Frederick Law Olmsted designed a small garden as an entry to the Richardson Public Library at Malden, Massachusetts (1883–85), a building Goodhue would certainly have known; and a half century earlier Henri Labrouste had initially proposed erecting a garden as an entryway to the Bibliothèque Ste.-Geneviève. In 1852 in the *Revue générale de l'architecture* (in a description Goodhue could also have known), Labrouste explained that such an area "laid out in front of the building," would "shield it from the noise of the street outside" and "prepare those who come there for meditation. A beautiful garden would

undoubtedly have been an appropriate introduction to a building devoted to study." See Breisch, *Henry Hobson Richardson*, 207–8.

17. "Ce catalogue monumental est la principale décoration de la façade, comme les livres eux-mêmes sont le plus bel ornament de l'intérieur. " Henri Labrouste, "A M. le directeur de la Revue d'architecture," *Revue générale de l'architecture et des travaux publics* 10 (1852): col. 383.

18. Winslow, "General Description," 11.

19. Van Zanten, *Designing Paris*, 225.

20. Joseph L. Wheeler and Alfred Morton Githens, *The American Public Library Building: Its Planning and Design with Special Reference to Its Administration and Service* (New York: Scribner, 1941), 112–13, 314–19. This scheme was also based in part on the organization of the Cleveland Public Library, which was being constructed at the same time as Los Angeles. See Perry, "New Library Building as the Librarian Sees It," 27.

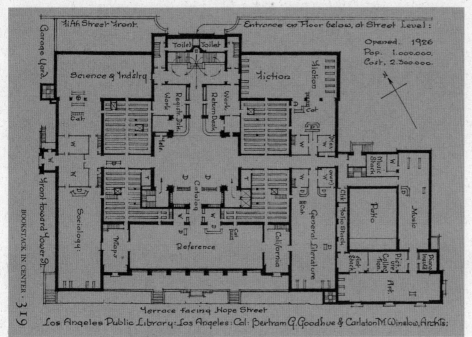

The plan contains the following labels:

Fifth Street Front.
Entrance on Floor below, at Street Level:

Opened. 1926
Pop. 1.000.000.
Cost. 2.300.000.

Garage Yard.
Science & Ind'stry
Toilet Toilet
Fiction
Fiction

Work
Regist. D.H.
Return Desk
Work
Cat

Cat.
W
W
Music Stack

Front toward Tower St.
Sociology
Maps
Catalog
Cat pam
Reference
California
Chk Folio Stack
Patio
Music

General Literature

Art Stack
Ceiling Room
Picture Insuld
Piano Insuld

Art.

BOOKSTACK IN CENTER · 319

Terrace facing Hope Street

Los Angeles Public Library: Los Angeles: Cal: Bertram G. Goodhue & Carleton M. Winslow, Arch'ts:

11 **Plan of Los Angeles Public Library.**

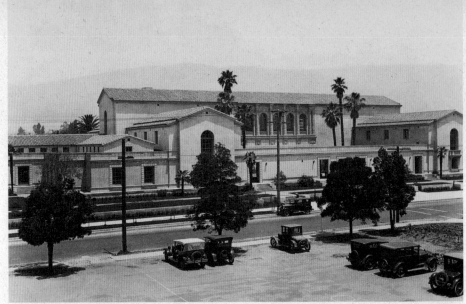

12 **Pasadena Public Library**,
designed by Myron Hunt and H. C. Chambers, 1927.

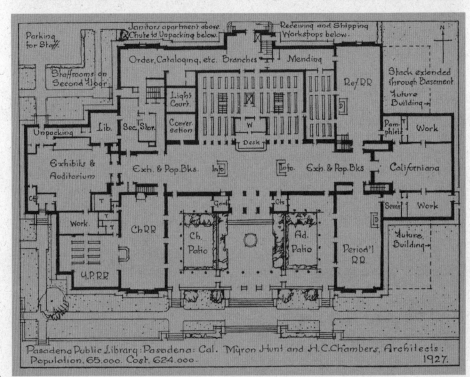

13 **Plan of the Pasadena Public Library.**

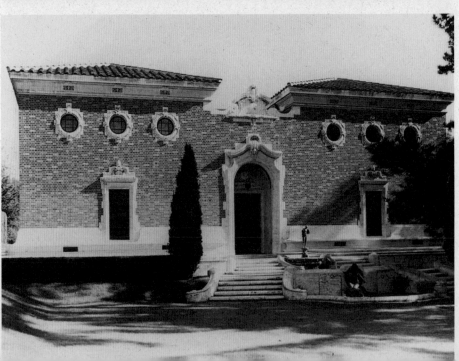

14 **William Andrews Clark Memorial Library,
Los Angeles**, designed by Robert Farquhar, 1924–26.

departure for any department you may seek."[21] Here you could register as a library patron, consult the main library catalogue, seek information, or return books. Arranged around this rotunda were four seven-story bookstacks with the capacity to house 1,212,500 volumes. Books were arranged in these stacks according to topic, so that the appropriate collections were adjacent to the related subject reading rooms, which themselves encircled the exterior of the building in order to take full advantage of ventilation and light. The varying dispositions of these spaces were articulated in the massing and fenestration of Goodhue's exterior elevations, while his broad abstract surfaces ultimately derived from the nature of the building's reinforced concrete construction.

Although admired by architectural critics such as Lewis Mumford, who praised Goodhue and Lawrie "for having the courage to explore together some of the possibilities of a modern symbolic architecture," the architect's stripped-down classical language was not as easily understood or appreciated by the general public, who seemed more comfortable with traditional styles of architecture.[22] As a result, all of the major library buildings subsequently erected in the Los Angeles area prior to World War II reverted to a variety of academic forms and—following the earlier experiments of Goodhue and Hunt—were typically ornamented with overt historical references to the Mediterranean region.

Both the Pasadena Public Library, which opened in 1927, and the smaller library building that William Andrews Clark Jr. completed a year earlier to house his private collection typify this more conservative taste (figs. 12–14). In their design for the Pasadena building, for example, Hunt and Chambers returned to the Italo-Iberian inspired vocabulary that Hunt had helped to popularize more than a decade earlier. Using classical motifs "in a manner peculiarly appropriate to California traditions, to California climate," as Harris Allen noted in *Pacific Coast Architecture*, Hunt had chosen to "clothe" his "archives historically—employing the principles of pure design, proportion, fenestration, scale, to express properly and beautifully the functional nature of the building—rather than to interpret the contemporaneous type of construction."[23] Robert D. Farquhar, who began work on the William Andrews Clark Memorial Library in 1923, by contrast, chose a more generic Mediterranean vocabulary for his edifice. Although Robert Judson Clark has pointed to Christopher Wren's late seventeenth-century Hampton Court Palace as a possible source for the Clark Library's decorative window surrounds, suggesting that they were intended to serve as an appropriate emblem for the British literature housed within, the building's red tile roof, Roman travertine stonework, and "Old Rose Face Brick" still suggested to some contemporaries, at least, "the refined, but colorful masterpieces found in old Italy."[24]

21. Perry, "New Library Building as the Librarian Sees It," 27.
22. Lewis Mumford, "American Architecture Today: The Third in a Series Analyzing and Criticizing Our Modern Architecture in Several Important Phases. Monumental Architecture," *Architecture* 58 (October 1928): 190.
23. Harris Allen, "The Housing of Libraries," *Pacific Coast Architecture* 32 (August 1927): 9; Clark, "Myron Hunt in Southern California," 36–48. Hunt and Chambers also designed the Palos Verdes Public Library in 1920 in a similar style.
24. Advertisement for Gladding, McBean and Company, manufacturers for the brick and terra-cotta for the building, *Pacific Coast Architect* 32 (August 1927): 52. For this building, see Robert D. Farquhar, "The Building," in *William Andrews Clark Memorial Library: Report of the First Decade, 1934–1944* (Berkeley and Los Angeles: University of California Press, 1946), 18–25; Robert Judson Clark, "Los Angeles Transfer: Romanticism and Integration, 1880–1930," in Robert Judson Clark and Thomas S. Hines, *Los Angeles Transfer: Architecture in Southern California* (Los Angeles: William Andrews Clark Memorial Library, UCLA, 1983), 34; William E. Conway, "Books, Bricks, and Copper: Clark and His Library," in *William Andrews Clark, Jr.: His Cultural Legacy* (Los Angeles: William Andrews Clark Memorial Library, UCLA, 1985), 1–27. The final cost of this building with furnishings was $767,000, compared to the estimated value of the books and manuscripts collected by Clark during his lifetime, which is about $683,000. Miscellaneous correspondence and many of the invoices related to the construction of this building can be found in the Clark Library Archives. See Archive Pre-1934, Library Building and Grounds, Box 1.

Set in a formal Italianate garden behind Clark's own residence (now demolished) on West Adams Boulevard, this edifice, which Clark dedicated to the memory of his father, recalls in form a Renaissance casino of the sixteenth or seventeenth century. Apparently inspired by McKim, Mead and White's Morgan Library in New York (1902–6), a similar private institution designed to house J. P. Morgan's personal collection of art and literature, Clark and his architect were cognizant as well of Huntington's recently completed library in San Marino. One wonders, too, if they were not aware of William L. Clements's recent gift of a small library building to the University of Michigan, which was intended to house his important collection of early Americana. The latter library, which itself bears a strong resemblance to the Morgan, was designed by the Detroit architect Albert Kahn and dedicated in 1923, the same year Farquhar apparently received the commission for the Clark Library.[25] In contrast to the marble and limestone elevations of the Morgan and Clements buildings, the Clark was constructed of brick with sculpted travertine ornament and trim. Although Wren had employed brick at Hampton Court, a more immediate precedent for the Clark Library can be found in Clarence H. Russell's design for the Cahuenga Branch Library (see fig. 5) or in the "Spanish Renaissance" style of Hudson and Munsell's Museum of History, Science, and Art, which opened in Exposition Park in 1913.

The interior decoration of the Clark Library was even more extravagant and eclectic than its façade. The vault of the marble-lined central hallway was lavishly decorated by Allyn Cox with Italian Renaissance murals allegorically depicting Clark's expansive interests in the arts and sciences.[26] This hall led back to the drawing room, which was to serve as the setting for concerts and lectures. Taking its proportions and ornament from the double cube of the Sala del Collegio in the Doge's Palace in Venice, this salon was ornamented with rich paneling and an elaborately carved ceiling of English oak with panels painted by Cox. Flanking either side of the hallway, and clearly articulated in the massing of the edifice, were two book rooms modeled on the library in the Château de Chantilly, outside Paris. Like the much larger reading room at the Huntington, each of these was two stories in height and encircled with bronze bookcases and galleries that offered access to an upper story of shelves. The model for their arrangement, intended for the conspicuous display of Clark's collection of rare books, was the hall library, or *Saalbibliothek*, a form that reflected a European tradition stretching back to the latter part of the sixteenth and early seventeenth centuries.[27]

Originally designed to house and exhibit the books of European royalty and religious institutions, the hall library had become by the nineteenth century the province of the wealthy American gentleman. In the version on West Adams, Clark and Farquhar were explicitly invoking its

25. Perhaps following Clements's lead as well, Clark announced in 1926 his intention to give his library and building to the University of California. For the Clements Library, see William L. Clements Library, *History of the William L. Clements Library, 1923–1973: Its Development and Its Collection* (Ann Arbor: University of Michigan, 1973); and Howard H. Peckham, "William L. Clements Library Building," in *The University of Michigan: An Encyclopedic Survey*, ed. W. A. Donnelly (Ann Arbor: University of Michigan Press, 1956), 1609–10. For the Morgan Library, see Roth, *McKim, Mead and White: Architects*, 288–92. According to Farquhar, however, the Clements is not among the half-dozen library buildings he visited in preparation for designing the

Clark Library. See Farquhar, "The Building," 19. For the gardens of the Clark Library, which were designed by Ralph Cornell, see Suzanne Tatian, "Far from All Noise, Some Silent Shade," *Center and Clark Newsletter*, no. 31 (spring 1998): 1–3.

26. Suzanne M. Wellman, "The Library Murals: Allyn Cox's First Major Commission," *Clark Newsletter: Bulletin of the Clark Center for 17th- and 18th-Century Studies*, no. 18 (spring 1990): 1–3.

27. For a good introduction to the literature on the development of library architecture in Europe, see Dennis M. Gromly, "A Bibliographic Essay of Western Library Architecture to the Mid-Twentieth Century," *Journal of Library History* 9 (1974):

earlier aristocratic roots. Like Huntington, Clark was presenting himself to the world in the guise of a Renaissance patron. But in distinct contrast to the siting and monumental form of Huntington's fortresslike temple, the clear intent of the Clark Library's precious aestheticism seems to have been to set its patron apart from the crass materialism of railroads and mining, land speculation and oil—all sources of the wealth that had made these institutions possible. Both men, as well, were pointedly rejecting any association with modern culture.

Early in 1923, for example, during the same months that Clark was working with Farquhar on preliminary plans for his library, the Los Angeles book dealer Alice Millard, one of the primary sources of Clark's collection, approached Frank Lloyd Wright to design a new home for her in Pasadena. "La Miniatura," as it became known, was completed in 1924 and represented Wright's earliest foray into concrete textile-block construction. In 1925 Millard asked Wright to prepare designs for a gallery addition to this house for the exhibition and preservation of her own collection of rare books. This small wooden and stucco structure, which was completed the following year and designed by Wright's son, Lloyd, ultimately proved inadequate for the purpose. As a consequence, many of Alice Millard's books were purchased by friends and donated to the Huntington Library at her death in 1938. Although both Wrights were experimenting with abstract ornament based upon regional botanical forms, the style they devel-

oped was far removed from the literal historicism of Clark's Renaissance retreat or Huntington's Ionic temple. In striking contrast to the more progressive notions of Alice Millard or Frank Lloyd Wright, it was culture validated by the patina of history that—in the words of Matthew Arnold—proved to be "a source of sure authority" for Clark and Huntington.[28]

While this approach was appropriate for a gentleman's private library or small research institute, larger public and academic libraries demanded a much more complex program than those of the Huntington or Clark libraries to accommodate their multiple functions and larger collections. Even as these collections continued to grow in size and book storage was more and more often relegated to utilitarian stacks of the type employed by Goodhue for the Los Angeles Public Library, architects still aspired to create inspirational spaces for the reading public. At Pasadena, for example, Hunt and Chambers placed a multistory bookstack with a projected capacity of 250,000 volumes at the rear of their building, behind a grand central hall that ran perpendicular to its façade and housed the circulation department (see fig. 13). Thus, enthused Wheeler and Githens, who acclaimed this arrangement as "one of the great library plans . . . anyone entering the building is at once not only in a room of imposing size and dignity, but in the midst of books and library activities."[29] Opening off this space, in addition to the stacks, were reading rooms, offices, and other services, with two wings extending

4–24. The primary sources for this topic include John W. Clark, *The Care of Books: An Essay on the Development of Libraries and Their Fittings, from the Earliest Times to the End of the Eighteenth Century* (Cambridge: Cambridge University Press, 1909); George Leyh, "Das Haus und seine Einrichtung," in *Handbuch der Bibliothekswissenschaft*, ed. F. Milkau (Leipzig: O. Harrassowitz, 1931–40), vol. 2, 1–38; Margaret Burton, *Famous Libraries of the World* (London: Grafton and Co., 1937); and Nikolaus Pevsner, *A History of Building Types* (Princeton: Princeton University Press, 1976), 91–110.

28. Matthew Arnold, *Culture and Anarchy*, ed. Samuel Lipman (London, 1869; New Haven: Yale University Press, 1994), 108. For Alice Millard and Frank Lloyd Wright, see Robert L. Sweeney, *Wright in Hollywood: Visions of a New Architecture* (New York: Architectural History Foundation, 1994), 27–42, 172–80; Conway, "Books, Bricks, and Copper," 10–16; and Starr, *Material Dreams*, 339–41. Henry Huntington was also an important customer of George and Alice Millard.

29. Wheeler and Githens, *The American Public Library Building*, 292–93, 300; George Diehl, "Pasadena's New Public Library," *Library Journal* 52 (15 March 1927): 297–303. This building was constructed at a cost of $586,000.

from the front of the building that housed the children's department and periodical reading room. These were linked with a low screen wall that opened into enclosed gardens for the use of patrons of these departments. To enter the building, one passed between these gardens, through a second entryway, and into the main hall. By arraying all of its primary activities on a single level around the book storage area, noted Wheeler and Githens, this scheme managed to achieve the advantage of the type of "center stack" plan evolved on multiple floors by Goodhue in Los Angeles.

In keeping with early twentieth-century academic tradition, the two major university libraries that Los Angeles spawned during this first great era of library building—at the University of California in Westwood and the University of Southern California—were both designed with monumental second-story reading rooms inspired by Labrouste's Bibliothèque Ste.-Geneviève and McKim, Mead and White's Boston Public Library (see figs. 6, 7). This pedigree is most evident in George W. Kelham's scheme for the University of California Library (now the Powell Library), which opened in 1929 (figs. 15, 16). Here, as at the Bibliothèque Ste.-Geneviève, one entered the building through a central atrium that opened into a color-fully ornamented double staircase at the back. As in Paris, these stairs led the patron up to a majestic reading room that was oriented parallel to the façade. While the exterior language on the Los Angeles building was now Lombard Romanesque, this reading space was identified and illuminated with a great arcade that articulated the front of the building.[30] Like Allison and Allison's Royce Hall (1928–29), which faces it across the central quadrangle, Kelham's

library exhibited a pastiche of motifs borrowed from a variety of medieval north Italian sources, including the churches of San Zeno in Verona and San Sepolcro in Bologna. Much of the interior decoration for this edifice, which reflects a more Spanish Romanesque and Islamic derivation, was completed by Julian Garnsey, who had earlier worked with Bertram Goodhue at the Los Angeles Public Library.

At the Edward L. Doheny, Jr. Memorial Library, which was dedicated in 1932 on the University of Southern California campus, Ralph Adams Cram, in association with Samuel E. Lunden, placed his primary reading room in the south wing of the building but still marked it with a broad band of windows (fig. 17).[31] As at the University of California, Cram clothed his building in Mediterranean quotations but of a somewhat more eclectic heritage. Here the ornament, as well as the overall plan, was derived from designs that he, Bertram Goodhue, and Frank Ferguson had prepared nearly two decades earlier for a new campus they designed for the William M. Rice Institute in Houston. As Cram would explain in his autobiography of 1937, the location of this college in Texas had drawn them to create "something. . . Southern in its spirit, and with some quality of continuity with the historic and cultural past. Manifestly the only thing to do was to invent something approaching a new style (though not *too* new) and to develop a psychological excuse for it."[32] Clearly medieval and Mediterranean in spirit, this new style "reassembled" elements borrowed from southern France and Italy, as well as Spain and Byzantium, to create richly articulated and colorful surfaces evocative of the polychromatic and picturesque taste of John Ruskin.

30. Richard Kent Nystrom, "UCLA: An Interpretation Considering Architecture and Site" (Ph.D. diss., University of California, Los Angeles, 1968), 47–67, 79–85; Alumni Association, University of California, Los Angeles, *California of the Southland: A History of the University of California at Los Angeles* (Los Angeles: UCLA Alumni Association, 1937), 35–45; and Clark, "Los Angeles Transfer," 39–41. On a much smaller scale Myron Hunt also designed the Mary Norton Clapp Library at Occidental College in 1924, and Gordon B. Kaufman, the Ella Strong Denison Library at Scripps College in Claremont (1930–31). See Stefanos Polyzoides and Peter de Bretteville, "Myron Hunt as Architect of the Public Realm," in *Myron Hunt, 1868–1952: The Search for a Regional Architecture*, vol. 4 of *California Architecture and Architects*, ed. David Gebhard (Los Angeles: Hennessey and Ingalls, 1984), 100–107; and Stefanos Polyzoides, "Gordon B. Kaufman, Edward Huntsman-Trout, and the Design of the Scripps College Campus," in *Johnson, Kaufman, Coate: Partners in the California Style*, ed. Jay Belloli (Santa Barbara: Capra Press, 1992), 83–113. For a discussion of academic library design at the time and the predominance of the monumental second-story reading room and compact stack book storage, see Charles Z. Klauder

and Herbert C. Wise, *College Architecture in America and Its Part in the Development of the Campus* (New York: C. Scribner's Sons, 1929), 70–92; and Arthur T. Hamlin, *The University Library in the United States: Its Origin and Development* (Philadelphia: University of Pennsylvania Press, 1981), 60–67, 158.

31. Cram was asked by Estelle Doheny in 1930 to design a library as a memorial to her son, an alumnus of the school who had been murdered the previous year. See Starr, *Material Dreams*, 127–28; "The Edward L. Doheny, Jr. Memorial Library, University of Southern California, Los Angeles," *Architecture* 72 (October 1933): 187–89; and Charlotte M. Brown, "Edward L. Doheny Jr. Memorial Library," *Library Journal* 57 (1 November 1932): 896.

32. Ralph Adams Cram, *My Life in Architecture* (Boston: Little, Brown and Company, 1937), 125; Clark, "Los Angeles Transfer," 36–41; Oliver, *Bertram Grosvenor Goodhue*, 105–8; and Stephen Fox, *The General Plan of William M. Rice Institute and Its Architectural Development*, Architecture at Rice, Monograph 29 (Houston: School of Architecture, Rice University, 1980).

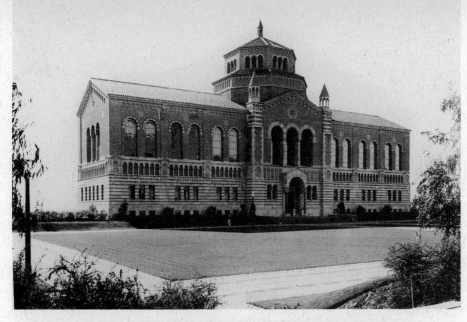

15 & 16 **University Library (Powell Library), University of California, Los Angeles,** designed by George W. Kelham, 1927–29.

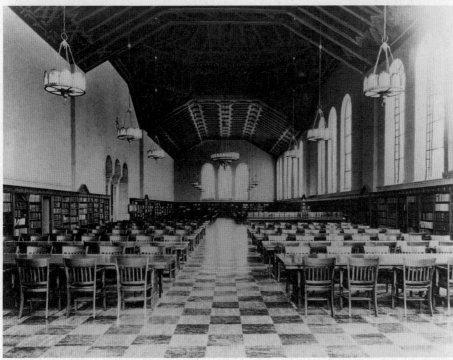

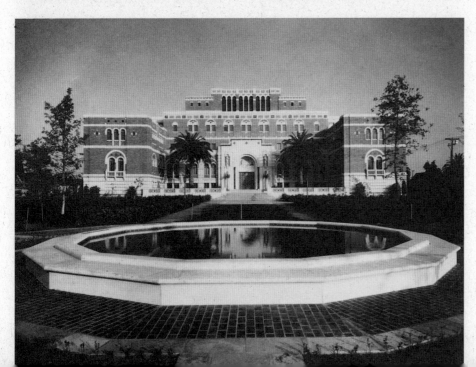

17 **Edward L. Doheny, Jr. Memorial Library, University of Southern California, Los Angeles,** designed by Ralph Adams Cram, 1932.

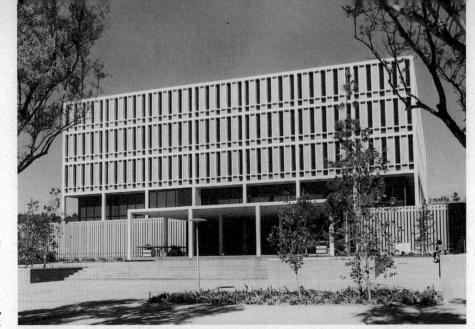

18 **University Research Library, University of California, Los Angeles**, designed by Jones and Emmons, 1964–67.

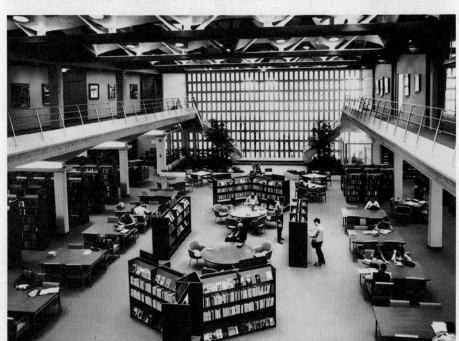

19 **Reading Room of the Santa Monica Public Library**, designed by Leizer and Russell, 1965.

Offered "as a sane and logical type of 'Modernism' better . . . than much of what bears the name and has been evolved since the Rice Institute was begun," Cram's deliberate resurrection of these forms at the Doheny Library might very well have been intended as a gentle rebuke to the subsequent work of his former partner, with whom he had parted ways in 1913.[33] While Goodhue had also employed sculpture, mosaics, and murals to adorn his Los Angeles Library, the severe demeanor of his concrete masses was quite different in character from Cram's warm tapestry of patterned Roman brick and rich inlaid marble. Yet the libraries shared a number of notable features. In a manner reminiscent of the plan of the Los Angeles Library, Cram also employed a central bookstack, which rose up through the core of his building and acted as a primary point of distribution for the adjacent departments and reading rooms that surrounded it. More significantly, the architecture of the Doheny Library, argued Cram (as Goodhue, no doubt, would have pleaded for his building), "expressed outwardly the varied function of all its parts, with no concessions to an *a priori* classical determinism; in other words, like a Gothic building it grew from within outward. . . . instead of from a predetermined exterior to an interior contingent on what the outside would permit."[34] This approach to design is most notably evident in Cram's façade, where the bookstack rises above the entryway of the building, as does Goodhue's more symbolic tower at the Los Angeles Public Library.

As Robert Clark has observed, it may have been the early work of Cram, Goodhue, and Ferguson at Rice that served as a model for the initial adaptation of north Italian and Byzantine revival styles at the campuses of both USC and UCLA during the decade before the Doheny Library was erected.[35] Utilized for its Mediterranean connotations but also, no doubt, for its associations with the great north

Italian universities at Bologna, Padua, and Modena, the Italian Romanesque had been introduced by John and Donald Parkinson at the University of Southern California as early as 1920. Employing a combination of red brick, cast stone, and terra-cotta, they, along with Ralph C. Flewelling and C. Raimond Johnson, eventually erected more than half a dozen buildings in this style. This ensemble, which would ultimately serve as the setting for Cram's Doheny Library, included Flewelling's Mudd Memorial Hall (1928–29). The latter building contains the Hoose Library of Philosophy on its second floor, a grand reading room, which was also decorated by Julian Garnsey and modeled on the late medieval Florentine basilicas of San Miniato and Santa Croce.[36] Five years later George Kelham, as the architect for the University of California, chose a similar north Italian idiom for the new Los Angeles campus in Westwood.

As noted earlier, the overt historicism exhibited by all of these early library buildings stood in stark contrast to the contemporary work of Frank Lloyd Wright and even more so to the more severe, modern aesthetic embraced by his colleagues Rudolph M. Schindler and Richard Neutra. Yet it would be the functionalist philosophy of these two European architects and their followers that would reemerge as the dominant school of design in Southern California during the decades following World War II. Unlike the prewar era, however, this was not a particularly auspicious time for the design of distinguished, large public and academic library buildings. Although more than a dozen of these were constructed or expanded on the rapidly growing campuses of the California State University system, at UCLA, Caltech, and other community colleges and private schools, none of these structures produced a powerful statement of their function or the nature of the collections they were erected to house. Following

33. Cram, *My Life in Architecture*, 127.
34. Ibid.
35. Clark, "Los Angeles Transfer," 36–41.
36. "Tuscan Motif in Murals of Philosophy Library," *University of Southern California Alumni Review* (November 1929); David Gebhard and Robert Winter, *Los Angeles: An Architectural Guide* (Salt Lake City: Gibbs Smith, 1994): 273–76.
37. Hamlin, *The University Library in the United States*, 68–83, 159–67.
38. Nystrom, "UCLA: An Interpretation Considering Architecture and Site," 165–69; "A Graduate Library Designed to Expand," *Architectural Record* 140 (September

1966): 214–17. "Award of Merit, University Research Library, University of California, Los Angeles, California," *American Institute of Architects Journal* 46 (August 1966): 54–55.
39. See Richard Meier, *Building the Getty* (New York: Alfred A. Knopf, 1997), 95–98, and idem, "A Vision of Permanence," in *Making Architecture: The Getty Center* (Los Angeles: J. Paul Getty Trust, 1997), 38–39; Harold M. Williams, Bill Lacy, Stephen D. Rountree et. al., *The Getty Center: Design Process* (Los Angeles: J. Paul Getty Trust, 1991); Clifford Pearson "A 'Secular Monastery,' The Research Institute Sets Itself Apart," *Architectural Record* 185 (November 1997): 98–101.

modernist tenets of architectural design and library plan-
ning, and reflecting, perhaps, the difficulty of adapting
principles of corporate functionalism to the design of
cultural institutions, the majority of these buildings were
simply cast as neutral and flexible containers for their
contents. While often constrained by limited budgets,
librarians, architects, and patrons were also encouraged by
the shift in focus of the Cold War curriculum from the
liberal arts to the sciences and engineering to embrace this
new aesthetic of America's postwar ascendancy.[37] Like
the industrial machine that had brought Americans victory
in war, it was seen as efficient, progressive, and modern.

The best of these postwar structures may be the
University Research Library by A. Quincy Jones and
Frederick E. Emmons, which opened at UCLA in 1966
(fig. 18).[38] Built to augment the earlier University Library
of George Kelham, this building was designed as a six-
story reinforced concrete structure with glass and brick
curtain walls surrounded by a twenty-foot-wide garden
moat to light the basement story. It was organized around
an open-plan concept of the type advocated by Keyes
Metcalf, a prominent librarian who acted as consultant to
the project, with interior piers set approximately twenty-
two feet on center to create the optimum flexibility for the
arrangement of freestanding banks of shelving, movable
partition walls, and study carrels. Hidden away on the bot-
tom story is the rare book room. The only space in the
building with traditional pretensions, it is tastefully fin-
ished with wood paneling and encircled with glass book-
cases in the manner of a private library but with none of
the opulence of those constructed privately by Huntington
and Clark.

Similar strategies were employed in the design of
reading and storage areas for other academic and larger
public library buildings erected during this period, where
books are typically arranged on freestanding metal shelves

in broad horizontal rooms illuminated with fluorescent
lighting. Although its main reading room was two stories
in height and encircled by a balcony, the Santa Monica
Public Library designed by Leizer and Russell and opened
in 1965 exhibits a typical open plan (fig. 19). Having
replaced the original Carnegie building (see fig. 4), which
was itself enlarged and remodeled in the Spanish Colonial
Revival style in 1927, the interior of this latest structure
was arranged with freestanding shelving, movable
partition walls, and flexible reading spaces.

While still embracing a vestige of the flexible plan,
the Getty Research Institute, which opened as a major
repository of rare books and special collections in
Brentwood in late 1997, was given a very different orien-
tation than its modernist predecessors (fig. 20).[39] The
building is organized around a central patio, which opens
toward Robert Irwin's garden and the museum, and visitors
and readers proceed through the library down a curving
glass ramp that leads from the entryway to the lower
floors. While the bulk of the institute's books are housed
in compact storage areas appended onto the central space,
freestanding bookshelves and reading areas, which radiate
outward from this ramp, exhibit about a third of the
collection. Designed by Richard Meier as part of the Getty
Center campus, this centrally planned pavilion is clad
in the same combination of glass, beige metal panels, and
cleft-cut Roman travertine as the other buildings in the
complex. While the use of travertine and the multiple gar-
dens again recall earlier Southern California traditions,
Meier's architectural lexicon derives more directly from the
work of European modernists such as Le Corbusier and the
architects of the Bauhaus. Envisioned as a "secular
monastery" by its former director, Kurt Forster, the
Research Institute is set apart from the more public areas
of the Getty Center on the western ridge of the institu-
tion's hilltop site.

40. Although there are earlier precedents, the idea of a panoptic library seems to
have been first popularized by Benjamin Delessert in his book *Mémoire sur la
Bibliothèque Royale, où l'on indique les mesures à prendre pour la transférer dans un
bâtiment circulaire, d'une forme nouvelle* (Paris: H. Dupuy, 1835). Here he proposed a
centralized book room as a means of enlarging the Royal Library (now the
Bibliothèque Nationale) in Paris. See Delessert, *Mémoire*, 10–11; Breisch, *Henry
Hobson Richardson*, 67–68; and also Jeremy Bentham, *Panopticon* (London: T. Payne,
1791); Michel Foucault, *Discipline and Punish: The Birth of the Prison*, trans. Alan
Sheridan (New York: Pantheon Books, 1979), 195–228, and idem, "The Eye of Power: A
Conversation with Jean-Pierre Barou and Michele Perrot," in *Power/Knowledge:
Selected Interviews and Other Writings: 1972–1977*, ed. and trans. C. Gordon (New
York: Pantheon Books, 1980), 146–65.

41. For all of the current branch libraries, see:
http://www.lapl.org/branches/branch_libraries.html. Frank O. Gehry's building has
been both the most acclaimed and the most criticized. See, for example, Pilar
Viladas, "Illuminated Manuscripts: Frances Howard Goldwyn Hollywood Regional
Branch Library, Hollywood, Calif.," *Progressive Architecture* 67 (October 1986): 76–84;
C. K. Gandee, "The Right Stuff," *Architectural Record* 173 (January 1985): 114–23; and
Mike Davis, "Frank Gehry as Dirty Harry" in *City of Quartz: Excavating the Future in
Los Angeles* (London and New York: Verso, 1990), 236–40.
42. Glenn M. Andres, "Hardy Holzman Pfeiffer: On Their Own Terms," *Hardy Holzman
Pfeiffer Associates: Concepts and Buildings*, ed. Jennifer Nelson (Middlebury, Conn.:
Middlebury College Museum of Art, 1993), 56–58.

20 **Getty Research Institute Library (interior), Los Angeles**, designed by Richard Meier, completed 1997.

Recalling the forms of Frank Lloyd Wright's Guggenheim Museum or the libraries of Finnish architect Alvar Aalto, this scheme also suggests the radiating shelving of a nineteenth-century panoptic library. Inspired by Jeremy Bentham's concept of the panopticon, as well as a variety of earlier eighteenth-century Neoclassical designs for libraries, hospitals, and prisons, this arrangement represented an efficient form of book storage, but as the term *panopticon* suggests, it also allowed for the supervision of readers and books from a central observation desk. While the Getty has thankfully eschewed the latter means of surveillance, the allusion, just the same, places the initial conception of this somewhat eccentric plan, which was evolved during the late 1980s, firmly within the sphere of the then-current American fascination with French academic theory, especially the ideas of Michel Foucault.[40]

Finally, although somewhat beyond the scope of this essay, it needs to be noted that throughout the twentieth century the cultural landscape of greater Los Angeles was being reshaped by the construction of dozens of branch library buildings by many of the area's larger library systems. From the time of Andrew Carnegie's gift in 1911 of $210,000 to the Los Angeles Public Library for the erection of its first six branch libraries, for example, this institution alone has erected or rebuilt more than seventy of these neighborhood institutions all across the county. Encompassing a full sweep of stylistic traditions, which range from regional classic revivals to postwar modernism, a good number of these small libraries stand out as significant architectural achievements. A brief review might include the Wilshire Branch Library by Allen Ruoff of 1927, the Canoga Park Branch Library (Bowerman and Hobson, 1959), or Frank O. Gehry's Frances Howard Goldwyn Hollywood Regional Library (1994).[41] Other smaller library systems—such as those in Pasadena, Glendale, and Santa Monica—also erected significant branch libraries during these years.

POSTSCRIPT

Even as the new Getty Center was in its initial stages of planning, two disastrous fires swept through the stacks of Bertram Goodhue's Los Angeles Public Library, destroying 20 percent of its collections and very nearly the building itself. Through the heroic efforts of the then-nascent Los Angeles Conservancy and with funding from Maguire Thomas Partners, an extensive rehabilitation of this structure, led by the architectural firm of Hardy Holzman Pfeiffer, was completed in 1993. What could be salvaged of the older building has been restored and a new eight-story wing added to the east with the subject departments now arrayed to either side of long escalators that advance downward beneath a monumental glazed atrium.[42] Significant rehabilitation efforts subsequently have been focused on the Pasadena Public Library, the Powell Library at UCLA, and, most recently, the University of Southern California's Hoose and Doheny Libraries. These endeavors, as well as this exhibition and catalogue, stand as a fitting celebration of Los Angeles's first great generation of library builders, one that established a fertile landscape for the continued nurturing and growth of architecture and reading in Southern California. Given the scope of their holdings and the impressive and varied nature of the structures erected to house these treasures, it seems clear that after little more than a century of library building, Los Angeles has truly come of age as a significant cultural center. Certainly its collection of libraries ranks among the most significant in the United States.

CATALOGUE OF THE EXHIBITION

4¾ in.

6 in.

Governor Pio Pico and His Family, c. 1852

Pico was the last Mexican governor of California
(1845–46)

I STARTING HERE

The first section of the exhibition focuses on Los Angeles in particular and California in general as a means of anchoring the world of collecting, an activity that is carried on in many places around the globe in a largely identical manner. Collections with "a local pride" at the heart of their builders' motivation (the phrase is from William Carlos Williams's poem *Paterson*) clearly have a greater likelihood of possessing unique elements than collections for which the local is less vital or even irrelevant. A kaleidoscopic representation through library artifacts of any city or state will predictably contain exploration narratives, maps, city directories, early photographs, posters, and literary works. But the city that is Los Angeles dictates, as no other city would, that the posters bear film images, that the range of local literature should run from noir fiction to German exile novels, that people of Latino and Asian ancestry should have a prominent place in the picture, and so on.

Section 1 is not an encapsulated history of Los Angeles. The selection of objects, as throughout *The World from Here*, mirrors the strengths of the collections from which they have been drawn and so reflects only a few facets of California and Los Angeles history. Aspects of the local have been chosen to represent the greater whole: the Spanish, and later Mexican, context from which Southern California emerged; the coming of age in cultural terms represented by the literature, architecture, and photography of the years between the wars; the forced relocation of Japanese American citizens during World War II; and the rise of the film business ("the industry" to Angelenos), that bit of the cultural mosaic most readily associated with Los Angeles by those who live elsewhere.

The books and other items by which the Los Angeles experience, as well as the larger context of California history, is recorded here do, at least, shine

a bright light on the "here" in the exhibition's title: the place where great collections have been formed by collectors whose interests extend to every imaginable subject, and who brought the harvest of more than a century of collecting to this very particular place. Even so unassuming, if not indeed enigmatic, a piece as the *Tablas para los niños que empiezan a contar*—a little arithmetic book printed in 1836 by Agustin Zamorano, California's first printer—is alive with historical evocation and is as polyvalent an object as a more visually accessible print by Paul Landacre or the poster from 1915 for the film in which Charlie Chaplin first portrayed the Tramp. A collector may indeed find the physically modest counting book, which survives only in the single copy at the Huntington Library, more compelling than the print or the poster. The point is that each object, in its very different way, has a small but significant place in the experience of Los Angeles, and all were saved out of a sense, however inchoate, that they mattered locally to a degree that they might not elsewhere.

The objects that document the history and culture of a particular place are often the ones that have the least obvious claim to being "treasures" in the conventional sense. *Tarzan of the Apes* and *Doktor Faustus* are undeniably famous works, but even in first edition they are perhaps not rare enough to be considered treasures in the way that the first editions of Chaucer's *Canterbury Tales* or Blake's *Book of Thel* (both of which may be found in other sections of *The World from Here*) irrefutably are. But if we extend the concept of local rarity defined by the bookseller and bibliographer John Carter in his *ABC of Book Collecting*, we are certainly justified in thinking of certain objects as local treasures. Some will not be universally acknowledged as such or even be well known at all—Jake Zeitlin's 1927 collection of poems, *For Whispers and Chants*, is an excellent example—but nevertheless their importance in their immediate sphere is acute enough to validate their inclusion in an exhibition of this kind. The presence of the Zeitlin book in fact responds more to the enormous importance of its author in the building of many Los Angeles collections than to its qualities as poetry. Perhaps no other bookseller's influence is as detectable throughout the entire range of *The World from Here*. *For Whispers and Chants* is a treasure for covert, or at least indirect, reasons, but a treasure it is, and it has a definite place in the "here" that is Los Angeles. *B.W.*

7⅜ in.

5¾ in.

Helen Hunt Jackson
Ramona, 1901

A rare copy of *Ramona* with watercolor illustrations

1

FRANCISCO MARIA PICOLO

Informe del estado de la nueva cristianidad de California

[Mexico City?, 1702]
11¼ x 7⁵⁄₁₆ in. (28.6 x 20.2 cm)
Los Angeles Public Library (972. P598-1 1702)

2

HELEN HUNT JACKSON

Ramona

Boston: Little, Brown, and Company, 1901
Watercolor sketches by W. H. Drake
7⁷⁄₁₆ x 5¼ in. (18.9 x 13.3 cm)
The Huntington Library, San Marino, California
(RB 18930)

Though not the first California novel, *Ramona* is perhaps the best known and most popular. Written in the same sentimental tradition as *Uncle Tom's Cabin*, *Ramona* generated both sympathy and political outrage by publicizing the nation's mistreatment of Native Americans. Originally one of the best-selling books of the nineteenth century, it was later adapted as a silent film by D. W. Griffith and remade several times in the sound era. The annual Ramona pageant—produced in Hemet, California, since 1927— attracts thousands of tourists and local enthusiasts. Unlike most works from the period, *Ramona* has stayed in print and remains controversial.

Helen Maria Fiske was born in 1830 in Amherst, Massachusetts, where her father was a professor of languages and her circle of friends included Emily Dickinson. She grew up in New England, but after the deaths of her first husband, Edward B. Hunt, and her two infant children, she traveled extensively. In Colorado Springs, Colorado, where she eventually settled, she married William Sharpless Jackson, a Quaker businessman. During a visit to Boston in 1879 she attended a talk on the plight of the Ponca Indians, delivered by Standing Bear. Afterward she decided to research and document the history of Indian dispossession, persecution, and genocide, publishing *A Century of Dishonor* in 1881. Although the treatise sold poorly, it launched Jackson's career as a political activist and transformed her into an "expert" on race relations and government policy.

As a result, the Commission of Indian Affairs formally appointed Jackson to investigate the living conditions of California's Mission Indians in 1883. During her tour of the region, Jackson was impressed by its picturesque scenery but appalled by the fallen state of its native inhabitants. In her novel, *Ramona*, published in 1884, she contrasted the present situation with the earlier idyllic existence that she believed the Indians had enjoyed while living in missions under Spanish and Mexican rule. While

condemning existing injustices, she nostalgically yearned for a return to a romanticized past. Jackson died a year after the book's publication, leaving behind a mixed legacy. Although her novel inspired the passage of legislation protecting the rights of Native Americans, it also created a cult craving for Mission aesthetics and colonial frontier iconography.

The original illustrations in this copy of the 1901 edition encourage the reader to interpret *Ramona* both as an accurate anthropological document and as a filtered gaze back on an earlier historical period. On the one hand, illustrator W. H. Drake set an authentic tone, providing visual documentation of many of the events described in the narrative. When the Huntington Library's copy was sold at auction in 1916, the sale catalogue stated, "Not only are incidents depicted, *but actual views of missions, buildings and localities* with which the volume treats, are represented with an accuracy possible only by actual knowledge of the places described." Drake rendered several missions, even some that don't appear in the novel; interspersed sketches of historical figures such as Pio Pico (p. 17) with portraits of Jackson's fictional characters; and included pictures of orange groves (p. 22), eucalyptus trees (p. 48), and indigenous animal species (p. 360) for contemporary readers unfamiliar with the region at the turn of the century.

On the other hand, the illustrator prettified California's flora and fauna, as well as its people and places. Unlike photographs or simple line drawings, the watercolors offer gauzy, blurred renderings in bright, vivid hues. Many of the paintings, which begin in the margins, bleed into the text, interfering with the reader's ability to experience the novel objectively. The antique lettering in the captions— and the gilt borders surrounding the title, the chapter headings, and the indented poetry (pp. 65–67, 277–78)—cloaks the novel in an atmosphere of quaintness and artifice. Hence, the charming aspects of this lovingly illustrated copy reflect the contradictions inherent within California's most famous novel. *Blake Allmendinger*

Bibliography

Helen Hunt Jackson, *A Century of Dishonor: A Sketch of the United States Government's Dealings with Some of Its Indians* (1881); David Luis-Brown, "'White Slaves' and the 'Arrogant Mestiza': Reconfiguring Whiteness in *The Squatter and the Don* and *Ramona*," *American Literature* 69 (December 1997): 813–39; Anne E. Goldman, "'I Think Our Romance Is Spoiled'; or, Crossing Genres: California History in Helen Hunt Jackson's *Ramona* and Maria Amparo Ruiz de Burton's *The Squatter and the Don*," in *Over the Edge: Remapping the American West*, ed. Valerie Matsumoto and Blake Allmendinger (Berkeley and Los Angeles: University of California Press, 1998), 65–85.

3

(a) Reglamento provicional para el gobierno interior de la Ecma: Diputación territorial de la Alta California Aprobado por la misma corporacíon en sesión de 31. de Julio del presente año

Monterey: Zamorano, 1834
5 ³⁄₁₆ x 4 in. (14.8 x 10.2 cm)
The Seaver Center for Western History Research,
Natural History Museum of Los Angeles County
(JK 8731 1834)

(b) [JOSÉ MARIANO ROMERO] Tablas para los niños que empiezan a contar

Monterey: Zamorano, 1836
3 ¹³⁄₁₆ x 2 ¹³⁄₁₆ in. (9.7 x 7.1 cm)
The Huntington Library, San Marino, California
(RB 4373)

(c) Botica general de los remedios esperimentados; que á beneficio del público se reimprime por su original en Cadiz, en Sonoma, de la Alta California

Sonoma: [José de la Rosa]
Por M. G. V. Impre[n]ta del Gobierno, 1838
5 ¹³⁄₁₆ x 4 in. (14.8 x 10.2 cm)
The Huntington Library, San Marino, California
(RB 42626)

There are very few extant examples of printing executed in California before July 1834. The presswork done in this period (1825–34) consisted of letterheads and sealed-paper headings created from woodblocks and an ancient set of type. The person usually credited with overseeing this crude printing is Agustin Vicente Zamorano.

In 1825 Zamorano came north from Mexico with the newly appointed governor of California, José Maria Echeandia, and was to serve as his executive secretary for the next eleven years through an era of turbulent territorial politics. His experiences as an officer in the Mexican infantry and a subsequent assignment in the corps of engineers prepared him little for becoming the first person in California to operate a printing press.

Zamorano was to upgrade his printing capabilities in 1834 with the acquisition of a Ramage press, along with a font of small pica type, which included "capitals, lower-case letters, small capitals, and figures, together with some small decorative units."[1] This became California's first printing press. A broadside announcement, or "Aviso al Publico," quickly came out. It reads in part: "The printing office of Citizen Agustin V. Zamorano and Company

established in this Capital offers its services to the public with the greatest punctuality and careful attention, accepting all kinds of manuscripts, under the regulations established by the laws of freedom of the press, . . . Monterey 1834 Zamorano and Co. Press."[2] Zamorano was in the business of printing.

Despite the limitations of his English-language type and the unsophisticated layout, composition, and presswork of his publications, Zamorano began to fill a real need in frontier California. Besides the initial announcement, two government broadsides, a ball invitation, and a sixteen-page pamphlet appeared in 1834. The pamphlet, entitled *Reglamento provicional para el gobierno interior de la Ecma*, contains fourteen articles, or regulations, of the territorial assembly of Alta California. It is a small first endeavor, but in fact it is probably "the first book printed in what is now the western United States."[3] Only two copies of this work are known: one in the Bancroft Library at the University of California, Berkeley, and the other in the Natural History Museum of Los Angeles County.

Almost all of Zamorano's work continued to be done for the government. On March 16, 1835, Governor José Figueroa addressed a proclamation to the people of Alta California ordering the seizure and deportation to Mexico of José María Híjar and José María Padrés, whom he considered traitors. This broadside was printed by Zamorano's press and was followed by his second book, entitled *Manifiesto a la Republica Mejicana*, which was a defense by Figueroa of his actions against Híjar and Padrés.[4] This was the largest book printed by the Mexican press in California, and it included a title page, errata and printer's note, and 183 pages of text. The "Nota del Impresor" (printer's note) reflects Zamorano's personal embarrassment over the book's typographic deficiencies: "The readers are asked to be kind enough to overlook the lack of accents which they will notice in this work, because of the fact that the complete supply of type which is expected has not yet arrived; also they are asked to be tolerant toward any other typographical defect . . . taking into consideration the fact that it is the first of its kind to be published in the only printing office of this Alta California." Printing historian and typographer Herbert Fahey noted: "In spite of its defects, the printing of the *Manifiesto* was a great accomplish-

ment for the Zamorano printer. This book represented the highest achievement of the Mexican press of California, and it demonstrated, for that era, a noteworthy manifestation of human endeavor."[5]

Early in 1836 the Zamorano press printed two small schoolbooks for children. One, the *Catecismo de ortologia*, is a pronunciation manual.[6] The other, *Tablas para los niños que empiezan a contar*, is an arithmetic primer. The manual was prepared by the principal of the Normal School of Monterey, José Mariano Romero, for his students, as most likely was the little arithmetic book, which contains ten leaves sewn in orange wrappers. Delightful ringed ornaments of daggers and dollar signs were used to highlight the title page of the *Tablas*. The text is without ornamentation and provides multiplication, conversion, and equivalency tables. These little works can claim to be the first schoolbooks printed in California, and both are exceedingly rare. Two copies of the pronunciation manual and only one copy of the arithmetic exist.

A revolution occurred in Alta California in November 1836, and Zamorano left Monterey, losing control of the press. By July 1837 General Mariano G. Vallejo—who, along with Juan B. Alvarado, had seized the government of the territory—moved the press to his headquarters in Sonoma, where California's first medical book was published in 1838. Probably printed by José de la Rosa, the *Botica general de los remedios esperimentados* (General formulary of tried and tested remedies) was an anachronistic oddity even in frontier California. The suggested formularies are based on folklore and superstition, and this publication is foremost an indication of the poor state of medical care in the region in the 1830s. Though of little use on the frontier, this twenty-six-page work stands as a remarkable rarity and was the first of its kind in California.

Agustin Zamorano became very ill on a voyage from Mexico and died in San Diego in September 1842. He was buried in the cemetery at the Mission San Diego de Alcalá. The Zamorano Ramage lasted into the American period and was employed in printing the *Sonora Herald* in 1850. Zamorano and his Ramage brought printing to California, and although the imperfections and shortcomings of the work are evident, it was a pioneering effort that we can certainly admire and treasure. *Alan H. Jutzi*

References
Robert Greenwood, *California Imprints, 1833–1862: A Bibliography* (Los Gatos, Calif.: Talisman Press, 1961), nos. 2, 29, 42.

Bibliography
George L. Harding, *Don Agustin V. Zamorano* (Los Angeles: Zamorano Club, 1934); *Botica general de los remedios esperimentados, Sonoma, 1838*, trans. María López de Lowther, introduction by Viola Lockhart Warren (Los Angeles: Friends of the UCLA Library, 1954); Herbert Fahey, *Early California Printing* (San Francisco: Book Club

of California, 1956); Carey S. Bliss, *The First School Book Printed in California, with an Exact Facsimile Reproduction of the Unique Copy in the Huntington Library* (Los Angeles: Zamorano Club, 1976).

Notes
1. Fahey, *Early California Printing*, 20.
2. Ibid., 17–18.
3. Ibid., 21.

4. José Figueroa, *Manifiesto a la Republica Mejicana que hace el general de brigada Jose Figueroa, comandante general y gefe politico de la Alta California, Sobre su conducta y la de los Señores D. Jose Maria de Hijar y D. Jose Maria Padres, como Directores de Colonizacion en 1834 y 1835* (Monterey: Zamorano, 1835).
5. Fahey, *Early California Printing*, 23.
6. José Mariano Romero, *Catecismo de ortologica: Dedicado a los alumnos de la escuela normal de Monterrey por su Director Jose Mariano Romero* (Monterey: Zamorano, 1836).

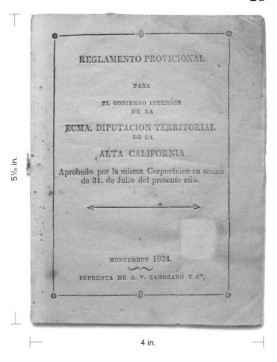

REGLAMENTO PROVICIONAL.

PARA

EL GOBIERNO INTERIOR
DE LA

ECMA. DIPUTACION TERRITORIAL
DE LA

ALTA CALIFORNIA

Aprobado por la misma Corporacion en sesion
de 31. de Julio del presente año.

⟵————————⟶

MONTERREY 1834.

IMPRENTA DE A. V. ZAMORANO Y Cª.

5 7/16 in.

4 in.

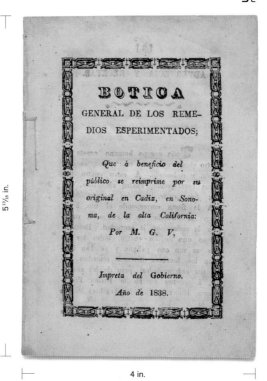

BOTICA
GENERAL DE LOS REME-
DIOS ESPERIMENTADOS;

Que á beneficio del
público se reimprime por su
original en Cadiz, en Sono-
ma, de la alta California:

Por M. G. V,

Impreta del Gobierno.

Año de 1838.

5 13/16 in.

4 in.

Pedro Castro

TABLAS

PARA LOS NIÑOS

QUE EMPIEZAN A CONTAR.

〜

MONTERREY. 1836.

〜

IMPRENTA DE A. ZAMORANO.

3 13/16 in.

2 13/16 in.

**Three books printed in the print shop
of Agustin Vicente Zamorano**, 1834–38

3a The first book printed in California

3c The first medical book printed in California

3b The only known copy of this early children's
arithmetic book

PRIMERA SECRETARIA
DE ESTADO.
DEPARTAMENTO DEL INTERIOR.

Por la Vía de Rel. y de Relaciones se me ha comunicado el decreto siguiente

El Exmo. Sr. Presidente interino de los Estados-Unidos Mexicanos se ha servido dirigirme el decreto que sigue.

„El Presidente interino de los Estados-Unidos Mexicanos, á los habitantes de la República, sabed: Que el Congreso general ha decretado lo siguiente.

„Se erige en ciudad el pueblo de los Angeles de la Alta California, y será para lo sucesivo la Capital de este Territorio.=Basilio Arrillaga, diputado presidente.=Antonio Pacheco Leal, presidente del Senado.=Demetrio del Castillo, diputado secretario.=Manuel Miranda, senador secretario."

Por tanto, mando se imprima, publique, circule, y se le dé el debido cumplimiento. Palacio del Gobierno federal en México, á 23 de Mayo de 1835.=*Miguel Barragán.*=A D. José Maria Gutierrez de Estrada."

Y lo comunico á V. para su inteligencia y fines consiguientes.

Dios y libertad. México 23 de Mayo de 1835.

Gutierrez Estrada.

[handwritten text]

[signatures]

"Se erige en ciudad el pueblo de Los Angeles de la Alta California," 1835

The document that established Los Angeles as a city

4

MIGUEL COSTANSO

Diario historico de los viajes de mar

Mexico City: Imprenta del Superior Gobierno, 1770
8⅝ x 7⅞ in. (21.9 x 20 cm)
Los Angeles Public Library (979.4 C838)

5

"Se erige en ciudad el pueblo de Los Angeles de la Alta California"

Mexico City, 1835
11⁵⁄₁₆ x 8⅛ in. (28.7 x 20.6 cm)
Los Angeles Public Library (fR 979.41 L881 Me)

In the Mexican period of California history (1821–46), between Spanish rule and American takeover, the political situation was fractious and confusing. The territory of Alta California was ruled by a Spanish, later Mexican, governor, who convoked, or refused to convoke, a body called the *diputación*, consisting of representatives from the leading families of the ranchos and presidios of both the northern and southern parts of the territory. The *diputación* sent one member, a *diputado*, to the Mexican congress, where he represented the territory, having the right to speak but not to vote. Jose Antonio Carrillo, a member of a prominent landholding family, was responsible, during his term as *diputado*, for the decree printed on this broadside. It raised the status of Los Angeles from that of a town to that of a city and made it the territorial capital, a distinction formerly belonging to Monterey. In fact, while Los Angeles remained a "city," it was the capital only briefly. The decree represents one of many efforts on the part of the Californios (Spanish-Mexican settlers) to give their part of the world the dignity it lacked. Ironically, within a decade the Californios were in decline.

On the fringes of the Spanish empire, and later of the new nation of Mexico, California was a neglected possession with a tiny population and a primitive economy. Its history, characterized by a series of revolts and by factional rivalries, was the stuff of comic opera. Supported by Indian labor, the huge ranchos, home to thousands of half-wild cattle, produced enormous quantities of hides and tallow for both local consumption and trade to British and New England sea captains. The missions, also supported by Indian labor, grew grain, fruits, and vegetables, mostly for local consumption. There was no formal education to speak of. Visiting Europeans were struck by the inhabitants' apparent lack of ambition. But at the same time the area offered a free and easy way of life, in a climate where one could live outdoors most of the time, where pasturage and water were abundant, and where the large, patriarchal rancho families extended fabulous hospitality to neighbors and strangers alike.

This "arcadia" came to an end with the takeover by the Americans. Within the space of scarcely more than a generation, the great historian Hubert Howe Bancroft began to extol the days of "Spanish Pastoral," and the creation of the fantasy heritage of Spanish California had begun. At the turn of the twentieth century, Charles F. Lummis, among many other boosters, presented the era of the ranchos and the missions as a time of high romance, a view that still informs our mental and physical landscape.

In the year 2001 another California historian, State Librarian Kevin Starr, commenting on the implications of the 2000 census, stated: "The Anglo hegemony was only an intermittent phase in California's arc of identity, extending from the arrival of the Spanish. The Hispanic nature of California has been there all along, and it was temporarily swamped between the 1880's and the 1960's, but that was an aberration. This is a reassertion of the intrinsic demographic DNA of the longer pattern, which is part of a California-Mexico continuum."[1] Carrillo and his compatriots would be happy to know this.

The broadside appears to be quite rare. This copy is from the Rare Books Department of the Los Angeles Public Library, Central Library, where it forms part of a small but choice collection on the history of California and Mexico. Other copies are located at the Bancroft Library of the University of California, Berkeley, and the Huntington Library.
Romaine Ahlstrom

References
Abstracted in *Recopilacion de leyes, decretos, bandos, reglamentos, circulares y providencias de Los Supremos Poderes y otras autoridades de la Republica Mexicana . . . por el Lic. Basilio Jose Arrillaga . . . enero a diciembre de 1835* (Mexico: J. N. Fernandez de Lara, 1836); facsimile edition (keepsake presented to the Mallorcan representation on the occasion of their visit to Los Angeles in connection with California's bicentennial in 1969), printed by Grant Dahlstrom at the Castle Press.

Bibliography
Hubert Howe Bancroft, *History of California*, vol. 3, *1825–1840*, vol. 20 of *The Works of Hubert Howe Bancroft* (San Francisco: History Company, 1886); idem, *California Pastoral, 1769–1848*, vol. 34 of *The Works of Hubert Howe Bancroft* (San Francisco: History Company, 1888); David J. Weber, *The Mexican Frontier, 1821–1846: The American Southwest under Mexico* (Albuquerque: University of New Mexico Press, 1982); Walton Bean and James J. Rawls, *California: An Interpretive History* (New York: McGraw-Hill, 1988); Todd Purdum, "California Census Confirms Whites Are in Minority," *New York Times*, 30 March 2001.

Notes
1. In Purdum, "California Census."

6
Governor Pio Pico and His Family, c. 1852
Daguerreotype (anonymous maker)
4¾ x 6 in. (12 x 15.2 cm)
The Seaver Center for Western History Research,
Natural History Museum of Los Angeles County
(A. 4811-754)

7
El clamor publico, 29 January 1859
18¼ x 11¾ in. (46 x 29.8 cm)
The Huntington Library, San Marino, California
(RB 225168)

8
Los Angeles Star, 30 July 1859
21⁵⁄₁₆ x 14⅛ in. (54.8 x 35.7 cm) (bound)
The Huntington Library, San Marino, California
(RB 57450)

9

Los Angeles City and County Directory

Los Angeles: [Waite and Beane], 1872
9⅞ x 6¾ in. (25.1 x 17.1 cm)
William Andrews Clark Memorial Library,
UCLA (Press Coll. Ritchie Lib.)

In his widely read guidebook *California for Health, Pleasure, and Residence* (1873), Charles Nordhoff began his overview of Los Angeles with the declaration: "The Puebla de Los Angeles—the town of the angels—is not, in its present state, a very angelic place." After this derogatory statement, he commenced to praise the town's marvelous climate for health seekers and to describe it as the center of trade for the citrus-growing region of Southern California.

In fact, Los Angeles can be viewed at the time as "in between." It was neither the Spanish-Mexican adobe village of the 1830s and 1840s nor the booming 1880s American city driven by the advancing intercontinental railroads. It had come a long way from its founding as a frontier settlement in 1781, but it was not yet the 1910 hub of a sprawling and increasingly diversified Southern California economy linked by the octopus tentacles of the Pacific Electric interurban rail line.

As Los Angeles's first city and county directory indicates, the potential for becoming a great city was there in 1872 but was still many decades away from fruition. The directory appears to have been organized out of the offices of A. J. Waite and Alonzo King, publishers of the *Los Angeles Daily News*. The project was begun in 1869, and since there was no precedent, the task of compiling names was indeed arduous, particularly because the city itself lacked a complete numbering system for its streets. But on December 10, 1871, the *Daily News* announced: "Mr. Mark Pemberton, who has had some experience in the business, will commence canvassing early this week. We understand that he is well supported with capitol [*sic*] in the enterprise, and will carry it through without fail." On January 6, 1872, the newspaper stated that the directory would be issued on March 1 and would "contain a Full List of Names of every Resident of the City; Also, Names of Residents of other Leading Towns in the County. And will be First-Class in all Respects."

The publishers' optimistic plans were never fully realized. The final product came out in June of 1872 and contained fifty-seven pages of advertising; twelve pages of names and addresses of city residents; six pages of names and occupations of county residents from the precincts of El Monte, Anaheim, Gallatin, Wilmington, Santa Ana, and San Jose; a listing of government officials; and a nineteen-page history of the city, county, and other localities, accompanied by descriptions of civic, social, and religious organizations and their officers. The publishers originally had intended to list the professions of each city resident but stopped complete entries in the letter *B*. There are only about fifteen hundred individual entries, most of which appear to be for heads of families. Only a small percentage of the county population is represented; it is obvious that no effort was made to identify Native Americans.

Los Angeles's first city and county directory is indeed a glimpse of Southern California on the verge of an explosion—a boom in population, agriculture, and commerce. The advertising section is particularly informative and typographically interesting. As printer and historian Ward Ritchie wrote, "Here is a museum of not only Los Angeles business firms of that time but a riot of ornamented nineteenth century typefaces arranged with vigor and imagination."[1]

Because this book exists in only three copies (Bancroft Library, University of California, Berkeley; the Natural History Museum of Los Angeles County; and the Clark Library, UCLA), and no copy contains a title page, the actual publisher in 1872 has never been definitively identified. Based on the Waite & Beane Job Printing Office advertisement on the last page of the directory, Ritchie convincingly argued that it was indeed this business that produced Los Angeles's first directory. The copy in the Clark Library comes from the collection of Ward Ritchie and was acquired in 1996. *Alan H. Jutzi*

Bibliography
The First Los Angeles City and County Directory, 1872: Reproduced in Facsimile with an Introduction by Ward Ritchie and Early Commentaries by J. M. Guinn (Los Angeles: Ward Ritchie Press, 1963).

Notes
1. Ward Ritchie, in *First Los Angeles City and County Directory*, 22.

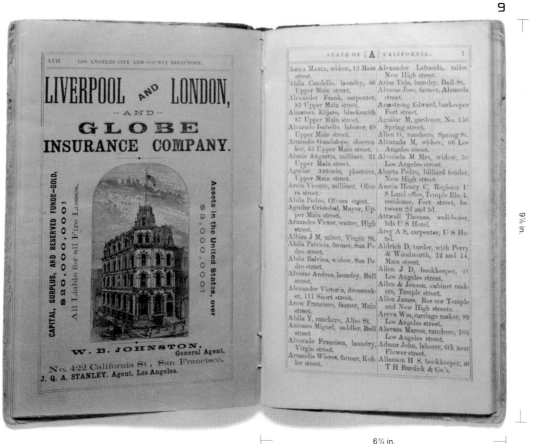

Los Angeles City and County Directory, 1872

One of only three known copies of the first
city directory of Los Angeles

15 in.

MISSION, SAN FERNANDO REY.
LOS ANGELES COUNTY, CALIFORNIA, ESTABLISHED SEPT. 8TH, 1797.
GENERAL VIEW FROM THE EAST.

No. 1216. WATKINS' New Series. 26 New Montgomery Street, San Francisco.

21⁵⁄₁₆ in.

Carleton Watkins
Mission San Fernando Rey, No. 1216, 1876–82

10
CARLETON WATKINS
Mission San Fernando Rey, No. 1216
From The New Series, 1876–82
Albumen print; 15 x 21⁵⁄₁₆ in. (38.1 x 54.1 cm)
Department of Special Collections, Young Research
Library, UCLA (*** 98 #1216)

Carleton Watkins (1829–1916) came to California from Oneonta, New York, between 1850 and 1851, encouraged by his hometown friend Collis P. Huntington (1821–1900),[1] who was living in Sacramento. With California in the throes of the gold rush, Watkins worked in Huntington's hardware business, delivering supplies to the mines. Watkins relocated to San Francisco around 1852 and began working as a clerk in a bookstore on Montgomery Street. He seems to have embarked upon a career in photography by chance in 1854, when he was asked to fill in as a daguerreotype technician in Robert Vance's portrait studio.

Watkins quickly moved outside the confines of the studio to photograph the varied landscape of California, often using a cumbersome large-format camera and wet glass-plate negatives. He was drawn to many of his subjects through commissions and created a number of photographs that documented property and land use and served as evidence in legal disputes. As California was still considered a very distant outpost, Watkins's images were many people's first exposure to the Western landscape. They were used both to sell California's land and to preserve it. His photographs of John C. Frémont's Mariposa estate, for example, were shown to potential land investors in Europe, whereas his breathtaking mammoth-plate views of Yosemite from the early 1860s apparently helped convince President Lincoln to sign a bill in June 1864 to preserve Yosemite Valley.

Watkins was not known for his business sense and had a number of financial ups and downs throughout his career. In 1875 he lost his San Francisco gallery, the Yosemite Art Gallery, and most of his Old Series negatives to John Jay Cook, who had previously lent money to him. To add insult to injury, Cook, in association with photographer Isaiah West Taber, took over Watkins's former gallery. Despite these financial setbacks, Watkins soon began a new body of work, which he called his New Series. In 1876 he traveled to Southern California on the Central Pacific Railroad in two railcars that were specially equipped for him. It was probably on this trip that he began to photograph the Southern California missions. Between 1876 and 1880 Watkins made several more trips by train and wagon, during which he worked on his mission project in Northern and Southern California.

By the 1870s the status of the California missions was at a low point. Many of the twenty-one Franciscan missions were in disrepair, and imagery of the missions found in art and literature in the 1870s and early 1880s was often negative or, at best, ambiguous. Around 1872 the artist Edward Vischer did, however, produce a number of lithographs and paintings accentuating the romantic and nostalgic qualities of the missions, which enjoyed some commercial success. The popularity of Vischer's works may have encouraged Watkins to create his series. He produced an album consisting of thirty-six mammoth plates (approximately 18 x 22 in.) of sixteen of the missions. He also made a number of stereographic views.

This particular image, number 1216 from Watkins's New Series, depicts Mission San Fernando Rey de España, the seventeenth mission founded by the Franciscans. It was established on September 8, 1797, by Father Fermin Lasuen and is located on Mission Drive, one and a half miles from the city of San Fernando and approximately twenty-two miles from Los Angeles. In this long-range view taken from the east, Watkins chose to emphasize the great expanse of land around the mission. There are few buildings and no people. The cloudless sky reinforces the feeling of wide-open space. This image displays elements of a new way of looking that was influenced by the railroads. Douglas R. Nickel has described this phenomenon as Watkins's "railroad vision," noting that many of his photographs bear "a striking resemblance to what one would have seen through the windows of a moving Pullman passenger car; travelers in the moving compartment would find the foreground indistinct, but the middle ground and distance [more] visually arresting since these went by more slowly."[2]

UCLA's Department of Special Collections purchased the complete set of thirty-six mammoth-plate prints that make up Watkins's mission series in 1973 from Gordon Bennett. Special Collections has other Watkins photographs as well, including fifteen of his mammoth plates of Yosemite from the 1860s.
Carolyn Peter

Bibliography
Peter E. Palmquist, *Carleton E. Watkins: Photographer of the American West* (Albuquerque: University of New Mexico Press, 1983); Douglas R. Nickel, *Carleton Watkins: The Art of Perception* (New York: Harry N. Abrams, 1999).

Notes
1 Collis P. Huntington eventually became one of the owners of the Central Pacific Railroad. His nephew Henry E. Huntington (1850–1927) came to California to help manage the Southern Pacific Railroad. After Collis's death, Henry greatly expanded the railway lines and created his own powerful business empire. He married his uncle's widow, Arabella Huntington, in 1913, and together they collected art and rare books. In 1919 they founded the Huntington Library, Art Collections, and Botanical Gardens.
2. Nickel, *Carleton Watkins*, 31.

1 1

Map of Hollywood, 1887
27 ⁹⁄₁₆ x 41⅛ in. (70 x 104.5 cm)
The Huntington Library, San Marino, California
(RB 442300)

1 2

**Topographical map of the
Los Angeles River**

C. S. Compton and J. H. Dockweiler, 1896–97
Four sheets:
29¾ x 114⅞ in. (75.6 x 291.8 cm);
30 x 73 in. (76.2 x 185.4 cm);
30⅝ x 127¹³⁄₁₆ in. (77.8 x 324.6 cm);
29⅞ x 53⅞ in. (75.8 x 136.7 cm)
The Huntington Library, San Marino, California
(HM 62463)

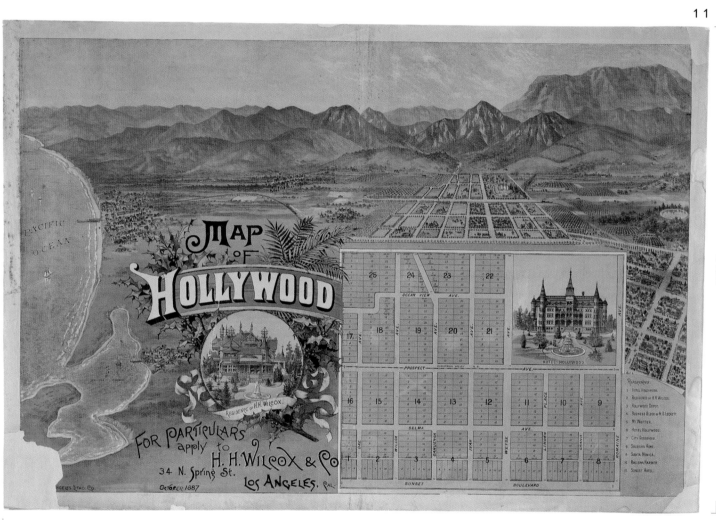

Map of Hollywood, 1887

The first printed map of Hollywood

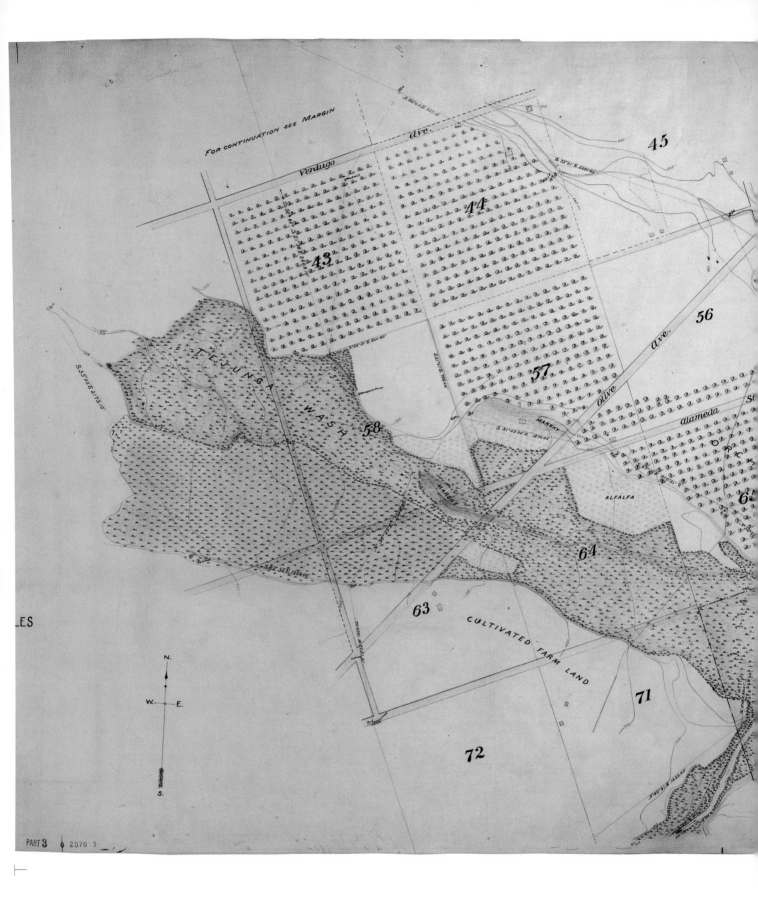

For continuation see Margin

Verdugo ave.

45

44

43

TEJUNGA WASH

56

58

57

Olive ave.

alameda St.

ALFALFA

64

63

65

CULTIVATED FARM LAND

71

N.

W. E.

S.

72

LES

PART 3 2070 3

58 in.

30⅝ in.

Topographical map of the Los Angeles River (detail), 1896–97

A manuscript map of the Los Angeles River showing the section between the Buena Vista Street Bridge and Main Tujunga Wash

13
Three broadside posters for "Land of Sunshine," 1896

(a) March 1896
(Indian against a stylized background)
Illustrated by Pierre Artigue
15½ x 8½ in. (39.4 x 21.6 cm)

(b) April [1896] (woman playing
a stringed instrument)
Illustrated by Pierre Artigue
15½ x 8⁷⁄₁₆ in. (39.4 x 21.4 cm)

(c) November 1896 (woman picking fruit,
red sun in background)
Illustrator unknown
11¹⁵⁄₁₆ x 9¹⁵⁄₁₆ in. (30.3 x 25.2 cm)
Los Angeles Public Library (741.4 L2535 folio)

Crude and colorful, like the man who commissioned them, these posters advertised three issues of Charles Fletcher Lummis's monthly magazine *Land of Sunshine* in 1896. Lummis claimed in his journal that this represented the first time posters had been used in Los Angeles to advertise a magazine. About the artists, nothing is known. To produce the posters, Lummis used the cyanotype process that he favored for his photographs.

Lummis (1859–1928) was a tireless popularizer of his idea of the West in the years just before and after the turn of the twentieth century. Born in New England, educated first by his Methodist minister father, then at Harvard, which he left just before getting a degree, Lummis became a passionate spokesperson for a variety of Western causes. This transformation can be traced to an unlikely decision. In 1884, bored with small-town life in Chillicothe, Ohio, where his wife's family lived, he conceived a plan to walk to Los Angeles, sending forth dispatches about his adventures to Colonel Harrison Gray Otis of the *Los Angeles Times* and to the *Chillicothe Leader*, for which he had been working. Otis had promised him a job with the *Times*, and Dorothea, Lummis's physician wife, would join him for a new start at life in an exciting young city. He arrived in February 1885.

This "tramp across the continent," an account of which was later published under that title (1892), changed Lummis's life direction completely. His East Coast prejudices about Indians and Hispanic Americans fell away in the face of wonderfully positive experiences with the people he met, and he devoted the rest of his life to explaining the native and Spanish background of California and the West to the new Anglo settlers pouring into California, as well as to the country as a whole. His brash personality, his energy, and his embrace of various causes made him a local celebrity for most of his life.

The mechanism that allowed him to broadcast his ideas and advertise his causes was *Land of Sunshine*, a one-dimensional booster magazine touting the benefits of life in Southern California. Lummis took over the editorship in 1894, changed the name to *Out West* in 1901, and remained as sole editor until 1905. After that, although the magazine continued until 1917, its importance declined steadily without his tireless input. In its prime, it nurtured new Western writers and artists such as Mary Austin, Sharlot Hall, Maynard Dixon, and Ed Borein. Lummis himself was responsible for a very large percentage of the writing in the magazine, however, as well as providing much of its illustrative material in the form of his photographs. Readers found articles on the history of the Spanish conquest extolling the essentially positive, civilizing role of the Catholic missionaries and read excerpts from previously untranslated documents of their explorations of the Southwest. There were numerous articles on Lummis's travels in the pueblos. Sometimes he challenged his readers by taking fervent stands against lynching and other expressions of racism and intolerance, as well as against U.S. imperialism at the time of the Spanish-American War, and by championing with equal fervor the rights of Indians to land, education, and basic respect. *Out West*, while never achieving the first rank of literary journals, did have a national readership and helped form America's idea of the West, its history, and its inhabitants.

While editing the magazine, which in itself would have been a full-time job, Lummis visited Peru (1892–93) on an archaeological expedition with Adolph Bandelier; worked with the Landmarks Club to save the deteriorating missions; began to build a home, El Alisal, by the Arroyo Seco (1898); helped the Warner's Ranch Indians find a new home (1901); became chief librarian of the Los Angeles Public Library (1905–10), where he laid the foundation for a choice rare book collection; and in 1903 began to plan what would be the project closest to his heart, the Southwest Museum (it opened in 1914). He published ten books, including the fund-raiser *The Landmarks Club Cookbook*, which contained his own recipes for Mexican food, and took innumerable photographs of family, friends, and Pueblo Indian ceremonies. He divorced his first wife, remarried, and had four children. His second marriage also ended in divorce amid suppressed allegations of infidelities with his "secretaries." An exponent of the "strenuous life," he slept too little, drank too much, and worked too hard.

Lummis's achievements were limited by his faults: an enormous ego, an abrasive personality, and an absolute belief in his own opinions. In the end, he died penniless and essentially alone. The Los Angeles of the 1920s had forgotten him. He had long since gone out of style, although his enthusiasms and unconventionality had once seemed to epitomize the young, growing city. No understanding of Los Angeles history is possible, however, without taking Lummis into account. Today his achievements in two areas are being actively reassessed by scholars: his leading role among the authors and artists who constituted "Arroyo culture" and his role in bringing about substantive changes in federal policy regarding Indian affairs. In addition to his vast trove of papers at the Southwest Museum, as well as holdings in other repositories, *Land of Sunshine* and *Out West* are primary sources for this endeavor. *Romaine Ahlstrom*

Bibliography
Edwin R. Bingham, *Charles F. Lummis: Editor of the Southwest* (San Marino, Calif.: Huntington Library, 1955); Turbesé Lummis Fiske and Keith Lummis, *Charles F. Lummis: The Man and His West* (Norman: University of Oklahoma Press, 1975); Mark Thompson, *American Character: The Curious Life of Charles Fletcher Lummis and the Rediscovery of the Southwest* (New York: Arcade, 2001).

April [1896] (woman playing
a stringed instrument)

An advertising poster for one of the early
Southern California booster magazines

4½ in.

7⅝ in.

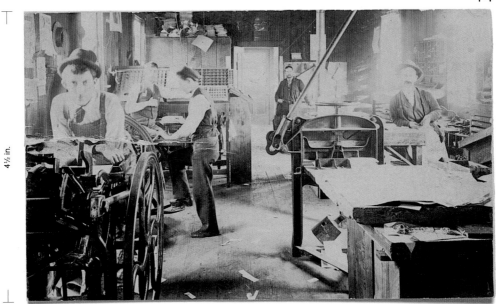

Harry Frantz Rile
**Interior of the Outlook Newspaper Plant,
Santa Monica**, c. 1890

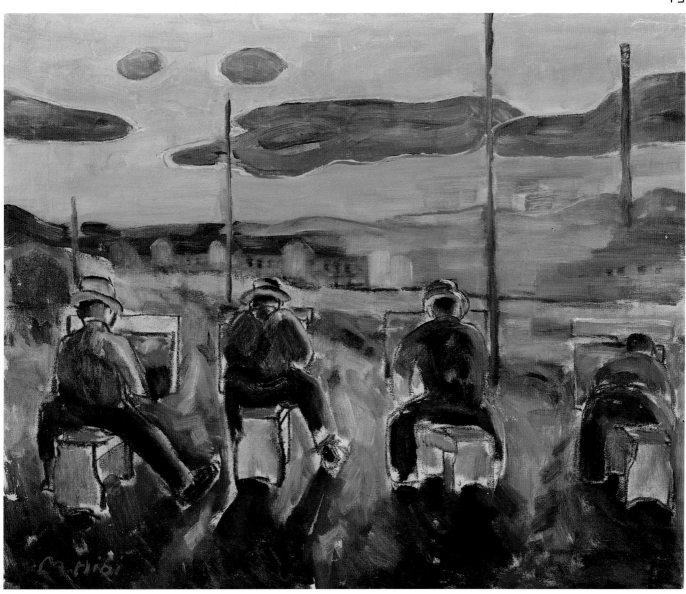

20 in.

24 in.

George Matsusaburo Hibi
Men Painting Sunset, Topaz, 1945

14

**Interior of the Outlook Newspaper Plant,
Santa Monica**, c. 1890

Albumen print; 4½ x 7⅝ in. (11.4 x 19.4 cm)
Santa Monica Public Library, Image Archives (#A32)

15

GEORGE MATSUSABURO HIBI

Men Painting Sunset, Topaz, 1945

Oil on canvas; 20 x 24 in. (50.8 x 61 cm)
Department of Special Collections, Young Research
Library, UCLA (Collection 2010, Box 776)

The subject of George Matsusaburo Hibi's *Men Painting Sunset, Topaz* (1945) might seem like an odd representation of the World War II incarceration of Japanese Americans, yet it highlights the tensions present in the art of the camps. Although he conceived of painting as an idealistic means of escaping the dismal circumstances of imprisonment, Hibi incorporated the camp surroundings into his visual vocabulary. The vibrant sunset is marred only by the rows of barracks on the horizon.

Hibi (1886–1947) was born in Shiga Prefecture, Japan, in 1886 and migrated to Seattle in 1906. After working as a cartoonist for several West Coast Japanese- and English-language newspapers, he settled in San Francisco, where he enrolled at the California School of Fine Arts (now the San Francisco Art Institute) in 1919. There he found himself amid a vital community of artists, including fellow Japanese-born painter Chiura Obata. The two were among the founders of the East West Art Society, whose membership included an impressive roster of California painters of European and Asian ancestry. The society aimed to synthesize the "Occidental and Oriental Arts" through exhibitions (two were held at the San Francisco Museum of Art, in 1921 and 1922) as well as "musical rehearsals and mutual lectures on literature."[1] Throughout the 1920s Hibi was regularly represented in the annual exhibitions of the San Francisco Art Association, the primary vehicle for the display of contemporary art in California. In 1930 he married painter Hisako Shimizu. Although Hibi continued to paint and exhibit, he eventually moved to Hayward, southeast of San Francisco, where he started a Japanese-language school for Nisei children, undoubtedly spurred by his new responsibilities as a husband and father of two children.

The entry of the United States into World War II dramatically altered the course of the Hibis' lives. The mass incarceration of Japanese Americans living in the Western states posed both political and practical problems. While imprisonment and an uncertain future were ominous prospects for Japanese Americans—especially immigrants like Hibi, who were legally barred from becoming naturalized citizens solely on the basis of their race—practical considerations proved equally daunting. After years spent building careers and communities, Japanese Americans were faced with the task of liquidating businesses, homes, and personal belongings in a climate of fear and hostility. Expressing an optimistic belief in the power of art to transcend political circumstances, Hibi donated fifty of his paintings and monoprints to the greater Hayward community. In an *Oakland Tribune* article announcing the gift, he declared: "There is no boundary in art. This is the only way I can show my appreciation to my many American friends here."[2]

Initially detained at the Tanforan Assembly Center, Hibi; his wife, Hisako; and other Japanese American artists quickly organized an art school under the leadership of Obata. Within a few short weeks, the Tanforan Art School was fully operational, with extensive course offerings for children and adults. Exhibitions of student work were presented both within the camp and at outside venues such as the Mills College Art Gallery. After the inmates were moved to the concentration camp in Topaz, Utah, the school continued, with Hibi as its director, from 1943 to 1945. Course offerings included advanced painting and the history of Western art, with an emphasis on modern art movements.

Hibi continued to search for exhibition opportunities outside the camp. In January 1945 two of his Topaz prints were selected for inclusion in the annual exhibition of the San Francisco Art Association. In the foreword to the exhibition catalogue, San Francisco Museum of Art director Grace L. McCann Morley quotes a letter from Hibi: "I am now inside of barbed wires but still sticking in Art—I seek no dirt of the earth—but the light in the star of the sky."[3] This exhibition was one of Hibi's last. He moved to New York City after the end of the war and died in 1947.

Bibliography

Yuji Ichioka et al., *A Buried Past: An Annotated Bibliography of the Japanese American Research Project Collection* (Berkeley: University of California Press, 1974); Karin Higa et al., *The View from Within: Japanese American Art from the Internment Camps, 1942–1945* (Los Angeles: UCLA Wight Art Gallery, Japanese American National Museum, and UCLA Asian American Studies Center, 1992); Karin Higa and Tim B. Wride, "Manzanar Inside and Out: Photo Documentation of the Japanese Wartime Incarceration," in *Reading California: Art, Image, and Identity, 1900–2000*, ed. Stephanie Barron, Sheri Bernstein, and Ilene Susan Fort (Los Angeles: Los Angeles County Museum of Art; Berkeley and Los Angeles: University of California Press, 2000), 315–37; Kimi Kodani Hill, *Topaz Moon: Chiura Obata's Art of the Internment* (Berkeley, Calif.: Heyday Books, 2000).

The exhibitions and art classes at Tanforan and Topaz were by no means unusual. There was some form of organized art activity, both instruction and opportunities for display, at all ten of the concentration camps. There were formal courses organized by inmates or the camp authorities, as well as individual efforts by incarcerated artists such as Kango Takamura (1895–1990). Takamura created detailed watercolors documenting the scientific research conducted at Manzanar while also producing eloquent meditations on the Eastern Sierra landscape. Furthermore, the skills of the inmates were often enlisted for administrative purposes. Estelle Ishigo (1899–1990)—a European American woman who chose to accompany her Japanese American husband to Heart Mountain, Wyoming, rather than be separated from him—was employed by the War Relocation Authority to illustrate official reports; she also created drawings as a means of personal expression. The photographer Ansel Adams (1902–84) was given tremendous access to Manzanar by its director, Ralph P. Merritt. He exhibited his photographs of the camp at its Visual Education Museum and sold prints through notices placed in the *Manzanar Free Press*, the camp newspaper. His Manzanar photographs were the subject of an exhibition, entitled *Born Free and Equal*, at the Museum of Modern Art in New York in 1944, as well as a book of the same title.[4]

The majority of the objects in the exhibition relating to the Japanese American internment come from the Japanese American Research Project (JARP) collection, initiated in 1960 by the Japanese American Citizens League, a community-based civil rights organization, and housed at the University of California, Los Angeles, since 1962. JARP's genesis demonstrates the central role played by community organizations in collecting, documenting, and preserving material largely ignored by traditional collecting institutions. It is among the oldest holdings of Japanese American material and remains one of the most significant library collections of Japanese American manuscripts and oral histories in the United States. *Karin Higa*

16

ESTELLE ISHIGO

The Last of Heart Mountain, November 9, 1945, 1945

Graphite on paper; 8⅝ x 13½ in. (21.9 x 34.3 cm)
Department of Special Collections, Young Research Library (Collection 2010, Box 719)

17

ANSEL ADAMS

Top of Radio in Yonemitsu Residence, 1943

Gelatin silver print; 9⅝ x 12⅝ in. (24.4 x 32 cm)
Department of Special Collections, Young Research Library, UCLA (Collection 122, Box 71)

18

ANSEL ADAMS

Roy Takeno in Front of Free Press Office, n.d.

Gelatin silver print; 9⅛ x 7⁵⁄₁₆ in. (23.2 x 18.6 cm)
Department of Special Collections, Young Research Library, UCLA (Collection 122, Box 71)

19

Manzanar Free Press, August 1942

8½ x 13 in. (21.6 x 33 cm)
University of Southern California, Archival Research Center, Regional History

Notes

1. George Matsusaburo Hibi, "A Propos" (November 1922), Archives of the San Francisco Art Institute.

2. *Oakland Tribune*, 7 April 1942.

3. *Ninth Annual Drawing and Print Exhibition, San Francisco Art Association, January 21 through February 25, 1945* (San Francisco: San Francisco Museum of Art, 1945), unpaginated.

4. Ansel Adams, *Born Free and Equal: Photographs of the Loyal Japanese-Americans at Manzanar Relocation Center, Inyo County, California* (New York: U.S. Camera, 1944).

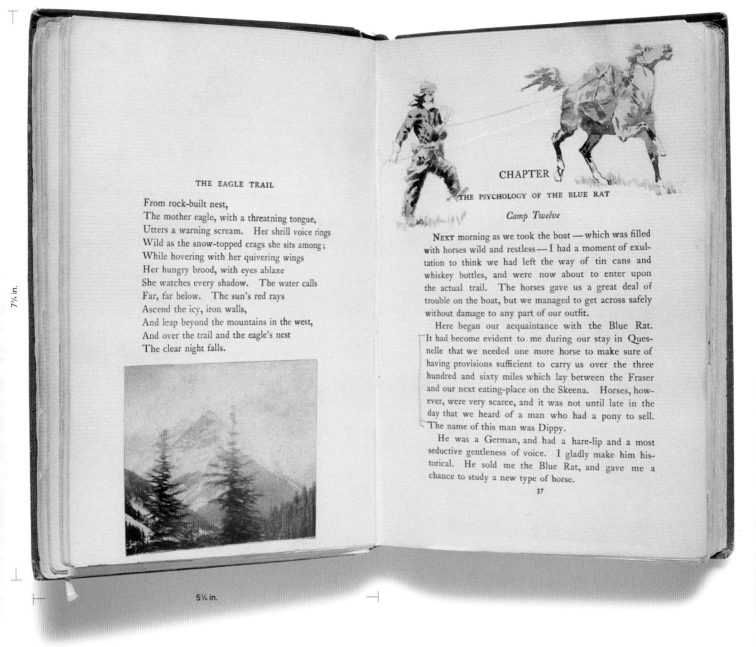

THE EAGLE TRAIL

From rock-built nest,
The mother eagle, with a threatning tongue,
Utters a warning scream. Her shrill voice rings
Wild as the snow-topped crags she sits among;
While hovering with her quivering wings
Her hungry brood, with eyes ablaze
She watches every shadow. The water calls
Far, far below. The sun's red rays
Ascend the icy, iron walls,
And leap beyond the mountains in the west,
And over the trail and the eagle's nest
The clear night falls.

CHAPTER V

THE PSYCHOLOGY OF THE BLUE RAT

Camp Twelve

NEXT morning as we took the boat — which was filled with horses wild and restless — I had a moment of exultation to think we had left the way of tin cans and whiskey bottles, and were now about to enter upon the actual trail. The horses gave us a great deal of trouble on the boat, but we managed to get across safely without damage to any part of our outfit.

Here began our acquaintance with the Blue Rat. It had become evident to me during our stay in Quesnelle that we needed one more horse to make sure of having provisions sufficient to carry us over the three hundred and sixty miles which lay between the Fraser and our next eating-place on the Skeena. Horses, however, were very scarce, and it was not until late in the day that we heard of a man who had a pony to sell. The name of this man was Dippy.

He was a German, and had a hare-lip and a most seductive gentleness of voice. I gladly make him historical. He sold me the Blue Rat, and gave me a chance to study a new type of horse.

37

Hamlin Garland

The Trail of the Goldseekers:
A Record of Travel in Prose and Verse, 1899

A gold rush novel illustrated with watercolor drawings

20

HAMLIN GARLAND

**The Trail of the Goldseekers: A Record
of Travel in Prose and Verse**

New York: Macmillan, 1899
Illustrated with watercolors by Ernest Shaw
7¾ x 5¼ in. (19.7 x 13.3 cm)
University of Southern California, Archival Research
Center, American Literature (810.G233 tTR)

21

L. FRANK BAUM

The Wonderful Wizard of Oz

Chicago: G. M. Hill, 1900
8¹¹⁄₁₆ x 6¹³⁄₁₆ in. (22.1 x 17.3 cm)
Department of Special Collections, Young Research
Library, UCLA (CBC PZ8 B327w 1900)

22

EDGAR RICE BURROUGHS

Tarzan of the Apes

Chicago: A. C. McClurg, 1914
7⅝ x 5¼ in. (19.4 x 13.3 cm)
Department of Special Collections, Young Research
Library, UCLA (SRLF G 000 027 670 9)

23

UPTON SINCLAIR

Oil!

Long Beach, Calif.: Privately printed, 1927
7½ x 5 in. (19.1 x 12.7 cm)
Occidental College, Mary Norton Clapp Library,
Special Collections Department (813.5 S6160i 1927)

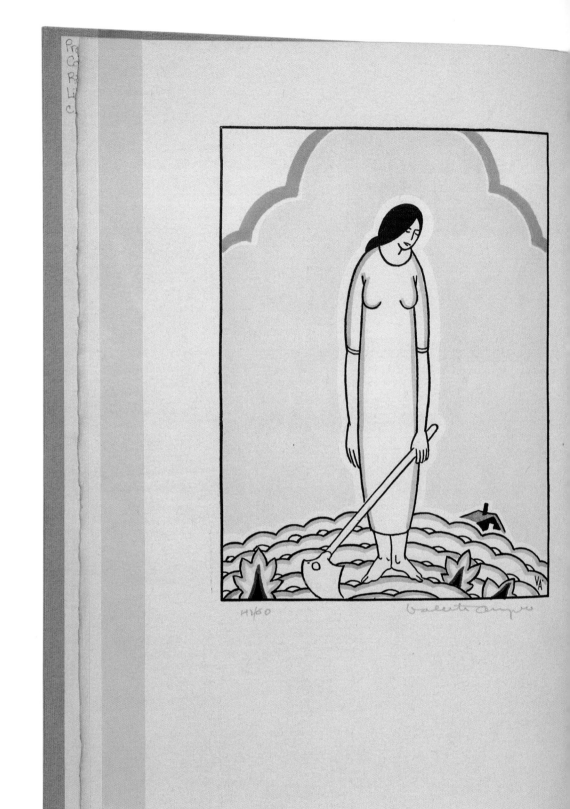

42/50

FOR

whispers &
chants

By

JAKE ZEITLIN

San Francisco

THE LANTERN PRESS

1927

7⁵⁄₁₆ in.

10 ⁷⁄₁₆ in.

Jake Zeitlin
For Whispers and Chants, 1927

A book of poems by the best-known Los Angeles
antiquarian bookseller of his generation

24

JAKE ZEITLIN

For Whispers and Chants

San Francisco: Lantern Press, 1927
10⁷⁄₁₆ x 7⁵⁄₁₆ in. (26.5 x 18.6 cm)
Department of Special Collections,
Young Research Library, UCLA (PS 3549 Z37)

In April 1925 a twenty-two-year-old Jake Zeitlin wrote a farewell note to his parents and left their home in Fort Worth. After two weeks of walking and hitchhiking, and with literally ten cents left in his pocket, he reached Los Angeles and rejoined his pregnant wife, whom he had married secretly in Texas. Restless, and now saddled with domestic responsibilities, he bounced from one menial job to another. It was an outwardly unpromising start for a man who, forty years later, would be recognized as one of America's leading antiquarian booksellers.

But Zeitlin already had a store of valuable experiences. He had done farmwork and become steeped in Texas folkways. He knew Ben Abramson, a former bookshop employee and hobo, who would later become a cofounder of Argus Book Shop in Chicago. This friendship ignited Zeitlin's love of literature and his resolve to become a bookseller. He had written some verse and won a poetry prize from a college in Waco, which gave him a cachet among his peers that is hard to imagine now. At age nineteen he met Carl Sandburg, stayed up late with him spinning yarns, and gave him some songs that ended up in The American Songbag (1927). Sandburg referred to Zeitlin as "a poet who used to send me each year a horned toad from the Great Staked Plains."[1] He had discovered a talent for attracting influential people, and for gaining their support.

After a rocky start in Los Angeles, Zeitlin's unself-conscious charm and a job in the book department at Bullock's brought him into contact with a group of bibliophiles dedicated to the cultural betterment of the city. Among them were Merle Armitage, Phil Townsend Hanna (editor of Touring Topics, the forerunner of Westways), and the photographer Will Connell. As author Carey McWilliams later put it, "We did our best . . . to conjure into

being the kind of intellectual atmosphere and interchange which the community needed and which we never doubted it would some day enjoy."[2] Zeitlin was more specific in a 1928 Los Angeles Times interview, which paraphrased his claim that "Los Angeles has everything else except a literary atmosphere, and . . . this can only come through the love, study, possession and production of books."[3] The article did not mention that he had recently opened his first bookshop.

Zeitlin was still getting mileage out of his reputation as a poet, and by 1927 he thought it was time to publish a collection. One of his friends, Louis Samuel (business manager for the actor Ramon Novarro), offered to front the cost. Samuel hooked Zeitlin up with two San Francisco firms that could bring the book out in appropriate style, there being no comparable choices in Los Angeles at that time. For a publisher he chose the Lantern Press, the imprint of the bookshop Gelber-Lilienthal, which had already issued limited editions by Hildegarde Flanner, Sherwood Anderson, and Stella Benson. To produce the book, he approached the Grabhorn Press—rivals of John Henry Nash as the finest printers in the western states—which had done the previous Lantern Press books. Thanks in large part to Samuel's persuasive skills, the three-way deal was closed over lunch in San Francisco. Valenti Angelo, a recent arrival at the Grabhorn Press, would provide a hand-colored frontispiece and title-page publisher's mark.

To give the book more attraction, Zeitlin called in an old debt and asked Sandburg to write an introduction. Sandburg was reluctant, but a mutual friend, Frank Wolfe, persuaded him to do the favor. He produced a masterpiece of faint praise in seven rolling sentences. The young poet could expect no more, and was grateful.

For Whispers and Chants came out as a modest luxury production of five hundred copies, most of them on mould-made Ingres paper, but the first fifty copies had handmade Van Gelder paper and

were signed by author, printer, and publisher. The edition sold quickly because Zeitlin had gotten Grabhorn to print a prospectus, which he circulated to his friends. Sales got an additional boost when Paul Jordan Smith published a good review in the Los Angeles Times that October. It is not certain whether the two men already knew each other, but around this time Zeitlin, in the capacity of bookseller, visited Smith at his Claremont home and drew further inspiration from the elder man's library and conversation. The copy on display here bears Zeitlin's inscription to Smith dated Christmas Day 1927, thanking him for "the human friendship and hospitality and the many little things that have helped me to hold up my head and believe in myself."

Around this time, McWilliams was looking for poets to feature in his newspaper column, and he pounced on Zeitlin with glee. "He was a real find," he wrote later. "He looked like a poet, he spoke like a poet, he lived like a poet—on a hilltop near Elysian Park—and, mirabile dictu!, he was a poet."[4] The 1928 Times interview pointed to a vague physical resemblance between Zeitlin and "the late San Francisco bard" George Sterling.[5] The hunt for local icons of high culture was in full cry.

Imbued though it is with Zeitlin's Texas experience (it is even dedicated to the state), For Whispers and Chants is not great poetry. (Referring later to his bardic period, Zeitlin lamented, "I could not draw long bow."[6]) It is more successful as an example of printing, and the American Institute of Graphic Arts named it one of its Fifty Books of the Year. But the book may have its greatest interest as a case study of one way that cultural values were promoted in Los Angeles. Zeitlin would make his major contribution by funneling rare books and manuscripts into collections both local and international. But for a brief time in the late 1920s, he became a focus for the aspirations of a young city eager to achieve respect and maturity.

Stephen Tabor

References

Elinor Raas Heller and David Magee, Bibliography of the Grabhorn Press, 1915–1940 (San Francisco: [Elinor Raas Heller and David Magee], 1940), no. 96.

Bibliography

J. M. Edelstein, ed., A Garland for Jake Zeitlin (Los Angeles: Grant Dahlstrom and Saul Marks, 1967); Jake Zeitlin, Books and the Imagination: Fifty Years of Rare Books, interviewed by Joel Gardner (Los Angeles: Oral History Program, University of California, 1980); Kevin Starr, Material Dreams: Southern California through the 1920's (New York: Oxford University Press, 1990).

Notes

1. Carl Sandburg, The American Songbag (New York: Harcourt, Brace, 1927), 483.
2. Edelstein, Garland for Jake Zeitlin, 5.
3. Los Angeles Times, 12 July 1928, sec. 2.
4. Edelstein, Garland for Jake Zeitlin, 3.
5. Los Angeles Times, 12 July 1928, sec. 2.
6. Starr, Material Dreams, 326.

25

PAUL LANDACRE

**California Hills and Other Wood
Engravings**

Los Angeles: Bruce McCallister, 1931
13^{13}⁄$_{16}$ x 9¾ in. (35.1 x 24.8 cm)
William Andrews Clark Memorial Library, UCLA
(Press Coll. McCallister)

13¹³/₁₆ in.

9¾ in.

Paul Landacre
**California Hills and Other Wood
Engravings**, 1931

An important early California fine press book

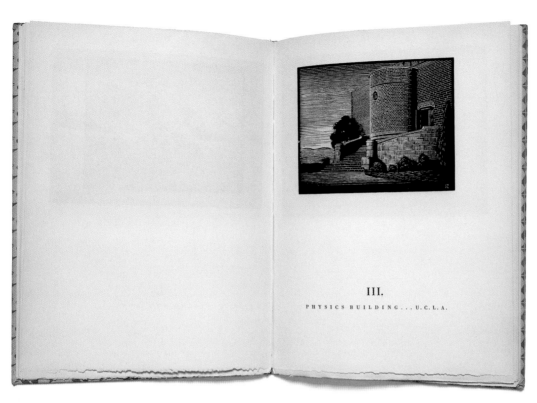

III.

PHYSICS BUILDING...U.C.L.A.

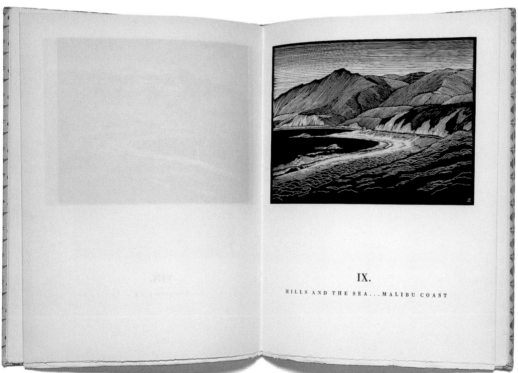

IX.

HILLS AND THE SEA...MALIBU COAST

lion feuchtwanger

in freundschaft

b

S.M. 44

Er war zwar ihres Feindes Feind, jedoch
War etwas an ihm, was man nicht verzeiht
Denn seht: ihr Feind war seine Obrigkeit.
So warfen sie ihn als Rebell ins Loch.

Dass sie da waren, gab ein Rauch zu wissen
Des Feuers Söhne, aber nicht des Lichts.
Und woher kamen sie? Aus Finsternissen.
Und wohin gingen sie von hier? Ins Nichts.

Ihr in den Tanks und Bombern, grosse Krieger
Die ihr in Algier schwitzt, in Lappland friert
Aus hundert Schlachten kommend als die Sieger:
Wir sinds, die ihr besiegt habt. Triumpfiert!

4 in.

4⅝ in.

Bertolt Brecht
Kriegsfibel, 1944

One of two known copies of this work
completed in Southern California

26

BERTOLT BRECHT
Kriegsfibel

Santa Monica, 1944
Photomontage; box: 6⅝ x 4¾ x 2 in. (16.8 x 12.1 x 5.1 cm);
sheet: 4⅝ x 4 in. (11.7 x 10.2 cm)
University of Southern California, Archival Research
Center, Feuchtwanger Memorial Library

The idea of Bertolt Brecht writing a primer on World War II in Santa Monica may seem far-fetched, but the writer did in fact compile a collection of satirical verses critiquing photojournalism and the war during the 1940s while residing in Southern California. Brecht's choice of the title *Kriegsfibel* (War primer) indicates his pedagogical intent. He strove to instruct readers in how to interpret the photographs he selected critically, and to use the powerful images as a catalyst for a reexamination of their ideas about war.

Brecht (1898–1956), born in Augsburg, Germany, studied medicine at the University of Munich. For a brief time during World War I, he worked as an orderly in a hospital. His experiences and those of Caspar Neher, a close friend who fought on the Western front, turned him into an outspoken opponent of the war. Around this time Brecht began writing in earnest, alternating between theater and poetry. In the 1920s he worked with two of the giants of German theater, Max Reinhardt and Erwin Piscator, as well as developing his own influential style of political theater. During the Weimar Republic he wrote his award-winning play *Trommeln in der Nacht* (Drums in the night) as well as collaborating with Kurt Weill on *Die Dreigroschenoper* (The three-penny opera) and *Der Aufstieg und Fall der Stadt Mahagonny* (The rise and fall of the city of Mahagonny). Brecht's biting satire and criticism of bourgeois German society made him an early enemy of the growing National Socialist party in Bavaria. When Hitler became chancellor of Germany in 1933, Brecht immigrated to Switzerland, moving to Denmark several months

later. Ultimately he, like thousands of German émigrés between 1933 and 1945, fled to Southern California. On a summer day in 1941 he and his family arrived in San Pedro after a long voyage on the *Annie Johnson* from Vladivostok, in the Soviet Union.

Brecht coined the term *photoepigrams* for the quatrains he penned in reaction to mass-media images of the war. In 1930 he had expressed skepticism about the wide distribution of photographic images: "The truth regarding the prevailing conditions in the world has profited little from the frightening development of photo-journalism: photography has become a terrible weapon against the truth in the hands of the bourgeoisie."[1]

Although the *Kriegsfibel* was completed in Southern California, Brecht began writing the photoepigrams in 1938, during his exile in Denmark. In the late 1930s the poems turn up here and there in his journal, sometimes accompanied by images he pasted onto the pages. In his journal entry for June 20, 1944, he described his thoughts about the *Kriegsfibel*'s epigrams and the war:

working on a new series of photo-epigrams. as i look over the old ones, which in part stem from the beginning of the war, i realize that here is almost nothing i need to cut out (politically nothing at all), proof of the validity of my viewpoint, given the constantly changing face of the war. there are now about 60 quatrains, and along with fear and misery of the third reich, the volumes of poetry, and perhaps five difficulties in writing the truth, the work offers a satisfactory literary report on my years in exile.[2]

In December 1944 Brecht and his collaborator, Ruth Berlau, assembled the photoepigrams into the small-format *Kriegsfibel* now in the collection of the

University of Southern California's Feuchtwanger Memorial Library. The collection contains seventy-one photoepigrams mounted on hand-cut sheets of black construction paper, with page numbers written by Brecht on the verso of each sheet. Also included is a title page and dedication sheet on onionskin paper. The pencil lines for marking the paper and the ragged hand-cut edges of the photographs are still visible. It is quite likely that Berlau herself reproduced the photographs from images Brecht found in various publications, including *Life* magazine and Swedish and American newspapers.

In 1944 Brecht presented this miniature copy of *Kriegsfibel* to Lion Feuchtwanger, his longtime friend, mentor, and collaborator and a fellow German exile living in Southern California.[3] Brecht sent another copy to his friend Karl Korsch in February 1945; whether additional copies were created or still exist is unknown. In 1949, after Brecht returned to Germany, he and Berlau assembled the *Kriegsfibel* for publication; it did not appear, however, until the fall of 1955. Interestingly, the published work does not duplicate Brecht's smaller format but instead re-creates the manuscript now located at the Brecht Archive in Berlin. Both the 1955 and 1994 versions were enlarged to two and a half times the size of the Feuchtwanger version.

The *Kriegsfibel* remains one of Brecht's least-known works, partly as a result of poor sales of the East German first edition of 1955.[4] Published ten years after the end of the war, Brecht's photoepigrams did not find a receptive audience, yet his observations about war and the dangers of mass media still hold true today, more than sixty years after he wrote them. Ruth Berlau beautifully sums this up in her foreword to the 1955 publication: "He who forgets the past remains its captive."[5]
Marje Schuetze-Coburn

Bibliography
Bertolt Brecht, *Journals*, trans. Hugh Rorrison, ed. John Willet (New York: Routledge, 1993); Bertolt Brecht, *Kriegsfibel*, 4th ed. (Berlin: Eulenspiegel, 1994); Stefan Soldovieri, "War-Poetry, Photo[epi]grammetry: Brecht's *Kriegsfibel*," in *A Bertolt Brecht Reference Companion*, ed. Siegfried Mews (Westport, Conn.: Greenwood Press, 1997), 139–67.

Notes
1. Soldovieri, "War-Poetry, Photo[epi]grammetry," 143.
2. Brecht, *Journals*, 320–21.
3. At the time Feuchtwanger (1884–1958) was one of the best-known and most successful members of the German émigré community on the West Coast. His historical novels were widely translated, and his home in Pacific Palisades served as a meeting place for the exiles. Feuchtwanger's widow, Marta, bequeathed his extensive private library and archive to the University of Southern California; the estate transferred to the university upon her death in 1987.

4. The publisher, Eulenspiegel, printed ten thousand copies but sold only thirty-four hundred in East Germany and barely two hundred in West Germany.
5. In Bertolt Brecht, *Kriegsfibel* (Berlin: Eulenspiegel, 1955), unpaginated.

27

DASHIELL HAMMETT

The Thin Man

New York: Knopf, 1934
7⅝ x 5¼ in. (19.4 x 13.3 cm)

Occidental College, Mary Norton Clapp Library,
Special Collections Department (Guymon 813.5 H224 th)

28

DASHIELL HAMMETT

Typescript for "The Thin Man," 1930

11 x 8½ in. (27.9 x 21.6 cm)
Occidental College, Mary Norton Clapp Library,
Special Collections Department (813.5 H224 th MSS)

29

THOMAS MANN

Doktor Faustus: Das Leben des deutschen
Tonsetzers Adrian Leverkühn, erzählt von
einem Freunde

Stockholm: Bermann-Fischer, 1947
7¾ x 5 in. (19.1 x 12.7 cm)
University of Southern California, Archival Research
Center, Feuchtwanger Memorial Library
(PT 2625.A44D6 1947)

9 ¾ in.

6 ⅝ in.

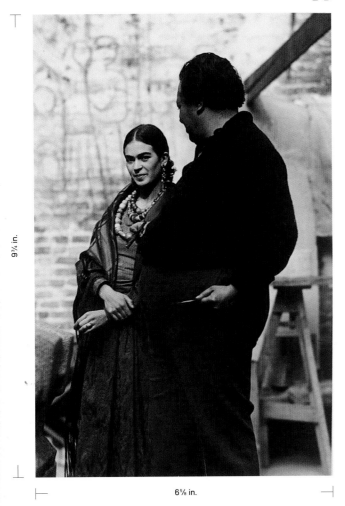

9 ⁹⁄₁₆ in.

7 ½ in.

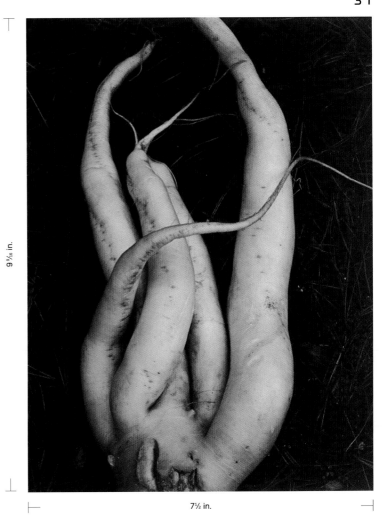

Edward Weston
Diego and Frida Rivera, 1930

Edward Weston
Untitled, 1933

30

EDWARD WESTON

Diego and Frida Rivera, 1930

Gelatin silver print; 9¾ x 6⅝ in. (24.8 x 16.8 cm)
Department of Special Collections, Young Research
Library, UCLA (*** 98, box 5, #14)

31

EDWARD WESTON

Untitled, 1933

Gelatin silver print; 9⁹⁄₁₆ x 7½ in. (24.3 x 19.1 cm)
Department of Special Collections, Young Research
Library, UCLA (*** 98, box 4, #13)

32

CHARLES BUKOWSKI

We'll Take Them

Los Angeles: Black Sparrow Press, 1978
9¼ x 6¼ in. (23.5 x 15.9 cm)
University of Southern California, Archival Research
Center, American Literature

33

CHARLES BUKOWSKI

Untitled drawing, n.d.

Pen and ink; 7¹⁵⁄₁₆ x 9⅞ in. (20.2 x 25.1 cm)
University of Southern California, Archival Research
Center, American Literature

34

DAVÍD ALFARO SIQUEIROS
Sketch for "América Tropical," c. 1932
Graphite; 8¼ x 11⅜ in. (21 x 28.9 cm)
Library, Getty Research Institute (960094)

Mexican painter and communist organizer Davíd Alfaro Siqueiros (1896–1974) visited Los Angeles from May to October 1932. During this period he produced three murals, two public and one private, his first in almost a decade and the only ones that he would ever paint in the United States. Siqueiros and the "Block of Mural Painters"—the students, mostly professional artists, in the course he taught on fresco painting at the Chouinard Art School—painted the earlier of the two public murals, *Street Meeting*, on one of the school's exterior walls. When the mural was inaugurated on July 7, 1932, its theme, a labor meeting, and the fact that it portrayed whites and African Americans together, provoked criticism. The new materials and experimental techniques Siqueiros and his collaborators used—compressors, air guns, film projectors, industrial paints, and cement—also proved unsuccessful, and as soon as it rained, the paint began to wash away.

This drawing from the Getty Research Institute Library's Siqueiros Papers is a study for the second of the public murals, *América Tropical*, painted on a second-story exterior wall of the Plaza Art Center (Italian Hall Building) on Olvera Street, at the invitation of its director, F. K. Ferenz. Ferenz proposed the theme, expecting, Siqueiros believed, a colorful folkloric treatment. Dividing the wall into three units, as seen in the drawing, the artist evoked pre-Hispanic Maya ruins. A small pyramid occupies the central portion, the largest of the three units, and drumlike remnants of two columns flank the façade and its two entrances (windows in the actual architecture).

In the finished mural, dense vegetation pulsates with thick, tentacle-like trunks and branches to either side of the pyramid. Loosely pre-Hispanic-style sculptures appear amid the sinister vegetation. To the right of the pyramid sits a smaller, boxlike structure that incorporates the door of the actual architecture, as is seen in the drawing. A Mexican *campesino* and an indigenous Andean peasant, both armed, crouch atop the little building, ready to attack. The two armed peasants face toward the center of the composition, where Siqueiros placed a crucified, presumably indigenous male.

Dressed only in a loincloth, the Christ-like victim is tied to the double cross at shoulders, wrists, and knees. A large—American—eagle perches on top of the cross, ready to tear at the dead flesh. Recently Tomás Zurián identified an 1865 photograph by Felice Beato (1825–1903) as the model for the crucified man. The photograph documents a servant punished for murder in Japan, where Beato lived and worked in the 1860s. Siqueiros transformed the murderer into a Native American victim, whom he described as "the violent symbol of feudal America's Indian peon, doubly crucified by the native exploiting classes and oppressive [that is, U.S.] imperialism."[1] Siqueiros added the central figure at the last minute, without alerting his fellow painters; indeed, he did not indicate it in any way on the preparatory sketch.

In a 1932 essay, artist and activist Grace Clements noted: "The use of the figure of this cross . . . must be recognized as being obscure. If the original plan had been adhered to and the wounded body of the peon was placed in the claws of the eagle, the work would have gained in revolutionary meaning and understanding."[2] Siqueiros too commented that "[*América Tropical*'s] only error stems from the use of the cross, which, although double [that is, not the Latin cross], lends itself to ideological confusion."[3] When the mural was dedicated on October 9, 1932, many discerned its revolutionary implications nevertheless.

Because of complaints from conservatives and pressure from the federal and city governments, the sections of *América Tropical* visible from the street were whitewashed by April 1934, and eventually the entire mural was covered. Since the late 1960s the Los Angeles–based art historian Shifra M. Goldman and the filmmaker and Chicano activist Jesús Salvador Treviño have campaigned to uncover and preserve *América Tropical*, a project that the Getty Conservation Institute has now undertaken. The preparatory drawing and the Siqueiros Papers as a whole contribute invaluable information to the effort to save Siqueiros's only extant public mural in the United States. *Eduardo de Jesús Douglas*

Bibliography
Laurance P. Hurlburt, *The Mexican Muralists in the United States* (Albuquerque: University of New Mexico Press, 1989), esp. 205–16; Shifra M. Goldman, "Siqueiros and Three Early Murals in Los Angeles," in *Dimensions of the Americas: Art and Social Change in Latin America and the United States* (Chicago: University of Chicago Press, 1994), 87–100; Olivier Debroise, "Action Art: Davíd Alfaro Siqueiros and the Artistic and Ideological Strategies of the 1930s," in *Portrait of a Decade, 1930–1940: Davíd Alfaro Siqueiros* (Mexico City: Museo Nacional de Arte, INBA, 1997), 19–67; Shifra M. Goldman, "Siqueiros en Los Ángeles," in Raquel Tibol, Shifra M. Goldman, and Agustín Arteaga, *Los murales de Siqueiros* (Mexico City: Américo Arte Editores and INBA, 1998), 39–71 (an expanded version of "Siqueiros and Three Early Murals in Los Angeles").

Notes
1. Siqueiros Papers, Series II, Los Angeles, 1932, box 3, folder 22, Library, Getty Research Institute. For Zurián's identification of the source of the figure, see Goldman, "Siqueiros en Los Ángeles," 62, ill. 99.
2. Siqueiros Papers, Series II, Los Angeles, 1932, box 3, folder 24.
3. Siqueiros Papers, Series II, Los Angeles, 1932, box 3, folder 22.

8¼ in.

11⅜ in.

David Alfaro Siqueiros
Sketch for "América Tropical," c. 1932

35
Poster for "The Tramp"
Essanay, 1915
Lithograph; 80 ¹³/₁₆ x 42 in. (205.3 x 106.7 cm)
Margaret Herrick Library, Academy of Motion Picture
Arts and Sciences (POST 20228)

36
Letter from Sigmund Freud to Max Schiller,
26 March 1931
11 ⅜ x 8 ¹⁵/₁₆ in. (28.9 x 22.7 cm)
Margaret Herrick Library,
Academy of Motion Picture Arts and Sciences

When Sigmund Freud wrote to Max Schiller in
the spring of 1931, he was seventy-five years old.
Schiller, a Viennese physician, and his wife, the
French singer Yvette Guilbert, were friends and con-
temporaries of Freud who shared his interest in the
psychology of artistic expression. Freud had seen his
stature in the world change remarkably, starting out
as an experimental neurologist trying to launch his
career with an important medical discovery, then, as
a fledgling clinician, treating middle-class sufferers
of a variety of neurotic ailments. He was greeted at
first with what he regarded as the most severe form
of contempt: indifference. But indifference had been
transformed into concern, admiration, and animosity
(and frequently a mixture of all three) by the second
decade of the twentieth century, as he developed his
new discipline of psychoanalysis into an international
intellectual movement. Freud's followers and critics
no longer came from the medical fields but instead
were applying psychoanalysis to all manner of cultural
phenomena, from social sciences such as anthropolo-
gy to the arts. The temptation to apply psychoanaly-
sis to various problems was too strong for Freud to
resist. And when he got into the act, he did so in a
big way, writing on the mystery of Leonardo da
Vinci's genius or on the origins of the incest prohibi-
tion (and hence of all society!).

In this letter Freud rather playfully returns to
the major themes of his writings on art. The artist
draws on the most powerful experiences and impulses
of his life, and these impulses and experiences are
crucially formed in childhood. An artist can either
repeat the painful or pleasurable memories, or he
can transform or "sublimate" them into something
that takes a different form. Freud cites Charlie
Chaplin as an example of a performer who "always
plays himself as he was . . . in youth." For Freud,
who else can one play?

Freud mentions in the letter that he considers
the idea that artistic achievements are intimately
bound up with childhood to be a precious discovery.
This is so despite the fact that his study of Leonardo
hinged on the reconstruction of a supposed memory
of the artist that turned out to be based on a faulty
translation from an Italian document. No matter,
Freud clung to his belief. Mme Yvette's rich reper-
toire of roles was surely based on the resources of
childhood too. For the founder of psychoanalysis,
this was the stuff art was made of.

Freud playfully begs off analyzing the child-
hood sources of Guilbert's success as a singer. She
thought she obliterated herself in performance,
while he was convinced that she was drawing on
parts of herself of which she might not be aware.
For Freud, the "beautiful puzzle" of art emerged out
of the enigma of our earliest desires. Whatever the
analysis might be, he was grateful for the results.

The great bulk of Freud's manuscripts and let-
ters are now housed in the Library of Congress in
Washington, D.C. This letter was acquired by Harry
Crocker, who had an on-and-off friendship with
Chaplin for many years and collected memorabilia
about him. The Margaret Herrick Library of the
Academy of Motion Picture Arts and Sciences
received Freud's letter from Crocker's sister in 1969.
Michael S. Roth

Bibliography
Sigmund Freud, *Eine Kindheitserinnerung des Leonardo da Vinci*
(Leipzig: F. Deuticke, 1910), translated by Alan Tyson under the title
Leonardo da Vinci and a Memory of His Childhood (Harmondsworth:
Penguin, 1963); Sigmund Freud, *The Letters of Sigmund Freud*, ed.
Ernst L. Freud (New York: Basic Books, 1960).

PROF. DR. FREUD

26.3.1931

WIEN, IX. BERGGASSE 19.

Letter from Sigmund Freud to Max Schiller, 1931 · A personal letter in which Freud offers an analysis of Charlie Chaplin

11 ⅜ in.

8 ¹⁵⁄₁₆ in.

Poster for "King Kong," 1933

Poster for "Citizen Kane," 1941

37

Poster for "King Kong"

RKO, 1933
Illustrators: S. Barret McCormick and Bob Sisk
Lithograph; 78½ x 39¾ in. (199.4 x 101 cm)
Margaret Herrick Library, Academy of Motion Picture
Arts and Sciences, Gift of the Cecil B. DeMille
Foundation (POST 20174)

The 1933 RKO film *King Kong* was largely the cre-
ation of Merian C. Cooper, a producer-director who
had previously made a number of expeditionary
documentaries, a type of film popular in the 1920s.
Eager to make a fantasy film about a giant gorilla,
Cooper and his codirector, former cameraman Ernest
Schoedsack, eventually created a film that incorporated
elements of his earlier jungle films, along with
components of films popular with contemporary audi-
ences. Filmmakers in the early 1930s sought novel
ways to attract audiences; films focusing on horror,
sex, and violence appeared in profusion, their impact
magnified by the dramatic use of sound. Not only
did *King Kong*'s tale of "beauty and the beast" offer
a unique combination of these elements, but its
central character—the monster beast who elicits
feelings of both terror and sympathy—has become
an icon in American and international popular culture.

The unique qualities of the film are, to a great
extent, attributable to the technical and artistic
wizards who worked behind the scenes. The special
visual and sound effects used in the film, as well
as the original music score, all constituted important
advances at the time. With the backing of executive
producer David O. Selznick, Cooper secured extra
funds to enable him to achieve the needed complex
effects; production costs ran to $672,000, quite
high for the time. Special effects genius Willis O'Brien
took to new heights the stop-motion animation
that he had previously used in *The Lost World*
(1925); this was combined in novel ways with tech-
niques such as mattes, rear projection, miniatures,
glass and background paintings, split-screen, and
optical printing. Max Steiner created a memorable
film score that directly complements the action
and drama on the screen. Murray Spivack devised
the special sound effects for the film, utilizing various
methods to create Kong's distinctive bellows. What
was perhaps most innovative was his adjustment
of the pitch and rhythm of sounds to coordinate
them with the music score. Today's special effects,
sound, and music creators clearly owe enormous
debts to the breakthroughs achieved in *King Kong*.

On March 2, 1933, *King Kong* premiered in
New York at two new theaters with a combined
capacity of nearly ten thousand: Radio City Music
Hall and the RKO Roxy Theatre. Its success at the
box office was of considerable help to the struggling
RKO studio.

The three-sheet poster for the film commands
attention by its sheer size and dramatic depiction.
King Kong clutches the blonde heroine in his huge
paw and roars defiantly at the attacking airplanes
from the top of the newly completed (but not yet
fully occupied) Empire State Building, the primitive
pitted against modern civilization. The film clearly
captivated Depression-era audiences, and its multiple
rereleases—as well as its ability to generate sequels,
spin-offs, remakes, and parodies in a wide range
of media, including advertisements—are testimony
to its abiding significance. While some insist that
the film should be viewed simply as escapist entertain-
ment, numerous scholars have expended consider-
able efforts to analyze it and extrapolate attitudes
toward modern life, sexuality, gender roles, race, and
nationality. Even technical expert Scott MacQueen,
who wrote about the film's restoration in the late
1980s, has remarked that King Kong "jostles a hairy
elbow alongside Paul Bunyan and Johnny Appleseed
in the pantheon of American mythology."[1]

When this poster advertising the film was
issued, it was viewed, like other posters of the day,
as a disposable tool to market a product and was
one of several designs and formats. Though fine
artists were frequently employed to create stone
lithographs of stunning design, neither the studios
nor most in the audiences regarded them as art-
istic works of lasting merit. In today's world, film
posters have became highly collectible, sometimes
for their artistic qualities, but particularly if they
advertise films that have become popular icons.
This poster, believed to be one of only four of this
style known to exist, went on auction at Sotheby's
in April 1999 and sold for what was at the time
the second-highest price ever paid for a film poster.
Cecilia DeMille Presley, as trustee for the Cecil B.
DeMille Foundation, purchased the poster and
donated it to the Academy's Margaret Herrick
Library. Among the library's multitude of treasures
relating to motion pictures are nearly twenty-two
thousand film posters. *Linda Harris Mehr*

Bibliography
Orville Goldner and George E. Turner, *The Making of King Kong:
The Story behind a Film Classic* (New York: Ballantine Books, 1976);
Richard B. Jewell with Vernon Harbin, *The RKO Story* (New York:
Arlington House: 1982); Scott MacQueen, "Old King Kong Gets Face
Lift," *American Cinematographer* 70 (January 1989): 78–83; Cynthia
Erb, *Tracking King Kong: A Hollywood Icon in World Culture* (Detroit:
Wayne State University Press, 1998).

Notes
1. MacQueen, "Old King Kong Gets Face Lift," 78.

38

Poster for "Phantom Empire"

Mascot, 1935
Offset color lithograph; 82⅞ x 44¾ in. (210.5 x 113.7 cm)
Autry Museum of Western Heritage Research Center
(95.232.1)

39
Poster for "Citizen Kane"
RKO, 1941
Offset lithograph; 42 x 28½ in. (106.7 x 72.4 cm)
Margaret Herrick Library, Academy of Motion Picture
Arts and Sciences, Blake Hunter Collection
(POST 19910)

Citizen Kane (RKO, 1941) has long been considered the best film ever made, an opinion endorsed by the 1962 *Sight and Sound* survey of film critics and validated in each succeeding survey. The film is often thought of as the sole creation of Orson Welles (1915–85), since he produced, directed, cowrote, and starred, but it would not have been possible without a unique conjunction of people and events. Welles would undoubtedly have gone to Hollywood and made films, but at any other studio the film we know would not have been the result.

RKO was one of the seven major studios, but a financially weak one (it finally emerged from seven years of receivership in 1940), and was well known for the chronic instability of its front office. Production heads tended to last only two or three years, and then the studio followed a new policy, at least until the next man was hired. In 1938 George Schaefer, formerly in charge of distribution and sales at United Artists, was appointed corporate president and became determined to make prestige pictures or, as he put it, "quality pictures at a premium price." Pandro Berman, head of production, resigned in 1939 because of Schaefer's interference, and from then on Schaefer made all the important decisions about which films to produce. One way to improve the reputation of RKO was to hire well-known talent, and one person he, and several other studios, wanted was Orson Welles.

Welles had started in the theater and was known for his acting and directing, but he became famous for his work in radio, specifically because of the furor aroused by the Halloween eve broadcast of "The War of the Worlds" in 1938. He was known as a boy genius, a renaissance man who could do everything and knew how to move audiences. Schaefer pursued Welles and, in July 1939, signed him to a two-picture contract, which granted Welles almost complete control over the films, including the right of final cut. This was an unprecedented concession for any studio to make, especially to someone making his first film. The contract and the publicity it generated caused a great deal of resentment against Welles in Hollywood, which no doubt made him feel that his first project had to be something out of the ordinary.

Unfortunately for Welles and RKO, it was not clear what would justify such extravagant hype. At first he intended to adapt Joseph Conrad's *Heart of Darkness* and spent months working on a script. When the film proved too expensive and experimental, Welles needed to find another story quickly. Luckily for him, he had befriended the writer Herman Mankiewicz, who had an idea.

Mankiewicz had been in Hollywood since 1926 and was known as a brilliant writer who was miserable working for the studios. At the beginning of 1940 he was laid up in bed with a fractured leg as a result of an auto accident. He and Welles talked and came up with the idea of doing an original screenplay about an important man's life seen from several different viewpoints. With this general idea, Mankiewicz was hired in February 1940 to write the screenplay. John Houseman had ended his partnership with Welles only a few weeks earlier, but Welles needed him to help Mankiewicz with the script, so he implored him to return. The two men moved to Victorville, northeast of Los Angeles, in order to work and by April had a script of more than three hundred pages.

This script, extensively edited and revised by Welles, became the examination of Charles Foster Kane that we know today. Depending on whom you believe, Kane is either William Randolph Hearst or Orson Welles, or is a composite of various people, from Joseph Pulitzer to Howard Hughes. But there is no key that explains Kane or the impact of the film. It is not just the work of a solitary genius, though many people seem to think that the film owes everything to Welles. Nor is it just another product of the studio system, though without Gregg Toland's German Expressionist–influenced photography, Bernard Herrmann's music, Vernon Walker's photographic effects, and Perry Ferguson's sets, the film would not have the emotional resonance and technical brilliance that it does. *Citizen Kane* is in the fullest sense a collaborative work. Welles could not have made it outside of the studio system, and RKO would not have let anyone except Welles make the film. It is our luck that the collaboration was so fruitful and that the finished film is, as the poster says, terrific. For once the hyperbole was justified.

This rare poster for *Citizen Kane*, donated to the Margaret Herrick Library by Blake Hunter in 1998, was one of two poster designs used by RKO to advertise the film. Neither of the designs hints at the originality of the film, and the red, white, and blue color scheme and the character's determined stance in this version may have been intended to position *Citizen Kane* as a crowd-pleasing film about politics, like *Mr. Smith Goes to Washington* (1939). The most striking thing about the poster is how clearly it demonstrates that the studio's advertising department was at a loss when it came to promoting a film as unusual as *Citizen Kane*.
Val Almendarez

40
Matte for "The Wizard of Oz," c. 1939
Pastel; 27¾ x 22 x ½ in. (70.5 x 55.9 x 1.3 cm)
University of Southern California, Cinema-Television
Library and Archives of Performing Arts
(MGM Matte Collection, #327)

41
ALEX NORTH
Manuscript score for the film "Spartacus," 1960
15⅝ x 11⅞ in. (39.7 x 30.2 cm)
UCLA Music Library Special Collections, Alex North
Motion Picture Music Collection (collection 17)

42
ERNEST LEHMAN
Script for "West Side Story," c. 1961
With annotations by script supervisor Stanley K. Scheuer
11½ x 9¼ in. (29.2 x 23.5 cm)
University of Southern California, Cinema-Television
Library and Archives of Performing Arts

Bibliography
Richard B. Jewell with Vernon Harbin, *The RKO Story* (New York:
Arlington House, 1982), esp. 8–12, 140–142, 144, 164; Simon Callow,
Orson Welles: The Road to Xanadu (London: Jonathan Cape, 1985),
esp. 449–539; Robert L. Carringer, *The Making of Citizen Kane*
(Berkeley: University of California Press, 1985); Harlan Lebo, *Citizen
Kane: The Fiftieth-Anniversary Album* (New York: Doubleday, 1990).

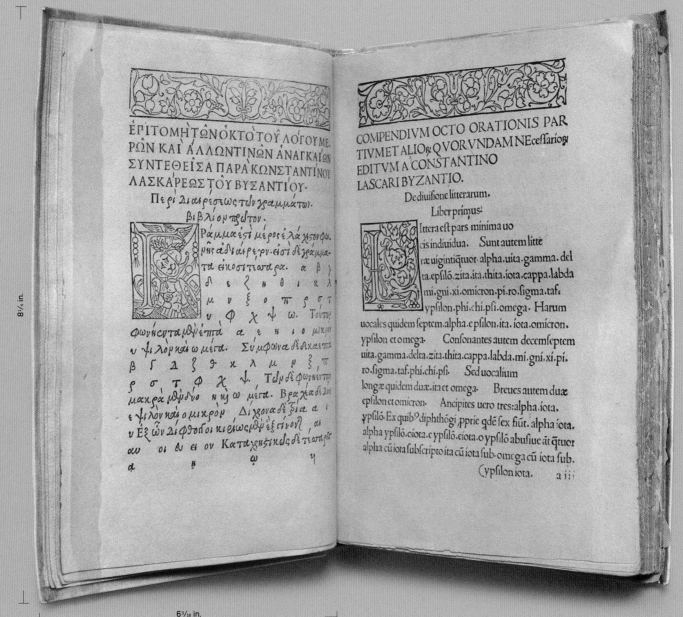

Constantine Lascaris
Erotemata, 1495

This Greek grammar was Aldus Manutius's first book

II THE PRINTED WORD

Since the eighteenth century the so-called monuments of printing have been central to the collecting enterprise. Within less than a century of Bernard von Mallinckrodt's invention in 1639 of the neologism *incunabula* to denominate the products of the earliest printers—the press in its "cradle" period— these early books became the central focus of all of the serious collectors of Europe, and were to remain so for 150 years and more. A small group of American collectors, Henry Huntington among them, following the European example, were perhaps the last to assemble a collection of fifteenth- century books that was much more than simply representative of the output of the incunabular press. For the most part, the known copies of the truly great monuments—the forty-two-line (or Gutenberg) Bible, the thirty-six- line Bible, the Subiaco Cicero, the Caxton Chaucer, and many others—now permanently reside in institutional collections and are no longer available to collectors, however well heeled. The last copy of the forty-two-line Bible to be sold at auction—the Doheny copy from Los Angeles, but the Old Testament volume only—was sold to a Japanese university library in 1987 for five million dollars. And although institutional copies themselves do not necessarily remain always in situ, it seems unlikely that any other copy of the first printed book in the West will come on the market ever again. In 1911 Huntington paid a record fifty thousand dollars for his vellum copy from the renowned collection of Robert Hoe; that copy, if permanence means anything at all beneath heaven, will remain forever in San Marino with what is today one of the three or four largest collections of incunabula in the world.

Printing is surely one of the very few inventions without which the history of the world would be inconceivably different. Others might include gun- powder, the telescope, the internal combustion engine, antibiotics, and a few

further miraculous *trouvailles* for which not "the beautiful fabric of the world" (Vasari's *Lives*) but human cleverness is the essential explanation. It is an extraordinary fact that by the end of the fifteenth century there were print shops in every major, and many a minor, city and town throughout Germany, Switzerland, Austria, Italy, France, the Low Countries, the Iberian peninsula, and England; and some forty thousand editions of books had been printed in what might conceivably have amounted to as many as several million printed books. The vast majority of these copies have not survived, and an estimated twelve thousand editions have entirely disappeared. Books as various and as important in their individual ways as the Caxton Chaucer (1476–77) or the Aldine Lascaris *Erotemata* (1495) survive in so few copies as barely to have defeated oblivion.

From circa 1455 to 1800 the technical bases for printing from movable type changed very little, and indeed the variety of achievement within printing history during the sixty years between the *Catholicon* (representing here the earliest European printing) and Tory's *Champfleury* (1529) is truly astounding. Most of the major texts of Greek and Roman antiquity had been printed by 1530, including the Florentine *editio princeps* of Homer (1488–89) and the Aldine Aristotle (included in section 8 of *The World from Here*). Illustration flourished along the lines of the illustrated medieval book (the 1476

Boccaccio and the Vérard *Livre de bien vivre* afford wonderful examples of printed books illuminated as though they were manuscripts meant for the wealthy class, which of course in almost every sense they were). It also found ways to coexist more directly with the mechanically produced printed book in the medium of the woodcut. Beginning with the block book, which used to be seen as a pre-Gutenberg form of printing but is now understood to be coeval with the earliest books printed from type, woodcut illustration attracted some immensely accomplished artists in the fifteenth century; it had already produced a pinnacle of exactitude and beautiful *mise-en-page* in 1499 in the renowned *Hypnerotomachia Poliphili*, with which Aldus Manutius salted his otherwise more sedate list of literary works and classical texts.

The monuments of printing in the later period (but before the Industrial Revolution entered the printing house and revised it beyond recognition) are perhaps more specialized. Books like the Pine Horace (completely engraved throughout) or the Bodoni type specimen that uses the Lord's Prayer and reproduces it in 154 languages, are astounding objects, if for slightly limited reasons. They come just before—as the freakish though beautiful *Livre de prières* woven on a Jacquard loom comes just at the close of—a period of almost a century during which every aspect of printing was mechanized, and printed

books, as a result, declined precipitously in physical quality. There are nineteenth-century books in other sections of *The World from Here*, but they are not included for their beauty mostly, or if they are—say, in the group of botanical books to be found in section 4—they are self-conscious exceptions to the rule that the mechanized book is usually a shoddy book.

Out of the postlapsarian world of the mechanization of printing there emerged a strong movement, centered on the private rather than the commercial press, to revive the craft values of the hand-press period. It is not surprising that Los Angeles, where printing played such a strong and determining role in the literary renaissance of the period after World War I, should be the home to several significant collections of what we now call the book arts. Books as different as the Kelmscott Chaucer (1896) and the Schmied *Cantique des cantiques* (1925) document the printing revival and remind us that some of the fine printers active in the city of Los Angeles from the late 1920s on (and including the book artists represented in section 3 of *The World from Here*) worked out of an English and European context that, by the time of Carolee Campbell's compelling book *The Real World of Manuel Córdova* (1995), was already more than a century old. *B.W.*

43

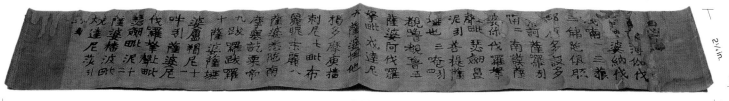

Muku jōkō kyō jishin'in darani, 764–70

This charm is considered to be the earliest known printed text

43

Muku jōkō kyō jishin'in darani

Translated by Mitrasānta (Nara, 764–70 C.E.)
Scroll in miniature pagoda
Scroll: 2¼ x 15⅜ in. (5.7 x 39 cm);
pagoda: 8⅞₁₆ x 4⅛ (diam.) in. (21.4 x 10.5 cm)
Richard C. Rudolph East Asian Library, UCLA
(SRLF H000 013 013 8)

This specimen of printing on paper, popularly known as *Hyakumantō darani*, is renowned as the earliest extant, reliably dated example of textual printing in the world. It is one of four brief *dhāranī* (Sanskrit for "talisman") texts printed at or near Nara, Japan, between 764 and 770 C.E. The four texts—known by the names *Konpon*, *Sōrin*, *Jishin'in*, and *Rokudo*— are contained in the work *Muku jōkō dai darani kyō*, translated around 704 by the central Asian monk Mitrasānta. *Hyakumantō*, meaning "one million pagodas," refers to a vow made by the Empress Shōtoku (718–70), who reigned from 749 to 758 and from 764 to 770. According to the historical work *Shoku Nihongi* (completed in 797), which is supported by other records, the empress ordered the making of one million three-tiered wooden pagodas, intended to be distributed among the ten great Buddhist temples of the realm: Daianji, Gangōji, Kōfukuji, Yakushiji, Tōdaiji, Saidaiji, Hōryūji, Gufukuji, Shitennōji, and Sūfukuji. One of the rolled-up printed charms was deposited within the hollow cavity located at the top of each pagoda.

Nara was the focal point of the fervent support for Buddhism that evolved in the seventh and eighth centuries in Japan, and nearby Hōryūji was one of the major Buddhist monastery temples. Hōryūji, famous thanks to its association with the charismatic Prince Shōtoku (574–622), who is traditionally said to have founded and built it, is the only original repository of pagodas and charms to have preserved some until modern times. Because of this fact, it has been suggested that the production of the pagodas and the printing of the charms may have taken place at Hōryūji.

Although occasional references to the *Hyakumantō darani* appear before the Meiji period (1868–1912), it was not until after the Meiji Restoration that serious study of these artifacts began. Due to taxes and restrictions placed on Buddhist establishments by the new Meiji government, many temples were obliged to sell their treasures and donate cultural artifacts to their benefactors in order to survive. In this way some of Hōryūji's holdings of the *Hyakumantō darani* came onto the market, circulated, and began to be studied. It is reported that Hōryūji still holds more than forty thousand wooden pagodas from the original deposit of one hundred thousand, although about three-fourths are badly damaged and fragmentary.

A variant edition of each of the four texts is known, accounting for a total of as many as eight different specimens. The two versions of each are often differentiated as "standard/variant" or "long/short" (referring to the slight difference in length of the printed area). An up-to-date international census of *Hyakumantō darani* imprints has not been made, but it is safe to say that several dozen, if not hundreds, of private and public collections around the world possess original specimens of the famed charm. The British Library in London is among the very few collections that possess all eight imprints, having acquired them as a group in 1980 from the Tokyo rare book dealer Kōbunsō. The Seikadō Bunko library in Tokyo also has all eight and recently reported the existence of a previously unknown version of the *Konpon* text. Hōryūji, with the largest collection of *Hyakumantō darani* scrolls, presently possesses nearly four thousand, most of which are severely defective. Among the total are one hundred superior printed examples that were designated national treasures in 1942, as well as three written by hand. The three manuscript versions

are probably contemporaneous with the printed scrolls, but no special significance has been attached to them. Earlier estimates have placed the total number of extant scrolls at 1,771. Clearly, although the *Hyakumantō darani* is one of the earliest specimens of printing, it is not one of the rarest.

The UCLA East Asian Library's example of the *Jishin'in* text of the *Hyakumantō darani* is the "standard" or "long" version, consisting of thirty-one columns of title and text. Generally speaking, the *Sōrin* and the *Jishin'in* texts are the most commonly seen; the *Konpon* and the *Rokudo* texts, respectively, are rarer. The UCLA specimen is printed on tan-colored laid paper. The head of the text is damaged and defective, lacking all or part of ten of eleven Chinese characters in the title. Twelve characters in the upper part of the next eleven columns are damaged, and the topmost character in each of the final four columns shows slight damage. The impression is good. One of the wooden pagodas accompanies the UCLA printed *darani* scroll. Except for a chunk of wood missing from the *hinoki* (Japanese cypress) base and chips to the outer edges of the three tiers, the pagoda is sound and in rather good condition. The removable seven-tiered spire, possibly of a different sort of wood, is whole. Only slight traces of the original white gesso coating remain on the surface of the pagoda.

Although the disparity between the number of surviving scrolls and pagodas, as well as the fact that the only remains of the *Hyakumantō darani* project are from Hōryūji, may cause us to question whether as many as one million charms were actually printed, the reality and the antiquity of what remains cannot be questioned. Despite many years of dedicated study and debate, there is still no consensus as to exactly how the *Hyakumantō darani*

scrolls were printed. At various times, scholars have argued for the use of movable type, woodblock printing (xylography), or printing from bronze blocks (often mislabeled "copperplate"). In recent times only the latter two theories have been considered seriously, especially the possibility of the use of bronze blocks. The craft of bronze casting in eighth-century Japan has been thoroughly analyzed, and facsimile impressions have been taken from newly cast bronze blocks and compared with the originals, but I have found none of the corollary arguments fully convincing. I believe xylography to have been the likely and logical method of production of the *Hyakumantō darani*. Much of the evidence cited to support printing from bronze blocks—the clumsy forms of characters in the text, uneven inking, and the appearance of uncharacteristic lines in some strokes in the characters, for example—can have other explanations, such as the use of extremely dense hardwoods. Nevertheless, the style of the characters in the *Hyakumantō darani* is not consistent with other early printed examples from China and Korea.

Strangely enough, the *Hyakumantō darani* is the only known textual imprint of the Nara period (710–94), and we do not have concrete evidence of another printed work until the later part of the Heian period (794–1185), in the form of an edition of the *Jōyuishikiron* printed in Nara in 1088. The gap of three hundred years is usually attributed to the fact that the literate elite in Japan represented an extremely small portion of the population or to the importance of calligraphy in Japanese life. Nevertheless, this must be viewed as another of the mysteries surrounding the *Hyakumantō darani*.
Sören Edgren

References
Jun Suzuki and Mihoko Miki, *Catalog of Rare Japanese Materials at the University of California, Los Angeles* (Tokyo: Tōsui shobō, 2000).

Bibliography
Brian Hickman, "A Note on the *Hyakumantō Dhōrānī*," *Monumenta Nipponica* 30, no. 1 (1975): 87–93; Mimi Hall Yiengpruksawan, "One Millionth of a Buddha," *Princeton University Library Chronicle* 48, no. 3 (1987): 224–38; Nakane Katsu, ed., *Hyakumantō darani no kenkyū* (Osaka: *Hyakumantō darani no kenkyū* kankō iinkai, 1987); Masuda Harumi, "Seikadō bunko shozō no hyakumantō oyobi darani ni tsuite," *Kyūko* 37 (2000).

44

Ars moriendi

[Netherlands, 1465]
11⅛ x 8¹⁵⁄₁₆ in. (28.3 x 22.7 cm)
The Huntington Library, San Marino,
California (RB 144968)

The *Ars moriendi* (Art of dying) is a staple of both early printing and late fifteenth-century manuscript production. Printers and scribes were blessed in finding a topic that concerned all classes of readers and book buyers: how should one prepare for death? Examples of this text exist in as many formats and styles as there were economic classes of readers to purchase them: manuscript and printed editions, illustrated editions and text-only editions, folio editions and pocket books.

The example here is from a block book— a kind of book printed not with movable type, but with page-size woodblocks into which both text and illustrations were carved by hand. Such block books were once considered transitional in the development of printing, that is, they were thought to precede printing with movable type and thus were dated to the first half of the fifteenth century. Both bibliographical and art historical studies have shown, however, that these books were produced well after the introduction of movable type. The present example, the earliest edition of the *Ars moriendi*, is now dated about 1465. Thus, in the late fifteenth century block books, manuscripts, and printed books coexisted. The woodcuts in this particular example have been associated with the work of a contemporary engraver known only as "E.S." and are likely copies and corrections of his copperplate engravings.

Most block books seem designed for buyers of marginal literacy. They include illustrated versions of the *Apocalypse* and *Song of Songs* and an illustrated version of the Bible showing the relation of Old and New Testaments (the *Biblia pauperum*). Yet individual copies do not always provide support for this tempting hypothesis. Early block books were printed by placing the paper down on the inked block and applying pressure to the verso of the leaf by hand. The ink itself is different from the ink used in ordinary printed books and tends to fade (as in the present example) to a light brown tint. The printing procedure, involving hand rubbing of the versos, meant that only one side of the leaf could be printed; the blank pages were then treated in various ways. In some copies (such as this one), blank sides are pasted together so that the book, once assembled, has no blank pages. In others, the blank pages were used for extensive handwritten notes and commentary explaining the images on the pages (a fact that belies the theory that block books were produced for nonreaders). Because of their means of production, particular copies of block books maintain their individuality in ways that particular copies of ordinary printed books do not: the book could be constructed in various ways, commentary could be added, and illustrations colored variously.

The Huntington copy is from the first of what are considered twenty separate editions of the *Ars moriendi* (there are thirteen different series of woodcuts used in these editions). Two other copies of this edition exist. In the eighteenth century this copy was part of the library of Thomas, eighth earl of Pembroke, as was a second block book, the *Biblia pauperum*, also in the Huntington, and both are bound in Pembroke's distinctive, uniform bindings. There are ten block books at the Huntington, making it one of the best collections of such books in the United States. The library continues to supplement its block book collection and obtained a missing leaf of one of these books as recently as 1996.

Joseph A. Dane

45

GIOVANNI BALBI

Catholicon

[Mainz: Printer of the Catholicon], "1460"
[not before 1469]
15½ x 11¾ in. (39.4 x 28.3 cm)
The Huntington Library, San Marino, California
(RB 104610)

46

LACTANTIUS

Opera

Subiaco: Sweynheym and Pannartz, 1465
13⅛ x 9⅜ in. (33.3 x 23.8 cm)
The Huntington Library, San Marino, California
(RB 90930)

References
Wilhelm L. Schreiber, *Manuel de l'amateur de la gravure sur bois et sur métal au XVe siècle* (Berlin: A. Cohn, 1902), vol. 4, no. 257 (IA); *Catalogue of Books Printed in the Fifteenth Century Now in the British Museum* (London: British Museum, 1908–), vol. 1, no. 4; Herman Ralph Mead, *Incunabula in the Huntington Library* (San Marino, Calif., 1937), xii.

Bibliography
Arthur M. Hind, *An Introduction to a History of Woodcut*, 2 vols. (Boston: Houghton Mifflin, 1935); *Blockbücher des Mittelalters: Bilderfolgen als Lektüre* (Mainz: P. von Zabern, 1991); Thomas V. Lange, "Intermuralia," *Huntington Library Quarterly* 58 (1996): 273–74.

47

GIOVANNI BOCCACCIO

De la ruyne des nobles hommes et femmes

Translated by Laurent de Premierfait
Bruges: Colard Mansion, 1476
15⅛ x 11⅚ in. (38.4 x 30.3 cm)
The Huntington Library, San Marino, California
(RB 85076)

This French-language edition of Boccaccio's *De casibus virorum illustrium* (Fall of illustrious noblemen) is an example of the luxurious books produced by Colard Mansion in Bruges from 1476 to 1484. Boccaccio's Latin text was the subject of numerous translations and adaptations (the most famous English version is Chaucer's "Monk's Tale"). Its lament for and glorification of the fall of various nobles found a ready audience in European courts, largely through the French translation by Laurent de Premierfait in 1400, itself revised in 1410. Premierfait's revised translation was widely disseminated; the Huntington Library has two French manuscripts of the work, both from the third quarter of the fifteenth century and thus roughly contemporaneous with this printed version. The Mansion text is taken from Premierfait's earlier translation, a version much rarer than his revision.

The Boccaccio is the second book printed by the Bruges calligrapher and printer Colard Mansion. Of Mansion's entire output (some twenty-five titles) only a half-dozen individual copies are now in American collections. The interest for collectors of English books is in the association of Mansion with William Caxton. Although no document mentions them together, the two clearly had close business associations. Caxton printed six books in Bruges in 1475–76; Mansion was active as a printer in Bruges from 1476 to 1485. Both printed their own translations, often adding to them explanatory prologues and epilogues. They printed many of the same texts: for example, translations of the *Ars moriendi* (see cat. no. 44), *The Sayings of the Philosophers*, the *Distiches* of Cato, and Boethius's *Consolation of Philosophy*. Certain technical details of printing are also common to books produced by both: the "ragged right" margin, once thought a sign of lack of skill in printing, but in these books doubtless designed to imitate contemporary manuscripts; the unusual method of printing in red, involving re-inking of individual letters; and, most important, the type itself. The typecutter for both was Johann Veldener; the type seen here is a larger version of Caxton's type 2, the type he used to print Chaucer's *Canterbury Tales* in 1476–77 (cat. no. 48).

The Boccaccio is an extreme example of the luxury editions destined for noble readership produced by Caxton at Bruges and by Mansion throughout his career. Mansion himself, in the epilogue to his contemporary translation of Boethius (1477), blames popular uprisings and the vicissitudes of Fortune for bringing about the "ruin and variation of many noblemen, in Holland, Brabant, Haynaut, Artois and Flanders," perhaps unknowingly foreshadowing the fall of his own patron and *compère*, Louis de Bruges. In 1484, lacking such patronage, Mansion ceased to print.

Copies of the Mansion Boccaccio exist in various states. Some are entirely unillustrated. Others, such as this example, contain spaces for half-page illuminations at the beginning of each book. In still others, the text on these pages is reduced even further to permit the inclusion of a series of copper-plate engravings at the beginning of each book. The Huntington copy has at least ten missing leaves, including the first six, containing the prologue and table of contents, and the beginning leaves to books 2, 4, 6, and 7 (which doubtless contained lavish illuminations like that shown here). These leaves have been added in pen facsimile, excellent even by twentieth-century standards of reproduction (of the first six leaves, the earliest auction records acknowledge only that 1, 3, 4, and 6 are in facsimile). In addition to the facsimiles noted in the auction records, one other pair of conjugate leaves (in quire s) may not be part of the original book. The rubrication is the same as in the rest of the volume, but the text columns are ruled with red ink, in a style not found in any other page in the book. There is no indication of when this bifolium was bound into the Huntington copy, but it clearly was once part of (or intended to be part of) a different copy. The Huntington copy has been part of three major nineteenth-century collections: those of Richard Heber, of the third earl of Asburnham, and finally of Robert Hoe (it brought seven thousand dollars in the Hoe auction of 1911). Other books in the Hoe collection were "improved" and "completed" while in his possession, and the pages noted here might be a further instance of this. *Joseph A. Dane*

References
Gesamtkatalog der Wiegendrucke, 10 vols. (Leipzig and Stuttgart: Hiersemann, 1925–), no. 4432; Frederick R. Goff, *Incunabula in American Libraries: A Third Census* (New York: Bibliographical Society of America, 1964), no. B-711; *Illustrated Incunabula Short-Title Catalogue*, 2d ed. (Reading: Primary Source Media, 1998), no. ib000711000.

Bibliography
Henri Michel, *L'imprimeur Colard Mansion et le Boccace de la Bibliothèque d'Amiens* (Paris: A. Picard, 1925); Seymour de Ricci, "Le Boccace de Colard Mansion (1476)," *Gutenberg Jahrbuch* (1927): 46–49; Witze Hellinga and Lotte Hellinga, *The Fifteenth-Century Printing Types of the Low Countries*, 2 vols. (Amsterdam: M. Hertzberger, 1966); George D. Painter, *William Caxton: A Quincentenary Biography of England's First Printer* (London: Chatto and Windus, 1976).

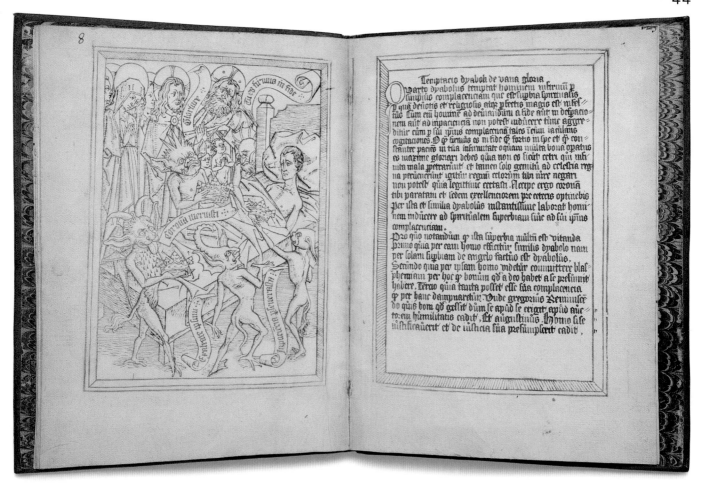

Ars moriendi, 1465

This fifteenth-century book about dying
is an example of early block printing

15⅛ in.

11⁵⁄₁₆ in.

Giovanni Boccaccio
De la ruyne des nobles hommes et femmes, 1476

A beautifully illustrated copy of Boccaccio's moral tales

48

GEOFFREY CHAUCER

The Canterbury Tales

[Westminster: William Caxton, 1476–77]
10⅝₁₆ x 7⅞ in. (27.3 x 20 cm)
The Huntington Library, San Marino, California
(RB 61667)

The Caxton *Canterbury Tales* (1476–77) is probably
the most famous, and with the recent Wentworth
sale, certainly the most expensive of English
incunabula. It is the second major work printed by
William Caxton (c. 1422–91), who is generally
considered to have introduced the art of printing to
England, and was one of the first books he pro-
duced after he moved from Bruges to Westminster
in 1476.

Chaucer's *Canterbury Tales* has always been
a safe bet financially, even for early printers. It was
extremely popular in the fifteenth century, as the
numerous surviving manuscript copies attest. There
are more than seventy of these, exceeding the
total number of surviving printed copies from all
fifteenth-century editions. It was printed again by
Caxton in 1483 and subsequently by Richard Pynson
in 1492 and by Wynkyn de Worde in 1498 (both
from Caxton's own edition).

Caxton's second edition is not merely a reprint
of the first. It is more lavish, containing numerous
woodcuts, and also includes a preface by Caxton
claiming that it is more faithful to the original. He
presumably corrected his first edition from a "very
true" manuscript, one he claims was copied from
a book written by Chaucer himself:

One gentleman came to me and said that this book
was not according in many places unto the book
that Geoffrey Chaucer had made [and] that he knew
a book which his father had and much loved that
was very true and according to his own first book by
him made [that is, by Chaucer]. If I would imprint it
again he would get me the same book for a copy. . . .
To whom I said in case that he could get me such

a book true and correct yet I would once endeavour
me to imprint it again for to satisfy the author,
whereas tofore by ignorance I erred in hurting and
defaming his book in diverse places in setting in
some things that he never said nor made and leaving
out many things which be requite to be set in it.
And thus we fell at accord and he full gently got of
his father the said book and delivered it to me,
by which I have corrected my book as hereafter all
along by the aid of Almighty God shall follow.

Corrections from this manuscript were apparently
written into a copy of the first edition, and the
second edition was printed from that. By modern
standards, the texts are far from "true and correct,"
but it is not certain whether Caxton's anecdote
testifies to his own gullibility or to that of his readers.

Caxton printed nearly all of what is now
considered the canon of Chaucer: *Canterbury Tales*
(1476–77, 1483), *Parlement of Fowls and Other*
Poems (1477), the translation of Boethius's
Consolation of Philosophy (1478), *House of Fame*
(1483), and *Troilus and Creseyde* (1483). These
works may have been issued together, but in the
format used by Caxton, they could not have been
bound together, and it remained for Pynson in
1526 and William Thynne in 1532, printing on much
larger folio pages, to print and disseminate them
as one-volume "complete works."

The Huntington collection of thirty-two
Caxton editions is one of the largest in the United
States (second only to the collection in the Pierpont
Morgan Library). And the Chaucer is the centerpiece
of the collection—a book more readily available to
exhibitors and the viewing public than to researchers
at the library. It complements the equally famous
Ellesmere manuscript of the *Canterbury Tales*, also
on almost continuous display. *Joseph A. Dane*

References
Seymour De Ricci, *A Census of Caxtons* (Oxford: Oxford University
Press, 1909), no. 22.10; E. Gordon Duff, *Fifteenth-Century English
Books* (Oxford: Oxford University Press, 1917), no. 87; *Gesamtkatalog
der Wiegendrucke*, 10 vols. (Leipzig and Stuttgart: Hiersemann,
1925–), no. 6585; Frederick R. Goff, *Incunabula in American Libraries:
A Third Census* (New York: Bibliographical Society of America, 1964),
no. C–431; A. W. Pollard and G. R. Redgrave, *A Short-Title Catalogue
of Books Printed in England, Scotland, and Ireland and of English
Books Printed Abroad (1475–1640)*, 2d ed. (London: Bibliographical
Society, 1976–91), no. 5082.

Bibliography
William Blades, *The Life and Typography of William Caxton, England's
First Printer*, 2 vols. (London: J. Lilly, 1861–63); George D. Painter,
*William Caxton: A Quincentenary Biography of England's First
Printer* (London: Chatto and Windus, 1976); Paul Needham,
*The Printer and the Pardoner: An Unrecorded Indulgence Printed
by William Caxton for the Hospital of St. Mary Rounceval, Charing
Cross* (Washington, D.C.: Library of Congress, 1986).

And eke men shul not make ernest of game
Here begynneth the Milleres tale.

Whilom ther was dwellyng in Oxenforde
A riche chuf that gestis hadde to borde
And of his craft he was a Carpenter
With hym ther was dwellinge a poure scoler
Hadde lernyd art but al his fantasye
Was turnyd for to lerne astrologye
And coude a certeyn of conclusions
To demyn by interrogacions
If that men ayed hym certayn houres
Whether they sholde haue drought or shoures
Or yf that men ayed hym what sholde befalle
Of euery thyng I may not rekene alle
This clerk was clepid hende Nicholas
Of derne loue he coude and of solas
And therto he was sly and ful pryue
And lyke a mayden meke forto se
A chambir hadde he in that hostelrye
Alone withoute ony companye
Ful fetously I dight with herbis sote
And he hym self was swete as is the rote
Of licorice or of ony Cetewale
His almageste his bokis grete and smale
His astrologye longinge for his art
His awgrym stones lay feire apart
On sheluis cowchid at his beddis heed
His presse ycouered with a foldyng reed
And al aboue ther lay a gay sawtre

Geoffrey Chaucer
The Canterbury Tales, 1476–77

The first printed edition of one of the monuments
of English literature

12⁷/₁₆ in.

9³/₁₆ in.

Homer
Opera (Greek), 1488–89

The first printed text in Greek of Homer's works

49

HOMER

Opera (Greek)

Edited by Demetrius Chalcondylas
Florence: [Bartolommeo di Libri and] Demetrius Damilas
for the brothers Bernardus and Nerius Nerlius,
9 December 1488 and 13 January 1488–89
12⁷⁄₁₆ x 9³⁄₁₆ in. (31.6 x 23.4 cm)
Department of Special Collections,
Young Research Library, UCLA
(*A1 H75)

The *editio princeps*, or first printed edition in the original language, of the Homeric canon—the *Iliad* and the *Odyssey*, together with the minor works—is the first major component of ancient Greek literature to appear in print and, in the view of some, the most important incunabular edition of a Greek classical text. For sheer scope, it was the most extensive instance of Greek printing until it was supplanted by the Aldine Aristotle a decade later. Along with the epics, it includes the Homeric Hymns and the *Batrachomyomachia*. Only this last mock epic had already been printed in Greek, with interlinear Latin translation, the Rylands copy of that undated edition being the sole known survivor. This edition also includes the life of Homer by Pseudo-Herodotus, Pseudo-Plutarch, and Pseudo-Dio Chrysostom.

The editor, Demetrius Chalcondylas (1423–1511), brought to Italy by Cardinal Bessarion in 1447, initially taught Greek in Perugia and Padua, gained Lorenzo de' Medici's patronage in the 1470s, and was tutor to Lorenzo's sons. (Bernardo Nerli's dedication of the edition to Piero de' Medici therefore has wider implications than the blessing needed for commercial success.) Chalcondylas assisted Marsilio Ficino with his translation of Plato. The Homer was his major achievement. He claims to have established his text on the basis of the extensive manuscripts available and to have consulted Eustathius's commentary to resolve textual difficulties, especially in the lesser works. He selected Demetrius Damilas for the creation of the font, which was based upon the hand of Damilas's fellow scribe Michael Apostolis.

The printing of the text was a more complex enterprise than a short bibliographical description would indicate, and controversy remains over the assignment of various responsibilities. The type fonts suggest more than one printer, and some of the assignments are disputed. Attribution to a printing establishment run by or for the Nerli brothers is dismissed as a needless assignment of physical undertakings to entrepreneurs whose sole involvement would have been in the funding. While the financial backing of the Nerli brothers made the edition a reality, they themselves had additional backing from Giovanni Acciaiuoli. Nor can all the typefaces be assigned with confidence to Bartolommeo di Libri, and on one telling, only the Latin dedication—a separate initial page originally left blank and printed some five weeks after the completion of the text—was actually printed in the di Libri shop.

It is fitting that this Homer appeared in Florence, the seedbed of the Renaissance, and ironic that it was not followed by the wholesale publication of the works of Greek classical antiquity. But political and social events in the city of the Medici created an unfriendly environment for intellectual and literary enterprises. Then there was the rise of Venice as the focal point for publishing throughout the era. For all its stringent controls on all aspects of life, Venice understood that her enlightened self-interest lay in welcoming foreign printers, and she went beyond this to flex her intellectual muscle in giving a home to numerous Greek émigré scholars and other learned outsiders. This confluence led to the Serenissima's complete dominance in the production of printed books, and the full exploitation of her trade routes brought many thousands of copies of hundreds of editions—in Latin, Greek, and the vernacular—to a distant clientele.

Apart from a few early marginalia, this copy offers only a relatively modern record of ownership, all British prior to its arrival in Los Angeles. It was owned by the earl and marquess of Donegall (Arthur Chichester, fifth earl, title elevated to marquess 1791, d. 1799), carries the Holland House label (Henry Edward Fox, fourth baron Holland, 1802–59; sale, Sotheby's, 23 July 1860), and was sold in 1949 by Charles J. Sawyer Ltd. to the Rt. Hon. Isaac Foot (1880–1960). The Foot collection was acquired by UCLA in 1962, and the Homer entered the Ahmanson-Murphy Early Italian Printing Collection in April 1963. *H. George Fletcher*

50

GIOVANNI DA CAPUA

Directorium humanae vitae

Strassburg: Johann Prüss, [c. 1488–93]
11³⁄₁₆ x 8 in. (28.4 x 20.3 cm)
Department of Special Collections,
Young Research Library, UCLA
(*A 1 B475d)

51

Le livre de bien vivre

Paris: Vérard, 1492
11¼ x 8³⁄₈ in. (28.6 x 21.3 cm)
The Huntington Library, San Marino,
California (RB 38182)

52

CONSTANTINE LASCARIS

Erotemata

Venice: Aldus Manutius, 1495
8¼ x 6³⁄₁₆ in. (21 x 15.7 cm)
Department of Special Collections,
Young Research Library, UCLA
(A1 L33e 1495)

References
Dietrich Reichling, *Appendices ad Hainii-Copingeri Repertorium Bibliographicum* (Munich: Rosenthal, 1905–11), no. 8772; *Catalogue of Books Printed in the Fifteenth Century Now in the British Museum* (London: British Museum, 1908–), vol. 6, 678–79; Frederick R. Goff, *Incunabula in American Libraries: A Third Census* (New York: Bibliographical Society of America, 1964), no. H-300.

Bibliography
Robert Proctor, *The Printing of Greek in the Fifteenth Century* (London: Bibliographical Society, 1900), 66–69, 83; Roberto Ridolfi, *La stampa in Firenze nel secolo XV* (Florence: Olschki, 1958), 95–111; Nicolas Barker, *Aldus Manutius and the Development of Greek Script and Type in the Fifteenth Century* (New York: Fordham University Press, 1992), 37–38.

Giovanni da Capua
Directorium humanae vitae, c. 1488–93

A compilation of moral tales illustrated
with woodcuts

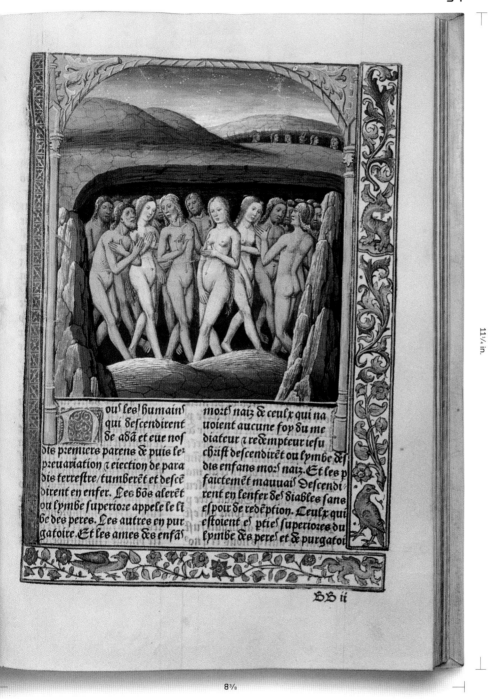

ou̅s les humain̅s
qui descendirent
de ada̅ et eue nos
dis premiers parens de puis le
preuariation 7 eiection de para
dis terrestre/tumbere̅t et desce̅
dirent en enfer. Les bo̅s alere̅t
ou lymbe superioze appele le li
6e des peres. Les autres en pur
gatoire. Et les ames des enfa̅s

morts naiz de ceulx qui na
uoient aucune foy du me
diateur 7 rede̅pteur iesu
chzist descendire̅t ou lymbe des
dis enfans morts naiz. Et les p
faicteme̅t mauuais descendi
rent en lenfer des diables sans
espoir de rede̅ption. Ceulx qui
estoient es pties superiozes du
lymbe des peres et de purgatoi

𝔅𝔅 ii

11¼ in.

8⅜

Le livre de bien vivre, 1492

An illuminated copy of a text on how to
live a moral life

HYEMI AEOLIAE.S.

Ad questo nobile figmento el
te artifice, electo solertemente el
ro hauea, che oltra la candide cia su
nato (al requisito loco) de nigro, a
mere el tenebroso aere illumino,
loso cum cadente grandine. Sopr
na della dicta ueneranda, Ara rigi
te rigoroso, pmineua el rude sim
del hortulano custode, cum tutti g
centi & propriati insignii. Laqual
riosa Ara tegeua uno cupulato um
lo, sopra quatro pali nel solo infix
mato & substentato. Gli quali pali
temente erano inuestiti di fructea,
frondatura, Et el culmo tutto int
multiplici fiori, & tra ciascuno p
lymbo della pertura, o uero hiato
braculo affixo pendeua una arden
pada, & in circuito ornatamente
doro dalle fresche & uerifere aure
stante uexate, & cum metallei crep
nante. nelquale simulachro, cum

ma religioně & prisco rito rurale & pastorale alcune amole, o uero
le uitree cum spumãte cruore del immolato Asello, & cum caldo
scintillante Mero spargendo rumpeuano, & cum fructi. fiori. fron
sta, & gioie libauano, Hora drieto a questo glorioso Triumpho, co
uano, cum antiqua & siluatica cerimonia illaqueato el senicul
no, de reste & trece intorte di multiplici fiori, cantanti carm
ni ruralméte Talassii, Hymænei, & Fescennii, & istru
menti rurestricum suprema lætitia & gloria, cele
bremente exultanti, & cum solenni plausi sal
tanti, & uoce fœmelle altisone, Per laquale
cosa nõ manco piacere & dilecto cum
stupore quiui tali solenni riti &
celebre feste me inuase, che
la admiratione de
gli præceden
ti trium-
phi.
*

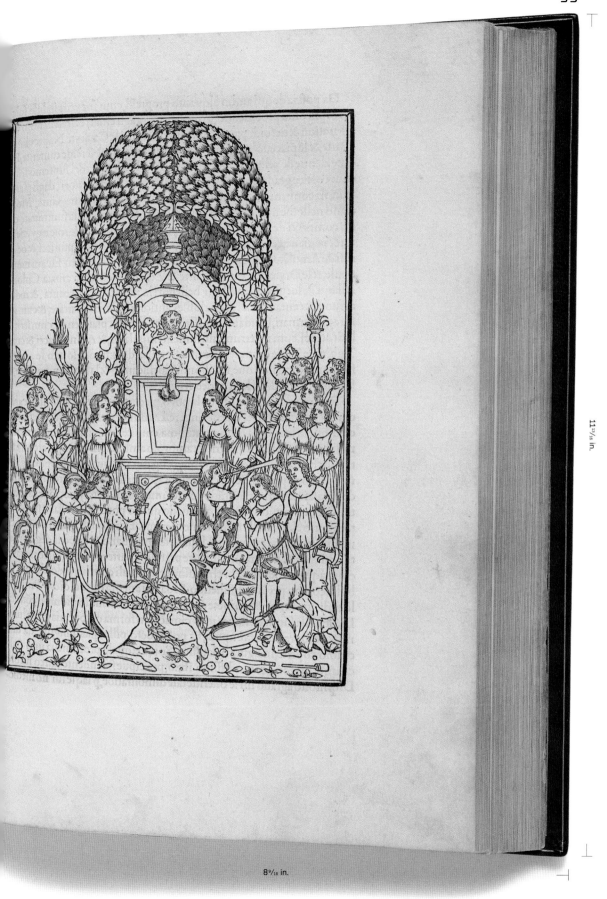

8 9/16 in.

11 13/16 in.

53

FRANCESCO COLONNA

Hypnerotomachia Poliphili

Venice: Aldus Manutius [for Leonardus Crassus],
December 1499
11¹³⁄₁₆ x 8⁹⁄₁₆ in. (30 x 21.74 cm)
Department of Special Collections,
Young Research Library, UCLA (*A1 C71h)

This work is a curious business. The text is an intricate, overwrought, and overwritten hothouse erotic fantasy. This kind of work seems to emerge in each fin-de-siècle era, even if much of the present example was apparently written in 1467, and then a small part after 1489, but in either case well before the miasmic days that seem to grasp each waning century by the throat. The language is a Latinizing Italian, with many unique forms. The story is set within an antiquarian architectural allegory, much influenced by the theories of Vitruvius and Alberti. It has exercised an artistic influence from the beginning; the copy in the Bayerische Staatsbibliothek, Munich, for example, was originally Albrecht Dürer's. Although widely popular for five hundred years, and traditionally quite expensive in the marketplace, the book cannot be termed genuinely "rare" in any strict sense; a great many copies survive, and it is found in virtually every appropriate public and private collection, sometimes in more than one example.

The anonymous author chiseled his identity in an acrostic formed by the decorative initials beginning the thirty-eight chapters: POLIAM FRATER FRANCISCVS COLVMNA PERAMAVIT (Brother Francesco Colonna loved Polia to distraction), which was discovered as early as 1512. Despite periodic upheavals in the settled order, the vote regularly goes to Francesco Colonna (c. 1433–1527), a Dominican of Treviso, Padua, and Venice, who had a checkered career as cleric, teacher, and entrepreneur, and who seems to have been devoted to the things of this world to a degree unbefitting his life's calling. It deserves stressing, however, that Colonna's authorship is far from universally accepted, especially among numerous senior Italian scholars.

A copy preserved in Berlin contains uniquely a leaf bearing printed verse. The leaf, part of what Paul Needham judges to be a cancellandum, records the sentiments of Matteo Visconti of Brescia, who writes that Colonna has ensured the fame both of Polia and of Visconti's own beloved Laurea.

This book is customarily cited as the most harmonious blend of text and woodcut in the Italian Renaissance; it is certainly the most celebrated printed book of the era. The weight of the typeface, which is a refined version of the roman font originally used by Aldus for Pietro Bembo's *De Aetna* of 1495, does indeed match the density of line of the very skillfully executed woodcuts. Shaped typography flatters the architectural conceit behind the work, offering elaborate early visions of concrete poetry.

There has been at least as much debate about the artist behind the woodblocks as about the author. The current scholarly consensus attributes the work to Benedetto Bordon—two cuts are signed with a lowercase *b*, although even this is controverted—and the style is in keeping with that of this Venetian artist. Bordon was also responsible for impressive woodcuts published at the same time by the Giunti and a generation later by Aldus's Torresani successors.

This book was completely out of the mainstream for the Aldine Press, being what modern publishing calls a commissioned work, produced for and remaining the property of an outside owner, the assumption being that the printer recoups his costs upon completion of the production. Ironically, in a sense the only original Aldine contribution is a final leaf containing a full page of errata and the colophon stating that Aldus had printed the book *accuratissime*. But the volume also contains what might be termed a proto-Aldine element: an anticipatory version, in elegant horizontal configuration, of what would emerge in the summer of 1502 as the dolphin-and-anchor device of the House of Aldus.

Supposedly financed with his own funds by Leonardo Crassi, who dedicated it to Guidobaldo da Montefeltro, duke of Urbino, the book may in reality have been published thanks to a loan secured from Colonna's monastery at the time, Santi Giovanni e Paolo (San Zanipolo, in Venetian). In June of 1501 Colonna's procurator demanded the repayment to their provincial of the monastery's loan. Then, as late as 1509, Crassi sought an extension of the expiring privilege from the Council of Ten, claiming that the French wars in Italy, waged against Venice in particular, had fatally disrupted trade and prevented many a guaranteed sale and that he still possessed

most of the print run. Since the War of the League of Cambrai continued in full vigor until 1512, he unknowingly had years of inaccessible foreign markets and continuing debts facing him.

Of its 170 woodcuts, the most famous (or should one say notorious?) is the garden scene of the sacrifice of a bull before a statue of the god Priapus, depicted as an ithyphallic herm. It has become something of a sport to use this woodcut to illustrate an entry on this work, whether scholarly or commercial. What becomes clear from repetitive viewing of the image from multiple copies is that the older claims of wholesale defacement by censors were exaggerated. But it did occur. In one of the two copies at the New York Public Library, for example, the paper copy in the Rare Books Division, the priapic woodcut is defaced, whereas in the Spencer Collection's vellum-printed copy (one of three recorded), it is intact.

When the Manuzio and Torresani families came to settling their mutual obligations and individual debts in May 1544, at the dissolution of the original, fifty-year-old Aldine publishing partnership, they distributed a cache of materials in a storeroom at San Stefano. The inventory recorded among the contents the original woodblocks for the *Hypnerotomachia*, which apparently were part of the one-fifth share that went to Aldus's sons. At least most of the blocks were there, because the 1545 Sons of Aldus line-for-line reprint, which is rarer than the 1499 original, reuses almost all of the old blocks. Six were recut, so one assumes that the originals had deteriorated beyond use or had been lost. The title of the 1545 edition was now rendered in Italian as *Hypnerotomachia di Poliphilo*.

A French translation, the *Hypnerotomachie de Poliphile* or *Le songe de Poliphile*, revised by Jean Martin from the work of an anonymous Knight of Malta, appeared in this period. Jacques Kerver issued three editions—in 1546, 1554, and 1561—each prepared for him by a different printer. Often undifferentiated, they in fact do not all carry the same illustrations. The French illustrations, in the Mannerist style, take their inspiration from, when they are not direct copies of, the original Italian woodcuts of 1499. The three editions within

References

W. A. Copinger, *Supplement to Hain's Repertorium bibliographicum* (London: H. Sotheran, 1895–1902), no. 5501*; *Catalogue of Books Printed in the Fifteenth Century Now in the British Museum* (London: British Museum, 1908–), vol. 5, 561–62; *Gesamtkatalog der Wiegendrucke*, 10 vols. (Leipzig and Stuttgart: Hiersemann, 1925–), no. 7223; Frederick R. Goff, *Incunabula in American Libraries: A Third Census* (New York: Bibliographical Society of America, 1964), no. C-767; *The Aldine Press: Catalogue of the Ahmanson-Murphy*

Collection of Books by or Relating to the Press in the Library of the University of California, Los Angeles: Incorporating Works Recorded Elsewhere (Berkeley and Los Angeles: University of California Press, 2001), no. 35.

Bibliography

Philip Hofer, "Variant Copies of the 1499 Poliphilus," *Bulletin of the New York Public Library* 36 (1932): 475–86; Francesco Colonna, *Hypnerotomachia Poliphili*, ed. Giovanni Pozzi and Lucia A. Ciapponi, rev. ed. (Padua: Antenore, 1980), a critical edition with commentary; Helena K. Szépe, "The *Poliphilo* Reconsidered in the Context of the Production of Decorated Books in Venice" (Ph.D. diss., Cornell University [Ann Arbor: University Microfilms, 1992]); *Aldo Manuzio Tipografo, 1494–1515*, ed. Luciana Bigliazzi et al. (Florence: Octavo,

fifteen years make one thing very clear: sales of
the French translation surpassed those of Aldus's
own edition.

It is noteworthy that this French version,
which lacks about a quarter of the original text,
should appear in the mid-1540s, just after the
release of the second Venetian edition, and particu-
larly that the venue is Paris. During this period,
Gian Francesco Torresani established an Aldine
export agency there, overseen by none other than
Jean Grolier, France's most famous bibliophile. It
was managed by the bookseller Jean Picard, latterly
identified as the Entrelac binder, from 1540 until
he and his wife decamped suddenly in the autumn
of 1547 to escape creditors. It seems plausible that,
in the same May 1544 distribution of materials and
purview between the two components of the Aldine
family, the export side went to the Torresani, who
cooperated with their Manuzio cousins in at least
some foreign business ventures.

English-speaking readers had to wait precisely
five hundred years for a complete English translation.
The complexity of the original language played a
large role. An early attempt was the partial translation,
published in 1592, attributed to Sir Robert
Dallington. The want (if that is the correct term) of
a complete text has now been supplied by Joscelyn
Godwin in a tour de force production. The new
translation has been released in what amounts
to a typographic facsimile of the complexities of the
original. Moreover, life imitates life here, when it
mirrors Aldus's page of errata by failing to include
one woodcut, which is supplied as a cancel to paste
over the cut erroneously repeated. One wishes the
publishers timelier financial success than Leonardo
Crassi and the Dominicans at San Zanipolo enjoyed.

The *Hypnerotomachia* in the Ahmanson-
Murphy Aldine Collection at UCLA is a sophisticated
copy, comprising parts of three or four distinct
copies, probably assembled prior to its present bind-
ing by Rivière, c. 1910. It carries the book labels,
printed at the Kelmscott Press, of John Ruskin
(1819–1900) and John Charrington, The Grange,
Shenley (Sir John Charrington, Kt., 1856–1939,
Hon. Fellow, Magdalene College, Cambridge), and
was acquired around 1953. *H. George Fletcher*

54

VIRGIL

[Works]

Venice: Aldus Manutius, 1501
5¹³⁄₁₆ x 3¹⁵⁄₁₆ in. (14.8 x 10 cm)
Department of Special Collections,
Young Research Library, UCLA
(Z233 A4V819 1501)

55

POLYBIUS

Historiarum libri quinque

Venice: Heirs of Aldus Manutius, 1521
13 x 9 in. (33 x 22.9 cm)
Department of Special Collections,
Young Research Library, UCLA
(*Z233 A4P767 1521)

1994), no. 36; [Paul Needham, in] *The Collection of Otto Schäfer,
Part I: Italian Books*, sale cat., Sotheby's, New York, 8 December
1994, lot 62; Lilian Armstrong, "The Hand-Illumination of Printed
Books in Italy, 1465–1515," in *The Painted Page: Italian Renaissance
Book Illumination, 1450–1550*, ed. J. J. G. Alexander (London: Royal
Academy of Art; New York: Pierpont Morgan Library, 1995), 35–47;
Francesco Colonna, *Hypnerotomachia Poliphili: The Strife of Love in
a Dream*, trans. Joscelyn Godwin (London: Thames and Hudson,
1999).

Aurêges,

LA plate forme du Theatre, côme l'en ay veu vng en vne Cite pres Auignon sus le Rosne dicte & nômee Aurenges, qui a le frôtispice, c'est a dire, la face de deuât en droicte ligne, & le derriere en circonferêce ronde, peut estre moult bien côsideree, en la lettre D. de laqlle la iambe droicte sera pour le dict frontispice & face anterieure, qui regardera Septêtrion, & le derrie=re qui est rond tornera le dos au mydy.

Plate for me du Collisee de Rôme,

La plate forme du Collisee q̃ iay veu mille fois en Romme, est toute manife ste & tres apparête en le O. entendu q̃ icelluy Collisee estoit iadis quât il estoit entier, tout rond par dehors, & par de dans en figure ouale. Ie porrois dire a ce propos beaucoup daultres choses, mais a cause de brefuete ie passeray oultre, & viêdray a môstrer cômant nosdi= ctes lfes Attiqs accordet en nôbre des corps de leur largeur selô la quadrature de pspectiue, cômât la figure Cube cy dessoubz designee, le nous manifestera.

IAy cy deuant dict que A. est de dix corps de haulteur, & de dix de largeur. F. de six de largeur, & I. en chef detrois, les quelz A. F. & I. côstitue en perspectiue & quadrature, en sorte quon peult en la presente figure co= gnoistre la manifeste perfection de noz let tres Attiques qui ac=cordêt si biê les vnes auec les aultres, qu'elles obseruent & gardent mesure symmetrique.

Iacorderois ainsi tou tes les aultres, mais ie les laisse pour les bons esperits, a eulx y exercer, si leur plaist y prendre esbat.

LA grace a Dieu, au moins mal q̃ iay peu, iay cy dess° accorde noz deux lfes pportiônaires & triûphalles I. & O. Seblablemêt A.H.& K. au corps hu=main. Ie veulx dauâtage en meoire & moralite des .IIII. Vertus Cardinalles.

Quatre vertus Cardi=nalles.

qui sôt Iustice, Force, Prudece, & Atrêpance, les accorder au visage & teste du dict hôme humain, q̃ ie diuiseray en quatre corps seullemét, pour tousiours pse=uerer a plus de demôstratiô de la diuine symmetrie de nosdictes lfes Attiqs.

Diuision du visage humain,

Premieremêt dôcqs no° predrôs vng quarre equilateral, & le diuiserôs en qua tre pties esgalles, puis aps y figurerôs vng visage hûain seullemêt pour la pmie re demôstration, & y escriprôs & logerons aux quatre angles en memoire des

dictes quatre pties, les quatre vertus Cardinalles pour môstrer q̃ noz lfes Atti ques côsistêt pfaictemêt en certaie quadrature qui gist en lôgitude & altitude.

Signification des quatre vert° cardinales, auec let tres Atti= ques,

LEttres Attiques, pour estre entie= remêt ordônes & faictes, requie rêt pat Iustice, l'obseruatiô de la haul=teur & largeur d'elles selon leur facon. Par Prudence, reigle & compas. Par Force, côtinuelle & obstinee perseue rance a les diuiser, mesurer & deumêt pportiôner. Par Atrêpence, certaine discretiô a les asseoir être deux lignes principalles equidistates, & a les y lo ger en deue espace pres ou loing l'une de l'aultre, selô qui leur appartiedra. Considerez en la dicte figure diui= see en quatre parties, cômât la face humaine accorde a la diuision, et la diuision a icelle. La prunelle de l'oeuil assize sus la ligne centrique & diametralle, nous monstre ce que iay dict cy dessus, que toute lettre ayant bri= seure, la doibt auoir assize sus la dicte ligne ceutrique precisemêt, & nô ailleurs.

SVs icelle face, entre les deux yeulx, tout au lôg des nees, & dessus la bouche Designerons nostre lettre proportiônaire & triûphalle I. pour bailler tousiours myeulx a entendre noz raisons, ia par plusieurs fois cy dessus escriptes.

LEs bons esperits peuuent icy en= droit aparceuoir la diuine côtem plation des Anciens qui ont voulu figu rer leur lettre proportiônaire lon= gue depuis la supreme ligne du Quar re iusques a la plus basse, & depuis la summite de la face humaine iusques au bas du mêton, & lont imaginee en tre les deux yeulx, y prenât deue pro portion ainsi côme le nes en vng hô= me bien forme, est la mesure de tout son corps p dimension faicte en nôbre multiplie p certaine raison. Ie dis en= cores dauantage, q̃ le I. qui est droict en ligne ppêdiculaire ainsi assiz entre les deux yeulx, nous signifie q̃ nous doibuôs auoir le visage esleue enuers le ciel pour recognoistre nre createur, & pour côtêpler le grâs biês & la sciêce qu'il nous dône. Et quil soit vray q̃ Dieu veult quayôs nre côtêplatiô enuers le ciel, il no° a dône la teste eleuee en sus, & aux bestes baissee en bas.

Notable regulier.

Ordon= nance de la lon= gueur & largeur de le I. au visage humain,

Ouide Poete iadis nô Crestiê, & neaumoings grât Philosophe, auoit bien ceste opinion quant au Premier liure de ses Metamor=phoses, apres auoir elegamment descript la Creation du monde, & volant en son stile Poeticque aussi descripre la Creation de Lhomme, dist,

Ouide,

» Sanctius his animal, mentisq̃ capacius altæ

» Deerat adhuc, & quod dominari cætera posset

» Natus homo est, siue hunc diuino semine fecit

Septêtrion

Midy

Orient

Iustice.　Prudence.

Force.　　Atrempence.

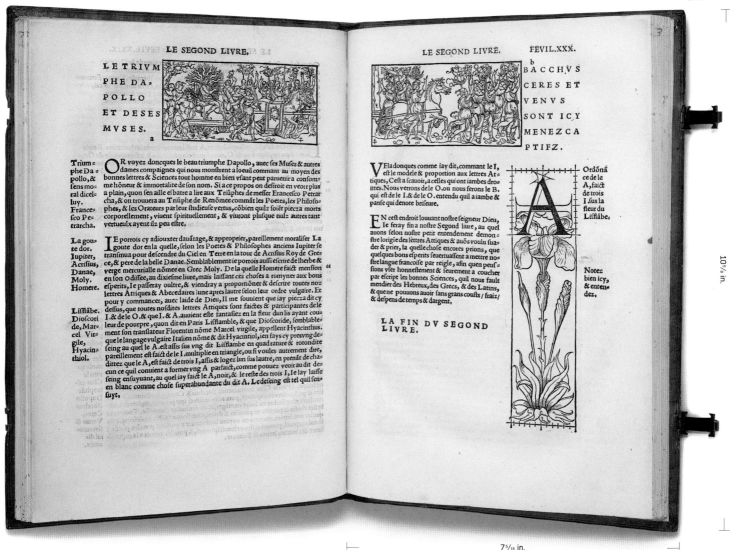

LE SEGOND LIVRE.

LE SEGOND LIVRE. FEVIL. XXX.

LE TRIVM=
PHE DA=
POLLO
ET DESES
MVSES.
a

b
BACCHVS
CERES ET
VENVS
SONT ICY
MENEZ CA
PTIFZ.

Trium=
phe Da=
pollo, &
sens mo=
ral dicel=
luy.
Frances=
co Pe=
trarcha.

OR voyez doncques le beau triumphe Dapollo, auec ses Muses & autres dames compaignes qui nous monstrent a loeuil comment au moyen des bonnes lettres & Sciences tout homme en bien vsant peut paruenir a consom= me hôneur & immortalite de son nom. Si a ce propos on desiroit en veoit plus a plain, quon sen aille esbatre a lire aux Triuphes de messer Francesco Petrar= cha, & on trouuera au Triuphe de Renômee commât les Poetes, les Philoso= phes, & les Orateurs par leur studieuse vertus, côbien quilz soiêt piecza morts corporellement, viuent spirituellement, & viuront plusque nulz autres tant vertueulx ayent ilz peu estre.

La gou=
te dor.
Iupiter,
Acrisius,
Danae,
Moly.
Homere.

IE porrois cy adiouxter dauãtage, & approprier, pareillement moraliser La goute dor en la quelle, selon les Poetes & Philosophes anciens Iupiter se transmua pour descendre du Ciel en Terre en la tour de Acrisius Roy de Gre= ce, & pere de la belle Danae. Semblablement ie porrois aussi escrire de lherbe & verge mercurialle nômee en Grec Moly. De la quelle Homere faict mension en son Odissee, au dixiesme liure, mais laissant ces choses a rumyner aux bons

Lisslâbe.
Dioscori=
de, Mar=
cel Vir=
gile,
Hyacin=
thiol.

esprits, Ie passeray oultre, & viendray a proportiõner & descrire toutes noz lettres Attiques & Abecedaires lune apres lautre selon leur ordre vulgaire. Et pour y commancer, auec laide de Dieu, Il me souuient que iay piecza dit cy dessus, que toutes nosdites lettres Attiques sont faictes & participantes de le I. & de le O. & que l. & A. auoient este fantasiez en la fleur dun lis ayant cou= leur de pourpre, quon dit en Paris Lisslamble, & que Dioscoride, semblable= ment son translateur Florentin nôme Marcel virgile, appellent Hyacinthus. que le langage vulgaire Italien nôme le I. multiplie en triangle, ou si voules autrement dire, dittez que le A, est faict de trois I, assis & logez lun sus lautre, en prenât de cha= cun ce quil conuient a former vng A parfaict, comme pouuez veoir au dit de= seing ensuyuant, au quel iay faict le A, noir, & le reste des trois I, Ie lay laisse en blanc comme chose superabundante du dit A. Le deseing est tel quil sen= suyt.

VEla donques comme iay dit, commant le I, est le modele & proportion aux lettres At= tiques, Cest a scauoir, a celles qui ont iambes dro= ittes. Nous verrons de le O. ou nous ferons le B. qui est de le I. & de le O. entendu quil a iambe & panse qui denote briseure.

Ordõnã=
ce de le
A, faict
de trois
I sus la
fleur du
Lisslâbe.

EN cest endroit louant nostre seigneur Dieu, Ie feray fin a nostre Segond liure, au quel auons selon nostre petit entendement demon= stre lorigie des lettres Attiques & auõs voulu sua= der & prier, la quelle chose encores prions, que quelques bons esprits seuertuassent a mettre no= stre langue francoise par reigle, afin quen peu= sions vser honnestement & seurement a coucher par escrit les bonnes Sciences, quil nous fault mendier des Hebreux, des Grecs, & des Latins, & que ne pouuons auoir sans grans cousts / fraiz / & despens de temps & dargent,

Notez
bien icy,
& enten=
dez.

**LA FIN DV SEGOND
LIVRE.**

Geofroy Tory

Champfleury: Au quel est contenu lart & science de la deue & vraye proportio des lettres attiques, 1529

An important Renaissance treatise on language and letter design

56

GEOFROY TORY

Champfleury: Au quel est contenu lart & science de la deue & vraye proportio des lettres attiques

Paris: [Geofroy Tory] and Giles Gourmont,
28 April 1529
10⅝ x 7⁵/₁₆ in. (27 x 19.9 cm)
Library, Getty Research Institute
(84-B7072)

A renaissance man in sixteenth-century France, Geofroy Tory (1480–1533) was an artist, writer, translator, and editor who published books that he designed and printed. Born in Bourges, he left France in the early sixteenth century to pursue humanistic studies in Rome and Bologna, making a second trip to Italy around 1516. Inspired by the examples of the Italian Renaissance printers and their editions of classical texts, Tory's first books were editions of Quintilian's *Institutiones* (1510) and Leon Battista Alberti's treatise on architecture (1512), published by other printers.

Not an edition or a translation, the *Champfleury* is Tory's own work. It epitomizes his integrated approach to making books and, in its design, provides the best illustration of his subject: the use of classical letters, lucid page designs, and proper French for the effective presentation of texts. The title of the book is emblematic; the "champfleury," a flowery field, alludes to both the beauty of the French language when used correctly and to the expressive design of Tory's work. Book 1 concerns the correct way to speak and write in French. Book 2 discusses the proportions of Attic (that is, roman) letters, with comparisons to those of the human body and face made following the theories of Leonardo da Vinci, Fra Luca Pacioli, and Albrecht Dürer. Book 3 provides instructions on the construction, meaning, and pronunciation of Attic capital letters. It shows how all the letters are based on the forms of the letters *I* and *O*; in addition, there are designs for letters of many other alphabets.

Tory's trade sign and printer's mark was the "pot cassé," a cracked funerary urn, pierced by a drill (a "toret"), standing on a book in lock and chains. An emblem of new times that break out of the mold of ancient arts, it was originally designed as a memento mori for Tory's beloved daughter Agnès. The broken vase was first printed with Latin verses written by her distraught father after she died at the age of nine in 1522.

The subtle use of emblems and the classic beauty of his book illustrations are further evidence of Tory's mastery of his craft. In concert with floriated initials and ornamental borders, resonant images enhance and support the presentation of ideas in the text. A vignette of the triumphal procession of Apollo symbolizes the way in which the cultivation of the arts and sciences leads to honor and immortality. On the facing page, the diagram of the letter *A* is shaped from three *I*s above a purple lily or iris; the letterform appears to rise out of the flower. Not only are the illustrations elegant, but a few have touches of wry humor. The men's faces in the proportionate cubes are expressive, looking up or to the side with certain understanding of the gravity and import of the subject at hand.

Tory's books transformed French book production. They replaced the decorative medieval style of illuminated manuscripts and printed books of hours with sophisticated, scholarly editions of classic texts in roman type with French accents. For almost five centuries the *Champfleury* has been admired and collected as a classic illustrated book. This copy formerly belonged to the great bibliographer and Voltaire scholar Theodore Besterman. Artists and designers today revere the book and return to its elegant page spreads for inspiration. For Geofroy Tory it seems that making books was never just a profession, but rather a lifelong endeavor that integrated all aspects of life, art, and the changing times in which he lived. *Marcia Reed*

57

Giunta House, stock inventory book

Florence, c. 1600
Bound manuscript
13 x 9⁵/₁₆ in. (332 x 23.7 cm)
Department of Special Collections,
Young Research Library, UCLA
(170/622)

References
Ruth Mortimer, *French Sixteenth-Century Books* (Cambridge, Mass.: Belknap Press, 1964), 524; Theodore Besterman, *Old Art Books* (London: Maggs Bros., 1975), 100; *En français dans le texte: Dix siècles de lumière par le livre* (Paris: Bibliothèque nationale, 1990), no. 41.

Bibliography
Auguste Bernard, *Geofroy Tory*, trans. George B. Ives (Cambridge, Mass.: Riverside Press, 1909); *Champfleury*, trans. George B. Ives (New York: Grolier Club, 1927).

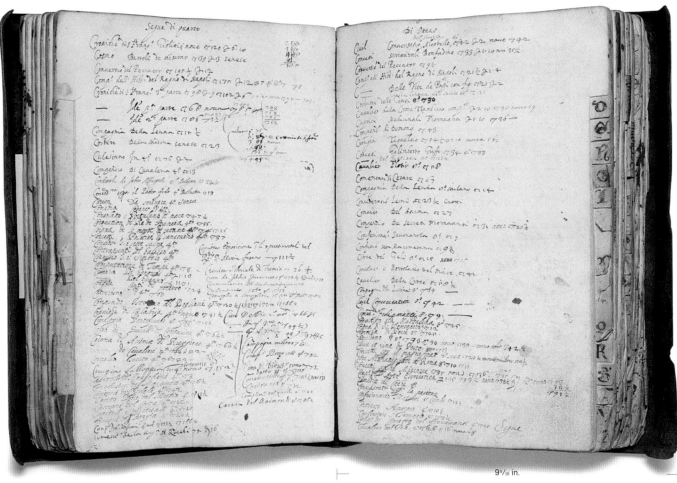

Giunta House, stock inventory book, c. 1600

The true Effigies of Laurenz Ians. Koster Delineated from his Monumentall Stone Statue, Erected at Harlem.

MEMORIÆ SACRVM.
LAVRENTIO COSTERO, HARLEMENSI, ALTERI CADMO, ET ARTIS TYPOGRAPHICÆ CIRCA AN. DOM. M.CCCC.XXX INVENTORI PRIMO,
BENE DE LITERIS AC TOTO ORBE MERENTI, HANC Q.L.C.Q.
STATVAM, QVIA ÆREA AVT MARMOREA DE FVIT, IRO MONVMEN-TO POSVIT CIVIS GRATISSIMVS
PETRVS SCRIVERIVS 1635.

MECHANICK EXERCISES:

Or, the Doctrine of

Handy-Works.

Applied to the Art of

Printing.

The Second VOLUMNE.

By *Joseph Moxon*, Member of the Royal Society, and *Hydrographer* to the King's Most Excellent Majesty.

LONDON.
Printed for *Joseph Moxon* on the West-side of *Fleet-ditch*, at the Sign of *Atlas*. 1 6 8 3.

Joseph Moxon
**Mechanick Exercises;
or, The Doctrine of Handy-Works
Applied to the Art of Printing**, 1683–84

The first printer's manual

58

STRADANUS (JAN VAN DER STRAET)

Nova Reperta

Antwerp: 1600?
10⅝ x 13½ in. (27 x 34.3 cm)
The Huntington Library, San Marino, California
(RB 78222)

59

JOSEPH MOXON

Mechanick Exercises; or, The Doctrine of Handy-Works Applied to the Art of Printing: The Second Volumne

London: Printed for Joseph Moxon, 1683–84
7⅞ x 6¼ in. (20 x 15.9 cm)
William Andrews Clark Memorial Library,
UCLA (*Z244 A2M9)

For five hundred years letterpress printing was the dominant mode of visual communication, the best means of transmitting and preserving information of all kinds and in all fields of the arts and sciences. Printers were proud to have practiced "the art preservative of all arts," yet they never described how they practiced it, except in passing or in shorter texts intended for other purposes. They published books about other occupations but were strangely silent about their own. Moxon set an excellent example with his *Mechanick Exercises*, a masterful performance and the first of its kind, but it did not inspire many others of its kind until the Industrial Revolution.

Printers rarely wrote about printing because they doubted that written instruction would be desirable or even feasible. Some wanted to protect the secrets of their trade, hoping to discourage competition. Others distrusted book learning and preferred the traditional training sanctioned by the guilds and embedded in the daily routine of the shop, where journeymen taught the apprentices on the job, tools in hand. In this situation one might learn typefounding, composition, or presswork, but one would rarely have the opportunity to study these operations systematically, as allied crafts and interdependent parts of the work flow, knowledge vital for those who wished to comprehend "the whole Art of Printing in all its Branches."

This is the sort of instruction Joseph Moxon offered in his classic treatise, a complete course of typography suitable either for tradesmen or gentlemen. The *Mechanick Exercises* could be a valuable guide for professionals interested in the latest technical improvements, for amateurs curious about

book production, or for authors eager to know what would happen to their writings in the composing room and in the press. Moxon could explain these matters better than most printers of his day, having all the requisite skills as well as a certain amount of independence. He could cut and cast types, which he displayed in a specimen issued in 1669. He had his own printing business "at the Signe of Atlas," where he published mainly mathematical, astronomical, and geographical works in his capacity of Hydrographer to the King, a post he received in recognition of his achievements in the manufacture of "Globes, Sphears, Mapps, and Sea-Platts." Because of this appointment and its prerogatives, he did not have to worry quite so much about antagonizing the Stationers' Company or affronting colleagues who would object to the publication of a printing manual. In any case, his learned friends did not object—and even elected him a fellow of the Royal Society in November 1678, after he had issued the first six parts of the *Mechanick Exercises*.

The *Mechanick Exercises* was not just a technological revelation but also a commercial innovation, the first English imprint to be issued in parts. Moxon adopted this economizing measure so that his customers could pay in convenient installments and so that he could test the market and receive some return on his investment while the publication was under way. He started by issuing monthly parts priced at sixpence each, fourteen parts making up the first volume, completed in 1680, which dealt with ironwork, woodturning, joinery, and carpentry. The second volume consisted of twenty-four numbers issued in several sections during 1683 and 1684. The two volumes together would have cost more than nineteen shillings, a formidable price for a workman, who might earn that amount in a week, but who could easily afford the monthly parts. Even so, the first volume sold poorly because customers were distracted by the Popish Plot, and some wanted to buy parts concerning a certain trade rather than the full set. After the first six parts, Moxon abandoned the monthly publication schedule and issued the rest in larger installments. He announced that he would proceed with the second volume only if he could find enough subscribers willing to pay two pence a sheet and two pence for each of the plates

(which he seems to have engraved himself). He assured his subscribers that they would receive good value for these high prices, an entirely original work printed on good paper in only five hundred copies.

Printing manuals are no less rare than other books of practical instruction. Printed in small editions and sold outside the usual channels of the trade, a few have disappeared entirely, and many are known in only two or three copies, victims of neglect and obsolescence. They were handled roughly, like other tools of the trade, and were discarded as soon as they were superseded by later editions or other manuals. This one serves as an exception to the rule, with more than sixty copies recorded in the latest census, after which a few more have emerged at impressive prices. No doubt it would have suffered the same fate as some of its short-lived successors were it not so precise, thorough, and comprehensive. It provided the definitive description of remarkably durable techniques. Later technical writers cribbed from it and each other so consistently that portions of this text descended nearly intact through a succession of manuals well into the industrial era.

Now that lead is dead, the trade no longer needs to know about metal type, but contemporary fine printers still set texts by hand and still have a lot to learn from Moxon. Bibliographers and textual critics still delve into his instructions for evidence of printing-house practice before and after his time. They regularly consult his work in research libraries, most stocking the excellent annotated edition of Herbert Davis and Harry Carter.[1] A few can offer the original edition, among them the Clark Library, which acquired its copy of the second volume in 1964, just after scholars recognized the importance of the *Mechanick Exercises* and just before collectors drove its price up beyond the reach of scholarly institutions. *John Bidwell*

60

HORACE

Opera

London: John Pine, 1733–37
8¹³⁄₁₆ x 6 in. (22.4 x 15.2 cm)
Libraries of the Claremont Colleges,
Honnold/Mudd Library
(PA 6393. A217 33x)

References
Donald Wing, *Short-Title Catalogue of Books Printed in England, Scotland, Ireland, Wales, and British America, and of English Books Printed in Other Countries, 1641–1700* (New York: Index Committee of the Modern Language Association of America, 1972–98), nos. M3013, M3014; E. C. Bigmore and C. W. H. Wyman, *A Bibliography of Printing* (London: Bernard Quaritch, 1880–86), vol. 2, 54–63.

Bibliography
Joseph Moxon, *Mechanick Exercises on the Whole Art of Printing (1683–4)*, ed. Herbert Davis and Harry Carter, 2d ed. (London: Oxford University Press, 1962); Philip Gaskell, Giles Barber, and Georgina Warrilow, "An Annotated List of Printers' Manuals to 1850," *Journal of the Printing Historical Society* 4 (1968): 11–31.

Notes
1. A new edition, based on the work of Davis and Carter, is being prepared by John A. Lane, who very kindly allowed me to see a preliminary draft of his corrections and commentary.

Livre de prières tissé d'après les enlumineurs
des manuscrits du XIVe au XVIe siècle, 1886–87

The only known book woven on a loom

61
Oratio Dominica in CLV linguas versa

Parma: Bodoni, 1806
17⅜ x 11½ in. (44.1 x 29.2 cm)
Department of Special Collections,
Young Research Library, UCLA
(**Z 233 B6L89)

62
William Morris's printing press

72 x 43¼ x 28⅛ in. (182.9 x 109.9 x 71.4 cm)
The Huntington Library, San Marino, California

63
Livre de prières tissé d'après les enlumineurs des manuscrits du XIVe au XVIe siècle

Lyon: A. Roux, 1886–87
Woven by J. A. Henry
Silk; 6⅞ x 5⁷⁄₁₆ in. (17.5 x 13.8 cm)
Libraries of the Claremont Colleges,
Denison Library, Scripps College

Despite the fact that this rare volume is not a printed book, it is of singular interest in that it was completely woven with silver and black silk thread. It also represents an extremely early book production involving automation and programming, and it challenges our conception of the "art of the book" in nineteenth-century France.

The book was manufactured on silk looms that were programmed using the punched-card system developed by Joseph-Marie Jacquard (1752–1834). Several hundred thousand cards were required to program this curious magnum opus (the actual figure is not known, but estimates range from 106,000 to 500,000). After fifty failed attempts, it took two years to weave approximately sixty copies. The prepublication price of the silk book to subscribers was 260 francs unbound, a large sum in those days. Unsold copies were evidently still available more than fifteen years later. It was in every way a "brilliant fiasco."

In the Jacquard system, instructions were directed to the looms through a sequence of punched cards that had been fastened together in a chain (the length could be varied); the chain passed over needles, which were fastened to warp threads. If there was no punched hole ("instruction"), the warp thread would remain compressed; if there was a punched hole, the warp thread would engage by means of a spring. It will be observed that the weave in the present volume is almost microscopic (it is exactly four hundred weft threads for every 2.5 centimeters [approximately one inch]); the disposition is unusual in that the warp is horizontal (instead of vertical) and the weft vertical (instead of horizontal). The movement of the machine was limited to one tenth of a millimeter, the result being an extremely precise piece of bookmaking, which, on account of the material used, truly gleams. It is noteworthy that Jacquard's looms, only slightly modified, are still in use today, producing some of the world's finest fabric for furniture.

The punched instructional cards utilized by Jacquard's weaving machinery served as the primary inspiration for the famous "Analytical Engine" conceived by Charles Babbage (1791–1871). Babbage's theoretical computing machine was never completed; nonetheless it possessed brilliant, almost alarming, parallels to modern computers.

The present volume may represent the first, and probably the only, successful attempt at weaving a book; although John Harthan stated that J. A. Henry's factory "specialized in the production of silken Books of Hours and Missals," other books woven by this firm have not been located.[1]

As the title indicates, the designs for the ornamental "illuminations" and historiated initials were copied from medieval manuscripts; the colophon states that the designer of the volume was one J. Hervier, a priest of the Marist order who unfortunately has not been further identified. Lilian Randall has shown that Hervier utilized nineteenth-century facsimiles of various books of hours, as well as reproductions of Italian Renaissance paintings, as source material for his designs. Thus, the present *Livre de prières* is a characteristically nineteenth-century "gothic" book production, albeit one that was manufactured by highly unorthodox means.

This copy has a distinguished provenance: its first owner was Henry Walters, founder of the Walters Art Gallery in Baltimore. Walters purchased it in 1896 from the publisher's Parisian agent, J. Kauffmann (the price was 330 francs, inclusive of the custom full-morocco binding by Charles Meunier); it then passed into the possession of Walters's widow and was sold at her auction to Dawson's Bookshop, Los Angeles.[2] An invoice from Dawson's to John I. Perkins dated May 7, 1941, records what must have been one of his last purchases (he died shortly thereafter). Perkins bequeathed his fine collection of more than six thousand rare books to the Denison Library, Scripps College, where the *Livre de prières* holds a justifiably distinguished place on its shelves. Because the *Livre de prières* is neither a printed book nor a manuscript, copies of the work have been difficult to trace. Besides the Denison Library copy, copies are recorded in the following North American institutions: the Cincinnati Historical Society; the University of Delaware; the College of Saint Catherine, Saint Paul; the Walters Art Gallery, Baltimore; and the Pierpont Morgan Library (Stillman Collection), New York.
Michael Laird

References
Georges Vicaire, *Manuel de l'amateur de livres du XIXe siècle, 1801–1893* (Paris: A. Rouquette, 1894–1920), vol. 5, 341.

Bibliography
P[aul] M[aurais], "Note sur un livre de prières en tissu du soie," *Bulletin du bibliophile* (1889): 163–66; Alfred Lailler, "Une merveille artistique: Notice sur un livre de prières tissé en soie," *Bulletin de la Société industrielle de Rouen* (1890): 3; Lilian M. C. Randall, "A Nineteenth-Century 'Medieval' Prayerbook Woven in Lyon," in *Art, the Ape of Nature: Studies in Honor of H. W. Janson*, ed. Moshe Barasch and Lucy Freeman Sandler (New York: Harry N. Abrams, 1981), 651–58.

Notes
1 John Harthan, *The Book of Hours* (New York: Thomas Y. Crowell, 1977), 174.
2 *Four Centuries of French Literature*, sale cat., Parke-Bernet, New York, 25 April 1941, lot 990.

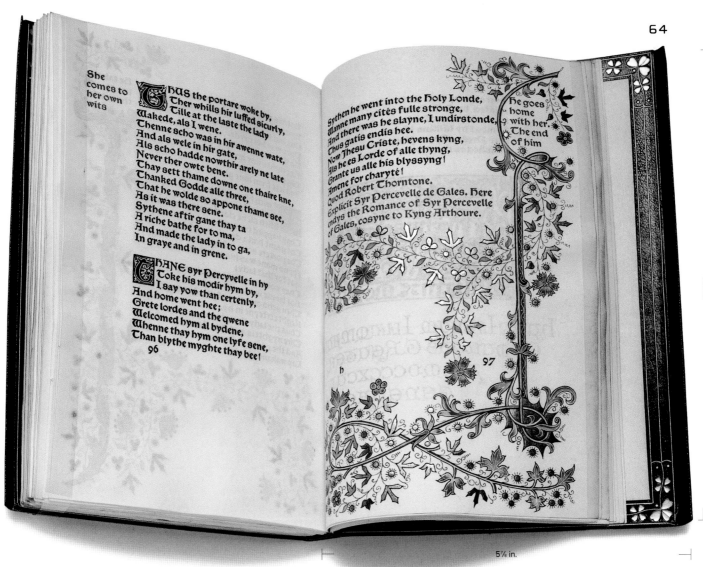

8⅞ in.

5⅞ in.

Syr Perecyvelle of Gales, 1895

This copy, printed on vellum, belonged
to William Morris's daughter May

64

Syr Perecyvelle of Gales

Hammersmith: Kelmscott Press, 1895
With illuminations by Edmund G. Reuter
8⅜ x 5⅞ in. (21.3 x 14.9 cm)
William Andrews Clark Memorial Library,
UCLA (Press Coll. Kelmscott Annex)

In 1895 William Morris (1834–96) published the first of three slender volumes of Middle English metrical verse derived from *The Thornton Romances* (1844), edited by James O. Halliwell. Like *Sire Degrevaunt* (1896) and *Syr Isambrace* (1897), *Syr Perecyvelle of Gales* was issued by the Kelmscott Press in an edition of 350, including 8 printed on vellum. The books were all modestly bound in quarter Holland (blue paper on boards with linen spine), and priced at fifteen shillings for the paper copies and four guineas for the vellum. *Syr Perecyvelle* sold briskly; two-thirds were purchased by subscription a month in advance of publication.

The Clark Library copy of *Syr Perecyvelle*, finely bound in green morocco by Thomas James Cobden-Sanderson of the Doves Bindery, is in fact part printed book and part illuminated manuscript. Though the Arthurian text was printed on vellum with the so-called Chaucer type designed by Morris, the borders of every recto were painted—in a style reminiscent of the later fourteenth century—by a Swiss decorator named Edmund G. Reuter. In addition to the illuminated borders, the book contains a splendid decorated initial on page 1 and an inscription in gold, dated 1898, beneath the Kelmscott

armorial on page 98. The book's richness, combined with the fact that it was owned by May Morris (the designer-author's beloved daughter), suggests that it was commissioned by William Morris himself.

Morris died before the decoration of *Syr Perecyvelle* was completed, so we can only guess at what might have been his reaction to the finished manuscript. The beauty and botanical precision of Reuter's flowers, vines, and tendrils—there are easily recognizable carnations, lilies, grapes, roses, and cornflowers—would undoubtedly have delighted Morris; his own wallpapers and woven and printed textiles are remarkable for their clarity and exactness of representation. Moreover, Morris himself decades earlier had tried his hand at manuscript illumination. In a few instances, he even added painted borders to copies of printed books intended as gifts for special friends, as was the case with the *Volsunga Saga* given in 1870 to Edward Burne-Jones (Huntington Library, formerly Sanford Berger Collection). But by the mid-1890s Morris had long since turned his attention away from illumination and toward book and typographical design and was generally uneasy with the idea of mixing the two forms. Indeed, the Clark Library *Syr Perecyvelle* is a highly idiosyncratic hybrid of printing and illumination, and a comparison of it with the regular Kelmscott edition effectively exposes the classical basis of Morris's bibliophilia.

In 1893 Morris wrote that the ornament of a book "must form as much a part of the page as the type itself, or it will miss its mark, and in order to succeed, and to be ornament, it must submit to certain limitations and become *architectural*."[1] By architecture, he meant the structure and balance of the elements that constitute a book: the typeface, text block, borders, ornamentation, and illustration. Morris conceived of his books as composed of a purposefully determined sequence of two-page openings, or spreads, not of an arbitrarily delimited succession of single rectos and versos. He wished, moreover, to highlight the unique materiality and specificity of books: letters should be rich, black, and inky; paper should be clean and white and contain a memory of the cotton rag from which it was derived; illustrations should be few and should complement the facing text block. (Morris never used tissue guards to protect illustrations, precisely because they would disrupt the balance of the spread.) By the measure of Morris's classical aesthetic, Reuter's architecture is mannerist, if not positively baroque. The rejection of the two-page opening as the basic unit of design (evident in the blank page facing the first recto), the extensive use of gold, and the frequent invasion of plant tendrils into text blocks create a flatness and allover ornamental effect that deny the balanced tectonics that generally characterizes Kelmscott Press books, including the standard edition of *Syr Perecyvelle of Gales*.

In 1895 *Syr Perecyvelle of Gales* took its place amid a large and still growing body of literature devoted to Arthurian legend. A year earlier an English translation of Wolfram von Eschenbach's thirteenth-century *Parzival* had been published.[2] Several editions of the twelfth-century French version of the tale of the pure-hearted knight, Chrétien de Troyes's *Le conte du Graal*, were also widely available at this time. (Morris owned the very rare *Tresplaisante et recreative hystoire du trespreulx et vaillant chevallier Perceval le galloys*, printed in 1530 in Paris by Jehan Sainct Denys and Jehan Longis.) Finally, in 1892–93, a splendid trade edition of Sir Thomas Malory's *Morte D'Arthur*, illustrated by Aubrey Beardsley, was published by J. M. Dent in London. Its decorative promiscuity suggests that it was conceived in opposition to the comparatively restrained architecture of Kelmscott Press books such as *Syr Perecyvelle of Gales*.

Syr Perecyvelle of Gales was acquired in 1960, an *annus mirabilis* for Morris at the Clark Library. In the same year, the library acquired a number of rare or unique Morris items belonging to the artist's friend and secretary, Sir Sidney Cockerell; these included designs, letters, prospectuses, and various ephemera. The library also acquired in that year some original designs by Cobden-Sanderson for bindings for Kelmscott Press books. Another copy of *Syr Perecyvelle of Gales*, also illuminated by Reuter, was in the Foyle sale in July 2000 and now belongs to a London bookseller. *Stephen F. Eisenman*

Bibliography
James O. Halliwell, ed., *The Thornton Romances* (London: Camden Society, John Bowyer Nichols, 1844); William S. Peterson, *A Bibliography of the Kelmscott Press* (Oxford: Clarendon Press, 1984); Chrétien de Troyes, *Perceval; or, The Story of the Grail*, trans. Ruth Harwood Cline (Athens: University of Georgia Press, 1985).

Notes
1. William Morris, *Essays and Lectures on the Arts of the Book*, ed. William S. Peterson (Berkeley and Los Angeles: University of California Press, 1982), 72–73.
2. Wolfram von Eschenbach, *Parzival, A Knightly Epic*, trans. Jessie L. Weston, 2 vols. (London: David Nutt, 1894).

65

GEOFFREY CHAUCER

The Works

Hammersmith: Kelmscott Press, 1896
Illustrated with wood engravings by
Edward Burne-Jones and William Morris
17 x 11¾ in. (48.3 x 29.8 cm)
William Andrews Clark Memorial Library,
UCLA (Press Coll. Kelmscott [Annex])

66

Le cantique des cantiques

Translated by Ernest Renan
Paris: F. L. Schmied, 1925
Unbound book; 10⅛ x 6⅞ in. (25.7 x 17.5 cm)
William Andrews Clark Memorial Library, UCLA
(Press Coll. Ritchie Lib.)

On their first exposure to one of François-Louis Schmied's productions, most Americans—even those with considerable book knowledge—are apt to declare they have never seen anything like it. There are good reasons for this. The aesthetic of fine twentieth-century French books, in which the illustrator almost always plays a major role, has had little impact on the Anglo-American one, which relies heavily on typographic effect. Furthermore, Schmied found his patrons in the exclusive world of French bibliophiles, usually limiting his editions to little more than a hundred copies. Although he drew artistic inspiration from Japan and the Middle East, the English-speaking world held little interest for him. Schmied's books still appear like rare birds on the American market, quickly snapped up by the few who are on the watch for them. Probably the most prized is this edition of the *Song of Solomon*, often cited as the most exuberant of his works and the pinnacle of Art Deco book design.

Schmied was born in Geneva in 1873. He went to art school and trained as a wood engraver, and his first job was cutting blocks for magazine and book illustrations. His emerging talent as an engraver and artist came to the attention of a group of collectors, who commissioned him to engrave some illustrations for a French edition of Rudyard Kipling's *Jungle Book*. Finished in 1919, this is the first book that displays Schmied's flair for printing illustrations in color through the use of multiple woodblocks. The success of this work, and the roaring economy of the 1920s, made possible an extraordinary series of books in which Schmied had both the means and the freedom to do what he wanted. His operation came to include a printing shop, an artist's studio, a bindery, a staff of wood engravers, and gracious living quarters, all under one roof. He was elected to the Legion of Honor; prominent artists and politicians dined at his table.

Le cantique des cantiques shows all the characteristics of the publications of Schmied's glory years. The illustrations began as fully realized gouache paintings by Schmied, which he handed over to his wood engravers. The workmen translated each one into a set of woodblocks, one for each color to be printed. The magic lay in the decisions of how to separate the colors, and in which order to print them. Each page might go through the press ten or fifteen times, but the title leaf of one 1930 book required forty-five blocks and was almost two months in the printing. No wonder that most of Schmied's books took years to complete, with several in the shop at a time in different stages of production. Around a thousand blocks went into *Le cantique des cantiques*.

Schmied's layouts are also arresting, the illustrations and the typography in close interplay but demarcated by broad strips of color. Here and there a trickle of text serves as mortar for two blocks of color, or vice versa; it is hard to say which illustrates which. Sometimes accused of creating unbalanced pages, Schmied claimed that he always designed his books as artistic unities. He was particularly proud of his inks, which included compounds of metallic dusts and a unique velvety black whose formula he kept secret. Unfortunately in this production the black contained too much linseed oil, which soaked into the leaves of all 110 copies of a book that can never be reprinted in anything approaching its original splendor.

Schmied produced some forty-five editions of great artistic variety. The bubble of his prosperity burst in 1931, when he lost most of his patrons to the Depression. Bankrupt himself and commissionless, he finally accepted a minor government post in a remote village in French Morocco. There he died of a fever in 1941. He had occupied part of his exile in decorating the walls of a deserted fort with colorful murals.

Much of the little we know about Schmied comes from the Los Angeles printer Ward Ritchie, who as a young man in 1930 talked his way into a short apprenticeship with the master. Later, as his own business prospered, Ritchie collected whatever Schmied books he could. On his death in early 1996 the Clark Library received the bequest of his library. This was found to include thirty Schmieds, including this one, making the Clark instantly the major repository of these books in the western United States.

In the French tradition of fine printing, *Le cantique des cantiques* was issued as loose sheets in a simple printed wrapper and slipcase. Patrons could order copies in custom bindings, which were often Art Deco jewels in their own right. This copy is still unbound and bears a signed inscription by Schmied to a recipient whose name has been erased. *Stephen Tabor*

References
Ward Ritchie, *Art Deco* (San Francisco: Book Club of California, 1987), no. 16; Mauro Nasti, *Schmied* (Vicenza: Guido Tamoni, 1991), no. B7.

Cette édition établie par
F.-L. Schmied sur l'initiative
d'un groupe d'amateurs, a
été tirée à cent dix exemplai-
res. Les six premiers étant
exemplaires de collabora-
teurs et comportant une
double suite des gravures.

Exemplaire d'auteur
à F.-L. SCHMIED

LE CANTIQUE DES CANTIQUES

TRADUCTION DE ERNEST RENAN

Paris
1 9 2 5

F.-L. Schmied
Peintre-Graveur-Imprimeur, 74bis Rue Hallé.

Oui, tu es belle, mon amie !
oui, tu es belle ! Tes yeux sont
des yeux de colombe, sous les
plis de ton voile. Tes cheveux
sont comme un troupeau de
chèvres suspendues aux
flancs du Galaad.
Tes dents sont comme un
troupeau de brebis tondues
qui sortent du bain ; chacune
d'elles porte deux jumeaux,
aucune d'elles n'est stérile.
Tes lèvres sont comme un fil
de pourpre, et ta bouche est
charmante. Ta joue est comme
une moitié de grenade, sous
les plis de ton voile. Ton cou
est comme la tour de David,

10⅛ in.

6⅞ in.

Le cantique des cantiques, 1925

An Art Deco edition of the *Song of Solomon*
illustrated with color wood engravings

67

Canticum canticorum Salomonis

Weimar: Cranach Press, 1931
Illustrated by Eric Gill
10⅛ x 5⅜ in. (25.7 x 13.7 cm)
William Andrews Clark Memorial Library,
UCLA (Press Coll. Gill Bible. O.T.
Song of Solomon. Latin)

68

ERIC GILL

Krisna and Parvati, 1926

Watercolor; 4³⁄₁₆ x 6 in. (10.6 x 15.2 cm)
William Andrews Clark Memorial Library, UCLA

69

WILLIAM SHAKESPEARE

The Tragedie of Hamlet

Weimar: Cranach Press, 1930
Illustrated by Edward Gordon Craig
14¹¹⁄₁₆ x 9¹¹⁄₁₆ in. (37.3 x 24.6 cm)
Libraries of the Claremont Colleges,
Honnold/Mudd Library
(PR 2807 .A2C7 1930c)

70

AGATHA CHRISTIE

The Murder at the Vicarage

England: Royal National Institute
for the Blind, [before 1940]
11¼ x 13⅝ in. (28.6 x 34.6 cm)
Braille Institute Library Services

ACT II SCENE II THE TRAGICALL HISTORIE OF

LINES 422-439

AVEC QVELLE RUSE AMLETH, QVI DEPUIS FUT ROY DE DANNEMARCH, VENGEA LA MORT DE SON PERE HORVVENDILLE, OCCIS PAR FENGON SON FRERE, ET AUTRE OCCURRENCE DE SON HISTOIRE

Quoy que j'eusse deliberé dès le commencement de ce mien oeuvre de ne m'esloigner, tant peu soit, des histoires de nostre temps, y ayant assez de sujets pleins de succez tragiques, si est-ce que partie pour ne pouvoir en discourir sans chatouiller plusieurs auxquels je ne voudroy desplaire, partie aussi que l'argument que j'ay en main m'a semblé digne d'estre offert à la noblesse Françoise, pour les grandes, et gaillardes occurrences qui y sont deduites, j'ay un peu egaré mon cours de ce siecle, et sortant de France et pays voysins, suis alle visiter l'histoire Danoise, afin qu'elle puisse servir et d'exemple de vertu, et de contentement aux nostres, auxquels je tasche de complaire, et pour le rasasissement desquels je ne laisse fleur qui ne soit goutee pour leur en tirer le miel le plus parfait et delicat, ne me souciant de l'ingratitude

Gens de lettre mesprisez et sans recompence en ce temps

du temps present, qui laisse ainsi en arriere et sans recompence ceux, qui servent au public, et honorent, par leur travail et diligence leur pays, et illustrent la France d'autant que souvent la faulte vient plustost d'eux que non de grands, lesquels ont d'autres affaires qui les destournent de chose qui semble de peu de consequence. Joinct que je me

Contentement de l'autheur de cet oeuvre

tiens pour plus que satisfait en ce contentement et grande liberté d'esprit, de laquelle je jouys estant aymé de la noblesse, pour laquelle je travaille avec si peu de relache, caressé des gens de sçavoir pour les admirer, et leur faire reverence, telle que leur excellence

62

Ham. O Jeptha Judge of Israell, what a treasure had'st thou!
Pol. What a treasure had he my Lord?
Ham. Why 'one faire daughter and no more, the which he loved passing well.'
Pol. Still on my daughter.
Ham. Am I not i'th' right old Jeptha?
Pol. If you call me Jeptha my Lord, I have a daughter that I love passing well.
Ham. Nay that followes not.
Pol. What followes then my Lord?
Ham. Why 'as by lot God wot,' and then you knowe 'it came to passe, as most like it was'; the first rowe of the pious chanson will showe you more, for looke where my abridgment comes.

HAMLET PRINCE OF DENMARKE ACT II SCENE II

LINES 440-454

Enter the Players.

THE PREFACE

Although in the beginning of this Hystorie, I had determined not to have troubled you with any other matter, then a Hystorie of our owne time having sufficient tragicall matter to satisfie the minds of men: but because I cannot wel discourse thereof, without touching many personages, whom I would not willingly displease, and partly because the Argument that I have in hand, seemed unto me a thing worthy to bee offered to our Frendh Nobilitie for the great and gallant occurrences therein set downe. I have somewhat strayed from my course, as touching the Tragedies of this our age, and starting out of France and over Netherlanders countries, I have ventured to visit the Hystories of Denmarke that it may serve for an example of vertue and contentment to our Nation (whom I specially seeke to please) and for whose satisfaction I have not left any flower whatsoever untasted, from whence I have not drawne the most perfect and delicate hony, thereby to bind them to my diligence herein: not caring for the ingratitude of the time present, that leaveth (and as it were rejecteth) without recompence, such as serve the Commonwealth, and by their travell and diligence honour their Countrey, and illustrate the Realme of France, no that often times the fault proceedeth rather from them, then from the great personages that have other affaires which withdraw them from thing that

63

Ham. You are welcome maisters, welcome all, I am glad to see thee well, welcome good friends, oh old friend, why thy face is valanct since I saw thee last, com'st thou to beard me in Denmark? what my young Lady and mistris, byrlady your Ladishippe is nerer to heaven, then when I saw you last by the altitude of a chopine, pray God your voyce like a peece of uncurrant gold, bee not crackt within the ring: maisters you are all welcome, weele e'n to't like French Faulkners, fly at any thing we see, weele have a speech straite, come give us a tast of your quality, come a passionate speech.
Play. What speech my good Lord?
Ham. I heard thee speake me a speech once, but it was

William Shakespeare
The Tragedie of Hamlet, 1930

Letterpress edition with illustrations
by Edward Gordon Craig

14¼ in.

18 in.

Robinson Jeffers
Granite and Cypress, 1975

71

ROBINSON JEFFERS

Granite and Cypress

Santa Cruz: Lime Kiln Press, 1975
Box: 14¼ x 18 x 1½ in. (36.2 x 45.7 x 3.8 cm);
book: 12⅝ x 17 in. (32 x 43.2 cm)
Occidental College, Mary Norton Clapp Library,
Special Collections (813.5 J45 xev 1975)

The title of this monumental volume of seventeen poems by Robinson Jeffers (1887–1962) comes from the first poem in the book. The subtitle— *Rubbings from the Rock, poems gathered from his stonemason years when submission to the spirit of granite in the building of house & tower & wall focused his imagination & gave massive permanence to his verse*—was surely the invention of poet-printer William Everson (1912–94), who directed the printing of this work on a double-crown Acorn handpress located at the McHenry Library of the University of California, Santa Cruz. This book's significance lies in the sense of perfection it attains through the interconnectedness of the text and the book as a physical object, the result of the intellectual dialogue between Everson's book design and Jeffers's poetry. *Granite and Cypress* is also significant for the high point in bookmaking it represents in the life of William Everson. It was not the last work of printing in which he had a hand. Yet it stands like a second pillar, twenty years distant from his first high point, *Novum Psalterium Pii XII*, to support and influence the craft of American fine printing and binding from the 1970s to the end of the twentieth century.

Though Robinson Jeffers was born in Pittsburgh and educated at Occidental College in Southern California, he was attracted to San Francisco and then to the Carmel coast, where he settled with his wife in 1916. It was here that he both confronted and lived with nature. He became something of a stonemason and built a home, called Tor House, for his family, using the natural granite on the site. He was well educated in literature, medicine, and forestry, but inherited wealth allowed him to live by the sea and write poetry. In general,

his poems celebrate the existence of a pantheistic God, the impermanence of human life, and the human struggle to survive. Granite and cypress are the materials of Jeffers the builder, and the poems in this volume are about natural things, man making things from nature, and nature's victory over anything man may construct. It is appropriate and only pleasantly ironic that a woodcut created by William Prochnow of Jeffers's rugged Tor House (which still stands in Carmel and is open to tourists) graces the title page.

William Everson was probably a poet before he was a printer. He grew up in the San Joaquin Valley, where his father had a print shop. Everson always maintained that he learned nothing about printing there. As a college student at Fresno State he discovered Jeffers's work and determined to become a poet himself. His first book of poetry was published in 1935. During World War II he was a conscientious objector and, as a consequence, was interned in a work camp, where he learned the basics of design and printing and began to print his own poetry. Eventually he printed the poetry of his hero, Robinson Jeffers.

Everson's sensitivity to the meaning of Jeffers's poems can be demonstrated in every detail of *Granite and Cypress*. The clothbound text is housed in a slipcase of Monterey cypress made by one who wished to remain anonymous, yet who was clearly skilled in carpentry. A "window" in the housing is made of granite from Jeffers's own stoneyard. It is a mixture of various shades of green and white. It could be either the sky with clouds or the sea with clouds reflected in it. Does one look out the window or into it? Is this a view from the inside of Tor House to the sea and sky? The window is granite—not a transparent substance, yet shiny and reflective. It is more like a mirror than a window. Moving to the interior of the book, much in both the poems and the book's design has to do with the various meanings

of the sea and sky, "reflection" and "mirror." The first printing that one encounters is the half title. It is simply the words *Granite and Cypress*, natural things used by man to build. The title page with the woodcut of Tor House shows through, and the half title floats on the sea of words forming the long subtitle on the title page.

The recto of each leaf is printed offset on the verso, thereby creating a mirror image and the false impression of "show-through." This is usually a printing defect, but here it is a part of Everson's design. Offsetting is often caused by wet ink being transferred from the recto of one sheet of paper to the verso of another. In the case of *Granite and Cypress*, Everson applied ink to the type and pulled an impression without a sheet of paper in the press. This process left ink on the tympan of the press, which would then offset onto the verso of the next sheet of paper put in the press.[1] Since the offset printing is a mirror image, one is able to read poems only on the right side of every opening. The left side, the offset or show-through side, balances its counterpart on the right without being a distraction. It is softer in color, more gray than black, somewhat blurred compared with the sharp impression on the right side of each opening.

No titles are given with the poems (they can be found in an index at the back), but the beginning of each poem is set off with an initial letter. The verses stretch to the right margin (to the left in the offset version). The last line of the last poem reads, "Reflected on the world for a mirror." Once a reading is completed and the book is closed, it may be returned to its slipcase "housing." The impermanent, the poetry and the printed leaves, return to their inspiration and the permanent, the rock and the tree.

This copy of *Granite and Cypress* is a part of the Robinson Jeffers Collection at the Mary Norton Clapp Library. It is copy number sixty-five of one hundred printed. *Susan M. Allen*

References
Art Museum of Santa Cruz County, *Dressing the Text: The Fine Press Artists' Book* (Santa Cruz, Calif.: Printers' Chappel of Santa Cruz, 1995), dedication [4].

Bibliography
Melba Berry Bennett, *The Stone Mason of Tor House: The Life and Work of Robinson Jeffers* ([Los Angeles]: W. Ritchie Press, 1966); Lee Bartlett, *William Everson: The Life of Brother Antoninus* (New York: New Directions, 1988); James Karman, ed., *Critical Essays on Robinson Jeffers* (Boston: G. K. Hall, 1990); William Everson, *On Printing* (San Francisco: Book Club of California, 1992); Robert Brophy, ed., *Robinson Jeffers: Dimensions of a Poet* (New York:

Fordham University Press, 1995); James Karman, *Robinson Jeffers: Poet of California*, rev. ed. (Brownsville, Ore.: Story Line Press, 1995); Felicia Rice, ed., *The Poet as Printer: William Everson and the Fine Press Artists' Book* (Santa Cruz, Calif.: Quarry West, 1995).

Notes
1. As reported by the printer Peter Koch, Berkeley, California (conversation with the author, New York, January 2001).

W. S. Merwin
The Real World of Manuel Córdova, 1995

27⅛ in.

13¼ in.

72

CHARLES G. FINNEY

The Circus of Dr. Lao

Newark, Vt.: Janus Press, 1984
13⅛ x 10⅞ in. (34 x 27.6 cm)
Libraries of the Claremont Colleges,
Denison Library, Scripps College
(f PS 3511.I64 C5 1964x)

73

W. S. MERWIN

The Real World of Manuel Córdova

Sherman Oaks, Calif.; Ninja Press, 1995
3¹¹⁄₁₆ x 13¼ in. (9.4 x 33.7 cm) (folded);
180 x 13¼ in. (457.2 x 33.7 cm) (fully extended)
Los Angeles Public Library

In the tradition of printer-poet William Everson (see cat. no. 71), Carolee Campbell, proprietor of the Ninja Press, has created a book that achieves such a perfect balance between its poetic text, by W. S. Merwin (b. 1927), and its design that the reader is transported to Manuel Córdova's "world." Campbell, who began publishing under the Ninja Press imprint in 1984, designed the book, printed it, and created and executed its binding. All of these elements are perfectly attuned to the meaning of the poem.

W. S. Merwin, poet and translator, is known particularly for his poems that express the alienation of humans from nature or the environment. In this particular poem, real events from the life of Manuel Córdova-Ríos (1887–1978) are retold to show how the lives of an indigenous group in the Amazon are transformed by the "civilization" of guns that Córdova brings to them.[1] Merwin first published the poem in 1993 in a larger work entitled *Travels*.[2] Here it stands alone as a poem of forty-three fourteen-line stanzas.

The Amazon River figures prominently in the poem, and the book mirrors the flow of this famous river. It is an accordion-fold book and can be read by unfolding it and refolding it, opening by opening. Or it can be extended to its full, magnificent fifteen feet. When extended, the river, printed in a succession of five colors, "flows" along the left-hand margin as a constant reminder of the power of the natural world. Campbell, herself a white-water rafting enthusiast, used the form of a river-rafting map as her model for the image of the Amazon.

If the book is read opening by opening, stanza by stanza, a transformation occurs. The handset Samson Uncial typeface begins to resemble calligraphy, and the Japanese *kakishibu* paper, with its slight persimmon hue, takes on the quality of vellum or parchment. Gradually the reading experience changes. Instead of holding a printed book, one seems to be holding a very old handwritten manuscript with a hand-drawn map. It is as if the book becomes a manuscript written by Córdova. The enclosure for it, made of handmade paper secured with goatskin and bone clasps, reinforces this perception.

This copy of *The Real World of Manuel Córdova* is part of the Book Arts Collection at the Los Angeles Public Library. It is copy number 73 of 178 printed, and it is signed by the author.
Susan M. Allen

Bibliography
"Women of the Composing Stick: Interviews with Carolee Campbell, Susan King, and Bonnie T. Norman" (radio program produced by KPFK, Los Angeles; aired on KCRW, Santa Monica, March 1992); Carl Clifton Toliver, "W. S. Merwin and the Postmodern Environment" (Ph.D. diss., University of Texas, Austin, 1997); Daniel C. Vanek, "Craftsmanship, Vision, and Poetic Truth: W. S. Merwin, Aesthetics, and His Critical Reception" (Ph.D. diss., University of Idaho, 1997); Jane Frazier, *From Origin to Ecology: Nature and the Poetry of W. S. Merwin* (Madison, N.J.: Fairleigh Dickinson University Press, 1999).

Notes
1. The full story can be found in Manuel Córdova-Ríos, as told to F. Bruce Lamb, *Wizard of the Upper Amazon* (New York: Atheneum, 1971).
2. W. S. Merwin, *Travels: Poems* (New York: Knopf, 1993).

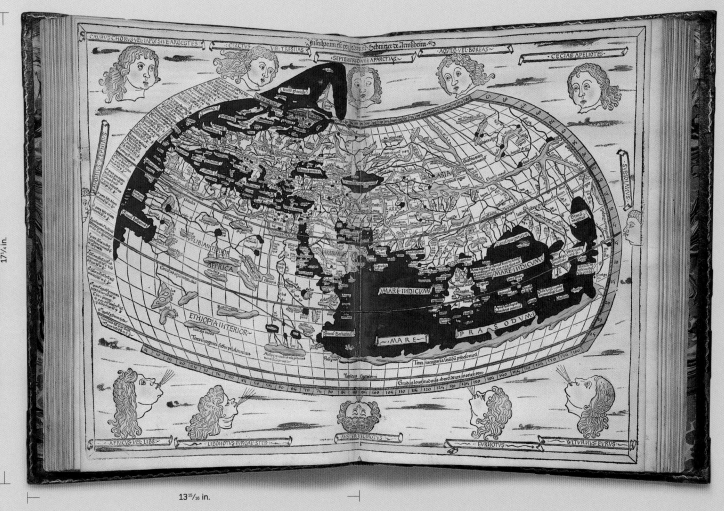

Claudius Ptolemaeus
Cosmographia (Geographia), 1482

A map of the world from one of the earliest
European atlases

III WORD AND IMAGE

In *A Study of Writing*, the Assyriologist I. J. Gelb noted the intimate relationship between pictures and writing that was prevalent in the early development of communication systems, particularly in prephonetic writing. Although this connection between words and images gradually disappeared from most writing systems as they developed toward the alphabetic, the power of the image to convey information and emotional charge has remained part of the communicative vocabulary of the "writer" and the "publisher," both before and since the invention of printing from movable type in the fifteenth century. Some texts naturally lent themselves better than others to the parallel expressiveness of the image: scientific and medical books come to mind, for example, as well as various books on technology, geography, and other visually dependent subjects. The technical challenges of printing woodcuts or copperplate engravings alongside metal type did not prevent the early printers from incorporating images into their books almost from the beginning. Albrecht Pfister's experiments with illustration in Bamberg in the 1460s did not produce any masterpieces of design or illustration, but as early as 1473, in the *Speculum humanae salvationis*, printed by Günther Zainer in Augsburg (exhibited in section 8 of *The World from Here*), we find a first example of an illustrated book in which the pictures and the words are detectably integrated and not merely stuck together paratactically.

Although we tend to think of our own culture as being increasingly based on visuality, it is estimated that fully one-third of all fifteenth-century books were illustrated, and that proportion doubtless held true for the early part of

the following century as well. The techniques available for pictorial representation in books did not so much change as ramify over the succeeding centuries, at least until the invention of photography and its introduction into the printing house in the nineteenth century. Books like the 1491 *Schatzbehalter der wahren Reichtümer des Heils* and the Nuremberg Chronicle of two years later brought the art of the woodcut-illustrated book, at least in the German style, to a high level of achievement. The illustrated book in Italy and France also embodied remarkable aesthetic qualities at this time, as books in other sections of *The World from Here* demonstrate. (The *Hypnerotomachia Poliphili* in section 2 and the Kerver *Horae* in section 8 are excellent examples.)

Among later books, this exhibition focuses in particular on three genres of printed books in which illustration and text play equally or almost equally prominent roles: scientific illustration, illustrated literature (including artists' books), and graphic satire and political imagery. Illustrating nature was already a vital method of communicating information, both scientific and popular, in the days when travel was difficult and art alone could capture what was seen by the naked eye or by the eye assisted by the microscope or the telescope. The animals illustrated in John Johnston's now rare 1678 book on quadrupeds would surely never have been seen by most of his readers, and the same was true of Thomas

Bewick's more sophisticated book of 1790 on the subject. The illustrations in Edward Tyson's important book on comparative morphology, *Orang-Outang* (1699), by contrast, are more evidentiary in that they provide comparative data to support the author's hypothesis of the evolutionary relationship (although he would not have used the phrase) between *Homo sapiens* and the higher apes. The nineteenth century was the day of the great color-illustrated nature books, especially books about birds and flowers. The strictly scientific value of these books varies, although some, such as James Bateman's study of the orchids of Mesoamerica (1843) and John James Audubon's famous *Birds of America* (1827–38), not only were visually stunning but also were carried out along reasonably well-informed lines where nomenclature and classification were concerned.

It is suggestive of its importance in both spheres that the discovery of photography was made almost simultaneously by a scientist (William Henry Fox Talbot) and a painter (Louis-Jacques-Mandé Daguerre). The value of photography to scientific investigation can hardly be overemphasized, and Eadweard Muybridge's protocinematic studies of movement and Francis Galton's foundational work *Finger Prints* (1892) provide two significant early examples. Early photographs often look very painterly, and it is clear from some of Talbot's

images in *The Pencil of Nature*, for example, that photography was not seen in any sense as an alternative to traditional artistic media, but that in fact the photographer approached a subject very much as a painter would, making it a parallel artistic medium.

In the illustrated literary books of the nineteenth and twentieth centuries, artists began to work as full and equal partners with authors in creating books in which the imagery is related to, or independent of, the words to whatever extent desired. Prototypical in this regard are the illuminated books of William Blake, in which the poems and the drawings occupy a Möbius-like continuum of word and image, a quality we also find in so superficially dissimilar a book as Paul Eluard's *Facile* (1935), with photographic images by Man Ray. But the abstract images created by Sonia Delaunay to accompany Blaise Cendrars's poem about the trans-Siberian railway (1913) coexist with the text rather than complementing it directly, as do Jasper Johns's images for Samuel Beckett's *Foirades/Fizzles* (1976). Constructivist, Expressionist, and Futurist artists took differing approaches to making art that was meant to accompany a text, but neither Wassily Kandinsky nor Oskar Kokoschka nor Filippo Tommaso Marinetti would have thought it appropriate to consider text and image as separate aspects of an object, or to privilege one over the other.

Out of the modernist *livre de peintre* came the artist's book, in which the artist is frequently responsible both for the text and for the images and in which the very form of the book itself is queried, if not rejected outright. The books in this section by artists Ed Ruscha and others might easily have been issued as series or portfolios of photographs, but their realization in book form allows for some play and irony around the ideas of time and narrative. Sue Ann Robinson's *Chisholm Hours* ludically invites the medieval book of hours to a rodeo and would not exist but for its model's formalities. Katherine Ng's "book," by contrast, is hardly a book, although there is no reason why the text in a fortune cookie should be any less seductive than the text of a private prayer book. The former, after all, is now far more prevalent than the latter, in Los Angeles as elsewhere in North America. *B.W.*

74

ROBERTUS VALTURIUS
De re militari
Verona: Johannes Nicolai, 1472
13¹³/₁₆ x 9⁹/₁₆ in. (35.1 x 24.3 cm)
The Huntington Library, San Marino,
California (RB 105187)

75

CLAUDIUS PTOLEMAEUS
Cosmographia (Geographia)
Edited by Nicolaus Germanus;
translated by Jacobus Angelus
Ulm: Lienhart Holle, 1482
17¹/₄ x 13¹⁵/₁₆ in. (43.8 x 35.4 cm)
The Huntington Library, San Marino,
California (RB 105406)

One of the oldest and most beautiful incunable atlases is the woodcut edition of Ptolemy's *Geographia* (originally incorrectly translated as *Cosmographia*), published in Ulm (Germany) in 1482. Earlier examples of manuscripts and prints from engraved copper plates of Ptolemy's maps exist, but the Ulm Ptolemy of 1482 is the first of several world atlases from woodblocks published north of the Alps.

Claudius Ptolemaeus, or Ptolemy (as he is known to us), was Greek-speaking and lived in Alexandria (Egypt) in the second century A.D. He was a mathematician and astronomer and is remembered for perpetuating the (earlier) geocentric theory of the universe. His later work was in cartography, however, and he is credited with devising projections specifically for terrestrial maps, as previously they had been used for astronomy. His first projection (Ptolemy I) was coniclike, and his second (Ptolemy II), preferred by Ptolemy, was cloak-shaped (*chlamys*). The latter projection was the one used for the world map in the Ulm and other Ptolemaic atlases.

In addition to the map of the whole of the world known to the later Greeks, about a quarter of the globe, the atlas contains thirty-one regional maps: ten for Europe (plus four "modern" maps), four for Africa (the northern part, or "Libya"), and twelve for Asia (plus one "modern" map, of Palestine). For these Ptolemy used an isosceles trapezoidal projection. His world extended eastward from a prime meridian running through Madeira and the Canary (Fortunate) Islands to inland China, 0 to 180 degrees longitude, and from 25 degrees south latitude to 63 north latitude (with extensions). Latitude is expressed in degrees on the right-hand side of the maps, and by *climata* on the left. The equator and tropics of Cancer and Capricorn are plotted on the world map, and around the border are twelve wind "blowers," indicating direction.

The Huntington Library copy is hand-colored with dark blue for water bodies, brown for mountains, and yellow for lowlands (which are also sometimes left uncolored). It is not known whether Ptolemy made maps himself or if they were made later from his instructions.

The thirty-two maps, most of which are double-page spreads, include many place-names and are accompanied by a substantial text in Latin, previously translated from the Greek by Jacobus Angelus. The text, in eight chapters or books, includes a discussion of methods of constructing maps, lists of latitude and longitude, introductions to the maps, and a dedication by the editor, Nicolaus Germanus. He is shown presenting a volume to Pope Paul II in an engraving, which, like the capital letters of the chapter headings, is hand-colored.

As far as the delineation of the earth and its parts on the maps is concerned, understandably it is most recognizable around the margins of the Mediterranean Sea and less so elsewhere. Thus Sri Lanka (Taprobane) is exaggerated in size, and the Indian subcontinent is truncated. Only the interior of China, not its coastline, is mapped, and it may be inferred that it is not possible to reach the Indian Ocean from the Atlantic by sea. Unlike earlier Ptolemaic world maps, this one shows the Arctic islands, beyond the northerly neat line of the map, but very imperfectly. Ptolemy's world atlas was both the starting point for subsequent maps showing new overseas discoveries and the model against which they were measured during the European Renaissance.

The Huntington Library copy was once owned by Michael Wodhull (1740–1816) and was bound for him by Roger Payne in full leather. It features the Wodhull coat of arms in gold on the cover. As well as being a beautiful book, Ptolemy's *Geographia* is one of the most influential volumes in the history of printing. It is the only atlas corpus to have come down to us from the ancients, serving as an inspiration for all modern atlases.
Norman J. W. Thrower

References
Catalogue of Books Printed in the Fifteenth Century Now in the British Museum (London: British Museum, 1908–), vol. 2, no. 538; Frederick R. Goff, *Incunabula in American Libraries: A Third Census* (New York: Bibliographical Society of America, 1964), no. P-1084.

Bibliography
Leo Bagrow, *History of Cartography*, rev. and enlarged by R. A. Skelton, trans. D. A. Paisey (Cambridge: Harvard University Press, 1966); O. A. W. Dilke, *Greek and Roman Maps* (London: Thames and Hudson, 1985); Tony Campbell, *The Earliest Printed Maps, 1472–1500* (Berkeley and Los Angeles: University of California Press, 1987).

76

STEPHAN FRIDOLIN

Schatzbehalter der wahren Reichtümer des Heils

Nuremberg: Anton Koberger, 1491
13⁷⁄₁₆ x 9⁵⁄₈ in. (34.1 x 24.5 cm)
Department of Special Collections,
Young Research Library, UCLA
(*A F91s)

77

HARTMANN SCHEDEL

Liber cronicarum

[Nuremberg: Anton Koberger, 1493]
18⅛ x 12½ in. (46 x 31.8 cm)
Libraries of the Claremont Colleges,
Denison Library, Scripps College

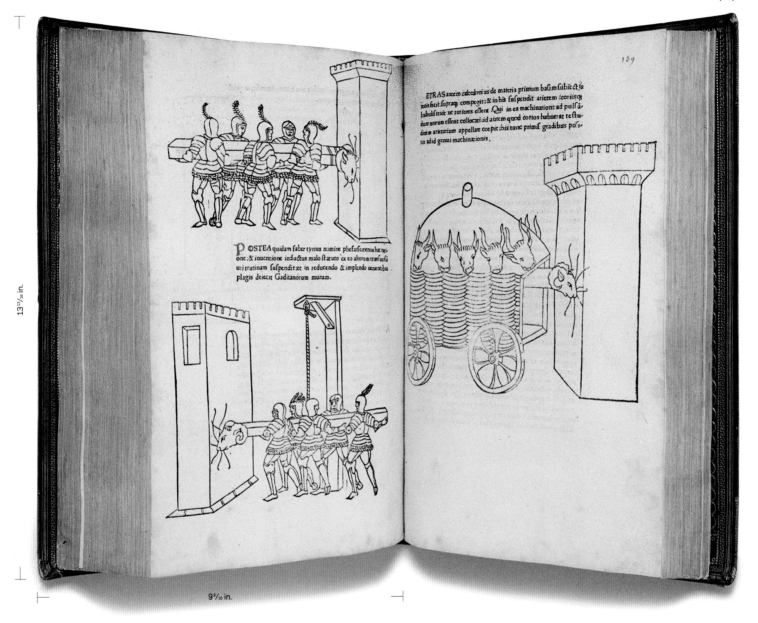

13¹³/₁₆ in.

9⁹/₁₆ in.

Robertus Valturius
De re militari, 1472

An important woodcut-illustrated book
on military science

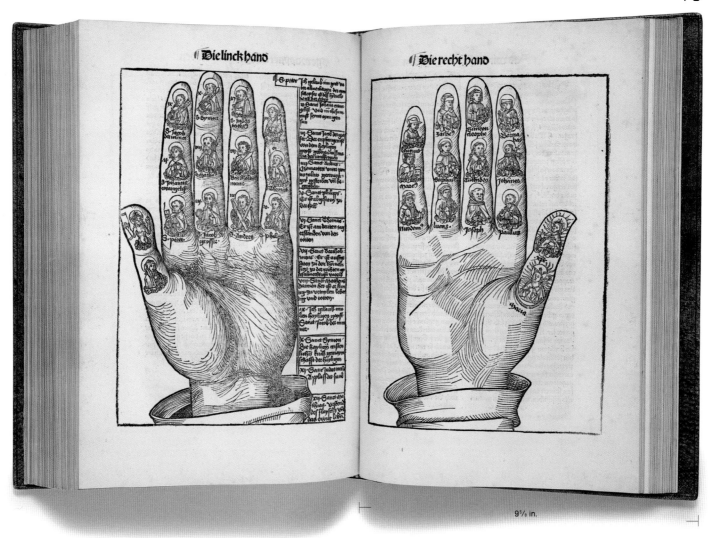

Stephan Fridolin
**Schatzbehalter der wahren
Reichtümer des Heils**, 1491

"The treasury of the riches of salvation,"
with woodcuts by Michael Wolgemut

76

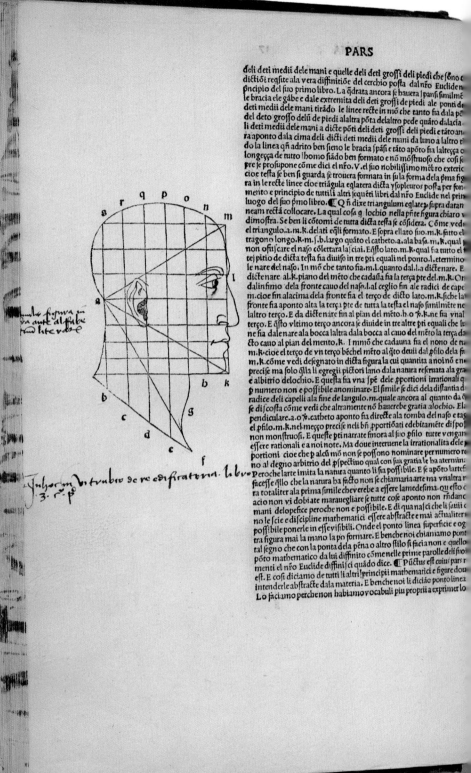

deli deti medii dele mani e quelle deli deti groffi deli piedi che fono t
dictiõi reqfite ala vera diffinitiõe del cerchio pofta dal nro Euclide ne
pncipio del fuo primo libro. La qdrata ancora fe hauera j panfi fimilmē
le bracia ele gãbe e dale extremita deli deti groffi de piedi ale ponti de
deti medii dele mani tirãdo le linee recte in mõ che tanto fia dala põ
del deto groffo delũ de piedi alaltra põta delaltro pede quãto dalacia.
li deti medii dele mani a dicte põti deli deti groffi deli piedi e tãto anc
ra aponto dala cima deli dicti deti medii dele mani da luno a laltro t
do la linea qñ adrito ben fieno le bracia fpãfi e tãto apõto fia la laltecca o
longecca de tutto lhomo fiãdo ben formato e nõ mõftruofo che cofi fo
pre fe profupone cõme dici el nro. V. el fuo nobiliffimo mētro exterio
cioe tefta fe ben fi guarda fe trouera formata in fu la forma dela pma fig
ra in le recte linee cioe triãgula eglatera dicta yfopleuros pofta per fon
mēto e principio de tutti li altri fequēti libri dal nro Euclide nel pri
luogo del fuo pmo libro. ¶ Q ñ dixe triangulum eglate fupra dat a n
neam rectã collocare. La qual cofa q lochio nella pñte figura chiaro ne
dimoftra. Se ben li cõtomi de tutta dicta tefta fe cõfidera. Cõme ved
el triangulo.a.m.k.delati egli formato. E fopra ellato fuo.m.k.fatto el
tragono longo.k.m.f.b.largo quãto el catheto.a.ala bafa.m.k.qual
non ofufcare el nafo cõlettara la fciai. Eñto lato.m.k.qual fia tutto el
tefpitio de dicta tefta fia diuifo in tre pti equali nel ponro.l.eterminc
le nare del nafo. In mõ che tanto fia.m.l.quanto dal.l.a dicte nare. E
dicte nare. al.k.piano del mēto che cadafia fia la terça pte del.m.k. Or
dalinfimo dela fronte cauo del nafo.l.al ceglio fin ale radici de capel
m.cioe fin alacima dela fronte fia el terço de dicto lato.m.k.fiche la
fronte fia aponto alta la terça pte de tutta la tefta el nafo fimilmēte ne
laltro terço. E da dicte nare fin al pian del mēto.b.o.k.ne fia vnal
terço. E ñto vltimo terço ancora fe diuide in tre altre pti equali che lu
ne fia dale nare ala bocca laltra dala bocca al cauo del mēto la terça da
cto cauo al pian del mento.k. In mõ che cadauna fia el nono de n a
m.k.cioe el terço de vn terço bechel mēto al ñto deuii dal pfilo dela fa
m.k.cõme vedi defegnato in dicta figura la cui quantita a noi nõ e n e
precife ma folo ñla li egregii pictori lano dala natura referuata ala g ra
e albitrio delochio. E quefta fia vna fpē dele pportioni irrationali q
p numero non e poffibile anominare. El fimile fe dici dela diftantia d
radice deli capelli ala fine de langulo.m.quale ancora al quanto da ñ
fe difcofta cõme vedi che altramēte nõ hauerebe gratia alochio. El a
pendiculare.a.o.ñ.catheto aponto fia directe ala tomba del nafo e tag
el pfilo.m.k.nel meçço precife neli bñ pportiõati e debitamēte difpo
non monftruofi. E quefte pti narrate finora al fuo pfilo tutte vengan
effere rationali e a noi note. Ma doue interuene la irrationalita dele p
portioni cioe che p alcũ mõ non fe poffono nominare per numero r e
no al degno arbitrio del pfpectiuo qual con fua gratia fe ha aterminal
Peroche larte imita la natura quanto li fia poffibile. E fe apõto larte fi
faceffe ñllo che la natura ha facto non fe chiamaria arte ma vnaltra n
ra totaliter ala prima fimile cheuerebe a effere lamedefima. qu efto e ñ
acio non vi dobiate marauegliare fe tutte cofe aponto non rñdanc
mani delopefice peroche non e poffibile. E di qua nafci che li fauii c
no le fcie e difcipline mathematici effere abftracte e mai actualiter c
poffibile ponerle in effe vifibili. Onde el ponto linea fuperficie e og
tra figura mai la mano la po formare. E benche noi chiamamo pont
tal fegno che con la ponta dela pēna o altro ftilo fi facia non e quello
põto mathematico da lui diffinito cõme nelle prime parolle deli fuo
menti el nro Euclide diffini ci quãdo dice. ¶ Pũctus eft cuius pars n
eft. E cofi diciamo de tutti li altri principii mathematici e figure doui
intenderle abftracte dala materia. E benche noi dicião ponto linea
Lo faciamo perchenon habiamo vocabuli piu proprii a exprimer lo

cepti &c cetera. E questo basti quanto ala proportionale diuisione del pro
filo dela testa humana debitamente formata lasciando el supfluo ala gra
tia delopefice come la tomba del ceglio e ponta del naso benche dale na
re a dicta ponta comunamete li se dia el nono del profilo pur aponto no
scpo terminare con proportione a noi nota come de sopra del mento so
detto. I deo &c.

¶ Dela distantia del profilo al cotocco de dicta testa cioe al ponto . a . qi
chiamao cotocco edele pti che in quella se interpongano ochio e oregia.

Capitulo. II.

Etto del pfilo dela testa hūana e sue diuisioni in maiesta
requisite. Ora scquente diremo dele proportioi delochio
cede loregia. Onde acio se intendano dire prima diuida
remo la largeçça del proposto tetragono . s . k . similmente
in tre parti equali come de sua longeçça so sutto . E diuiso
m . s . in tre coi li luna fia . m . o . laltra . o . q . la terça . q . s . E poi
apiu chiara vostra notitia cadaũa de queste terçe diuideremo in doi par
ti equali neli ponti . n . p . r . E ciascuna depse fia la sexta parte de tutta dicta
largeçça . m . s . E queste ancora porremo subdiuidere in altre mita e serebo
no duodecime del tutto e queste tali ancora i altre doi equali pti e ogni
na seria la vigesimaquarta del tutto . E cosi porremmo andar quāto cipia
ci diuidendolo in parti note a noi secondo maggiore e minor largeçça.
E quante piu parti si fia note tanto fia piu comodo al pspectiuo pero che
meglio vene con lochio aprenhendere la quantita dela cosa che vol por
re o sia testa o sia che altra cosa seuolia come animali albori hedifitii &c.
E per questo li pictori se hano formato certo quadro o vero tetragono lo
go commolti sotili fili tirati de citera o seta o nenti grandi e picoli com
me alor pare in lopere che hano adisponere in tela taula o muro . Doue
sopra la propria forma ponendo detto tetragono equello ben fermato ch
non si possa per alcun modo crollare sralui ela cosa che intende retrare la
qual cosa medesimamente bisogna che la sia ben fermata secondo el sito
che la vol sare . E lui poi se a setta a sedereritto ingnochioni comme me
glio li pare stare acomodato e col suo diligente ochio guardando or ch
or la quella cosa considera li termini de quelli fili comme respondeno
per longo e largo sopra dicta cosa . E cosi loro con suo stilo lauanno se
gnando in foglio o altroue proportionando li quadreti de dicto tetra
gono per numero equantita maggiore o menore a quello e sbogando for
mano lor figure quali poi vestano dela gratia visuale . E questo tale in
strumento fia dicto da loro rete . Comme vedite qui in la testa del qua
le instrumento qui non curo poner altra forma peroche facil sia per le co
se dette sua aprehensione . Ora tomādo al nostro proposito dela testa tro
uarete lochio col desotto e sopra cilio dele palpetre comunamente essere
alto el sexto de tutto el profilo . m . k qualeno so curato con linee osusscar
lo ma voi con lo vostro sexto facilmente lo trouarete e altre tanto largo
Lorechia se ben guardate trouarete esser alta quanto la longheçça del na
so cioe el terço de dicto profilo . E largo vn sexto dela largheçça de detto
tetragono . m . s . ela magior sua ampieçça fia diametraliter sral cotoçço e
gobba del naso aponto super lo catheto . a . terminata desotto ala ponta
del naso e principio dela guancia . El collo fia li doi terçi de la dicta lar
gheçça . m . s . cioe quanto . o . s . e cosi responde la ponta del petto enodo de
la gola . Lo occiputo cioe amodo nostro lacicotola excede dicta larghe
ça adrieto per doi terçi del suo sexto cioe per vn nono de tutta . m . s . el uer
tice cioe la cima del capo excede la radice di capelli per lo sexto de dicta
m . s . in alteçça cioe fin al ponto . p . qual fia el suo meçço . Laltre parti
poi vanno degradando proportionalmente alor contorno dal . p . al . o .
n . m . ãgulo del tetragono dinãçe e cosi drieto dal dicto . p . al . q . r . s . cō qlla

E ii

78

LUCA PACIOLI
Divina proportione
Venice: A. Paganius Paganinus, 1509
With illustrations based on drawings
by Leonardo da Vinci
12⁵/₁₆ x 8¹³/₁₆ in. (31.3 x 22.4 cm)
Library, Getty Research Institute
(84-B9582)

Fra Luca Pacioli's *Divina proportione* (Divine proportion)—written in 1497, published in 1509—ranks as one of the great books of the Italian Renaissance, both for its advanced mathematical content and for the beauty of its conception. Most notably, its fifty-nine woodcut illustrations of complex geometrical solids were copied from prototype drawings provided by Pacioli's close friend Leonardo da Vinci. The five regular bodies (tetrahedron, hexahedron, octahedron, dodecahedron, and icosahedron) were illustrated both in solid form and, more important, in transparent, skeletal form, thus effectively demonstrating their complete spatial configuration. The influence of these illustrations on future treatises on perspective and geometry was profound and pervasive.

As Martin Kemp has explained: "For Pacioli the interest of the solids extended far beyond the realms of pure geometry. Plato had regarded the five regular bodies . . . as the archetypal forms of the elements and the quintessence from which the cosmos was constructed. Pacioli allied this cosmological geometry with the 'divine' harmony of the golden section."[1] For Renaissance Platonists like Pacioli (d. c. 1514) and Leonardo, nature conformed to an underlying system of divine proportion, and harmonic beauty rested firmly upon a foundation of mathematics. Pacioli, like Plato, believed that the regular solids were the fundamental components of the universe and that familiarity with them was essential for all educated people, particularly architects, painters, and musicians. In fact, the influence of artists such as Leonardo and Piero della Francesca on Pacioli's analyses of the regular solids should not be underestimated, and Pacioli in turn had a profound influence on Leonardo. *Divina proportione* should be understood, then, as an aesthetic and intellectual collaboration between two great men who met in the 1490s in Milan, where both enjoyed the enlightened patronage of Duke Ludovico Sforza.

In the introduction to *Divina proportione*, Pacioli generously acknowledges Leonardo's contribution to his book, referring to the artist's illustrations as having been "made and formed by the ineffable left hand" of the "most worthy of painters, perspectivists, architects, and musicians, one endowed with every perfection."[2] He goes on to praise Leonardo's recently painted *Last Supper* in the refectory of Santa Maria delle Grazie, and his famous, subsequently destroyed model for the equestrian monument of Duke Ludovico.

Pacioli himself designed the twenty-three elegant classical letters of the alphabet, printed one to a page, which also appear in *Divina proportione*.

Their construction is based upon mathematical principles used to establish ideal proportions. Pacioli's commentary on the letters lays out his guiding principles, although in at least one case, for the letter *O*, he merely exclaims enthusiastically, "Questo O e perfectissimo" (This *O* is most perfect).

Three manuscript originals of *Divina proportione* are known to have been made, although only two survive. Of these, one (now in Geneva) was dedicated to Ludovico Sforza, the other (now in Milan), dated 1498, to Giangaleazzo Severino. The printed edition of 1509 (the book's only edition) was dedicated to Piero di Tommaso Soderini, then ruler of Florence, to whom the one lost manuscript was also dedicated. Two additional texts were added to the printed version: a translation into the vernacular of Piero della Francesca's *Libellus de quinque corporibus regularibus* (Book of the five regular bodies), its actual authorship unacknowledged by Pacioli; and an architectural treatise by Pacioli himself, *Tractato del architectura*.

The Getty Research Institute's copy of *Divina proportione*, acquired in 1983, came from the art library of the well-known bibliographer and Voltaire scholar Theodore Besterman. At the Research Institute, it forms part of an encyclopedic collection of early treatises essential to the theory and production of art and architecture, ranging in date from the fifteenth to the eighteenth century.
Kevin Salatino

References
David E. Smith, *Rara arithmetica: A Catalogue of the Arithmetics Written before the Year MDCI* (Boston: Ginn, 1908), no. 87; Margaret B. Stillwell, *Incunabula in American Libraries: A Second Census of Fifteenth-Century Books Owned in the United States, Mexico, and Canada* (New York: Bibliographical Society of America, 1940), no. 202; *Catalogue of Books and Manuscripts*, compiled by Ruth Mortimer under the supervision of Philip Hofer and William A. Jackson, pt. 2, *Italian Sixteenth-Century Books* (Cambridge: Belknap Press of Harvard University Press, 1964), no. 346; Herbert M. Adams, *Catalogue of Books Printed on the Continent of Europe, 1501–1600, in Cambridge Libraries* (London: Cambridge University Press, 1967), no. P7; Max Sander, *Le livre à figures italien depuis 1467 jusqu'à 1530: Essai de sa bibliographie et de son histoire* (Nendeln: Kraus Reprint, 1969), no. 5365/6.

79

ALBRECHT DÜRER

Underweysung der Messung

Nuremberg: H. Andreas Formschneider, 1525
12 x 8½ in. (30.5 x 21.6 cm)
Library, Getty Research Institute
(84-B7142)

80

CAMILLO AGRIPPA

Trattato di scientia d'arme

Rome: Antonio Blado, 1553
9³/₁₆ x 6¹³/₁₆ in. (23.3 x 17.3 cm)
William Andrews Clark Memorial Library,
UCLA (*U860 A827)

81

JOHN HEYWOOD

The Spider and the Flie

London: Tho. Powell, 1556
7¹⁵/₁₆ x 5¹⁵/₁₆ in. (20.2 x 15.1 cm)
William Andrews Clark Memorial Library,
UCLA (*PR2564 S71)

Bibliography
Paolo Portoghesi, "Luca Pacioli e la *Divina proportione*," *Civiltà delle macchine* 5 (1957); 21–28; Martin Kemp, *Leonardo da Vinci: The Marvellous Works of Nature and Man* (Cambridge: Harvard University Press, 1981); idem, in *Circa 1492: Art in the Age of Exploration* (Washington, D.C.: National Gallery of Art, 1991), 242–45, nos. 142, 143; Enrico Giusti and Carlo Maccagni, eds., *Luca Pacioli e la matematica del Rinascimento* (Florence: Giunti, 1994).

Notes
1. Kemp, in *Circa 1492*, 244.
2. Quoted in Kemp, *Leonardo da Vinci*, 149.

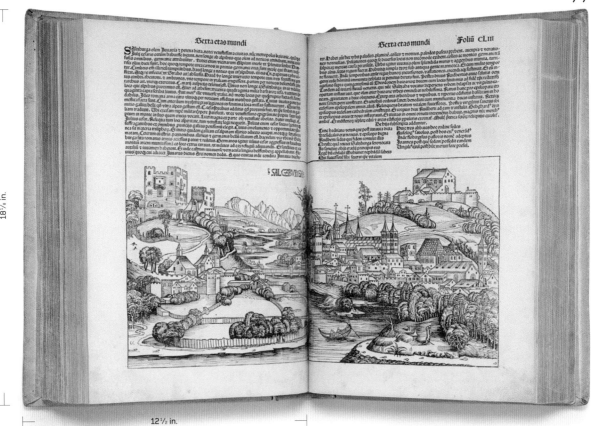

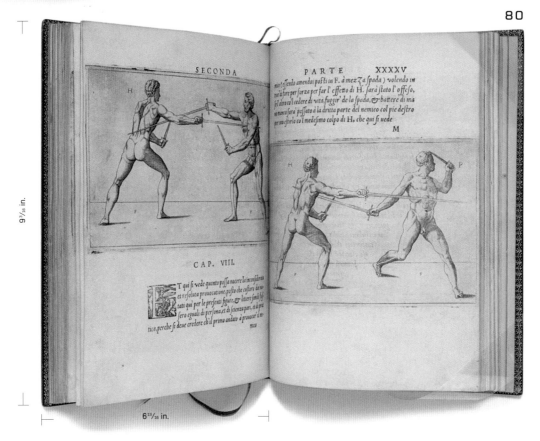

Hartmann Schedel
Liber cronicarum, 1493

A history of the world, famous for its
woodcut illustrations of cities and people

Camillo Agrippa
Trattato di scientia d'arme, 1553

A manual about sword fighting

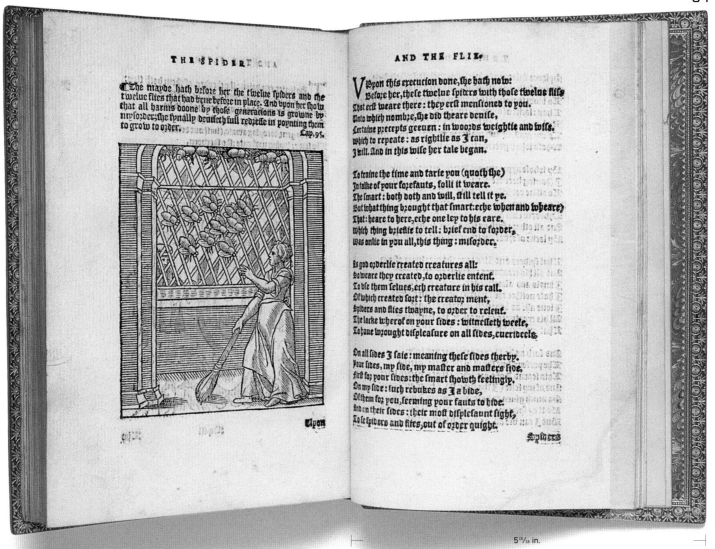

7 15/16 in.

5 15/16 in.

John Heywood
The Spider and the Flie, 1556

An allegorical poem in which the Catholic
Queen Mary is described as sweeping out the
cobwebs of Protestantism

82
Schempart Buech

Nuremberg, c. 1600
Illuminated manuscript; 116 leaves;
14⅝ x 9½ in. (37.2 x 24.1 cm)
Department of Special Collections,
Young Research Library, UCLA (*170.351)

More than seventy Schembart Books record the fifteenth- and sixteenth-century carnival festivals in Nuremberg. As illuminated manuscripts, the books are unusual because they were produced in substantial numbers in the century after the invention of printing. Nuremberg is noted for its early printed books, especially Hartmann Schedel's impressive Nuremberg Chronicle of 1493 (cat. no. 77); yet, parallel to printed editions, artists in Nuremberg continued to produce illuminated manuscripts as commissions for wealthy families. The Schembart Books used a traditional format to chronicle the city's carnivals from 1449 to 1539.

The Schembart (sometimes called Schoenbart) carnival was one of the precursors of the Mardi Gras festival in New Orleans and, more generally, of festivities like the Rose Parade on New Year's Day in Pasadena. It was an early springtime celebration that began as a dance held by the butcher's guild. According to this and other manuscripts, the Schembart carnival took place at least sixty-four times from 1449 to 1539 during Shrovetide, the three days preceding Ash Wednesday and the Lenten fasts. Unlike the elite entertainments planned for Renaissance court festivals, the Schembart was a popular event. All classes and professions came together to celebrate the solidarity of the city and to acknowledge its leading citizens. The carnival took place during years of extraordinary prosperity in Nuremberg, when civic pride in humanistic achievements and artistic productions was at its height. The artists Michael Wolgemut and Albrecht Dürer and the poet Hans Sachs were all active in this period, and the people of Nuremberg invested extraordinary energy in producing books and manuscripts on their history and accomplishments.

With focus on the elaborate decorative arts and festive costumes made possible by the support of the patrician families, the illuminations show the people of Nuremberg at leisure, shooting off fireworks, dancing, and playing practical jokes. The manuscript features full-length depictions of the costumes worn by the festival captains, with their names and historical notes at left and the *Läufer* with heraldic devices on the right. The *Läufer*, or runners, were members of well-known families, but these are not portraits because all wear masks. Indeed the name of this festival comes from the masks, or *Schemen*, although they are not bearded, as the suffix *-bart* would seem to indicate. Each year the *Läufer* wore distinctive, newly designed costumes made of rich fabrics decorated with gold and silver embroidery, feathers or fur, and bells that jingled as the men ran by. Most runners carried a pike and brandished the Schembart's characteristic gathering of leaves, from which fireworks exploded.

Wild men, fools, and acrobats cavorted in the streets, and everyone joined in the mock tournaments and circle dances. In the last years of the fifteenth century there were decorated floats on wheels or sleighs called *Hölle* (or hells), which were burned in the city square. The castles and fortresses built on the *Hölle* were a place for street spectacles: mock battles, fireworks, and *tableaux vivants* with extraordinary creatures like elephants. Grotesque monsters and fire-breathing dragons were often shown eating people. The illustration for the festival in 1539 depicts a ship of fools in the Nuremberg city square. Up in the crow's nest a fool plays a horn, a doctor examines a urine glass, and an astrologer looks at a quadrant. A figure playing the role of the famous Lutheran minister Osiander stands on board the ship. This blatant satire of a respected Nuremberg cleric was one of the final straws that ended the carnival for good. Although the festival ceased because of concerns about its rowdiness coincident with the Reformation climate in southern Germany, the Schembart Books continued to be produced in manuscript and printed editions through the twentieth century.

The coat of arms and engraved portrait pasted inside the front cover of this manuscript identify it as having belonged to Sebastian Schedel. Like his namesake Hartmann Schedel, he was a doctor. This manuscript was formerly in the Liechtenstein collection and was acquired from the dealer H. P. Kraus by UCLA in 1961 as a gift from the Kress Foundation.
Marcia Reed

83
JOHN STALKER
A Treatise of Japaning and Varnishing

Oxford: For the author, 1688
15⅛ x 9⁹⁄₁₆ in. (38.4 x 23 cm)
William Andrews Clark Memorial Library,
UCLA (*fTP938.S78)

References
Mirella Ferrari, *Medieval and Renaissance Manuscripts at the University of California, Los Angeles*, ed. R. H. Rouse (Berkeley and Los Angeles: University of California Press, 1991), 147.

Bibliography
Samuel L. Sumberg, *The Nuremberg Schembart Carnival* (New York: Columbia University Press, 1941); Hans-Ulrich Roller, *Der Nürnberger Schembartlauf* (Tübingen: Tübinger Vereinigung für Volkskunde, 1965); Keith Moxey, *Peasants, Warriors, and Wives: Popular Imagery in the Reformation* (Chicago: University of Chicago Press, 1989), 14–15.

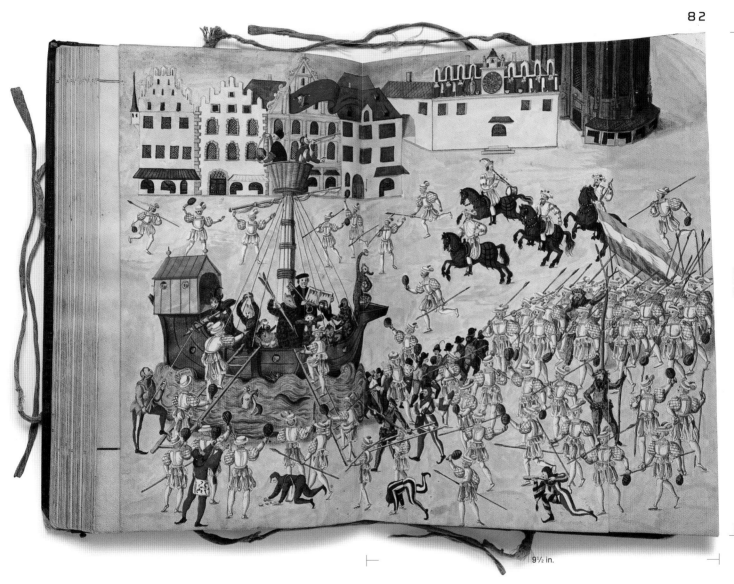

14⁵/₈ in.

9¹/₂ in.

Schempart Buech, c. 1600 A manuscript illustrating the Nuremberg carnival

84

JOHN JOHNSTON

A Description of the Nature of Four-Footed Beasts

London: Moses Pitt, 1678
14¹⁵/₁₆ x 9³/₈ in. (37.9 x 23.8 cm)
Research Library, Natural History Museum
of Los Angeles County

85

EDWARD TYSON

Orang-Outang, sive Homo Sylvestris; or, The Anatomy of a Pygmie

London: Thomas Bennet and Daniel Brown, 1699
11³/₁₆ x 9³/₁₆ in. (28.4 x 23.3 cm)
History & Special Collections,
Louise Darling Biomedical Library,
UCLA (WZ 250 T987o 1699 Rare)

86

WILLIAM HAMILTON

Campi Phlegraei: Observations on the Volcanos of the Two Sicilies

Naples, 1776
Illustrated by Pietro Fabris
18⁷/₁₆ x 13³/₁₆ in. (46.8 x 33.5 cm)
Libraries of the Claremont Colleges,
Seeley G. Mudd Science Library,
Pomona College (551.21 H18)

The Campi Phlegraei are the "fiery fields" in the volcanic region from Naples to the west in the ancient area of Cumae. From the times of the first Greek colonists and ancient Roman tourists, the picturesque region has been a legendary place that is thought by some to be the origin of the mythic Elysian Fields. Pliny the Elder commanded a fleet in the Bay of Naples and perished in the volcanic eruptions of August A.D. 79. In the eighteenth century travelers on the Grand Tour came to Naples to see the ruins of the ancient cities of Herculaneum and Pompeii, buried in the Vesuvian explosions. As they admired the exotic landscape, hot springs, and tufa (crumbly, dark gray ash) in the region dominated by the towering silhouette of Mount Vesuvius, the visitors collected rocks, shells, and antique shards found along the paths that followed the flow of lava.

The views of Naples and the volcano in these volumes were sketched by the English painter Pietro Fabris on commission from Sir William Hamilton (1730–1803), who was the British ambassador to Naples from 1764 to 1800. For visitors to Naples, Sir William served as a genteel host and knowledgeable cicerone on the antiquities and natural history of the region. He was well known for his fascination with Vesuvius; his friend Horace Walpole called him the "Professor of Volcanoes." The texts of the Campi Phlegraei are Hamilton's detailed descriptions of the eruptions of Vesuvius, written for presentation to the Royal Society in London. They are drawn from his firsthand observations and convey a precise idea of the volcano and its effects on the land and its history. During the early phases of eruptions, he made frequent trips to the volcano, spending entire days and nights in order to get as close as

possible, making notes documenting his observations of the spectacular explosions. His observations were initially published separately and remain part of the extensive literature on the history and science of volcanoes.

Campi Phlegraei was part of a campaign undertaken by the king of Naples and Hamilton to promote Naples as a "little Rome," well worth a visit by travelers on the Grand Tour. The nine-volume Antichità di Ercolano (1755–92), sponsored by the Neapolitan Academy, and Hamilton's vase books publicized the region as an important locale for antiquities, featuring the buried cities at Herculaneum and Pompeii. With lavish colored illustrations, these books were as luxurious as Giovanni Battista Piranesi's great folios of etchings on Rome.

The volcano was itself an emblem of Naples, expressing the dual modes of Vesuvius as an impressive natural phenomenon and a frightening primal force. Campi Phlegraei brings together the myths and magical qualities of the volcano, illustrating its beauty and its destructive violence. While Hamilton's writings are fundamentally scientific observations, the book retains elements of wonder and art. The National Geographic–style illustrations are framed and set off by gray backgrounds; they seem less like prints and more like miniature paintings that convey the true grandeur and sublime effects of Mount Vesuvius. Prior to Hamilton's Neapolitan publications, color was frequently seen in maps and views but only occasionally in books for travelers, usually in special editions. Hamilton recognized the value of dramatic, quasi-cinematic depictions in color. These prints of the Neapolitan landscape and its antiquities are the precursors of postcards and full-color guidebooks as well as the snapshots and videos of present-day tourists. Before photography, these books served as souvenirs of experiences in a foreign land and provided surrogates for the specimens collected to illustrate its natural history.
Marcia Reed

References
Edward Godfrey Cox, A Reference Guide to the Literature of Travel, Including Voyages, Geographical Descriptions, Adventures, Shipwrecks, and Expeditions (Seattle: University of Washington Press, 1935–49), vol. 1, no. 146; ESTC t71231.

Bibliography
Mark Cheetham, "The Taste for Phenomena: Mount Vesuvius and Transformations in Late Eighteenth-Century Landscape Depictions," Wallraf-Richartz-Jahrbuch 45 (1984): 131–44; Carlo Knight, "Sir William Hamilton's Campi Phlegraei and the Artistic Contribution of Peter Fabris," in Oxford, China, and Italy: Writings in Honour of Sir Harold Acton on His Eightieth Birthday, ed. Edward Chaney and Neil Ritchie (London: Thames and Hudson, 1984), 192–208; Ian Jenkins, Vases and Volcanoes: Sir William Hamilton and His Collection (London: British Museum, 1996).

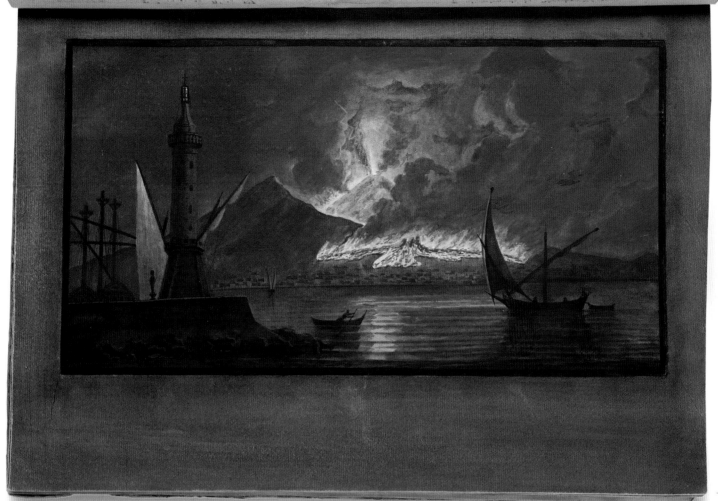

13³/₁₆ in.

18⁷/₁₆ in.

William Hamilton
**Campi Phlegraei: Observations
on the Volcanos of the Two Sicilies**, 1776

87

THOMAS BEWICK

A General History of Quadrupeds

Newcastle upon Tyne: S. Hodgson,
R. Beilby, & T. Bewick, 1790
$8^5/_{16}$ x $5^9/_{16}$ in. (21.1 x 14.1 cm)
University of Southern California,
Archival Research Center,
Hancock Collection (QL706.B5 1790)

88

JAMES BATEMAN

**The Orchidaceae of Mexico
and Guatemala**

London: John Ridgeway, for the author, 1843
$29^5/_8$ x $21^5/_8$ in. (75.3 x 54.9 cm)
Rancho Santa Ana Botanic
Garden Library (581.972.B178.3)

89

WILLIAM LEWIN

**"British Birds Eggs Painted
from the Portland Museum,"**

c. 1785
Manuscript text and watercolor drawings;
$11^{11}/_{16}$ x $9^7/_{16}$ in. (29.7 x 24 cm)
Los Angeles Public Library (598.22 L672)

90

WILLIAM LEWIN

The Birds of Great Britain with Their Eggs

London: For the author, 1789–94
$13^{11}/_{16}$ x $10^{13}/_{16}$ in. (34.8 x 27.5 cm)
Los Angeles Public Library
(598.2942 L672 folio)

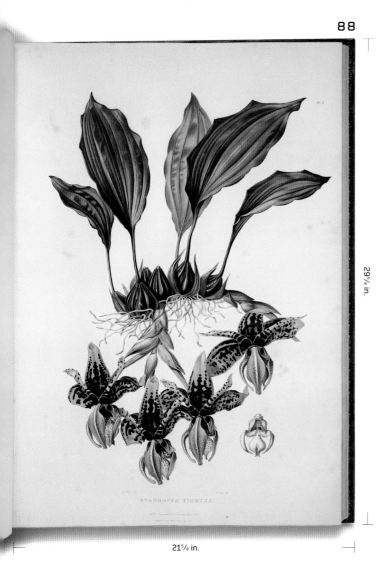

29⁵⁄₈ in.

21⁵⁄₈ in.

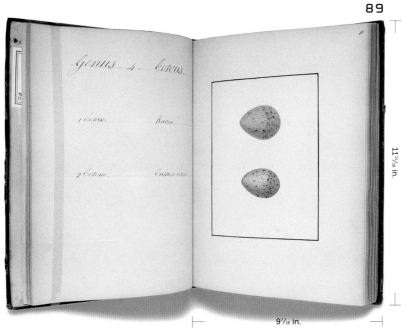

11¹¹⁄₁₆ in.

9⁷⁄₁₆ in.

James Bateman
The Orchidaceae of Mexico and Guatemala, 1843

William Lewin
**"British Birds Eggs Painted
from the Portland Museum,"** c. 1785

91

JOHN JAMES AUDUBON

The Birds of America: From Original Drawings

London: For the author, 1827–38
39 1/8 x 27 5/16 in. (99.4 x 69.4 cm)
University of Southern California,
Archival Research Center, Hancock Collection
(fffQL674.A9 1827)

By any standard, John James Audubon's *Birds of America* is one of the most remarkable achievements in publishing history. With 435 hand-colored aquatint engravings measuring 39 1/8 x 27 5/16 inches, the so-called double-elephant folio would have achieved bibliographic notoriety even if its contents had not been of such remarkable beauty, for the size of its plates pushed the very limits of nineteenth-century printing technology and set standards of quality in execution that have rarely been equaled. But the book's status ultimately derives more from the stunning originality of Audubon's vision than from its size or the consummate skill with which it was produced. Blending the best of science, art, and printmaking technology, the book has become one of the great landmarks in natural history publishing.

Audubon, who had achieved international acclaim as a naturalist and artist long before his death in 1851, began his life in Haiti in 1785 as the illegitimate son of a French sea captain named Jean Audubon (1744–1818) and a French chambermaid named Jeanne Rabine (1758–85). He spent his childhood in France, where he was adopted and raised by his father's wife, Anne Moynet Audubon (1756–1821). In 1803 he moved to America to avoid service in Napoleon's army, settling near Philadelphia, where his father had purchased a farm and a modest lead-mining operation. There he met his future wife, Lucy Bakewell (1787–1874), who would loyally support him through good times and bad for the rest of his life.

Audubon's early career was as erratic and unsuccessful as it was unfulfilling. He moved from place to place, mostly in the southeastern United States, trying to make a living in business while pursuing an increasingly consuming passion for the study and painting of birds. In 1810, in Louisville, Kentucky, he met the Scottish naturalist Alexander Wilson (1766–1813), who showed him the plates for his book *American Ornithology* (1808–25). Certain that he knew more about birds and that his own paintings were superior to Wilson's, Audubon determined that he would create a magnificent illustrated book of his own.

In 1824 Audubon traveled to Philadelphia to seek the support of the Academy of Natural Sciences in publishing *The Birds of America*. When his efforts were opposed by the academy's irascible vice president, George Ord (1781–1866), who had assisted Wilson with the writing and publication of *American Ornithology*, other members of the academy encouraged Audubon to pursue his ambitious dream by seeking support abroad.

With his burgeoning portfolio and letters of introduction from influential friends, Audubon traveled to Great Britain in 1826. He exhibited his work to great acclaim in Liverpool, Manchester, and Edinburgh. In Edinburgh he entered into an agreement with the engraver William H. Lizars (1788–1859) to make prints of his life-size paintings. A strike by Lizars's colorists the following year caused Audubon to move his project to the firm of Robert Havell & Sons in London. For the next eleven years, under Audubon's careful supervision, the huge plates were printed, hand-colored, and distributed to subscribers in "parts" of five.

Because the British copyright act of 1709 required that copies of all domestically published books be deposited gratis in nine officially designated libraries throughout Great Britain, Audubon decided to publish the plates and the text for his massive project separately, allowing the costly plates to be exempted from the deposition requirements. His five letterpress volumes, entitled *Ornithological Biography* (1831–39), written with help from the Scottish naturalist William MacGillivray (1796–1852), provided a personal and scientific context for Audubon's heroically scaled illustrations. *The Birds of America*, although started earlier, took three years longer to complete. The book ultimately included stunning, life-size portraits of some 1,065 individual birds.

Audubon's book was the largest of its kind ever published, but the edition was small and, at one thousand dollars per set, very expensive. To the author's dismay and financial hardship, fewer than 175 of the original 308 subscribers fulfilled their obligations. In the ensuing years, many of the original sets were broken up or lost. For this reason, it is estimated that today fewer than 134 full sets of the book exist intact. California is fortunate in having four of these sets (at the California Academy of Sciences, San Francisco; the California State Library, Sacramento; the Huntington Library, San Marino; and the University of Southern California, Los Angeles).

The copy exhibited in *The World from Here* was originally owned by the Boston philanthropist Thomas H. Perkins (1764–1854), who presented it to the Boston Natural History Society in 1840. Although the society had subscribed to a copy of its own in 1836, it accepted the Perkins gift (believed to be more complete and beautifully colored than its own) and sold its original copy, applying the proceeds to the purchase of other books of natural history. Facing financial difficulties a century later, the society sold its Perkins copy of *The Birds of America* to the Allan Hancock Foundation Library of the University of Southern California in 1947.
Robert McCracken Peck

References
Jean Anker, *Bird Books and Bird Art* (Copenhagen: Levin and Munksgaard, 1938), 77–78, 94–95; Claus Nissen, *Die illustrierten Vogelbücher: Ihre Geschichte und Bibliographie* (Stuttgart: Hiersemann, 1953), 59–60, 85–86; Sacheverell Sitwell, Handasyde Buchanan, and James Fisher, *Fine Bird Books, 1700–1900*, rev. ed. (New York: Atlantic Monthly Press, 1990), 22–28, 73–74.

Bibliography
Francis Hobart Herrick, *Audubon the Naturalist: A History of His Life and Time*, 2 vols. (New York and London: D. Appleton & Co., 1917; reprint, New York: Dover Publications, 1968); Waldemar H. Fries, *The Double Elephant Folio: The Story of Audubon's "Birds of America"* (Chicago: American Library Association, 1973); Alice Ford, *John James Audubon: A Biography* (New York: Abbeville Press, 1988); Annette Blaugrund and Theodore E. Stebbins Jr., eds., *John James Audubon: The Watercolors for "The Birds of America"* (New York: Villard Books; New York Historical Society, 1993); Ron Tyler, *Audubon's Great National Work: The Royal Octavo Edition of "The Birds of America"* (Austin: University of Texas Press, 1993).

John James Audubon
**The Birds of America: From Original
Drawings**, 1827–38

The double-elephant folio edition,
with life-size illustrations

92

W. VINCENT LEGGE

A History of the Birds of Ceylon

London: For the author, 1880
Illustrated with hand-colored lithographs
by John Gerrard Keulemans
14⁵/₁₆ x 10⁷/₈ in. (35.9 x 27.6 cm)
Research Library, Natural History Museum
of Los Angeles County (QL 691.572 L44 1878)

During the nineteenth century the European colonial powers fanned out across the world, sending sons and daughters to far-flung outposts. For some it was the perfect opportunity to pursue an avid interest in natural history, be it birds, butterflies, reptiles, mammals, or plants. British colonials in particular, coming from a long tradition that found natural history to be an acceptable gentlemanly activity, combined avocation with vocation. In addition to doing the work of the nation, they observed, collected, and catalogued the exotic flora and the fauna around them on the side. They did their jobs in a competent way, but they are remembered chiefly for their contributions to natural history. Sometimes they published their findings. Many of the works published were fairly quotidian, but others took advantage of England's flourishing book trade, which had the means to produce fine natural history works, illustrated with detailed hand-colored lithographs. The work discussed here is a product of both of these traditions.

William Vincent Legge (1841–1918) was born in Tasmania and educated in England. By profession, he was an officer in the Royal Artillery and was stationed in a variety of British colonial outposts. A biographical entry for him on the World Wide Web says it all: "Ornithologist and Soldier."[1] From 1869 to 1877 he was stationed in Ceylon, where he pursued both his soldiering vocation and his ornithological avocation. He decided to produce a guide to the birds of Ceylon and, using methods not available to amateurs today, collected birds from all over the island and documented their habits and life histories. In 1877 he returned to England, where he published the work himself, commissioning one of the most experienced bird artists of the period, John Gerrard Keulemans, to execute the artwork.

Keulemans (1842–1912) was born in Rotterdam, but he spent most of his professional career as a natural history artist and lithographer in England. As Christine Jackson has noted, "Any author of a bird-book between 1870 and 1900 requiring an illustrator almost automatically thought first of Keulemans."[2] An artist who could draw both on paper and on stone, Keulemans frequently worked directly from specimens and transferred the images to stone. He supervised the coloring of the lithographs and consistently created high-quality, accurate images, arranged attractively in a natural habitat.

It is known for sure that Keulemans made the majority of the lithographs for Legge's *A History of the Birds of Ceylon* because he signed his lithographs. The Natural History Museum of Los Angeles County also owns the original watercolors for the book (not in the exhibition), and attributing those to him is more problematic. They are not signed by him, and most extant Keulemans originals are signed. Upon examination, they appear in most instances to be the models for the lithographs, but there are obvious as well as subtle differences. Consultations with a variety of experts elicited a variety of opinions. To an ornithologist the originals appear a little amateurish and slightly wrong— a beak too big, an eye too oval. These errors have been corrected in the lithographs, which show a sophistication of execution and an understanding of bird anatomy and behavior. Keulemans's great-grandson said that it is possible the watercolors were painted by Keulemans but are "patterns," or sketches roughly and quickly done to provide a guide for the colorists.[3] The other possibility is that the author painted them himself or had a local artist create them in the field. Whoever made them, they were prized by their owner, who bound them, along with their typescript descriptions, in full deep green crushed morocco with ornamental gilt panels, broad gilt side borders, and gilt emblematic tooling on the spine. Given the way it is bound, it is not too much of a stretch to suppose that it was the property of the author.

The two works together provide insight into both nineteenth-century book production and nineteenth-century natural history. The printed work is rare in itself, having been distributed to the 247 people named in the subscribers' list, and the typescript with original watercolors is of course unique.

The manuscript in typescript was purchased by the Natural History Museum through the good offices of Ed N. Harrison, founder of the Western Foundation for Vertebrate Zoology and member of the museum's board of governors, in 1974. The printed work was purchased in 1983 as a companion to the manuscript. *Katharine E. S. Donahue*

93

LOUIS-JACQUES-MANDÉ DAGUERRE

Historique et description des procédés du daguerréotype et du diorama

Paris: Susse Frères, 1839
8 x 5¼ in. (20.3 x 13.3 cm)
University of Southern California,
Archival Research Center,
Special Collections (770 D128H)

References
Casey A. Wood, *An Introduction to the Literature of Vertebrate Zoology* (London: Oxford University Press; H. Milford, 1931), 430; Jean Anker, *Bird Books and Bird Art* (Copenhagen: Levin and Munksgaard, 1938), 154; Claus Nissen, *Die illustrierten Vogelbücher: Ihre Geschichte und Bibliographie* (Stuttgart: Hiersemann, 1953); Sacheverell Sitwell, Handasyde Buchanan, and James Fisher, *Fine Bird Books, 1700–1900*, rev. ed. (New York: Atlantic Monthly Press, 1990), 115.

Bibliography
E. M. Dollery, "Legge, William Vincent (1841–1918), Soldier and Scientist," in *Australian Dictionary of Biography*, ed. Douglas Pike, vol. 5 (Melbourne: Melbourne University Press, 1974), 78; Tony Keulemans and Jan Coldewey, *Feathers to Brush: The Victorian Bird Artist John Gerrard Keulemans, 1842–1912* (Epse, the Netherlands: Privately published, 1982).

Notes
1. Bright Sparcs, biographical entry, at http://www.asap.unimelb.edu.au/bsparcs/biogs/P000122b.htm.
2. Christine Jackson, *Bird Illustrators: Some Artists in Early Lithography* (London: Witherby, 1975).
3. Dr. Tony Keulemans, correspondence with author, 6 October 2000.

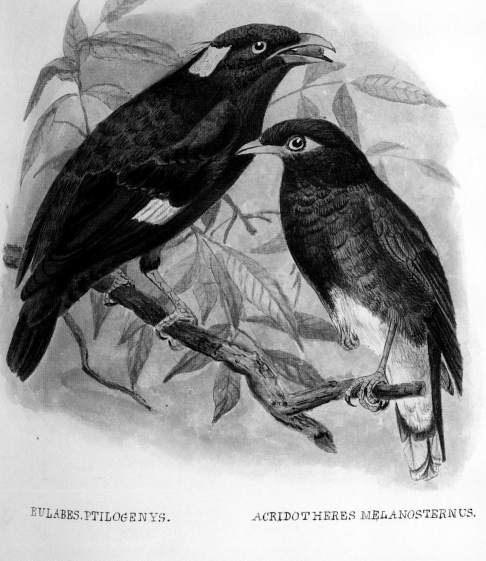

EULABES. PTILOGENYS. ACRIDOTHERES MELANOSTERNUS.

14⁵/₁₆ in.

10⅞ in.

W. Vincent Legge
A History of the Birds of Ceylon, 1880

94

WILLIAM HENRY FOX TALBOT

The Pencil of Nature

London: Longman, Brown, Green, and Longmans, 1844
Salted-paper prints from calotype negatives;
plate 6 (doorway with broom): 5^7/$_{16}$ x 7^5/$_8$ in.
(13.8 x 19.4 cm); plate 20 (lace): 6^{13}/$_{16}$ x 8^{11}/$_{16}$ in.
(17.3 x 22.1 cm); p. 1 ("A Brief Historical Sketch of the
Invention of Art"): 9^3/$_4$ x 12^1/$_4$ in. (24.8 x 31.1 cm)
Seaver Center for Western History Research,
Natural History Museum of Los Angeles County
(A.4100-1, A.4100-6, A.4100-20)

Given its singular importance, it is a shame that William Henry Fox Talbot's *Pencil of Nature* is not the first book illustrated by photography. Only a few months before Talbot's work began its two-year serialization, the *Record of the Death of C. M. W.* was published with a salted-paper print of the deceased as frontispiece, making it technically the earliest photographically illustrated publication.

Still *The Pencil of Nature* is a scarce and highly prized publication consisting of six fascicles or installments, each issued with from three to seven salted-paper, or "Talbotype," prints, printed from paper, or "calotype," negatives, and printed out at the Talbotype Establishment in Reading, England. The installments were issued between June 24, 1844, and April 23, 1846. As a set it usually contains, in letterpress, Talbot's introduction, an essay on how he invented his version of photography, and a short descriptive essay for each of the twenty-four prints. Eighty-one distinct holdings, including this copy and thirty-nine other substantially complete sets, have been located in sixty-two collections.[1] Not all the plates are identical in each set since slightly different negatives of the same subject were sometimes used by the printers.[2] Talbot planned to publish four to six additional installments but did not.

A skilled etymologist, crystallographer, chemist, astronomer, physicist, politician, and a specialist in Assyrian cuneiform inscriptions, Talbot (1800–1877) was a complete failure as a draftsman and artist. Nonetheless, transfixed by the transient "fairy pictures" he saw on the focusing glass of his portable drawing aid, a *camera obscura*, he wondered "how charming it would be if it were possible to cause these natural images to imprint themselves durably, and remain fixed upon the paper."[3] He articulated the essential properties of photography as early as 1833 and achieved at least stabilized, if not fixed and permanent, images by the following year. By the time the daguerreotype process was made public in Paris in August 1839, Talbot had figured out how to fix his prints more permanently and had published a paper entitled "Some Account of the Art of Photogenic Drawing, or the Process by Which Natural Objects May Be Made to Delineate Themselves without the Aid of the Artist's Pencil."[4]

The Pencil of Nature is not a technical manual; rather, it might be best appreciated as an art theory of photography and a celebration of its potential. Nearly every application of photography that would ensue over the next 150 years is represented within the twenty-four plates and their essays. Even a highly improbable application of photography, considering the date, was predicted by Talbot. There are cityscapes of Paris; views of architectural monuments and pastoral settings; photographic inventories of library shelves and of crystal and china collections; images of statuary, prints, old master drawings, and early printing; a still life of fruit; a "positive" of a leaf made from a photogram of it that was in turn used as the "negative"; an actual photogram of a piece of lace; and three plates that are clear masterpieces of early photography.

About one of these masterpieces, his rustic view *The Haystack* (pl. 10), Talbot commented that photography "will enable us to introduce into our pictures a multitude of minute details which add to the truth and reality of the representation." *The Open Door* (pl. 6)—an elegantly composed arrangement of doorway, broom, and lantern—reminded Talbot that "a painter's eye will often be arrested where ordinary people see nothing remarkable."[5] And *The Ladder* (pl. 14), a rivetingly surreal image of three men, is included as an example of portraiture, "one of the most attractive subjects of photography." But these three men—one with a jacket and two in shirtsleeves, two standing with backs to the camera on a cobbled pavement, with one holding an upright of a ladder, and the third facing out an open second-story window and holding another upright of the ladder—are subjects of one of the more arcane and enigmatic "portraits" ever taken.

And then there is the prediction. In the text for *A Scene in a Library* (pl. 8), Talbot writes about photographing a darkened room with people in it using an invisible spectrum of light—he infers ultraviolet; we would presume infrared—and recording what the human eye could not see. He even considered that such a technique could provide a nice surprise twist to a modern novel, "for what a *dénouement* we should have, if we could suppose the secrets of the darkened chamber to be revealed by the testimony of the imprinted paper."
Robert A. Sobieszek

References
John Carter and Percy H. Muir, eds., *Printing and the Mind of Man: A Descriptive Catalogue Illustrating the Impact of Print on the Evolution of Western Civilization during Five Centuries* (London: Cassell and Company, 1967), no. 318; Larry J. Schaaf, "Henry Fox Talbot's *The Pencil of Nature*: A Revised Census of Original Copies," *History of Photography* 17 (winter 1993): 395, no 81.

Notes
1. Schaaf, "Henry Fox Talbot's *The Pencil of Nature*." The Seaver Center copy is unbound, lacks *Gate of Christchurch* (pl. 18), has extra mounted and unmounted plates, and was donated to the museum by Miss Matilda Talbot in 1936.
2. See Beaumont Newhall, introduction to William Henry Fox Talbot, *The Pencil of Nature* (New York: Da Capo Press, 1968), unpaginated; Hans P. Kraus Jr., *Sun Pictures*, cat. 3 (New York: Hans P. Kraus Jr., 1987), 60, no. 57b.
3. Talbot, "Brief Historical Sketch of the Invention of the Art," in *Pencil of Nature*, unpaginated.

4. Read before the Royal Society, 31 January 1839, and published by R. and J. E. Taylor, London, 1839.
5. For Talbot's variations on this image, see Hans P. Kraus Jr., *Sun Pictures*, cat. 5 (New York: Hans P. Kraus Jr., 1990), 25, nos. 17, 18.

95

EADWEARD MUYBRIDGE
**The Attitudes of Animals in Motion:
A Series of Photographs
Illustrating the Consecutive Positions
Assumed by Animals in Performing
Various Movements**
[San Francisco]: Muybridge, 1881
Album of albumen chronophotographic prints;
10 x 13¼ in. (25.4 x 33.7 cm)
Margaret Herrick Library, Academy of Motion
Picture Arts and Sciences

This privately published album of albumen chronophotographic prints was the direct result of an inspired collaboration between an industrialist and an artist, which began in 1872. It was also the indirect cause of their falling-out and subsequent lawsuits a decade later.

By 1872 Eadweard Muybridge (1830–1904) was establishing himself as a photographer, principally a landscapist, while working for the firm of Bradley and Rulofson in San Francisco. His grand, operatic album of albumen prints of the California wilderness, *Views of the Valley of the Yosemite, the Sierra Nevada Mountains, and the Mariposa Grove of Mammoth Trees*, would be published in that year and awarded a gold medal in Vienna the following year.[1]

In 1872 Leland Stanford (1824–93) was president of the Central Pacific Railroad, had been governor of California, and would later be a U.S. senator and found an eponymous university. Around this time Stanford, a serious horseman, was seeking to develop a theory of equine locomotion that could be the basis of a scientific method of horse training. In the spring of 1872 he commissioned Muybridge to document photographically the horse in motion.

Muybridge began to photograph Stanford's horses in Sacramento in 1872 and 1873. In 1874 he shot and killed his young wife's lover, was acquitted, and spent the next year photographing in Central America. He returned to Sacramento in 1876 and moved the enterprise to Stanford's Palo Alto "stock farm" the following year. New cameras and lenses were purchased, an "electro-shutter" was invented, and the use of cords and wires to trigger the shutters was perfected.

The result of these innovations was *The Horse in Motion*, copyrighted by Muybridge and published in San Francisco in 1878, a depiction of horses walking, trotting, cantering, and running in a series of six cards mounted with albumen prints, each print a grid of individual images illustrating from six to twelve different positions of the moving horse. Over the course of 1878 and 1879 Muybridge continued to photograph, increased the shutter's speed to 1/2000 of a second, invented the "zoöpraxiscope" (a variant of many nineteenth-century anticipations of Thomas Edison's and the Lumière brothers' experiments with motion pictures of the 1890s), and ultimately concluded *The Attitudes of Animals in Motion* in 1881.

Muybridge spent nearly a year printing, editing, mounting, rubber-stamping, and hand-captioning the 203 prints in the album, which was copyrighted in May 1881. The exact number of copies produced is not known; in some lists, at least six copies and one "proof" copy (with salted-paper instead of albumen prints) are cited, while Sotheby's recently claimed that "only two complete sets are known."[2]

Barely alluded to in the Muybridge literature, the pictorial sequencing of the album is remarkable; it is constructed like a storyboard for a documentary film in five acts. Part 1 establishes the context; four prints document the farm, the rancho, a camera with its electro-shutter, and the track where the horses were photographed. Part 2 is the argument of the project; nearly half of the album's plates show more than a dozen horses going through various gaits: Edgington walking, Gypsie cantering, Albany pacing, Phrynne L. running, Eros trotting and changing to running, and Frankie leaping are examples.[3] Part 3 ups the ante, as it were; horses for the most part disappear, and dogs, bulls, and cows are portrayed in various gaits; a man chases a goat while another walks a pig on a leash; Muybridge himself runs naked across the track; men leap, jump, box, wrestle, somersault, and balance; and Muybridge doffs his hat in greeting two scantily clad male gymnasts. Part 4, approximately one-quarter of the album's plates, includes foreshortened, sequential views of men running on foot and riding on horseback shot from angles of at most thirty degrees. Part 5 is a surprise: ten shots of a horse's skeleton, photographed against a dark background, and articulated to represent standing, running, trotting, galloping, leaping, and jumping.

The skeleton of the horse was actually purchased for a Dr. J. D. B. Stillman, who had been hired by Stanford to write and publish Muybridge's findings in a book of illustrations entitled *The Horse in Motion, as Shown by Instantaneous Photography*.[4] Stillman had shown Muybridge a title page that acknowledged the photographer's work, but in the published version the title page made no mention of Muybridge, and Stanford's preface simply referred to him as a "very skilled photographer." A series of lawsuits concerning authorship took place between 1882 and 1885, with Muybridge losing. His fame, and recognition for his role in the chronophotography of the horse, was assured a few years later, however, with the publication of his monumental eleven-volume set, *Animal Locomotion*.[5]
Robert A. Sobieszek

96

EADWEARD MUYBRIDGE
**Animal Locomotion: An Electro-
photographic Investigation
of Consecutive Phases of Animal
Movements, 1872–1885**
Philadelphia: University of Pennsylvania, 1887
Collotypes; 19⅜ x 24⅛ in. (49.2 x 61.3 cm)
University of Southern California, Archival Research
Center, Hancock Collection
(ffQP301.M8 1887)

97

FRANCIS GALTON
Finger Prints
London: Macmillan, 1892
8⅝ x 5⅜ in. (21.9 x 13.7 cm)
Los Angeles Public Library
(573.6 G181)

Notes
1. Most of the information in this entry comes from the pioneering work of Robert Bartlett Haas and the intrepid scholarship of Anita Ventura Mozley; see *Eadweard Muybridge: The Stanford Years, 1872–1882* (Palo Alto, Calif.: Stanford University, Department of Art, 1972). See also Robert Bartlett Haas, *Muybridge: Man in Motion* (Berkeley and Los Angeles: University of California Press, 1976).

2. For a list of copies in American collections that interestingly omits the Margaret Herrick Library's copy, see Gordon Hendricks, *Eadweard Muybridge: The Father of the Motion Picture* (New York: Grossman, 1975), 255–59. For the recent auction, see *Photographs*, Sotheby's, New York, sale 7518, 12 October 2000, lot 44, 34.
3. It is roughly at this point that the hand captioning of the prints stops in the Margaret Herrick Library's copy.
4. Boston: James R. Osgood and Co., 1882.
5. Philadelphia: University of Pennsylvania, 1887.

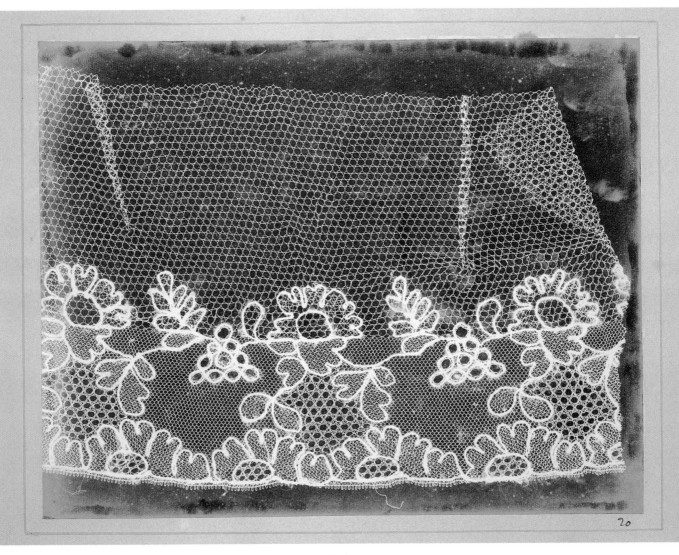

6¹³/₁₆ in.

8¹¹/₁₆ in.

William Henry Fox Talbot
The Pencil of Nature, 1844

One of the first printed books illustrated
with photographs

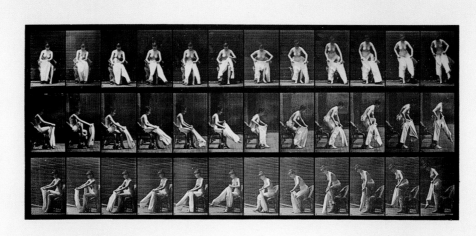

19³/₈ in.

24¹/₈ in.

10 in.

13¹/₄ in.

Eadweard Muybridge
**Animal Locomotion: An Electro-photographic
Investigation of Consecutive Phases of Animal
Movements**, 1887

Eadweard Muybridge
**The Attitudes of Animals in Motion:
A Series of Photographs Illustrating
the Consecutive Positions Assumed by Animals
in Performing Various Movements**, 1881

THE

BOOK

of

THEL

The Author & Printer Will.m Blake. 1789.

2

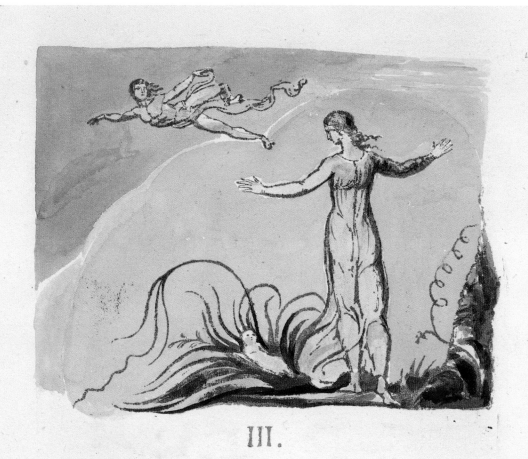

4

11⅛ in.

III.

Then Thel astonish'd view'd the Worm upon its dewy bed.

Art thou a Worm? image of weakness. art thou but a Worm?
I see thee like an infant wrapped in the Lillys leaf:
Ah weep not little voice. thou canst not speak. but thou canst weep;
Is this a Worm? I see thee lay helpless & naked: weeping,
And none to answer, none to cherish thee with mothers smiles.

The Clod of Clay heard the Worms voice, & raisd her pitying head:
She bowd over the weeping infant. and her life exhald
In milky fondness. then on Thel she fix'd her humble eyes.

O beauty of the vales of Har. we live not for ourselves.
Thou seest me the meanest thing. and so I am indeed;
My bosom of itself is cold. and of itself is dark,

But

6

9½ in.

William Blake
The Book of Thel, 1789

Blake wrote, illustrated, and printed this book

98

WILLIAM BLAKE

The Book of Thel

[London]: William Blake, 1789
Illustrated with etchings by Blake
11⅞ x 9½ in. (30.2 x 24.1 cm)
The Huntington Library, San Marino,
California (RB 57434)

In 1788 the artist, poet, and engraver William Blake (1757–1827) developed a method for etching in relief his words and pictures. Soon thereafter he began to use his invention to produce "illuminated books," such as *The Book of Thel*, which combine poems and designs of haunting power. Blake drew his pictures and wrote his texts directly on copper plates, etched away the surrounding metal, and, with his wife's help, printed them on his own rolling press. As Alexander Gilchrist was the first to declare, "never before surely was a man so literally the author of his own book."[1]

The eponymous heroine of *The Book of Thel*, a young shepherdess, is troubled by questions about the meaning of life and her own destiny. In her quest for knowledge she comes upon personifications of a lily, a cloud, a worm, and a clod of clay. These interlocutors accept their transience within the cycles of nature—directed, they believe, by a spiritual presence—and try to counsel Thel. The words of the "Lilly" are typical:

I am very small, and love to dwell in lowly vales;
So weak, the gilded butterfly scarce perches on my
* head.*
Yet, I am visited from heaven and he that smiles
* on all.*

On its eighth and final plate, the poem abruptly shifts from pastoral mildness to the horrific sublime as Thel confronts her own grave and hears a voice that echoes her fears, less of death than of embodiment and sexuality:

Why an Ear, a whirlpool fierce to draw creations in?
Why a Nostril wide inhaling terror trembling &
* affright.*
Why a tender curb upon the youthful burning boy!
Why a little curtain of flesh on the bed of our
* desire?*

Thel, "with a shriek," flees back to the protective "vales of Har," unable to confront the rigors of experience.

The accompanying illustrations depict Thel's encounters with nature's representatives and stress her position as an observer of life more than a participant. The title page is typical in this respect, with Thel standing on the left under a protective tree and watching the male and female forms of two flowers engaging in an activity poised ambiguously between pursuit and embrace. While the final section of the text describes innocence overwhelmed, the closing vignette, showing three children riding on and apparently controlling a giant snake, suggests a more harmonious conclusion. The composite visual-verbal art of *Thel* raises issues that have intrigued Blake's many modern interpreters, including the relationship of matter to spirit, the pleasures and the limits of the human senses, and the ways we interpret symbolic representations. These themes are epitomized by "Thel's Motto" on a prefatory plate:

Does the Eagle know what is in the pit?
Or wilt thou go ask the Mole:
Can Wisdom be put in a silver rod?
Or Love in a golden bowl?

The Huntington copy of *Thel* was produced in the book's first printing, in late 1789 or early 1790. Blake used delicate watercolor washes to tint the designs in all thirteen extant copies of this printing. He printed only three further known copies in later years. The copy exhibited was first owned by Thomas Butts, one of Blake's few loyal patrons; it was later in the collections of Francis Turner Palgrave and Frederick Locker-Lampson. Henry E. Huntington acquired the volume in May 1911, only a month after beginning to form his great collection of Blake's art and writings at the legendary Robert Hoe auction. *Robert Essick*

99

WILLIAM BLAKE

Milton

London: William Blake, 1804
Illustrated with etchings by Blake
9¼ x 6¾ in. (23.5 x 17.1 cm)
The Huntington Library, San Marino,
California (RB 54041)

References
G. E. Bentley Jr., *Blake Books* (Oxford: Clarendon Press, 1977), 118–33 (copy L); Robert N. Essick, *The Works of William Blake in the Huntington Collections: A Complete Catalogue* (San Marino, Calif.: Huntington Library, Art Collections, Botanical Gardens, 1985), 147–49; ESTC t64905.

Bibliography
William Blake, *The Book of Thel*, ed. Nancy Bogen (Providence, R.I.: Brown University Press, 1971); William Blake, *The Illuminated Blake*, ed. David V. Erdman (Garden City, N.Y.: Anchor Press/Doubleday, 1974), 33–41; William Blake, *The Complete Poetry and Prose of William Blake*, ed. David V. Erdman (New York: Anchor Press, 1988), 3–6; Brian Wilkie, *Blake's "Thel" and "Oothoon"* (Victoria, B.C.: English Literary Studies, University of Victoria, 1990); William Blake, *The Early Illuminated Books*, ed. Morris Eaves, Robert N. Essick, and Joseph Viscomi (Princeton: Princeton University Press, 1993), 71–110; Helen P. Bruder, *William Blake and the Daughters of Albion* (New York: St. Martin's Press, 1997), 38–54.

Notes
1. Alexander Gilchrist, *Life of William Blake, "Pictor ignotus"* (London and Cambridge: Macmillan, 1863), vol. 1, 70.

100

YOSHIWARA SEIRO

Nenchugyoji, 1804

Illustrated by Utamaro
8$^{15}/_{16}$ x 6$^{1}/_{4}$ in. (22.7 x 15.9 cm)
Richard C. Rudolph East Asian Library,
UCLA (HQ 247 A5J57 1804B /
SRLF G 000 073 583 7)

101

WILLIAM ALLINGHAM

In Fairyland

London: Longmans, Green,
Reader, and Dyer, 1870
Illustrated by Richard Doyle
11$^{1}/_{8}$ x 15$^{3}/_{16}$ in. (28.3 x 38.6 cm)
Department of Special Collections,
Young Research Library, UCLA
(CBC **PZ8 D777i 1870)

102

RICHARD DOYLE

The Fairy's Ball, n.d.

Watercolor; 8$^{3}/_{8}$ x 11$^{15}/_{16}$ in. (21.3 x 30.3 cm)
Department of Special Collections,
Young Research Library, UCLA (*ORIG 99 #642)

11 1/8 in.

15 3/16 in.

William Allingham
In Fairyland, 1870

Richard Doyle illustrated this important
Victorian children's book

8 ³/₈ in.

11 ¹⁵/₁₆ in.

Richard Doyle
The Fairy's Ball, n.d.

103

JULIA MARGARET CAMERON
Paul and Virginia, c. 1865
Albumen print; 10½ x 8¹⁄₁₆ in. (26.7 x 20.4 cm)
Department of Special Collections, Young Research
Library, UCLA (***98 #43)

Paul and Virginia dates from around 1865, approximately two years after Julia Margaret Cameron (1815–79) took up photography in late 1863, at the age of forty-eight. The two children depicted are the title characters of the popular French novel *Paul et Virginie*, by Bernardin de Saint-Pierre. First published in France in 1788, it appeared in numerous editions and translations during the nineteenth century.

Born in Calcutta to an affluent British family, Cameron was educated in France and England, and in 1938 she married Charles Hay Cameron, a colonial official. They settled in Ceylon, returning to England in 1848. They established themselves on the Isle of Wight in 1860 in order to be near their friend the poet Alfred Lord Tennyson. During the early period of her career Cameron focused on portraiture as well as religious, symbolic, and allegorical works. Using her family, servants, and friends as sitters, she continued to explore these subjects throughout a relatively brief career that ended with her return to Ceylon in 1875. Her literary illustrations include characters from Shakespeare's plays, such as Ophelia and Romeo and Juliet, and from poems by her contemporaries, such as Christabel from the eponymous poem by Samuel Taylor Coleridge. Children are frequently represented during this period as angels, Cupid, and the infant Christ. In representing Paul and Virginia, characters from a story of two children from vastly different social backgrounds who are brought up as brother and sister on the tropical island of Mauritius, Cameron does not provide an illustration of the story. As with other works inspired by literary subjects, Paul and Virginia are idealized representations of the novel's subject, embodying virtue and innocence without representing a detailed narrative.

Around 1864 Cameron began to be recognized for her work and started to present her friends with albums of her photographs. This photograph is part of an album that she presented in September 1869 "as a gift to Aubrey Ashworth Taylor from his earliest, truest, and fondest friend Julia Margaret Cameron." Aubrey Taylor (1845–70) was the youngest son of Sir Henry Taylor, a close friend of Cameron's. As a youth, Taylor showed great intellectual promise and impressed many of the distinguished intellectuals in Cameron's circle of acquaintances. Unfortunately he was beset by long periods of illness and died in 1870 at the age of twenty-five, only one year after Cameron presented him with this album.

These albums often included handwritten inscriptions beneath each photograph, as well as dedication and contents pages. The contents page for the Taylor album lists fifty-one photographs, of which thirty-one remain. The photographs date from circa 1864 to 1869 and contain a representative selection from an extremely productive period of Cameron's career. The Taylor album appeared at auction at Sotheby's in London on May 24, 1965. It was given to the Department of Special Collections in the University Research Library at UCLA in 1967 by Albert Boni. *Cynthia Burlingham*

Bibliography
Helmut Gernsheim, *Julia Margaret Cameron: Her Life and Photographic Work* (New York: Aperture, 1975); Mike Weaver, *Julia Margaret Cameron, 1815–1879* (New York: New York Graphic Society; Boston: Little, Brown, 1984).

8 1/16 in.

10 1/2 in.

Julia Margaret Cameron
Paul and Virginia, c. 1865

Two Victorian children costumed
as the protagonists
of Bernardin de Saint-Pierre's novel

BLAISE CENDRARS

La Prose du Transsibérien
et de la Petite Jehanne de France

Couleurs simultanées de Mme DELAUNAY-TERK

TIRAGE DE LUXE N°

De 1 à 8 pour les exemplaires parchemin
De 9 à 36 pour les exemplaires japon
De 37 à 150 pour les exemplaires simili japon

ÉDITIONS
DES
HOMMES NOUVEAUX
4, rue de Savoie, 4
PARIS
1913
Tous droits réservés

PROSE DU TRANSSIBÉRIEN
ET DE LA PETITE JEHANNE DE FRANCE

En ce temps-là j'étais en mon adolescence
J'avais à peine seize ans et je ne me souvenais déjà plus de mon enfance
J'étais à 16 000 lieues du lieu de ma naissance
J'étais à Moscou, dans la ville de mille et trois clochers et des sept gares
Et je n'avais pas assez des sept gares et des mille et trois tours
Car mon adolescence était alors si ardente et si folle
Que mon cœur, tour à tour, brûlait comme le temple d'Éphèse ou comme la Place Rouge de Moscou
Quand le soleil se couche.
Et mes yeux éclairaient des voies anciennes
Et j'étais déjà si mauvais poète
Que je ne savais pas aller jusqu'au bout.

Le Kremlin était comme un immense gâteau tartare
Croustillé d'or
Avec les grandes amandes des cathédrales toutes blanches
Et l'or mielleux des cloches...
Un vieux moine me lisait la légende de Novgorode
J'avais soif
Et je déchiffrais des caractères cunéiformes

Puis, tout à coup, les pigeons du Saint-Esprit s'envolaient sur la place
Et mes mains s'envolaient aussi, avec des bruissements d'albatros
Et ceci, c'était les dernières réminiscences du dernier jour
Du tout dernier voyage
Et de la mer.

Pourtant, j'étais fort mauvais poète
Je ne savais pas aller jusqu'au bout
J'avais faim
Et tous les jours et toutes les femmes dans les cafés et tous les verres
J'aurais voulu les boire et les casser
Et toutes les vitrines et toutes les rues
Et toutes les maisons et toutes les vies
Et toutes les roues des fiacres qui tournaient en tourbillons sur les mauvais pavés
J'aurais voulu les plonger dans une fournaise de glaives
Et j'aurais voulu broyer tous les os
Et arracher toutes les langues
Et liquéfier tous ces grands corps étranges et nus sous les vêtements qui m'affolent...
Je pressentais la venue du grand Christ rouge de la révolution russe...
Et le soleil était une vilaine plaie
Qui s'ouvrait comme un brasier.
En ce temps-là j'étais en mon adolescence
J'avais à peine seize ans et je ne me souvenais déjà plus de ma naissance
J'étais à Moscou, où je voulais me nourrir de flammes
Et je n'avais pas assez des tours et des gares que constellaient mes yeux
En Sibérie tonnait le canon c'était la guerre
La faim le froid la peste le choléra
Et les eaux limoneuses de l'Amour charriaient des millions de charognes

Dans toutes les gares je voyais partir tous les derniers trains
Personne ne pouvait plus partir car on ne délivrait plus de billets

104
BLAISE CENDRARS
La prose du Transsibérien
et de la petite Jehanne de France
Paris: Éditions des Hommes Nouveaux, 1913
Illustrated with pochoir prints by Sonia Delaunay-Terk
78¾ x 14⅛ in. (200 x 35.7 cm) (unfolded)
Library, Getty Research Institute (89-B4994)

Conceived at a time when the manifestos of the Expressionists and Futurists called for new kinds of art and literature, *La prose du Transsibérien* is perhaps the most astonishing publication from the early years of the avant-garde. This "simultaneist poem" by the Swiss writer Frédéric Louis Sauser (1887–1961), who wrote under the pseudonym Blaise Cendrars, is illustrated with the "simultaneous colors" of Sonia Delaunay-Terk (1885–1979). The nonfigurative shapes draw their energy from the color theories of the nineteenth-century physicist M. E. Chevreul, which described the special intensity that results from adjacencies of complementary colors (such as red and green or blue and orange) and the halo effects that appear around strong colors. Delaunay's pochoir prints explode upward like sparks from an electrical wire, ascending at the same time that the words descend. The poem appears on twenty-one double panels that unfold like the largest imaginable map from a city guide; it was said that if 150 copies of this work were put together they would be as high as the Eiffel Tower. The outsize format serves to identify the poem as a monumental endeavor, with the impertinent comparison to the Eiffel Tower (illustrated in silhouette at the lower left) as part of the production. Imagine that a work on paper could be compared to this enduring symbol of the city and its most popular tourist attraction!

The Michelin railroad map in the upper right-hand panel is a key element. Facing the title like a frontispiece, it introduces the subject of transcontinental travel. But unlike the cozy hotel that we sometimes seek as a refuge in faraway places, this travelogue is concerned with new visions. Reading the poem is itself a trip, like riding and chatting on a train, all the while staring out the window. We read a few lines and look off to the side, attracted by the bright areas of color that appear like blurred images seen from a moving railway car.

The metaphor of travel refers to the personal transformations that marked the lives of the author and artist, and it is emblematic of the radical goals of the avant-garde movements. Sonia Delaunay-Terk was born in Ukraine, and the trans-Siberian journey reflected, appropriately in reverse, her own westward immigration to Paris. She was best known for her designs for textiles and bookbindings and for her collaborative studies of color with her husband, Robert Delaunay. These resulted in the "simultaneous" colors seen in their artwork. Cendrars's life was a journey in many senses. He joined the French foreign legion during World War I and was injured. He lived in many countries on both sides of the Atlantic, including Italy, France, Russia, and Brazil. As an editor, writer, and publisher, he worked with a wide circle of friends and collaborators in many media—writing prose, poetry, and criticism; publishing books and journals; making films; and staging ballets.

Issued by Cendrars's small press, Les Hommes Nouveaux, *La prose du Transsibérien* is a radical rethinking of the design of books and the possibilities of illustration. Not only did it foreshadow later avant-garde books that used design and materials expressively, but it also has provided continuing inspiration for the artists' books of the second half of the twentieth century. Its format yokes art and text in a cooperative endeavor to communicate content. The poem literally opens and unfolds as words surrounded by vivid colors describe the journey. Delaunay's way of illustrating Cendrars's epic poem is like an epiphany, conveying the excitement yet also the dislocations of travel. This "simultaneous book" creates a new, unified way of seeing and reading. Taking the form of a poster, it heralds the new promotional media of popular culture.

This copy is number 124 of an edition of 150, enclosed in a vellum wrapper painted by Sonia Delaunay. Texts are printed in rainbow colors: red, orange, green, and blue. This copy is signed by Cendrars and Delaunay and dated 1918, with an inscription to the artist Alexander Archipenko. Cendrars's awkward signature was written with his left hand, following the loss of his right arm during World War I. *Marcia Reed*

Blaise Cendrars
**La prose du Transsibérien
et de la petite Jehanne de France** (detail), 1913

References
En français dans le texte: Dix siècles de lumière par le livre (Paris: Bibliothèque nationale, 1990), no. 344; Riva Castleman, *A Century of Artists Books* (New York: Museum of Modern Art, 1994), 168–69.

Bibliography
Marjorie Perloff, *The Futurist Moment* (Chicago: University of Chicago Press, 1986); see also idem, "From the Futurist Moment," in *A Book of the Book* (New York: Granary Books, 2000), 160–77, with a reproduction of the poem and an English translation.

ABENTEUER

Einmal besuchte ich eine Villenkolonie, wo niemand lebte. Alle Häuser waren schmuckweiß und hatten festgeschloßne grüne Läden. In der Mitte dieser Villenkolonie war ein grasbewachsener grüner Platz. In der Mitte dieses Platzes stand eine sehr alte Kirche mit einem hohen Glockenturm mit spitzem Dach. Die große Uhr ging, schlug aber nicht. Am Fuße dieses Glokkenturmes stand eine rote Kuh mit einem sehr dicken Bauch. Sie stand unbeweglich und kaute schläfrig. Jedesmal, wenn der Minutenzeiger an der Uhr eine Viertel-, Halbe- oder Ganzestunde zeigte, brüllte die Kuh: „ei! sei doch nicht so bange!" Dann kaute sie wieder.

Wassily Kandinsky
Klänge, c. 1913

A book of prose poems about sound

105

WASSILY KANDINSKY

Klänge

Munich: R. Piper, [c. 1913]
Illustrated with woodcuts by Kandinsky
11¼ x 11¼ in. (28.6 x 28.6 cm)
Library, Getty Research Institute
(88-B12816)

Among the most magnificent books of the twentieth century, *Klänge* (Sounds) is a remarkable synthesis of prose poetry and rich visual imagery. Its fifty-six woodcuts convey Wassily Kandinsky's (1886–1944) unprecedented progression from Jugendstil (and the influence of Félix Vallotton, among others) to a profoundly expressive and original abstraction during the seminal period of his career from 1907 to 1912.

Anticipated by his earlier books *Gedichte ohne Worte* (Poems without words; 1904) and *Xylographies* (1907), *Klänge* partakes of the synesthesia of sound, color, and music that so absorbed the artist at the time of his stage works *Der gelbe Klang* (The yellow sound), *Schwarz und Weiss* (Black and white), and *Grüner Klang* (Green sound), all of 1909, and *Violett* (Violet), from around 1911. In a prospectus published by the Piper Verlag prior to the appearance of *Klänge* (scheduled for autumn 1912), Kandinsky stated: "The book is called 'Sounds.' I did not intend to form anything as sounds. But they formed themselves. That is the designation of the content, the inner. . . . I wrote all of the 'prose poems' in the course of the last three years. The woodcuts go back to the year 1907."[1] If only four of the woodcuts date so early, the project apparently has its genesis in a "musical album" mentioned in Kandinsky's notes of around 1909–10, followed by a maquette for a Russian version of *Klänge* created in Odessa in December 1910. Yet Kandinsky's correspondence with Gabriele Münter shows him creating most of the woodcuts during the following summer,[2] with such vignettes as *Improvisation 22—Variante II* (Improvisation 22—variant II, 1911; Roethel 119)— as well as full-page woodcuts such as *Komposition II* (Composition II, 1911; Roethel 97) and *Motiv aus Improvisation 25* (Motif from improvisation 25, 1911; Roethel 105)—being based on, or sometimes anticipating, contemporaneous paintings charting the way toward abstraction.

The book's color woodcuts, printed under Kandinsky's supervision at the Bruckmann firm in Munich, are small masterpieces in which delicately transparent colors often overlap to create a rich palette. This subtlety evolved from early states of some of the woodcuts, printed using watercolor before the bolder oil-based inks of the final states were selected. In *Orientalisches* (Oriental, 1911; Roethel 106), blue, yellow, and pink overlap to produce green, orange, and maroon; while red and blue create purple in the nearly abstract *Drei Reiter in Rot, Blau und Schwarz* (Three riders in red, blue, and black, 1911; Roethel 107).

In the thirty-eight accompanying prose poems—for Kandinsky merely a "change of instrument"[3]—repetition and incantatory rhythms render language as an abstract means of suggestion rather than description to convey elemental situations and enigmatic events. Sometimes humorous and often paradoxical, the poems contrast sound and meaning, gaining the admiration of the Dadaists when they were read by Hugo Ball at the Cabaret Voltaire in Zurich in 1916. Hans Arp wrote that something "from the eternally unfathomable drifts through these poems."[4] Yet dispute over their literary merit dogged the innovative project from its inception. As Kandinsky later recalled: "My book *Sounds* was published in Munich in 1913. . . . It was a small example of synthetic work. I wrote the poems, and I 'adorned' them with many woodcuts. . . . My editor was rather skeptical, but he had the courage nevertheless to publish it in a deluxe edition: special type, transparent hand-made Holland paper. . . . The book was very quickly out of print."[5]

However rapidly the book sold, the edition was strictly limited by contract, making it especially scarce today. The volume is essential to any Expressionist library, and this copy was part of the unique archive compiled by the German attorney and consultant Wilhelm F. Arntz, whose expertise in Expressionism benefited countless scholars, the auction trade, and those seeking information on the fate of "degenerate art." This copy is number ninety-three of the limited edition of three hundred copies signed and numbered by Kandinsky.

Timothy O. Benson

106

ARDEGNO SOFFICI

BÏF§ZF+18

Florence: Edizione della "Voce," 1915
18 x 13½ in. (45.7 x 34.3 cm)
Library, Getty Research Institute
(1568-453)

107

OSKAR KOKOSCHKA

Die träumenden Knaben

Leipzig: K. Wolff, 1917
9⅝ x 11¾ in. (24.5 x 29.9 cm)
Library, Getty Research Institute
(89-B16811)

108

VLADIMIR MAYAKOVSKY

Dlia golosa

Berlin: Lutze & Vogt, 1923
7⁷⁄₁₆ x 5¼ in. (18.9 x 13.3 cm)
Library, Getty Research Institute
(85-B4888)

References

Hans Konrad Roethel, *Kandinsky: Das graphische Werk* (Cologne: M. Dumont Schauberg, 1970), 71–74, 85, 95–140, 142–46; Riva Castleman, *A Century of Artists Books* (New York: Museum of Modern Art, 1994), 138.

Bibliography

Hans Arp, "Der Dichter Kandinsky," in *Kandinsky*, ed. Max Bill (Paris: Maeght, 1951); Wassily Kandinsky, *Sounds*, trans. Elizabeth R. Napier (New Haven: Yale University Press, 1981); idem, *Kandinsky: Complete Writings on Art*, ed. Kenneth C. Lindsay and Peter Vergo (Boston: G. K. Hall, 1982); Annegret Hoberg, *Wassily Kandinsky and Gabriele Münter: Letters and Reminiscences, 1902–1914* (Munich and New York: Prestel, 1994).

Notes

1. Roethel, *Kandinsky: Das graphische Werk*, 445; translation by the author.
2. Ibid., 448.
3. Kandinsky, "My Woodcuts" (1938), trans. in Lindsay and Vergo, *Complete Writings on Art*, 817.
4. Arp, "Der Dichter Kandinsky," 147; translation by the author.
5. Kandinsky, "My Woodcuts" (1938), 818.

Vladimir Mayakovsky
Dlia golosa, 1923

A collection of poems with Russian
Constructivist illustrations

18 in.

13½ in.

Ardegno Soffici
BÏFℱℨF+18, 1915

A Futurist book focusing on type as design

109

FILIPPO TOMMASO MARINETTI

Parole in libertà

Rome: Edizioni futuriste de poesia, 1932
Illustrated with lithographs by Tullio d'Albisola
9⅞ x 9¾ in. (25.1 x 24.8 cm)
Library, Getty Research Institute
(89-B4381)

110

MAX ERNST

**Une semaine de bonté;
ou, Les sept éléments capitaux**

Paris: J. Boucher, 1934
9⅞ x 9¾ in. (25.1 x 24.8 cm)
Library, Getty Research Institute
(89-B3398)

111

PAUL ELUARD

Facile

Paris: Editions G.L.M., 1935
Illustrated with photogravure reproductions after
photographs by Man Ray
9½ x 7¼ in. (24.1 x 18.4 cm)
Library, Getty Research Institute
(84-B22293)

Driven by the promise of a more nurturing environment for his art, Man Ray (born Emmanuel Radnitsky, 1895–1976) departed New York for Paris in July 1921. Upon arriving at the Gare Saint-Lazare, he was met by his former mentor and New York Dada accomplice, Marcel Duchamp, who immediately introduced him to the inner circle of avant-garde poets for whom Dada was rapidly evolving into little more than a rallying point for malcontents. In addition to dissident Dadaist André Breton, already asserting himself as group leader and formulating the tenets of the future Surrealist movement, Paul Eluard (born Eugène Grindel, 1895–1952) attended Man Ray's social and artistic launch. Eluard, whom Man Ray later called "the most human and simple of the poets," was soon to become both a lifelong friend and dedicated collaborator.[1]

Man Ray quickly established himself as a professional portrait photographer of the haute monde, the literary intelligentsia, and art world notables.

Throughout his prewar Paris years, his independently created photographs—employing solarization, multiple exposures, and the cameraless technique of the photogram (which he renamed the rayograph)—appeared in numerous Surrealist-associated reviews, journals, and books, as well as in his own portfolio of rayographs, *Champs délicieux*.[2] His fashion photographs, often displaying the darkroom manipulations that the Surrealists recognized as his own distinctive brand of automatism, revolutionized the look of international magazines such as *Vanity Fair*, *Vogue*, and *Harper's Bazaar*.

Applying the combined resources of his art for the first time to a book of poetry, Man Ray contributed twelve photographs for reproduction in *Facile*, a small volume containing Eluard's five poems of love and desire dedicated to his beautiful young wife, Nusch.[3] Eleven of the photographs are of the nude Nusch (who wears bracelets, a ring, and a wristwatch in the final photograph), and one, a headpiece for the poem "L'entente," shows the feminine attribute of a chic pair of gloves. Within the limits of these few images, Man Ray acknowledges his frequent model and muse as an idealized woman, the quintessential subject of Surrealist photography in the 1930s. Never exposing her entirely in a single composition, he emphasizes individual parts of her somewhat androgynous body—torso, breasts, arms, legs, feet—from multiple angles and in variable conditions of visibility. Her face is fully presented only once, her eyes downcast or closed.[4] The photographer enhances her perfect contours through contrasts of light and dark and outlines her silhouette with solarization, achieving cinematic stop-action effects through a rhythmic sequencing of her body in motion, posing, turning, stretching in a dreamlike state. The passage of time, from morning to night, is implied.

Paul Eluard is thought to have initiated *Facile* to serve as the setting for his passionate verbal responses to the ongoing series of photographs of his wife that Man Ray had begun around 1932.[5] As precedent, in 1924 he had anonymously published

poems of infatuation for his first wife and more infamous muse, Gala, in *Au défaut du silence* (1924), with twenty pages of numerous and obsessively clustered unsigned ink drawings of her face by Max Ernst.[6] Since two of the poems included in *Facile* had already appeared separately in print slightly earlier, it was probably poet Guy Lévis Mano's creative participation as typographer and publisher that brought the more ambitiously realized *Facile* to fruition.[7] Lévis Mano's active role is further signaled on the book's front cover, which features Man Ray's photograph of the printer's type magnified and set to form the title and contributors' names as they appear on the title page. Eluard's initial proposal that Man Ray's photographs face his text in the conventional manner of illustrated books (echoing the layout of *Au défaut du silence*) was revised by the collaborating team, so that photographs and poems in *Facile* are joined on all but two of the book's pages in a harmonic interplay of images and words. Nusch's arching torso frames the beginning of the third poem, "À la fin de l'année. . . " Lengths of lines vary, and ends of lines rhyme in space with the shape of her body. Only in *Parallèlement*, thirty-five years before, did Bonnard's lithographs embrace Verlaine's verses as intimately.[8]

Man Ray lived in Hollywood from 1940 to 1951 but felt himself to be an exile within his own country. He once wrote to his sister: "California is a beautiful prison. . . . I like it here, but I cannot forget my previous life."[9] During these years he often took pains to disavow his work as a professional photographer in favor of productively furthering his talents as a painter and object maker. In Los Angeles today, however, we find at the Getty Center not only a copy of *Facile*, his most celebrated photographically illustrated book, but also the richest collection in the United States of photographs from all periods of his career.[10] The Getty's copy of *Facile* is from the Jean Brown Collection and is number 42 from the regular edition of 1,000 copies (total edition 1,225).
Robert Rainwater

References
Riva Castleman, *A Century of Artists Books* (New York: Museum of Modern Art, 1994), 183.

Notes
1. Man Ray, *Self-Portrait* (Boston: New York Graphic Society, 1988), 289.
2. Man Ray, *Champs délicieux: Album de photographies*, preface by Tristan Tzara (Paris: Société générale d'imprimerie et d'édition, 1922).
3. Born Maria Benz, Nusch has been variously described as a *berlinoise*, an Alsatian, and a Czech. Eluard encountered her, apparently destitute, on a Paris street in 1930. He gave her assistance and began an affair, which led to marriage in 1934.
4. Nusch Eluard is not only easily recognizable in *Facile* from the many studio and personal photographs of her by Man Ray but also

from portraits of her by Picasso, one of Eluard's closest friends in the 1930s. Notably, Picasso's aquatint portrait of Nusch appeared in Eluard's *La barre d'appui* (Paris: Editions "Cahiers d'Art," 1936). Her role as spur to Picasso's artistic and, possibly, amorous activities is discussed in William Rubin, "Reflections on Picasso and Portraiture," in *Picasso and Portraiture: Representation and Transformation*, ed. William Rubin (New York: Museum of Modern Art, 1996), 78–88.
5. Nicole Boulestreau, "Le photopoème 'Facile': Un nouveau livre, dans les années 1930," in *Le livre surréaliste*, special issue of *Mélusine*, no. 4 (1982): 165. Correspondences between Man Ray's photographs and Eluard's poems in *Facile* are sensitively analyzed in detail in Renée Riese Hubert, *Surrealism and the Book* (Berkeley and Los Angeles: University of California Press, 1988), 73–83.
6. Paul Eluard, *Au défaut du silence* [Paris, 1924].

7. *Facile* was published on October 24, 1935. The poem "L'entente" was first published in *Mesures*, no. 2 (15 April 1935): 91–96; "À la fin de l'année . . ." was first published in the *Revue de Paris*, no. 12 (25 June 1935): 846–48. See notes on *Facile* in Paul Eluard, *Oeuvres complètes* (Paris: Gallimard, 1968), 1465–67. Prolific and adventuresome, Guy Lévis Mano supported a large number of Surrealist authors and artists in his publishing career from 1923 to 1974. See Antoine Coron, ed., *Les éditions GLM, 1923–1974* (Paris: Bibliothèque nationale, 1981).
8. Paul Verlaine, *Parallèlement: Lithographies originales de Pierre Bonnard* (Paris: A. Vollard, 1900).
9. Quoted in Dickran Tashjian, "'A Clock That Forgets to Run Down': Man Ray in Hollywood, 1940–1951," in *Man Ray: Paris, L.A.* (Santa Monica, Calif.: Smart Art Press, 1996), 25.
10. See *Man Ray: Photographs from the J. Paul Getty Museum* (Los Angeles: J. Paul Getty Museum, 1998).

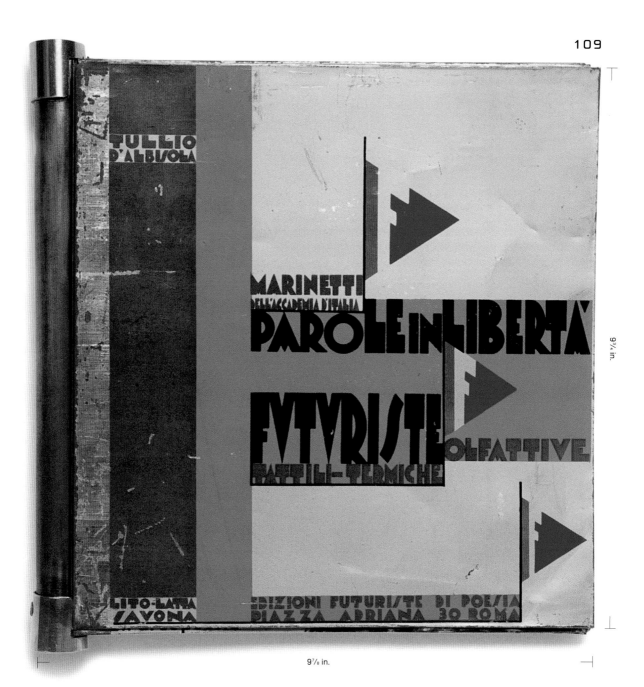

9³/₄ in.

9⁷/₈ in.

Filippo Tommaso Marinetti
Parole in libertà, 1932

Marinetti's book, constructed from metal
sheets, embodies the machine age aesthetic
of the Futurist movement

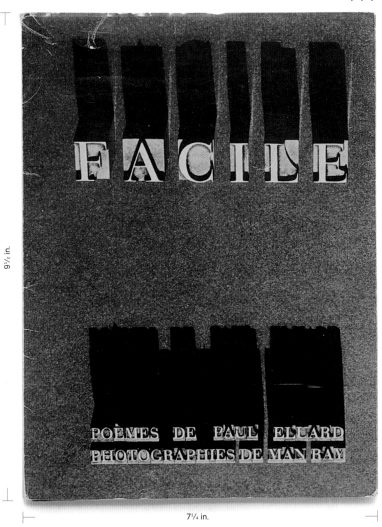

9½ in.

7¼ in.

Paul Eluard
Facile, 1935

A book of poems with photographic illustrations
by Man Ray

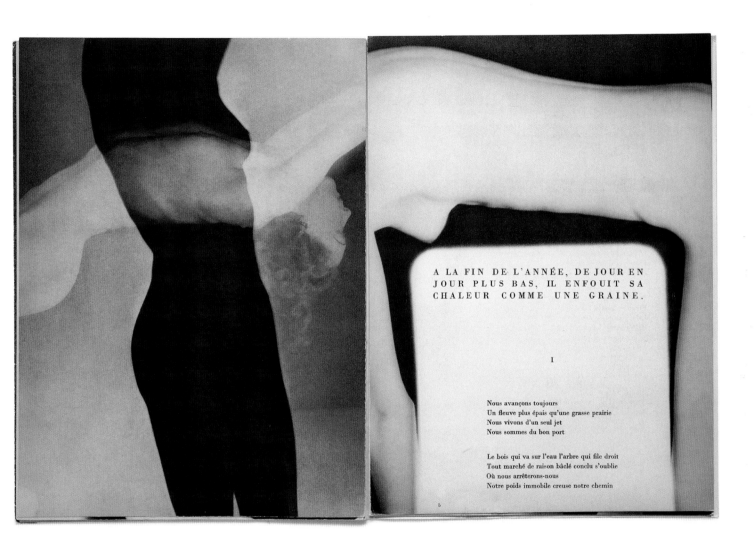

A LA FIN DE L'ANNÉE, DE JOUR EN
JOUR PLUS BAS, IL ENFOUIT SA
CHALEUR COMME UNE GRAINE.

I

Nous avançons toujours
Un fleuve plus épais qu'une grasse prairie
Nous vivons d'un seul jet
Nous sommes du bon port

Le bois qui va sur l'eau l'arbre qui file droit
Tout marché de raison bâclé conclu s'oublie
Où nous arrêterons-nous
Notre poids immobile creuse notre chemin

5

4½ in.

5¹⁄₁₆ in.

8³⁄₈ in.

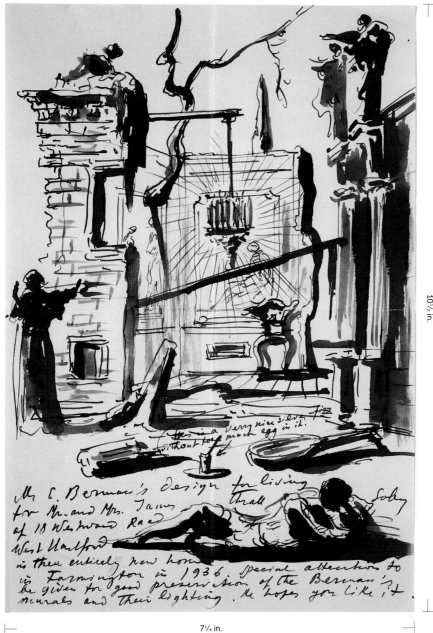

10½ in.

7¼ in.

Eugene Berman
Letters to James Thrall Soby
1930s–1950s

Illustrated letters by a Russian
expatriate artist

112

EUGENE BERMAN

Letters to James Thrall Soby

1930s–1950s
Letter: 10⅞ x 8⅜ in. (27.6 x 21.3 cm);
envelope: 4½ x 5⅟₁₆ in. (11.4 x 12.9 cm);
drawing: 10½ x 7¼ in. (26.7 x 18.7 cm)
Library, Getty Research Institute, James Thrall
Soby papers 1928–1975 (910128*)

Born in Saint Petersburg, Russia, in 1899, Eugene Berman moved with his family to Western Europe in 1908. In France, Germany, and Switzerland, he received basic art instruction before enrolling in the Académie Ranson in Paris at the age of twenty. There he attended courses taught by Édouard Vuillard (1868–1940) and Maurice Denis (1870–1943), and within two years began exhibiting his work at the Galerie Druet in Paris. In 1926 Berman and three other artists—the French painter Christian Bérard, the Russian painter Pavel Tchelitchew, and Berman's brother Leonid— exhibited together at that gallery and were hailed as a vital new force in modern painting by the French critic Waldemar George, who called them "Neo-Romantics" for their merging of a traditional pictorial vocabulary with a modern sensibility.

Despite his ongoing identification with and lifelong support of this group of artists, Berman's development and artistic pursuits were largely solitary. A deep interest in Renaissance and Baroque painting and architecture (particularly the work of Andrea Palladio and Giovanni Battista Piranesi) drew him frequently to Italy. He was also influenced by the Italian Metaphysical/Surrealist painter Giorgio De Chirico (1888–1974), who imbued pseudoclassical architectural settings with an eerie, dreamlike aura. Berman too combined the historical and the fantastic, drawing upon various architectural styles to create elaborate, stagelike scenes in fluently rendered oil paintings and drawings. These he peopled with attenuated figures garbed in vaguely classical dress to evoke a world in which (Western) history appears to be collapsed into a single visionary moment. A highly productive artist, Berman maintained an

active, although not prosperous, studio practice, which he supplemented with theater and ballet set and costume design work in Europe and the United States.

The two letters that appear here are drawn from a collection of some 130 letters and a dozen drawings and cards that Berman sent to James Thrall Soby (1906–79), an influential American critic, scholar, and collector, as well as a curator at New York's Museum of Modern Art between 1942 and 1968. In the mid-1920s Soby traveled to Paris, where he began to collect contemporary art. From 1928 to 1938, during his tenure at the Wadsworth Atheneum in Hartford, Soby acquired a substantial collection of modern art—including works by Max Ernst, Henri Matisse, Joan Miró, Pablo Picasso, and Yves Tanguy, as well as by Bérard, Berman, and Tchelitchew—for that institution's collection. His and Berman's correspondence begins in 1932, the year of the artist's first show at the Julien Levy Gallery in New York, and spans thirty-seven years, although most of it is concentrated in the years 1932 to 1945.

Berman's letters to Soby from the first few years are long and effusive, filled with discussion about art (his own as well as that of other artists), travel (both traveled frequently), mutual friends, and daily life. Their association underwent a significant shift in 1935, when Soby commissioned the artist to create a decorative scheme for the dining room of his new house in Connecticut. Berman's involvement in virtually every aspect of the room's installation—from the trim, molding, color, and lighting to the furniture design—is evident in exhaustive discussions that fill twenty letters from that year. All of these elements were conceived to showcase a cycle of Berman's murals set into the room's paneled walls. Berman's drawing, or "design," of this scheme, replete with brooding figures, typifies his melancholic, picturesque style—one that

he relieves with whimsical touches, such as "a verry [*sic*] nice silver fizz without too much egg in it."

The playful wit that punctuates Berman's early correspondence with Soby is also seen in the letter written on a pen-and-ink portrait (perhaps of a younger, idealized self?) and envelope decorated with Piranesi-like trompe l'oeil elements. Such tokens of friendship and affection, often sent as holiday greetings or to mark special occasions, are cast into vivid relief by letters that grow unrelentingly serious, dwelling on mundane difficulties and uncertain prospects and, increasingly, on ideological differences with Soby that developed in the late 1930s. Berman also made frequent appeals to Soby to garner financial support for his artist friends struggling in Paris (particularly his brother Leonid), and indeed Soby and his associates responded by sending funds to them at various intervals. Gradually, however, strains emerged in their relationship, which were further aggravated by Berman's disappointment with his work's reception in the United States (where he had moved in 1939) and, in particular, at the Museum of Modern Art, where Soby was made director of painting and sculpture in 1942. A letter from 1943 counters Soby's criticism of Berman's recent work; two years later the artist signs off as "Genia" for the last time (thereafter he is "E.B."), and the once-voluminous correspondence tapers off until 1969, three years before Berman's death in Rome.

Eugene Berman's letters and drawings are part of the James Thrall Soby papers acquired in 1994 by the Getty Research Institute, which collects materials related to the history of modernism. This collection documents Soby's nearly forty-five-year engagement in twentieth-century scholarship and criticism and includes letters from artists and other professional correspondence, as well as some manuscripts and notes for his own publications.
Noriko Gamblin

113
EDWARD RUSCHA
Every Building on the Sunset Strip
Los Angeles: E. Ruscha, 1966
7⅛ x 5⅝ in. (18.1 x 14.2 cm)
Library, Getty Research Institute
(86-B19486)

114
SAMUEL BECKETT
Foirades/Fizzles
[London and New York]:
Petersburg Press, 1976
Illustrated with etchings by Jasper Johns
13¹/₁₆ x 10 in. (33.4 x 25.4 cm)
Library, Getty Research Institute
(93-B4484)

Bibliography
James Thrall Soby, *Eugene Berman: Catalogue of the Retrospective Exhibition of His Paintings, Illustrations, and Designs* (Boston: Institute of Modern Art, 1941); *Eugene Berman in Perspective* (Austin: University Art Museum, University of Texas, 1975); John E. Bowlt, in *The Dictionary of Art*, ed. Jane Turner (New York: Grove, 1996), 806.

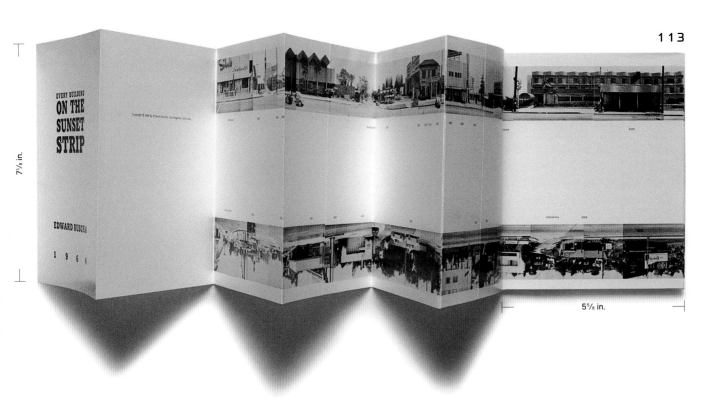

7⅛ in.

5⅝ in.

Edward Ruscha
Every Building on the Sunset Strip, 1966

A landmark Los Angeles artist's book

1 1 4

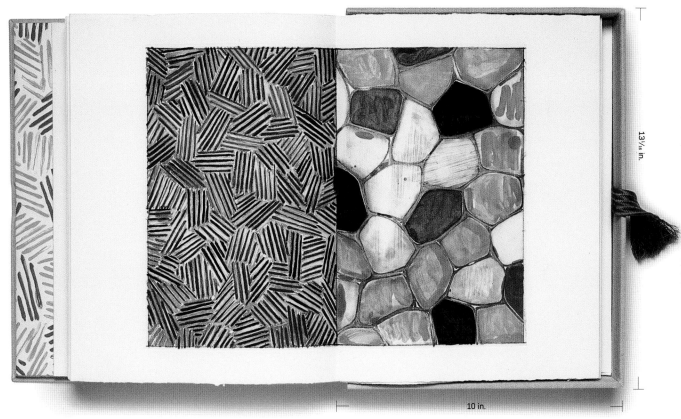

13⁷/₁₆ in.

10 in.

Samuel Beckett
Foirades/Fizzles, 1976

An artist's book with text by Samuel Beckett
and etchings by Jasper Johns

115

LINDA MONTANO

The Art/Life Institute Handbook

[Saugerties, N.Y. : Art/Life Institute], 1988
8½ x 5⅜ in. (21.6 x 13.7 cm)
California Institute of the Arts,
Division of Library and Information Resources
(CalArts Reserve N7433.4.M66 A8)

116

CHERI GAULKE

The Los Angeles: River inside a River

[Los Angeles: C. Gaulke, 1991]
6⅝ x 6⁷⁄₁₆ in. (16.8 x 16.4 cm)
Library, Getty Research Institute
(92-B23775)

117

SUSAN KING

Support Living Artists!

Santa Monica: Paradise Press, 1987–89
Postcards and envelopes;
6¾ x 5 in. (17.1 x 12.7 cm)
Otis College of Art and Design,
Millard Sheets Library

118

BETH THIELEN

Why the Revolving Door: The Neighborhood, the Prisons

Los Angeles: Beth Thielen, 1992
11½ x 8¼ in. (29.2 x 21 cm)
Library, Getty Research Institute
(95-B116)

119

RACHEL ROSENTHAL
AND DANIEL J. MARTINEZ

Soldier of Fortune

Los Angeles: Paradise Press, 1981
Portfolio of gelatin silver prints;
photographs: 11 x 14 in. (27.9 x 35.6 cm)
each; portfolio: 14½ x 12 in. (36.8 x 30.5 cm)
Library, Getty Research Institute
(95-B989)

120

SUE ANN ROBINSON

Chisholm Hours

Rochester, N.Y.: Visual Studies Workshop, 1988
14¾ x 12 in. (37.5 x 30.5 cm)
Library, Getty Research Institute
(91-B35779)

121

KATHERINE NG

Fortune Ate Me

[N.p.: Second Story Press, 1992]
Box: 5 x 7 x 1½ in. (12.7 x 17.8 x 3.8 cm)
Library, Getty Research Institute
(92-B26152)

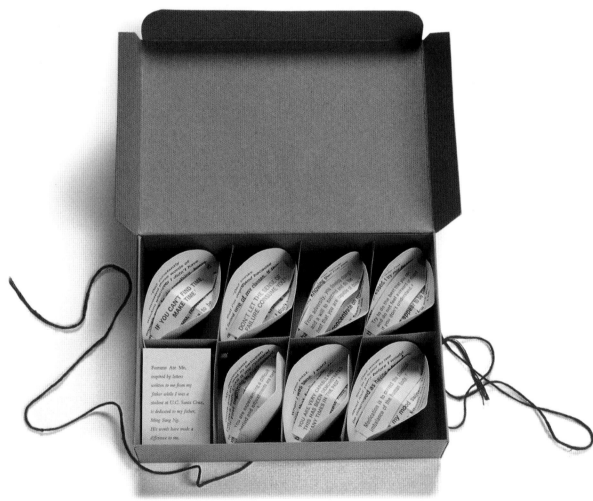

5 in.

7 in.

Katherine Ng
Fortune Ate Me, 1992

An artist's book in the form of a box
of fortune cookies

37 in.

27 in.

Angel Bracho
No Olvidemos! 1953

A Mexican poster memorializing Ethel and Julius Rosenberg

122

ANONYMOUS

Tableau des papiers et monnoyes, c. 1795

Etching with hand-coloring;
21³/₄ x 27³/₄ in. (52.7 x 67.9 cm)
Library, Getty Research Institute
(P980009*)

123

ANTOINE MAXIME MONSAIDY

Le triomphe des armées françaises,
c. 1797

Etching with hand-coloring;
13⁹/₁₆ x 19⁵/₈ in. (34.4 x 49.9 cm)
Library, Getty Research Institute
(P980009*m box 1 françaises)

124

The Black Panther 4

19 May 1970
17⁵/₈ x 8¹⁵/₁₆ in. (44.8 x 22.8 cm)
Southern California Library
for Social Studies and Research

125

Labor Defender 6

June 1931
11¹⁵/₁₆ x 8¹⁵/₁₆ in. (30.3 x 22.7 cm)
Southern California Library
for Social Studies and Research

126

JEAN CARLU

Pour le désarmement des nations

Paris: Office de propagande
graphique pour la paix, 1932
Lithograph; 28½ x 20 in. (72.4 x 50.8 cm)
Center for the Study of Political Graphics
(10765)

127

ANGEL BRACHO

No Olvidemos!

Mexico City: Taller de Gráfica Popular, 1953
Linocut; 37 x 27 in. (93.5 x 67.5 cm)
Center for the Study of Political Graphics
(10145)

128

RUPERT GARCÍA

El Grito de Rebelde, 1975

Silkscreen; 26 x 20 in. (66 x 50.8 cm)
Center for the Study of Political Graphics
(3390)

8 in.

6 ⅜ in.

76 JOANNIS KEPPLERI

	Longit.	Sagit.	Latit.	Magn.
In Isoscele spiræ Serpentis, apex	15. 3/		10. 25/ S.	4
Prior basis	19. 26/		8. 4/ S.	4
Posterior	20. 12/		10. 21/ S.	4
Dextri Pedis Tibia	15. 43/		1. 37/ S.	4
Digitus	14. 10/		3. 27/ Au.	4
Dorsum	14. 50/		1. 27/ S.	4
Palmæ clara	15. 50/		1. 43/ A.	4
Vola	16. 40/		0. 59/ A.	4
Calx seu Talus	18. 8/		0. 57/ A.	4
Quatuor informium in Rhombo ad humerum dextrum borealissima	25. 10/		28. 0/ S.	4
Mediarum prior	25. 0/		26. 40/ S.	4
Posterior	26. 53/		26. 28/ S.	4
Infima	25. 43/		24. 41/ S.	4
Duarum parvarum supra caudam, superior 29. 51/		22. 26. 18/ S.		6
Inferior	1. 42/ Capr.		23. 28/ S.	6
Infra caudam clara	3. 3/		13. 49/ S.	4
Post pedem dextrum, socia novæ	20. 7/ Sagit.		1. 21/ S.	4
Trium minimarum inter ultimam & penultimam caudæ Serpentis, præcedens	2. 5/ Capr.		21. 29/ S.	6
Media	4. 9/		22. 42/ S.	6
Postrema	6. 43/		24. 51/ S.	6
Proximè infra ultimam, infor.	10. 25/		25. 2/ S.	6
Cuspis Sagittæ	25. 23/ Sagit.		6. 54/ A.	4

*Huc refer figuram ex Cupro, signo * * *, in qua Æ æquator notat; EC, Eclipticam: a & ı, Saturnum; n & ı, Jovem; Mars, N, Novam: hoc discrimine, ut a & n, circuli vacui, designent loca Saturni & Jovis conjunctorum die , ♄ Decembris anni 1603, u. ı. ... cent situm Saturni Jovis & Martis die 30. Sept. vel 10. Octob. quasi... Pragæ primùm visa est Nova stella. Reliqua rectè & curva lineis paulo supra sunt explicatæ. Stellarum verò cæterarum nomina pauca ex imaginum membris, quibus inhærent.*

De loco

* * *

Johannes Kepler
De stella nova in pede Serpentarii, 1606

A book about a newly discovered star

IV EARTH AND UNIVERSE

Bruno Snell once cited a fragment from the post-Homeric Greek poet Xenophanes in an essay on knowledge among the early Greeks: "Truly the gods have not revealed to mortals all things from the beginning, but by long seeking do men discover what is better." It is a sentiment that was echoed almost twenty-five hundred years later by the American poet Charles Olson in his postmodern epic *The Maximus Poems*: "that we are only / as we find out we are." It is also, broadly speaking, the impulse that has animated much of descriptive and experimental science, and we see it not only in the medieval project to rationalize the infinite (Whitehead put it that way) but equally in the modern need to noumenalize the finite. The earlier need led from religion to science; our own need leads back from science to spirituality, although we can never be disencumbered of the accumulated scientific knowledge of five centuries and more.

Scientific and medical books have a surprisingly short history as an important part of bibliophily. They are keenly collected today: the Ratdolt Euclid (1482) fetched more than half a million dollars at the Freilich sale in New York in January of 2001. Less than ninety years before, the physician Sir William Osler was able to buy his copy of Copernicus (1543) for £18, about $100 at the time. The UCLA copy of Vesalius's *Fabrica*, as Ynez O'Neill tells us, cost $1,645 when Dr. John Benjamin acquired it in 1949. The copy in the Norman sale in March 1998, albeit an extraordinarily sumptuous one, fetched more than $1,600,000. These *jeux de prix* can be played with many books, of course, but the fact remains that there were very few collectors

for even the most famous scientific books before World War I. They were thought to be recherché and hard to understand, and it was difficult to be remotely sentimental about Euclid or Robert Hooke in the way that one could be about *Paradise Lost* or even Cicero's *Offices*. The usefulness of old science and medical books for research was more clear-cut: they had little or none, apart from the classics of geology and a few other landmark works, such as Newton's *Principia* (1687) or Darwin's *Origin of Species* (1859).

This section of *The World from Here* begins at the macrocosmic level with a group of wonderful astronomical books. In the center of these books lies Galileo's *Sidereus nuncius* (1610), the modest publication in which the invention of the telescope and the earliest results of its use were announced. Earlier astronomers had to be content with observing the sky with the unaided eye, a fact that makes Copernicus's theory that the sun, not the earth, was at the center of the observable heavens even more remarkable. Galileo was able to determine that the surface of the moon was not smooth, but was very much like the earth's. He also discovered four of the moons of Jupiter, which with political astuteness he named the Medicean Stars. Galileo's observations supported the heliocentric contention at least indirectly, and as is well known, he suffered the wrath of the Catholic Church after the publication of his substantial *Dialogo sopra i due massimi sistemi del mondo* (1632), a book that remained on the *Index* for two centuries. Apart from the evocative photograph of Edwin Hubble, Walter Sidney Adams, and Albert Einstein—taken near Los Angeles when Einstein visited the Mount Wilson Observatory in 1930—*The World from Here* does not pursue

astronomy into the modern era. Observation has remained an essential tool of the astronomer, of course, but as it had been in the sixteenth century, so mathematics became again the primary tool of the modern astronomer, and beautiful illustrated works like those of Hevelius and Cellarius gradually became outmoded.

Until relatively recent times the pure and applied sciences were not always so obviously distinct. Natural history and natural philosophy, as the Renaissance and early modern scientist would have thought of them, were separate pursuits, certainly, and Thomas Martyn's beautiful *Universal Conchologist* (1784) is as characteristic an example of the first as Newton's *Principia*, a century earlier, is of the second. But science mixed with theology (represented here by two outstanding alchemical manuscripts) and science mixed with the collecting instinct (represented here in Ferrante Imperato's record of a *Wunderkammer*) long continued to play an important role in the scientific endeavor generally. Many of the wonderful illustrated natural history books of the nineteenth century differ little, apart from their greater technical and artistic sophistication, from a book like Ippolito Salviani's 1554 study of fishes, despite the increasing emphasis on experiment and classification over the intervening 300 years. Two hundred years after Redouté's book on lilies and 150 years after Edward Lear's book on parrots, these works remain highly compelling as objects, however dated their scientific substratum has become. Photography would soon replace the illustrative function in scientific books in any case.

In medicine, as in science, discoveries were always traditionally recorded in printed books, even if they had circulated earlier in the form of

correspondence or draft manuscripts. But as the representation in *The World from Here* of Wilhelm Conrad Röntgen's discovery of X rays and James Watson and Francis Crick's revelation of the structure of DNA in the form of the modest periodical and its meiotic child, the offprint, demonstrates, this has not been the case for more than a century now. Some of the most far-reaching medical discoveries were disseminated in books of a very unassuming character, books like William Harvey's on the circulation of the blood (1628) or Edward Jenner's on smallpox inoculation (1798). Anatomy books, almost by definition, tend to be grander objects, and the group of them here, from Vesalius's epochal *Fabrica* to Cowper's *Anatomy of Human Bodies* (1698) to Hunter's *Anatomy of the Human Gravid Uterus* (1774), embody the highest perfection of the engraver's art. More specialized works, like that of Gautier D'Agoty, who pioneered color printing, or the Japanese scroll that records a late eighteenth-century autopsy of a criminal, are almost equally compelling. With the Japanese woodblock prints concerning pregnancy and the *materia medica*, the distinction between the practical and the aesthetic falls away entirely. These beautiful prints come from the period (roughly the second third of the nineteenth century) when, as was also the case with scientific literature, photography was beginning to be used to illustrate medical books. The wonderful little *Obstetrical Pocket-Phantom* carries the representation of the human microcosm in *The World from Here* to the end of the nineteenth century, where it stops, save for an allusion to psychiatry in the curious colored patterns devised for diagnosis by Hermann Rorschach in the early 1920s. *B.W*

129

JOHANNES REGIOMONTANUS

Calendarium

Venice: Bernard Maler, Erhard Ratdolt,
and Peter Löslein, 1476
10⁵⁄₁₆ x 8¹⁄₁₆ in. (26.2 x 20.5 cm)
Libraries of the Claremont Colleges,
Wilson Collection, Honnold/Mudd Library

For centuries scribes slowly copied out the tables from which planetary positions could be calculated, and astronomers used these precious manuscripts for their tedious computations. But within two decades of Gutenberg's invention, the most brilliant mathematical astronomer of the fifteenth century recognized the laborsaving possibilities of the new information technology. Thus it was that Johannes Müller (1436–76), alias Regiomontanus (from his hometown of Königsberg), became the first astronomical printer.

Regiomontanus's most ambitious project was the publication of daily planetary positions for thirty-two consecutive years. His ephemerides, printed in 1474, set the formatting standards for the next two centuries. Whereas the fat volume of ephemerides was designed for astronomer-astrologers, he also printed a more popular perpetual calendar that recorded the saint's days, the position of the sun, and the phases of the moon. It included a set of volvelles, or moving disks that could assist in getting the positions of the moon, plus an extraordinarily ingenious universal sundial with a small brass attachment, making his little calendar into a real scientific instrument (his very own invention). And, to broaden its market, Regiomontanus issued both German and Latin editions of the work. His calendar proved very popular and was reprinted many times in the next four decades.

Regiomontanus printed an advertising broadsheet in which he provided an ambitious list of scientific titles that he proposed to print. Unfortunately his career as a printer was cut short when, on a visit to Rome in 1476, he died of the plague. Soon thereafter a young German printer in Venice, Erhard Ratdolt, published a similar list of proposed titles (which survives in a unique copy in Leipzig), leading many experts to conjecture that Ratdolt had been an apprentice working for Regiomontanus. Ratdolt established himself as the finest printer of scientific titles in the incunabular period, and he actually published several of the books on Regiomontanus's list, including the first edition of Euclid's *Elements* (cat. no. 144) and this reprint of the *Calendarium*.

Among the innovations that Regiomontanus introduced was the use of large woodblock initials in the Italian style to open chapters in his books, thus eliminating the need for manuscript illuminators to add the initials in blank places provided by the earliest printers. Ratdolt also followed this practice, a fact that provides yet another link to his putative Nuremberg mentor.

Although this is a reprint of Regiomontanus's *Calendarium*, which had been published two years earlier, this edition is particularly celebrated as the first printed book with a title page. Previously titles had typically been run in with the first page of the text, with the date of publication included only at the end, in keeping with the ongoing manuscript tradition. In this case the place and date, the printers (Bernard Maler and Peter Löslein, together with Ratdolt), and the title all appear on a special opening page, although the title itself is rather buried in a poem that acts as a publisher's blurb. Published in both Latin and Italian versions, this was the first of a long series of Ratdolt publications.

Owen Gingerich

References

W. A. Copinger, *Supplement to Hain's Repertorium bibliographicum* (London: H. Sotheran, 1895–1902), no. *13776; *Catalogue of Books Printed in the Fifteenth Century Now in the British Museum* (London: British Museum, 1908–), vol. 5, 243; Arnold C. Klebs, *Incunabula scientifica et medica: Short Title List* (Bruges: Saint Catherine Press, 1938), no. 836.2; Fredrick R. Goff, *Incunabula in American Libraries: A Third Census* (New York: Bibliographical Society of America, 1964), no. R–93.

Bibliography

Gilbert R. Redgrave, *Erhard Ratdolt and His Work at Venice* (London: Printed for the Bibliographical Society at the Chiswick Press, 1894); *Der deutsche Kalender des Johannes Regiomontan*, introduction by Ernst Zinner (Leipzig: O. Harrassowitz, 1937).

1515	1516	1516
Eclipfis de la Luna	Eclipfis de la Luna	Eclipfis de la Luna
29 15 20	19 6 0	13 11 39
Zenaro	Zenaro	Luio
Meça duration	Meça duration	Meça duration
1 47	1 45	1 42

1516	1518	1518
Eclipfis del Sole	Eclipfis de la Luna	Eclipfis del Sole
23 3 59	24 11 22	7 17 54
Decembrio	Maço	Zugno
Meça duration	Meça duration	Meça duration
0 40	1 34	1 6
Puncti tre	Puncti noue	Puncti undece

Johannes Regiomontanus
Calendarium, 1476

A text recording the saint's days, the position of the sun, and the phases of the moon

18

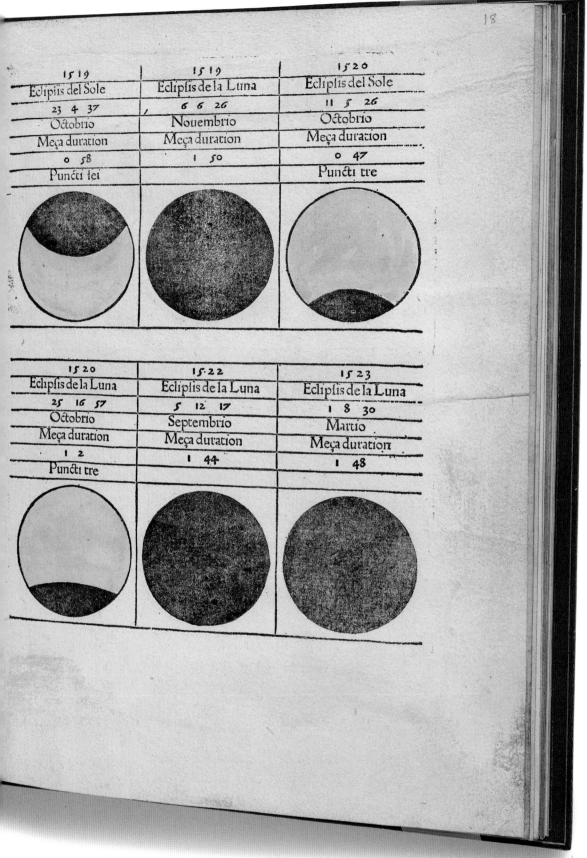

1519	1519	1520
Ecliplis del Sole	Ecliplis de la Luna	Ecliplis del Sole
23 4 37	6 6 26	11 5 26
Octobrio	Nouembrio	Octobrio
Meça duration	Meça duration	Meça duration
0 58	1 50	0 47
Punćti lei		Punćti tre

1520	15.22	1523
Ecliplis de la Luna	Ecliplis de la Luna	Ecliplis de la Luna
25 16 57	5 12 17	1 8 30
Octobrio	Septembrio	Martio
Meça duration	Meça duration	Meça duration
1 2	1 44	1 48
Punćti tre		

10 5/16 in.

8 1/16 in.

10⅞ in.

8⅛ in.

Nicolaus Copernicus
De revolutionibus orbium coelestium, 1543

The announcement of the heliocentric theory
of the universe

130

NICOLAUS COPERNICUS

De revolutionibus orbium coelestium

Nuremberg: Johannes Petreius, 1543
10⅞ x 8⅛ in. (27.6 x 20.6 cm)
History & Special Collections, Louise Darling Biomedical
Library, UCLA (BENJ QB 41 C791dr 1543 Rare)

Precisely when Copernicus got the idea of a revolutionary new heliocentric arrangement for the planetary system is unknown. He already had a strong interest in astronomy as an undergraduate at the University of Cracow and may have begun to explore the radical new cosmology while he was a graduate student in Italy, around 1500. After he returned to his native Poland, he took up a career position as canon in the cathedral at Frauenburg (now Frombork), the country's northernmost Catholic diocese. There, by 1514, he had produced a small tract advocating the sun-centered arrangement of the planets, with a moving earth numbered among them.

Precisely why he opted to explore such an unorthodox arrangement is also unknown. In his day there was no observational proof that the earth moved, so his invention sprang from the mind's eye, a "theory pleasing to the mind," as he described it. After the first printed edition of Ptolemy's *Almagest* appeared in 1515, Copernicus must have realized that to compete with the traditional earth-centered cosmology, he would have to produce a full-blown treatise that would show how the positions of the planets could actually be calculated on the basis of the heliocentric system. This in itself would have posed no serious problem, for the heliocentric computations were essentially a transformation of the geocentric ones. But Copernicus was keen to improve on some of Ptolemy's geometrical techniques, which he felt violated the principles of uniform circular motion. Hence his treatise, while introducing the heliocentric hypothesis, was even more concerned with the working out of orbits composed of circles upon circles, an aesthetic idea that would finally meet a dead end in the work of Johannes Kepler.

The observations that Copernicus needed to complete his work required patience, as slow-moving Jupiter and Saturn took many years to go from one set of critical positions to another. Finally, in the late 1530s, Copernicus had most of his information in hand, and he began in earnest to finish his treatise. Nevertheless, his manuscript might have languished in the cathedral library if not for the arrival of Georg Joachim Rheticus, a newly minted professor from the Lutheran University of Wittenberg. Rheticus quickly became an enthusiastic young disciple, and eventually he persuaded Copernicus to allow him to take a copy of the manuscript to Germany, where in Nuremberg Johannes Petreius had an establishment large enough to print a complex scientific work and to give it a wide international distribution. By April 1543 approximately five hundred copies were ready. Copernicus himself soon received the final pages, but only on the very day he died, at the age of seventy.

De revolutionibus orbium coelestium (Concerning the revolutions of the heavenly orbs) was promptly recognized as an important book, even though virtually all sixteenth-century astronomers suspended judgment on its controversial but unproven assumption of a sun-centered cosmos. As Copernicus had argued, "Only in this arrangement do we find a sure harmonious commensurability between the motion of the spheres and their size"—that is, swift Mercury naturally orbits closest to the sun, while Jupiter and Saturn automatically take their positions at the outskirts of the system. Eventually the aesthetic appeal of this arrangement took root, after Kepler and Galileo promoted it as a true description of physical reality.

Copernicus's *De revolutionibus* has had a high survival rate—a recent census lists more than 270 copies—but relatively few are in private hands, so the auction price for the book that started the scientific revolution now stands at half a million dollars or more. This copy, one of four of the first edition in the Los Angeles area, bears an interesting Latin testimonial on the back flyleaf: "Ephemerides coming from the Prutenic Tables, from the Copernican doctrine, are praiseworthy." *Owen Gingerich*

131

Scriptores astronomici veteres

Venice: Aldus Manutius, 1499
12⅜ x 8½ in. (31.4 x 21.6 cm)
Department of Special Collections,
Young Research Library, UCLA
(*A1 S43 1499)

132

ATTRIBUTED TO ANTONIO SANTUCCI

Armillary sphere, c. 1580

42 x 19 x 19 in. (106.7 x 48.3 x 48.3 cm);
The Huntington Library,
San Marino, California

133

JOHANNES KEPLER

De stella nova in pede Serpentarii

Prague: Paul Sessius, 1606
8 x 6⅜ in. (20.3 x 16.2 cm)
William Andrews Clark Memorial Library, UCLA
(*QB41.K38)

References
H. M. Adams, *Catalogue of Books Printed on the Continent of Europe, 1501–1600, in Cambridge Libraries* (London: Cambridge University Press, 1967), no. C2602; John Carter and Percy H. Muir, eds., *Printing and the Mind of Man: A Descriptive Catalogue Illustrating the Impact of Print on the Evolution of Western Civilization during Five Centuries* (London: Cassell and Company, 1967), no. 70.

Bibliography
Nicholas Copernicus, *On the Revolutions*, ed. Jerzy Dobrzycki, trans. Edward Rosen (Baltimore and London: Johns Hopkins University Press, 1992); Owen Gingerich, *The Eye of Heaven: Ptolemy, Copernicus, Kepler* (New York: American Institute of Physics, 1993); idem, *An Annotated Census of Copernicus' "De revolutionibus" (Nuremberg, 1543 and Basel, 1566)* (Leiden: Brill, 2001).

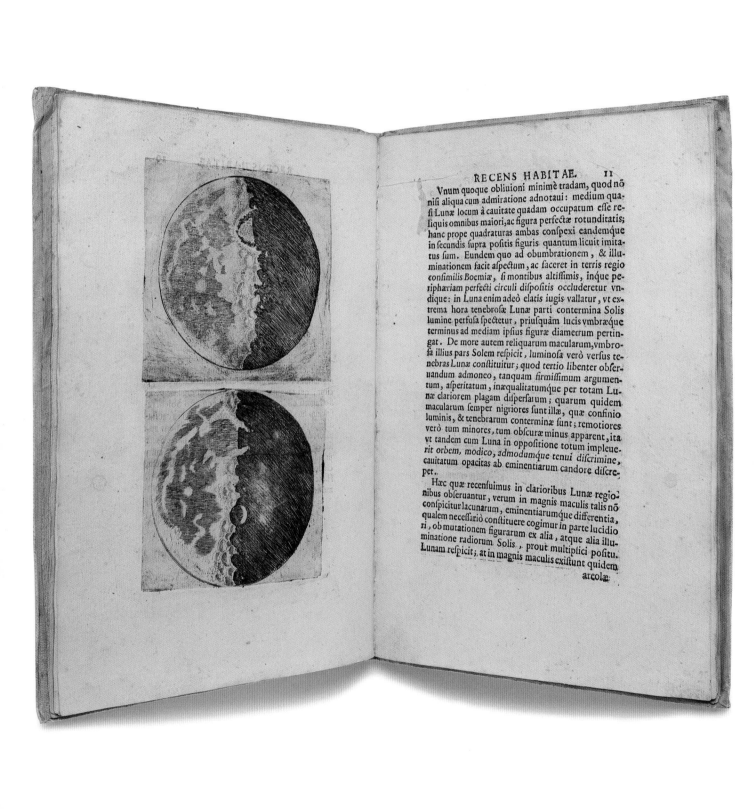

Vnum quoque obliuioni minimè tradam, quod nõ
nisi aliqua cum admiratione adnotaui: medium qua-
si Lunæ locum à cauitate quadam occupatum esse re-
liquis omnibus maiori, ac figura perfectæ rotunditatis;
hanc prope quadraturas ambas conspexi eandemque
in secundis supra positis figuris quantum licuit imita-
tus sum. Eundem quo ad obumbrationem, & illu-
minationem facit aspectum, ac faceret in terris regio
consimilis Boemiæ, si montibus altissimis, inque pe-
riphæriam perfecti circuli dispositis occluderetur vn-
dique: in Luna enim adeò elatis iugis vallatur, vt ex-
trema hora tenebrosæ Lunæ parti contermina Solis
lumine perfusa spectetur, priusquàm lucis vmbræque
terminus ad mediam ipsius figuræ diametrum pertin-
gat. De more autem reliquarum macularum, vmbro-
sa illius pars Solem respicit, luminosa verò versus te-
nebras Lunæ constituitur; quod tertio libenter obser-
uandum admoneo, tanquam firmissimum argumen-
tum, asperitatum, inæqualitatumque per totam Lu-
næ clariorem plagam dispersarum; quarum quidem
macularum semper nigriores sunt illæ, quæ confinio
luminis, & tenebrarum conterminæ sunt; remotiores
verò tum minores, tum obscuræ minus apparent, ita
vt tandem cum Luna in oppositione totum impleue-
rit orbem, modico, admodumque tenui discrimine,
cauitatum opacitas ab eminentiarum candore discre-
pet.

Hæc quæ recensuimus in clarioribus Lunæ regio-
nibus obseruantur, verum in magnis maculis talis nõ
conspicitur lacunarum, eminentiarumque differentia,
qualem necessariò constituere cogimur in parte lucidio-
ri, ob mutationem figurarum ex alia, atque alia illu-
minatione radiorum Solis, prout multiplici positu.
Lunam respicit; at in magnis maculis existunt quidem
areolæ

Quòd tertio loco à nobis fuit obſeruatum, eſt ipſiuſ-
met LACTEI Circuli eſſentia, ſeu materies, quam Per-
ſpicilli beneficio adeò ad ſenſum licet intueri, vt & alter-
cationes omnes,quæ per tot ſæcula Philoſophos excrucia
runt ab oculata certitudine dirimantur,noſque à verboſis
diſputationibus liberemur. Eſt enim GALAXYA nihil
aliud, quam innumerarum Stellarum coaceruatim conſi-
tarum congeries;in quamcunq; enim regionem illius Per-
ſpicillum dirigas,ſtatim Stellarum ingens frequentia ſe ſe
in conſpectum profert,quarum complures ſatis magnæ,ac
valde conſpicuæ videntur;ſed exiguarum multitudo pror-
ſus inexplorabilis eſt.

At cum non tantum in GALAXYA lacteus ille candor,
veluti albicantis nubis ſpectetur,ſed complures conſimilis
coloris areolæ ſparſim per æthera ſubfulgeant,ſi in illarum
quamlibet Specillum conuertas Stellarum conſtipatarum
cœtum

134

GALILEO GALILEI
Sidereus nuncius

Venice: Thomas Baglionus, 1610
9⅜ x 6¾ in. (23.8 x 17.4 cm)
Carnegie Observatories Collection
at the Huntington Library
(RB 487000.71)

Printed in an edition of 550 copies, Galileo's *Sidereus nuncius* (Starry messenger) is one of the most sought-after rarities among the milestones of science. After hearing rumors of an optical device that made distant objects appear closer, Galileo (1564–1642) reinvented and substantially improved the spyglass, converting it from a novel toy into a scientific instrument. Near the end of November 1609 he first turned his "optic tube" to the moon and was amazed to find a jagged edge where the sunlight was just grazing across a lunar landscape that he correctly interpreted as consisting of earth-like mountains and valleys. Six weeks later he examined the bright planet Jupiter and found it near a row of little stars; within a week he realized that the planet was actually accompanied in its motion by a retinue of four small companions. Shortly thereafter he uncovered the secret of the Milky Way: its glowing milkiness was the consequence of a dense background of faint stars unresolved by the unaided eye.

Armed with these spectacular discoveries, he rushed his findings into print within several weeks. "In this short treatise I propose great things for inspection and contemplation by every explorer of Nature," he declared, and in a letter to the Tuscan court he added, "God has made me alone the first observer of an admirable thing, kept hidden all these ages." Hoping to win a court appointment with Duke Cosimo de' Medici in his native Tuscany, he proposed naming the new satellites of Jupiter the "Cosmican Stars." When the duke's private secretary objected, pointing out that "Cosmican Stars" sounded too much like "cosmic stars" and that readers would fail to catch on, Galileo hastily changed the name to the "Medicean Stars." The scheme worked, and Galileo soon left his professorship in Padua to become "mathematician and philosopher" to Cosimo in Florence. As a philosopher, he was credentialed to move beyond mathematical hypotheses to conjectures as to how the universe was really arranged. Although none of the observations reported in his little book proved Copernicus's proposals, his *Sidereus nuncius* in fact became a stepping stone to his brilliant defense of the heliocentric system.

In only one place in the *Sidereus nuncius* did Galileo reveal his Copernican leanings. Some critics had argued that the earth could not possibly keep the moon in orbit around it as the earth itself circled the sun. But Galileo pointed out that Jupiter was performing this very trick. "This should give some pause to those who can't accept the heliocentric system on account of the moon," Galileo wrote, but he stopped short of endorsing the new cosmology.

Galileo chose to write his book of discoveries in Latin, seeking to gain an international audience. Very quickly the book was reprinted elsewhere, and he became a celebrity. But he published his later books in the vernacular Italian in order to persuade his countrymen of the power of mathematical science and of the reasonableness of the Copernican system. His *Dialogo sopra i due massimi sistemi del mondo, tolemaico e copernicano* (Dialogue concerning the two chief world systems, Ptolemaic and Copernican; cat. no. 135) of 1632 proved to be such a powerful defense of the heliocentric cosmos that for the rest of his life he was placed under house arrest by the Inquisition and forbidden to write further on cosmological topics. *Owen Gingerich*

135

GALILEO GALILEI
Dialogo sopra i due massimi sistemi del mondo, tolemaico e copernicano

Florence: Giovanni Battista Landini, 1632
8⅝ x 6¼ in. (21.9 x 15.9 cm)
Libraries of the Claremont Colleges,
Wilson Collection, Honnold/Mudd Library

136

JOHANNES HEVELIUS
Selenographia: Sive lunae descriptio

Danzig: The author, 1647
14 x 9⅛ in. (35.6 x 23.2 cm)
Department of Special Collections,
Young Research Library, UCLA
(SRLF H 000 007 718 0 / *QB29 H48s)

137

ANDREAS CELLARIUS
Harmonia macrocosmica

Amsterdam: Joannis Janssonius, 1661
19¾ x 11¾ in. (50.2 x 29.8 cm)
Carnegie Observatories Collection
at the Huntington Library
(RB 478000.1079)

138

JOHN FLAMSTEED
Atlas coelestis britannica

London, 1729
21⅛ x 15⅛ in. (54.6 x 38.4 cm)
William Andrews Clark Memorial Library,
UCLA (*ff QB65 F58 A8)

References
Dino Cinti, *Biblioteca galileiana raccolta dal principe Giampaolo Rocco di Torrepadula* (Florence: Sansoni, 1957), no. 26; Harrison D. Horblit, *One Hundred Books Famous in Science: Based on an Exhibition Held at the Grolier Club* (New York, 1961), no. 35; John Carter and Percy H. Muir, eds., *Printing and the Mind of Man: A Descriptive Catalogue Illustrating the Impact of Print on the Evolution of Western Civilization during Five Centuries* (London: Cassell and Company, 1967), no. 113.

Bibliography
Galileo Galilei, *Sidereus Nuncius; or, The Sidereal Messenger*, trans. Albert Van Helden (Chicago: University of Chicago Press, 1989).

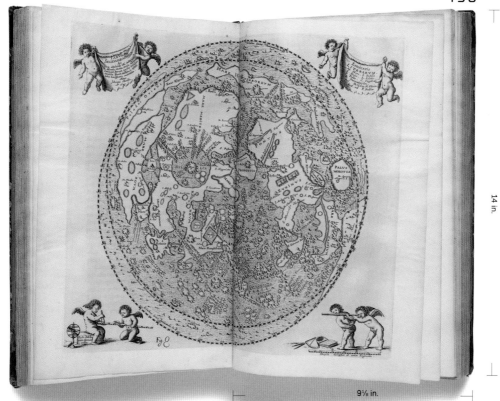

14 in.

9⅛ in.

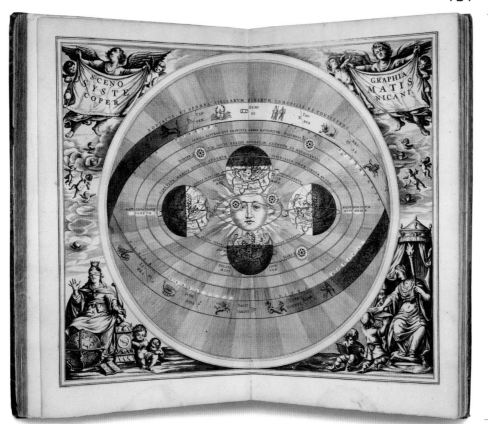

19¾ in.

11¾ in.

Johannes Hevelius
Selenographia: Sive lunae descriptio, 1647

A book about the moon's topography

Andreas Cellarius
Harmonia macrocosmica, 1661

A celestial atlas

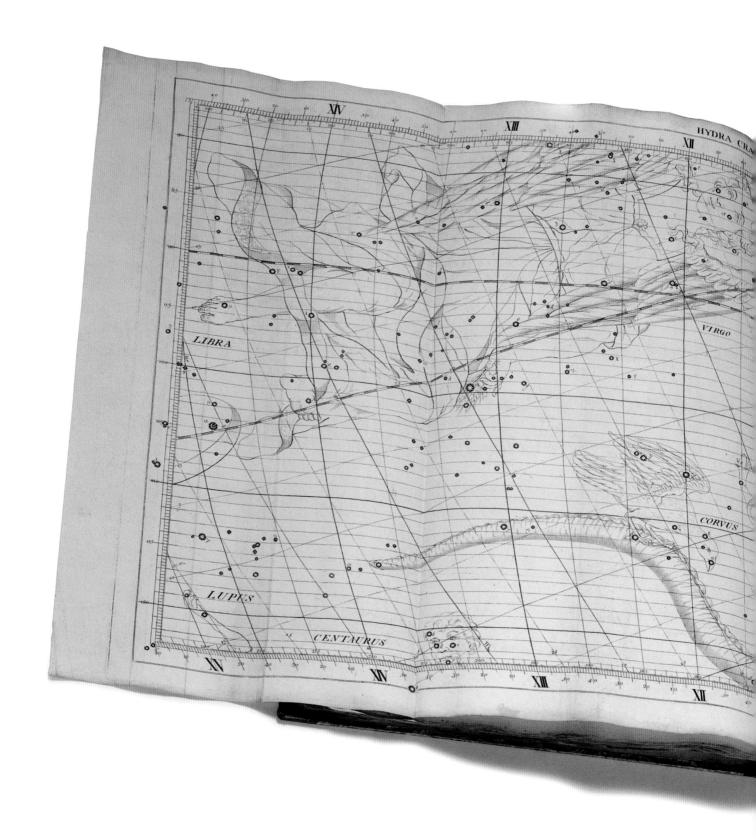

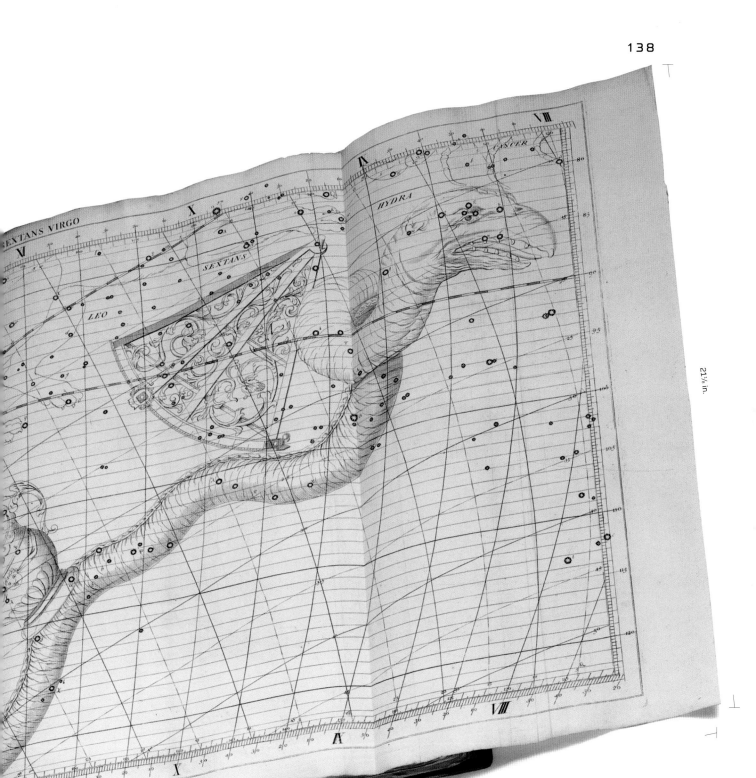

John Flamsteed
Atlas coelestis britannica, 1729

Star maps based on four decades of observations

14 in.

10⅜ in.

8 in.

10 in.

Julia Margaret Cameron
Sir John Herschel, 1867

A portrait of the nineteenth-century astronomer
by an important Victorian photographer

**Albert Einstein, Edwin Hubble, and Walter Sidney
Adams at Mount Wilson Observatory**, 1931

139

JULIA MARGARET CAMERON

Sir John Herschel, 1867

Albumen print; 14 x 10⅞ in. (35.6 x 27.8 cm)
Department of Special Collections,
Young Research Library, UCLA (***98 #9)

140

**Albert Einstein, Edwin Hubble,
and Walter Sidney Adams
at Mount Wilson Observatory**, 1931

Copy print; 8 x 10 in. (20.3 x 25.4 cm)
Carnegie Observatories Collection
at the Huntington Library (HUB 1057)

141

ISAAC NEWTON

**Philosophiae naturalis
principia mathematica**

London: Royal Society and Joseph Streater, 1687
9⅞ x 7⅝ in. (25.1 x 19.4 cm)
William Andrews Clark Memorial Library,
UCLA (*Q143 N506)

The world of scientific publishing has altered radically since Newton's time, indeed since Darwin's time. The article has replaced the book. Yet the fact remains that within the genre of the book the *Philosophiae naturalis principia mathematica* (Mathematical principles of natural philosophy), known as the *Principia*, is in a class by itself. When it appeared in 1687, there were about a dozen natural philosophers in Europe who possessed the mathematical skills needed to follow Newton's explications in mechanics and celestial dynamics. Even John Locke wrote to Christiaan Huygens asking him to confirm that the mathematical proofs worked. Once it was clear that they did, progressive thinkers seized upon the book as unlike any before it: the *Principia* proved that knowable laws governed the movements of the heavens, from the planets and the moon to comets. Building on Galileo's work, combined with Kepler's, Newton had produced a work of unprecedented power with implications for all of human thought.

If there are laws in the heavens, if mathematical order governs nature, what are the implications for the works of human nature, for society and government? Newton told his close followers that he wanted his design of the world, as revealed in the *Principia*, to demonstrate the majesty and power of God. Indeed the *Principia* was also distinctive in its time because its contents were explained from Anglican pulpits, and a genre of religious thought immediately emerged, which came to be known as physico-theology.

Within two decades, by contrast, freethinkers had taken up Newton's science to argue that nature is, in effect, God. Newton's piety was deeply offended, and his followers spent much ink and oratory shoring up the Newtonian theology inspired by this great book. Newton chose to write in Latin to make his text as inaccessible as possible to controversy. (The use of Latin, borrowed from Catholic practice, was intended to suggest that nothing in the book was meant to contradict revealed religion.) Newton's friend Edmond Halley, who is credited with getting him to write it, added an ode as a preface intended to flatter King James II. The king's Catholicism had the Royal Society deeply worried, and it added its imprimatur to the title page. None of this maneuvering seemed to impress a king whose dismal future unfolded with the Revolution of 1688, which resulted in his deposition. Newton sided with the revolution, briefly served in Parliament, and witnessed his clerical friends become leaders within the pro-revolution wing of the Church of England. From the pulpit of St. Martin-in-the-Fields in London, Newton's followers, most notably Richard Bentley, proudly explicated the *Principia* in sermons that were unlike any ever heard in a church before.

"Newtonian" became an appellation both in England and on the Continent. The name came to stand for being on the cutting edge in science and even being pro-English in matters of custom and politics. One of the French Newtonians, Gabrielle Emilie du Châtelet, published a translation of the *Principia* in 1759 that remains to this day the only version of the text in French. Recently a team of scholars led by I. Bernard Cohen published a new and revised English translation with extensive notes. The Clark Library's copy, which bears the earlier form of the imprint, was acquired in 1937 from the Los Angeles bookseller Jake Zeitlin.
Margaret C. Jacob

References
Henry P. Macomber, *A Descriptive Catalogue of the Grace K. Babson Collection of the Works of Sir Isaac Newton* (New York: H. Reischner, 1950), no. 10; G. J. Gray, *A Bibliography of the Works of Sir Isaac Newton*, 2d ed., rev. and enl. (London: Dawsons, 1966), no. 6; Donald Wing, *Short-Title Catalogue of Books Printed in England, Scotland, Ireland, Wales, and British America, and of English Books Printed in Other Countries, 1641–1700* (New York: Index Committee of the Modern Language Association of America, 1972–98), no. N1048.

Bibliography
John Herivel, *The Background to Newton's "Principia"* (Oxford: Clarendon Press, 1965); Margaret C. Jacob, *Scientific Culture and the Making of the Industrial West* (New York: Oxford University Press, 1997); Isaac Newton, *The Principia: Mathematical Principles of Natural Philosophy*, trans. I. Bernard Cohen and Anne Whitman (Berkeley and Los Angeles: University of California Press, 1999).

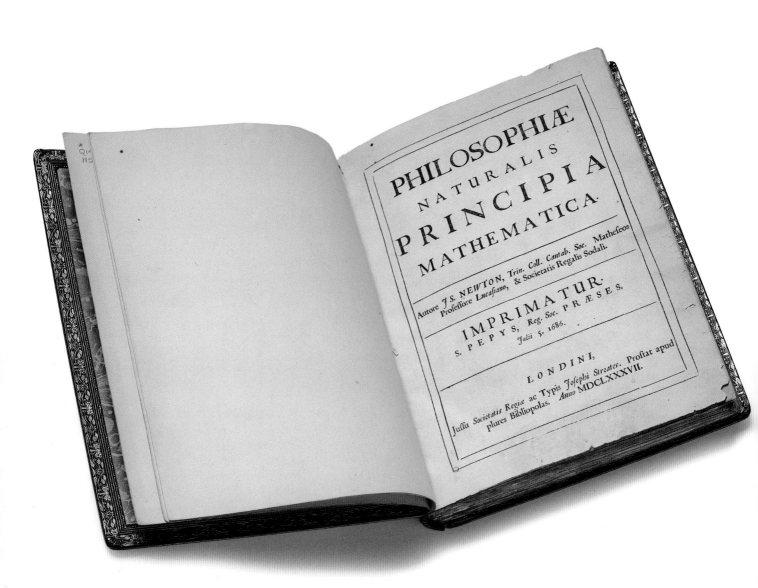

PHILOSOPHIÆ
NATURALIS
PRINCIPIA
MATHEMATICA.

Autore JS. NEWTON, Trin. Coll. Cantab. Soc. Matheseos Professore Lucasiano, & Societatis Regalis Sodali.

IMPRIMATUR.
S. PEPYS, Reg. Soc. PRÆSES.
Julii 5. 1686.

LONDINI,

Jussu Societatis Regiæ ac Typis Josephi Streater. Prostat apud plures Bibliopolas. Anno MDCLXXXVII.

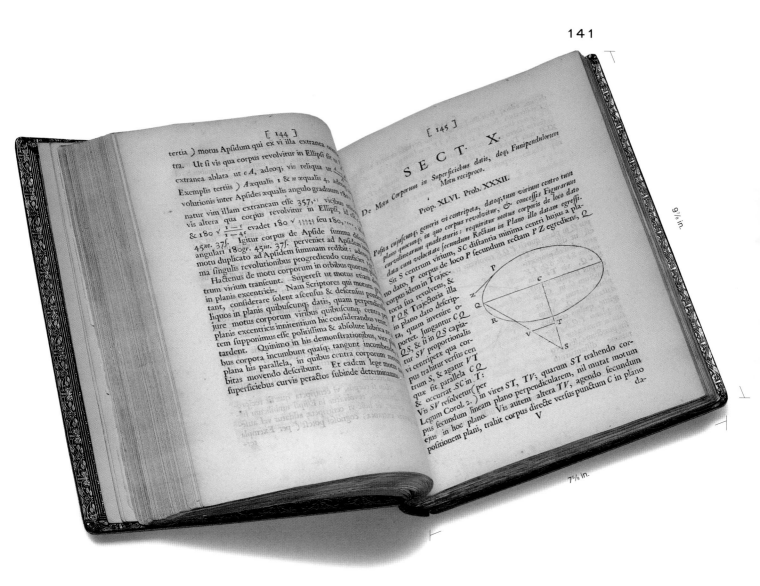

9⅝ in.

7⅝ in.

Isaac Newton
**Philosophiae naturalis
principia mathematica**, 1687

One of the most important scientific books
ever published

Fornax in qua opus secernendi perficitur A. Fornax in qua non perfici-
tur B. Catinus C. Catilli D. Panes E. Spinæ F.

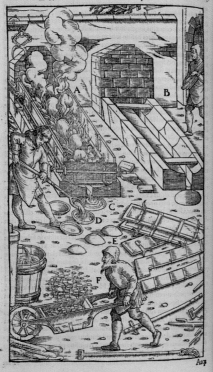

Atq;

Atq; argenti quidem, siue plumbi cum argento permisti, quod stannum
appellamus, ab ære secernendi hæc ratio est. Stannum uerò in secundas for-
naces insertur, in quibus plumbū ab argento separatur; de qua ratione, q̄d
eam proximo libro pluribus uerbis exposui, unum illud dicam. Apud nos
abhinc aliquot annos stanni tantummodo quatuor & quadraginta centū-
pondia, & æris unum simul in secundis fornacibus fuerunt cocta, nunc stan
ni sex & quadraginta, æris unum & dimidium coquuntur:alibi uerò stanni
plerunq; centum & uiginti, æris sex: quo modo spumæ argenti centūpon-
dia plus minus centū & decem, molybdænæ triginta conflantur. Omnibus
autem his modis argentum, quod inest in ære iniecto, cum reliquo argento
permiscetur, ipsum æs, æque ac plumbum, partim in argenti spumam, par-
tim in molybdænam mutatur. Stannum, quod non liquescit, è margine in
catinum conto uncinato trahatur. At munus torrendi, in quatuor operas
distribuitum, quatuor perficiatur diebus. Primò, ut etiam cæteris tribus, ma-
gister mane hora quarta ordiatur, & unà cum ministro stirias è panibus fa-
gnificentibus decutiat, & hos aduehat ad fornacem, illas auectas spinis super
inijciat. Malleus uerò longus sit palmos tres & totidem digitos, acuta eius
pars lata palmum, teres crassa digitos tres, manubrium ligneum longū qua-
tuor pedes.

Penes A. Malleus B.

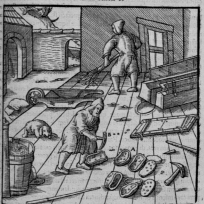

Deinde

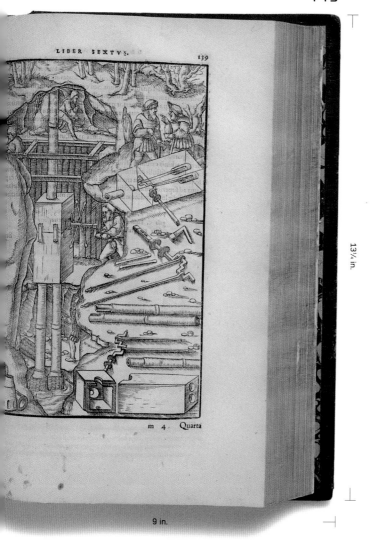

142

DENIS DIDEROT ET AL.

Encyclopédie; ou, Dictionnaire raisonné des sciences, des arts, et des métiers

Paris: Briasson, 1751–65
16 x 10½ in. (40.6 x 26.7 cm)
California State University, Long Beach,
University Library, Special Collections
(AE 25 E53)

143

GEORGIUS AGRICOLA

De re metallica

Basel: J. Froben and N. Episcopius, 1556
13¾ x 9 in. (33.7 x 22.9 cm)
Libraries of the Claremont Colleges,
The Hoover Collection, Special Collections,
Honnold/Mudd Library

Georgius Agricola's remarkable book *De re metallica* (On the subject of metals) attests to a unique moment in sixteenth-century Europe, when a society dominated by agrarian rhythms and natural values, one whose knowledge was derived from classical authorities, gave way to a new world of technological innovation and capitalist merchant ventures.

Georg Bauer (1494–1555), the son of a dyer and woolen draper, was born in Glauchau, Saxony, in the midst of an extraordinary mining boom in the nearby towns of Chemnitz, Zwickau, and Freiberg and in neighboring Bohemia. After matriculating at the late age of twenty at Leipzig University, he taught Greek until 1523 there and at Zwickau, where he published his first scholarly work, on teaching Greek grammar. By this time he had begun to call himself Agricola, a Latin translation of *Bauer* (peasant farmer), a common practice among humanist scholars wishing to emulate classical Greek and Roman models. By 1526 he had obtained his medical degree at Bologna and had steeped himself in the new methods of humanist philology, assisting in editing Galen and Hippocrates at the press of Aldus Manutius in Venice. Agricola returned to Germany in 1526, married the widow of a mining official from Schneeberg, and in spring 1527 became town physician of Sankt Joachimsthal (now Jáchymov, Czech Republic).

In 1527 Sankt Joachimsthal was a busy mining boomtown in the Erzgebirge. Ore deposits had been discovered only eleven years earlier, but the town had already grown to several thousand inhabitants. In his medical practice and in the material conditions of his life, Agricola was confronted with a world for which his training in ancient languages and classical medical authors offered little preparation. From

1460 until the 1550s (when New World silver brought down the value of precious metals), the princes and merchants of central Europe enjoyed a tremendous surge in prosperity fueled by innovations in mining. Silver production increased fivefold in this period. Although silver had been mined in central Europe since ancient times, the turning point came in the 1450s, when the technique of separating silver from copper ores by means of lead was introduced into central Europe. This made profitable the greater capital investment in the machinery needed for digging deep shafts to follow rich veins and the new methods of drainage and ventilation that made these shafts possible. Simultaneously the rediscovery of the blast furnace allowed more effective cast-iron tools for digging and breaking up the ore to be produced at a lower cost. Independent partnerships of miners and smelters gave way to managers operating mines on behalf of absentee shareholders, including nobles, large merchants, even monasteries and universities.

Agricola responded to these new conditions by studying miners' diseases and the remedies advocated by his contemporaries. He visited smelters and read the books of metallurgists as well as the works of alchemists, but he always returned to the classical authors in an effort to connect his world to that of the ancients. In 1530 he apparently bought shares in a newly discovered mine in Albertham, which provided him with a handsome return for the rest of his life. He resigned his position as city physician and began publishing a series of works on metals, mining, and subterranean processes. In about 1533, at the same time he became town physician of Chemnitz, he began work on *De re metallica*, but it did not appear until 1556, the year after his death. The delay was caused in part by his involvement in politics during the last nine years of his life. In 1546 Maurice, duke of Saxony, appointed him burgomaster of Chemnitz. Agricola assisted the duke in a

References

Georgius Agricola, *Ausgewählte Werke*, 12 vols., ed. Hans Prescher (Berlin: VEB Deutscher Verlag der Wissenschaften, 1955–71); Harrison D. Horblit, *One Hundred Books Famous in Science: Based on an Exhibition Held at the Grolier Club* (New York, 1961), no. 26; H. M. Adams, *Catalogue of Books Printed on the Continent of Europe, 1501–1600, in Cambridge Libraries* (London: Cambridge University Press, 1967), no. A349; John Carter and Percy H. Muir, eds., *Printing and the Mind of Man: A Descriptive Catalogue Illustrating the Impact of Print on the Evolution of Western Civilization during Five Centuries* (London: Cassell and Company, 1967), no. 79; *The Herbert Clark Hoover Collection of Mining and Metallurgy, Bibliotheca de Re Metallica*, annotated by David Kuhner, catalogue by Tania Rizzo, introduction by Cyril Stanley Smith (Claremont, Calif.: Libraries of the Claremont Colleges, 1980), no. 17.

secret pact with Emperor Charles V and was honored by the dukes of Saxony until the end of his life. Interestingly, they urged him not to publish *De re metallica*, but rather to have it translated into German and keep it secret (presumably while its usefulness to the territory could be assessed).

De re metallica, like most of Agricola's books, was published by the leading humanist press in northern Europe, Froben in Basel. Like all Agricola's works, it reflects his desire to reconcile ancient ideas and values—most notably the classical valuation of agriculture as the highest form of livelihood—with contemporary realities. He modeled *De re metallica*'s twelve books on mining on the Roman author Moderatus Columella's twelve books on agriculture, *De re rustica*. Agricola defended mining against the charges that it was *sordidum*—demeaning, dirty manual labor—by emphasizing the knowledge and dignity required of the miner, and that it was *fortuitum*, or risky, by explaining that shareholding allowed for allocation of risk and that mining had historically offered high returns and, especially, by providing the knowledge of mining that the shareholder needed in order to understand and assess his investment. Mining was, he insisted, more profitable than agriculture and far less risky and more honorable than commerce.

In *De re metallica*, Agricola succeeded in establishing a continuity between the ancient world and his own, inventing Latin words for the new mining terms, for example. But he also asserted the superiority of his own effort: "I have not only described [the tools and processes of mining], but have also hired illustrators to delineate their forms, lest descriptions which are conveyed by words should either not be understood by men of our own times, or should cause difficulty to posterity, in the same way as to us difficulty is often caused by many names which the Ancients . . . have handed down to us without any explanation." Indeed, the remarkable woodcut illustrations by Blasius Weffring of Sankt Joachimsthal, which complemented Agricola's own vivid verbal descriptions, would go on to be reprinted numerous times into the seventeenth century. Agricola also insisted that the new methods were necessary in cases where there were no ancient precedents: "I have omitted all those things which I have not myself seen, or have not read or heard of from persons upon whom I can rely." In his desire for both literary and observational authenticity and accuracy, he revealed himself caught in a moment of transition from a world rooted in ancient tradition—newly re-created by the philological techniques of humanism—to a world of capital and industry powered by technological innovation.

When the future mining engineer and U.S. president Herbert Clark Hoover and his bride-to-be, Lou Henry, were at Stanford University in the 1890s, they were shown a copy of Agricola's *De re metallica* by their geology professor. After they finished their degrees at Stanford, married, and settled in London in 1901, they decided to translate the book into English, with Lou providing the translation from Latin and Herbert the extensive technical annotations. Their fine translation appeared in 1912, and about the same time, they set about acquiring a collection of early works on metallurgy and mining. This first edition of *De re metallica* was their initial acquisition and remained the centerpiece of their library. After President Hoover's death, the collection remained in the house of his son Herbert "Pete" Hoover Jr. in Pasadena and then was stored in the basement of the Huntington Library. In 1970 Hoover's library was given to the Honnold Library of the Claremont Colleges, which had been endowed by the mining engineer William Lincoln Honnold, a close friend of President Hoover, and was housed in the library of Harvey Mudd College, named for another mining engineer friend of the president.
Pamela H. Smith

144
EUCLID
Elementa
Venice: Erhard Ratdolt, 1482
11^{15}/$_{16}$ x 8^{9}/$_{16}$ in. (30.3 x 21.7 cm)
Libraries of the Claremont Colleges,
The Hoover Collection, Honnold/Mudd Library

145
EUCLID
Elements of Geometrie
London: John Day, 1570
13 x 9 in. (33 x 22.9 cm)
William Andrews Clark Memorial Library,
UCLA (*fQZ31 E86 1570)

Bibliography
Helmut M. Wilsdorf, "Georgius Agricola," in *Dictionary of Scientific Biography*, ed. C. G. Gillispie (New York: Scribner's, 1970), vol. 1, 77–79; Jon U. Nef, "Mining and Metallurgy in Medieval Civilisation," in *The Cambridge Economic History of Europe*, vol. 2, *Trade and Industry in the Middle Ages*, 2d ed., ed. M. M. Postan and Edward Miller, assisted by Cynthia Postan (Cambridge: Cambridge University Press, 1987); Georgius Agricola, *Briefe und Urkunden*, ed. Ulrich Horst and Hans Prescher (Heidelberg: Hüthig, 1992); Owen Hannaway, "Georgius Agricola as Humanist," *Journal of the History of Ideas* 53 (1992): 553–60; Bernd Ernsting, ed., *Georgius Agricola: Bergwelten, 1494–1994* (Essen: Glückauf, 1994); Friedrich Naumann, ed., *Georgius Agricola: 500 Jahre* (Basel: Birkhäuser, 1994).

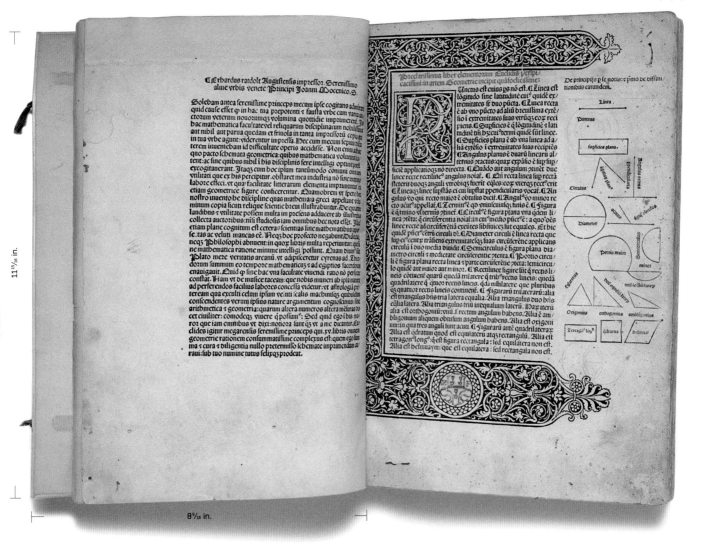

Euclid
Elementa, 1482

The first printed edition of Euclid's geometry

13 in.

9 in.

The eleuenth Booke

Sixth diffinition.

6 *Parallell plaine superficieces are those, which being produced or extended any way neuer touch or concurre together.*

Neither needeth this definition any declaration, but is very easie to be vnderstanded by the definition of parallel lines : for as they being drawen on any part, neuer touch or come together : so are plaine superficieces such, which admitte no touch, that is, being produced any way infinitely neuer meete or come together.

Seuenth diffinition.

7 *Like solide or bodily figures are such, which are contained vnder like plaine superficieces, and equall in multitude.*

What plaine superficieces are called like, hath in the beginning of the sixth booke, bene sufficiently declared . Now when solide figures or bodies be contained vnder such like plaine superficieces as there are defined, and equall in number, that is, that the one solide haue as many in number as the other, then their sides and limites : they are called like solide figures, or like bodies.

Eighth diffinition.

8 *Equall and like solide (or bodely) figures are those which are contained vnder like superficieces, and equall both in multitude and in magnitude.*

In like solide figures it is sufficient, that the superficieces which containe them be like and equall in number onely, but in like solide figures and equall, it is necessary that the like superficieces containyng them, be also equall in magnitude. So that besides the likenes betwene them, they be, as the latter compared to his correspondent superficies of one greatnes, and that their areas or sides be equall. When such superficieces contayne bodies or solides, then are such bodies equall and like solides or bodies.

Ninth diffinition.

9 *A solide or bodily angle, is an inclination of moe then two lines which touch themselues mutually, and are not in one and the selfe same superficies.*

Or els thus : *A solide or bodily angle is that which is contained vnder moe then two playne angles, not being in one and the selfe same plaine superficies, but consisting all at one point.*

Of a solide angle doth Euclide here geue two seuerall definitions. The first is geuen by the touch and touch of many lines. The second by the touch & concurse of many superficiall angles. But these definitions tende to one, and are not much different, for that lynes are the limites and immediate superficieces are the next and immediate limites of bodies, and so are not lines. An example of such a solide angle cannot wel and at fully be geuē or described in a plaine superficies. But touching this definition, lay before you a cube or a die, and consider any of the corners or angles thereof, so that ye see that euery angle there concurre three lines (for two lines cōcurring cannot make a solide angle) namyng, the edge of his breadth, of his length, and of his thicknes, which their so inclining & concurring the maketh a solide angle, and so of others. And now concerning the second definitiō, what superficiall plaine angles be, hath bene taught before in the first booke, namely, that it is the touch of two right lines. And as a superficiall or playne angle is caused & contained of right lines, so is a solide angle contained or contayned of plaine superficiall angles. Two right lines touching together, make a plaine angle, but moe then two as three, foure, fiue, or moe : which also must not be in one & the selfe same superficies, but must be in diuers superficieces, meeting at one point. This definition is so hard, but may easily be cōceiued in a cube or a die, where ye see three angles of any three superficieces or sides of the die to concurre and meete together in one point, which three plaine angles so ioyned together, make a solide angle. Likewise in a Pyramis or a figure of a steeple or any other such thing, all the sides thereof rising vp

Tenth diffinition.

10 *A Pyramis is a solide figure contained vnder many playne superficieces set vpon one playne superficies, and gathered together to one point.*

[dense right-column text largely illegible in reproduction]

Euclid
Elements of Geometrie, 1570

The first English edition of Euclid
with three-dimensional illustrations

Claudio de Domenico Celentano de Vallis Nova
Alchemical manuscript,
17th or 18th century

An illustrated alchemical manuscript

146

GEORGE RIPLEY

Ripley Scroll, 16th century

Manuscript (watercolor on laid paper
applied to canvas); 18 x 237 in. (45.7 x 602 cm)
Library, Getty Research Institute, Manly Palmer
Hall Collection of Alchemical Manuscripts,
1500–1825 (950053)

147

CLAUDIO DE DOMENICO CELENTANO
DE VALLIS NOVA

Alchemical manuscript

Italy, 17th or 18th century
11½ x 8¼ in. (29.2 x 20.9 cm)
Library, Getty Research Institute,
Manly Palmer Hall Collection
of Alchemical Manuscripts, 1500–1825
(950053)

148

ROBERT HOOKE

**Micrographia; or, Some Physiological
Descriptions of Minute Bodies Made by
Magnifying Glasses**

London: Printed by J. Martyn and J. Allestry, 1665
12¹³⁄₁₆ x 8¼ in. (31 x 21 cm)
University of Southern California,
Archival Research Center, Hancock Collection
(fQH271.H79 1665)

through so many scourings, washings, dressings and dryings, as the parts of old Paper must necessarily have suffer'd; the digestive faculty, it seems, of these little creatures being able yet further to work upon those stubborn parts, and reduce them into another form.

And indeed, when I consider what a heap of Saw-dust or chips this little creature (which is one of the teeth of Time) conveys into its intrals, I cannot chuse but remember and admire the excellent contrivance of Nature, in placing in Animals such a fire, as is continually nourished and supply'd by the materials convey'd into the stomach, and *fomented* by the bellows of the lungs; and in so contriving the most admirable fabrick of Animals, as to make the very spending and wasting of that fire, to be instrumental to the procuring and collecting more materials to augment and cherish it self, which indeed seems to be the principal end of all the contrivances observable in bruit Animals.

Observ. LIII. *Of a Flea.*

THe strength and beauty of this small creature, had it no other relation at all to man, would deserve a description.

For its strength, the *Microscope* is able to make no greater discoveries of it then the naked eye, but onely the curious contrivance of its leggs and joints, for the exerting that strength, is very plainly manifested, such as no other creature, I have yet observ'd, has any thing like it; for the joints of it are so adapted, that he can, as 'twere, fold them short one within another, and suddenly stretch, or spring them out to their whole length, that is, of the fore-leggs, the part A, of the 34. *Scheme,* lies within B, and B within C, parallel to, or side by side each other; but the parts of the two next, lie quite contrary, that is, D without E, and E without F, but parallel also; but the parts of the hinder leggs, G, H and I, bend one within another, like the parts of a double jointed Ruler, or like the foot, legg and thigh of a man; these six leggs he clitches up altogether, and when he leaps, springs them all out, and thereby exerts his whole strength at once.

But, as for the beauty of it, the *Microscope* manifests it to be all over adorn'd with a curiously polish'd suit of *sable* Armour, neatly jointed, and beset with multitudes of sharp pinns, shap'd almost like Porcupine's Quills, or bright conical Steel-bodkins; the head is on either side beautify'd with a quick and round black eye K, behind each of which also appears a small cavity, L, in which he seems to move to and fro a certain thin film beset with many small transparent hairs, which probably may be his ears; in the forepart of his head, between the two fore-leggs, he has two small long jointed feelers, or rather smellers, M M, which have four joints, and are hairy, like those of several other creatures; between these, it has a small *proboscis*, or *probe*, N N O, that seems to consist of a

tube,

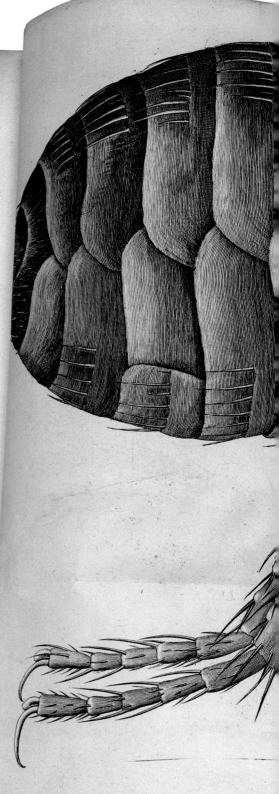

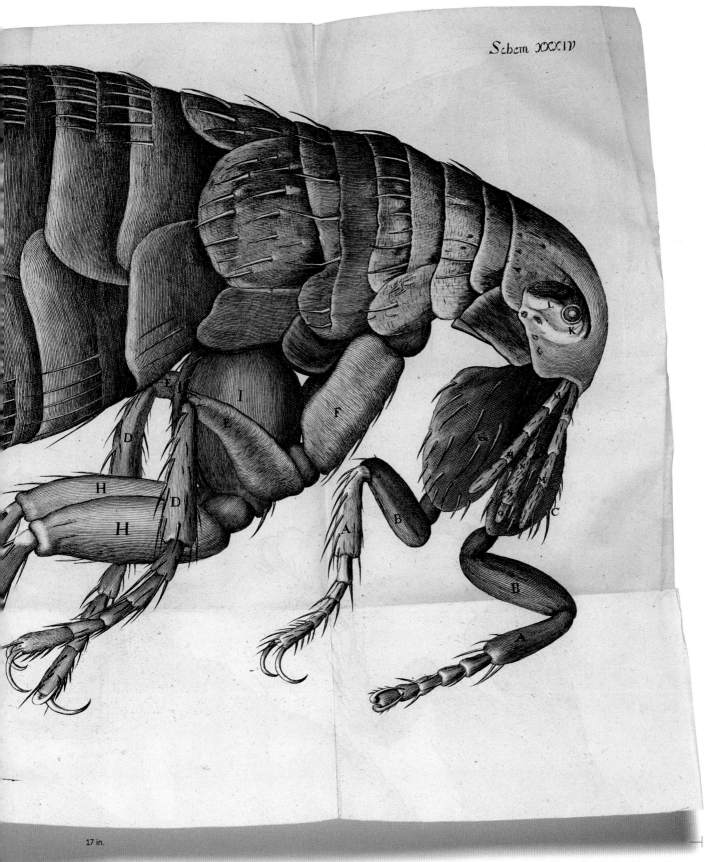

Robert Hooke

Micrographia; or, Some Physiological Descriptions of Minute Bodies Made by Magnifying Glasses, 1665

One of the earliest books with engravings based on microscopic observations

149

PLINY THE ELDER

Historia naturalis

Venice: Johannes de Spira, 1469
16⅛ x 11½ in. (41 x 29.2 cm)
The Huntington Library, San Marino,
California (RB 105162)

Pliny's *Historia naturalis* (Natural history) is a grand treasure trove of the ancient Roman world as it was not long after the birth of Christ, a book greatly beloved and esteemed in the Renaissance for its seemingly endless number of fascinating details about animals, plants, and foreign lands. Especially in Italy, it was an obvious candidate to bring out in the new medium of print, as Johannes de Spira so sumptuously did at Venice in 1469. De Spira was the first printer in Venice, and his edition of Pliny is the *editio princeps*.

Pliny himself was neither a naturalist nor an explorer by occupation, but rather a high official of the vigorously expanding Roman Empire who spent his free moments reading and collecting information—a praiseworthy combination of the civic and the scholarly life that would well have appealed to Renaissance humanists. Born Gaius Plinius Secundus at Como in northern Italy in A.D. 23 or 24, he is usually called Pliny the Elder to distinguish him from his nephew and ward, the epistolary author Gaius Plinius Caccilius Secundus (Pliny the Younger). He came from a wealthy family, seems in his youth to have been at court during the principate of Caligula, practiced law, and had three tours of military service in Germany. He apparently retired from public life during the reign of Nero, whom he despised as luxury loving and degenerate. Pliny resuscitated his career under Vespasian and seems to have spent the last ten years of his life as a procurator in what is now Belgium, France, Spain, and North Africa. His death was an apposite mixture of officialdom and

science. He was in command of the fleet at Misenum, on the Bay of Naples, in August of A.D. 79, when Vesuvius began to erupt. Both to help friends and to investigate the outbreak more closely, Pliny sailed across the bay and was killed by fumes when the volcano exploded.

Although Pliny wrote works on throwing the javelin from horseback, on the German wars, on the education of an orator, and on Latin grammar, the *Historia naturalis* is the only one to survive. It is divided into thirty-seven books. After a highly detailed table of contents (book 1), the books treat the heavens and the earth (2), the lands of the known world (3–6), and human reproduction and characteristics (7). It is indicative of Pliny's collector's mentality that he gives us totals for the geography subjects: "1,195 towns, 576 races, 115 famous rivers, 38 famous mountains, 108 islands, 95 extinct towns and races, 2,214 facts and investigations and authorities."

Pliny hits his stride as he comes to the natural world. His books on animals (8–11) are among his most famous, filled with details about species ranging from elephants, serpents, bison, panthers, and tigers, down to insects such as gnats and ants. His presentation exemplifies perfectly his belief that nothing in nature is unworthy of study. Plants take up even more space, as he records massive detail about wild and cultivated trees (12–17) as well as field crops (18–19). These collections are in turn dwarfed by the lengthy books on plant medicines (20–27). As a patriotic Roman of a distinctly Stoic cast, Pliny was suspicious of Greek intellectual arrogance and especially of the subtleties and potential destructiveness of Greek medicine. His detailed

exposition of medicinal plants was meant to reinforce the simple empiricism of Roman herbal practice and to defend its efficacy and dignity. Herbals can rightly be supplemented, he thought, with drugs derived from animals, both terrestrial and aquatic (28–32). He closes with books on metals (33–34), on the materials used in painting and sculpture (35–36), and of the profusion of stones and gems (37).

In assembling this stupendous collection of "facts and observations," Pliny seldom "investigated" the world in the sense that the naturalists who would come on the European scene post-1600 did. As the younger Pliny's fond verbal portrait of his uncle shows, the elder Pliny loved to collect his facts out of other books. He would rise early before his official duties to read and abstract authors. A slave would read to him in the baths, or on horseback, and he would dictate notes as he soaked or rode. Never was a moment to be wasted. For each book in the *Historia naturalis* he proudly lists the scores of authors from whose works the facts had been culled. Post-Renaissance writers often criticized Pliny for his credulity and fondness for wondrous tales, yet the twentieth century has confirmed a number of exotic "facts" that formerly seemed farfetched. Most of all, as Europe expanded into the so-called New World—and even California—during the Renaissance, Pliny continued to serve as a model for both the savant and his subject. He embodied upright behavior, indefatigable curiosity, respect for the diversity of nature, an anthropocentric belief that it was created for man to explore, and a capacity for absorbing ever-expanding knowledge.
Robert G. Frank Jr.

References
Dietrich Reichling, *Appendices ad Hainii-Copingeri Repertorium Bibliographicum* (Munich: Rosenthal, 1905–11), no. 13087; *Catalogue of Books Printed in the Fifteenth Century Now in the British Museum* (London: British Museum, 1908–), vol. 5, 153; Frederick R. Goff, *Incunabula in American Libraries: A Third Census* (New York: Bibliographical Society of America, 1964), P-786; John Carter and Percy H. Muir, eds., *Printing and the Mind of Man: A Descriptive Catalogue Illustrating the Impact of Print on the Evolution of Western Civilization during Five Centuries* (London: Cassell and Company, 1967), no. 5.

Bibliography
The *Historia naturalis* is available in ten volumes of translation, with facing Latin and English texts, in the Loeb Classical Library (Cambridge: Harvard University Press, 1938–49); Roger French and Frank Greenaway, eds., *Science in the Early Roman Empire: Pliny the Elder, His Sources and Influence* (London: Croom Helm, 1986); Mary Beagon, *Roman Nature: The Thought of Pliny the Elder* (Oxford: Clarendon Press, 1992).

C. PLINII CAECILII VITA EX SEXTO RVFO.

PLINIVS secundus nouocomensis equestribus militiis industriȩ functus: procu-
rationes quoqȝ splendidissimas atqȝ continuas summa integritate administrauit. Et
tamen liberalibus studiis tantam operam dedit: ut non temere qs plura inotio scripserit.
Itaqȝ bella omnia quȩ undiqȝ cum romanis gesta sunt. xxxvii. uoluibus comprehendit. Itḗ
naturalis historiȩ. xxxvii. libros absoluit. Periit gadis campaniȩ. Nam cum misenési classi
prȩesset & flagrante Veseuo: ad explorandas propius causas liburnicas prȩtendisset: neqȝ
aduersantibus uentis remeare posset: ui pulueris ac fauillȩ oppressus est: uel ut quidam
existimant a seruo suo occisus: quḗ deficiens ȩstu ut necem sibi maturaret orauerat hic in
his libris. xx. milia reȝ dignaȝ ex lectione uoluminú circiter duum milium cóplexus est.
Primus aút liber quasi index. xxxvi. libroȝ sequentium consumationem totius operis &
species continet tituloȝ.

C. PLINII VERONENSIS ORATORIS
HISTORIAE NATVRALIS LIBER I

IBROS NATVRALIS HISTORIAE
nouitiú campnis qritiú tuoȝ opus natú apud me
proxima fȩtura licentiore epistola narrare cóstitui
tibi iocúdissime imperator. Sit enim hȩc tui prȩ-
fatio uerissima: dum maxime consenescit i patre.
Namqȝ tu solebas putare esse aliqd meas nugas:
ut obicere moliar Catullum conterraneú meum
agnoscis & hoc castrȩse uerbum: ille enim ut scis
pmutatis prioribus syllabis duriusculum se fecit
q̄ uolebat existimari a uernaculis tuis & famulis.
Simul ut hac mea petulantia fiat qȝ proxime non
fieri questuses in alia procaci epistola nostra ut in
quȩdam acta exeant. Sciantqȝ omnes q̄m exȝquo
tecum uiuat iperium triumphalis & censorius tu
sexiesqȝ cósul ac tribunitiȩ potestatis particeps: et
qȝ iis nobilius fecisti: dú illud patri pariter& equeſ
tri ordini prȩstas prȩfectus prȩtorii eius omniaqȝ
hȩc rei publicȩ: et nobis quidé qualis incastrḗsi contubernio. Nec qc̄q mutauit ite fortunȩ
amplitudo in his: nisi ut prodesse tantundé posses ut uelles. Itaqȝ cú cȩteris iuenerationé
tui pateant omnia illa: nobis adcolḗdum te familiarius audatia sola supest. Hanc igit̄ tibi
imputabis: et in nostra culpa tibi ignosces. Perfricui faciḗ: nec tamḗ profeci quoniam alia
uia occurris: igens & longius etiam summoues igḗtibus fascibus fulgorat in nullo unq̄
uerius dicta uis ȩloquḗtiȩ tribunitiȩ potestatis facundiȩ: q̄to tu ore patris laudes tonas:
q̄to fratris amas: q̄tus ipoetica es. O magna fȩcunditas animi quéadmodum frḗm quoqȝ
imitareris excogitasti: sed hȩc quis posſet itrepidus extimare subiturus igenii tui iuditiú
prȩsertim lacessitum. Neqȝ eim similis é conditio publicantium & noiatim tibi dicantiú.
Tum possem dicere qd ista legis iperator humili uulgo scripta sunt agricolaȝ opificum
turbe deniqȝ studioȝ ociosis quid te iudicé facis: quia hanc operam cum dicerḗ nó eras in
hoc albo: maiorem te sciebam quam ut descensurum huc putarem. Prȩterea est quȩdam
publica etiam eruditoȝ reiectio: utitur illa: et M. Tullius extra oḗm igḗs italiam positus
etqȝ miremur per aduocatum defendit́ nec doctissimum ónium Persium hoc legere uolo
Lelium Congium uolo. Q̄ si hoc Lucilius qui primus condidit stili nasum legerit quasi
abusionem & uituperationé reputabit: primus enim satyricum carmen conscripsit i quo
utiqȝ uituperatio uniuscuiusqȝ continet́. Nasum auté dixit quasi uituperationis signú uel
maxime naso declarandum dicendumqȝ é: si aduocatum sibi putauit Cicero mutuandum
prȩsertim cum de re publica scriberet quanto nos cautius ab aliquo iudice defendimur.

16½ in.

11½ in.

Pliny the Elder
Historia naturalis, 1469

The first edition of Pliny's *Natural History*

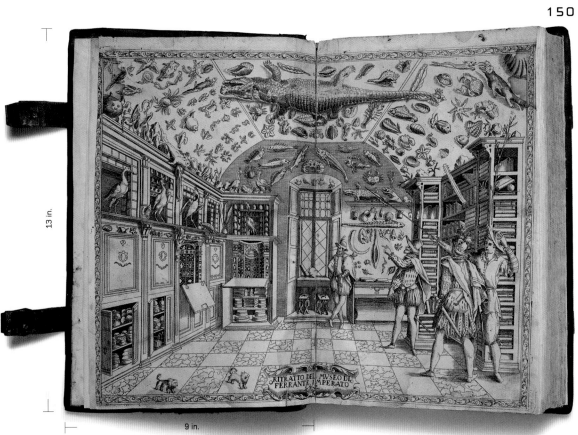

13 in.

9 in.

Ferrante Imperato
Historia naturale, 1672

A book about a cabinet of wonders

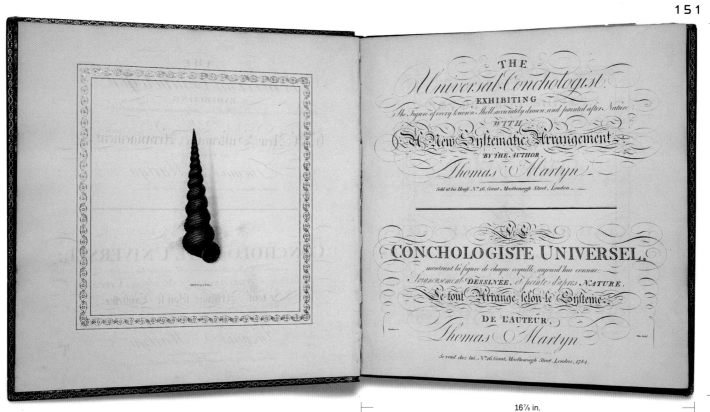

16⅞ in.

16⅞ in.

Thomas Martyn
The Universal Conchologist, 1784

CAPUT PHOENICOPTERI NATURALIS MAGNITUDINI[S]

The Bill of the Flamingo *in its full Dimensions.*

Need not attempt to describe the Texture of the Bill otherwise than Dr. *Grew* has done in his *Muſ. R. Soc.* p. 67. His Words are these: " The Figure of each Beak is truly " Hyperbolical. The upper is rid- " ged behind; before, plain or flat, and pointed " like a Sword, and with the Extremity bended a " little down; within, it hath an Angle or ſharp " Ridge, which runs all along the Middle. At the " Top of the Hyperbole, not above a quarter of an " Inch high. The lower Beak in the ſame Place " above one Inch high, hollow, and the Margins " ſtrangely expanded inward, for the Breadth of " above a quarter of an Inch, and ſomwhat convex- " ly. They are both furniſhed with black Teeth, " as I call them, from their Uſe, of an unuſual Fi- " gure; ſcil. ſlender, numerous, and parrallel, as in " Ivory-Combs; but alſo very ſhort, ſcarce the " eighth Part of an Inch deep. An admirable Inven- " tion of Nature; by the Help of which, and of the " ſharp Ridge abovementioned, this Bird holds his " ſlippery Prey the faſter."

When they feed (which is always in ſhallow Wa- ter) by bending their Neck, they lay the upper part of their Bill next the Ground, their Feet being in continual Motion up and down in the Mud; by which Means they raiſe a ſmall round Sort of Grain, reſembling Millet, which they receive into their Bill. And as there is a Neceſſity of admitting into their Mouths ſome Mud, Nature has provided the Edges of their Bill with a Sieve, or Teeth, like thoſe of a fine Comb, with which they retain the Food, and reject the Mud that is taken in with it. This Account I had from Perſons of Credit; but I never ſaw them feeding my ſelf, and therefore can- not abſolutely refute the Opinion of others, who ſay, they feed on Fiſh, particularly Eels, which ſeem to be the ſlippery Prey Dr. *Grew* ſays the Teeth are contrived to hold.

The accurate Dr. *James Douglaſs* hath obliged the World with a curious and ample Deſcription of this Bird in *Phil. Trans.* No. 350.

Le Bec du Flamant de ſa grandeur naturelle.

L n'eſt pas néceſſaire que j'entrepren[ne] de décrire la forme de ſon bec, a[u]- trement que le Dr. Grew ne l'a fai[t] dans l'ouvrage intitulé, Mus. R. p. 6[.] Voici ſes propres paroles. " La [Fi]- gure de chaque mandibule eſt ver[i]- " tablement hyperbolique. Celles de deſſus eſt rel[e]- " vée par derriere; plate par devant; pointuë comm[e] " une épée, & un peu courbée à ſon extremité. Elle " en dedans un angle, ou un filet, fort etroit, q[ui] " s'étend depuis un bout juſques à l'autre, & la [se]- " pare par le millieu; n'ayant pas plus d'un qua[rt] " ds pouce au haut de l'hyberbole. La mandibu[le] " inférieure eſt dans le même endroit de plus d'[un] " pouce d'épaiſſeur, vuidée, & ayant les bords ite[n]- " dus vers le dedans d'une manière fort étrange, [de] " la largeur de plus d'un quart de pouce, & un p[eu] " convexes. Elles ſont toutes deux garnies de de[nts] " noires, car c'eſt ainſi que je les appelle à cauſe [de] " leur uſage. Ces dents ſont d'une figure extrao[r]- " dinaire, minces, en grand nombre, & paralell[es] " comme celles d'un peigne d'ivoire; de plus, fo[rt] " courtes, ayant à peine un quart de pouce de pr[o]- " fondeur; invention admirable de la Nature, p[ar] " le moyen de laquelle, & du filet ci-deſſus mentionn[é] " cet oiſeau tient plus ferme ſa proye gliſſante."

Lorſqu'ils mangent & c'eſt toujours dans une ea[u] baſſe, en ployant le cou, ils ſont toucher à la terre [la] partie ſuperieure de leur bec. Leurs pieds cependa[nt] ſe remuent ſans ceſſe en haut & en bas, dans [la] vaſe; & par ce moyen ils élévent une petite grai[ne] ronde qui reſſemble au millet: Ils la reçoivent da[ns] leur bec. Et comme ils ne peuvent s'empêcher d'y [re]- çevoir en même temps un peu de limon, la nature [a] garni les bords de leur bec d'un crible, ou de de[nts] commes celle d'un peigne fin; par le moyen deſquel[les] ils retiennent leur nourriture, & rejettent le li- men qui eſt entré avec elle. C'eſt ce que j'ai app[ris] de perſonnes dignes de foi, car je n'ai jamais vû m[oi] même ces oiſeaux manger. C'eſt pourquoi je ne ſça[u]- rois refuter abſolûment l'opinion de ceux qui diſe[nt] qu'ils ſe nouriſſent de poiſſon, & ſur tout d'anguille[s] & il ſemble que c'eſt que le Dr. Grew a entendu p[ar] cette proye gliſſante, qu'il dit que leurs dents ſont fai[tes] pour retenir. L'exact Dr. Jacques Douglaſs, a pu[b]- lié une ample & curienſe deſcription de cet oiſe[au] dans les Phil. Trans. No. 350.

Keratophyton fruticis ſpecie, nigrum.

THIS Species differs from the former, in that it is black, and hath a large Stem like the Trunc of a Tree, which riſes up thro' the Middle of the Plant, and ſends out ſeveral lar- ger Branches, from which ariſe the ſmaller Twigs, which are more crooked and ſlender than thoſe of the preceeding: So that in the Whole it reſembles a Tree without Leaves.
This grows to Rocks in the ſame Places with the preceeding.

CETTE eſpéce diffère de la précédente en ce qu'elle eſt noi[re] & qu'elle a une groſſe tige, comme le tronc d'un arbre, q[ui] paſſe par le milieu de toute la plante, & envoye pluſieurs gr[oſſes] branches, d'où ſortent les petits rejettons, qui ſont plus tortus, [&] plus minces que ceux de l'eſpéce precédente; en ſorte que celle-ci [re]- ſemble en gros à un arbre ſans feuilles. Elle vient ſur des rocs a[ux] les mêmes endroits que la précédente.

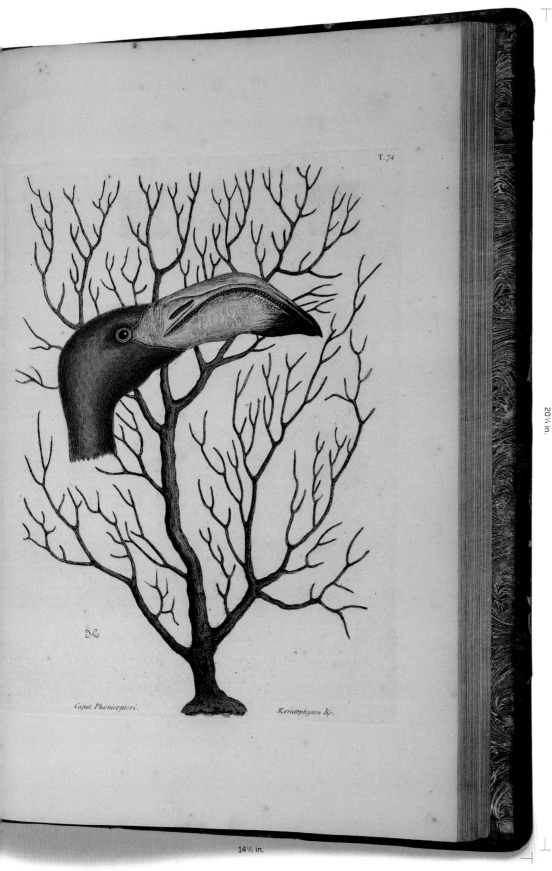

T. 74

Caput Phænicopteri.

Keratophyton &c.

Mark Catesby
**The Natural History of Carolina,
Florida, and the Bahama Islands**, 1731–43

20¼ in.

14½ in.

150

FERRANTE IMPERATO

Historia naturale

Venice: Combi & La Noù, 1672
13 x 9 in. (33 x 22.9 cm)
History & Special Collections,
Louise Darling Biomedical Library, UCLA
(QH 41 134d 1672 Rare)

151

THOMAS MARTYN

The Universal Conchologist

London: The author, 1784
16⅞ x 16⅞ in. (42.9 x 42.9 cm)
Research Library, Natural History
Museum of Los Angeles County
(++QL 404 M38 1784)

152

MARK CATESBY

The Natural History of Carolina,
Florida, and the Bahama Islands

London: The author, 1731–43
20¼ x 14½ in. (51.4 x 36.8 cm)
University of Southern California,
Archival Research Center, Hancock
Collection (QH41.C38 1731)

153

EDWARD LEAR

Illustrations of the Family
of Psittacidae

London: E. Lear, 1832
21⁵⁄₁₆ x 14¹¹⁄₁₆ in. (54.1 x 37.3 cm)
Research Library, Natural History Museum
of Los Angeles County

154

JOHN GOULD

Icones avium; or, Figures and Descriptions
of New and Interesting Species of Birds
from Various Parts of the Globe

London: The author, 1837–38
22¹⁄₁₆ x 15¼ in. (56 x 38.7 cm)
University of Southern California,
Archival Research Center, Hancock Collection
(ffQL674.G68 1837)

155

EUGENE A. SEGUY

Insectes

Paris: Duchartre & Van Buggenhoudt, 1929
18 x 13 in. (45.7 x 33 cm)
Long Beach Public Library
(740 545)

18 in.

13 in.

Eugene A. Seguy
Insectes, 1929

DE LXXII. AFBEELDING.

DEwyl in het voorgaande de Verandering en Voort-teeling der Americaanfe en Europiaanfe Kickvorfchen heb aangetoond, zal hier aanwyzen, op welke manier de Afiatifche en Africaanfe Kickvorfchen haar voort-teeling hebben, dat met de Europiaanfe in allen deele overeenkomt, uytgenomen in grooter gedaante en kouleur, gelijk op N°. 1. aangetoont word, dat het Vifje twee agterfte pootjes bekomt, (gelijk de gedaante van N°. IV. van de Europiaanfe) by de daar aan volgende op N°. II zijn d'agterfte pooten merkelijk grooter; by de N°. III. komt een linker voorpoot te vertoonen, en de vierde de laafte is mede in 't uytpuylen, om door de buyd te breken. N°. IV. vertoont de Kickvorfch met zijn vier pooten, zijn hoofd volkomen na een Kikvorfch gelijkende, en de ftaart klijnder, gelijk N°. V. aantoont, daar de ftaart nog klijnder bekomt; zo dat deze foort met de Europiaanfe overeenkomt in haare voort-teeling en aangroey; of nu dezelve met de tyd en jaaren wederom in Vis verandert, daar van heeft men tot nog toe geen obfervatie, of narigt gezien of gehoort.

Het Kroosje, dat zig heen en weder op de Kickvorfchen in het water vertoont, met letter A gemerkt, komt uyt Africa, uyt de Kroos-Zee, daar het ordinair by menigte, in verfcheide foort en kouleuren gezien en opgevift word. Letter B is een Coraal-moesje, groeyende op een fchulpje, het Arkje Noä genoemd, komende van de Guineefe Kuft, als mede het Zee-takje Letter C. De twee onderfte fchulpen zijn een bifondere foort van Amboinfe Haane-kammen, die op malkander fluyten, van een feldfaam formaat, gemerkt met de Letter D. Het Hoorentje met de mond opwaarts, en gemerkt Letter E is een bezonder Amboins Agat toortje, met verfcheide kouleuren, zeer raar; als mede het Hoorentje Letter F is wonderlijk fraay van teekening, en komt ook uyt Ambon. De Tor Letter G komt uyt Mocha, is niet alleen gantfchelijk zwart, maar heeft een fchoone weerfchijnende glans, en twee feldfame hoorentjes als Offe-hoorens, en in de midden een lange Snuyt, opftaande als een Olifants-Snuyt.

De Areekboom is hier niet gezet, om die te befchrijven, nademaal daar al veel van befchreven is in diverfe boeken, die van uytlandfe gewaffen handelen, maar enkel om de Rupfen en Capellen, die daar aan groeyen en voortkomen, aan te toonen; de groote Rups trekt zijn voetfel uyt de bloemen en de vrugt van dezen boom, en na dat die tot zijn volkomentheid is geraakt, fpind zy zich in tot een Poppetje, en na eenigen tijd komt een fchoone groote Capel te voorfchijn, met mooje zwarte bove-vlerckjes, goudgeele ondervleugeltjes, met zwarte randen en ftreepen uytgemonftert, hebbende verfcheide roode ftippels op de rug; de tweede en derde foort zijn mede zwart en geel, fchoon geteekent, en hoog van kouleur, zeer fraay in haar natuur te befchouwen.

21 in.

14⅞ in.

Maria Sibylla Merian
Over de voortteeling en wonderbaerlijke veranderingen der Surinaemsche insecten, 1719

A book of engravings about the insects of Suriname by the eighteenth-century Dutch naturalist

156

MARIA SIBYLLA MERIAN

Over de voortteeling en wonderbaerlijke veranderingen der Surinaemsche insecten

Amsterdam: Johannes Oosterwyk, 1719
21 x 14⅞ in. (53.3 x 37.8 cm)
Library, Getty Research Institute
(89-B10750)

Abundantly illustrated with delicately hand-colored copper engravings and truly fascinating because of the alluring story behind its making—the story of a fifty-two-year-old woman artist of the late seventeenth century brave enough to travel to a barely charted part of the New World with her twenty-year-old daughter as her only companion—Merian's book has an immediate appeal to every reader. This appeal is also a predicament for the book, as it makes one forget that it is more than a collection of stunningly beautiful prints made by a female artist. Far from a simple picture book, *Over de voortteeling en wonderbaerlijke veranderingen der Surinaemsche insecten* (On the procreation and miraculous metamorphoses of the insects of Suriname) is part of a larger tradition of seventeenth- and eighteenth-century publications that present observations of natural phenomena in word and image. In a sense, Merian's book can be seen as the printed version of the *Wunderkammer*, in which collectors of her time gathered all kinds of unheard-of objects from the natural world together with products from the art world in order to thrill the viewer with the new and thereby instigate further study of all of creation. It is exactly this combination in Merian's book of images of high aesthetic quality and serious descriptions of the insects and plants of a foreign country that makes the volume so interesting.

Maria Sibylla Merian (1647–1717) was the daughter of the influential Frankfurt printmaker and publisher Matthäus Merian (1593–1650). It is not surprising that in this family of engravers Maria Sibylla grew up to be an artist who was trained to draw flowers and developed a specialization in depicting insects. As she says in her introduction to *Over de voortteeling*, from a very young age she had an interest in caterpillars, especially the silkworm, which she could easily find in her native city of Frankfurt am Main. Through personal observations of insects that she herself caught or had delivered to her home, Merian studied the various stages of development of caterpillars, from egg to butterfly, and recorded her discoveries in drawings on vellum. Because of the quality of these drawings, people urged Merian to make them into engravings and publish them for "the consideration and enjoyment by the curious researchers of Nature." In her work the twin goals of scholarly attention and artistic pleasure were completely interwoven.

Merian did not stay put. Together with her husband, Johann Andreas Graff (1636–1701), she moved to Nuremberg and then back to Frankfurt again, all the while working on her caterpillar studies; then, in 1686, leaving her husband behind in Germany, she traveled with her mother and two daughters to Friesland (in the Netherlands) to join a strict religious group, the Labadist community, founded by the former Jesuit Jean de Labadie (1618–74), who preached the abandonment of all personal property and promoted a life of repentance. Even here, at a place with very severe rules, Merian was able to study and paint plants and insects. Not long after her mother died in 1690, however, she and her two daughters moved to Amsterdam.

Here Merian discovered several important collections of zoological and botanical objects brought together from foreign countries. While she admired these collections, she was at the same time very aware of their inadequacy, as they enabled one to see the insects in only a single stage of development. She therefore decided in 1699 to study the insects in their natural setting and set off for Suriname, a relatively small country along the northern coast of South America. The choice of Suriname as a destination to study insects is not as strange as it may at first appear. Merian must have heard about this Dutch colony at several stages in her life: the Labadist community in Friesland had very close missionary connections with Suriname, her older daughter married a businessman who traded frequently with people there, and, finally, several of her friends in Amsterdam had built up collections of Surinamese flora and fauna.

Merian stayed in Suriname for about two years and made many drawings of insects in their various stages of development, as well as of the plants on which these insects were found. Upon her return to Amsterdam she again was urged to make engravings of her drawings and publish them so that the prints, as she said in the introduction, "would give pleasure and delight to both the art connoisseur and the lover of insects and plants." Here too she had both an artistic and scientific audience in mind.

The book was first published in 1705. This particular edition was published two years after Merian's death, in 1719, and contains a few additional plates. *Over de voortteeling* is here bound with Merian's *De Europische insecten* (European insects) of 1730. *Wim de Wit*

References
Claus Nissen, *Die botanische Buchillustration: Ihre Geschichte und Bibliographie* (Stuttgart: Hiersemann, 1966), 122–23.

Bibliography
Natalie Zemon Davis, *Women on the Margins: Three Seventeenth-Century Lives* (Cambridge: Harvard University Press, 1995), 140–202; Kurt Wettengl, ed., *Maria Sibylla Merian, 1647–1717: Artist and Naturalist* (Ostfildern: Hatje, 1998).

IV.
LA PASTENAQUE.

LXXXIIme PLANCHE.

La queue sans nageoire, & armée d'un piquant: *Raja cauda apterygia, aculeo sagittato.*

Raja Pastinaca, R. corpore glabro, aculeo longo anterius serrato in cauda & dorso apterygio. *Linn.* S. N. p. 396. n. 7.
Raja corpore glabro, aculeo longo anterius serrato in cauda apterygia. *Artéd.* Gen. p. 71. n. 3. Syn. p. 100. n. 3. & Raja corpore glabro, aculeis sæpe duobus postice serratis in cauda apterygia. n. 4.
Raja Pastinaca, Rokkel. *Müll.* Prodr. p. 37. n. 310.
— lævis, dorso caudaque apterygiis: aculeo postice serrato in cauda. *Gronov.* Zooph. p. 37. n. 158. Mus I. p. 64. n. 141.
Raja nebulata, aculeo quandoque duplici major barbato in cauda. *Brown.* Jamaic. p. 459. n. 2.
Leiobatus, in medio crassus, ad margines tenuis, lævis; ore exiguo, maxillis granulatis; cauda tereti, mox tenuata, tandemque in exiguam veluti setam desinente, processu osseo, digiti longitudine, serrato, prædita. *Klein.* M. Pisc. III. p. 33. n. 5. & Leiobatus cauda brevissima, processu cuspidato, quandoque duobus instructa. n. 9. ὄτρεγὸν. *Arist.* H. A. lib. 1. cap. 5. l. 5. c. 3. 5. l. 6. c. 1. 11.

Trigon. *Plin.* N. H. lib. 9. cap. 48. Pastinaca. lib. 9. cap. 24. 42.
Raja cauda sagittata. *Basser.* Opusc. Subsc. Tom. II. p. 23. tab. 4. fig. 5—10.
Bruco. *Salv.* p. 144. 145.
Pastinaca, Altavela, Cuccio. *Cetti.* Sard. Tom. III. p. 64.
Pastinaca marina. *Gesn.* Aquat. p. 679. Icon. Anim. p. 121. 122. Thierb. p. 63. a.
Pastinaca marina. *Jonst.* p. 32. tab. 9. fig. 7.
— — lævis. *Bellon.* p. 95.
— — nostra. *Aldrov.* p. 426.
— — prima rondelet. *Willughb.* p. 67. tab. C. 3. & Pastina marina altera. p. 65. tab. C. 1. fig. 3.
Rokkel. *Pontopp.* Dænn. p. 385.
Gaj. *Kämpf.* Japan. Tom. II. p. 155.
The Sting-Ray. *Penn.* B. Z. III. p. 95.
The Fire-Flaire. *Ray.* Synops. p. 24. n. 2. & Pastinaca marina altera. n. 3.
La Pastenaque. *Rondel.* Hist. des Poiss. P. I. p. 265.
Steckrochen, Gröne-Töpel. *Schonev.* p. 58.
Der Pfeilschwanz. *Müller.* L. S. III. p. 246. tab. 11. fig. 3.

La queue sans nageoire, & armée d'un piquant, sont des caractères suffisans pour faire reconnoître ce poisson.

Le corps est uni & couvert d'une matière gluante. La tête se termine en une pointe courte. Les yeux ont une prunelle noire dans un iris blanc. On remarque sur le dos, des côtes cartilagineuses en forme de croissant. Il est brun sur le côté supérieur vers l'épine du dos & les nageoires; & entre ces parties, on remarque une couleur olivâtre. Le côté inférieur est blanc. Il n'a point de nageoires ventrales, de même que le poisson précédent. Les Grecs & les Romains, excepté *Aristote*, font une description

Part. III. P

Marcus Elieser Bloch
Ichthyologie; ou, Histoire naturelle générale et particulière des poissons, 1785–97

The French edition of Bloch's important work on fish

5 13/16 in.

3 3/4 in.

Jacques Henri de Sevé
**Two bound volumes of original
drawings for the French edition of
"Histoire naturelle des poissons"**

The original watercolor drawings executed
for a later French edition of Bloch's study

157

IPPOLITO SALVIANI

Aquatilium animalium historiae

Rome: The author, 1554
16¹⁵⁄₁₆ x 11 in. (43 x 27.9 cm)
University of Southern California,
Archival Research Center,
Hancock Collection (QL615.S3 1554)

158

MARCUS ELIESER BLOCH

Ichthyologie; ou, Histoire naturelle générale et particulière des poissons

Berlin: The author, 1785–97
18 x 11¹⁵⁄₁₆ in. (45.7 x 30.3 cm)
University of Southern California,
Archival Research Center,
Hancock Collection (QL615.B65 1785)

In the vast literature of natural history, and of ichthyology in particular, Bloch's richly illustrated volumes describing the fishes of the German states, and later those of the world, stand out as exceptional, both graphically and taxonomically. Attempting to provide for the first time a complete inventory, Bloch included every species that he had examined himself, every one he could purchase from other collections, and every one for which he could find descriptions and drawings made by others. Introducing many species to a large audience through color images for the first time, and based on a collection of preserved fishes that was by far the most complete in existence up until that time, Bloch's publications represented the most credible compilation, and certainly the most widely useful and appreciated work, subsequent to Carl Linnaeus's *Systema naturae* of 1758. "Bloch's work is unique, and probably will forever remain so" were the words used by Albert Günther (1830–1914), the great nineteenth-century naturalist of the British Museum, London. French comparative anatomist Georges Cuvier (1769–1832), a colossal figure in biology during the first third of the nineteenth century, referred to Bloch's contribution as that "great and magnificent work with which he enriched ichthyology." For Claus Nissen, writing in his *Zoologische Buchillustration* (1969), "Bloch's *Ichthyologia* is the finest illustrated work on fishes ever produced."[1]

Marcus Elieser Bloch, a physician-surgeon by profession living in Berlin, was born at Ansbach in 1723 and died on August 6, 1799, while taking the waters at Karlsbad for a chest ailment. At the age of forty-seven he began to study and write about fishes, evidently as a hobby. Bloch recalled his own beginnings in ichthyology:

Chance gave me an occasion to apply myself to the study of fishes. Someone sent me a great Maräne, a species of salmon, from Lake Madui. I opened my Linnaeus to read what he said of it. But I saw, to my great astonishment that he had not known of this Maräne, only the little one, which is however quite common in the Marche Electorale, in Silesia, in Pomerania, and in Prussia. This omission excited my curiosity and I searched in the same author's work for the other fishes known in our country. I found also that he spoke neither of our Güster, nor of the Giebel, species of carp that are known not only in the provinces that I named, but also in all Germany. I noticed also that many fishes, above all those that are in the genus of carps, were not exactly identified, not only in Linnaeus, nor in Artedi, nor in the ancient ichthyological authors.[2]

Intending at first to collect, describe, compile, and publish a guide to the fishes of the German states, he produced from 1782 to 1784 the *Oeconomische Naturgeschichte der Fische Deutschlands*, three volumes of text in quarto, with 108 color plates in folio. Expanding his coverage to fishes of the world, shortly afterward Bloch published *Naturgeschichte der ausländischen Fische* (1785–95), nine volumes in quarto, with color plates

References
Claus Nissen, *Die zoologische Buchillustration: Ihre Bibliographie und Geschichte* (Stuttgart: Anton Hiersemann, 1969), no. 2.

Bibliography
Ellen B. Wells, "M. E. Bloch's *Allgemeine Naturgeschichte der Fische*: A Study," in *History in the Service of Systematics: Papers from the Conference to Celebrate the Centenary of the British Museum (Natural History) 13–16 April, 1981*, ed. Alwyne Wheeler and James H. Price (London: Society for the Bibliography of Natural History, 1981), 7–13; Hans-Joachim Paepke, *Bloch's Fish Collection in the Museum für Naturkunde der Humboldt Universität zu Berlin: An Illustrated Catalog and Historical Account* (Ruggell, Liechtenstein: A.R.G. Gantner, 1999).

Notes
1. Albert Günther, *An Introduction to the Study of Fishes* (Edinburgh: Adam and Charles Black, 1880), 14; Georges Cuvier, *Tableau historique des progrès de l'ichthyologie, depuis son origine jusqu'à nos jours*, in Georges Cuvier and M. Valenciennes, *Histoire naturelle des poissons*, vol. 1 (Paris: Levrault, 1828), 143; Nissen, *Die zoologische Buchillustration*, vol. 1, 415.

in folio numbered 109 to 432; the joint twelve-volume work came to be known as *Allgemeine Naturgeschichte der Fische*. From 1785 to 1797, almost simultaneous with the appearance of the first German edition, the two sets were translated into French and published together in twelve volumes in folio, with 432 color plates, under the name *Ichthyologie; ou, Histoire naturelle générale et particulière des poissons*.

It is important to understand that this first French edition, that is, the *Ichthyologie*, which is represented in the present exhibition, is not simply a translation of the original German *Allgemeine Naturgeschichte der Fische*. A close examination shows that Bloch used the French edition as an opportunity to add new information that he had acquired after the equivalent text in the German edition had been published. As pointed out by Smithsonian Institution librarian Ellen B. Wells, "since a great many more people spoke and read French than German at that time, Bloch could reach an international audience."[3]

Today Bloch's works are extremely rare and command enormous prices in the antiquarian book trade. In a worldwide request for information on holdings of the various editions sent by Wells to 140 libraries and institutions where sets might be expected to exist, the *Allgemeine Naturgeschichte der Fische* was reported by only 9 libraries, and the *Ichthyologie*, by 15. In a rare book catalogue published in 1995, a copy of the *Ichthyologie* was offered for $112,000.[4] *Theodore W. Pietsch*

159
JACQUES HENRI DE SEVÉ
Two bound volumes of original drawings for the French edition of "Histoire naturelle des poissons"
5¹³⁄₁₆ x 3¾ in. (13.2 x 9.5 cm)
The Huntington Library, San Marino, California (RB 113553)

160
CHARLES DARWIN
On the Origin of Species
London: John Murray, 1859
8⅛ x 5⁷⁄₁₆ in. (20.6 x 14.9 cm)
History & Special Collections, Louise Darling Biomedical Library, UCLA (BENJ QH 365.2 1859 Rare)

161
JAMES WATSON AND FRANCIS CRICK
Two offprints from "Nature" announcing the DNA discovery
April–May 1953
8¼ x 5½ in. (21 x 14 cm) each
History & Special Collections, Louise Darling Biomedical Library, UCLA (Ms. Coll. No. 84)

2. Marcus Elieser Bloch, "Vorerinnerung," in *Oeconomische Naturgeschichte der Fische Deutschlands* (Berlin: Privately printed, 1782), vol. 1, iii–iv.

3. Wells, "M. E. Bloch's *Allgemeine Naturgeschichte der Fische*," 8.

4. Ibid., 12; *Natural History and Travel: Old and Rare Books*, cat. 270 (Amsterdam: Antiquariaat Junk, 1995), 82, no. 491.

S. Zamenhof

(Reprinted from Nature, Vol. 171, p. 964, May 30, 1953)

GENETICAL IMPLICATIONS OF THE STRUCTURE OF DEOXYRIBONUCLEIC ACID

By J. D. WATSON and F. H. C. CRICK

Medical Research Council Unit for the Study of the Molecular Structure of Biological Systems, Cavendish Laboratory, Cambridge

THE importance of deoxyribonucleic acid (DNA) within living cells is undisputed. It is found in all dividing cells, largely if not entirely in the nucleus, where it is an essential constituent of the chromosomes. Many lines of evidence indicate that it is the carrier of a part of (if not all) the genetic specificity of the chromosomes and thus of the gene itself.

D.N.A.

Fig. 1. Chemical formula of a single chain of deoxyribonucleic acid

Fig. 2. This figure is purely diagrammatic. The two ribbons symbolize the two phosphate-sugar chains, and the horizontal rods the pairs of bases holding the chains together. The vertical line marks the fibre axis

8¼ in.

5½ in.

James Watson and Francis Crick
Offprint from "Nature" announcing the DNA discovery, May 1953

One of two offprints in which the discovery of DNA was announced

162

Hortus sanitatis

Mainz: Meydenbach, 1491
11¾ x 8½ in. (29.8 x 21.6 cm)
History & Special Collections,
Louise Darling Biomedical Library,
UCLA (*WZ 2230 H789 1491 Rare)

163

LEONHARD FUCHS

De historia stirpium commentarii

Basel: Officina Isingriniana, 1542
14½ x 9⅞ in. (36.8 x 25.1 cm)
History & Special Collections,
Louise Darling Biomedical Library,
UCLA (BENJ *WZ 240 F951dh 1542 Rare)

164

PIERRE-JOSEPH REDOUTÉ

Les liliacées

Paris: The author, 1808
21⁵⁄₁₆ x 14⅛ in. (53.8 x 35.9 cm)
Libraries of the Claremont Colleges,
Pomona College Library,
housed at Rancho Santa Ana
Botanic Garden Library (f584.32.R249)

Pierre-Joseph Redouté (1759–1840) is today probably the most famous of botanical artists; even in his own lifetime he was nicknamed the "Raphael of flowers." He made his name in the 1790s producing illustrations for the *Histoire des plantes grasses* (cat. no. 166), the epoch-making work on cacti and succulents by the Swiss botanist Augustin-Pyramus de Candolle (1778–1841), and for various works by Louis L'Héritier de Brutelle (1746–1800), most notably his *Geraniologia, Stirpes novae,* and *Sertum anglicum.*

By the time the career of the pugnacious L'Héritier was cut short by an unsolved murder, Redouté's reputation had grown to the degree that he could dictate his own projects. With the financial backing of the empress Joséphine, who commissioned him to paint plants from her garden at Malmaison, Redouté was in the unique position of being able to publish his own works and to choose a botanist to write the descriptions for his plates, rather than the other way around.

For the first and largest of his great works, *Les liliacées,* he chose his colleague Candolle—with whom he was still working on the book on succulents—who wrote the text for the first four volumes. Candolle was succeeded by François Delaroche (1780–1813), otherwise known mainly as the author of a monograph on *Eryngium,* for volumes 5 and 6, and by Alire Raffeneau Delile (1778–1850), who had been the botanist on Napoleon's expedition to Egypt, and who was to become professor of botany at Montpellier, for the last two volumes. (Delile has an interesting American connection: at one point he traveled in North Carolina, planning a revision of Michaux's book on North American trees.) Despite its title, *Les liliacées* was not devoted solely to what would today count as liliaceae, which make up about half the subjects; it extended its range throughout the petaloid monocotyledons, including amaryllis, irises, gladioli, and even some orchids.

Les liliacées was published in eighty installments, making eight volumes in all, with a total of 486 plates. The plates were stipple-engraved and printed in color by a process that Redouté claimed to have invented himself, in which all the colors were applied to the copper plate before printing. This method produced excellent results but was cumbersome and expensive, as was the process of copying the drawings onto the plates, for Redouté wanted to avoid the usual result, whereby the engraved image is reversed right to left from the original drawing. To this end he devised a system of mirrors so that the drawing could be copied exactly, the right way around, onto the copper plate. (He used the same system in his later book *Les roses* [cat. no. 165].)

Joséphine bought Redouté's original drawings, or rather those that had been completed by her death in 1814, for a sum variously recorded as twenty-five thousand to eighty-four thousand francs. From her they descended to Prince Eugène de Beauharnais, whose library was sold in 1935; the drawings were acquired by Edward Weyhe, who brought them to America, and they were finally sold at Sotheby's, New York, in 1985. As no buyer could be found who would purchase the entire lot, the set was broken up and the drawings dispersed.

The print run for *Les liliacées* was roughly two hundred copies. Redouté also prepared a large-paper edition, which was issued from 1807 and ran concurrently with the ordinary folio edition from volume 3. Instead of the announced forty copies, however, only eighteen were issued.

The copy of *Les liliacées* displayed in this exhibition is one of these large-paper copies, the property of Pomona College, and is deposited at the Rancho Santa Ana Botanic Garden, where it is known as the "Hapsburg set" because the Hapsburg coat of arms is embossed on each volume. The history of the copy before its arrival at Pomona College is unknown. It was apparently purchased by the college at the instigation of Philip Alexander Munz (1892–1974), the author of *A Manual of Southern Californian Botany* (1935). Munz taught at Pomona College from 1917 to 1944 and then, after a few years at Cornell, served as director of the Rancho Santa Ana Botanic Garden from 1946 to 1960.
Brent Elliott

References
Frans A. Stafleu and Richard S. Cowan, *Taxonomic Literature: A Selective Guide to Botanical Publications and Collections with Dates, Commentaries, and Types,* 2d ed. (Utrecht: Bohn, Scheltema & Holkema, 1976–88), no. 8747.

Bibliography
B. B. Woodward, "Redouté's Works," *Journal of Botany* 43 (1905): 26–30; Charles Léger, *Redouté et son temps* ([Paris]: Éditions de la Galerie Charpentier, 1945); *A Catalogue of Redoutéana Exhibited at the Hunt Botanical Library, 21 April to 1 August 1963* (Pittsburgh: Hunt Botanical Library, 1963); *Pierre Joseph Redouté's "Les Liliacées,"* sale cat., Sotheby's, New York, 20 November 1985.

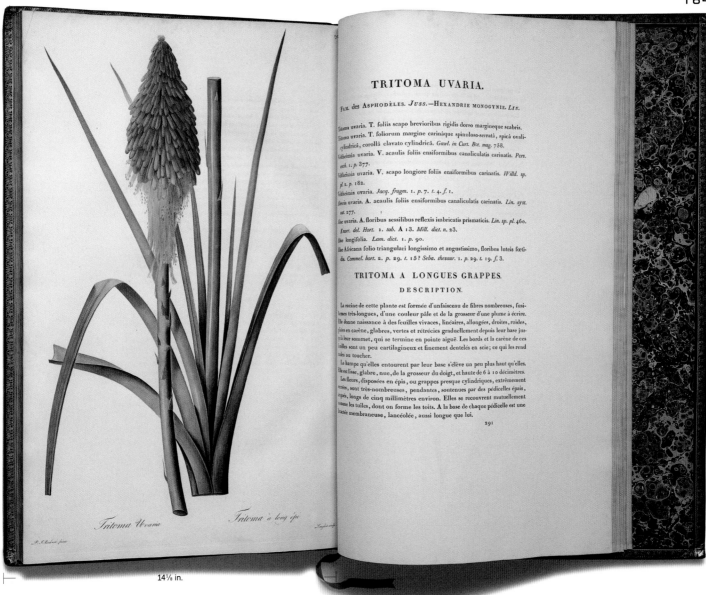

Pierre-Joseph Redouté
Les liliacées, 1808

The most elaborate of Redouté's illustrated
botanical books

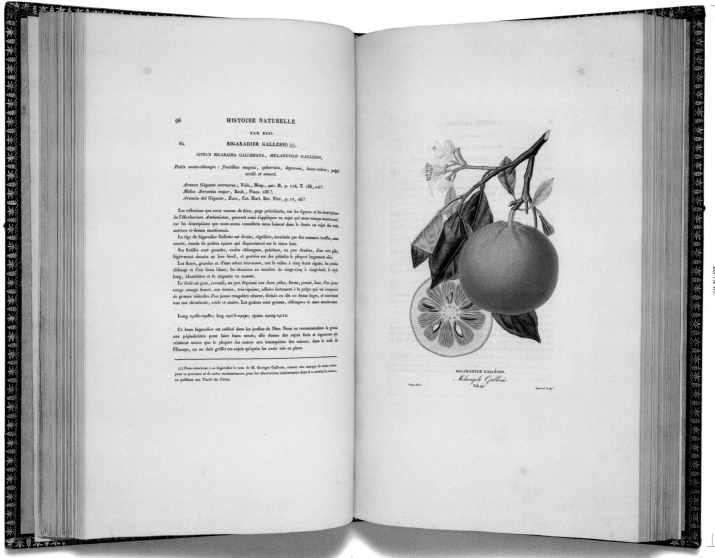

Joseph-Antoine Risso and Pierre-Antoine Poiteau
Histoire naturelle des orangers, 1818–20

The duchesse de Berry's copy of a book
on the natural history of citrus fruit

165

PIERRE–JOSEPH REDOUTÉ

Les roses

Paris: Firmin Didot, 1824
20⅝ x 14½ in. (52.4 x 36.8 cm)
Rancho Santa Ana Botanic Garden Library
(715.172337.R25. LP)

166

AUGUSTIN PYRAMUS DE CANDOLLE

Histoire des plantes grasses

Paris: A. J. Dugour et Durand, [1798–1805]
Illustrated by Pierre-Joseph Redouté
Two fascicles, 13½ x 10⅝ in.
(34.3 x 27 cm) each
Rancho Santa Ana Botanic Garden Library

167

JOSEPH–ANTOINE RISSO AND
PIERRE–ANTOINE POITEAU

Histoire naturelle des orangers

Paris: Imprimerie de Madame
Hérissant le Doux, 1818–20
18⁹⁄₁₆ x 12½ in. (47.1 x 31.8 cm)
Rancho Santa Ana Botanic
Garden Library (634.3R111.LP)

Joseph-Antoine Risso (1777–1845) was a pharmacist and teacher in Nice; by the time this book was published, he had become senior professor of natural sciences at the lycée there. His collaborator, Pierre-Antoine Poiteau (1766–1854), was a botanist and botanical artist who at the time was head gardener of the royal kitchen garden at Versailles.

Despite the title, this book deals with citrus fruit generally. Risso and Poiteau attempted, as far as they could using the available documentary evidence, to trace the history of the development of citrus and to work out a classification. Risso's scheme employs eight categories: sweet-fruited oranges (*orangiers à fruit doux*), acid-fruited oranges (*bigaradiers*), bergamot oranges (*bergamotiers*), limes (*limetiers*), grapefruits (*pompelmouses*), certain orange-lemon hybrids (*lumies*), lemons (*lemoniers*), and citrons (*cédratiers or citronniers*). This classification was presented as an improvement on that offered earlier by Linnaeus, though portions of it consisted of a reversion to the ideas of some of Linnaeus's seventeenth-century predecessors. Although much of it will still be familiar to twentieth-century readers, it is no longer accepted as botanically correct.

The *Histoire naturelle des orangers* was published in nineteen parts between July 1818 and August 1820, usually with 6 plates per part, making 109 in all. Poiteau was the artist; the plates were

engraved by the stippling process, which made for a uniformity in tone well adapted to the texture of lemon and orange skins. The plates were partially printed in color and retouched by hand. The original drawings are today in the collection of the earl of Derby at Knowsley Hall, Lancashire.

While their masterwork was still in its planning stage, Risso and Poiteau found themselves eclipsed by a competitor. One of the great botanical enterprises of recent years had been the "Nouveau Duhamel," the revised edition of the eighteenth-century work on trees by Duhamel du Monceau, *Traité des arbres et arbustes* (1801–25), with illustrations by Pierre-Joseph Redouté, Pierre-Jean-François Turpin, and Pancrace Bessa. Its editor, Etienne Michel, had corresponded with Risso and Poiteau over the classification of citrus fruits. They were due to be discussed in the seventh volume, but before it could be completed, Michel published an advance installment under the title *Traité du citronnier*, using the plates that had already been engraved from Bessa's drawings and adding a text based on Risso's notes. Michel acknowledged Risso's work fully, and disclaimed his own authorship, in a footnote on the first page, but it was still his name that appeared on the title page. In 1819 the seventh volume duly appeared, with this material incorporated. Risso was silent in his own book about Michel's publication, though he frequently cited the revised page entries in the Nouveau Duhamel in his discussions of cultivated varieties.

The *Histoire naturelle* was dedicated to the duchesse de Berry (1798–1870), who had been born Caroline-Ferdinande-Louise de Bourbon, the daughter of the king of the Two Sicilies. Risso's dedication therefore expresses the hope that the illustrations will remind her of the fruits she used to enjoy in Italy, while praising her encouragement of their cultivation in her adopted France. A special dedication copy was prepared for her, a large-paper printing on vellum (prepared goat or sheepskin, rather than paper), bound by Simier, the royal binder, in blue morocco with extensive gilt decorations and watered-silk endpapers. This is the copy displayed in *The World from Here*; today it belongs to the Rancho Santa Ana Botanic Garden. The duchesse was a patron of botanical art and an amateur artist herself, having taken lessons from Bessa, one of the artists of the Nouveau Duhamel. When the Bourbons were overthrown in the July Revolution of 1830, she followed the king into exile but soon after attempted to foment a royalist counterrevolution and was briefly imprisoned. Much of her collection of botanical art she left to her sister, the empress of Brazil. The route through which this copy came to the Rancho Santa Ana Botanic Garden is not documented; it was acquired after 1930, presumably by Susanna Bixby Bryant, the former owner of Rancho Santa Ana, who died in 1946, for it was listed as part of the collection in 1949.

In 1872 a new edition was issued by the Paris publishing house of Henri Plon; Alphonse Du Breuil, a noted writer on the cultivation of fruit trees, revised the text, and the illustrations were reprinted from the original plates, though not so well colored. There was a partial English translation in 1853 by Lady Sarah Reid, the wife of the governor of Malta.
Brent Elliott

168
NICHOLAS THOMAS HOST
Icones et descriptiones graminum austriacorum
Vienna: Mathias Andrea Schmidt, 1801
19 x 13½ in. (48.3 x 34.3 cm)
Rancho Santa Ana
Botanic Garden Library

169
Icones plantarum flora danica
Havniae, 1764–75
14⁹⁄₁₆ x 9½ in. (37 x 24.1 cm)
Rancho Santa Ana
Botanic Garden Library

References
Frans A. Stafleu and Richard S. Cowan, *Taxonomic Literature: A Selective Guide to Botanical Publications and Collections with Dates, Commentaries, and Types*, 2d ed. (Utrecht: Bohn, Scheltema & Holkema, 1976–88), no. 9248.

Bibliography
H. Frederic Janson, *Pomona's Harvest: An Illustrated Chronicle of Antiquarian Fruit Literature* (Portland, Ore.: Timber Press, 1996), 296.

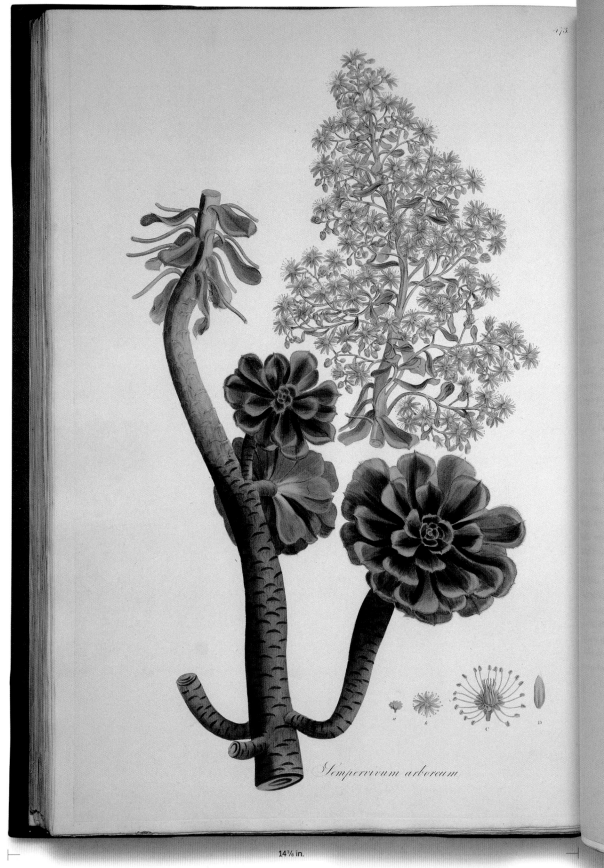

Sempervivum arboreum

John Sibthorp
Flora graeca, 1806–40

An Illustrated book on the flora of Greece

170

JOHN SIBTHORP

Flora graeca

London: Richard Taylor, 1806–40
19¾ x 14⅜ in. (50.2 x 36.5 cm)
Rancho Santa Ana Botanic
Garden Library (581.9495.si 11)

The *Flora graeca* is the greatest illustrated flora ever undertaken and also possibly the rarest. It was the culmination of a tradition that had lasted more than two centuries, in which botanists living in western Europe had tried to identify conclusively the plants described by Dioscorides, the greatest botanist of classical antiquity. John Sibthorp (1758–96), professor of botany at Oxford, traveled to Greece in 1786 to settle this difficulty once and for all. As artist for the expedition, he hired Ferdinand Bauer (1760–1826), whose work he had seen at the Vienna Botanic Garden.

After this promising beginning, the project ran into endless problems. Sibthorp died in 1796; Bauer went off to Australia as botanical artist to Matthew Flinders's expedition. Responsibility for editing the text fell to Sir James Edward Smith (1759–1828), the founder of the Linnean Society. Publication began in 1804, in folio volumes of one hundred plates each, with engraved title pages depicting scenes in the Near East. Smith died in 1828, having completed the first six volumes only, and a new editor had to be found. This proved to be John Lindley (1799–1865), the assistant secretary of the Horticultural Society and professor of botany at University College. Lindley was an opponent of the Linnaean system of classification, to which Smith had devoted his life, but as the work had been begun on Linnaean principles, so Lindley continued it. In the final volume (1840), however, he added an appendix in which he listed the plants according to the system of classification he thought should have been used.

The *Flora graeca* was a large and labor-intensive publication; each of the ten folio volumes held one hundred plates, engraved on copper by James Sowerby from Bauer's drawings, and hand-colored. A print run of fifty copies was originally planned, but the number of subscribers never exceeded thirty, and by the time of its completion it was both an essential work and a difficult one to find. The Italian botanist Michele Tenore had to travel from Naples to Paris to consult a copy. There was an obvious market for additional copies, and the bookseller and publisher Henry G. Bohn undertook to republish it. He purchased the copper plates and letterpress, as well as a quantity of already-colored illustrations that had never been distributed, and in 1856 issued a reprint in about forty copies. It is not easy to tell the two states of the work apart; the only unambiguous way of doing so is to examine the watermarks in the paper.

The copy displayed in *The World from Here* belongs to the Rancho Santa Ana Botanic Garden; it is a Bohn reprint copy but incorporates a certain proportion of material left over from the original print run, for it carries watermarks of 1824 and 1845. It was apparently owned by Susanna Bixby Bryant, who owned the Rancho Santa Ana and developed part of it as a collection of native Californian flora before it was officially established as a botanic garden, but no acquisition record for the book has yet come to light.

Today Bauer's original drawings are held by the Department of Plant Sciences at Oxford University. No one has yet issued a facsimile, or even an anthology of the drawings, of this greatest of floras.
Brent Elliott

171

NICHOLAS JOSEPH JACQUIN

Icones plantarum rariorum

Vienna: C. F. Wappler, 1781–86
18¹¹⁄₁₆ x 11¾ in. (47.5 x 29.8 cm)
Rancho Santa Ana Botanic
Garden Library (580.91.J159)

172

THOMAS MOORE

The Ferns of Great Britain and Ireland

London: Bradbury and Evans, 1855
22⅛ x 15 in. (56.2 x 38.1 cm)
History & Special Collections,
Louise Darling Biomedical Library,
UCLA (**QK 527 M786f 1855 Rare)

References
Frans A. Stafleu and Richard S. Cowan, *Taxonomic Literature: A Selective Guide to Botanical Publications and Collections with Dates, Commentaries, and Types*, 2d ed. (Utrecht: Bohn, Scheltema & Holkema, 1976–88), no. 11935.

Bibliography
W. T. Stearn, "Sibthorp, Smith, the 'Flora Graeca' and the 'Florae Graecae Prodromus,'" *Taxon* 16 (1967): 168–78; idem, "From Theophrastus and Dioscorides to Sibthorp and Smith: The Background and Origin of the Flora Graeca," *Biological Journal of the Linnean Society* 8 (1976): 285–98; H. Walter Lack and David J. Mabberley, *The Flora Graeca Story: Sibthorp, Bauer, and Hawkins in the Levant* (Oxford and New York: Oxford University Press, 1999).

173

DIOSCORIDES

De materia medica

Colle: Johannes de Medemblick, 1478
12¹⁵⁄₁₆ x 9¹⁄₈ in. (32.9 x 23.2 cm)
The Huntington Library, San Marino,
California (RB 103188)

174

Persian handbook on ophthalmology,

c. 1300–1600 C.E.

9⁵⁄₁₆ x 5½ in. (23 x 14 cm)
History & Special Collections,
Louise Darling Biomedical Library,
UCLA (Persian medical manuscript,
Ms. Coll. No. 60, Ms. 75)

This leather-bound manuscript is a heavily used medieval Persian handbook on ophthalmology. The manuscript is missing a number of folios at the beginning and the end. Without the incipit, the explicit, and the colophon, it is impossible to know the work's exact title and the date when it was composed or copied. The author's name is likewise unknown. The manuscript contains eighty-nine leaves on two types of paper and is written in two hands. This indicates that the work was repaired and a number of folios replaced sometime after its initial composition. The main body of the text, comprising most of the folios, is written in a strong hand—scribal *nasta'liq* leaning to the *naskh*—in eighteen lines, on a surface measuring 165 by 85 millimeters (6½ by 3⅜ in.) in black ink with titles and punctuation in red. This main body of the manuscript may be dated c. 1300–1400 C.E. The later substitutions are all on a different paper than the original and include folios 12–13, 21–22, 38, 51–54, 61–63, 69–77, 80–84. They are written in a distinctly different hand, more consistent with sixteenth-century scribal *naskh*, in fifteen to eighteen lines, on a surface measuring 160 to 170 by 80 to 85 millimeters (6¼ to 6¹¹⁄₁₆ by 3⅛ to 3⅜ in.), in black ink, with red for titles and punctuation. The present binding is not original and is probably the one used after the substitutions were made.

Based on a careful examination of the two types of paper, the two orthographic types, as well as elements of Persian style and medical terminology, we may date the work within the period 1300–1600, the main body closer to 1300 and the later substitutions and binding closer to 1600.[1] The text must have been employed by practicing physicians for centuries after its initial completion, a surmise

supported by the several marginal notes in various hands, some bearing the dates 1838, 1842, and 1844 (probably indicating the writers' birth dates).

The manuscript was probably prepared for a practicing physician by a book dealer as a short but comprehensive handbook on ophthalmology, or by the physician himself, assisted by a scribe. No single text is known from which this work could have been copied. In this respect the work is an "original" composition, but as with almost all other "scholastic" works in Arabic and Persian after the thirteenth century, it too is based on an earlier major scientific text. By the time of the preparation of the present manuscript, several major medical texts had been compiled. A number of them were also known in the Latin West, foremost among them Avicenna's magnum opus on medical sciences, titled *The Canon of Medicine*. While the Latin translations of Avicenna's work greatly influenced the study and practice of medicine in the Latin West, it was the twelfth-century Persian medical treatise titled *Zakhīreh-ye Khwārazmshāhī*, by Ismā'īl b. Hosayn Jorjānī (d. c. 1136 or 1140), that became one of the most widely employed texts in the study and practice of medicine in the Persian East.[2] As noted by Lutz Richter-Berburg, the present manuscript was indeed based on Jorjānī's work and may be seen as a short epitome of section 2.2 of his *Zakhīreh-ye* (On ophthalmology) but also bears resemblance to 'Alī b. 'Isā's *Tadhkirat al-Kahhālīn*, an independent work on the science and history of ophthalmology which also includes biographies of ophthalmologists.[3]

Based on an examination of these works, it may be deduced that the present manuscript is a carefully compiled epitome on ophthalmology derived from the earlier works, with the specific aim of providing a *practical* handbook. In almost all instances in the text, emphasis is placed on short descriptions of anatomy and physiology of the eye, eye diseases, and treatments in a readily accessible form for the practicing eye doctor. In fact, the "original" component of the manuscript is the Persian mnemonic verses in the form of rhyming couplets—the Persian poetic form known as the *masnavī*—which are added after many sections to summarize salient elements of procedures pertaining to the diagnosis and treatment of eye disease.

The mnemonic verses in most cases also include names of diseases, for example, "induration of the conjunctiva" (fol. 50v).

While the manuscript is not a major scientific text, it is nonetheless of great historical significance. Here we have an actual ophthalmologic handbook, employed, we may presume with a fair degree of accuracy, by a goodly number of physicians in their daily practice of diagnosing and treating eye disease. Equally significant is the sophisticated "scientific" nature of the work, which is evident from an examination of its table of contents. This stands in contrast to the many pseudo-medical texts of the period, in which the prescribed cures are mainly in the form of talismans and amulets to be worn by, or incantations to be said by, or over, the diseased person. It is interesting to note that on several leaves there are drawings of the eye, eyebrows, and nose *en face*, which are produced by a process known as "puncturing," some of which are finished with indications in red ink that show where the ophthalmologist was to operate on the eye, for example, for the removal of cataracts and problems associated with the uvea.

The extant folios of the manuscript are divided into seven discourses (*maqāla*) as follows: (1) On the Anatomy and Physiology of the Eye, (2) General Principles and Treatments and the Diseases of the Eyelid, (3) The Diseases of the Lachrymal Duct, (4) The Diseases of the Conjunctiva, (5) Diseases of the Cornea, (6) Diseases of the Uvea and Cataract, and (7) Other Diseases of the Eye.[4] The seventh discourse is divided into thirteen chapters: (a) Phantoms in Vision Not Related to Cataract, (b) Diseases of the Albuminoid Humor, (c) Diseases of the Crystalline Humor, (d) Diseases of the Visual Spirit, (e) Night Blindness, (f) Day Blindness, (g) The Blinding Effect of Coldness on the Eye, (h) Diseases of the Vitreous Humor, (i) Diseases of the Retina, (j) Diseases of the Hollow Nerve, (k) Diseases of the Muscles of the Hollow Nerve, (l) Exophthalmos Because of Paralysis, and (m) Amblyopia. It should be noted that the manuscript ends within the fifth chapter of the seventh discourse, as everything after leaf 89 is missing.

Hossein Ziai

References

Lutz Richter-Berburg, *Persian Medical Manuscripts at the University of California, Los Angeles: A Descriptive Catalogue* (Malibu: Undena Publications, 1978), 214–17.

Notes

1. The manuscript is briefly described in Richter-Berburg, *Persian Medical Manuscripts*, 214–17. Richter-Berburg also gives different dates for the two parts of the manuscript: first, "ca. 1500" (p. 215) and, later, based on orthographic considerations, "a date no later than 1300" (p. 216).

2. See Ismā'īl b. Hosayn Jorjānī, *Zakhīreh-ye Khwārazmshāhī*, ed. M.-T. Danesh-Pajhuh and I. Afshar (Tehran, 1965), esp. the editors' introduction, 1ff.

3. See Richter-Berburg, *Persian Medical Manuscripts*, 215.

4. This description of the manuscript's contents is based in part on Richter-Berburg, *Persian Medical Manuscripts*, 215, with minor changes.

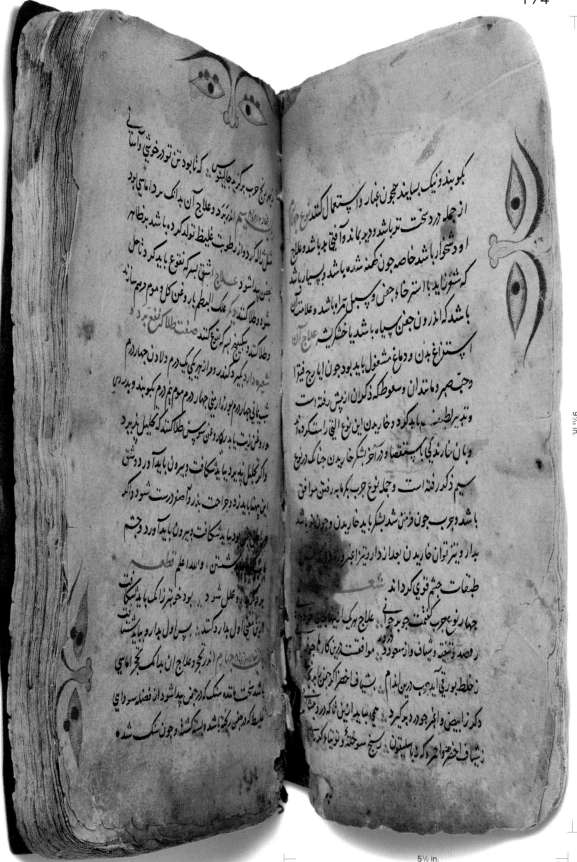

Persian handbook on ophthalmology, c. 1300–1600 C.E.

12⅜ in.

9 in.

Joannes de Ketham
Fasciculus medicinae, 1500

One of the most important anatomy books
before Vesalius

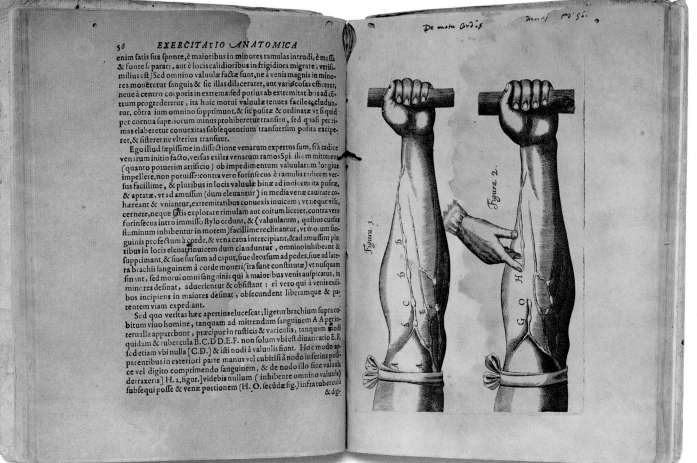

8¼ in.

6¼ in.

William Harvey
**Exercitatio anatomica de motu
cordis et sanguinis in animalibus**, 1628

The book that announced the discovery of the
circulation of the blood

175

JOANNES DE KETHAM

Fasciculus medicinae

Venice: Johannis and Gregorius de Gregoriis, 1500
12⅜ x 9 in. (31.4 x 22.9 cm)
History & Special Collections,
Louise Darling Biomedical Library,
UCLA (BENJ * WZ 230 K499f 1500 Rare)

176

WILLIAM HARVEY

Exercitatio anatomica de motu cordis et sanguinis in animalibus

Frankfurt: William Fitzer, 1628
8¼ x 6¼ in. (21 x 15.9 cm)
History & Special Collections,
Louise Darling Biomedical Library,
UCLA (BENJ WZ 250 H262dm 1628 Rare)

William Harvey (1578–1657) discovered the circulation of the blood. This small book announcing the discovery is generally considered to be the most important book in the history of medicine. These statements are so familiar that it is easy to take them for granted.

Yet unlike Edward Jenner's discovery of smallpox inoculation, or Joseph Lister's introduction of antiseptic surgery, or Florence Nightingale's reform of nursing, Harvey's discovery did not save any lives or make any difference to medical practice. The importance of *De motu cordis* is that it convincingly showed how observation and experiment could be used to establish the truth about the workings of the human body. To arrive at his conclusion that the blood circulates around the body, rather than being continually used up and regenerated, Harvey had to convince his contemporaries to put more faith in experimental science than in the authority of Galen as the ultimate source of scientific knowledge. It was the great achievement of Vesalius to reveal, by detached observation, the "fabric of the human body" (see cat. no. 179). This new knowledge of anatomy forced a reexamination of the workings of various organs. Harvey's achievement was to demonstrate, in the case of the most fundamental of all bodily functions, that physiology must be based on hypothesis, experiment, and logical reasoning. This represented nothing less than the invention of modern medical science.

Harvey put forward three propositions: (1) the quantity of blood pumped out by the heart is so great that it cannot be provided by the food we eat,

(2) the quantity of blood pumped into the body is far greater than is required for nutrition and is greater than the total amount of blood in the body, and (3) the veins bring the blood back to the heart. He wrote: "These propositions being proved, I think it will be abundantly clear that the blood goes around and is returned, is driven onwards and flows back, out of the heart into the extremities and from the extremities back into the heart again, and thus completes a movement as it were in a circle."[1] The first two propositions he proved by quantitative measurements of the volume of blood in the body and in the heart, the heart rate, and the rate of flow in the major arteries. The third he proved by his knowledge of the valves in the veins, which he had learned from his teacher in Padua, Girolamo Fabrizio (Fabricius of Aquapendente). Since the valves allow blood to pass only one way, which is toward the heart, they must be carrying it away from the rest of the body, completing the circuit. The pulmonary circulation had already been proposed by Realdus Columbus, and this idea was incorporated into Harvey's theory of the general circulation. Harvey's achievement is all the more remarkable in that at this stage it was only a theory, because he could not show how the arterial blood was transferred into the venous system, and he correctly predicted the existence of tiny vessels, invisible to the naked eye, to carry out the transfer. These vessels, the capillaries, were duly discovered under the microscope by Marcello Malpighi in 1660.

Harvey later told Robert Boyle that it was the working of the valves that first suggested to him the idea of the circulation, and it was this that he chose to illustrate in the book, in two engravings containing four figures. They show a man's arm, the hand clutching a barber's pole and a ligature above the elbow to make the veins stand out. This was a familiar

References

Harrison D. Horblit, *One Hundred Books Famous in Science: Based on an Exhibition Held at the Grolier Club* (New York, 1961), no. 46; John Carter and Percy H. Muir, eds., *Printing and the Mind of Man: A Descriptive Catalogue Illustrating the Impact of Print on the Evolution of Western Civilization during Five Centuries* (London: Cassell and Company, 1967), no. 127; Bern Dibner, *Heralds of Science as Represented by Two Hundred Epochal Books and Pamphlets Selected from the Burndy Library* (1955; reprint, Cambridge: MIT Press, 1969), no. 27; Geoffrey Keynes, *A Bibliography of the Writings of Dr. William Harvey, 1578–1657*, 3d ed., rev. by Gweneth Whitteridge and Christine English (Winchester: St. Paul's Bibliographies, 1989), no. 1 (this copy described on p. 34); Jeremy M. Norman, ed., *Morton's Medical Bibliography: An Annotated Checklist of Texts Illustrating the History of Medicine (Garrison and Morton)*, 5th ed. (Brookfield, Vt.: Gower, 1991), no. 759; William H. Helfand, Haskell F. Norman, and Jeremy M. Norman, eds., *One Hundred Books Famous in Medicine: Notes for the Exhibition at the Grolier Club, New York City, September 20–November 23, 1994* (New York: Grolier Club, 1994), no. 27.

setup for bloodletting and was illustrated by Fabrizio
to show the swellings in the vein where the blood
built up behind the valves. Harvey's first figure
copies the Fabrizio illustration, and the following
three show Harvey's vivid demonstration, in which
a short section of the vein is emptied by pressing
down on it with a finger and stroking the blood
toward the heart, where it is held back by the next
valve and then refills from the body side when the
finger stopping the vein is lifted.

De motu cordis was published when Harvey
was fifty years old, and it was his first book. He was
the king's physician, a leading member of the Royal
College of Physicians, highly respected and well
liked, a very correct, even pompous man. It is still a
mystery why he chose to send his manuscript to
Frankfurt, where it was very inaccurately printed on
poor paper. Harvey certainly knew the importance
of his work and was not afraid to acknowledge
its radical departure from traditional teaching. Why
then did he present it in such a small book and
publish it almost surreptitiously?

Fewer than seventy copies of the first edition
of De motu cordis are known to survive. The UCLA
Louise Darling Biomedical Library copy is of excep-
tional interest, having belonged to Harvey's contem-
porary the French astronomer and patron of science
Nicolas Claude Fabri de Peiresc (1580–1637) and
having annotations that are possibly in his hand.
The errata leaf, found in only a minority of copies,
is present, but the title page is in facsimile. It forms
part of the core collection of the Louise Darling
Library, the books donated by John A. Benjamin,
M.D., who bought it from the New York dealer
F. Thomas Heller in 1953. *Roger Gaskell*

177
NICCOLÒ LEONICENO
Libellus de epidemia, quam vulgo morbum Gallicum vocant
Venice: Aldus Manutius, 1497
8¾ x 6¼ in. (22.2 x 15.9 cm)
Department of Special Collections,
Young Research Library, UCLA (A1 L554l)

178
GIROLAMO FRACASTORO
Syphilis, sive morbus gallicus
Verona: [Stefano Nicolini da Sabbio], 1530
8⅛ x 6³⁄₁₆ in. (20.6 x 15.7 cm)
History & Special Collections,
Louise Darling Biomedical Library,
UCLA (WZ 240 F 841s 1530 Rare)

Notes
1. William Harvey, *An Anatomical Disputation Concerning the Movement of the Heart and Blood in Living Creatures*, trans. Gweneth Whitteridge (Oxford: Blackwells, 1976), 78.

179

ANDREAS VESALIUS

De humani corporis fabrica libri septem

Basel: Oporinus, 1543
16⅛ x 11⅜ in. (41 x 28.9 cm)
History & Special Collections,
Louise Darling Biomedical Library,
UCLA (BENJ * WZ 240 V631dh 1543 Rare)

The year 1543 witnessed the publication of two seminal works in the history of science. The first, *De revolutionibus orbium coelestium* (cat. no. 130), was the work of an old man, Nicolaus Copernicus, who saw the first printed copy of his life's work on his deathbed. Copernicus died in May, barely a month before the Belgian anatomist Andreas Vesalius (1514–64) published the second of the year's great books, *De humani corporis fabrica* (On the structure of the human body), the work of a youthful investigator seeking to transform medical education and practice.

Vesalius was only twenty-eight when his masterpiece was printed in Basel by the famous humanist scholar Joannes Oporinus. Written to demonstrate that the traditional anatomical texts of his day were fallacious since they derived from ideas advanced by Galen, the Greek physician who lived in the second century A.D., Vesalius's work was motivated by his belief that a knowledge of human anatomy could be acquired only by dissecting human bodies with one's own hands. Since Galenic anatomy was based on the dissection and observation of animals, Vesalius believed that both it, and the writings eventuating from it, were worthless as explanations of the human structure. He hoped, both by his example as a "hands-on" teacher at the University of Padua and especially by his careful and detailed presentation in the *Fabrica*, to convince the medical world that the study of anatomy was fundamental to all aspects of medicine. Furthermore, he believed that by applying the principles of investigation described in the *Fabrica*, the student as well as the medical practitioner could achieve a genuine knowledge of human anatomy, which he contrasted to the restricted, traditional outlook of some contemporary physicians, who uncritically accepted even the most outlandish tenets of the Galenic corpus.

Thus Vesalius directed the *Fabrica* toward the established physician, whom he sought to attract to the study of anatomy as a major but often overlooked aspect of true medicine, as well as to his fellow instructors of anatomy, whom he hoped to lure away from their slavish devotion to Galenic texts. Although it must be admitted that Vesalius made only a few anatomical discoveries, the *Fabrica* is a gathering together of virtually all anatomical knowledge up to that time. Moreover, this knowledge is systematized and frequently expanded so that the previous brief account of a discovery gains practical application. Perhaps Vesalius's and the *Fabrica*'s greatest single contribution to the study of anatomy, however, is its illustrations.

These begin on the *Fabrica*'s title page, which depicts a dramatic, if rather inaccurate, presentation of a public anatomy, with Vesalius dissecting a female body before a huge crowd of spectators, some of whom are interested in the procedure and many of whom are not. A few pages later we find the only authentic portrait of Vesalius, created, as it tells us, in 1542, when he was twenty-eight years old. With the exception of a few diagrammatic illustrations, which we know Vesalius drew himself, we cannot identify any of the artists who created the other illustrations. It has generally been believed, however, that students from Titian's studio in Venice were employed in the work.

What is obvious from the anatomical detail of the illustrations and from the textual descriptions that accompany them is that the drawings were made under Vesalius's direct supervision. In contrast to those that preceded them, each illustration relates specifically to a particular portion of the text. Marginal references to the illustrations often provide explanations that lead readers to other illustrations located in different parts of the work. For the first time the true purpose of illustrations in a scientific work was achieved. Such a description of the entire structure of the human body, and the interrelationship of its parts, had never before been attempted and was not to be equaled again until centuries later.

This copy of Vesalius's landmark work was purchased by John Benjamin, M.D., in 1949 from the New York bookseller F. Thomas Heller for $1,645. In 1962 Dr. and Mrs. Benjamin presented more than seven hundred rare books and manuscripts to the UCLA Biomedical Library. This copy of the *Fabrica* was part of that valuable gift.

Ynez Violé O'Neill

References
John Carter and Percy H. Muir, eds., *Printing and the Mind of Man: A Descriptive Catalogue Illustrating the Impact of Print on the Evolution of Western Civilization during Five Centuries* (London: Cassell and Company, 1967), no. 71.

Bibliography
L. R. Lind, *The Epitome of Andreas Vesalius* (New York: Macmillan, 1949); J. B. de C. M. Saunders and C. D. O'Malley, *The Illustrations from the Works of Andreas Vesalius of Brussels* (Cleveland: World Publishing, 1950); Charles Singer, *Vesalius on the Human Brain* (London: Oxford University Press, 1952); C. D. O'Malley, *Andreas Vesalius of Brussels* (Berkeley and Los Angeles: University of California Press, 1964); Andreas Vesalius, *On the Fabric of the Human Body, Book I: The Bones and Cartilages: A Translation of De Humani Corporis Fabrica Libri Septem*, trans. William Frank Richardson in collaboration with John Burd Carman (San Francisco: Norman Publishing, 1998); Andreas Vesalius, *On the Fabric of the Human Body, Book II: The Ligaments and Muscles: A Translation of De Humani Corporis Fabrica Libri Septem*, trans. William Frank Richardson in collaboration with John Burd Carman (San Francisco: Norman Publishing, 1999).

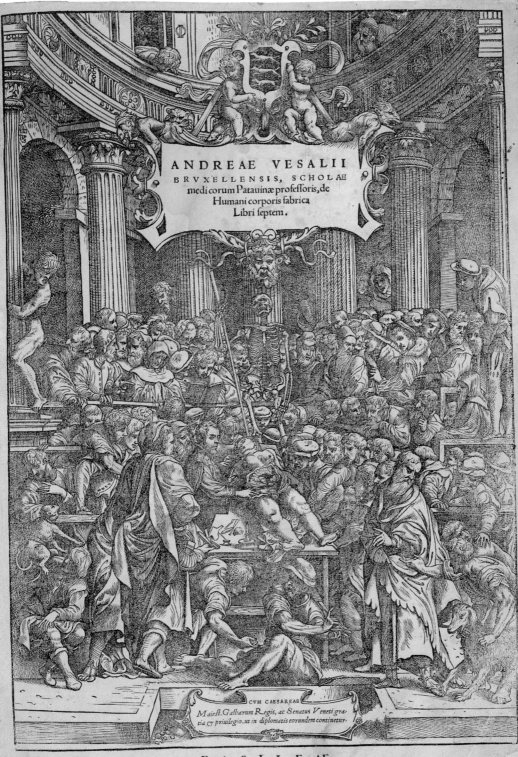

16⅛ in.

11⅜ in.

Andreas Vesalius
De humani corporis fabrica libri septem, 1543

The most famous Renaissance anatomy book

NONA
MVSCV,
LORVM TA-
BVLA.

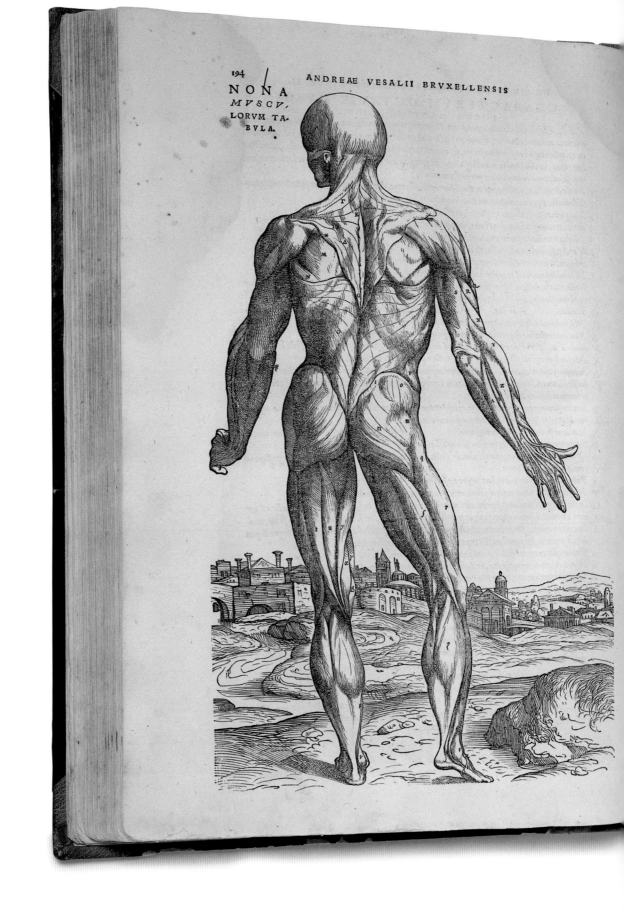

NONAE MVSCVLORVM TABVLAE

CHARACTERVM INDEX.

PRAESENS tabula omnium posteriorem corporis faciem exprimentiū, prima ha
bebitur, hic ordine non a. Si tamen anterioribus seriatim ac uicissim posteriores subsequi uelles,
posset hæc omnium esse aut tertia, aut quarta. nullum enim absectum habet musculum, præter
eos, quos carnea membrana constituit, tertiaǵ tabula obuij sunt. Præterea transuersa in cubi
ti externa sede, iuxta brachiale reposita ligamenta hic dissecuimus, quod prima & secunda ta
bulis abundè conspicua fuerint, hancǵ tabulam ad disciplinam prorsus parauerimus.

A *Temporalis musculus.*

B *Os iugale.*

C *Masseter. Auris uero foramen cum ipsi subiectis glandulis, citra characterum subsidium est
obuium.*

D *Musculus caput mouentium, à pectoris osse, & clauicula enatus, in mamillarem capitis pro
cessum inseritur.*

E,Δ *Musculus secundo loco inter scapulam mouentes recensendus. Atǵ huius principium ab occi
F. pitij osse pronatum, E ac F insignitur. E uerò usǵ ad G musculi principium ab occipite, ad
G. octauæ usǵ thoracis uertebræ spinam, à mediarum uertebrarum apicibus quodammodo enatū.
I. H, I insertio, quam musculus in scapulæ spinam, & summum humerum, latiusculamǵ clauicu
*. læ sedem molitur. * hac sede præsens musculus, quasi membraneum semicirculum obtinet, seu car
K. nosæ ipsius fibræ, in semicirculi cessant circunferentiam. K hac parte ceruix collumǜue, thoracis
elatissimæ parti committitur. Lineæ autem lateráue musculum circunscribentia in hunc modum
colliguntur. Ab E ad F prima protenditur, ad occiput transuersim ducta. Quòd autem hu
ius extremum F notatum, non tantùm ab auris radice distare hic uideatur, quantùm F remouè
tur ab E pictura, in causa est oculum fugiens, quod & sinistrum brachium in anteriora porre
ctum liquidò commonstrat, quod fortè ὀπτικῆς ignarus, plus æquo breuius esse arbitrabitur. Por
rò secunda linea præsentis musculi ab E per K ad G metitur. Tertia autem ab F ad H.
Quarta ab H ad G. Atǵ his lineis musculus terminatur. Insertionis autem linea ab I ad
K pertinens, nulla prorsus separationis nota existit.*

L *Musculus brachium attollens, eiusǵ motorum secundus.*

M *Musculus gibbam scapulæ sedem occupans, brachiumǵ mouentium quintus.*

N *Musculus ab humiliori scapulæ costa pronatus, & brachij motus opificum tertius.*

O *Musculus brachium agentium quartus, sequenti tabula ⊙ insigniendus.*

P *In præsentis tabulæ dextro latere P, indicat portionem abdominis musculi, quem obliquè de
scendentem uocamus.*

Q *Nonnihil in dextro brachio occurrit, brachium flectentium musculus.*

R *Posterior cubitum flectentium musculus.*

S *Musculus cubiti extensionis autorum, cuius principium ab humeri pendet ceruice.*

T *Musculus cubitum extendentium, cuius principium ab humiliori scapulæ costa pronascitur.*

V *Vlnæ sedes triangula, nullis obtecta musculis, excarniśue, ac præcipuè insertionem excipiens
neruosæ cubitum extendentium musculorum insertionis.*

X *Musculus radium in supinum agentium, qui in inferiorem radij appendicem inseritur.*

Y *Musculus bicorni tendine brachiale extendens.*

Z *Musculum Z insignitum, autorem extensionis indicis, medij ac anularis recensebimus, cuius
b. initium a indicatur. Sedes uerò, qua carneus esse desinit, b insignitur.*

*Musculus qui nobis extensionis autor parui digiti recensebitur. Commixtionem tendinum mu
Θ sculi Z insigniti, ac musculi ⊙ indicati, quæ ad digitorum sit radicem, ita hic delineauimus,
quemadmodum crebriùs nobis occurrit.*

Λ *Musculus brachiale extendentium, cui principium offertur ab humero c insignitum. Insertio
d. nem uerò d indicatam, in postbrachialis os, paruum sustinens digitum molitur.*

Ξ *In utroǵ cubito Ξ insignitur musculus, brachiale flectens, octauoǵ brachialis ossi insertus, ac
in nulla musculorum tabula æquè atǵ hic conspicuus. Quemadmodum & musculi latum manus*

R 2 *tendinem*

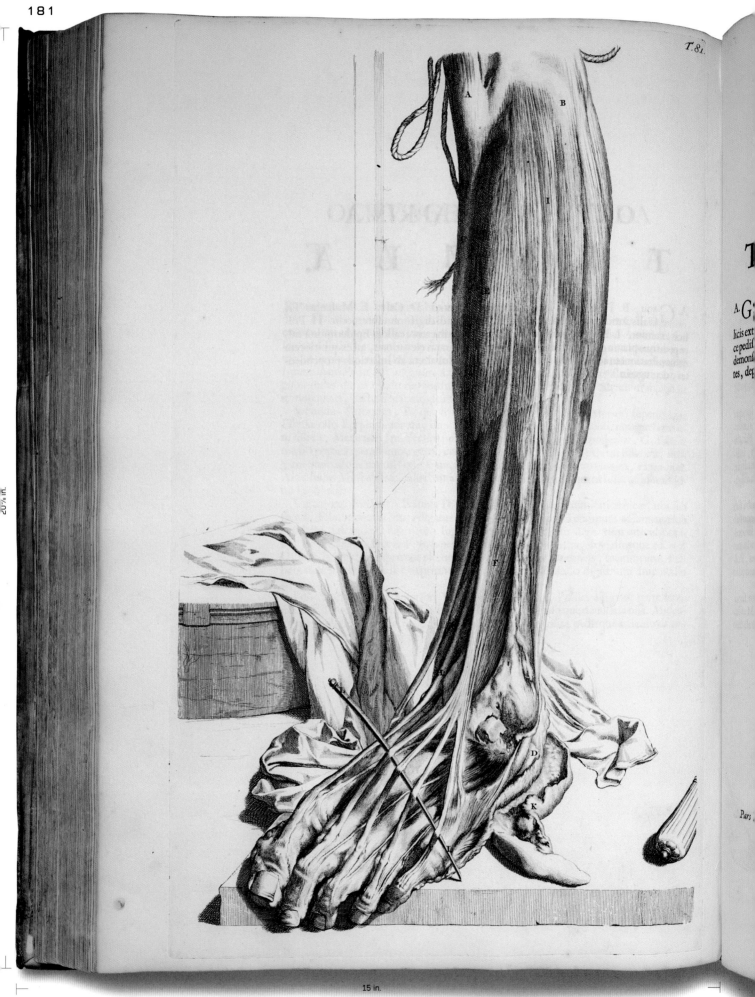

10³⁄₈ in.

7¹⁄₈ in.

Govard Bidloo
**Anatomia humani corporis centum
& quinque tabulis**, 1685

An influential seventeenth-century anatomy book

Genpaku Sugita
Kaitai Shinsho, 1774

An eighteenth-century Japanese anatomy book
influenced by Western anatomical studies

180

Here Begynneth the Seynge of Uryns

London: R. Banckes, 1525
7⅛ x 5⅟₁₆ in. (18.1 x 13.5 cm)
The Huntington Library,
San Marino, California (RB 59283)

181

GOVARD BIDLOO

Anatomia humani corporis
centum & quinque tabulis

Amsterdam: Sumptibus viduae
Joannis à Someren (et al.), 1685
20⅝ x 15 in. (52.4 x 38.1 cm)
History & Special Collections,
Louise Darling Biomedical Library,
UCLA (** WZ 250 B474o 1685 Rare)

182

GENPAKU SUGITA

Kaitai Shinsho

Edo: Suharaya, 1774
10⅜ x 7⅛ in. (26.4 x 18.1 cm)
History & Special Collections,
Louise Darling Biomedical Library,
UCLA (AC 9 QS S947k 1774 Rare)

183

WILLIAM COWPER

The Anatomy of Humane Bodies

London: Sam. Smith and Benj. Walford, 1698
24 x 15⅜ in. (61 x 39 cm)
William Andrews Clark Memorial Library,
UCLA (*ff QM21 C 87)

184

FREDERIK RUYSCH

Opera omnia anatomico-medico-chirurgica

Amsterdam: Janssonio-Waesbergios, [1696–1724]
9½ x 8 in. (24.1 x 20.3 cm)
Library, Getty Research Institute
(94-B12267)

185

JACQUES FABIEN GAUTIER D'AGOTY

Anatomie des parties de la génération
de l'homme et de la femme

Paris: J. B. Brunet et Demonville, 1773
71¼ x 19⅜ in. (181 x 49.2 cm)
The Huntington Library,
San Marino, California
(Ephemera Coll.)

186

WILLIAM HUNTER

The Anatomy of the Human Gravid Uterus

Birmingham: John Baskerville, 1774
27½ x 19⅞ in. (69.9 x 50.5 cm)
The Elmer Belt Library of Vinciana,
Arts Library, UCLA (***RG520.H9)

187

JACQUES GAMELIN

Nouveau recueil d'ostéologie
et de myologie

Toulouse: J. F. Desclassan, 1779
21⅜ x 15⅛ in. (54.3 x 38.4 cm)
Library, Getty Research Institute
(91-B35736)

188

EDWARD JENNER

An Inquiry into the Causes
and Effects of the Variolae Vaccinae

London: The author, 1798
10¹³⁄₁₆ x 8⁹⁄₁₆ in. (27.5 x 21.7 cm)
History & Special Collections,
Louise Darling Biomedical Library,
UCLA (BENJ WZ 260 J432i 1798 Rare)

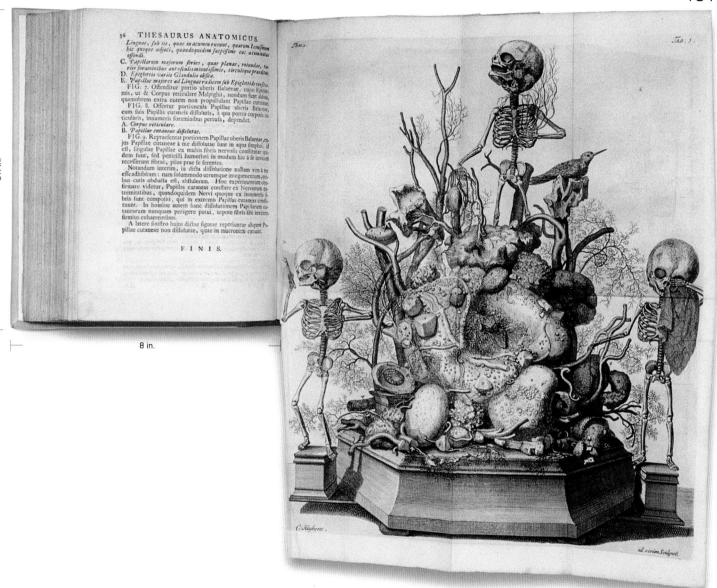

Frederik Ruysch
Opera omnia anatomico-medico-chirurgica,
[1696–1724]

An illustration of an arrangement of human anatomical
parts and skeletons

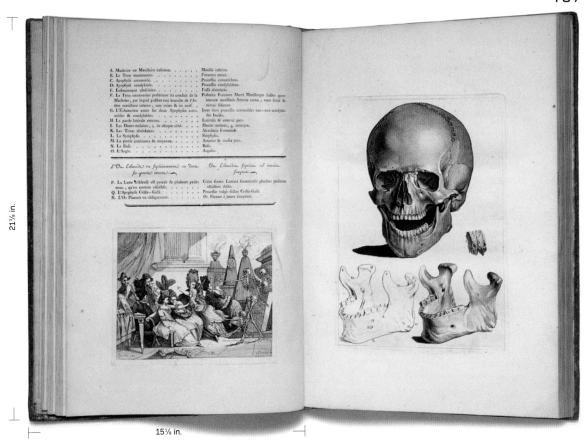

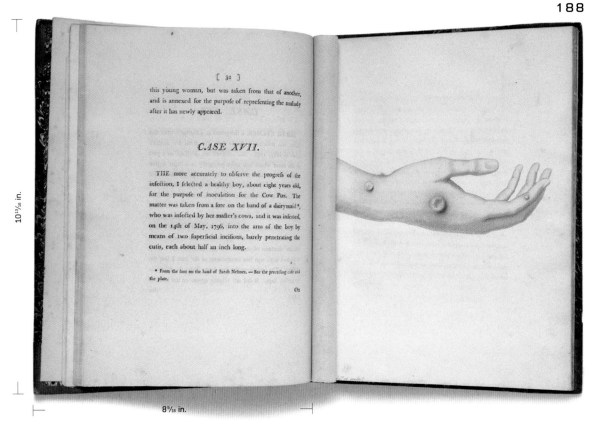

Jacques Gamelin
**Nouveau recueil d'ostéologie
et de myologie**, 1779

Large-scale illustrations of muscles and nerves

Edward Jenner
**An Inquiry into the Causes and Effects
of the Variolae Vaccinae**, 1798

Jenner was one of the earliest proponents
of smallpox inoculation

TAB. VI. *Fœtus in utero, prout a naturâ positus, rescissis omnino parte uteri anteriori, ac Placentâ, ei adhærente.*

27½ in.

19⅞ in.

William Hunter
The Anatomy of the Human Gravid Uterus, 1774

Anatomical engravings of the fetus in utero

189

NANKEI TACHIBANA

Heijiro Kaibōzu

Kyoto, 1784
Illustrated by Ranshū Yoshimura
Scroll (pen and ink with color);
11½ x 576 in. (29.2 x 1464.3 cm)
History & Special Collections,
Louise Darling Biomedical Library,
UCLA (*AC 9 QS T117h 1784)

190

Diagrams for applying moxa

Japan, [1800]
Scroll (pen and ink with color);
11½ x 124 in. (29.2 x 315 cm)
History & Special Collections,
Louise Darling Biomedical Library,
UCLA (*AC 9 WB J564 1800)

191

Box of glass eyes

German, c. 1860s
6⅞ x 13¼ x 1⁵⁄₁₆ in.
(17.5 x 33.7 x 3.3 cm)
History & Special Collections,
Louise Darling Biomedical Library,
UCLA (1517263BX)

192

HERMANN RORSCHACH

Psychodiagnostik

Bern: E. Bircher, 1921
Pamphlet and prints (four cards);
9¹⁄₁₆ x 6⅛ in. (23 x 15.6 cm)
History & Special Collections,
Louise Darling Biomedical Library,
UCLA (WM 145 R697p 1921 Rare)

193

WILHELM CONRAD ROENTGEN

Ueber eine neue Art von Strahlen

Würzburg, 1895–96
9 x 5⅞ in. (22.9 x 14.9 cm)
History & Special Collections,
Louise Darling Biomedical Library, UCLA
(BENJ *WZ 295 R627e 1896c Rare)

194

WALTER KÖNIG

Fourteen X-rays

Leipzig: Johann Ambrosius Barth, 1896
13 x 10⅛ in. (33 x 25.7 cm)
History & Special Collections,
Louise Darling Biomedical Library, UCLA
(BENJ *WZ 295 K819f 1896 Rare)

11½ in.

31 in.

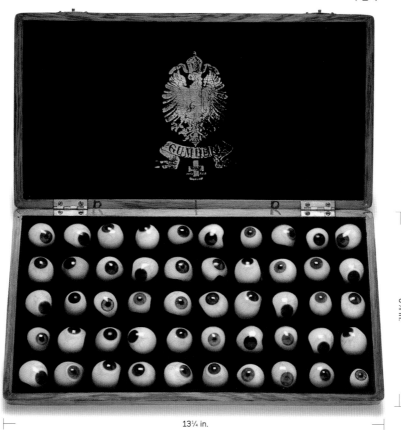

6⅞ in.

13¼ in.

Nankei Tachibana
Heijiro Kaibōzu, 1784

Box of glass eyes, c. 1860s

A scroll chronicling the dissection of the body
of an executed criminal

195
KOICHI SHIBATA
Obstetrical Pocket-Phantom

Translated by Ada Howard-Audenried
Philadelphia: P. Blakiston, Son & Co., 1895
6⁷⁄₁₆ x 4⅜ in. (16.4 x 11.1 cm)
History & Special Collections,
Louise Darling Biomedical Library,
UCLA (WQS550 1895 Rare)

This thin book, so small that it fits neatly into a purse or coat pocket, represents not just a clever piece of paper engineering but also an era of rising feminist ambitions in American medicine, as well as the cultural ties that linked Germany, Japan, and the United States.

Its author, Koichi Shibata, was one of the bright young doctors sent in the 1880s and 1890s by the Westernizing imperial government of Japan for advanced training in the nation that was the acknowledged world leader in scientific medicine: the German Empire. At least part of Shibata's sojourn (c. 1889–92) was spent studying at the University of Munich. There he made himself a disciple of the eminent professor of obstetrics and gynecology Franz von Winckel (1837–1911), and served, as did German students, in the university's women's clinic as a voluntary physician in order to gain experience in the potentially complicated processes of childbirth.

As Shibata worked in Munich under von Winckel's tutelage, he became aware that novices had difficulty visualizing the various possible positions that the fetus could assume in the uterus. For more than a century such knowledge had been taught to medical students and midwives in continental Europe in part by using a wood and leather mannequin, the "phantom," which fit into an artificial pelvis. These phantoms were, however, bulky, stiff, and too expensive for a student to own. They were also unavailable when the student's knowledge most needed refreshing, that is, when he or she was working on the wards. As a modest solution to this problem, Shibata reached back into the Japanese tradition of paper working (exemplified most notably by origami) and designed paper mannequins and an expandable paper pelvis, all at one-third scale. He wrote up a brief set of instructions, solicited a commendatory preface by von Winckel, and published the whole with J. F. Lehmann in Munich in 1891. The little book, entitled *Geburtshülfliche Taschen-Phantome*, proved so popular that within nine months an expanded and improved edition was demanded (Munich: J. F. Lehmann, 1892), and Shibata brought out a Japanese version (Tokyo: Sekodo, 1893) upon his return home.

As a teaching device the work is cleverly functional. The pelvis is shown from the front and has little linen attachments on each side so that it can move forward from the hardboard page as the phantom moves through. The two mannequins represent the fetus facing to either side, or to the front and back. They are articulated at the neck, shoulders, elbows, torso, hips, and knees, so that body and limbs can be moved into virtually any fetal position. The head of each mannequin has measured and labeled diameters at three different angles, so that the obstetrician can judge the match between fetal head and cervix. The text recapitulates the key features of (1) head presentations, (2) pelvic (including breech and foot) presentations, and (3) oblique and transverse presentations, communicating spatial relations with a series of seven lithographic drawings that guide the reader's use of the paper mannequins. As von Winckel noted, the work is a convenient and inexpensive way for the student as well as the practicing physician to get a clearer conception of the relation of fetal parts to the birth canal.

The translator of the English-language edition, Ada Howard-Audenried, received her M.D. in 1892 from the distinguished and pioneering American medical school for women, Woman's Medical College of Pennsylvania (WMCP), in Philadelphia. She was a protégé there of the obstetrics professor Anna Elizabeth Broomall. Howard-Audenried may well have spent a postgraduation sojourn in Munich, since she writes in the translator's preface of how "personal experience has taught me the value of Dr. Shibata's *Obstetrical phantom*." Such a German training would certainly have been urged by her mentor, Broomall, who had herself studied obstetrics in Vienna in the early 1870s, when that city was a mecca for American doctors.

In 1895, when Howard-Audenried carried out the translation of Shibata's text, she was back in Philadelphia as physician at the Children's Clinic of the Woman's Hospital of Philadelphia. This was the teaching facility of the WMCP, laboriously built with feminist dollars in order to provide clinical opportunities for women doctors. Indeed, the translation was probably intended in the first instance for the hospital's medical students and interns. Howard-Audenried continued to work there through the late 1890s, publishing a few modest communications in surgery and reading papers before the college's Alumnae Medical Society. Although contemporary sources refer to her as Dr. Ada Audenried or Dr. Ada Howard Audenried, both the title page and the embossed cover of the book show her most particularly insisting on the hyphenated form—at the time a rare assertion of feminine identity.
Robert G. Frank Jr.

OBSTETRICAL

POCKET-PHANTOM

BY

Dr. K. SHIBATA,

Specialist in Gynaecology and Obstetrics, Tokio, Japan;
physician to the Woman's Clinic at the University of Munich.

Preface
by
Prof. Franz von Winckel.

With eight illustrations, one pelvis and two jointed manikins.

Translated from the third edition
by
Ada Howard-Audenried, M. D.,
Physician to the Children's Clinic at the Woman's Hospital,
Philadelphia.

PHILADELPHIA
P. Blakiston, Son & Co., 1012 Walnut Street.
1895.

— 20 —

Scheme of Presentations.
1. Longitudinal presentations.
A) Head presentations.

1. **Vertex.**
2. **Face.**
3. **Brow.**
4. **Occipital Anterior.**

Back left, small parts to the right, 1st.
Back right, small parts to the left, 2nd.

B) Presentation of Extremities.
1. **Breech.**
2. **Breech and Foot.**
3. **Foot,** incomplete and complete.
4. **Knee.**

Head right, back left, left buttock anterior, 1st.
Head left, back right, buttocks anterior, 2nd.

II. Oblique or Transverse.

Head left, 1st.
Back anterior, a.
Back posterior, b.

Head right, 2nd.
Back anterior, a.
Back posterior, b.

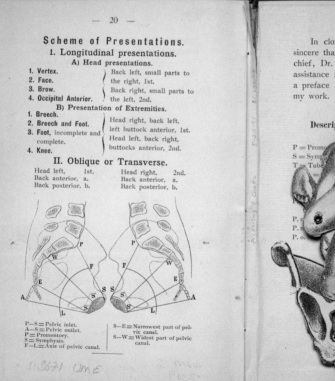

P—S = Pelvic inlet.
A—S = Pelvic outlet.
P = Promontory.
S = Symphysis.
F—L = Axis of pelvic canal.

S—E = Narrowest part of pelvic canal.
S—W = Widest part of pelvic canal.

— 21 —

In closing, allow me to express my sincere thanks to my honored teacher and chief, Dr. v. Winckel, for his friendly assistance and his kindness in contributing a preface to serve as an introduction to my work.

Description of the Abbreviations
on the phantom.

P = Prom
S = Symp
T = Tube

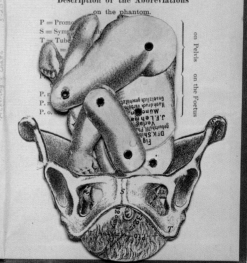

P. r
P. r
P. o.

on Pelvis on the Foetus

6 7/16 in.

4 3/8 in.

Koichi Shibata
Obstetrical Pocket-Phantom, 1895

An obstetrical guide for students and physicians
including paper dolls with which to practice

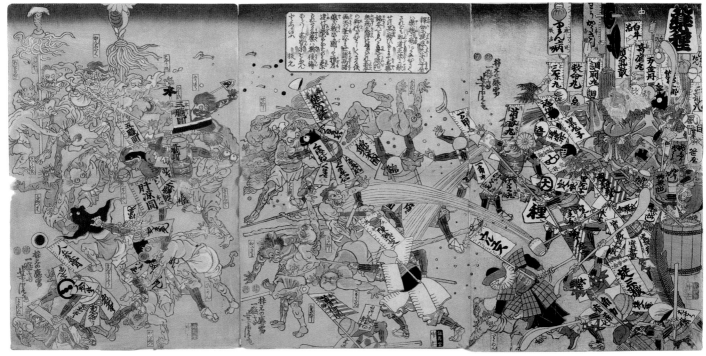

Utagawa Yoshitora
Shoboyo shoyaku kassenzu, 1844–47

A triptych in which battling figures personify
the effects of medicines on diseases

196

UTAGAWA YOSHITORA

Shoboyo shoyaku kassenzu

Edo: Ebisuya Shoshichi, 1844–47
Woodblock triptych; 14¼ x 29⅜ in.
(36.2 x 74.6 cm)
History & Special Collections,
Louise Darling Biomedical Library, UCLA
(Japanese Print #11)

197

UTAGAWA KUNITOSHI

Shinhatsumei nimpu rokutō jŭnitai

1880
Woodblock print; 14¾ x 19½ in.
(37.5 x 49.5 cm)
History & Special Collections,
Louise Darling Biomedical Library, UCLA
(Japanese Print #31)

In *Shinhatsumei nimpu rokutō jŭnitai* (A new invention: A pregnant woman with six heads and twelve bodies), Utagawa Kunitoshi (1847– 99) presents a circus troupe of female acrobats performing a gravity-defying maneuver in midair while hanging from a long cloth banner. The three most remarkable features of the "invention" are that the twelve women share six heads with perfect hair, their bellies are transparent, and they all are pregnant! Faced with these wonders, it hardly seems surprising that the fluttering cloth manages to support the women's weight, but the stiffness of the text by Chikushi holds it firmly in place. "However rich, a childless person feels incomplete," he begins. "A childless person may own treasures, but lacks happiness. . . . Conception begins when the man's sexual essence reaches the nest of eggs on either side of the woman's waist bone." He then describes the course of pregnancy in ten monthly stages, which Kunitoshi illustrated. Traditional social philosophy and modern medical information secure *Shinhatsumei's* flighty fancy.

Kunitoshi's picture and Chikushi's text both had precedents. Around 1840, long before Commodore Perry's black ships sailed into Uraga Bay and the Japanese government reluctantly opened its first treaty ports to foreign trade, Utagawa Kuniyoshi (1797–1861) designed a print whose title translates as "a calico print of people pinching their noses to keep from yawning." This curious picture showed thirty-five nearly naked, cavorting male bodies, which shared fourteen heads. Kuniyoshi may have used the word *calico*, referring to a cotton fabric with bold, colorful designs originally imported to Japan from India in the late sixteenth and early seventeenth centuries, to hark back to Indian pictures of composite figures and people sharing heads and bodies. Kunitoshi modeled his "invention" on similar Kuniyoshi prints.

Chikushi's essay descends from illustrated translations of Dutch medical books published in Japan in the late eighteenth century and to prints published during a measles epidemic of the early 1860s which included medical advice, an early form of privately sponsored health education.

The notion of a transparent body was not new either. Artists in the 1850s designed large prints of the digestive process that showed people's insides. The authors of the accompanying texts moralized too. "However beautiful a courtesan may be on the surface," one wrote, "inside she is not a pretty sight." But the artists and their audience were fascinated by all the internal activity, the dozens of tiny people running the complicated machinery of the "five organs." Pretty was not the point.

As medical prints grew more popular in the second half of the nineteenth century, pregnancy was an obvious subject. It combined the transparent body, pretty young women in scant clothing, and a subject of general interest. Most prints of pregnancy, however, were terribly dull. They usually showed ten women standing in rows like dolls on a shelf. Kunitoshi finally brought the lively subject to life.

Shinhatsumei is a little risqué by late nineteenth-century Japanese standards. The women are naked except for tie-dyed waist bands, cut open in front to reveal their wombs, which show the fetus's growth month by month from conception (the beginning of the first month) to term (the beginning of the tenth month). The five young women at the top and right complete the ten months of pregnancy. The two bodies at the lower left share an older, married woman's head. Her eyebrows are shaved, and she is carrying twins in one womb and triplets in the other.

Kunitoshi's family name was Yamamura Seisuke. Utagawa Kunisada, his first teacher, gave him his art name; his first signed work appeared in 1867. He was one of many artists who documented the transformation of Japanese culture under the influence of the West. He was fascinated by the changes around him and by new technologies. He designed woodcuts, tried his hand at intaglio printmaking, and etched maps. Calling his print of pregnant women *Shinhatsumei*, or "a new invention," associated him with the creative activity that was transforming Japan. His sympathy to change led him to the discovery that pregnancy itself is a process of transformation. The child grows within the mother's womb; at the same time the woman herself changes. His "invention" is an ingenious demonstration of this insight. *Roger S. Keyes*

Bibliography
Little has been published about Kunitoshi or his work; for a short biography of the artist, see *Genshoku ukiyo-e dai hyakka jiten* (Tokyo: Taishukan, 1980–82), vol. 2, 34.

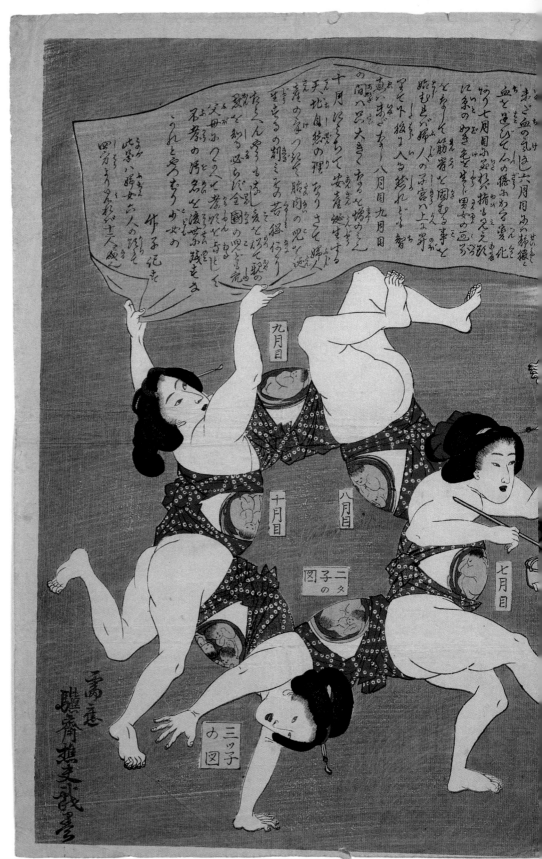

14³/₄ in.

Utagawa Kunitoshi
Shinhatsumei nimpu rokutō jūnitai, 1880

A Japanese woodblock print depicting the
monthly stages of pregnancy

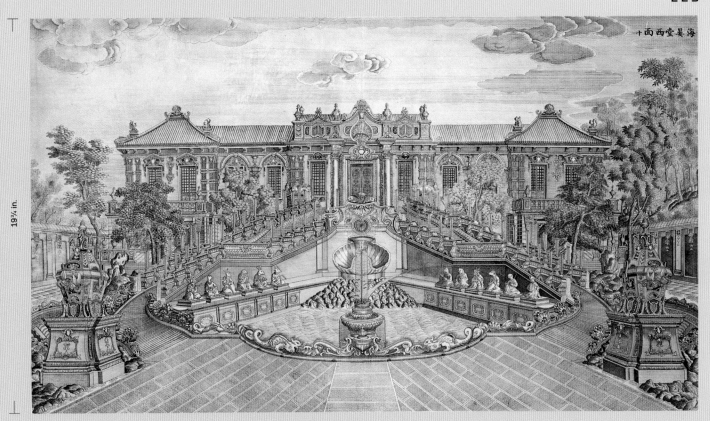

海晏堂西面十

19¾ in.

34½ in.

Yuan-ming-yuan, 1786(?)

Engravings of the palace and gardens
in the Yuan-ming-yuan imperial complex

V LANDS OF HOPE AND FEAR

Following his discovery of the mouth of the Orinoco River during his third voyage to the New World, in 1498, Christopher Columbus indulged in his journal in a speculation about the form of the earth. It was not, he decided, perfectly round, but was shaped like a pear, "which is very round except where the stalk grows, at which part it is most prominent; or like a round ball, upon one part of which is a prominence like a woman's nipple, this protrusion being the highest and nearest the sky." It was on that part closest to the heavens that Columbus thought paradise would be found, and his cosmogonic theory reminds us that even an expedition with very earthbound motives might also have a covert metaphysical compulsion underlying it. Perhaps none of the travelers whose various books are included in section 5 of *The World from Here* specifically reveals that the search for the unknown might be motivated at heart by a desire for paradise, but whether it is Marco Polo in China, Captain Cook in the South Pacific, Amelia Earhart over the Atlantic Ocean, or the *Apollo 15* astronauts on the moon in Michael Light's powerful composite photograph, the nostalgia for the infinite has surely always animated to some extent the human search for the new and the unknown. "Lands of Hope and Fear" focuses mainly on trips of exploration and discovery. There is a subsection here of books that one might think of as pure travel, that is, travel to well-known places—Bernhard von Breydenbach's beautifully illustrated account of his pilgrimage to the Holy Land in 1483 and 1484 surely counts as a guidebook, and John Ogilby's *Britannia* (1698)

is a kind of AAA TripTik before its time—but the majority of the books, especially in the first two subsections, record encounters with *terrae incognitae*. (*Robinson Crusoe*, *Gulliver's Travels*, and *The First Men in the Moon* are of course fiction, but they are exhibited here to give an edge to traditional narrative accounts such as Marco Polo's and Samuel de Champlain's. It is worth remembering in this context that a number of nineteenth-century exploration texts, Paul Kane's *Wanderings of an Artist among the Indians of North America* [1859] being a good example, were actually written up or novelized by professional writers from the traveler's notes.) There are also books here that resulted from travel for scholarly research purposes, such as Lord Kingsborough's magnificent *Antiquities of Mexico*, or the Robert Wood or James Stuart and Nicholas Revett works gathered in the "Artists' Views" subsection, or the vast *Description de l'Egypte* commissioned by Napoleon. But the encounter with the unknown remains a leitmotif of this section.

Travel and voyages have constituted a specialized area of collecting for a long time. Robert Hayman's *Quodlibets* (1628) has been a desirable book since Richard Heber's day, although admittedly few nineteenth-century collectors would have considered it a travel book. (Perhaps it *is* eccentric to treat it as such, despite the fact that its qualities as poetry are negligible. But its author did travel several times between England and Newfoundland, and the poems reflect his experience in the New World less

than a century and a half after Columbus and not quite a hundred years after Jacques Cartier became the first European to sail up the Saint Lawrence River.) At the very beginning of the age of exploration stand the incunables—the Breydenbach, or the Columbus *Epistola*—and toward its conclusion come wonderful color-plate books like George Catlin's portfolio on the North American Indians or Maximilian von Wied-Neuwied's account of a trip to the upper reaches of the Missouri River in the years 1839–41, with its lovely plates executed after the original drawings by Swiss painter Karl Bodmer. Books like these have long been sought after by collectors. So too have the wide-ranging exploration and travel accounts that form part of the broader collecting area denominated Americana. Charles Fletcher Lummis, posters for whose magazine *Land of Sunshine* are in the first section of *The World from Here*, was collecting material relating to the American Southwest and California in the late nineteenth century. But it was in 1911, when Henry Huntington purchased the Church Library *en bloc*, that a first-rate collection of Americana became destined for Los Angeles. Giuliano Dati's verse translation into Italian of the Columbus letter (1495) comes from the Church Library. It contains the first depiction of America in a printed book. Other astonishing survivals, such as the unique copy of the English version of Antonio de Espejo's narrative of a trip through New Mexico, come from the same trove.

"Lands of Hope and Fear" concludes with a group of objects that reflect travel by artists. Artists, perhaps more than explorers (whose multidimensional motives are almost invariably colored by some mundane appetite, usually of an economic variety), might be thought to be driven by the search for the paradisiacal. David Roberts's sumptuous illustrated work *The Holy Land* (not in the exhibition) is almost too obvious an example. More subtle is the wonderful photograph taken by Ansel Adams (mythologized in his own prose) when the natural world contrived to offer him an unforgettable image of human habitation made perfect by an otherwise commonplace cosmic event: the rising of the moon. Edward Curtis did not set out to find the Garden of Eden, but like every nineteenth-century ethnographer, he would have traveled with his Rousseau firmly in mind as well as his cameras carefully packed. The newly discovered place ipso facto exhibits elements of the desirability of paradise. Hayman found the four basic elements in Newfoundland (earth, air, fire, and water) to be "good" and wondered, "What man made of these foure would not live there?" despite the winter, which he apostrophized, seemingly with a clear conscience, as "short, wholesome, constant, [and] cleare." Poetry, perhaps by its very nature, will emphasize hope over fear—the "imperishable bliss" spoken of by Wallace Stevens (whose books are at the Huntington Library), in contradistinction to the simple contentment provoked by what is closest at hand. *B.W.*

198

MARCO POLO

Liber de consuetudinibus et conditionibus orientalium regionum

Gouda: Gerard Leeu, 1483–84
7⅞ x 5¹¹⁄₁₆ in. (20 x 15.1 cm)
The Huntington Library, San Marino,
California (RB 13962)

199

PEDRO DE MEDINA

Arte de navegar

Valladolid: Francisco Fernandez de Cordova, 1545
11⁵⁄₁₆ x 8¼ in. (28.7 x 20.9 cm)
The Huntington Library, San Marino, California
(RB 89286)

The period of Spanish navigational ascendancy was the seventy years following the four "New World" voyages of Christopher Columbus (1492–1504), sponsored by the Catholic monarchs of Castile and Aragon. These voyages had been preceded by the efforts of the Portuguese to reach India by sea, beginning a half-century earlier, and were to be followed by those of France, England, and the Netherlands. During the late fifteenth and early sixteenth centuries, however, there was much interaction between the sailors and theoreticians of several European countries. The Portuguese Ferdinand Magellan, for example, commanded a voyage of circumnavigation for Spain, and the Italian Sebastian Cabot was appointed pilot major (head) of the Casa de la Contratación in Seville (an institution for the instruction and examination of navigators) before he returned to England.

It was in this milieu that the influential *Arte de nauegar en que se contienen todas las reglas, declaraciones secretos, y auisos q a la buena nauegació son necessarios, y se deue saber*, to give the volume its full title, was produced. It was the work of Pedro de Medina (1493–1569), who was in the employ of the duke of Medina Sidonia. It was in the duke's service, and with later sponsorship by other members of his family, that Medina was to undertake his most enduring work. Trained in mathematics, he combined a lifelong interest in navigation with the position of tutor to the duke's son, the count of Niebla, who may have encouraged his mentor to publish a navigational manual. Medina took Holy Orders in 1538, and his writings reflect a devotion to the Church.

Medina's *Arte de navegar* was anticipated and followed by other manuscript and printed works by the author. It was influenced by his appointment as teacher, examiner, astronomer, and expert on charts and instruments attached to the Casa de la Contratación, owing to a license from Emperor Charles V. Medina cooperated in the amendment of the *Padron general*, or master map of explorations, as new overseas discoveries were reported. In this spirit a manuscript copy of the *Arte de navegar* was circulated to other cosmographers and pilots and amended as the result of their suggestions.

The *Arte de navegar* consists of eight parts, which cover all aspects of navigation as practiced by Europeans in the mid-sixteenth century. For determination of latitude there are tables of the "altitude," or angular distance of the sun, and of the polestar (longitude at sea was a problem not solved until much later). There are instructions for the use of the magnetic compass and calendars of the moon and tides. By these means the navigator could fix a position when out of sight of land, and set a course.

The *Arte de navegar* is introduced by a title page featuring the royal coat of arms of Spain and by a dedication to Don Philipe, *principe* (later King Philip II of Spain), printed in red and black. There is an illustration of ships of the period (including a caravel and a galleon), diagrams of compass points, and a map showing both the Old World and the New. Especially interesting is a geocentric diagram of the universe. Only two years before the appearance of the *Arte de navegar*, Copernicus had published his *De revolutionibus* (cat. no. 130), with its revival of the heliocentric theory. This did not affect the *Arte de navegar*'s practical value to the navigator, and it remained in print for many years. It was simplified, published in more than twenty versions, and translated, with the last French edition being dated 1633.

Although not the earliest European printed navigational manual (this distinction seems to belong to the Portuguese *Regimento do estrolabio e do quadrante* [Lisbon, 1509?]), Pedro de Medina's *Arte de navegar* was a most valuable work, one that was used by the sailors of several nations over a long period of time. *Norman J. W. Thrower*

References

Joseph Sabin, *Bibliotheca Americana: A Dictionary of Books Relating to America*, 29 vols. (1868–92, 1928–36; reprint, Amsterdam: N. Israel; New York: Barnes & Noble, 1961–62), no. 47344; José Toribio Medina, *Biblioteca Hispano-Americana (1493–1810)*, 7 vols. (1898–1907; reprint, Amsterdam: N. Israel, 1958–62), no. 123; Herbert M. Adams, *Catalogue of Books Printed on the Continent of Europe, 1501–1600, in Cambridge Libraries* (London: Cambridge University Press, 1967), no. M1024; John Alden and Dennis C. Landis, eds., *European Americana: A Chronological Guide to Works Printed in Europe Relating to the Americas, 1493–1776* (New York: Readex Books, 1980–97), no. 545/19.

Bibliography

Julio F. Guillén y Tato, *Europa aprendió a navegar en libros españoles* (Barcelona, 1943); Pedro de Medina, *A Navigator's Universe*, trans. Ursula Lamb (Chicago: Newberry Library, 1972); David W. Waters, *The Art of Navigation in England in Elizabethan and Early Stuart Times*, 2d ed. (Greenwich: National Maritime Museum, 1978).

cabeça y cola del dragon, y tambien los astrolabios y armillas y los otros ystrumentos delos astronomos serian falsos/ y porellos nūca se podrian hallar los cursos ni cōputaciones delas estrellas / como por los dichos ynstrumentos nuestros sentidos los alcançan, mas siempre acontescerian diuersos / o differentes porque dela tierra no ygualmente se verian los circulos del cielo todo lo qual tenemos prouado por geometria y astronomia Es de considerar que dios que hizo el cielo y la tierra y todo lo que enello es puso la tierra en medio fixa/ porque el cielo y las estrellas la cercassen consu mouimiento, dōde la diuina potencia la sustēta en medio assi como punto. Desto esta escripto dize el señor. Yo suspendi la tierra en vn ñudo / fundada sobre su estabilidad.

❧ Capitu. xvj. Del

Centro dela tierra. Y como se puede dezir ser la tierra centro del mundo

L centro dela tierra se puede entender en tres maneras. ⁌ La primera quāto al cētro de su grandeza. La segunda quanto al centro de su grauedad. Tercera quanto al cētro del agregado, el qual agregado es en medio del firmamento. Tenido esto notarse an quatro cosas. La primera, que en la tierra no es vn mismo centro el dela grā

deza/ y el dela grauedad por tierra disformemente es gra vna parte es cubierta de ag otra parte es descubierta. Se que el centro dela grauedad tierra no es en medio del f mento/ porque si se ymagina dir la tierra en dos partes les/ entōce aquella parte qu bierta de agua rempujaria tra parte. Tercera, q̄ no s el centro dela grandeza ōla y el centro del firmamēto/ la tierra no es ygualmēte cu de agua. Delo qual se sigue, la tierra podemos ymagina centros realmente distinto primero es el centro dela g dela tierra. El segundo/ el ce la grauedad. El tercero el del firmamento. Quarta que el centro del agregado gua y tierra es en medio ōl mento. Esto es porque el tal gado es cuerpo grauē y no dido/ y assi el centro de su g dad es en medio del mundo es de natura graue. Donde de dezir la tierra ser en med firmamento porque es parte gregado / el qual agregado medio del mundo.

⁌ FIN DEL P
MER LIBRO

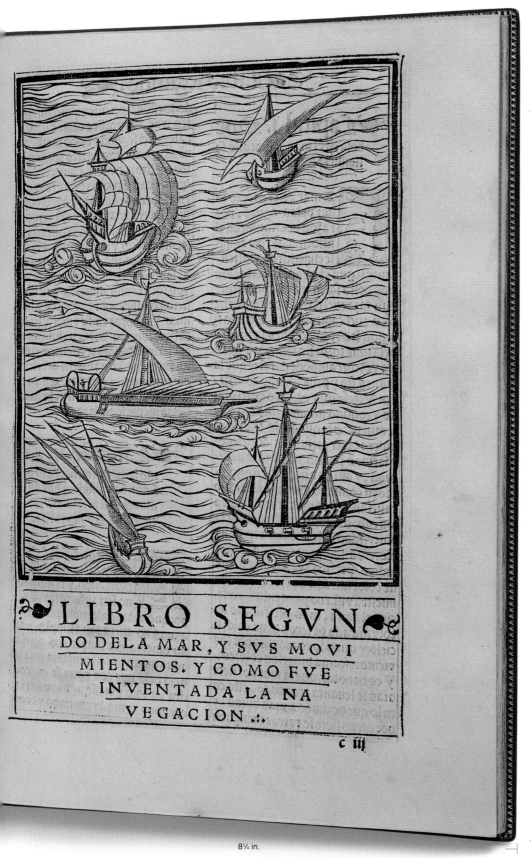

11⁵⁄₁₆ in.

8¼ in.

Pedro de Medina
Arte de navegar, 1545

An important Renaissance treatise on navigation

Willem Janszoon Blaeu
Grooten Atlas, 1642–65

The most famous of the seventeenth-century atlases

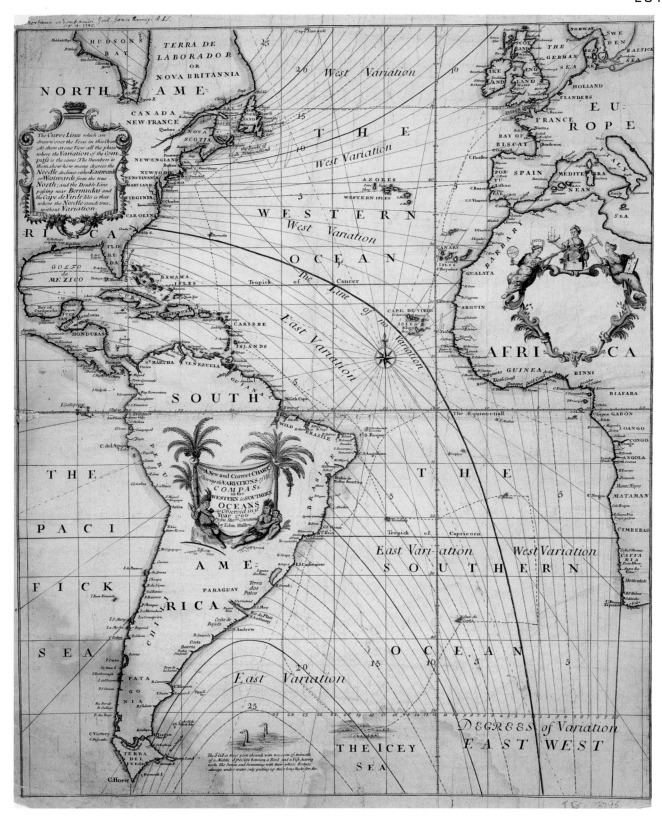

23 9/16 in.

20 in.

Edmond Halley

**A New and Correct Chart Showing the Variations
of the Compass in the Western and Southern
Oceans**, 1700

The rare first state of a map of the New World
by the discoverer of Halley's comet

200

WILLEM JANSZOON BLAEU

Grooten Atlas

Amsterdam: J. Blaeu, 1642–65
20³⁄₁₆ x 13⁹⁄₁₆ in. (51.3 x 34.4 cm)
The Huntington Library, San Marino,
California (RB 330000)

201

EDMOND HALLEY

A New and Correct Chart Showing the Variations of the Compass in the Western and Southern Oceans

London, 1700
23⁹⁄₁₆ x 20 in. (59.8 x 50.8 cm)
William Andrews Clark Memorial Library,
UCLA (map G9101 C93)

202

DANIEL DEFOE

Robinson Crusoe

London: For W. Taylor, 1719
7⅞ x 5 in. (20 x 12.7 cm)
William Andrews Clark Memorial Library,
UCLA (PR3403.A1*)

203

JONATHAN SWIFT

Gulliver's Travels

London: Benjamin Motte, 1726
7¹³⁄₁₆ x 5¼ in. (19.8 x 13.3 cm)
Loyola Marymount University,
Charles Von der Ahe Library
(PR3724.G7 1726)

204

BARTHÓLEMI FAUJAS DE SAINT-FOND

Description des expériences de la machine aérostatique de MM. De Montgolfier

Paris: Cuchet, 1783–84
8⅝ x 5⅝ in. (21.9 x 14.3 cm)
Libraries of the Claremont Colleges,
Caruthers Collection,
Honnold/Mudd Library (TL544. F272)

205

FILIPPO MORGHEN

Raccolta delle cose … da Giovanni Wilkins

Naples, c. 1764
Etching; two prints, 16⅛ x 19¹⁵⁄₁₆ in.
(41 x 50.6 cm) each
Library, Getty Research Institute
(1392–451)

206

JAMES COOK

A Voyage to the Pacific Ocean

London: By W. & A. Strahan,
for G. Nicol & T. Cadell, 1784
22½ x 17 in. (57.2 x 43.2 cm)
Occidental College, Mary Norton Clapp Library,
Special Collections Department
(910.45 C771 Co 1785)

207

H. G. WELLS

The First Men in the Moon

London: George Newnes, 1901
8 x 5¼ in. (20.3 x 13.3 cm)
Occidental College, Mary Norton Clapp Library,
Special Collections Department
(Guymon 823.91 w454 fi)

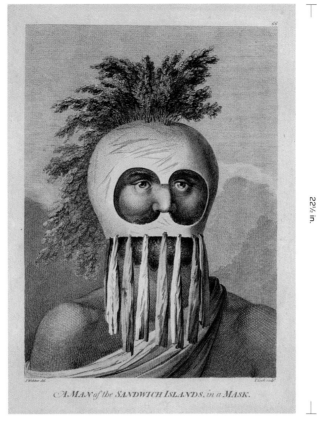

James Cook
A Voyage to the Pacific Ocean, 1784

H. G. Wells
The First Men in the Moon, 1901

Engravings depicting indigenous life
in the South Pacific, from
the narrative of Cook's third voyage

208

AMELIA EARHART

**Log of flight across the Atlantic
(as a passenger),** 1928
**Two letters to her fiancé,
George Putnam,** c. 1931 and 8 January 1935

Log: 7⅟₁₆ x 4⁷⁄₁₆ in. (17.9 x 11.3 cm)
Letters: 10 x 6³⁄₁₆ in. (25.4 x 15.7 cm) (2 pages),
9¾ x 6⅝ in. (24.8 x 16.8 cm)
Seaver Center for Western History Research,
Natural History Museum of Los Angeles County
(L2100.P.1.58-153 [log], L2100.P. 1.58-137
[letter, c. 1931], L2100. P. 1.58-138
[letter, 8 Jan. 1935])

Just after dawn, on the morning of June 15, 1928, only a year after Charles Lindbergh completed the first solo flight across the Atlantic, Amelia Earhart (1897–1937) hunkered down in the passenger compartment of a tri-motor Fokker at East Boston Airfield, bound for England. Already famous for her aerial exploits, Earhart hoped to become the first woman to make the transatlantic flight. While she had logged countless hours of flying, no one had considered her for the job of pilot. Wilmer Stultz had that responsibility. For a woman to fly at all on a transatlantic crossing was considered danger enough.

While she would have preferred to be at the controls, Earhart relished the opportunity nonetheless. Her log of that flight, part of the Earhart Collection in the Seaver Center for Western History Research in the Natural History Museum of Los Angeles County, reflects the joy she found in aviation and the taste for adventure that drove her exploits. Over Nova Scotia, Earhart recorded the scenes unfolding below her: "We are flying at 2000 [feet]. I can look down and see many white seagulls flying over the green land. A few houses are clustered together and a dory is pulled up on the shore." Later, after taking off from Newfoundland, across the vast expanse of the Atlantic, she saw a full rainbow circle and "the sun . . . sinking behind the limitless sea of fog."

Soon deep in that sea of fog, bucking strong headwinds, and with the radio out of commission, Stultz forged ahead with only his airspeed and compass to guide him. They had hoped to make landfall over Ireland's Dingle Peninsula, but their calculations put them well past that point, with still no sight of landfall. To gain some visibility, Stultz

brought the plane down steeply, emerging from the clouds at five hundred feet. They spied a ship and circled several times. Hoping to get the captain to signal their position, they tied notes to oranges and tried twice to toss them onto the deck of the ship but failed on both attempts.

Resuming their course, they saw more small craft. The fuel was so low now that the engines sputtered every time Stultz dipped the nose. Then, out of the mist loomed the coast of Wales. Earhart excitedly recorded their descent: "Coming down now in a rather clear spot. 200 feet. Everything sliding forward . . . ten boats!!!!" As the plane glided to a landing, she grew philosophical. The flight had thrilled her deeply, but the risk they had taken was abundantly clear. Yet, she concluded, "The essence of adventure is risk—probably the risk of life. It is the great temptation because of the awful odds. To those who love life, the temptation is greater, of course. [To] play with the thing most highly valued is adventure."

The flight log records not only this premonition of her fate but also the bold character of its author. The words themselves are echoed in her hand, flowing but full of energy, the three *t*s of the word *temptation* crossed with a single curving sweep.

Her flight brought worldwide fame, but Earhart believed the notoriety unfounded. "It really makes me resentful," she told reporters after her arrival in London, "that the mere fact that I am a woman apparently overshadows the tremendous feat of flying Bill Stultz has just accomplished."

Perhaps it was the pressure of her fast-growing fame that drew her to George Palmer Putnam, her future husband and the recipient of the two letters included here. Putnam, co-owner of the publishing house G. P. Putnam's Sons, knew how to handle publicity and how to capitalize on it. Even before Earhart's transatlantic flight, he had been guiding her public career. The letters make clear that she came to their relationship with her eyes wide open. Perhaps it was the fact that he had walked away from his first wife to marry her, or that deep love, at least on Amelia's part, was not at the root of their

209

MICHAEL LIGHT

**Composite of David Scott Seen Twice
on Hadley Delta Mountain, from the project
"Full Moon,"** 1999
Photographed by James Irwin, Apollo 15
26 July–7 August 1971
Direct-digital chromogenic prints; two panels,
48 x 192 in. (121.9 x 487.7 cm) overall
Library, Getty Research Institute
(2000.R.17**)

relationship, but whatever the reason, she wanted Putnam to know where they stood.

Hours before their marriage, on borrowed stationery, she struggled to make clear her conflict. "You must know again my reluctance to marry," she began, "my feeling that I shatter thereby chances to work which means so much to me." She wanted no part of traditional confinements: "I want you to understand I shall not hold you to any medieval code of faithfulness to me, nor shall I consider myself bound to you similarly. . . . I must exact a cruel promise, and that is you will let me go in a year if we find no happiness together."

Her husband hid the letter away until after her death. It was, he noted, "a sad little letter, brutal in its frankness, but beautiful in its honesty." Four years later, before she took off from Honolulu, bound for Oakland, and the first solo flight across the Pacific by anyone, man or woman, she wrote George an equally blunt and honest letter. Many had criticized her plans as foolhardy, but she defended her resolve. "Please know I am quite aware of the hazards of the trip," she wrote. She felt that her equipment was up to the task and so was she. As to why she would venture such risk, she answered as she always had: "I want to do it because I want to do it. Women must try to do things as men have tried. When they fail, their failure must be but a challenge to others."

That flight, yet another dazzling success, was followed two years later by her most daring adventure, a circumnavigation of the globe that ended in her disappearance somewhere over the mid-Pacific. Her death was, as she had predicted, a continuing challenge to those who followed.

These letters, the log of her first transatlantic flight, and roughly four hundred other letters, photographs, and ephemera related to the life and career of Amelia Earhart were purchased for the Natural History Museum by the Museum Associates in 1958 for one hundred dollars from Betty Bowers, a close friend of Earhart's mother. They are among the most intriguing and widely consulted materials in the collections of the Seaver Center.
Jonathan Spaulding

Bibliography
Amelia Earhart, *20 Hrs., 40 min.* (New York: G. P. Putnam's Sons, 1928); idem, *The Fun of It* (New York: Harcourt, Brace, 1932); idem, *Last Flight* (New York: Harcourt, Brace, 1937); George Palmer Putnam, *Soaring Wings* (New York: Harcourt, Brace, 1939); Jean L. Backus, *Letters from Amelia: An Intimate Portrait of Amelia Earhart* (Boston: Beacon Press, 1982); Susan Butler, *East to the Dawn: The Life of Amelia Earhart* (Reading, Mass.: Addison-Wesley, 1997).

Amelia Earhart
**Log of flight across the Atlantic
(as a passenger)**, 1928

PHONE MYSTIC 1016
TELEPHONE NOANK

NOANK
CONNECTICUT

THE SQUARE HOUSE
CHURCH STREET

Dear Gyp,

[handwritten letter, largely illegible]

PHONE MYSTIC 1016
TELEPHONE NOANK

[handwritten text, largely illegible]

2709 KALAKAUA AVE
HONOLULU, HAWAII

January 8, 1935

Dear G. P.

There has been so much criticism of my proposed flight. That I preferred to take off as quietly as possible. B— if I get the plane into the air successfully on the test— with everything working well. I shall head eastward.

Please know I am quite aware of the hazards

9¾ in.

6⅝ in.

Amelia Earhart
Two letters to her fiancé, George Putnam,
c. 1931 and 8 January 1935

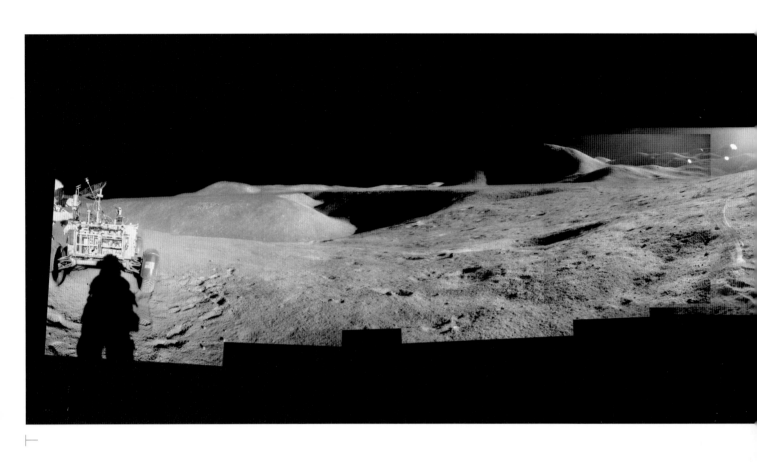

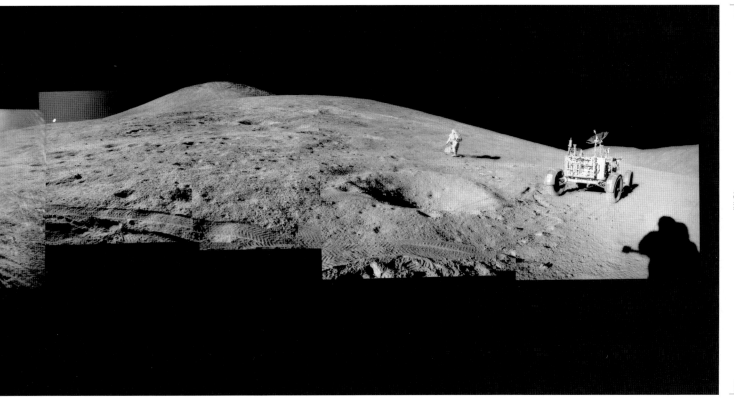

48 in.

192 in.

Michael Light
**Composite of David Scott Seen Twice
on Hadley Delta Mountain**, from the project
"Full Moon," 1999

210

CHRISTOPHER COLUMBUS

Epistola de insulis Indie supra Gangem nuper inventis

Rome: Stephan Plannck, 1493
9¼ x 6¹³/₁₆ in. (23.5 x 17.3 cm)
University of Southern California,
Archival Research Center,
Special Collections (E1 16 1493)

Christopher Columbus's letter to the Spanish court reporting on his first voyage to the Western Hemisphere is the earliest printed account of the New World. The Genoese navigator, representing the Spanish Crown, sailed from Palos, in southern Spain, on August 3, 1492. After a monthlong layover in the Canary Islands, he continued his voyage and sighted land on October 12. After visiting several islands, Columbus began the return voyage to Europe in early 1493. He landed first in the Azores, proceeded to Lisbon, and arrived back in Palos on March 15.

Columbus (1451–1506) wrote this account of his findings during his return trip. After its receipt by the Spanish king and queen, manuscript transcriptions were produced, and a Spanish edition was published in Barcelona in April 1493. A Latin translation, prepared by Leandro di Cosco from the first Spanish edition, was printed in Rome the following month. It was this publication, and the subsequent editions and translations printed through the end of the fifteenth century, that first informed European readers of the results and potential of Columbus's journey. It should be noted, however, that Columbus believed until his death in 1506 that he had reached lands connected to Asia, as he had originally intended, by sailing west from Europe.

Following the first Spanish edition, an astounding eight printings of the letter in Latin, the international language at the time, were published by the end of 1493. These were printed in Rome, Basel, Paris, and Antwerp. An Italian verse paraphrase of the Columbus letter by Giuliano Dati also appeared in three editions in 1493. (The Huntington's copy of Dati's *La lettera dell'isole che ha trovato nuovamente el Re di Spagna* [cat. no. 211] is one of two 1495 editions of this poem.) A German translation and another Spanish edition were published in 1497. The distribution of the text in this manner was quite remarkable and signifies not only the "news" of Columbus's findings but also the potential of the printing press, even in the incunabular period, to disseminate information across geographic, cultural, and linguistic borders.

The letter was clearly directed to the Spanish monarchy with the hope of receiving additional funding for future voyages, and Columbus appealed to the king and queen's interests in both the earthly and spiritual realms. After noting the existence of gold and other resources, he wrote of the natives in terms most appealing to royal sponsors considering overseas expansion and colonization. He describes the indigenous population as extremely timid, without firearms, and lacking any form of government. Those Columbus met seemed to him straightforward, trustworthy, and "most liberal with all that they have; none of them denies to the asker anything that he possesses; on the contrary they themselves invite us to ask for it." He also informed the sovereigns that the prospects were quite good for the natives' "conversion to the holy faith of Christ, to which indeed as far as I could see they are readily submissive and inclined."

Columbus's letter is the earliest European documentation of the Western Hemisphere. It initiated a major shift in Europe's geographic, political, social, and economic conception of the world, which led to further voyages and to European exploration, colonization, and settlement of the Americas. Columbus's account of the first encounter between Europeans and Amerindians represents the initiation of a process of conquest, engagement, and interchange between the Old and New Worlds that took place throughout the hemisphere during the entire colonial period. It also marks the beginning of the written and published documentation and interpretation of the New World and its inhabitants as seen from a European perspective. *Daniel J. Slive*

References
Joseph Sabin, *Bibliotheca Americana: A Dictionary of Books Relating to America*, 29 vols. (1868–92, 1928–36; reprint, Amsterdam: N. Israel; New York: Barnes & Noble, 1961–62), no. 14628; Elihu Dwight Church, *A Catalogue of Books Relating to the Discovery and Early History of North and South America, Forming a Part of the Library of E. D. Church [1482–1884]*, 5 vols. (1907; reprint, Gloucester, Mass.: P. Smith, 1951), no. 3A; *Catalogue of Books Printed in the Fifteenth Century Now in the British Museum* (London: British Museum, 1908–), vol. 4, nos. 97–98; *Gesamtkatalog der Wiegendrucke*, 10 vols. (Leipzig and Stuttgart: Hiersemann, 1925–), no. 7173; Frederick R. Goff, *Incunabula in American Libraries: A Third Census* (New York: Bibliographical Society of America, 1964), no. C-757; John Alden and Dennis C. Landis, eds., *European Americana: A Chronological Guide to Works Printed in Europe Relating to the Americas, 1493–1776* (New York: Readex Books, 1980–97), no. 493/4.

Bibliography
J. M. Cohen, ed. and trans., *The Four Voyages of Christopher Columbus* (New York: Penguin Books, 1969); *The Letter of Columbus on His Discovery of the New World* (Los Angeles: USC Fine Arts Press, 1989); Margarita Zamora, *Reading Columbus* (Berkeley and Los Angeles: University of California Press, 1993).

¶Epistola Christofori Colom: cui etas nostra multū debet: de
Insulis Indie supra Gangem nuper inuentis·Ad quas perqui∕
rendas octauo antea mense auspicijs τ ere inuictissimi Fernan∕
di Dispaniarum Regis missus fuerat:ad Magnificum dnm Ra∕
phaelem Sanxis:eiusdem serenissimi Regis Tesaurariū missa:
quam nobilis ac litteratus vir Aliander de Cosco ab Dispano
ideomate in latinum conuertit : tertio kals Maij·M·cccc·rciij·
Pontificatus Alexandri Sexti Anno primo·

Quoniam suscepte prouintie rem perfectam me cōsecutum
fuisse gratum tibi fore scio: has constitui exarare: que te
vniuscuiuscᶻ rei in hoc nostro itinere geste inuentecᶻ ad∕
moneant: Tricesimotertio die postcᶻ Gadibus discessi in mare
Indicū perueni:vbi plurimas insulas innumeris habitatas ho∕
minibus repperi:quarum omnium pro foelicissimo Rege nostro
preconio celebrato τ verillis extensis contradicente nemine pos∕
sessionem accepi:primecᶻ earum diui Saluatoris nomen impo∕
sui:cuius fretus auxilio tam ad hanc: cᶻ ad ceteras alias perue∕
nimus·Eam vo Indi Guanabanin vocant·Aliarum etiā vnam
quancᶻ nouo nomine nuncupaui·Quippe aliā insulam Sancte
Marie Conceptionis·aliam Fernandinam · aliam Dysabellam·
aliam Johanam·τ sic de reliquis appellari iussi·Quamprimum
in eam insulam quā dudum Johanā vocari dixi appulimus: iu∕
xta eius littus occidentem versus aliquantulum processi:tamecᶻ
eam magnā nullo reperto fine inueni:vt non insulam: sed conti∕
nentem Chatai prouinciam esse crediderim:nulla tñ videns op∕
pida municipiaue in maritimis sita confinib? preter aliquos vi∕
cos τ predia rustica:cum quoꝛ incolis loqui nequibam·quare si∕
mul ac nos videbant surripiebant fugam· Progrediebar vltra:
existimans aliquā me vrbem villasue inuenturum·Denicᶻ vidēs
cᶻ longe admodum progressis nibil noui emergebat:τ bmōi via
nos ad Septentrionem deferebat:cᶻ ipse fugere exoptabā:terris
etenim regnabat bruma: ad Austrumcᶻ erat in voto cōtendere·

211

GIULIANO DATI

**La lettera dell'isole che ha trovato
nuovamente el Re di Spagna**

Florence, 1495
8 x 5¹¹⁄₁₆ in. (20.3 x 14.4 cm)
The Huntington Library, San Marino,
California (RB 18654)

212

HERNÁN CORTÉS

**Praeclara Ferdinandi Cortesii de nova
maris oceani Hyspania narratio**

Nuremberg: Fridericum Peypus Arthimesius, 1524
11³⁄₈ x 8¹⁄₈ in. (28.9 x 20.6 cm)
Library, Getty Research Institute (93-B9631)

213

GIAN BATTISTA RAMUSIO

Navigationi e viaggi

Venice: Giunti, 1550–59
13³⁄₁₆ x 9¼ in. (33.5 x 23.5 cm)
Los Angeles Public Library
(910.8 R184 folio)

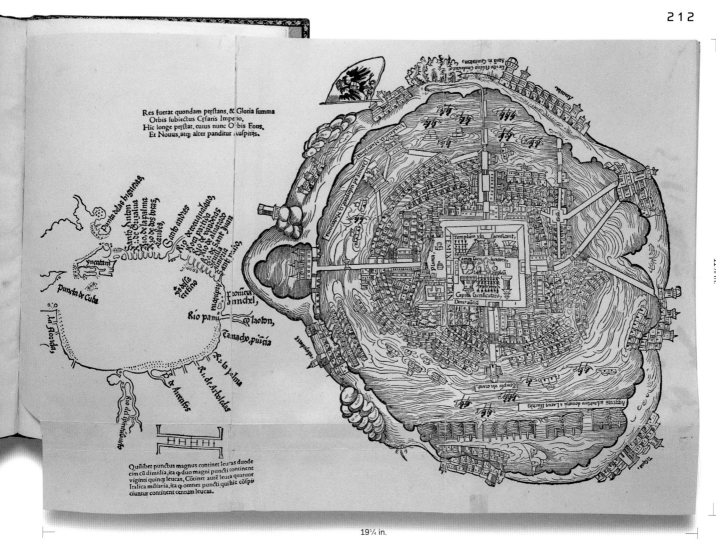

Hernán Cortés
Praeclara Ferdinandi Cortesii de nova maris oceani Hyspania narratio, 1524

One of the letters Cortés wrote to the Spanish court regarding his explorations in the Americas

How the bartaile of Chupas was fought. Chapt. 19.

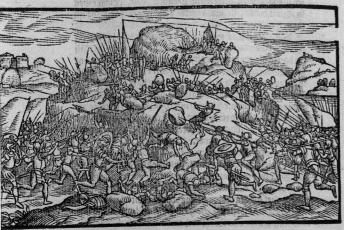

Hileſt the Armie of *Vaca de Caſtro* marched towarde the enemie, who ceaſſed not in ſhootyng of his Ordinaunce: whiche ſhotte paſſed on high, cleane ouer the armie of *Vaca de Caſtro*. Wherevpon *Don Diego* ſuſpected, that *Candia* who was Maiſter Gonner, had been ſuborned, and that therefore willyngly, he diſcharged his ordinaunce in ſuche ſorte: ſo that without any further hearyng of the matter, he ſlewe the Gonner with his owne handes, and when he had ſo doen, he hym ſelf ſhotte of a peece of Ordinance whiche entred into one of the Squadrons, and ſlue many of thē.

When Captaine *Caranajall* conſidered, that their Artillarie could not bee brought with ſuche ſpeede, as tyme required: he determined with his companie to leaue it behinde them, and to enter the battaile without any longer delaye, or benefite of their Ordenaunce.

At this inſtant *Don Diego* and his Captaines *Iuan Balſa, Iuan Tellio, Diego Mendez, Diego de Hoces, Martyn de Bilbao, Iuan de Oſlo*, and the reſtdue: had placed their horſemen in twoo Squadrons, and betweene theim the Squadron of the Infauterie, and their greate Ordinaunce in front, towarde the place, where *Vaca de Caſtro* was thought to giue the onſette. And demyng it a cowardie, to ſtaie any longer, the Squadrōs marched on with the Artillarie, towarde the face of the force of *Vaca de Caſtro*, cleane againſt the will, and opinion of *Pedro Suarez* cheef Seriant of his Armie, who beeyng a manne experte in the warres, liked not their doynges: for as ſoone as he ſawe the ſettyng forwarde of the Ordenaunce, he iudged the feelde to be loſte. Becauſe in the place where before the Campe was pitched, there was ſpace ſufficient for the Artillarie, to offende at will, before the enemie might come nere, and with proceadyng forwarde, thei of force loſte their benefite of the Ordenaunce, and ſo came without diſcretion vpon the power of their aduerſaries. When *Pedro Suarez* ſawe that thei would not accepte and followe his counſell: he ſette ſpurres to his horſe, and fledde to the parte of *Vaca de Caſtro*.

In this meane while, *Paulo*, brother vnto *Lynga* encountered with *Vaca de Caſtro* on the left hande of his armie, with a greate companie of Indian Souldiars, who ſhot with dartes and throwyng of ſtones with ſlynges and other engines. But the hargubuzers whiche were placed for tyme of neede, ſet vpō them and ſlewe many: wherevpon thei began to flee, in whoſe place entered *Martin Cote*, Captaine of the hargubuzers of *Don Diego*, who began to ſkirmiſh with the companie of captaine *Caſtro*, and the Squadrōs proceded by the ſounde of their drumnes, till thei came to the place where thei abode, whileſt the Ordnaunce was ſhot of: whiche was doen with ſuche furie that thei could not breake ſo ſone as thei would: and althogh thei were within ſhot, yet thei received thereby no damage, ſauyng the companie of footemen whiche were placed on high ground, ſo that the Ordnaunce made a greate ſpoyle among them, and forced the Squadron to open: yet notwithſtandyng, the Captaines with greate dilligence cauſed them to ioyne againe.

At

Z.ij. In

NEW MEXICO.
Otherwise,
The Voiage of Anthony of
ESPEIO, who in the yeare 1583. with
his company, discouered a Lande of 15.
Prouinces, replenished with Townes and vil-
lages, with houses of 4. or 5. stories height,
It lieth Northward, and some suppose
that the same way men may by pla-
ces inhabited go to the Lande
tearmed De Labrador.

Translated out of the Spanish copie prin-
ted first at Madreel, 1586, and afterward
at Paris in the same yeare.

Imprinted at London for
Thomas Cadman.

5⅝ in.

3¾ in.

Antonio de Espejo
**New Mexico: Otherwise the Voiage
of Anthony of Espeio**, 1587

The unique surviving copy of the narrative
of an expedition to New Mexico

214

AGUSTÍN DE ZÁRATE

The Strange and Delectable History of the Discoverie and Conquest of the Provinces of Peru, in the South Sea

Translated by Thomas Nicholas
London: R. Jones, 1581
6⅞ x 5³⁄₁₆ in. (17.5 x 13.2 cm)
Libraries of the Claremont Colleges,
Hoover Collection, Honnold/Mudd Library

Agustín de Zárate (b. 1514) was secretary to the royal council of Castile for fifteen years before being sent to Peru with the first viceroy in 1543 as comptroller-general to oversee the colony's finances. He returned to Spain two years later and began writing this history of the Spanish discovery and conquest of Peru. Based on his own notes, documents about the civil war between the Spaniards in Peru, and other published sources, his history begins with the first European explorations of Peru in the 1520s and ends with the restoration of royal authority in 1548, after years of civil unrest. Conscious of the difficulties of writing about recent political and controversial matters such as the struggles for power in colonial Peru, the author was reluctant to see his work published during his lifetime. Prince Philip, the future king of Spain, read a manuscript copy, however, and ordered its publication. The first edition, *Historia del descubrimiento y conquista del Perú*, was printed in 1555 in Antwerp.

This first English edition contains the first four of the seven books of the first Spanish edition. A second Spanish edition was printed in 1577, and Dutch and Italian versions were also published prior to this translation by Thomas Nicholas. A total of nine editions and translations were printed by the end of the sixteenth century, an indication of continuing European interest in the region and Spanish activity there. Of the four books in this edition, one is devoted to the conquest of the Inca empire, and six brief chapters describe aspects of the history and beliefs of the Indians. Most of the volume is concerned with Spanish government and military figures and their intrigues, political maneuverings, and military actions.

The copy on display is from the Hoover Collection, a library concentrating on the history of science, with a special focus on mining and metallurgy. Of particular interest in this context is the final chapter (a translation of chapter four, book six, of the 1555 edition) regarding the silver mines of Potosí in Upper Peru, now Bolivia. Discovered by the Spaniards in 1547, Potosí contained the largest concentration of silver in the Western world. Despite enormous fluctuations in silver production during the colonial period, the ore was a major revenue source for Spain before 1700, and the mines were known throughout Europe as the source of previously unheard-of riches. Zárate wrote of the silver extracted from the mines: "The riches was so great which heare they founde, that almost in every vayne where they made their ensay, they founde the greatest part of Ewre to be fine silver, and the basest Mines were by valuacion .480. buckets, in every hundred weight of Ewre, which is the greatest riches, that ever hath ben seen or written of."

Potosí's fame and economic importance are also acknowledged in this edition by the illustration found on the second title page and at the beginning of the Potosí chapter. The woodcut is of the mountain (complete with silver veins delineated) dominating the town, inscribed with the legend "The riche mines of Potossi." Derived from an illustration in Pedro de Cieza de León's *Parte primera de la chronica del Peru* (Seville, 1553), the image has lost none of its power to excite the imagination with the possibility of fabulous wealth. *Daniel J. Slive*

References
Joseph Sabin, *Bibliotheca Americana: A Dictionary of Books Relating to America*, 29 vols. (1868–92, 1928–36; reprint, Amsterdam: N. Israel; New York: Barnes & Noble, 1961–62), no. 106272; Elihu Dwight Church, *A Catalogue of Books Relating to the Discovery and Early History of North and South America, Forming a Part of the Library of E. D. Church [1482–1884]*, 5 vols. (1907; reprint, Gloucester, Mass.: P. Smith, 1951), no. 126; A. W. Pollard and G. R. Redgrave, *A Short-Title Catalogue of Books Printed in England, Scotland, and Ireland and of English Books Printed Abroad (1475–1640)*, 2d ed. (London: Bibliographical Society, 1976–91), no. 26123; *The Herbert Clark Hoover Collection of Mining and Metallurgy, Bibliotheca de Re Metallica*, annotated by David Kuhner, catalogue by Tania Rizzo, introduction by Cyril Stanley Smith (Claremont, Calif.: Libraries of the Claremont Colleges, 1980), no. 905; John Alden and Dennis C. Landis, eds., *European Americana: A Chronological Guide to Works Printed in Europe Relating to the Americas, 1493–1776* (New York: Readex Books, 1980–97), no. 581/70.

Bibliography
Agustín de Zárate, *A History of the Discovery and Conquest of Peru, Books I–IV Translated out of the Spanish by Thomas Nicholas, Anno 1581* (London: Penguin Press, 1933); idem, *The Discovery and Conquest of Peru*, trans. J. M. Cohen (Baltimore: Penguin Books, 1968); idem, *Historia del descubrimiento y conquista del Perú*, ed. Franklin Pease G.Y. and Teodoro Hampe Martínez (Lima: Pontificia Universidad Católica del Perú, Fondo Editorial, 1995).

215

ANTONIO DE ESPEJO

New Mexico: Otherwise the Voiage of Anthony of Espeio

London: For T. Cadman, 1587
5⅝ x 3¾ in. (14.3 x 9.5 cm)
The Huntington Library, San Marino,
California (RB 18490)

Antonio de Espejo (d. 1585) arrived in Mexico in 1571 as an official of the Inquisition, which was being introduced there at that time. A merchant by profession, he became quite wealthy in the following decade. In an effort to extricate himself from legal difficulties, Espejo offered to lead and underwrite the cost of a rescue party to find two friars from an earlier expedition who had stayed behind in order to convert natives to Christianity. If successful, Espejo's mission would greatly assist him in his plea for relief from his legal problems. As with many expeditions in the New World, the desire to serve Christianity and the Crown and the desire to obtain wealth were all motivating factors for Espejo. In addition to resolving his problems with the law, he was interested in surveying the region for possible gold, silver, and other riches.

The expedition—consisting of Espejo, two friars, a dozen soldiers, and additional servants and interpreters— left San Bartolomé, in Nueva Vizcaya, on November 10, 1582. In the course of ten months the group traveled through the northern regions of New Spain, most of which had not yet been explored by Europeans. Their route through the "Spanish Southwest" took them into what is now Arizona, New Mexico, Texas, and the adjacent regions of Northern Mexico. Thus, the "New Mexico" in the title refers to the regions beyond the areas of Mexico already conquered and inhabited by the Spaniards.

The text itself is a straightforward, sparse, chronological account of the journey and the people, settlements, and places encountered by the expedition. The essentials of food, clothing, and shelter for the various native groups are described. The religious practices, weapons, and warlike activities of a few of the groups are discussed briefly. The author also mentions the search for gold and a few mining prospects. While he never found the former, he did succeed in encountering the latter. He also discovered that the two friars he had hoped to rescue had died.

After his return Espejo attempted to secure a contract from the Spanish court for the further exploration and colonization of the region. Letters of recommendation written by two representatives of the Church on his behalf, a petition to the king, and a copy of his relación (the account of his travels) were sent to the court in Madrid. Espejo did not live long enough to receive the contract he desired, but his reports about the potential riches of the region led to the recognition by the Spanish government of the need to colonize the area. Juan de Oñate was awarded the contract for the conquest of New Mexico in 1595 and led the exploration and occupation of the province of New Mexico from 1598 to 1608.

Espejo's petition and relación were brought to Spain by Pedro González de Mendoza. In addition to being Espejo's son-in-law, he was also the brother of the author Fray Juan González de Mendoza. The earliest mention in print of Espejo's expedition was in the first edition of the latter's Historia de las cosas mas notables, ritos y costumbres, del gran reyno dela China, published in Rome in 1585. A more extensive account was first inserted in the Madrid 1586 edition. Espejo's narrative also appeared in later Spanish editions of the Historia published in 1587 and 1595 and in French editions published in 1588, 1589, and 1600.

The Huntington Library holds the only recorded copy of New Mexico, the first separately printed English translation of Espejo's account. Printed in London in 1587, it is based on the 1586 Spanish edition of Espejo's relación published in Paris. That edition in turn was extracted from the Madrid 1586 edition of González de Mendoza's Historia mentioned above. A second English translation of Espejo's account was included in the London 1588 edition of González de Mendoza entitled The Historie of the Great and Mightie Kingdome of China, and a third translation appeared in volume 3 of Richard Hakluyt's Voyages, published in 1600. Apparently a unique survivor, this copy of Espejo also represents one of only seventeen separate editions of English translations of Spanish and Portuguese books on the New World published in the Elizabethan era. Works such as this, while small in number, were highly influential in creating the earliest English images of the Iberian discoveries in the Western Hemisphere. Daniel J. Slive

References
Joseph Sabin, Bibliotheca Americana: A Dictionary of Books Relating to America, 29 vols. (1868–92, 1928–36; reprint, Amsterdam: N. Israel; New York: Barnes & Noble, 1961–62), no. 53283; Henry Raup Wagner, The Spanish Southwest, 1542–1794: An Annotated Bibliography (Albuquerque: Quivira Society, 1937) no. 8b; A. W. Pollard and G. R. Redgrave, A Short-Title Catalogue of Books Printed in England, Scotland, and Ireland and of English Books Printed Abroad (1475–1640), 2d ed. (London: Bibliographical Society, 1976–91), no. 18487; John Alden and Dennis C. Landis, eds., European Americana: A Chronological Guide to Works Printed in Europe Relating to the Americas, 1493–1776 (New York: Readex Books, 1980–97), no. 587/12.

Bibliography
Herbert Eugene Bolton, Spanish Exploration in the Southwest, 1542–1706 (New York: Charles Scribner's Sons, 1916); Antonio de Espejo, New Mexico: Otherwise, the Voiage of Anthony of Espejo ([Lancaster, Penn.: Lancaster Press,] 1928); Diego Pérez de Luxán, Expedition into New Mexico Made by Antonio de Espejo, 1582–1583, trans. George P. Hammond and Agapito Rey (Los Angeles: Quivira Society, 1929); Henry Raup Wagner, One Rare Book (Los Angeles: Zamorano Club, [1956]).

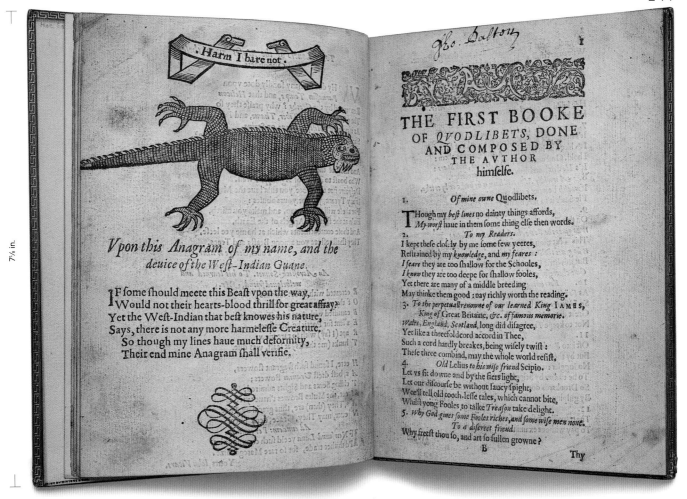

Robert Hayman
Quodlibets, Lately Come Over from New Britaniola, Old Newfoundland, 1628

The first book of poems written in the New World

216

ROBERT HAYMAN

JOHN SMITH

The Generall Historie of Virginia

London: For M. Sparkes, 1624
12⅛ x 8³⁄₁₆ in. (30.6 x 20.8 cm)
The Huntington Library, San Marino,
California (RB 18537)

217

ROBERT HAYMAN

Quodlibets, Lately Come Over from New
Britaniola, Old Newfoundland

London: Elizabeth Allde for Roger Michell, 1628
7⅛ x 5⅝ in. (18.1 x 14.3 cm)
The Huntington Library, San Marino,
California (RB 3421)

One might not expect to find a collection of poems
in a section of an exhibition that deals essentially
with travel from Europe to the Americas, where it is
flanked by the more famous narrative accounts of
Samuel de Champlain and Captain John Smith. It
must be admitted too that Robert Hayman's poetry,
were it not for its evidentiary value and its unique
claim to being the first poetic work in English to be
written in North America, might not be very well
remembered. The poetry, in other words, is not
Caroline verse at its best (Hayman himself speaks of
"my rude rimes"), and the book, besides, is very
rare. Fewer than twenty copies have survived, and
three of them are incomplete.

Robert Hayman (1575–1629) was born in the
town of Totnes in Devon, England, and his boyhood
coincided with a period of great English success at
sea. Newfoundland, for example, which would play
a large role in Hayman's adult years, was claimed
by Sir Humphrey Gilbert in 1583. Hayman studied
at Oxford and the University of Poitiers, and after
receiving his B.A. in 1596, he was a student at
Lincoln's Inn, where he studied law. *Quodlibets*
attests to some experience at the court of Elizabeth,
but no other documentary evidence survives of
Hayman's duties or service there. He was married in
1604, but it seems likely that his wife died young.
Certainly she was not alive when he first went to
Bristol's Hope, in Newfoundland, in 1618 as gover-
nor of a colony of men and women sent out by the
Bristol Society of Merchant Venturers.

Hayman was in Newfoundland off and on over
the decade between 1618 and 1628, and the poems
and epigrams in his only book of poetry, published
in 1628, were apparently all written there.
A quodlibet, in a university context, is a kind of
ad-libbed exercise on a theological or philosophical
question; as a musical term, it is a more or less for-
mal piece that includes popular themes or ditties
(the final variation of J. S. Bach's *Goldberg
Variations* is the most famous of all musical quodli-
bets). It means literally "as you please," and Hayman
uses it here in this loose sense to denote what is
basically an epigrammatic approach to verse. An
example from the first book, entitled "Why there are
so few Hospitals built," gives the flavor:

*If us hath Will, but wants good Meanes to do it.
Croesus hath Meanes, but wants a will unto it.*

After he left Newfoundland in 1628, Hayman
became interested in South America, and in
November of that year he and a group of colonists
sailed to Guiana. He died of a fever there in 1629,
at the age of fifty-four.

The only copy of Hayman's *Quodlibets* on the
West Coast is at the Huntington Library. It was
among the earliest of Henry Huntington's purchases,
as it was acquired in 1911 at the famous Robert
Hoe sale in New York. Hoe acquired it in 1892 at a
Sotheby's auction for the considerable sum of $115
(Huntington paid $205 nineteen years later). Copies
of the book have sold publicly very seldom in the
ninety years since the Hoe sale. The last time a copy
sold at auction was in 1949, although a copy
(acquired by the donor much earlier in the century)
was bequeathed to Memorial University in Saint
John's, Newfoundland, in 1996 by Mr. Justice
Robert Furlong. *Bruce Whiteman*

References
John Carter Brown, *Bibliotheca Americana: Catalogue of the John
Carter Brown Library in Brown University, Providence, R.I.*, 3d ed.
(Providence: John Carter Brown Library, 1919–31), vol. 2, no. 335;
Reginald Eyre Watters, *A Checklist of Canadian Literature and
Background Materials, 1628–1960, in Two Parts*, 2d ed., rev. and enl.
([Toronto]: University of Toronto Press, [1972]), 88; A. W. Pollard and
G. R. Redgrave, *A Short-Title Catalogue of Books Printed in England,
Scotland, and Ireland and of English Books Printed Abroad
(1475–1640)*, 2d ed. (London: Bibliographical Society, 1976–91), no.
12974.

Bibliography
Dictionary of Canadian Biography (Toronto and Buffalo, N.Y.:
University of Toronto Press, 1966–98), vol. 1, 365–66; David
Galloway, "Robert Hayman (1575–1629): Some Materials for the Life
of a Colonial Governor and First 'Canadian' Author," *William and
Mary Quarterly* 24 (October 1967): 76–87.

218
SAMUEL DE CHAMPLAIN
Voyages
Paris: Collet, 1632
8¹⁵⁄₁₆ x 7 in. (22.7 x 17.8 cm)
The Huntington Library,
San Marino, California (RB 18574)

219
MICHAEL BURGHERS
**A New Map of North America Shewing Its
Principal Divisions, Chief Cities, Townes,
Rivers, Mountains &c.**
London, 1722
20 x 27⅞ in. (50.8 x 70.8 cm)
Library, Getty Research Institute
(Gutierrez Coll. 233; P840001)

220
EDWARD KING, VISCOUNT KINGSBOROUGH
Antiquities of Mexico
London: R. Havell [etc.], 1831–48
21¾ x 16 in. (55.2 x 40.6 cm)
Department of Special Collections,
Young Research Library, UCLA
(***F1219 K61a)

Born on November 16, 1795, Edward King, Viscount Kingsborough, was the eldest son of George, third earl of Kingston, an Anglo-Irish aristocrat. Lord Kingsborough attended Exeter College and, from 1814 to 1818, Oxford University. Elected member of Parliament for County Cork beginning in 1818, he relinquished the seat to his youngest brother eight years later. Today Lord Kingsborough is remembered neither for his pedigree nor public service, but for the monumental—with its oversize "imperial" folios—and lavishly illustrated nine-volume publication *The Antiquities of Mexico*.

Lord Kingsborough's interest in Mexico developed during his time at Oxford, where he happened to see the pre-Hispanic Mexican manuscripts from the collection of Sir Thomas Bodley (1545–1613) at the Bodleian Library. Fascinated, he undertook research on preconquest Mexico, which he concluded had been colonized by the Israelites, a theory occasionally entertained since the sixteenth century. Lord Kingsborough's conviction became an obsession, and he devoted the remainder of his life and his considerable fortune to proving it. His quest led to the compilation and the sumptuous publication, beginning in 1831, at an estimated cost of thirty-

two thousand pounds, of *The Antiquities of Mexico*, even including two copies on vellum. Incarcerated for debt, the hapless Lord Kingsborough died of typhus fever in a sheriff's prison in Dublin on February 27, 1837, eleven years before the final two volumes were issued.

Published from 1831 (volumes 1 through 7) to 1848 (volumes 8 and 9), *The Antiquities of Mexico* made available for the first time (in volumes 1 through 4) sixteen preconquest and early colonial indigenous Mexican pictorial manuscripts as well as smaller early colonial indigenous paintings (maps, figural illustrations, calendar wheels), all in facsimile. Moreover, Luciano Castañeda's previously unpublished drawings of Mexican archaeological sites appeared in volume 4, illustrating monuments surveyed in situ between 1805 and 1808 as part of the three expeditions led by Captain Guillermo Dupaix at the behest of the Spanish Crown. Volumes 5 and 6 contain transcripts of the Spanish and Italian annotations written in the pictorial manuscripts (volume 5) and English translations (volume 6) of the annotations. Volumes 7 through 9 offer a selection of previously unpublished sixteenth- through eighteenth-century Spanish-language studies of pre-Hispanic Mexico, such as the Franciscan Fray Bernardino de Sahagún's *General History of the Things of New Spain* (also known as the Florentine Codex, c. 1580), plus a fragment of a projected tenth volume (included in volume 9). Lord Kingsborough argued his case for the Israelite origin of pre-Hispanic Mexican cultures in extensive notes included in volumes 6 and 8.

The luxurious plates in the first four volumes, hand-colored or uncolored lithographs, were drawn from watercolors by the Italian painter and decorator Agostino Aglio (1777–1857), who had lived and worked in England since 1803. Aglio first went to England to illustrate a book, *The Antiquities of Magna Graecia* (1807), for the architect William Wilkins (1778–1839). He established himself as a portraitist—even making a portrait of Queen Victoria—and a decorative painter, working on churches, theaters, and private residences throughout England and Ireland. Commissioned by Lord Kingsborough, Aglio spent five years (1825–30)

copying Mexican pictorial manuscripts in European libraries in order to produce the illustrations for *The Antiquities of Mexico*.

Although Aglio's renditions have long been superseded, the Kingsborough facsimiles were for many years the only published editions of Mexican pictorial manuscripts such as the Codex Borgia (Borg. Messicano 1, Biblioteca Apostolica Vaticana, Rome) from south central Mexico, a ritual and divinatory manuscript painted on animal skin, and one of the handful of pre-Hispanic manuscripts to survive the European conquest and subsequent Christian evangelization. The facsimiles, in tandem with Castañeda's illustrations of actual monuments and the anthology of colonial-era ethnographic and historical texts, formed an invaluable, if costly (it originally sold at £175!), resource for nineteenth-century students of preconquest Mexico. In the words of the historian William H. Prescott (1796–1859), "by this munificent undertaking, which no government probably would have, and few individuals could have, executed, [Lord Kingsborough] has entitled himself to the lasting gratitude of every friend of science."[1]
Eduardo de Jesús Douglas

221
RICHARD BURTON
The City of the Saints
New York: Harper, 1862
9¹¹⁄₁₆ x 6¼ in. (24.6 x 15.9 cm)
Autry Museum of Western Heritage
Research Center (90.253.30)

222
RICHARD BURTON
**Three drawings for "The City of the Saints":
(a) In the Sierra Nevada
(b) The Dead Sea (Black Rock from S. E.
Angle of Great Salt Lake)
(c) Virginia City from the North-East**
(a) ink; 7¼ x 5 in. (18.4 x 12.7 cm)
(b) watercolor; 7⅛ x 5 in. (18.1 x 12.7 cm)
(c) ink; 7¼ x 5 in. (18.4 x 12.7 cm)
Autry Museum of Western Heritage Research Center
(93.182.1.1, 93.182.1.19)

References
Joseph Sabin, *Bibliotheca Americana: A Dictionary of Books Relating to America*, 29 vols. (1868–92, 1928–36; reprint, Amsterdam: N. Israel; New York: Barnes & Noble, 1961–62), no. 37800.

Bibliography
William H. Prescott, *History of the Conquest of Mexico* and *History of the Conquest of Peru*, reprint (New York: Modern Library, n.d.); Sir Leslie Stephen and Sir Sidney Lee, eds., *The Dictionary of National Biography: From the Earliest Times to 1900* (London and Oxford: Oxford University Press, Geoffrey Cumberlege, 1949–), vol. 11, 130–31, s.v. King, Edward; Emmanuel Bénézit, *Dictionnaire critique et documentaire des peintres, sculpteurs, dessinateurs et graveurs*, rev. 2d ed. (Paris: Librairie Gründ, 1976), vol. 1, 55, s.v. Aglio (Agostino); Ignacio Bernal, *A History of Mexican Archaeology* (London and New York: Thames and Hudson, 1980).

Notes
1. Prescott, *History of the Conquest of Mexico*, 75n.

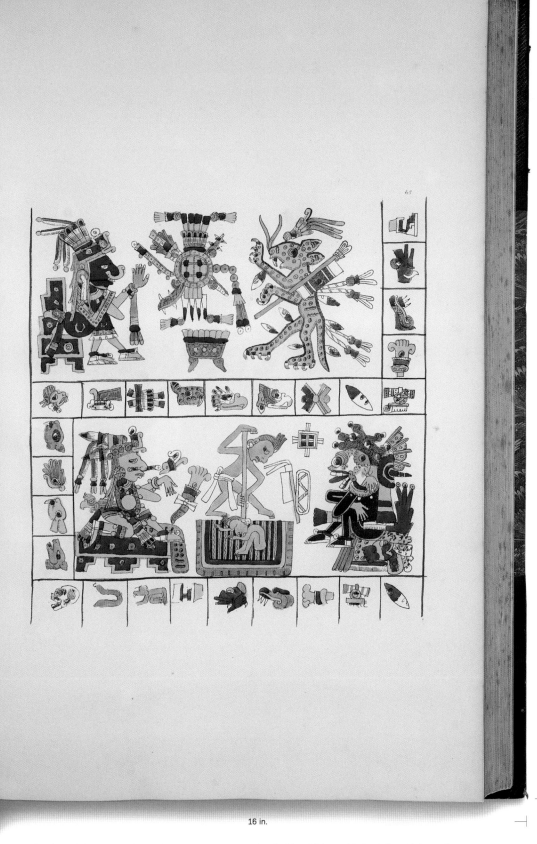

16 in.

Edward King, Viscount Kingsborough
Antiquities of Mexico, 1831–48

A collection of lithographic facsimiles of Aztec codices
and other pre-Hispanic and colonial documents

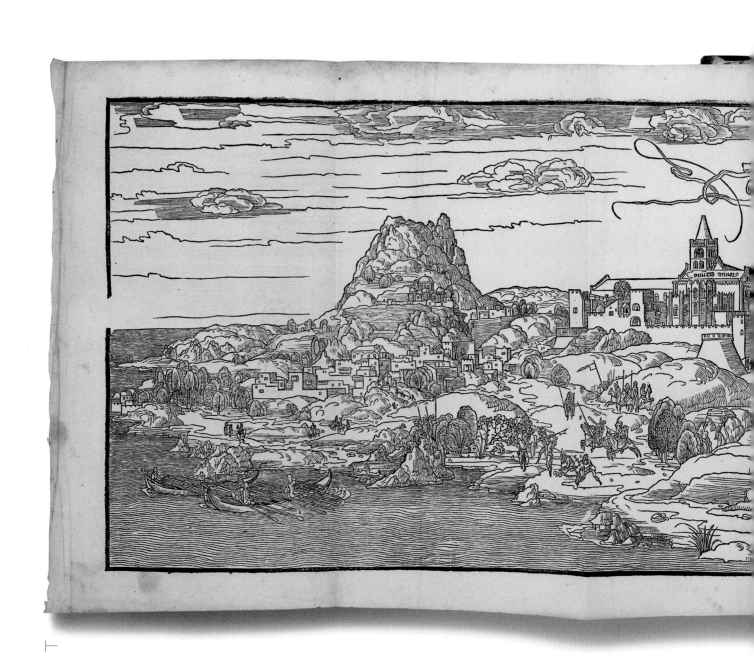

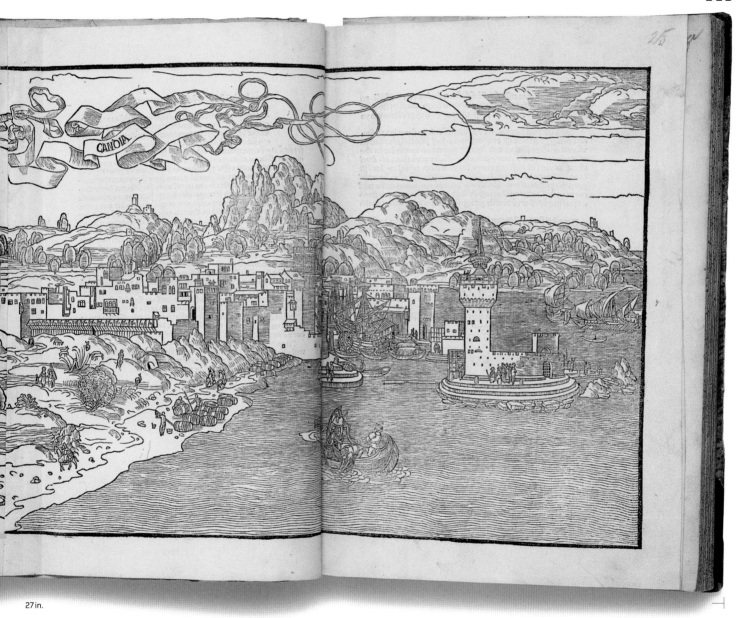

11½ in.

27 in.

Bernhard von Breydenbach
Die heyligen Reyssen gen Jherusalem,
21 June 1486

The narrative of a pilgrimage
from Venice to Jerusalem
with foldout woodcut plates

223

BERNHARD VON BREYDENBACH

Die heyligen Reyssen gen Jherusalem

Mainz: Erhard Reuwich, 21 June 1486
Illustrated with woodcuts by Erhard Reuwich
11⅞ x 9⅛ in. (30.2 x 23.2 cm)
The Huntington Library, San Marino, California
(RB 85684)

This precious incunable in elegant Gothic type is the first German translation of the *Peregrinationes*, the Latin account of Bernhard von Breydenbach's pilgrimage to the Holy Land. The book stands out among late medieval pilgrimage accounts as the first to include illustrations of the places and people encountered by the author. The woodcuts by Erhard Reuwich of Utrecht, who accompanied Breydenbach on his journey, show exquisite views of the major cities they visited and visually describe the various populations, their costumes and alphabets, and even exotic animals. These illustrations are the only works by Reuwich known to us.

Although Breydenbach wrote a manuscript account of the pilgrimage, the original text was most likely prepared by Martin Roth, a Dominican monk from Pforzheim. The book was originally published in Latin—as was customary for important works—and published in February 1486. The Latin and German editions were printed only four and a half months apart and are virtually identical, except for a notice about the coronation of King Maximilian I that appears only in the German version. The vernacular translation of the text was probably supervised by Breydenbach himself, as was the Flemish edition

of 1488. The text of the *Peregrinationes* was later translated into French and Spanish and reprinted in twelve independent editions.

Breydenbach (d. 1497), who had been canon of Mainz since 1450, undertook the pilgrimage from April 25, 1483, to the end of January 1484; he had resolved to go to the Holy Land to expiate some youthful excesses and attain salvation. He left his country in the company of Reuwich, the young Count Johann von Solms, and the count's guardian, Philip von Bicken. The four traveled from their homeland to Venice, where they met other pilgrims and set out on their sea voyage aboard a Venetian galley. After a short preface, the account of the journey begins with a description of the contract between the pilgrims and the captain, specifying the round-trip fare and other services, such as meals and land transportation. Breydenbach subsequently describes Venice, its many religious sites, and the relics to be found in and around the city. The panoramic view of Venice is the largest and most impressive in the book, and one of the oldest visual representations of the city. The beautifully detailed woodcut shows the city from the vantage point of the modern church of San Giorgio Maggiore.

From Venice, the ship progressed slowly along the Dalmatian coast (for safety reasons, Venetian galleys never sailed too far from shore), stopping at

various ports in the Adriatic, Ionian, and Aegean for food, water, or other contingencies. Breydenbach's account gives a literary and visual description of the major ports en route: Parenzo, Corfu, Modon, Candia, and Rhodes. The last folding panorama shows the arrival of the galley at Jaffa and an extensive and conceptual view of the Holy Land that stretches from Mecca and Alexandria, on the right, to Damascus and Tripoli, on the left. In the center stands the city of Jerusalem, with the major Christian sites labeled.

Like most late medieval pilgrimage accounts, Breydenbach's text follows a distinctive, nearly stereotypical pattern. There are many similarities to other accounts in the descriptions of the holy sites, probably due to the fact that pilgrims brought along previous accounts, from which they borrowed passages for their own descriptions. The introduction of illustrations was the innovative feature that set this book apart and made it one of the most popular and widely copied in its time and in succeeding centuries.

Henry E. Huntington purchased this copy of Breydenbach's *Peregrinationes* as part of a large stock of incunabula (1,750 books) sold by the German agent and bibliophile Otto H. F. Vollbehr in March 1925. The sale, long one of the largest ever recorded in the history of American bibliophily, netted Vollbehr $770,000. *Roberta Panzanelli*

References
Catalogue of Books Printed in the Fifteenth Century Now in the British Museum (London: British Museum, 1908–), vol. 1, no. 44; Wilhelm Ludwig Schreiber, *Manuel de l'amateur de la gravure sur bois et sur métal au XVe siècle*, vol. 5, *Un catalogue des incunables à figures imprimés en Allemagne, en Suisse, en Autriche-Hongre, et Scandinavie* (Leipzig: O. Harrassowitz, 1910–11), no. 3630; *Gesamtkatalog der Wiegendrucke*, 10 vols. (Leipzig and Stuttgart: Hiersemann, 1925–), no. 7173; Frederick R. Goff, *Incunabula in American Libraries: A Third Census* (New York: Bibliographical Society of America, 1964), no. B-1193.

Bibliography
Bernhard von Breydenbach, *Les saintes pérégrinations de Bernard de Breydenbach (1483)*, trans. F. Larrivaz (Cairo: Imprimerie nationale, 1904); Hugh William Davies, *Bernhard von Breydenbach and His Journey to the Holy Land 1483–4: A Bibliography* (1911; reprint, Utrecht: Haentjens Dekker & Gumbert, 1968); Bernhard von Breydenbach, *Die Reise ins Heilige Land: Ein Reisebericht aus dem Jahre 1483*, ed. Elizabeth Geck (Wiesbaden: G. Pressler, 1961);

Die Reise nach Jerusalem: Bernhard von Breydenbachs Wallfahrt ins Heilige Land, ed. Cornelia Schneider (Mainz: Gutenberg-Museum, 1992); Bernard Rosenthal, "The History of Incunabula Collections in the United States," *Aus dem Antiquariat* (June 2000): 357–58.

224

Traveling library of Sir Thomas Egerton, Lord Ellesmere, 1613

16 x 11⅛ x 3⅜ in. (40.6 x 28.3 x 8.6 cm)
The Huntington Library, San Marino,
California (RB 88313)

225

ATHANASIUS KIRCHER

China monumentis

Amsterdam: Johannes Janssonius
van Waesberge, 1668
15⁵⁄₁₆ x 10³⁄₁₆ in. (40.5 x 25.9 cm)
Library, Getty Research Institute
(85-B12590)

16 in.

11⅛ in.

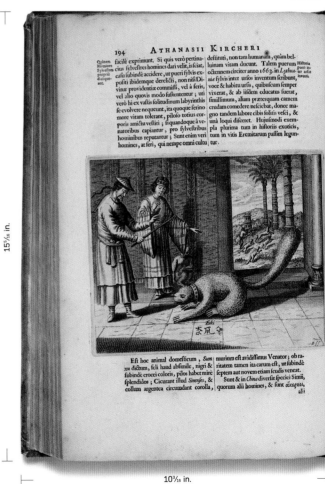

15⁵⁄₁₆ in.

10³⁄₁₆ in.

**Traveling library of Sir Thomas Egerton,
Lord Ellesmere**, 1613

A collection of small books designed for travel

Athanasius Kircher
China monumentis, 1668

A Baroque illustrated book about China
by the Jesuit polymath

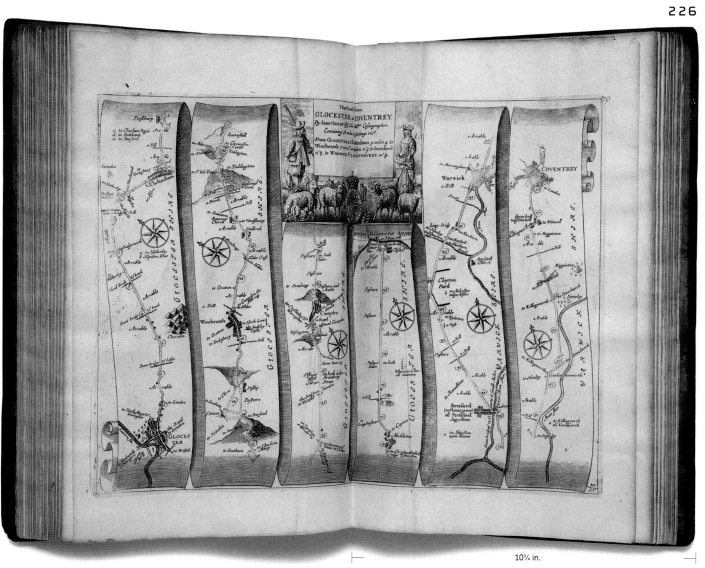

15¾ in.

10¾ in.

John Ogilby

**Britannia; or, The Kingdom of England and the
Dominion of Wales, Actually Survey'd**, 1698

The first English road atlas

226

JOHN OGILBY

Britannia; or, The Kingdom of England and the Dominion of Wales, Actually Survey'd

London: Abel Swall
and Robert Morden, 1698
15¾ x 10¾ in. (40 x 27.3 cm)
William Andrews Clark Memorial Library,
UCLA (*fDA 615 O34 1698)

As the reader is informed in the foreword to John Ogilby's *Britannia*, or *Itinerarium Angliae*, road maps are an ancient cartographic genre. Roads have not, however, been delineated consistently on general maps. For example, a readily available source about which the author of *Britannia* knew, the maps of the counties of England and Wales published between 1570 and 1579 by Christopher Saxton, lacks roads altogether.

Britannia (1698) is a revised and reformatted version of *Britannia*, a road atlas with maps and descriptions of the principal highways of England and Wales, the first edition of which is dated 1675. As is stated on the title page of the original edition, John Ogilby (1600–1676), the originator of this atlas, had the appointments of "His Majesty's *Cosmographer*, and *Master* of His Majesty's *Revels* in the Kingdom of Ireland"; the title page concludes with the statement, "*London*, Printed by the Author at his House in *White-Fryers*. *M.DC.LXXV*." In the 1698 edition these statements have been altered to "Cosmographer to King *Charles* the Second," and "London: printed by Abel Swall, at the Unicorn in *Pater-noster-row* and Robert Morden at the Atlas in *Corn-hill*. MDCXCVIII." These last statements indicate that both King Charles II (d. 1685) and Ogilby were deceased when the later edition appeared.

Even considering the turbulent times in which he lived, Ogilby had an extraordinary career. Born near Edinburgh in 1600, he had little formal education. Apprenticed to a dancing master in London, he became an accomplished performer until an accident forced him to quit. He then opened a successful dancing school in the city before moving to Dublin, in the service of the earl of Strafford, lord deputy of Ireland. There Ogilby began a literary career, opened a small theater, and was appointed deputy master of the revels in Ireland.

As the result of the English Civil War, Ogilby lost everything and returned to England. He learned Latin and Greek, translated classical works, and, as noted by Dryden, produced a literary piece for the coronation of Charles II. The king appointed Ogilby master of the revels in Ireland, to which country he returned and again opened a theater, which failed. Following this, he settled once again in England, where he translated, published, and sold books in Whitefriars, London. His stock was destroyed in the Great Fire of 1666, but after this disaster he set up once more as a publisher.

For the illustrations in his beautiful folio editions, Ogilby employed some of the best engravers of the time, including the Bohemian Wenceslaus Hollar, then living in England. It was only in the last years of his life that Ogilby published geographical works, inspired by practical needs after the fire, for which he employed William Leybourne, author of *The Compleat Surveyor* (London, 1674), and others. These works included a map of London, preparatory to its rebuilding, and a series of atlases of continental areas. Ogilby's most valuable contribution was,

however, *Britannia*, in which he was assisted by the surveyor John Holwell, who undertook the actual measurement of the roads of England and Wales and described his methods of gathering data in his *Sure Guide to the Practical Surveyor* (London, 1678).

Although the formats of the first and second editions of *Britannia* differ, the contents of the two volumes are similar. Each consists of one hundred double-page spreads of engraved strip maps on the scale of one inch to one mile, showing sixty-three principal roads in the kingdom (e.g., 1, London to Aberistwith [*sic*]), with geographical descriptions of these routes. *Britannia* is credited with helping standardize the English mile of 1,760 yards. There is a wealth of topographical information both on the maps and in the descriptions. Beautiful cartouches, some with rural scenery and figures, surround the titles of the plates, and a splendid full-page engraving of contemporary surveyors at work (by Hollar) introduces the volume.

John Ogilby's *Britannia* was the first English road atlas, including new information that was later added to other maps, including those of Saxton. Publication of Ogilby's original work inspired a number of derivatives during the century following: versions with text alone, reductions of the road maps (some in book form for use in carriages), and foreign road maps using Ogilby's methods. Eventually, in the late eighteenth century, new road atlases superseded *Britannia*, but Ogilby's ideas are perpetuated today in automobile strip maps with descriptions of routes. *Norman J. W. Thrower*

References
Donald Wing, *Short-Title Catalogue of Books Printed in England, Scotland, Ireland, Wales, and British America, and of English Books Printed in Other Countries, 1641–1700* (New York: Index Committee of the Modern Language Association of America, 1972–98), no. O 169; Margret Schuchard, *A Descriptive Bibliography of the Works of John Ogilby and William Morgan* (Bern: Herbert Lang; Frankfurt am Main: Peter Lang, 1975), no. 44.

Bibliography
Sir H. G. Fordham, "John Ogilby (1600–1676)," *Transactions of the Bibliographical Society*, 2d ser., 4 (1925): 157–78; John Ogilby, *Britannia*, reprinted with an introduction by J. B. Harley (Amsterdam: Theatrum Orbis Terrarum, 1970), containing a portrait of Ogilby.

227

ROBERT WOOD

The Ruins of Palmyra, Otherwise Tedmor, in the Desart

London: The author, 1753
Illustrated by J. B. Borra
23¹⁄₁₆ x 15⁵⁄₁₆ in. (58.6 x 38.9 cm)
Library, Getty Research Institute
(85-B25010)

Robert Wood summarized the chief goal of his travels to the eastern Mediterranean as being to read "the Iliad and Odyssey in the countries where Achilles fought, where Ulysses traveled, and where Homer sung." "Classical ground," he argued, "not only makes us always relish the poet, or historian, more, but sometimes helps us understand them better." The decision to publish the record of his travels was based on his wish to extend his own "amusement and improvement," to offer "some advantage to the public," and in the process, "to rescue from oblivion the magnificence of Palmyra."

Wood (1717?–71) was born at Riverstown Castle, near Trim, in England, and is said to have been educated at Oxford. His early travels took him to Italy, Greece, Syria, and Egypt in 1742–43. He set off for Greece again in 1749, accompanied by Oxford-trained scholars John Bouverie and James Dawkins, and an Italian "architect and draughtsman" named J. B. Borra. Bouverie died on the way. The survivors arrived in Athens in May 1751 to find James Stuart and Nicholas Revett, "successfully employed in taking measures of all the architecture there, and making drawings . . . with a view to publish them," in Wood's words. Trusting that "some of

the most beautiful works of art of ancients were to be preserved by persons so much more equal to the task," Wood and his colleagues left in good conscience for Syria. The Ruins of Palmyra and its successor, The Ruins of Balbec, Otherwise Heliopolis in Celosyria (1757), are the results of their surveys and observations in these two antique towns.

The text of The Ruins of Palmyra gives readers a historical background, emphasizing the scarcity of knowledge on the manners and customs of the society and thereby providing the book's raison d'être. Wood argues that the people of Palmyra had developed a synthetic culture: "their funeral customs were Egyptian, their luxury was Persian, and their letters and arts were from the Greeks." Significantly the narrative also introduces the contemporary society living in and around Palmyra through proto-ethnographic descriptions of "Arabs," flavored with an exoticism typical of the Orientalist discourse and revealing a particular fascination with women. "They were veiled," Wood reported, "but not so scrupulous of showing their faces, as the Eastern women generally are. They paint the ends of their fingers red, their lips blue, and their eye-brows and eye-lashes black, and wear very large brass rings in their ears and noses."

It is nevertheless the visual material that makes The Ruins of Palmyra a keystone of eighteenth-century travel literature. The measured

drawings range from perspective views to site plans, building plans, plans of building parts, renditions of façades, and details. The exquisite technical presentations are complemented by the picturesque depictions in the perspective views, often framed by ruined arches and enriched by human figures in "oriental" costumes.

Wood's books contributed to the emerging literature on Greek antiquity which began to challenge the unique authority of Rome during the second half of the eighteenth century. Together with other richly documented surveys, such as Stuart and Revett's Antiquities of Athens (1762–1830; cat. no. 236) and J. D. Le Roy's Les ruines des plus beaux monuments de la Grèce (1758), they expanded the scope of archaeological research and eventually contributed to the birth of a Greek revival style in architecture. At the same time, the archaeological interest in Greek antiquities appealed to collectors' sensibilities, and taking away fragments became a commonplace practice with consequences that extend to the present day. As Wood wrote in his introduction to The Ruins of Palmyra, he and his colleagues were equipped with "tools for digging," and they "carried off the marbles wherever it was possible." If the antique pieces could not always be transported literally, their accurate documentation enabled their possession metaphorically. The Ruins of Palmyra is the embodiment of this claim.
Zeynep Çelik

References
Edward Godfrey Cox, A Reference Guide to the Literature of Travel, Including Voyages, Geographical Descriptions, Adventures, Shipwrecks, and Expeditions (Seattle: University of Washington Press, 1935–49), vol. 1, no. 227; Leonora Navari, Greece and the Levant: The Catalogue of the Henry Myron Blackmer Collection of Books and Manuscripts (London: Maggs Bros., 1989), no. 1834 (1753 French ed.); ESTC t137526.

Bibliography
C. G. Addison, Damascus and Palmyra: A Journey to the East (London: R. Bentley, 1838); P. V. N. Myers, Remains of Lost Empires: Sketches of the Ruins of Palmyra, Nineveh, Babylon, and Persepolis, with Some Notes on India and the Cashmerian Himlayas (New York: Harper & Brothers, 1875); John W. Early, Palmyra: Its History and Surroundings (Lebanon, Penn.: Lebanon County Historical Society, 1908); Theodor Wiegand, ed., Palmyra: Ergebnisse des Expeditionen

von 1902 und 1917 (Berlin: H. Keller, 1932); Iain Browning, Palmyra (London: Chatto & Windus, 1979); Anita Damiani, Enlightened Observers: British Travellers to the Near East, 1715–1850 (Beirut: American University of Beirut, 1979); International Symposium of Palmyra and the Silk Road (Damascus: Matab'i Wizarat al-Thaqafah, 1992); Paul Scheerbart, Der alte Orient: Kulturnovelletten aus Assyrien, Palmyra, und Babylon (Munich: Editions Text + Kritik, 1999).

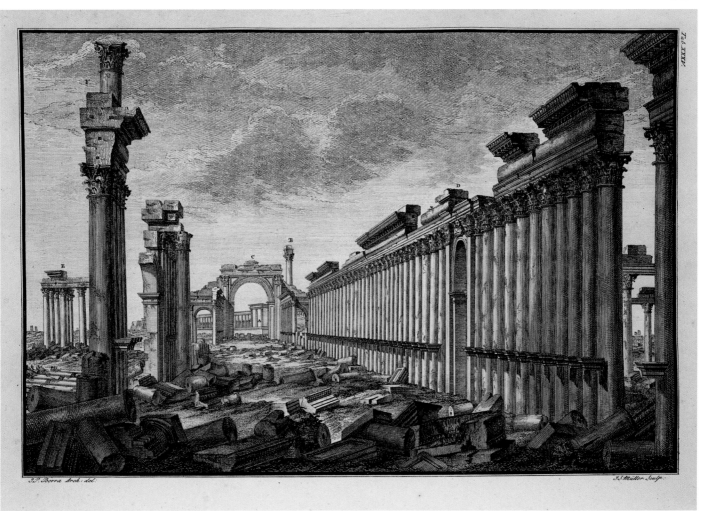

15⁹⁄₁₆ in.

23¹⁄₁₆ in.

Robert Wood
The Ruins of Palmyra, Otherwise Tedmor, in the Desart, 1753

A study of the culture and antiquities of an ancient Syrian city

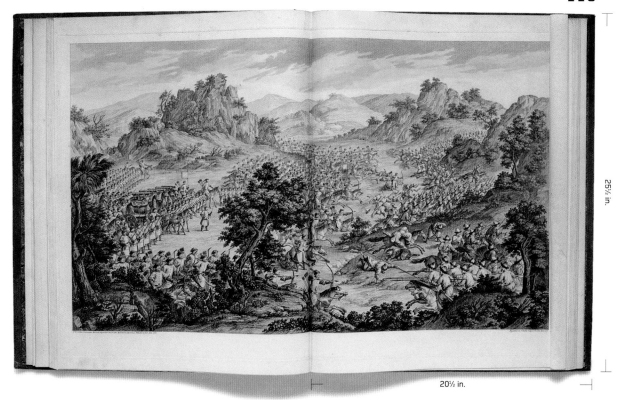

25½ in.

20½ in.

14⁵⁄₁₆ in.

20¹⁄₁₆ in.

Suite des seize estampes représentant les conquêtes de l'empereur de la Chine, avec leur explication, 1765–75

A collection of engravings representing the conquests of a Chinese emperor

Dai Nihon Chokanzu, late 18th or early 19th century

A bird's-eye view of the islands of Japan

228

Suite des seize estampes représentant les conquêtes de l'empereur de la Chine, avec leur explication

Paris, 1765–75
Suite of engravings; 25½ x 20½ in. (64.8 x 52.1 cm) each
Library, Getty Research Institute
(1369-468)

229

Yuan-ming-yuan

Beijing, 1786(?)
Suite of engravings; 19¾ x 34½ in.
(50.2 x 87.6 cm) each
Library, Getty Research Institute
(86-B26695)

230

Dai Nihon Chokanzu, late 18th or early 19th century

Map mounted onto scroll;
14⁵⁄₁₆ x 20¹⁄₁₆ in. (36.4 x 51 cm)
Department of Special Collections,
Young Research Library, UCLA
(1013 Box 15 II 4 a / SRLF F 000 053 327 3;
Rudolf collection of Japanese maps)

231

Description de l'Egypte

Paris: Commission des sciences
et arts d'Egypte, 1809–28
28½ x 21⅝ in. (72.4 x 54.9 cm)
California Institute of the Arts,
Division of Library and Information Resources,
CalArts Special Collections (DT46.F8)

232

ANTOINE IGNACE MELLING

Voyage pittoresque de Constantinople et des rives du Bosphore

Paris: Didot, 1819
41½ x 25⅝ in. (105.4 x 65.1 cm)
Library, Getty Research Institute
(93-B15373)

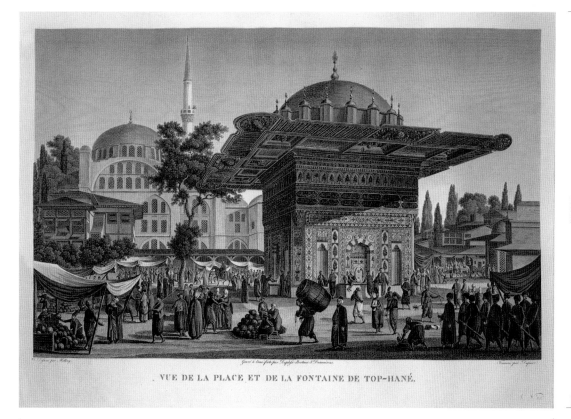

INTÉRIEUR D'UN CAFÉ PUBLIC,
Sur la Place de Top-hané.

VUE DE LA PLACE ET DE LA FONTAINE DE TOP-HANÉ.

25 ⅝ in.

41½ in.

Antoine Ignace Melling
**Voyage pittoresque de Constantinople
et des rives du Bosphore**, 1819

Views of Constantinople and environs
by the architect to the ruler
of the Ottoman Empire

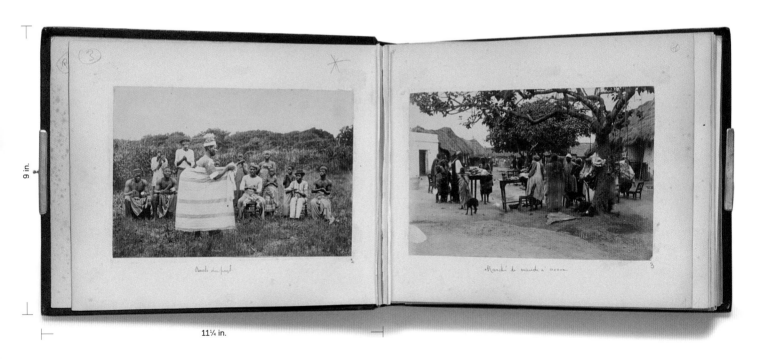

Edouard Foà
Views of Africa, c. 1886–90

One of many photographic albums chronicling the
expeditions of the young French explorer

9 in.

11¼ in.

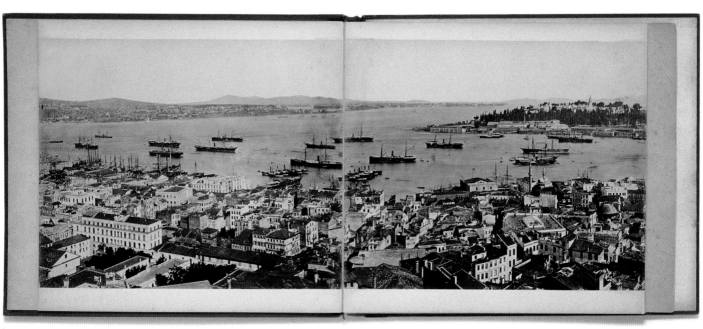

30 in.

12⁵/₁₆ in.

Sebah and Joaillier
Panorama de Constantinople,
late 19th century

233

EDOUARD FOÀ

Views of Africa, c. 1886–90

Album of albumen prints;
9 x 11¼ in. (22.9 x 28.6 cm)
Library, Getty Research Institute
(Bonnemaison Collection, 93.R.114)

234

SEBAH AND JOAILLIER

Panorama de Constantinople,
late 19th century

Albumen print; 12⁵⁄₁₆ x 135⅛ in.
(31.3 x 343.2 cm)
Library, Getty Research Institute
(Bonnemaison Collection, 88.R.12)

235

MARIE–JOSEPH PEYRE

**Recueil de morceaux d'architecture
et de divers fragmens de monumens
antique faite en Italie**, 1753–85

Album with sketches; 16⅞ x 11 in.
(42.9 x 27.9 cm)
Library, Getty Research Institute (840015*)

236

JAMES STUART AND NICHOLAS REVETT

**The Antiquities of Athens
Measured and Delineated**

London: John Haberkorn, 1762–1830
22⅝ x 15¹¹⁄₁₆ in. (57.5 x 39.8 cm)
The Huntington Library, San Marino,
California (RB 382720)

237

JACQUES-LOUIS DAVID

Roman Album No. 11, 1775–80

Twenty-six leaves with eighty-two
sketches and sixteen tracings
(graphite, pen and brown ink, brown
and gray wash, and black chalk);
20⅜ x 13¾ in. (51.8 x 34.9 cm)
Library, Getty Research Institute
(940049*)

Jacques-Louis David's famous proclamation, "The Antique will not seduce me," made to François Boucher before leaving Paris for Rome in 1775, must rank as one of the great false prophecies in the literature of art history. So profoundly affected was David (1748–1825) by what he found in Italy that he experienced a kind of madness, devoting his seemingly inexhaustible energy to copying the old masters and, especially, to the study of classical sculpture. The fruit of this period, from 1775 to 1780 as a *pensionnaire* (recipient of the Prix de Rome) of the French Academy in Rome, was a prodigious body of drawings mostly after the antique. David saved these sketches (perhaps as many as a thousand), systematically organizing them at some later date into two large albums.

Expanded by his heirs into twelve albums, these were described in the catalogue of the Paris David sale of 1826 (a year after his death) as: "Twelve great books consisting of sketches after Antique reliefs, figures after the antique, landscapes, mainly Italian, and tracings, . . . the precious deposit of the inspirations of M. David that trace the route he took to achieve his great goal, to wit,

to regenerate the school [of painting]. It was his desire that such classical models would forever guide young artists and perpetuate the great principles of painting."

Of the twelve albums, at least eight are still intact. Album 1 has been in the Fogg Art Museum of Harvard University since 1943; Album 3 was acquired by the Nationalmuseum, Stockholm, in 1959; the National Gallery of Art, Washington, D.C., acquired Album 4 in 1998; Albums 7 and 9 have been in the Musée du Louvre, Paris, since the second David sale in 1835; Album 8 was bought by the Pierpont Morgan Library, New York, in 1998. Albums 6 and 10 were broken up (both within the last fifty years), their drawings sold separately. Album 5 remains with the heirs of Baron Jeanin, son of Pauline David. The whereabouts of Albums 2 and 12 are unknown.

The Getty Research Institute's Album 11 consists of twenty-six large folio pages (measuring 18⅞ x 13 in. [48 x 33 cm]), on each of which is pasted from one to ten drawings, most bearing the authenticating initials of the artist's sons Jules and Eugène (significantly, the tracings are not initialed). While the album includes studies after old masters (e.g., Sebastiano del Piombo's *Raising of Lazarus* and Raphael's *Fire in the Borgo*) and several beautifully rendered Italian landscapes and views of Rome, the greater part consists of copies after classical sculpture, reliefs, and vases in Roman collections. The subjects include standing or seated rhetoricians,

reclining river gods, mythological figures, portrait busts, and sarcophagus reliefs, many labeled by the artist as to identity and location and arranged on the page according to perceived formal similarities and his own system of classification. The quantity of private and semipublic collections visited attests to David's tireless diligence in the pursuit of his goal "to regenerate the school of painting."

David's contemporary Thomé de Gamond, in his 1826 *Vie de David*, informs us that the artist used the albums for reference throughout his life. Certainly David drew upon them in composing those paintings executed in the first Roman period, but it is really only with the *Oath of the Horatii* of 1785 that we see his thorough absorption of the antique, the assimilative culmination of his studies after classical antiquity. We may conceive of these sketches then as a library of sources for David, as essential *aides-mémoires*, as spurs to inspiration, and as compendia of the discovery of the antique mode that transformed David's art, in turn transforming the history of European painting.

Originally purchased by Monsieur A. Chassaignolle (uncle and adoptive father of the artist's grandson Jacques-Louis-Jules David) at the 1835 sale, the album remained in his descendants' possession until 1986, when it was sold at auction in Monaco (Sotheby's, 22 February). The Getty acquired it through the New York dealer Stephen Mazoh in 1994. *Kevin Salatino*

References
Pierre Rosenberg and Louis-Antoine Prat, *Jacques-Louis David, 1748–1825: Catalogue raisonné des dessins* (forthcoming).

Bibliography
Arlette Sérullaz, *Inventaire général des dessins, école française: Dessins de Jacques-Louis David* (Paris: Éditions de la Réunion des musées nationaux, 1991); Kevin Salatino, "J.-L. David's Roman Album 11 at the Getty Center," *Apollo* 140 (November 1994): 50–51.

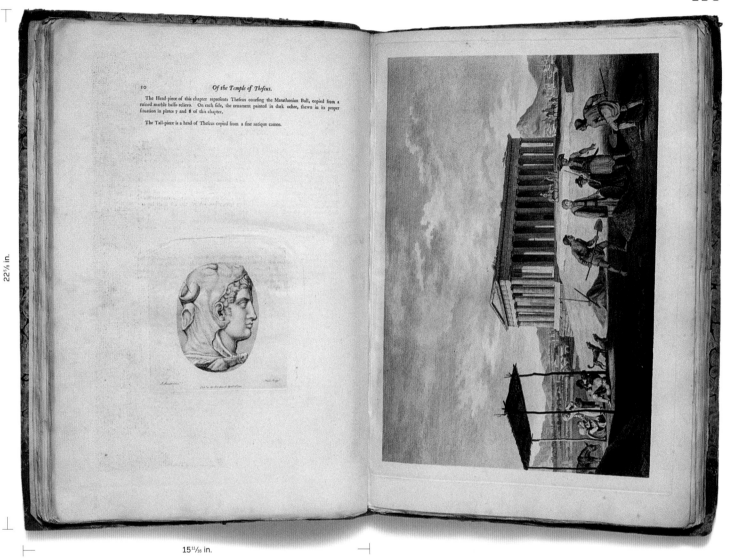

James Stuart and Nicholas Revett
The Antiquities of Athens
Measured and Delineated, 1762–1830

The earliest archaeological study of Athens

Jacques-Louis David
Roman Album No. 11, 1775–80

6½ in.

nel circo di floia

n° 31

9¼ in.

Louis Gauffier
Roman Sketchbook, 1784–89

238

LOUIS GAUFFIER
Roman Sketchbook

Rome, 1784–89
Forty-eight drawings on forty-seven
leaves (pencil, black and white chalk,
pen and black and brown ink,
and gray and brown wash);
9¼ x 6½ in. (23.5 x 16.5 cm)
Library, Getty Research Institute
(950096) (folio #31)

This small sketchbook belonged to the French
painter Louis Gauffier (1761–1801) while he was liv-
ing at the French Academy in Rome from 1784 to
1789 as a recipient of the Prix de Rome, simultane-
ously awarded to him and to Jacques-Louis David's
protégé Jean-Germain Drouais (1763–88) in 1784.
The greater part of the sketchbook contains urban
views of Rome (twenty-three drawings), some
helpfully inscribed by the artist (e.g., "S. gregorio,"
"S. Lorenzo fuori delle mura," "lato di S. gio.
Laterano"), others difficult to identify because of
Gauffier's penchant for the anonymous. These archi-
tectural landscapes, or urban *vedute*, are character-
ized by a severe simplification of forms, with a
quality at once abstract and reductivist.

In contrast to the more cluttered Roman views
of David (see cat. no. 237), Gauffier effectively uti-
lized large expanses of the page's white surface to
suggest the brilliance of Roman light, blanching
detail from the noonday landscape. Largely eschew-
ing the remains of ancient Rome, the artist concen-
trated instead on the fabric of the post-antique city
(even what appears to be an ancient ruin turns out,
upon closer inspection, to be the seventeenth-
century Casino Saccheti, already in a state of disrepair
by Gauffier's day). In a strikingly original decision,
Gauffier turned his attention to the more anonymous

fabric of the Middle Ages and Renaissance, where
congeries of plain, unadorned buildings on a monu-
mental scale must have appealed to his rigid formal-
ist instinct. In a drawing of San Giovanni in Laterano
(folio 31), for example, the worm's-eye view
enhances the monumentality of the building com-
plex, while the isosceles triangle formed by the
raking shadow slicing across the foreground stairs
underscores the geometry of the whole. For
Gauffier, Rome functioned as an enormous
classroom for the study of solid form.

In many of his drawings, Gauffier emphasized
the rusticity rather than the urbanity of Rome. An
evocative, indeed romantic, sketch of the Villa
Negroni (folio 21) emphasizes the massive cluster of
umbrella pines and cypresses to the right of the
dwarfed building, all rendered in pure wash, while
in two sketches inscribed "dietro di S. Pietro"
(folios 24 and 30), the rising ground characteristic
of prepaved Rome threatens to swallow up the
faceless, cubic medieval structures.

The remainder of the sketchbook's drawings
depict Gauffier's studies after classical sculpture and
furniture in the collections of the Villa Borghese,
Palazzo Lancelloti, Villa Ludovisi, Palazzo Mattei,
and Villa Negroni; studies after paintings in other
Roman collections (e.g., Simon Vouet's *Temptation
of Saint Anthony*); a handful of landscapes (not all
of which appear to be autograph); and subjects that
caught the artist's attention on his rambles around
the city (a fountain in the Campo Vaccino, the
base of the Lateran obelisk, a profile sketch of Gian

Lorenzo Bernini's famous elephant sculpture at
Santa Maria sopra Minerva). The studies of Roman
sculpture in particular were intended as deliberate
academic exercises (David's Roman albums are full
of them). Gauffier's spare line and flattened planes,
so quintessentially Neoclassical in their economy of
means, at times suggest a cross between the
stripped linear style of his contemporary John
Flaxman and the more animated and dramatic line
of Henry Fuseli.

Gauffier's arrival in Rome coincided with
David's second Roman visit (1784), the latter
accompanied by the brilliant and promising Drouais.
The influence of the celebrated David's severe style
on Gauffier and Drouais is obvious, though each
conveyed already in his twenties a distinctive style
of his own. (Drouais's promise would remain unful-
filled with his tragic death at the age of twenty-five.
Gauffier's career was also cut short by his death at
forty.) Their similar approach to drawing the urban
Roman landscape is clearly a rejection of the roman-
ticism imposed by artists from Nicolas Poussin to
Giovanni Battista Piranesi, replaced by a progressive
abstraction of forms in space—that is, by the new
Neoclassical landscape.

The Gauffier sketchbook was acquired by the
Getty Research Institute in 1995 from the New York
firm of Wildenstein and Co. It entered an astonish-
ingly rich collection of materials related to the city
of Rome from antiquity to the present, including
Rome albums and sketchbooks by David, Hubert
Robert, Charles Percier, and Marie-Joseph Peyre.
Kevin Salatino

Bibliography
Anna Ottani Cavina, "Rome 1780: Le thème du paysage
dans le cercle de David," in *David contre David* (Paris: Documentation
française, 1993); idem, *I paesaggi della ragione: La città neoclassica
da David à Humbert de Superville* (Turin: Einaudi, 1994).

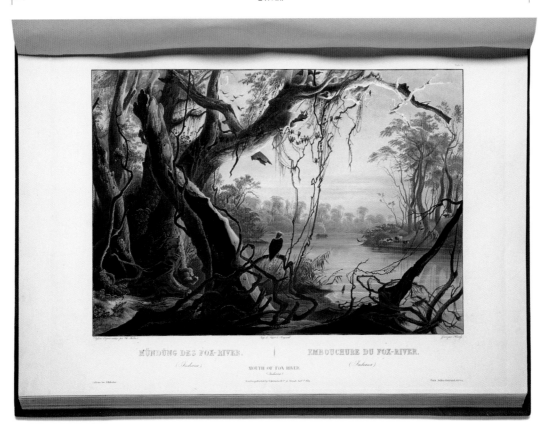

Maximilian von Wied-Neuwied
Travels in the Interior of North America, 1843

A color-plate book illustrating scenes from a trip up the Missouri River, including Native American subjects

239

MAXIMILIAN VON WIED-NEUWIED

Travels in the Interior of North America

London: Ackermann & Co., 1843
Illustrated by Karl Bodmer
24¼ x 17¾ in. (61.6 x 45 cm)
William Andrews Clark Memorial Library,
UCLA (*ff E165 W64E)

This set of magnificently executed tableaux and vignettes by Karl Bodmer with a text by Maximilian, prince of Wied-Neuwied, represents one of the great achievements of early nineteenth-century anthropological and ethnographic exploration. It was undertaken to record the culture and environment of the indigenous population of the upper Missouri region before it became engulfed by the westward expansion of Anglo-American colonization. Though Bodmer's illustrations have achieved a life of their own, validated by their soaring prices in auction houses, they constituted an integral part of a project formulated by Wied-Neuwied. The text and plates were designed to explore central problems concerning human nature and its history posed in the late Enlightenment.

The driving force behind the expedition was Maximilian von Wied-Neuwied (1782–1867), the son of a ruler of a small, independent principality in the Holy Roman Empire. Maximilian's career trajectory reflected the cultural shifts that had occurred in Germany during the eighteenth century, compelling the nobility to acquire a liberal education and even to make a mark as scholars and scientists. His first love was natural history, which was reinforced when he studied with Johann Friedrich Blumenbach at the University of Göttingen in 1800 and then again in 1812.

Wied-Neuwied's lifelong project can be seen as the practical application of Blumenbach's basic "scientific" assumptions, enhanced by ideas drawn from the most famous German explorer-scientist of the nineteenth century, Alexander von Humboldt, also a Blumenbach student. Blumenbach had argued that all humans were part of a single species, differentiated only through "variations" shaped by environment and culture. Race was merely a heuristic category allowing one to bring some order into classifying the multitude of peoples who populated the earth. Individuals were the basic entity and therefore could not be judged without knowing how and under what environmental conditions they lived. For Blumenbach and Wied-Neuwied, physical characteristics were products of environmental forces and did not reflect basic spiritual or intellectual distinctions. Blumenbach argued that only through careful observation, guided by imaginative "reason," could one understand the human condition. Humboldt implemented this program with a vengeance. His famous South American trip was the most elaborately organized scientific expedition of the time. Humboldt measured, but he also believed that measurement should be complemented by poetic and visual imagination, which provided "living pictures of primeval nature."

Wied-Neuwied tried to realize this program in his first research expedition, carried out in Brazil between 1815 and 1817. He sought encounters with native inhabitants who had not been debased by European civilization. The published results were impressive. They included an initial work, *Reise nach Brasilien in den Jahren 1815–1817* (1820–21), which was supplemented by articles and multivolume books. One thing was missing in these works, however: a true pictorial representation of individual life. When he undertook his North American expedition, he decided to bring an accomplished artist and chose Karl Bodmer.

The expedition lasted from 1832 to 1834. The *Travels* is written in journal form, charting the progression from "Anglo-American" culture to encounters with natives less tainted by that culture and then returning to the East Coast and Europe. The core of the work focuses upon native culture— alive, spontaneous, and filled with all of the conflicting drives that constitute human nature— the world in which Wied-Neuwied reveled.

Bodmer's plates viscerally succeed in realizing Wied-Neuwied's goal of resurrecting his subjects before our eyes. They run the gamut from landscapes and vignettes of the expedition's travels to the life of the native tribes the explorers encountered. The latter are the most compelling. Bodmer was energized by the native Americans he drew. His concern with detail was enhanced by his feeling for his subjects' character and life. The plates cover the whole anthropological agenda Wied-Neuwied had adopted from Blumenbach: religious rites, symbols, community activities, normal living arrangements, utensils and arms, copies of Indian painting, and portraits of individuals who represent types for specific groups. Some of the pictures are electrifying. Bodmer's portrayal of the bison hunt, the scalp dance, and the idols of the Mandans surpass anything done by contemporaries such as George Catlin. Most impressive are the portraits of individual native Americans such as the "warrior in the costume of the dog dance" or the "Mandan chief adorned with his warlike deeds." They reach out to us with a vibrancy that overcomes the distance separating us from them. When Wied-Neuwied and Bodmer recorded their impressions, they believed that the world they witnessed would slowly disappear as the Native Americans became increasingly "repressed, degenerated, or sent into foreign areas, left to dissipate." They were wrong. By the time Wied-Neuwied's text and Bodmer's plates appeared, the tribes they had so lovingly portrayed had been eradicated by a smallpox epidemic imported from Europe.

The Clark Library's copy of the *Travels* is in impeccable condition. John J. Audubon first purchased the plates and the one-volume English translation and abridgment in 1843 for $160. The Montana book collector Charles Kessler bought them in 1922 for $700 from Audubon's granddaughter Maria R. Audubon (whose name is on the binding). Kessler's Montana collection, including the German and French editions of the *Travels* and a letter from Wied-Neuwied to Titian Peale, was purchased by William Andrews Clark in 1924.
Peter Hanns Reill

References
J. R. Abbey, *Travel in Aquatint and Lithography, 1770–1860, from the Library of J. R. Abbey: A Bibliographical Catalogue* (London: Privately printed at the Curwen Press, 1956–57), no. 615; Joseph Sabin, *Bibliotheca Americana: A Dictionary of Books Relating to America*, 29 vols. (1868–92, 1928–36; reprint, Amsterdam: N. Israel; New York: Barnes & Noble, 1961–62), no. 47017.

Bibliography
Johann Friedrich Blumenbach, *On the Natural Varieties of Mankind: De Generis Humani Varietate Nativa: The Anthropological Treatises of Johann Friedrich Blumenbach*, trans. Thomas Bendyshe (London: Longman, Green, Longman, Roberts & Green, 1865); Karl Bodmer, *Karl Bodmer's America* (Lincoln: University of Nebraska Press, 1984); Gunter Mann, ed., *Die Natur des Menschen: Probleme der physischen Anthropologie und Rassenkunde (1750–1850)* (Stuttgart and New York: Gustav Fischer, 1990); Michael Dettelbach, "Global Physics and Aesthetic Empire: Humboldt's Physical Portrait of the Tropics," in *Visions of Empire: Voyages, Botany, and Representations of Nature*, ed. David Miller and Peter Hanns Reill (Cambridge and New York: Cambridge University Press, 1996), 258–92.

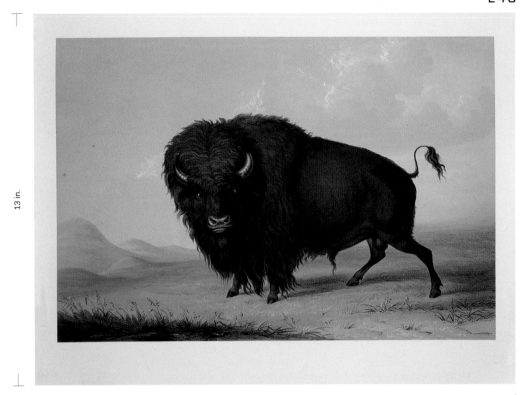

13 in.

17 ¾ in.

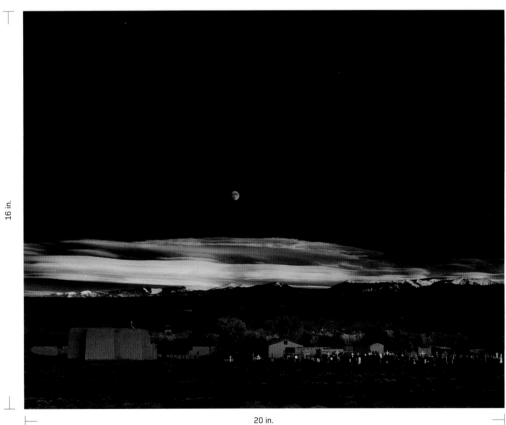

16 in.

20 in.

George Catlin
Catlin's North American Indian Portfolio, 1844

Ansel Adams
Moonrise over Hernandez, New Mexico, 1941

Hand-colored engravings of Western scenes
and peoples

240

GEORGE CATLIN

Catlin's North American Indian Portfolio

London: The author, 1844
13 x 17¾ in. (33 x 45.1 cm)
William Andrews Clark Memorial Library,
UCLA (*ffE77 C36n)

241

EDWARD S. CURTIS

The North American Indian

Cambridge, Mass.: University Press, 1909
12⅞ x 9¾ in. (32.7 x 24.8 cm)
Seaver Center for Western History
Research, Natural History Museum
of Los Angeles County (+E77.C978 W.H.L.C.)

242

ANSEL ADAMS

Moonrise over Hernandez, New Mexico, 1941

Gelatin silver print; 16 x 20 in. (40.6 x 50.8 cm)
California State University, Long Beach, University
Library, Special Collections (#130)

The long and successful career of Ansel Adams (1902–84) is closely linked to the landscape and culture of the western United States. Born and raised in San Francisco, he began photographing at age sixteen while on a family vacation to Yosemite. His passion for photography, Yosemite, and the natural wonders of the West continued throughout his life. As an artist, a teacher, and a writer, Adams was highly influential. Many of his images have come to stand as icons of the Western landscape. His workshops and books on photography and the Zone System have educated and inspired many generations of photographers.

Adams took the photograph *Moonrise over Hernandez, New Mexico* while traveling in the Southwest with his eight-year-old son, Michael, and his close friend Cedric Wright during the fall of 1941. Adams spent time on this trip photographing the national parks for a commission from the Department of the Interior. On his way to Carlsbad, Arizona, where he planned to do a job for the U.S. Potash Company, he took a break in New Mexico for a few days of personal photography. On October 31, 1941, around 4 p.m., Adams and his traveling companions were in the Chama River Valley heading south on the highway back to Santa Fe after a tiring day. Adams's own words best capture the scene and the experience of taking this photograph.

Driving south along the highway, I observed a fantastic scene as we approached the village of Hernandez. In the east, the moon was rising over distant clouds and snowpeaks, and in the west, the late afternoon sun glanced over a south-flowing cloud bank and blazed a brilliant white upon the crosses in the church cemetery. I steered the station wagon into the deep shoulder along the road and jumped out, scrambling to get my equipment together, yelling at Michael and Cedric to "Get this! Get that, for God's sake! We don't have much time!" With the camera assembled and the image composed and focused, I could not find my Weston exposure meter! Behind me the sun was about to disappear behind the clouds, and I was desperate.

I suddenly recalled the luminance of the moon was 250 candles per square foot. I placed this value on Zone VII of the exposure scale; with the Wratten G (No. 15) deep yellow filter, the exposure was one second at f/32. I had no accurate reading of the shadow foreground values. After the first exposure I quickly reversed the 8 x 10 film holder to make a duplicate negative, for I instinctively knew I had visualized one of those very important images that seem prone to accident or physical defect, but as I pulled out the slide the sunlight left the crosses and the magical moment was gone forever.[1]

Over the years Adams experimented with and refined the printing of this image. He explained: "During my first years of printing the *Moonrise* negative, I allowed some random clouds in the upper sky area to show, although I had visualized the sky in very deep values and almost cloudless. It was not until the 1970s that I achieved a print equal to the original visualization that I still vividly recall."[2] This particular print was made in the 1970s. It was purchased directly from Ansel Adams for the modest sum of $250 for the library at California State University, Long Beach, by photography professor Robert D. Routh. Routh, who had conducted photography workshops with Adams in Monterey, had been given the task of starting a collection of original photographs to be used in the education of photography students. Stephen Horn, the president of the university, allotted $1,000 toward this goal. Routh chose *Moonrise over Hernandez, New Mexico* after asking Adams, "Which photograph do you think you will best be known for?" Routh recalls that "Adams replied, with little hesitation, 'I suppose "Moonrise."'"[3]

Perhaps this image can be considered a case of the artist being in the right place at the right moment, but Adams would likely have argued that it was not an accident: "Truly 'accidental' photography is practically non-existent, with preconditioned attitudes we recognize and are arrested by the significant moment. The awareness of the right moment is as vital as the perception of values, form, and other qualities."[4] *Carolyn Peter*

Bibliography

Ansel Adams, *Basic Photo*, 5 vols. (New York: Morgan and Lester, 1948–56); Nathan Lyons, ed., *Photographers on Photography* (Englewood Cliffs, N.J.: Prentice Hall, 1966); Ansel Adams, *Ansel Adams: An Autobiography* (Boston: Little, Brown, 1985).

Notes

1. Adams, *An Autobiography*, 273.
2. Ibid., 274.
3. Robert D. Routh to Irene Still Meyer, August 2000, Ansel Adams files, Special Collections, University Library, California State University, Long Beach.
4. Ansel Adams, "A Personal Credo," in *Photographers on Photography*, 31.

Georg Braun and Frans Hogenberg
Civitates orbis terrarum, 1593–94

A collection of woodcut illustrations
of cities of the world

VI INGENIOUS STRUCTURES

Architecture, in Goethe's memorable characterization, is frozen music or music made visible. It is a highly suggestive parallel, since both architects and composers record their work in a somewhat esoteric notation that must then be interpreted and realized by others: builders, on the one hand, and instrumentalists, on the other. Books such as Virgilio Marchi's *Architettura futurista* (1924) or IAkov Chernikhov's *Arkhitekturnye fantazii* (1933) contain purely imaginary buildings that were never intended to be constructed. Their titles remind us of the word that the Romantic composer Robert Schumann popularized and which was later used by Johannes Brahms and Aaron Copland, among others. Schumann's Fantasy in C Major (1836) for piano was originally conceived as a way to help support the construction of the Beethoven monument in Bonn (architecture memorializing music), and some of its movements originally even bore architecture-related titles (Ruins, Victory Arch).

Few subjects have created illustrated books with such a determined purpose as architecture, despite the fact that the earliest printed architecture book, Leon Battista Alberti's *De re aedificatoria* (1485), was, perhaps surprisingly, not illustrated at all. From an early masterpiece like the first Italian translation of Vitruvius (1521) to a late eighteenth-century project like the survey of ancient Greek architecture in James Stuart and Nicholas Revett's *Antiquities of Athens* (1762–1830, in section 5 of *The World from Here*), from the treatise to the equivalent of the coffee-table book, architectural books have uniquely depended on the power of illustration. Fortunately that desideratum has sometimes resulted in books that have recorded the

contemporary built environment (as the cliché now has it) in certain places that have so evolved as to leave these books a crucial and vital archive of something long lost. Sebastiano Serlio's or Giovanni Battista Piranesi's efforts to describe the antiquities of Rome, like Stuart and Revett's parallel work in Athens, have preserved not simply an important corpus of architectural antiquities but also a cityscape, combining the antique and the contemporary, that has irretrievably disappeared. The city views permitted us in the woodcuts illustrating the Nuremberg Chronicle (1493, in section 3) or in the *Civitates orbis terrarum* (1593–94) are, by contrast, rather idealized and unspecific and hence not nearly so precious, beautiful and impressive in their way though they are.

This function of architectural illustration has long been superseded by photography, of course, and as photography became the standard medium for recording buildings and their contexts, architectural drawings began to be collected with much the same fervor (and ultimately for similar scholarly reasons) as literary manuscripts. The sketchbooks now owned by the Getty Research Institute which record Daniel Libeskind's evolving design for the Jewish Museum in Berlin differ not at all in principle from the manuscript of *Walden* at the Huntington Library

or that of Oscar Wilde's *Sphinx* at the Clark Library (both in section 8). These are all working papers for achieved works, and they permit us access to the creative process that led to a finished text or a finished building. And if it is not to press the analogy too far, one might even view an architectural model like Frank Gehry's for the Schnabel house as a kind of proof copy.

This section of *The World from Here* focuses not only on domestic and public buildings, which one might think of as architecture at peace, but also on architecture in the service of society at war. All of the early treatises, from Vitruvius on, contained sections on fortification, which for centuries remained as important for city planning as the design of gardens, canals, locks, and roadways. The Bonino sketchbook at UCLA and the two anonymous military manuscripts at the Getty Research Institute (one of the seventeenth and one of the eighteenth century) are examples of a genre of which a huge number survive. Jacques Perret's *Des fortifications et artifices* (1601) is a compelling printed book that demonstrates the reality that architecture was still not disconnected from military science in general, and that in the Renaissance and the early modern period the gulf between the design of defensive devices and that of offensive devices—i.e., weapons—was not large.

Architecture has always been closely allied to science and to philosophy. (Leibniz was once asked to edit Vitruvius for an edition that was to form part of a series of classical authors intended to educate the dauphin.) Where science is concerned, architects have always needed to know something about weight and measure, about materials for construction, and so on; their expertise in earlier centuries meant that the distinction between architecture and engineering was seldom as clear-cut as it is today. Santiago Calatrava's sketch for a bridge is free of any concern with the problems of construction and materials that its execution might raise. Domenico Fontana, by contrast, who became architect to Pope Sixtus V, faced a thousand very practical difficulties in his successful attempt to move the Vatican obelisk in 1586, and his book about the project, with engravings by Natale Bonifacio, records in unforgettable detail this amazing feat of Baroque engineering. It is suggestive of the dissociation of architecture and civil engineering in the twentieth century that the building of the Panama Canal (documented here in a series of stereographs from the University of Southern California), incomparably a more staggering engineering project than Fontana's—a quarter of a billion cubic yards of earth moved at a cost of $336,000,000 over seven years—is not associated with an architect as famous as Fontana. *B.W.*

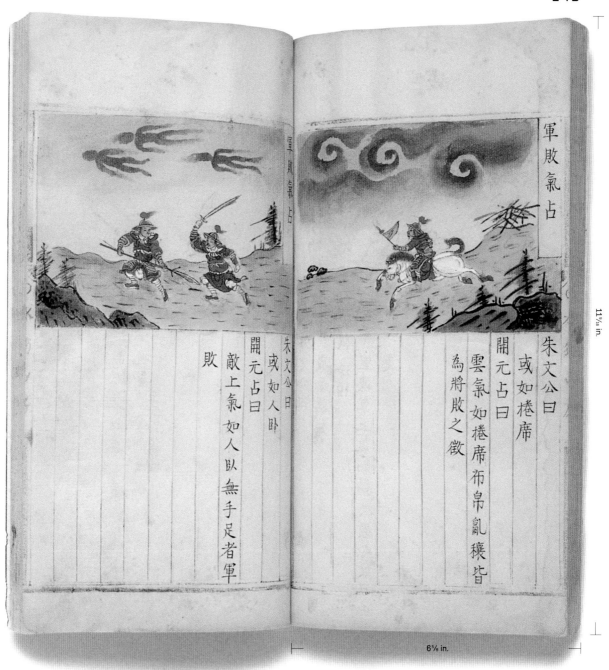

Tian yuan yu li xiang yi fu,
Ming dynasty (1573–1644)

An illustrated manuscript concerning
the use of divination in military strategy

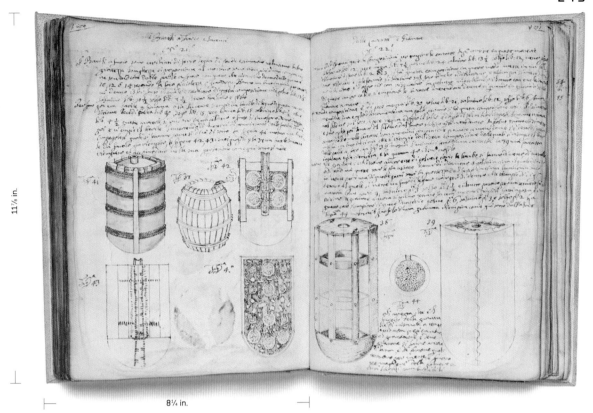

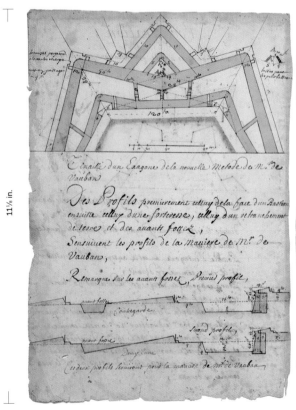

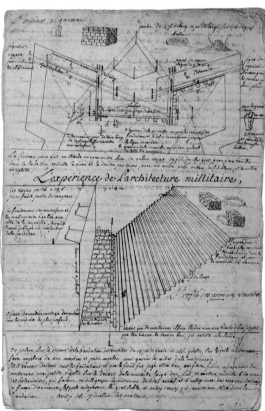

"Del arte militare," c. 1690

A manuscript manual on fortifications
and weapons

"Fortification," 1690–1750

A French manuscript about constructing
fortifications

243

Tian yuan yu li xiang yi fu

Ming dynasty (1573–1644)
Two bound manuscripts;
each 11⁹⁄₁₆ x 6⅝ in. (29.4 x 16.8 cm)
Richard C. Rudolph East Asian Library, UCLA
(BF 1714 C5T53 / SRLF H 000 011 9024)

244

JACQUES PERRET

Des fortifications et artifices; architecture et perspective

[Paris], 1601
17⁷⁄₁₆ x 11⅞ in. (44.3 x 30.2 cm)
Library, Getty Research Institute
(87-B2436)

245

"Del arte militare," c. 1690

Manuscript (ink and wash);
11⅞ x 8¼ in. (30.2 x 21 cm)
Library, Getty Research Institute
(880439)

246

"Fortification," 1690–1750

Manuscript (ink, watercolor, and crayon);
15 leaves, each 11⅛ x 7⅝ in. (28.3 x 19.4 cm)
Library, Getty Research Institute
(950019)

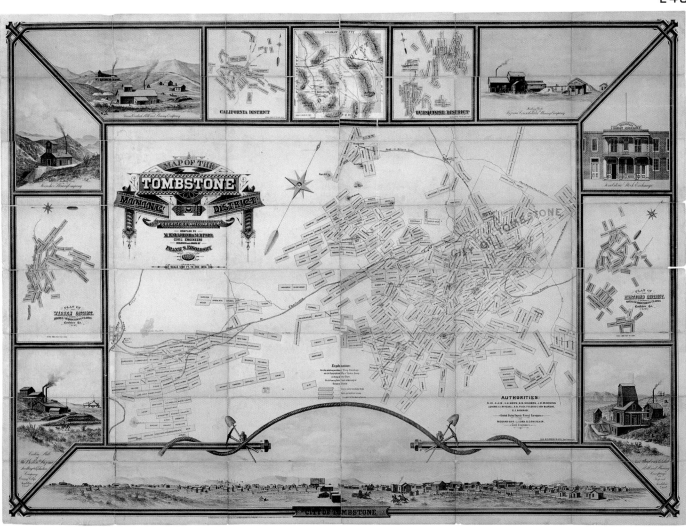

**Map of the Tombstone Mining District,
Cochise Co., Arizona Territory**, 1881

A color lithograph map showing mining claims

247

G. BRON

"Plan de projet pour l'etablissement
de la ville du Port Napoleon," 1806

Manuscript (watercolor); 18 9/16 x 23 7/8 in. (47.1 x 60.6 cm)
Library, Getty Research Institute (861132*)

248

Map of the Tombstone Mining District,
Cochise Co., Arizona Territory, 1881

Compiled by M. Keleher and M. R. Peel,
civil engineers; designed and drawn by Frank S. Ingoldsby
Lithograph; 50 3/4 x 67 3/4 in. (37.5 x 172.1 cm)
Autry Museum of Western Heritage Research Center
(98.139.1)

249

Moskva rekonstruiruetsia

[Moscow: In-t izobrazitel'noi statistiki
sov. stroitel'stva I khoziaistva TSUNKhU
Gosplana SSSR], 1938
13 11/16 x 13 5/8 in. (34.8 x 34.6 cm)
Library, Getty Research Institute
(1372-568)

250

RICHARD NEUTRA

Rush City (Reformed)

Graphite on tracing paper; 14 3/4 x 20 1/4 in. (37.5 x 51.4 cm)
Department of Special Collections,
Young Research Library, UCLA (CK69 #107)
(#1179 f 1129 #20)

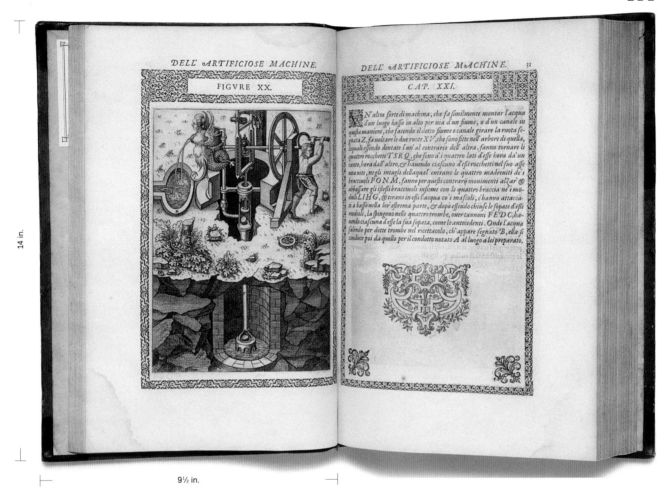

Agostino Ramelli
**Le diverse et artificiose machine del capitano
Agostino Ramelli**, 1588

Depictions and descriptions of early machines

NEL PRESENTE DISEGNO
SI MOSTRA LA GVGLIA
Dentro al Castello,
NEL MODO CHE STAVA
mentre calaua à baſſo.

A. Guglia dentro del Caſtello pendente, che va a poco à poco calando verſo terra.
B. Scale fatte ſopra il Caſtello per poter ſalire, e ſcendere ad ogni biſogno.
C. Quattro traui, che ſeruiuano per pontelli ſotto la Guglia, mentre ſ'abbaſſaua.
D. Traſcino longo palmi ottanta, largo palmi noue compoſto per il longo di quatro tra-
 ui con le trauerſe bene incaſtrate di groſſezza palmi due, e vn quarto, ſopra il
 quale poſò la Guglia, al cui piede egli ſtaua attaccato con corde, e mentre, ch'ella
 ſdrucciolaua all'indietro, ſe l'andò ſempre tirando ſotto da ſe medeſima.
E. Argani, che s'accordano nel calare à baſſo della Guglia.
F. Curli ferrati à capi d'vn palmo di diametro ſotto lo ſtraſcino ſettanta, alcuni de
 quali per il gran peſo ſi ſracellorno, e alcuni entrorno dentro à traui del letto.
G. Straſcinetto longo palmi trenta, qual prima ſtaua ſotto il piede, e dopo, che la Gu-
 glia fu diſteſa, reſtò libero del peſo.
H. Scala di due canne per miſura del preſente diſegno.

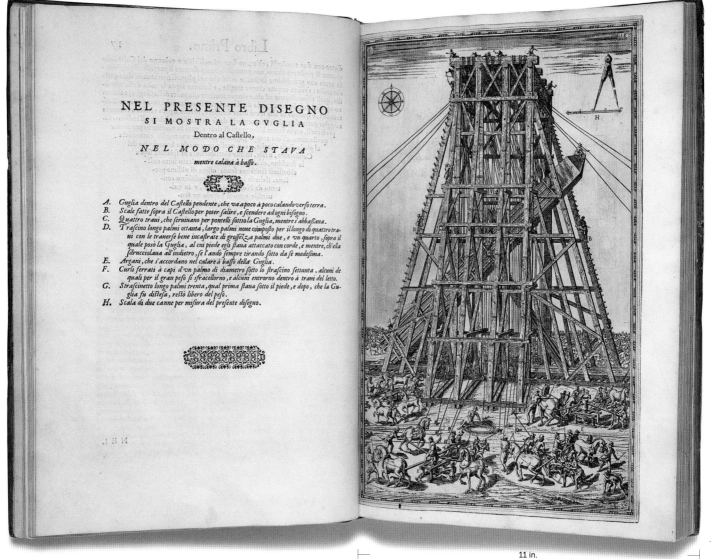

Domenico Fontana

**Della trasportatione dell'obelisco vaticano
et delle fabriche di Nostro Signore papa
Sisto V**, 1590

An illustrated book about moving
the Vatican obelisk

251

MARCO BONINO

Sketchbook, 16th century

Ink, red crayon, and watercolor wash;
8⅜ x 6¼ in. (21.3 x 15.9 cm)
Department of Special Collections,
Young Research Library, UCLA
(#170/358)

252

AGOSTINO RAMELLI

**Le diverse et artificiose machine
del capitano Agostino Ramelli**

Paris: The author, 1588
14 x 9½ in. (35.6 x 24.1 cm)
Library, Getty Research Institute
(85-B7030)

253

DOMENICO FONTANA

**Della trasportatione dell'obelisco
vaticano et delle fabriche
di Nostro Signore papa Sisto V**

Rome: D. Basa, 1590
16⅜ x 11 in. (41.6 x 27.9 cm)
Library, Getty Research Institute
(87-B7401)

Domenico Fontana's *Della trasportatione dell'obelisco vaticano* (On the transfer of the Vatican obelisk) is among the best-known and most lavishly produced late sixteenth-century Italian books on architecture and civil engineering. A large folio volume illustrated, in this example, with forty-one large engravings—thirty-six of which (including the frontispiece bearing a portrait of the author) are full-page, four of which span two pages, and one of which is an oversize foldout—and two small diagrams in the text, it is at once a monumental homage to Pope Sixtus V (r. 1585–90), Fontana's patron, and a work of unprecedented self-promotion on the part of its author.

Born in Melide in the Swiss canton of Ticino, Domenico Fontana (1543–1607) arrived in Rome at about the age of twenty. Initially he found work as a stuccoist and mason, and a decade later he entered the service of Cardinal Felice Peretti, the future Sixtus V, for whom he worked as an architect, constructing for him a suburban villa on the Esquiline Hill in Rome. When Peretti was elected pope in 1585, he appointed Fontana papal architect. In this capacity Fontana oversaw Sixtus V's vast program of urban development, consisting of the construction of many new buildings; the creation of new, wide streets connecting the major pilgrimage sites in Rome; the building of the city's first new aqueduct since antiquity; and the re-erection of four ancient obelisks, which had been brought to Rome from Egypt in the days of the Roman Empire.

Among all of these projects, Fontana is best remembered for transferring the Vatican obelisk from its original position in the former Circus of Nero, south of Saint Peter's, to its present location in the center of the piazza in front of the basilica. Although this enterprise had been considered repeatedly since the mid-fifteenth century, it was not until 1586 that it was carried out. The colossal undertaking involved hundreds of men and horses, forty giant capstans, countless meters of rope, and the construction of an enormous double tower of oak timbers to encase the monolith as well as an elevated causeway on which it was rolled within a wooden carriage. After several months of effort, in September 1586 the obelisk was re-erected before Saint Peter's upon a new pedestal, and in a grand ceremony it was purified and exorcised, and then crowned with a gilt bronze cross. What had once stood as a pagan monument thus became a symbol of Catholic triumph.

Fontana's remarkable feat of engineering—for which the pope rewarded him with the title Knight of the Golden Spur—was lauded by contemporaries in poems and panegyrics. None, however, was as successful in extolling the achievement as Fontana himself, in his *Della trasportatione dell'obelisco vaticano*. Although the volume contains descriptions (and engravings) of a number of his other projects for Sixtus—thirty-five in all—the first third of the book's text and almost a third of its engravings are devoted to a detailed description and illustration of the author's successful "transportation" of the Vatican obelisk.

Fontana's account of the operation is both vivid and technical, providing a wealth of information about the history of the obelisk, how he determined its weight, the various types of machines he employed, and the engineering principles that enabled him to first raise the monolith from its original position, lower it, transport it, and then raise it again—all, as he states in his introductory letter "to readers," for the benefit of others who would wish to do likewise. But even more compelling than the description of the process are the illustrations that accompany it, which provide plans, elevations, and various views of every phase of the enterprise. These illustrations, as well as all the others in the volume, representing a number of Fontana's additional projects for Sixtus, were engraved by Natale Bonifacio (1538–92), an artist from Sibenik (Croatia), after designs most likely by Fontana himself (perhaps with the assistance of Giovanni Guerra). For the way in which they "document" not only the moving of the Vatican obelisk but also the entire range of Sixtus V's building program, Bonifacio's engravings in *Della trasportatione dell'obelisco vaticano* are the most frequently reproduced images of late sixteenth-century Rome.

Following the death of Sixtus V in 1590, Fontana fell from favor in the papal capital, and in 1592 he accepted an invitation to become the royal architect in Naples. To publicize his accomplishments in Rome, as well as his various Neapolitan projects, in 1604 he published a second, cheaper edition of his *Della trasportatione dell'obelisco vaticano*, which included a second book, entitled "Libro secondo in cui si ragiona di alcune fabriche fatte in Roma et in Napoli" (Second volume, in which some of the buildings in Rome and in Naples are discussed). He died three years later, in 1607.

This copy of Fontana's volume was purchased in 1987 by the Getty Research Institute from the estate of Giovanni Muzio (1893–1982), a practicing architect and professor in Turin and Milan, who amassed a vast collection of architectural books in the course of his career. The Getty acquired it, along with all of Muzio's collection of architectural books, through the Milanese bookseller Carla C. Marzoli (La Bibliofila). *Steven F. Ostrow*

Bibliography
Cesare D'Onofrio, *Gli obelischi di Roma*, 2d ed. (Rome: Bulzoni, 1967), 81ff; Domenico Fontana, *Della trasportatione dell'obelisco vaticano e delle fabriche di Nostro Signore papa Sisto V fatte dal cavalliere Domenico Fontana architetto di Sua Santita*, facsimile edition, ed. Adriano Carugo, introduction by Paolo Portoghesi (Milan: Polifilo, 1978).

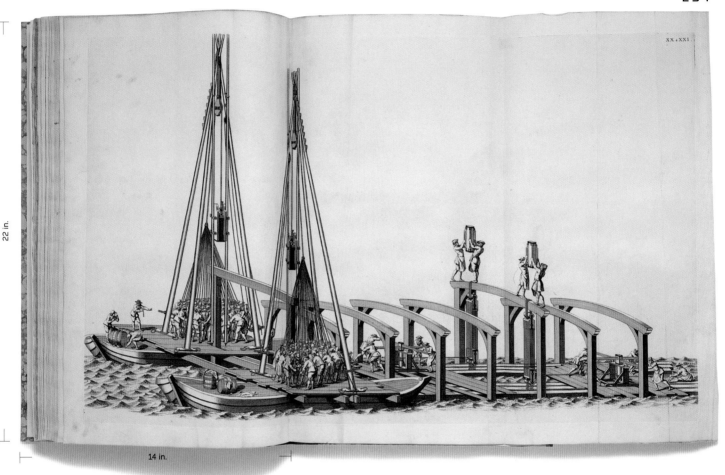

Tieleman van der Horst
Theatrum machinarum universale, 1736–37

A book about locks and canals

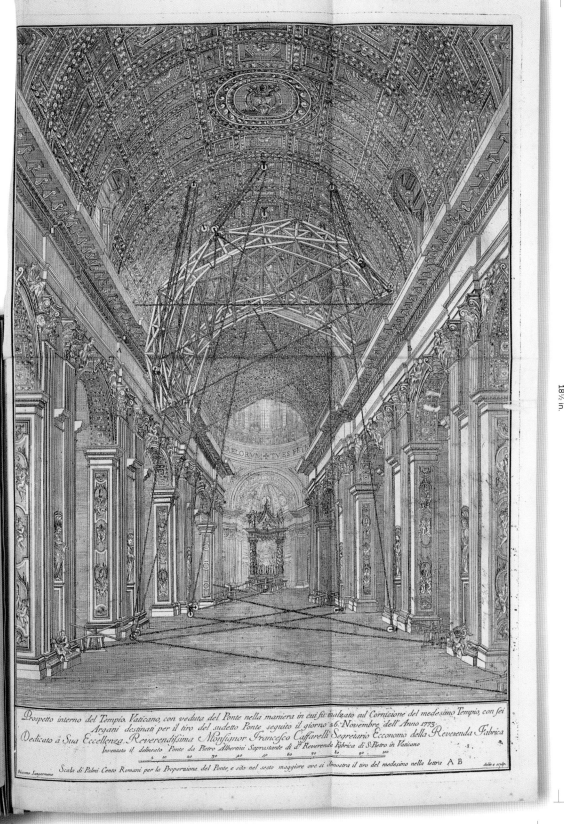

Prospetto interno del Tempio Vaticano, con veduta del Ponte nella maniera in cui fu inalzato sul Cornicione del medesimo Tempio, con sei
Argani destinati per il tiro del sudetto Ponte, seguito il giorno 26. Novembre dell'Anno 1773.
Dedicato à Sua Eccellenza Reverendissima Monsignor Francesco Caffarelli Segretario Economo della Reverenda Fabrica
Inventato il delineato Ponte da Pietro Albertini Soprastante di d.a Reverenda Fabrica di S.Pietro in Vaticano
Scala di Palmi Cento Romani per la Proporzione del Ponte, e sito nel sesto maggiore ove si dimostra il tiro del medesimo nella lettra A B

Giacomo Sangermano dolm e sculp.

18½ in.

14 in.

Niccola Zabaglia

Contignationes ac pontes, 1743

A book about bridges and scaffolding

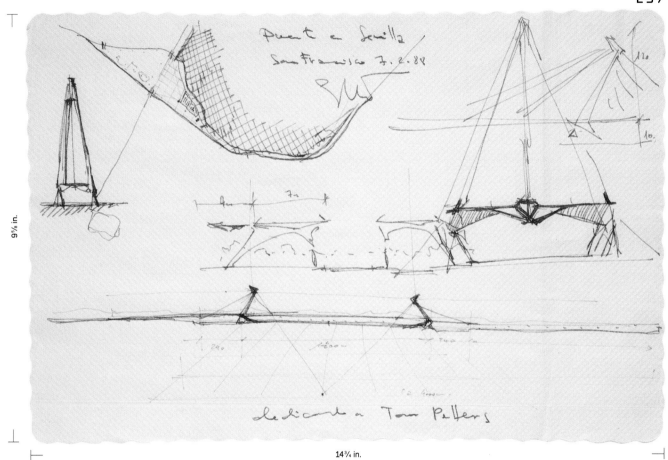

Santiago Calatrava
Sketches for a bridge, 1988

9 ⁵⁄₈ in.

14 ¾ in.

254

TIELEMAN VAN DER HORST

Theatrum machinarum universale

Amsterdam: Petrus Schenk, 1736–37
22 x 14 in. (55.9 x 35.6 cm)
Library, Getty Research Institute
(84-B8919)

255

NICCOLA ZABAGLIA

Contignationes ac pontes

Rome: Ex typographia Palladis, 1743
18½ x 14 in. (47 x 35.6 cm)
Library, Getty Research Institute
(85-B16478)

256

Stereographs documenting the building of the Panama Canal

3½ x 7 in. (8.9 x 17.8 cm)
University of Southern California,
Archival Research Center,
Special Collections

257

SANTIAGO CALATRAVA

Sketches for a bridge, 1988

Ink on paper place mat;
9⅝ x 14¾ in. (24.4 x 37.5 cm)
Library, Getty Research Institute
(910154)

IDEA. GEOMETRICAE ARCHITECTONICAE AB ICHNOGRAPHIA. SVMPTA· VT PERAMVSSIM POSSIT
PER ORTHOGRAPHIAM AC SCAENOGRAPHIAM PERDVCERE OMNES QVASCVNQVE LINEAS· NON
SOLVM AD CIRCINI CENTRVM· SED QVAE A TRIGONO ET QVADRATO AVT ALIO QVOVISMODO
PERVENIVNT POSSINT SVVM HABERE RESPONSVM· TVM PER EVRYTHMIAM PROPOR
TIONATAM QVANTVM ETIAM Æ SYMMETRIAE QVANTITATEM ORDINARIAM JC PER
OPERIS· DECORATIONEM OSTENDERE· VTI ETIAM HEC QVAE A GERMANICO MORE PER VE
NIVNT DISTRIBVENTVR PENE QVEMADMODVM SACRA CATHEDRALIS AEDES MEDIOLANI
PATET· ELG... P.M.C.A.A.F.V.I. Q. C. AC AF. D.

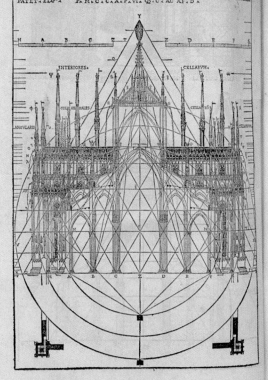

LIBER TERTIVS

LIBER TERTIVS

A PARIQVADRATA SVPERFICIE HVMANI CORPORIS PERDISTINCTA, EO NATVRALI CENTRO
VMBILICI CIRCVLVM EXCIPERE: ET IN EO QVADRATVM MINOREM INSCRIBERE. FIG.

G ij

16 7/8 in.

11 7/8 in.

Vitruvius Pollio
De architectura libri dece, 1521

An illustrated edition of the classical work
on architecture

258

LEON BATTISTA ALBERTI

De re aedificatoria

Florence: Nicolaus Laurentius, 1485
11 x 7¾ in. (27.9 x 19.7 cm)
The Elmer Belt Library of Vinciana,
Arts Library, UCLA (*A1.A334d)

259

VITRUVIUS POLLIO

De architectura libri dece

Como: P. Magistro Gotardus da Pōte, 1521
16⅞ x 11⅞ in. (42.9 x 30.2 cm)
Library, Getty Research Institute
(86-B6552)

260

SEBASTIANO SERLIO

Il primo libro d'architettura

Paris: Jean Barbé, 1545
13¹³⁄₁₆ x 10¹⁄₁₆ in. (35.1 x 25.6 cm)
The Elmer Belt Library of Vinciana, Arts Library,
UCLA (*NA2515.s481.1545)

261

GEORG BRAUN AND FRANS HOGENBERG

Civitates orbis terrarum

Cologne: Petrus à Brachel
for the authors, 1593–94
16 x 11½ in. (40.6 x 29.2 cm)
The Huntington Library, San Marino,
California (RB 180544)

262

GIACOMO BRIANO DA MODENA

**Architectural drawings for two
buildings in Poland**, c. 1613–45

Ink; cross-section with two towers:
16⅜ x 10¹³⁄₁₆ in. (41.6 x 27.5 cm);
elevation with alternatives pasted on:
10¾ x 16⅝ in. (27.3 x 42.2 cm)
Library, Getty Research Institute
(840084**)

263

STEFANO DELLA BELLA

**Views of the Gardens of Villa Demidoff
in Pratolino**, c. 1642–50

Three etchings; garden with a folly:
10⁵⁄₁₆ x 15³⁄₁₆ in. (26.2 x 38.6 cm);
garden with a garden sculpture:
10¾ x 15½ in. (27.3 x 39.4 cm);
garden with a large tree:
10¼ x 15³⁄₁₆ in. (26 x 38.6 cm)
Library, Getty Research Institute
(P830003)

264

FRANCESCO BORROMINI

Architectural drawing for the cupola of Sant'Ivo alla Sapienza

Rome, late 1651–early 1652
Graphite; 19¼ x 14⁵⁄₁₆ in. (48.9 x 36.4 cm)
Library, Getty Research Institute
(89 0225*)

This working plan of the spiral crowning the Roman university church of Sant'Ivo is the only drawing in the United States by Francesco Borromini (1599–1667), the revolutionary innovator of Roman Baroque architecture. Swiss by birth, having served an apprenticeship in Milan, Borromini immigrated to Rome when he was twenty and worked at Saint Peter's in the shadow of Carlo Maderno, the architect of the façade, and Gianlorenzo Bernini, designer of the baldachin and the sculpture program of the crossing. His last work as an apprentice was the supervision of the construction of Palazzo Barberini in 1629–32, while his first independent commission was the small monastic church of San Carlo alle Quattro Fontane (1634–41), built for the Spanish reformed Trinitarians, the order that had rescued Cervantes from the Barbary pirates in 1578.

The masterpiece of Borromini's maturity was the chapel of the Roman university, the Sapienza. He was awarded the commission in 1632, although construction did not begin until 1641. The design took shape in the atmosphere of mathematical sophistication and antiquarian research nurtured by the court of Pope Urban VIII Barberini. In devising a plan for what was in the end a very small chapel, constricted on three sides by wings already built or about to be built, Borromini looked back to the antiquarian drawings of Baldassare Peruzzi and to the project sponsored by Cardinal Francesco Barberini to map Hadrian's Villa in Tivoli. After the first construction campaign of 1641–44 the unfinished shell would have looked like nothing so much as a ruined "tempietto" from the villa. But Borromini also drew inspiration from contemporary science. He knew Galileo's most faithful disciple, the Benedictine monk Benedetto Castelli, who was professor of mathematics at the Sapienza and a figure of note in the Barberini court. The plan of the church was a modified triangle, a most unusual design for a central church, though one also found among the unexecuted sketches of Peruzzi. An image of the dove of the Holy Spirit once flew from the vault of Borromini's lantern, bringing Pentecostal wisdom, and before its forceful advent the walls of the church seem to be all in motion.

The construction of Sant'Ivo extended over three pontificates. The "rustic" shell was built under Urban VIII Barberini, the lantern and spiral under Innocent X Pamphili, and the decoration of the interior and exterior was completed under Alexander VII Chigi, along with the famous library, the Biblioteca Alessandrina, meant to house the printed books of the dukes of Urbino. Of these three popes Innocent X showed the least interest in the church and spent the least on it.

It is the strange spiral, however, conceived for Innocent X in the present drawing and built in 1652, that gives Sant'Ivo a place on the Roman skyline. Early sources call the spiral a "tempietto over the temple of the cupola," a "tempietto or tower girt by a crowned spiral loggia," a "pyramid around which is a crown turned in a spiral . . . leading to the summit of glory of which this entire dome is a symbol."[1] The spiral is studded with jewels, the sign of nobility. It leads to a huge laurel crown sculpted in travertine, symbol of the *laurea*, or doctorate, which only the Sapienza had the right to confer in subjects such as law. The exclusivity of this right was contested by the Jesuits of the Collegio Romano, who were extremely successful pedagogues. But in response the Sapienza asserted its age-old claims both in court and in the design of the spiral, an ennobled route ascending to a flaming *laurea*. For most it was a vicarious journey and a symbolic route, but the spiral could in fact be climbed; the earliest *veduta*, made by the Flemish artist Lievin Cruyl in 1664, four years after it was finished, shows diminutive visitors climbing around its highest reaches.

The faint inscriptions on Borromini's drawing refer not to its symbolic content, but to the varying degrees of slope of the spiral. A messy and much-folded document, the sheet was probably used by the construction crew to build the spiral and thus became separated from the large corpus of Borromini drawings bequeathed by the architect to his nephew, now in the Graphische Sammlung Albertina in Vienna. *Joseph Connors*

265

FRANCESCO BORROMINI

Opera del Cavaliere Francesco Borromini

Rome: Sebastiani Giannini, 1720
22⁵⁄₁₆ x 16½ in. (57.3 x 41.9 cm)
Library, Getty Research Institute
(83-B2236)

266

ANDREA PALLADIO

Architecture de Palladio, divisée en quatre livres

The Hague: P. Gosse, 1726
18¼ x 11½ in. (46.4 x 29.2 cm)
Library, Getty Research Institute
(93-B6672)

Bibliography
Anthony Blunt, *Borromini* (Cambridge: Harvard University Press, 1979); Joseph Connors, "Borromini's S. Ivo alla Sapienza: The Spiral," *Burlington Magazine* 138 (October 1996): 668–82.

Notes
1. Connors, "Borromini's S. Ivo alla Sapienza," 676.

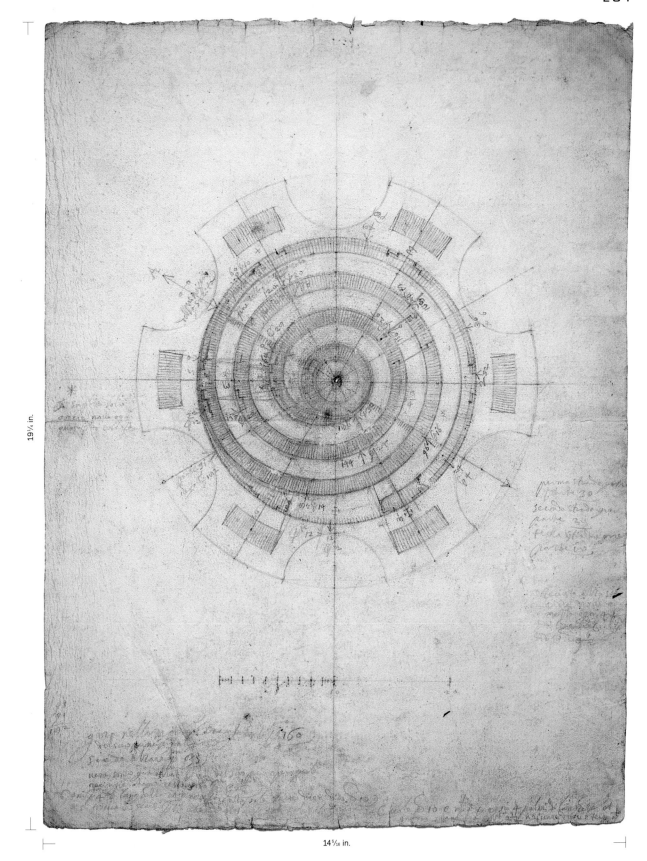

Francesco Borromini
**Architectural drawing for the cupola
of Sant'Ivo alla Sapienza**, late 1651–early 1652

18¼ in.

11½ in.

Andrea Palladio
**Architecture de Palladio,
divisée en quatre livres,** 1726

The central work of Neoclassical architecture

21¾ in.

16⅝ in.

Giovanni Battista Piranesi
Le antichità romane, 1784

Engravings of classical antiquities in Rome

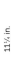

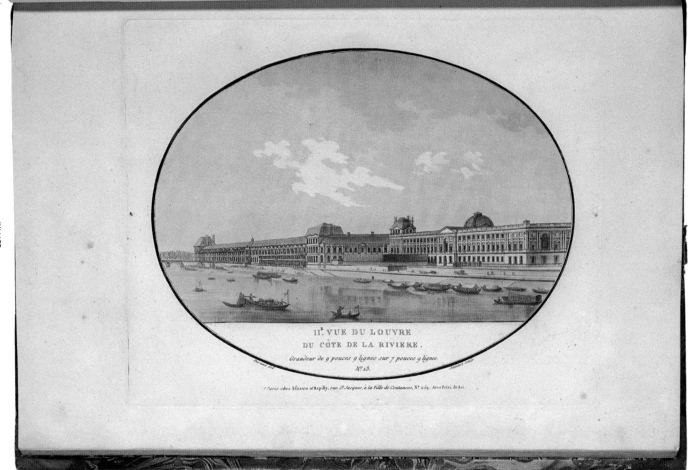

Jean-François Janinet
**Vues des plus beaux édifices publics
et particuliers de la ville de Paris**, [1787?]

Eighteenth-century engravings of buildings in Paris

267

GIOVANNI BATTISTA PIRANESI

Le antichità romane

Rome: Nella Stamperia Salomoni, 1784
21¾ x 16⅝ in. (55.2 x 42.2 cm)
Library, Getty Research Institute
(90-B18427)

The eighteenth century saw significant advances in publications on antiquities and architecture. Ancestors of modern coffee-table books, these volumes featured images that were as important as their texts. With parallel contributions to the polemics of art and the design of great illustrated books, the architect and graphic artist Giovanni Battista Piranesi (1720–78) played a central role in the creation of these key monuments of art literature.

This set of four folios on Roman antiquities is the second edition, published by his son Francesco after Piranesi's death. A double-page frontispiece bears a prominent dedication to the Swedish king Gustav III. The 1756 first edition had been dedicated to James Caulfeild, Lord Charlemont, Piranesi's Irish patron, with whom he had a public falling-out over its patronage. When Charlemont's support did not materialize, an infuriated Piranesi published his side of the affair in the *Lettere di giustificazione a Milord Charlemont* in 1757.

These monumental volumes present the ancient architecture of Rome as the foundation for Western culture. The title page elaborates Piranesi's coverage: the first volume contains the ancient buildings and urban structures keyed to the Marble Plan of Ancient Rome, which is illustrated and for which the text could be seen as an extended label; volumes 2 and 3 contain the sepulchral monuments; and volume 4, the bridges, theaters, and other monuments. As an opening to the book, the frontispiece for volume 1 depicts inscribed tablets, bas-reliefs, aqueducts, and arches. It provides a visual summary of the contents and a view of how history is itself constructed from ruins, the fragmentary remains of times past.

Piranesi's purpose was not only to document ancient Roman architecture but also to provide paradigms for contemporary taste and design. Unlike the *Carceri* (Prisons), his fantastic reconstructions and *capricci* based on ancient structures, this book seeks to be an accurate, detailed rendering of the remains. Piranesi studied these with great care, sketching fragments, measuring ruins, recording inscriptions, reading and referencing ancient authors. Scholars and print connoisseurs have tended to focus on his magisterial etchings because they are so impressive, but it is important to see these works as books; words and images were intended to work together and to reinforce each other. Embedded in the text, the decorative chapter heads and initial letters feature ruins and fragments, providing visual cues to the reader. The prints are themselves filled with titles and labels. Small numbers in the etchings refer to longer text descriptions in which Piranesi explains the prints further in almost relentless detail. Yet the prints are always more than plans, elevations, or analytic diagrams. By placing people in his architectural landscapes and contrasting their diminutive scale and the quotidian nature of their activities with the urban monuments, he acknowledges the human element amid the looming architecture and the haggard face of architectural decay. Ruins evoke times past, but their setting is Rome as it was in the eighteenth century.

Piranesi's passion for Rome and its monuments was expressed in the form of the impressive books and prints produced in his print shop there. His books helped create a new category of collecting, becoming important components of greater holdings in palaces and castles, châteaux and country houses. While prints could be seen as pictorial souvenirs of faraway places, a kind of travel literature, or as secondary reproductions of the works of great masters, Piranesi's magnificent etchings possessed an intrinsic value that made them collectible per se.

These four volumes are part of a set of Piranesi's complete works. All twenty-two volumes are bound in contemporary cream-colored boards with vellum spines and salmon sponge-print edges. The books are in original condition, as they would have been seen by those who frequented Piranesi's workshop in the Palazzo Tomati. The set was commissioned by King Gustav III for presentation to the Swedish ambassador Baron Carl Bonde (whose heraldic bookplate is found in each volume). The volumes remained in the family collection until their sale at Christie's, New York, on December 17, 1983, after which they were acquired by the library of the Getty Research Institute. *Marcia Reed*

268

JEAN-FRANÇOIS JANINET

Vues des plus beaux édifices publics et particuliers de la ville de Paris

Paris: Esnauts & Rapilly, [1787?]
16½ x 11¼ in. (41.9 x 28.6 cm)
Library, Getty Research Institute
(1406-529)

269

HUMPHRY REPTON

Designs for the Pavilion at Brighton

London: J. C. Stadler, 1808
21½ x 15⅛ in. (54.6 x 38.4 cm)
Library, Getty Research Institute
(94-B3849)

References
John Wilton-Ely, *Giovanni Battista Piranesi: The Complete Etchings* (San Francisco: Alan Wofsy Fine Arts, 1994), 327–582, no. D.II.

Bibliography
Philip Hofer, "Piranesi as Book Illustrator," in *Piranesi* (Northampton, Mass.: Smith College Museum of Art, 1961), 81–87; John Wilton-Ely, *The Mind and Art of Giovanni Battista Piranesi* (London: Thames and Hudson, 1978).

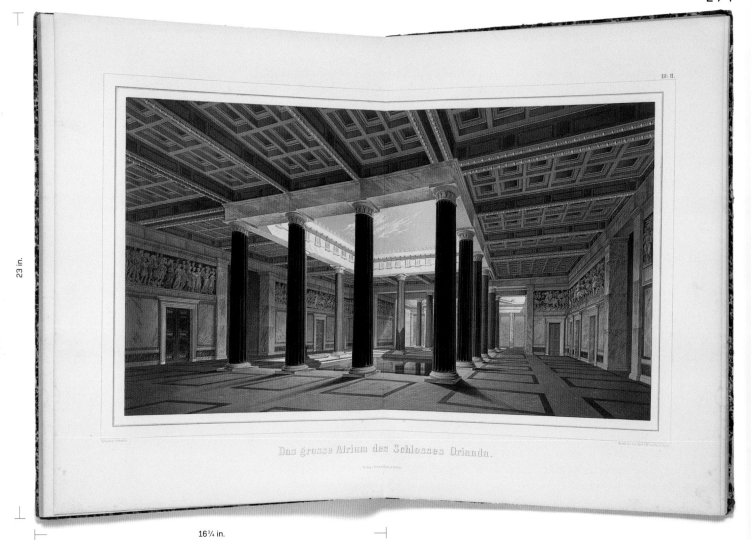

Bl: II.

Das grosse Atrium des Schlosses Orianda.

Karl Friedrich Schinkel
**Entwurf zu dem kaiserlichen
Palast Orianda in der Krimm**, 1873

Engravings after drawings of a palace
for the Russian tsarina Alexandra Feodorovna

270

SIMON-CLAUDE CONSTANT-DUFEUX

Record drawings of ancient monuments, 1825–33

Ink and watercolor; 18⅛ x 12⅜ in. (46 x 31.4 cm)
Library, Getty Research Institute
(890252*)

271

KARL FRIEDRICH SCHINKEL

Entwurf zu dem kaiserlichen Palast Orianda in der Krimm

Berlin: Ernst & Korn, 1873
23 x 16¾ in. (58.4 x 42.5 cm)
Library, Getty Research Institute
(94-F36)

272

VIRGILIO MARCHI

Architettura futurista

Foligno: Campitelli, 1924
7¹⁵⁄₁₆ x 5½ in. (20.2 x 14 cm)
Library, Getty Research Institute
(90-B22148)

273

VIRGILIO MARCHI

Futurist drawing, c. 1919

Red ink; 12¼ x 9⅜ in. (31.1 x 24.9 cm)
Library, Getty Research Institute
(890250)

274

IAKOV GEORGIEVICH CHERNIKHOV

Arkhitekturnye fantazii: 101 kompozitsiia v kraskakh, 101 arkhitekturnaia miniatura, ispolneny pri uchastii D. Kopanitsyna i E. Pavolovoi

Leningrad: Izd. Leningradskogo obl. otd-niia Vses. obedineniia "Mezhdunarodnaia kniga," 1933
12⅜ x 9 in. (31.4 x 22.9 cm)
Library, Getty Research Institute
(84-B17617)

It was in the fifteenth century that architectural drawings began to be used as a means of communicating spatial and structural concepts. This development coincided with the emergence of the architectural profession as the design practice was distanced from the actual construction work at the building site. The architectural designer needed a medium to convey to the builder and his workmen what his creation should look like. A drawing in ink on paper took on this role. Over time, however, the architectural drawing has also taken on the additional role of exploring ideas (stylistic, structural, or spatial) that do not necessarily require realization in three dimensions.

There is today an established tradition of architects producing design drawings that are pure fantasies, drawings never intended to be realized in tangible form. Giovanni Battista Piranesi's prison etchings of the mid-1700s, the *Carceri*, are probably the best-known examples in this tradition. While these prints have appealed to many generations because of their nightmarish images of vast and seemingly inescapable spaces, others convey a more utopian message in their representation of buildings far ahead of their time and impossible to build with the available technology. Such drawings are often produced in revolutionary or socially unstable times, when architects have few commissions for actual buildings and are therefore able to devote themselves to the development of ideas that represent the spirit of the new era. This was the case, for example, in the years following the French Revolution, when such architects as Etienne-Louis Boullée and Claude-Nicolas Ledoux drew gigantic buildings symbolizing the power of the bourgeoisie, as well as in the post–World War I period, when German and Dutch architects designed buildings in the shape of mountains, crystals, or shells, buildings that seemed to have grown organically, without the input of a designer. IAkov Chernikhov's *Arkhitekturnye fantazii* (Architectural fantasies), published in the early years of Stalin's regime, belongs to this category of utopian design. The book had another purpose as well, however, which was to provide models for students and architects learning how to design buildings in a style popular at the time, that of the Constructivist movement.

IAkov Chernikhov (1889–1951) spent most of his professional life as a teacher of architecture, first at the Institute for Engineers of Railway Transportation in Saint Petersburg and after 1936 at the Academy for Transportation in Moscow. His corpus of built work is relatively small and consists mostly of industrial structures designed and executed at the end of the 1920s and in the early 1930s. According to Jean-Louis Cohen, Chernikhov struggled all his life to keep up with the architectural debates in his country and participated in all the movements of his time.[1] He was, however, never able to establish himself as a leader of any of these movements. His book should be seen in this light. In spite of the daring character of the book's drawings, the designs are actually based on the work of other architects active in the 1920s, including El Lissitzky, the Vesnin brothers, Moisei Ginzburg, and Ivan Leonidov. Like the work of these architects, Chernikhov's designs show a "disassemblage" of functions into individual forms that are connected or supported by elements appropriated from industrial contexts, such as steel bridges, trusses, cables, and pylons. It is here that Chernikhov's major contribution lies. He was able to translate the ideas of his contemporaries into extremely beautiful images, images that would appeal to and inspire young architects. Although his influence as a Constructivist designer in the 1930s was limited because of changing attitudes toward modern art and architecture in the Soviet Union, he has been appreciated posthumously from the 1970s onward, when his work was rediscovered in the West. *Wim de Wit*

Bibliography
Jacob Tchernikov and His Architectural Fantasies (Tokyo: Process Architectural Publishing; Westfield, N.J.: Eastview Editions, 1981); Carlo Olmo and Alessandro de Magistris, eds., *Iakov Tchernikov: Documents et reproductions des archives de Aleksei et Dimitri Tchernikov* (Paris: Editions d'Art Somogy, 1995).

Notes
1. Jean-Louis Cohen, "Le Ballet méchanique de Tchernikov, ou L'*Amerikanizm fantastique*," in *Iakov Tchernikov: Documents et reproductions*, 74.

5

Демонстрация усиленных динамико-сложных архитектурных форм. Фантастическое сооружение здания специального назначения. Цветовая иллюминовка в сочных красках. Сочетание изогнутых тел.

12⅜ in.

IAkov Georgievich Chernikhov
Arkhitekturnye fantazii: 101 kompozitsiia v kraskakh, 101 arkhitekturnaia miniatura, ispolneny pri uchastii D. Kopanitsyna i E. Pavolovoi, 1933

Visionary designs for buildings

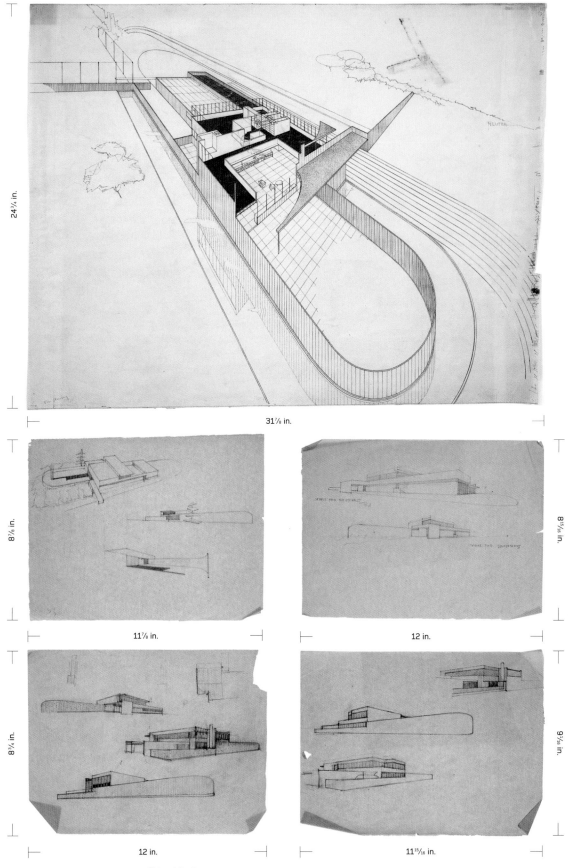

24¾ in.

31⅞ in.

8⅞ in.

8¹⁵⁄₁₆ in.

11⅞ in.

12 in.

8¾ in.

9⅛⁄₁₆ in.

12 in.

11¹⁵⁄₁₆ in.

Richard Neutra
**Drawings of the Josef von Sternberg House,
San Fernando Valley**, 1935

275

RICHARD NEUTRA

Drawings of the Josef von Sternberg House, San Fernando Valley, 1935

Axonometric view (ink and graphite on linen):
24¾ x 31⅞ in. (62.9 x 81 cm);
Four sketches (graphite on tracing paper):
8⅞ x 11⅞ in. (22.5 x 30.2 cm);
8¹⁵⁄₁₆ x 12 in. (22.7 x 30.5 cm); 8¾ x 12 in.
(22.2 x 30.5 cm); 9¹⁄₁₆ x 11¹⁵⁄₁₆ in. (23 x 30.3 cm)
Department of Special Collections, Young Research
Library, UCLA ([*] 1179; 179 f.939)

Born and raised in the rich cultural ambience of fin-de-siècle Vienna, Richard Joseph Neutra (1892–1970) received his earliest architectural stimulation from the Viennese masters Otto Wagner and Adolf Loos. Following service in World War I, he worked in the Berlin office of Erich Mendelsohn and the Wisconsin studio of Frank Lloyd Wright, then settled in Los Angeles in 1925. There he formed a short-lived partnership with his fellow Viennese expatriate Rudolph Schindler before establishing his own practice in the late 1920s. After the completion of his first great work, the Lovell House, Los Angeles (1929), Neutra and his architectural peers faced the Depression of the 1930s with greatly diminished prospects for work. His survival in that decade depended heavily on a series of commissions connected with Hollywood, the industry that not only survived the Depression but also thrived on its audiences' need for escape and elevation. Neutra's office building for Carl Laemmle's Universal Studios and his houses for actress Anna Sten, composer Edward Kaufman, editor Leon Barsha, and directors Albert Lewin and Josef von Sternberg countered popular notions of "Hollywood taste" as being only of the glitzy, historicist sort and confirmed the presence in the Los Angeles film community of figures of artistic and intellectual sophistication drawn to modernist art and architecture.

Of these works, the most famous was the villa in the then-rural San Fernando Valley for Sternberg, the German-American director of *The Blue Angel* (1930) and other classics starring Marlene Dietrich. The client and his architect met in the early 1930s, and as Neutra's wife, Dione, recalled, sat up until daybreak talking of Germany, California, and modern art—especially their own worlds of film and architecture. After several years of informal conversations, the director commissioned Neutra in 1934. "I selected a distant meadow," Sternberg recounted later, "in the midst of an empty landscape, barren and forlorn, to make a retreat for myself, my books, and my collection of modern art."

The building's double-height living room was surrounded by a picture gallery balcony. Sternberg's exotically mirrored bath and bedroom, overlooking a rooftop reflecting pool, were the only rooms on the second floor. On the ground level, east of the living room, lay the studio, kitchen, servant's room, and two garages, one for regular cars and a larger one for the Rolls-Royce. There was also a specially designed space for the owner's immense dogs. The basic shell for these exotic internal functions was a series of straightforward, juxtaposed rectangles, but to enliven the otherwise simple, aluminum-clad façade, Neutra designed—in the best Hollywood manner—a series of remarkable "special effects," which reached into the landscape. The first and most significant was the high, curving wall enclosing the front patio, which gave the house its streamlined personality. Surrounding the wall and, in broken stretches, the entire house was a shallow, moatlike lily pool. To further exaggerate the size of the house, a long, thin wall extended from the west façade, dividing front and rear gardens. An actual

ship's searchlight over the entrance gate, along with the moat and curving wall, imparted a "nautical" ambience to the scene. A sensuous swimming pool, specially designed by sculptor Isamu Noguchi, was unfortunately never constructed.

Later, in his autobiography, Neutra averred with heavy irony that there was "one item that first astounded me when I brought the magnificent plans to the owner, but it is no more proper for an architect in a successful world of free enterprise to be surprised at any time than a chamberlain of the Borgias a few hundred years earlier. I had to feel with the man from dear old Hollywood when he said, 'Take all the locks off the bathroom doors. . . . It is my experience that there is always somebody in the bathroom threatening to commit suicide and blackmailing you, unless you can get in freely.' In a moment I adjusted myself to the natural anxiety of a wealthy producer."[1]

Following the war, the Sternberg house passed through several hands before it was acquired by none other than the writer-philosopher Ayn Rand. Though Frank Lloyd Wright was the apparent prototype for the protagonist of *The Fountainhead* (1943), her throbbing novel of architectural heroics, Rand admired Neutra and was pleased to own the house. "I don't know where she got her political ideas," Neutra enjoyed quipping at cocktail parties, "but it's obvious she used me as the model for Howard Roark's sexuality."[2] In 1971, after Rand had sold it, the house was demolished to make way for a condominium tract. It had been one of Neutra's—and modern architecture's—finest achievements.

Thomas S. Hines

Bibliography
Richard J. Neutra, *Life and Shape* (New York: Appleton Century-Crofts, 1962); Josef von Sternberg, *Fun in a Chinese Laundry* (New York: Macmillan, 1965); Thomas S. Hines, *Richard Neutra and the Search for Modern Architecture* (New York: Oxford, 1982).

Notes
1. Neutra, *Life and Shape*, 283–89.
2. Dione Neutra, interview with the author, 20 March 1980.

Le Corbusier
**Elevation for Heidi Weber Pavilion,
Zurich**, 1964

Daniel Libeskind
**Sketchbooks for the Jewish Museum
in Berlin**, 1988–89

276

PARKINSON AND PARKINSON

Four drawings of Union Station,
Los Angeles, 1929–39

Charcoal, graphite, and yellow crayon on tracing paper;
17³/₈ x 23 in. (18.7 x 58.4 cm); 22 x 24⅛ in.
(55.9 x 61.3 cm); 19⅛ x 29¹³/₁₆ in. (48.6 x 75.7 cm);
12³/₁₆ x 36⁷/₁₆ in. (31 x 92.6 cm)
Library, Getty Research Institute
(990035)

277

LE CORBUSIER

Elevation for Heidi Weber Pavilion,
Zurich, 1964

Collage, crayon, and pencil on tracing paper;
9½ x 18⅝ in. (24.1 x 47.3 cm)
Library, Getty Research Institute (900242★★)

278

DANIEL LIBESKIND

Sketchbooks for the Jewish Museum
in Berlin, 1988–89

Felt-tip pen, ink, and crayon;
9 x 9 in. (22.9 x 22.9 cm) each
Library, Getty Research Institute
(920061)

279

FRANK GEHRY

Models for Schnabel house, 1980–c. 1988

Painted wood, plastic, metal, and foam-core base;
3⅝ x 16 x 7⅞ in. (9.2 x 40.6 x 20 cm);
7 x 36⅛ x 18¾ in. (17.8 x 91.8 x 47.6 cm)
Library, Getty Research Institute
(930088★★)

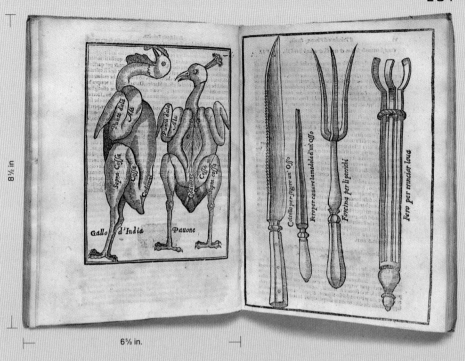

Vicenzo Cervio

**Il trinciante … ampliato et a perfettione ridotto
dal cavalier Reale Fusoritto da Narni**, 1593

The earliest known book on carving and serving

VII THE PRACTICE OF EVERYDAY LIFE

Books are an intricate part of private life as well as of the public sphere. Indeed, few activities in contemporary life remain as fixedly private as reading. If the phrase "private life" itself has come to seem almost an anachronism in a culture in which self-revelation is demanded and valued and in which even sex is more and more accepted as a social activity, reading survives as a solitary everyday practice that resists socialization and the public gaze. Scholars have become increasingly interested in the social and psychological nexus that the reader and the book provoke and make possible, but the evidence that might form the basis for such a study can often be gleaned only indirectly. What is read—and when, where, and with what effect it is read— can sometimes be got at through library circulation records, through annotated copies of texts and reading journals, through library and book auction catalogues, and even ex post facto through oral history. But in general the reading experience leaves no visible traces, however certain we all are that the activity itself has ramifications at every level of human society. Even if someone had filmed Joyce reading Homer or Henry Miller reading Rimbaud, how much would the resulting footage tell us? Very little, really.

Paradoxically the objects in section 7 of *The World from Here* bear evidence of the pervasiveness of the book in everyday existence, yet for the most part they represent reading experiences that do have a marked social impact, taking reading beyond a solitary exercise to a sphere in which the results, in varying degree, can be seen and even measured. One thinks not so much of the contemporary phenomenon of the reading group (though that is evidence enough of the peculiarly North American need to socialize private experience), but of the fact that one of the earliest remembered experiences most people have is of being read to as children. It is a defining memory for

many men and women, and however we explain the sempiternal attraction of children's books among bibliophiles, this is surely one significant factor. Whatever else children's books represent to an adult—the beauty of the illustrations, the classic appeal of the stories—they irrefutably stand also for that primal experience that being read to represents, as well as the complicated linguistic process that evolves from storytelling to private reading. The development of the genre that led from seventeenth-century books like the *Orbis pictus* to the illustrated Victoriana embodied in Beatrix Potter's books can be attributed to changes in educational practice, in printing-house practice, and in the cultural meaning of childhood as a construct. But the collector of children's books will typically look far beyond an initial enthusiasm for the books of her own childhood and want the child's precious objects of every age as witnesses of that key experience that learning to read embodied.

Outside the nursery, the library of everyday life includes books to be found in the kitchen, the dining room, the bathroom, the drawing room, and even the room in a modest house that in different epochs might have been called the playroom, the rec room, the TV room, the den, or the family room. These books as a whole might be more consulted than read, but their importance was and is unarguable for all that.

Books about cooking and eating go back at least to the late fourth century, when the cook-ery book associated with Marcus Gravius Apicius was compiled. (Apicius actually lived under Tiberius, the reigning emperor at the time of the crucifixion, and he died by his own hand after a life devoted to feasting.) Two ninth-century manuscripts of Apicius's *De re coquinaria* survive, one from Tours and one from Fulda, and it was printed as early as the end of the fifteenth century. Over the succeeding five hundred years the printed cookbook changed radically, as it evolved from a kind of *omnium gatherum* that included not only recipes but also household hints, pharmaceutical advice, housekeeping regimens, and even counsel concerning sex, childbirth, and child rearing, to today's guides to specialized cuisines of every stripe. Manuscript cookery books remained common until well into the nineteenth century, as two fine examples in this section of the exhibition demonstrate, one Italian and from the seventeenth century, the other Mexican and from the period ending in 1829. Like children's books, which get read to tatters, cookbooks are working books and are often used to death, with the result that many are rare. The two nineteenth-century Los Angeles cookbooks in this section are almost as rare as the fifteenth-century Apicius, and many other cookery titles recorded in the standard bibliographies survive in very small numbers.

Caring for the body involves not just ensuring that it is well fed but also that it be protected from illness and kept in good physical condition, and books on those subjects have long abounded.

Physical culture as an obsession is a relatively recent cultural development, but two sixteenth-century books, one on tennis and one on swimming, show that the "how-to" sports book is nothing new. Everyday pleasure extends from sport to entertainment and spectacle, and where people alive during earlier centuries would have found such pleasure in groups (as the marvelous Panini fireworks print and the lithograph of the Great Exhibition of 1851 reveal), spectacle today has grown more solitary (like reading itself) in the form of television. Yet away from the public spaces, the body at home is still prey to social rule and to disease, and a small group of objects in this section of the exhibition focus on *mens sana in corpore sano*, or a sound mind in a sound body, at a time (the early modern period) when medicine and morality were urgent home matters and access to books of advice was essential. These ranged from children's books meant to instill sound moral training, on the one hand, to medical books intended to encourage and permit self-diagnosis and treatment, on the other. Behavior and health are often intertwined, and Samuel Tissot, who is represented here with his influential text on the "nocturnal folly" of masturbation (1758), also wrote a much-reprinted and much-translated book of the family physician type called *Avis au peuple sur le santé* (1761). Where such books were concerned, reading as part of the practice of everyday life could clearly be a life-and-death matter. *B.W.*

280

APICIUS

De re coquinaria

Venice: Bernardinus de Vitalibus, [c. 1500]
8⁵⁄₁₆ x 6⁷⁄₁₆ in. (21.1 x 16.4 cm)
The Huntington Library, San Marino, California
(RB 85982)

281

VICENZO CERVIO

Il trinciante … ampliato et a perfettione ridotto dal cavalier Reale Fusoritto da Narni

Rome: Typographia Gabiana, 1593
8½ x 6⅝ in. (21.6 x 16.8 cm)
Department of Special Collections,
Young Research Library, UCLA
(134436 AMEIP)

282

FERNANDO COSPI

Manuscript for "Ricette secrete,"

late 17th century
12¹¹⁄₁₆ x 8¹¹⁄₁₆ in. (32.2 x 22.1 cm)
Los Angeles Public Library

EL COCINERO MEXICANO,

ó

COLECCION

DE LAS

MEJORES RECETAS

PARA GUISAR

AL ESTILO AMERICANO,

Y DE LAS MAS SELECTAS SEGUN EL METODO DE LAS COCINAS ESPAÑOLA, ITALIANA, FRANCESA E INGLESA.

Con los procedimientos mas sencillos para la fabricacion de masas, dulces, licores, helados y todo lo necesario para el decente servicio de una buena mesa.

TOMO I.

MEXICO: 1831.

IMPRENTA DE GALVAN, A CARGO DE MARIANO ARÉVALO, CALLE DE CADENA NUM. 2.

6¼ in.

4⁵⁄₁₆ in.

8⁷⁄₁₆ in.

...jonjoli tostado vino y azucar se abren las manzanas por arriba y se llenan del picadillo y se vuelven a tapar con su tapita y se ponen a asar con una poca de manteca sal y fuego manso asi va y asado

Guiso de Carnero

Se pone a cocer una pierna de carnero con tres tazas de agua dos de vino sal un real de canela clavo pimienta y se esta cociendo hasta que el caldo se con... una

Sopa de Capirotada de Leche

Echaras la leche azucar clavos y en ella estrellaras huevos los apartaras y en la leche echaras unas rebanadas de pan frio y pondras en el platon y en cima los huevos azucar canela pastillas

Agridulce

Se frien ajos picados en manteca y se muele bastante jitomate ya que estan fritos los ajos se echa el jitomate con la gallina y su caldo de dicha un poco se echan pasas almendra rebanadas de jamon vinagre azitron ajonjoli tostado todas especies menos azafran

La Guaxaquita

Se cuecen betabeles y sevollas ya cocidas se apartan se parten las sevollas en cuarterones se pica el betabel se rebana chorizos y jamon se pica pero sil y ~~...~~ un poco de caldo de las gallinas se unta una cazuela con manteca y se pone una capa de gallina otra de todo esto con aceitunas tornachiles azafran y todas...

6⁷⁄₁₆ in.

El cocinero mexicano, 1831

Maria Dolores Calderon
Manuscript cookbook, 1829

A manuscript Mexican cookbook and the earliest printed Mexican cookbook

283

MARIA DOLORES CALDERON

Manuscript cookbook, 1829

51 leaves, 69 pages of text; 8⁷⁄₁₆ x 6⁷⁄₁₆ in.
(21.4 x 17.5 cm)
Los Angeles Public Library

284

El cocinero mexicano

Mexico: Galvan, 1831
6¼ x 4³⁄₁₆ in. (15.9 x 10.6 cm)
Los Angeles Public Library (R641.5972 c6338-1)

One of the most remarkable expressions of Mexican culture is its cuisine. The fundamental appeal of Mexican food is the Baroque fusion that developed from the layering of Spanish and French traditions on top of a long-standing Indian culture. From the arrival of the first Europeans in what is now Mexico, there have been tantalizing descriptions of the country's foods. One of the great curiosities is that while printing was established in Mexico by the 1540s, it was nearly three hundred years before a cookbook was published.

In Mexico, recipes were historically transmitted from mother to daughter during the child's domestic training. The tradition of recording recipes in the form of manuscripts began in the seventeenth century. Most of those that still exist came from the monastic tradition. Nuns were educated and active in culinary practice, and they frequently recorded their recipes. The most famous of the manuscripts is the *Libro de cocina del Convento de San Jeronimo*, attributed to Sor Juana Inés de la Cruz (1651–95), written in the late seventeenth century. The low level of female literacy and the early teaching of culinary techniques are two explanations for the failure to publish recipe books.

Doña Maria Dolores Calderon's recipe book is one of a few surviving manuscripts that precede the publication of the first printed cookbooks in Mexico. It is unusual in that it presents domestic recipes from a middle-class home. Written by several hands over a long period, the manuscript is still in its original leather folder. The recipes represent foods typical of the late eighteenth and early nineteenth centuries, most of which would be easily recognized today. Calderon included dishes such as roast kid, chicken meatballs, salt cod with garlic, a rice tart, and peanut mole. Her use of wine in 28

of the 110 recipes points to an affluent and sophisticated household. The manuscript came to the Los Angeles Public Library with the Paul Fritzche collection. Previous owners of the manuscript included noted cookbook collectors Marshall Blum and Elizabeth Woodburn.

While England and France produced many culinary publications beginning in the sixteenth century, Iberia did not share this publishing tradition. France, for example, published at least 255 cookbooks between 1650 and 1789. In contrast, about eight titles were printed during the first 350 years of printing in Spain, and there were even fewer titles from Portugal. Nonetheless, cookbooks from Spain were available for sale in Mexico as early as 1584. Among the influential books used in Mexico were Juan de Altamira's *Nuevo arte de cocina*, Francisco Martinez Montiño's *Arte de cocina, pastelería, vizcochería y conservía*, and Juan de la Mata's *Arte de repostería*.

El cocinero mexicano was the first cookbook printed in Mexico. It is remarkable that the country's first cookbook was a three-volume encyclopedic work, including recipes from a number of European cuisines. Published a decade after independence, it set a nationalist tone and went through a dozen editions. The anonymous author was a man, as were most cookbook authors during the rest of the century. It wasn't until 1896, when Vicenta Torres de Rubio's *Cocina michoacana* appeared, that a woman was named as a cookbook author in Mexico.

Probably thirty or more cookbooks were published in Mexico during the nineteenth century. *El cocinero mexicano* went on to reappear in a new arrangement as the *Nuevo cocinero mejicano en forma de diccionario*. It was published in Paris in 1858, and several subsequent editions appeared, the last in 1907. A reprint of the 1888 edition has seen several printings during the twentieth century.

The Los Angeles Public Library has both the first and second printings of *El cocinero* (1831, 1834). The first edition, acquired by Charles Lummis while he was city librarian, bears the distinctive LAPL *marca del fuego* brand, patterned after similar brands burned into books in Mexican monasteries to denote ownership. *Dan Strehl*

285

**How to Keep a Husband;
or, Culinary Tactics**

San Francisco: Cuberry & Company, 1872
8³⁄₈ x 5⅛ in. (21.3 x 13 cm)
Los Angeles Public Library
(R641.59 H 8475-1)

286

MRS. ABBY FISHER

**What Mrs. Fisher Knows about
Old Southern Cooking, Soups, Pickles,
Preserves, Etc.**

San Francisco: Women's Cooperative
Printing Office, 1881
8⅛ x 5⁷⁄₁₆ in. (22.5 x 13.8 cm)
Los Angeles Public Library
(641.5975 F533)

287

HUGH PLAT

**Delights for Ladies, to Adorn Their
Person, Tables, Closets, and
Distillatories with Beauties, Bouquets,
Perfumes, and Waters**

London: For J. Young, 1644
4¼ x 2¾ in. (10.8 x 7 cm)
William Andrews Clark Memorial Library, UCLA
(TX151.C64*)

References
William R. Cagle, *A Matter of Taste: A Bibliographical Catalog of International Books on Food and Drink in the Lilly Library, Indiana University* (New Castle, Del.: Oak Knoll Press, 1999), no. 1200.

Bibliography
Janet Long Solís, *Conquista y comida: Consecuencias del encuentro de dos mundos* (Mexico City: Universidad Nacional Autónoma de México, 1996); Jeffrey Pilcher, *Que vivan los tamales: Food and the Making of Mexican Identity* (Albuquerque: University of New Mexico Press, 1998).

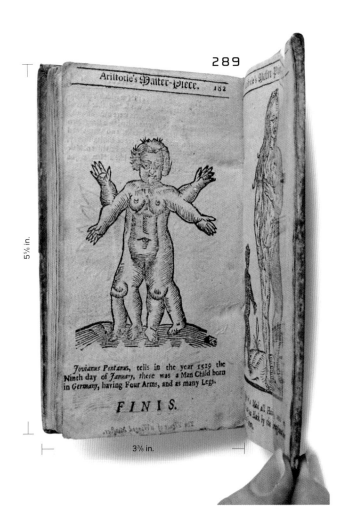

Aristotle's Master-Piece; or, The Secrets
of Generation Displayed in All the Parts Thereof,
1695

A manual on sex and childbirth

288

WILLIAM WALWYN

Physick for Families: Discovering
a Safe Way, and Ready Means, Whereby
Everyone May with God's Assistance
Be in a Capacity of Curing Themselves

London: By J. Winter, 1669
6½ x 4⅜ in. (16.5 x 11.1 cm)
History & Special Collections, Louise Darling
Biomedical Library, UCLA
(WZ250.W179P 1669 Rare)

289

Aristotle's Master-Piece; or,
The Secrets of Generation Displayed
in All the Parts Thereof

London: For W. B., 1695
5⅝ x 3⅜ in. (14.3 x 8.6 cm)
William Andrews Clark Memorial Library, UCLA
(*RG73 A71m 1695)

290

SAMUEL AUGUSTE DAVID TISSOT

Tentamen de morbis ex manustupratione

Lausanne: M.-M. Bosquet & Soc., 1758
7⅞ x 4¹⁵⁄₁₆ in. (20 x 12.5 cm)
University Library, California State University,
Northridge (RC157.T58 1758)

291

Anonymous medical manuscript

18th century
7¹⁵⁄₁₆ x 5¼ in. (20.2 x 13.3 cm)
History & Special Collections, Louise Darling
Biomedical Library, UCLA (Ms. Coll., No. 120)

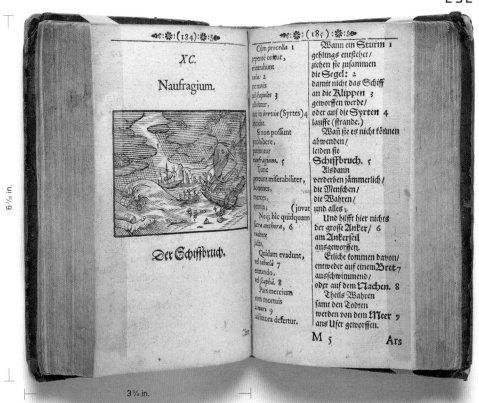

6 ⁷/₁₆ in.

3 ³/₄ in.

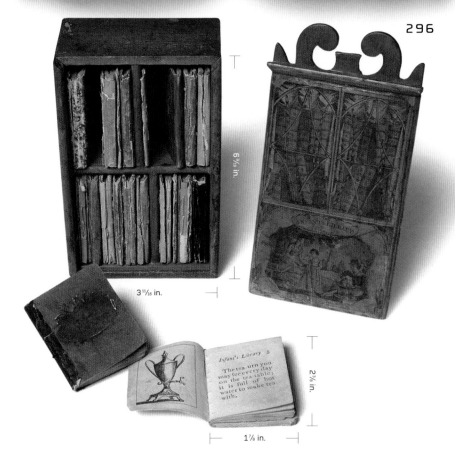

6 ³/₄ in.

3 ¹¹/₁₆ in.

2 ⅜ in.

1 ⅞ in.

Johann Amos Comenius
Orbis sensualium pictus, 1659

The earliest printed children's book

The Infant's Library, [after 1799]

A collection of miniature children's books

15 15/16 in.

19 9/16 in.

The Royal Game of the Dolphin: An Elegant, Instructive, and Amusing Pastime, 1821

An imaginatively designed early children's board game

292

JOHANN AMOS COMENIUS

Orbis sensualium pictus

Nuremberg: Michael Endterus, 1659
6 ³⁄₁₆ x 3 ¾ in. (15.7 x 9.5 cm)
Department of Special Collections,
Young Research Library, UCLA
(CBC LT101 C73o 1659)

293

MADAME D'AULNOY

Les contes des fées

Amsterdam: Estienne Roger, 1708
5 ⁷⁄₁₆ x 3 ⅜ in. (13.8 x 8.6 cm)
Department of Special Collections,
Young Research Library, UCLA
(CBC 112799)

294

**The History of Little Goody Two-Shoes;
Otherwise Called Mrs. Margery Two-Shoes**

London: Printed for Newbery & Carnan, 1768
3 ¹⁵⁄₁₆ x 2 ⅝ in. (10 x 6.7 cm)
Department of Special Collections,
Young Research Library, UCLA
(CBC PZ6 G64 1768)

295

Peep show with pastoral scene,

19th century
6 x 7 ¾ x ⁵⁄₁₆ in. (15.2 x 19.7 x .8 cm) (closed);
box: 6 ⅛ x 7 ¹³⁄₁₆ x ⁷⁄₁₆ in. (15.6 x 19.8 x 1.1 cm)
Department of Special Collections,
Young Research Library, UCLA
(CBC Z1033. T689 P3735 1800)

296

The Infant's Library

London: John Marshall, [after 1799]
Case: 6 ⁹⁄₁₆ x 3 ¹¹⁄₁₆ x 2 ¼ in. (16.6 x 9.4 x 5.7 cm);
books: 2 ⅜ x 1 ⅞ x ¼ in. (6 x 4.7 x .6 cm)
Department of Special Collections,
Young Research Library, UCLA
(CBC PZ6. I4367 1800, copy 2)

297

Cinderilla; or, The Little Glass Slipper

London: John Marshall, 1819
3 ¹⁵⁄₁₆ x 3 ¹⁵⁄₁₆ in. (10 x 10 cm)
Department of Special Collections,
Young Research Library, UCLA
(CBC PZ8. C4915 1819)

298

The Royal Game of the Dolphin: An Elegant, Instructive, and Amusing Pastime

London: William Darton, 1821
Game with instructional booklet; 15¹⁵⁄₁₆ x 19⁹⁄₁₆ in.
(40.5 x 49.7 cm) (open)
Department of Special Collections,
Young Research Library, UCLA
(CBC PZ6.R8124 1821)

The Royal Game of the Dolphin is one of the spectacular board games produced in the early 1820s by the Quaker William Darton Jr., a distinguished member of the Darton family publishing dynasty, which continuously issued children's books from 1787 until the end of World War I. Darton was also the great-grandfather of F. J. Harvey Darton, the author of *Children's Books in England* (1932), which remains the subject's standard history. Trained as an engraver and printer, William Darton Jr. may have invented and designed the finely crafted games he sold to affluent middle-class families at his shop, the Repertory of Genius, in London's Holborn Hill.

What at first appears to be a hand-colored engraving of a voracious fish feeding on smaller ones is the track for an educational race game. (The large fish is actually a dorado, or *Coryphaena hippurus*, a fish that was also known as a dolphin.) The sequence of twenty beautifully illustrated squares has been placed within the outlines of the three fishes, rather than laid out in the traditional pattern resembling a coiled snake. The first player to reach the otter, the twentieth and last square, wins. Players advance their pieces along the track according to the numbers they spin on the teetotum, which is similar to a dreidel. (Teetotums often replaced dice in children's games so that young players would not develop a taste for gambling, the era's endemic and flamboyant vice.) When a player lands on a space, he or she is supposed to find the image's description in the rule book and read it aloud to the group. The subjects, which have no necessary relationship to the scene the game board depicts, include an archer, Shambles (London's equivalent of Les Halles in Paris), a smuggler, a tulip, a hot-air balloon, a turban, a virago, and a pioneer (the laborer who prepares the roads and digs lines for an advancing army). Like one

of Darton's best-known publications for children, Ann, Isaac Jr., and Jane Taylor's charming *City Scenes*, the *Dolphin*'s images and their accompanying descriptions offer a peek into contemporary English life. Darton issued five other equally striking games in the same format, including *The Delicious Game of the Fruit Basket* and *The Majestic Game of the Asiatic Ostrich*.

Only three examples of this "elegant, instructive, and amusing pastime" are known, and the copy at UCLA is the only one with its rule book, which was the gift of Lily Bess Campbell, a professor in the English Department. But does the game's rarity suggest that the children of George IV's England played their sets to pieces? Perhaps Edmund and Fanny Bertram's family would have taken it out evenings at Mansfield Park, but most Georgian children probably found this sort of improving race game rather dull even by that time's quieter standards. Like all games of this type, *The Royal Game of the Dolphin* is a variation on the old European tavern diversion, the game of the goose, and successful play depends on chance rather than strategy. But the *Dolphin*'s inventor eliminated any skill or interaction among players as an incentive to win by making the payoff and penalties the same: sharing information about the animals, people, places, and things represented on the game board with the other players.

Because the game was structured so that no clear winner emerged at the end, the *Dolphin* may be seen as a forerunner of the late twentieth-century's so-called cooperative board games, such as *Buzz around the Bee Board*, *Free the Princess*, or *Ungame*. These games, which discourage competition and promote teamwork, offer interesting bits of information to pique players' curiosity about the world as they move around the track toward the final square. The *Royal Game of the Dolphin* may not have been a general favorite in many families, but such a handsomely presented experimental pastime certainly shows why the design of engaging games has never been child's play. *Andrea Immel*

299

The Areaorama: A View on the Thames

[London?], [1827?]
4⅜ x 5⁷⁄₁₆ x ⁵⁄₁₆ in. (11.1 x 13.8 x .8 cm)
(closed); box: 4¾ x 5¾ x ⁷⁄₁₆ in. (12 x 14.6 x 1.1 cm)
Department of Special Collections,
Young Research Library, UCLA
(CBC Z1033 T689A75 1827)

300

Lane's Telescopic View of the Interior of the Great Industrial Exhibition

[London]: C. Lane, 1851
Peep show; 6⁵⁄₁₆ x 7⅛ x ½ in. (16 x 17.9 x 1.3 cm)
(closed); box: 6½ x 7⅜ x ⁹⁄₁₆ in. (16.5 x 18.7 x 1.4 cm)
Department of Special Collections,
Young Research Library, UCLA
(CBC Z1033.T689 L319 1851)

301

WALTER CRANE

The Alphabet of Old Friends

London and New York: George Routledge and Sons,
[c. 1874–76]
10⁵⁄₁₆ x 9³⁄₁₆ in. (26.8 x 23.3 cm)
Department of Special Collections,
Young Research Library, UCLA
(CBC *PR4518 C18a1 1874)

302

BEATRIX POTTER

The Tale of Peter Rabbit

London: The author, [1900 or 1901]
5½ x 4 in. (14 x 10.2 cm)
Department of Special Collections,
Young Research Library, UCLA
(CBC PZ10.3 P85tp)

303

HERIBERTO FRÍAS

Biblioteca del niño mexicano

Mexico City: Maucci Hermanos, 1899–1901
Illustrated by José Guadalupe Posada
4¾ x 3⁵⁄₁₆ in. (12.1 x 8.4 cm) each
Department of Special Collections,
Young Research Library, UCLA
(CBC F1226 F75 1899)

304

ARTHUR RACKHAM

Untitled, 1904

Watercolor; 14¼ x 11 in. (36.2 x 27.9 cm)
Department of Special Collections,
Young Research Library, UCLA
(*ORIG 99) (#642)

Bibliography
F. R. B. Whitehouse, *Table Games of Georgian and Victorian Days* (Royston, Hertfordshire, and Harbourne, Birmingham: Priory Press, 1971); John Brewer, "Childhood Revisited: The Genesis of the Modern Toy," *History Today* 30 (December 1980): 32–39; Linda David, *Children's Books Published by William Darton and His Sons* (Bloomington, Ind.: Lilly Library, 1992); David Parlett, *The Oxford History of Board Games* (Oxford: Oxford University Press, 1999); Jill Shefrin, "'Make It a Pleasure and Not a Task': Educational Games for Children in Georgian England," *Princeton University Library Chronicle* 60 (winter 1999): 251–75.

10⁹⁄₁₆ in.

9³⁄₁₆ in.

Walter Crane

The Alphabet of Old Friends, c. 1874–76

A Victorian alphabet book

4¾ in.

3⁵⁄₁₆ in.

Heriberto Frías
Biblioteca del niño mexicano, 1899–1901

A series of Mexican children's books
illustrated by José Guadalupe Posada

305

ANTONIO SCAINO

Trattato del Givoco della palla

Venice: Gabriel Giolito de Ferrari, et fratelli, 1555
6 x 4 in. (15.2 x 10.2 cm)
Department of Special Collections,
Young Research Library, UCLA
(Z233.G4S27)

306

EVERARD DIGBY

De arte natandi libri duo

London: T. Dawson, 1587
7 7/16 x 5½ in. (18.9 x 14 cm)
The Huntington Library, San Marino, California
(RB 380148)

307

CHARLES PERRAULT

Festiva ad capita annulumque decursio

Paris: E. Typographia Regia, 1670
21⅝ x 16⅛ in. (54.9 x 41 cm)
Library, Getty Research Institute (87-B10181)

308
THOMAS MATHISON

The Goff: An Heroi-comical Poem

Edinburgh: J. Cochran and Company, 1743
7¾ x 4¹⁵⁄₁₆ in. (19.7 x 12.7 cm)
The Huntington Library, San Marino, California
(RB 449244)

Goff, and the Man, I sing, who, em'lous, plies
The jointed club; whose balls invade the skies . . .

It is fitting that the first book on golf should be a
satire and that the epic match it describes should be
directed by the capricious gods. Golf's demands
of skill and luck have proved addictive to centuries
of players, and a tincture of the ridiculous seems
only to add to its attraction.

Thomas Mathison's poem stands in a tradition
of English burlesque verse that reached its height of
popularity in the first half of the eighteenth century.
Virgil's *Aeneid* was the inspiration for most of these
pieces, usually lending its heroic tone and theme as
well as its opening lines, or sometimes itself serving
as the butt of the satire. Mathison's term for his
confection, "an heroi-comical poem," was coined by
Alexander Pope for *The Rape of the Lock* (1714)
and was borrowed by more than thirty other authors
during the century following.

The Goff's plot is a thin one. Two players,
Castalio and Pygmalion, meet for a game on the
Leith links—in those days a wild patch of grass-
covered sand dunes near the Firth of Forth. The
proceedings are watched over by the goddess
Golfinia, who is also the muse to whom Mathison
addresses his formulaic invocations. Two of her
subdeities, Verdurilla and Gambolia, decide to sup-
port their respective favorites and begin meddling in
the outcome, with seemingly random effects that

will be familiar to modern golfers. The battle reaches
the critical final hole, where a drive by Castalio acci-
dentally strikes down a grazing ewe. The great god
Pan appears, easing the sheep's suffering by the
curious method of urinating on the wound. He turns
in fury on Castalio, who, impatient with the distrac-
tion, drives the god off with his club. From the
bunker where Pan has kicked the ball, Castalio then
sinks an extraordinary chip shot over a wagon road;
Pygmalion muffs his final putt, and the victory
goes to Castalio.

Recognizable people and places are scattered
in disguised form through Mathison's mini-epic.
Some of these are identified in a manuscript key
bound with the copy of the first edition at the
National Library of Scotland; others appear in an
unpublished 1946 typescript by Charles B. Clapcott
in the same library. According to Clapcott, "Castalio"
is the Edinburgh bookseller Alexander Dunning,
the vanquished "Pygmalion" is the author himself,
and the two were brothers-in-law. The text makes
undisguised reference to the famous club maker
"Dickson, who in Letha dwells." (Andrew Dickson
claimed to have served in his youth as caddie
to James II.) Mathison's most interesting digression
deals with the manufacture of golf balls:

That with Clarinda's *breasts for colour vye,*
The work of Bobson; *who with matchless art*
Shapes the firm hide, connecting ev'ry part,
Then in a socket sets the well-stitch'd void,
And thro' the eyelet drives the downy tide ...
The feathers harden and the Leather swells;
He crams and sweats, yet crams and urges more,
Till scarce the turgid globe contains its store:
The dreaded falcon's pride here blended lies
With pigeons glossy down of various dyes

The behavior of these feather-filled leather balls on
the turfy dunes under blustering Scottish skies must
have added immeasurably to the fun of the game.

Golf has probably existed in some form since
there were stones, sticks, and anthropoid apes. Its
English name (still pronounced "gowf" or "goff"
in the British Isles) derives obscurely from Germanic
roots. The game makes its bow in the historical
record in an act of the Scottish Parliament of March
6, 1457, which decrees that "the fut ball ande the
golf be utterly cryit doune and not usyt" (¶6). Most
other early references are equally negative, reflect-
ing concerns with either morals or national defense
readiness. By the time *The Goff* appeared, golf had
moved well beyond the shadow of disrepute and
was becoming an organized sport. The Edinburgh
Burgess and the Bruntsfield Links Golfing Societies
were established in 1735, the Honourable Company
of Edinburgh Golfers in 1744.

Thomas Mathison (1721–60) found his first
employment as a legal clerk in Edinburgh but
in 1748 became a Presbyterian minister. In the
last year of his life he published *A Sacred Ode*
(Edinburgh: Printed for W. Miller), a seriously heroic
and dull poem celebrating Britain's victories in the
Seven Years' War. *The Goff* went into two more
well-deserved separate editions in the eighteenth
century (Edinburgh, 1763 and 1793), the last
of which finally identifies Mathison as the author.
Stephen Tabor

References
David F. Foxon, *English Verse, 1701–1750* (London and New York:
Cambridge University Press, 1975), no. M137; ESTC t2226.

Bibliography
James Lindsay Stewart, ed., *Golfiana Miscellanea* (London:
Hamilton, Adams & Co.; Glasgow: Thomas D. Morison, 1887); *The
Goff: Facsimiles of Three Editions*, introductory essays by Joseph
S. F. Murdoch and Stephen Ferguson (Far Hills, N.J.: United States
Golf Association, 1981).

(3)

THE
GOFF.

CANTO I.

GOFF, and the *Man*, I sing, who, em'lous, plies

 The jointed club; whose balls invade the skies;

Who from *Edina*'s tow'rs, his peaceful home,

In quest of fame o'er *Letha*'s plains did roam.

Long toil'd the hero, on the verdant field, 5

Strain'd his stout arm the weighty club to wield;

Such toils it cost, such labours to obtain

The bays of conquest, and the bowl to gain.

A 2 O thou

Francesco Panini

**Il prospetto del Castel' St. Angiolo con lo sparo
della Girandola**, c. 1780–85

A hand-colored etching of fireworks in Rome

309

FRANCESCO PANINI

Il prospetto del Castel' St. Angiolo con lo sparo della Girandola, c. 1780–85

Etching with watercolor and gouache;
22 15/16 x 34 13/16 in. (58.3 x 88.4 cm)
Library, Getty Research Institute (970025**)

The so-called *Girandola* (from the Italian verb *girare*, "to turn") was, from the fifteenth to the nineteenth centuries, the most celebrated firework display in Rome, occurring on important feast days and papal elections, and attracting visitors from around the world. It held a special appeal for the eighteenth-century Grand Tourist, its explosive energy calling to mind the contemporary philosophical concept of the sublime. A typical response to it was that of the Neoclassical architect Robert Adam, who evocatively wrote in 1755 that the Girandola "exceeded for beauty, invention, and grandeur anything I had ever seen or indeed could conceive. . . . Thousands of rockets . . . are sent up at one time, which spread out like a wheat sheaf in the air, each one of which gives a crack and sends out a dozen burning balls like stars. . . . They, to appearance, spread a mile, and the light the balls occasioned, illuminating the landscape, showed the Castle of Sant'Angelo, the river Tiber, and the crowds of people, coaches and horses which swarmed on all sides and appeared to me the most romantic and picturesque sight I have ever seen."[1]

Goethe, too, commented enthusiastically on the Girandola and the accompanying illumination of the façade of Saint Peter's, in a diary entry of June 1787, as did William Beckford in 1782 ("Last night five thousand rockets flew up from the summit of the castle of St Angelo like a flame of fire and filled the air with millions of stars").[2] The English painter Joseph Wright of Derby was impressed enough to speak of the Girandola in the same breath as Naples's Mount Vesuvius in eruption, exclaiming that "the one is the greatest effect of Nature the other of Art that I suppose can be." He painted the subject several times, pairing it with a canvas of the famous volcano. A reviewer of the Royal Academy exhibition of 1778 called one of these pairs "wonderful examples of sublimity."[3]

Prints of the Girandola exist from as early as 1579, and it is frequently depicted throughout the next two and a half centuries. Panini's hand-colored etching, then, follows a long trajectory of illustrations of the Girandola, though he breaks with the canonical vertical view, choosing instead a horizontal format that allows him to expand the night sky to create a powerful contrast of light and dark. Panini is particularly effective at rendering the brilliant orange, yellow, and white umbrella of exploding rockets, and the bellying clouds of smoke that followed. Though the watercolor and gouache are applied over an etched outline, the etching is so light, and so completely concealed by the coloring, that the print could easily be mistaken for a watercolor drawing. The illusion is further enhanced by the handwritten addition of the subject's title and Panini's signature.

Little is known about the life of Francesco Panini (c. 1725–after 1794), the son of the celebrated Giovanni Paolo Panini (1691–1765), painter of Roman views and architectural fantasies whose pictures enjoyed a great vogue among Grand Tourists. Francesco trained in his father's workshop and probably contributed to its large output of painted views, but he is better known as a draftsman and watercolorist. He prepared drawings of Roman monuments for professional printmakers to etch (e.g., Giuseppe Vasi, Giovanni Volpato), and while his compositions were often derived from his father's paintings, they were also sometimes strikingly original, as with the *Prospetto* of the Girandola. Whether Francesco etched this image himself is unclear, although his is the print's only signature. It is conceivable that Panini intended the work to be sold as a watercolor, the imperceptible etched line functioning only as a means to hasten production.

Acquired from the London firm of Artemis Fine Arts in 1997, the *Prospetto* joined a large nucleus of firework images that forms a subgroup of the Getty Research Institute's wide-ranging collections of books, prints, drawings, and manuscript material documenting the early modern European festival.
Kevin Salatino

310

JOSEPH NASH

The Great Industrial Exhibition of 1851

London: Dickinson Brothers, 1851
Color lithograph; 26 x 33 1/4 in. (66 x 84.5 cm)
Library, Getty Research Institute (960088)

311

HARRY FRANTZ RILE

Four photographs of Santa Monica:

(a) Crystal Plunge, Ocean Park Bathhouse, c. 1886

(b) Tent Village on Santa Monica Beach, c. 1880s

(c) Bathers in the Surf, Santa Monica Beach, 1895

(d) Ferris Wheel on the Santa Monica Hotel Grounds, 1887

(a) 5 x 7 10/16 in. (12.7 x 19.4 cm)
(b) 4 9/16 x 7 in. (11.6 x 17.8 cm)
(c) 5 x 7 10/16 in. (12.7 x 19.4 cm)
(d) 4 12/16 x 7 5/16 in. (12.1 x 18.7 cm)
Santa Monica Public Library (Image Archives #A17, #C5, #C24, #A12)

312

Diary of an automobile trip, 1909

Six postcards, 5 1/2 x 3 5/16 in. (14 x 10 cm) each
The Huntington Library, San Marino, California (HM 59363)

313

ALFRED DINSDALE

Television

London: Sir I. Pitman & Sons, 1926
7 1/4 x 4 13/16 in. (18.4 x 12.2 cm)
Department of Special Collections,
Young Research Library, UCLA
(TK6630 D56t 1926)

Bibliography
Kevin Salatino, *Incendiary Art: The Representation of Fireworks in Early Modern Europe* (Los Angeles: Getty Research Institute, 1997), 77.

Notes
1. John Fleming, *Robert Adam and His Circle in Edinburgh and Rome* (London: John Murray, 1978), 177.
2. Francis W. Hawcroft, *Travels in Italy, 1776–1783* (Manchester: University of Manchester, 1988), 30.
3. Judy Edgarton, ed., *Wright of Derby* (London: Tate Gallery, 1990), 172, 175.

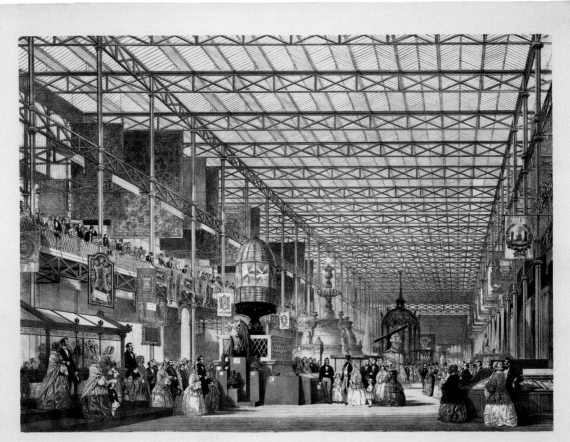

THE GREAT INDUSTRIAL EXHIBITION OF 1851.

Plate 3. The British Nave.

Joseph Nash
The Great Industrial Exhibition of 1851, 1851

A color lithograph of the Crystal Palace
showing the royal family

314

THOMAS ELYOT

The Boke Named the Governour

London: T. Berthelet, 1531
6⁵⁄₁₆ x 4¹³⁄₁₆ in. (16 x 12.2 cm)
The Huntington Library, San Marino, California
(RB 59208)

315

SHINSEN IKENOBO

Heika zui

Japan, after 1698
11⅞ x 8⅞ in. (30.2 x 22.5 cm)
Richard C. Rudolph East Asian Library, UCLA
(SB 450.5 I4H45 / SRLF H 000 012 993 2)

316

**Utsubo Monogatari,
Toshikage no maki**, c. 1716–80

Scroll; 13 x 554¼ in. (33 x 1407.8 cm)
Richard C. Rudolph East Asian Library, UCLA
({*} PL 787 U72 1716 v. 2–5 / SRLF H 000 018 920 9)

317

MARIA ELIZABETH BUDDEN

**Right and Wrong: Exhibited in
the History of Rosa and Agnes**

London: J. Harris, 1818
5⅝ x 3⅝ in. (14.3 x 9.2 cm)
Department of Special Collections,
Young Research Library, UCLA
(CBC PZ 6 B859r 1818)

318

The Two Boys; or, The Reward of Truth

London: J. Harris, 1808
4³⁄₁₆ x 3⅜ in. (10.6 x 8.6 cm)
Department of Special Collections,
Young Research Library, UCLA
(CBC PZ 6 R245 1808)

John Cage
Musical notation book, 1958

The experimental composer's notations
for the realization of two pieces he performed
with David Tudor

VIII FULLY ALIVE

In his first collection the American story writer Guy Davenport has a wonderfully realized story about Edgar Allan Poe called "1830," in which he places Poe at the Russian court as a pleader for funds for the Greek War of Independence. Toward the close of the story Poe muses to himself: "Our sense of the old is always modern. Starlight is hundreds of years old. We live in the phoenix time of antiquity." It is a remark that Poe, who wrote a poem about Tycho Brahe's new star, first observed in 1572, might well have made, but it also embodies a peculiarly postmodern view of things. Davenport also puts the sentiment into the mouth of Otto Brod, Kafka's friend, in another story, called "The Airplanes at Brescia": "The newest style, he said, is always in love with the oldest of which we are aware."

It is a very modern idea, that the avant-garde should rhyme with the prehistoric, and it is visible everywhere in twentieth-century art, literature, and music. Section 8 of *The World from Here* contains many examples of the modern sensibility flourishing by allusion to the archaic: through parody and parallel in James Joyce's *Ulysses* (1922), through parataxis and quotation in T. S. Eliot's *Waste Land* (1922), through image in a painting executed by Pablo Picasso for Gertrude Stein (1909), and through aural primitivism in a little-known symphony by George Antheil (1922). These are all works of high modernism, of course, and the earliest art was especially influential with the generation of 1914, as Ezra Pound called them, a generation that made some of its most lasting art in the 1920s, when Los Angeles too was coming alive artistically. No Stein or Man Ray made a mark so lasting in the city at that time (though Man Ray later lived here), but it is hardly surprising that the great modernists should have been collected by the bibliophiles and institutional buyers of Los Angeles, given the modernity of the Southern California aesthetic from the very start.

Literature has long been at the center of the biblio-philic enterprise, especially since the late nineteenth century, when English collectors like Thomas J. Wise and Frederick Locker-Lampson popularized the collecting of English literature and of what we now know as modern first editions. Earlier nineteenth-century bibliophiles—Sir Thomas Phillipps and Richard Heber are the outstanding figures—formed part of the last generation of acquirers who tried to be completists in the most extraordinary way. Each man filled houses (literally) in an attempt to own copies of virtually every book ever printed. Locker-Lampson went almost to the opposite extreme by forming a small, or "cabinet," collection that included only what a later generation would call the high spots of English literature, from Chaucer to Swinburne. He did not want hundreds of Restoration plays or gothic novels, but only the best; his approach combined bibliophilic sentimentality with what literary critics now think of as a somewhat narrow-minded emphasis on the canon of great books. Science books, medical books, press books, indeed books on any imaginable subject have had their defenders and enthusiasts over the last century, but collections devoted to literature remain perhaps the most common of all.

The literary collections in the institutional libraries of Los Angeles could furnish many different selections of thirty-odd objects, and all of them would be equally breathtaking. Literary and biblio-philic fashions do ebb and flow, but a number of texts resist all changes of critical value, and some of the objects here are constituent parts of an all-but-sacred shelf: Dante's *Divine Comedy* (in the first illustrated edition of 1481); the Shakespeare First Folio (1623); books by Jane Austen, Percy Bysshe Shelley, and John Keats (in a wonderful presentation copy); and the great classics of nineteenth-century American literature, including the manuscript

of Henry David Thoreau's *Walden*. Other books displayed were chosen for their astonishing rarity: *Everyman* (the only surviving copy), *Fanny Hill* (a dull book to look at, to be sure!), and the first books of Poe, Kipling, Yeats, and Pound. Robinson Jeffers, a poet associated like no other with California, is represented by a little-known text that was printed in only five copies. D. H. Lawrence, whose writing forms part of a nucleus of objects that together almost define 1920s modernism, is here in the book that picks up where *Fanny Hill* left off. *Lady Chatterley's Lover* (1928) is not especially rare, but its sexual primitivism was an epochal literary event. (Like *Ulysses*, it was typeset by non-English-speaking compositors, and it was just as well.) Lawrence Clark Powell, the great UCLA librarian, donated the copy of *Lady Chatterley's Lover* in the exhibition after smuggling it into the United States dressed in a dust jacket temporarily borrowed from another, less offensive book.

From John Cleland and Lawrence to Henry Miller, William S. Burroughs, and Allen Ginsberg, *The World from Here* traces a line of authors whose books have met the steely gaze of the censor and survived. Oscar Wilde and Anaïs Nin also made raids into morally and legally dangerous territory, although their books were never banned as such. Miller is represented here also as part of a tributary to the main river of literary history that might well be called the Rimbaud stream. Arthur Rimbaud himself connects to William Blake before him (here in a wonderful presentation copy of his rare first book, but also represented in section 3), and to William Butler Yeats after him, as a poet who defined an infernal quality for post-Romantic European poetry. Miller and Nin both deeply admired Rimbaud for his highly modern view of poetry and his disgust for bourgeois society. Nin recorded her infatuation in her diary. Miller not only wrote a superb study of

Rimbaud *(The Time of the Assassins)* but also made a translation of *Une saison en enfer* that was never published and is exhibited here in manuscript form.

With the literary objects in this section are other objects representing philosophy, religion, and music. All of these four subjects bear out the highest aspirations and the most complex and beautiful intellectual and emotional structures of which humans are capable. The degree of beauty and the degree of universality clearly vary, of course. Most of the philosophy books contain texts that every thoughtful reader must encounter and confront, from Aristotle and Plato to John Locke and David Hume. Political philosophy and texts that present classic treatments of the relationship between the individual, the church, and the state include Benedict de Spinoza and Jean-Jacques Rousseau, as well as Thomas Hobbes's extremely rare *De cive* (1642). Cicero, Michel de Montaigne, and John Milton add a more subjective lure to the abstract reasoning of the philosophers as such, and Adam Smith's now highly prized *Wealth of Nations* (1776), published in the year of the Declaration of Independence, deals with issues of freedom (as Cicero, Montaigne, and Milton also had) on the much more practical level of economic activity.

Spiritual activity, as enacted in some of the world's defining religious texts, is addressed in the second subsection of this portion of *The World from Here*. If evidence of the Christian tradition predominates here, it is the "here's" history that accounts for such a fact. Spanish Catholicism in the Americas is registered by the 1543 *Dotrina breve*, the earliest complete surviving book printed in the New World. John Eliot's translation of the Old and New Testaments into the Massachuset dialect of the Algonquian Indian language documents the proselytizing character of seventeenth-century colonial culture. Other important Bibles range from the splendid

Complutensian Polyglot (published in 1522, though printed a few years earlier), to the 1611 King James version, to the austere and beautiful five-volume Bible printed by Thomas James Cobden-Sanderson at the Doves Press and published in 1903.

Of the other religious texts represented here, the object honoring Buddhism is surely the most beautiful. This is the so-called *Lotus Sūtra*, a late seventeenth-century scroll that rivals aesthetically most of the great Books of Hours of the European tradition. An Islamic manuscript of prayers from the same century contains striking and unusual representational illustrations. A small and extremely rare *Biblia hebraica* demonstrates the sophistication of Hebrew printing at a very early period.

The World from Here concludes with a small section devoted to music, the art that, if any does, expresses the human spirit at its most universally captivating and pure. A small number of objects leap balletically from the late sixteenth century past the nineteenth (represented by Beethoven and Mendelssohn) directly into the twentieth, which is most fully documented in the collections of Los Angeles. Major manuscripts such as those of Antheil's Symphony no. 1 and Stravinsky's *Rake's Progress* sit as isolated masterpieces at the University of Southern California. Other musical objects represent the avant-gardism of the 1950s generation in America as well as the film industry (represented in section 1), a business that feeds many important living Los Angeles composers. Music on the page, whether manuscript or printed, curiously can seem more mute and inscrutable than most cultural objects. Its unfamiliarity is part of its iconic beauty, and in that respect it is not unlike many of the books and manuscripts that make up *The World from Here*—one of the paradoxical threads that weaves through the entire exhibition. *B.W.*

319
CICERO
De officiis
Mainz: Fust and Schöffer, 1466
10⅛ x 7 in. (25.7 x 17.8 cm)
The Huntington Library, San Marino, California
(RB 105402)

320
PLATO
Opera omnia
Venice: Aldus Manutius, 1513
11¹⁵⁄₁₆ x 7⁹⁄₁₆ in. (30.3 x 19.2 cm)
Department of Special Collections, Young Research Library, UCLA (*Z233 A4P69)

321

ARISTOTLE

Opera [in Greek]

Edited by Aldus Manutius, Thomas Linacre,
Justin Decadyos, Gabriel Braccius et al.
Venice: Aldus Manutius, 1 November 1495;
29 January 1497–June 1498
12¹¹⁄₁₆ x 9 in. (32.2 x 22.9 cm)
Department of Special Collections,
Young Research Library, UCLA
(*A1 A71A1 1495)

The *editio princeps* of Aristotle's works is a monumental achievement on any account, and it may justifiably be viewed as the central achievement of the Renaissance in printing. It is the most substantial piece of Greek printing during the incunabular period. The volumes contain all the works of Aristotle known at the time, plus works by Galen, Theophrastus, Philo Judaeus, Alexander Aphrodisiensis, and others, all of these also *editiones principes*.

Aldus issued his Aristotle in two separate series, which is reflected in his published catalogues and prefaces. The first part was the one-volume *Organon*, or the six treatises on logic, with the colophon date of November 1, 1495. The preface to the *Organon*, a dedicatory letter from Aldus to his former pupil and sometime patron Alberto Pio di Savoia, prince of Carpi, serves as Aldus's announcement of his heroic intention to publish all the works of Greek antiquity on philosophy. The second series, containing the balance of the Aristotelian corpus, appeared as four additional volumes, regularly bound as five, between early 1497 and mid-1498. The signatures reflect the sequence of planning, proceeding from single letters sequentially through groups of four; thus, under this schema, the volume dated February 1497 in the colophon preceded the one dated January of the same year. (Whether the dates are Old Style or New Style remains an unresolved question. It has been long posited that the fifteenth-century Aldines bear Old Style dates, and the sixteenth-century ones New Style. Were this the case in the present instance, it would raise the tantalizing notion that these four immense and complex volumes came out in astonishingly short sequence, from January to June 1498. This would seem, on the face of it, implausible.) The most elaborate and ambitious instance of Greek printing in the fifteenth century, its five super-chancery folio volumes constitute a monument to the art of the book.

We know that there were financial strains at the Aldine Press during this period, and the Aristotle would have contributed to them in a major way. The entire Greek publishing program demanded very large capital resources, not least because of the intricate method of Greek typecasting that Aldus invented. The Aristotle in particular would have tied up considerable money in paper, typecasting and typesetting, and unsold inventory. The purchases of paper alone would have been massive. Paul Needham estimates that, allowing for a print run of five hundred copies, Aldus required at least 926 reams of paper. Paper was very expensive, typically constituting half the cost of production. We can deduce from the empirical evidence of extant copies, moreover, that there must have been unsold inventory available for years after production was complete. The cumulative retail sale price for the Aristotle of nearly thirteen gold ducats would have constituted two or three months' salary for someone intellectually capable of using its contents.

The editorial "team" is striking for its international composition and its reflection of the borderless world of humanistic scholarship. The English element is especially affecting, both for what it reflects and for what it portends. The English physician Thomas Linacre also lent a hand in Aldus's edition of the ancient astronomical writers, published in 1499, and he is a harbinger of the accomplishments of such compatriots as John Colet and Thomas More, not to mention that famous guest, happy in England, Erasmus. It is lamentable to consider what might have been, and how the Renaissance might have taken early and lasting root in England. But that particular scholarly barque ran aground on the shoals of the testosterone wars that masqueraded as Henry VIII's struggle for religio-political hegemony. If one sees a long-displaced literary tradition arising with Edmund Spenser, and a philological dominance with as late a practitioner as Richard Bentley, one mourns for the lost decades.

Substantial fragments of the setting-copy manuscripts of the Aldine Aristotle survive. A small part is in the Houghton Library at Harvard. Much more is in the Bibliothèque nationale de France, a legacy from the royal library at Blois. These survivors came to Blois originally from Gian Francesco Torresani, successor to Aldus as chief operative of the Aldine Press from Aldus's death in February 1515. Torresani engaged the services of the French ambassador to Venice, Guillaume Pellicier, bishop of Montpellier, to act as intermediary for the sale of the press's collection of Greek manuscripts to Francis I. Pellicier was close to Pierre Du Chastel, then master of the king's library, and wrote to him in January 1542 (likely an Old Style date, given the French environment). The result was the transfer, by a combination of sale and gift, of more than eighty manuscripts that either, like the Aristotle, had served as setting copy or were at one time intended to form the basis of a printed edition. All these manuscripts survive at the Bibliothèque nationale, and a number of them bear Aldus's notation of ownership.

Another legacy from the royal libraries at Blois and Fontainebleau is a set of the Aristotle, of which the four volumes from the second series are printed on vellum (the *Organon* volume apparently was printed only on paper) and retain their original Venetian bindings, made about 1539 for Girolamo Fondulo by the Mendoza binder.

The Ahmanson-Murphy Aldine Collection set was owned in the sixteenth century by the father and son Christophorus and Paulus Mauricius of Bologna, bearing the latter's composite ownership entry dated 1597, and then somewhat later by Ludovicus Septalius, a Milanese physician. The intervening centuries are silent, in part perhaps a result of its twentieth-century rebinding. It was acquired by UCLA around 1961. *H. George Fletcher*

References
W. A. Copinger, *Supplement to Hain's Repertorium bibliographicum* (London: H. Sotheran, 1895–1902), no. 1657*; *Catalogue of Books Printed in the Fifteenth Century Now in the British Museum* (London: British Museum, 1908–), vol. 5, 553, 555–57, 558–59; *Gesamtkatalog der Wiegendrucke* [Leipzig and Stuttgart: Hiersemann, 1925–), vol. 2, no. 2334; Frederick R. Goff, *Incunabula in American Libraries: A Third Census* (New York: Bibliographical Society of America, 1964), no. A-959.

Bibliography
Johanna Harlfinger, Joseph A. M. Sonderkamp, and Martin Sicherl, *Griechische Handschriften und Aldinen* (Wolfenbüttel: Herzog August Bibliothek, 1978); Roger Stoddard, ed., *Marks in Books Illustrated and Explained* (Cambridge: Houghton Library, Harvard University, 1985), no. 2; Paul Needham, "Aldus Manutius's Paper Stocks: The Evidence of Two Uncut Books," *Princeton University Library Chronicle* 55 (winter 1994): 287–307; Annaclara Cataldi Palau, *Gian Francesco d'Asola e la tipografia Aldina* (Genoa: SAGEP, 1998), 386; Marie-Pierre Laffitte and Fabienne Le Bars, *Reliures royales de la Renaissance: La librairie de Fontainebleau, 1544–1570* (Paris: Bibliothèque nationale de France, 1999), no. 25.

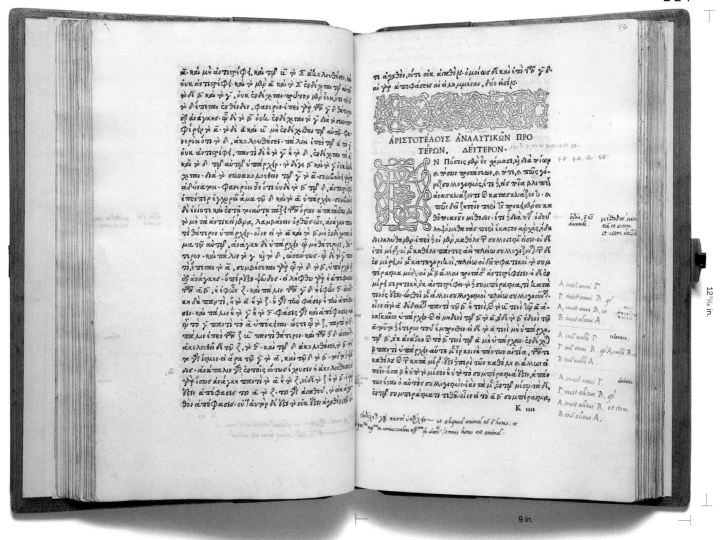

Aristotle
Opera [in Greek], 1495–98

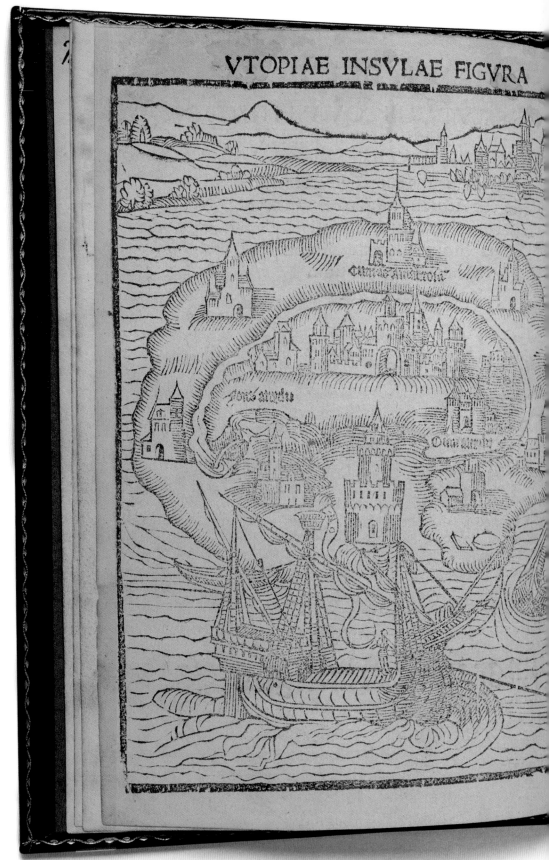

UTOPIAE INSVLAE FIGVRA

Thomas More
Utopia, 1516

The most important political fable of the Renaissance

VTOPIENSIVM ALPHABETVM.

b c d e f g h i k l m n o p q r s t v x y.

Tetrastichon vernacula Vtopiensium lingua.

pos ha Boccas peu la

chama polta chamaan

Bargol he maglomi baccan

foma gymno sophaon

grama gymnosophon labarembacha

bodamilomin

Voluala barchin heman la

lauoluola dramme pagloni.

Horum versuum ad verbum hæc est sententia.
Opus me dux ex non insula fecit insulam
Vna ego terrarum omnium absq philosophia
Ciuitatem philosophicam expressi mortalibus
Libenter impartio mea, no grauatim accipio meliora.

322

THOMAS MORE

Utopia

Louvain: Thierry Martin, 1516
7⅝ x 5½ in. (19.4 x 14 cm)
The Huntington Library, San Marino, California
(RB 88394)

Sir Thomas More's *Utopia*, first published in Louvain in 1516, is a revolutionary work in many ways despite itself, and it reflects the spirit and the intellectual and ethical concerns of a group of northern humanists who looked to the great Dutch scholar Erasmus as their leader. It is indeed a companion piece to Erasmus's *Praise of Folly* (1511), whose Latin title, *Encomium moriae*, contains a pun on More's name. (*Moros* in Greek means "stupid," but *il moro* in Italian signifies the late-leafing mulberry tree, thought to be the wisest of the trees even as it first appeared stupidly to have missed the spring.) This wisely foolish, oxymoronic character typifies *Utopia* itself, which consists of two very different books written in reverse order.

The first but later of the two contains a savage and tragic analysis of contemporary abuses in sixteenth-century England, focusing on the plight of the poor, the greed of the rich, misgovernance, and misbelief. It echoes the similarly savage attacks of William Langland and the Lollards and of other medieval social and religious reformers and underscores the dark underbelly of Tudor misrule. The earlier and second of the books, by contrast, plays with visions, dreams, and ideals, invoking especially the social engineering and aristocratic command (but not in our sense republican) structure of Plato's *Republic* as well as the pleasure-based ethics of his *Philebus*. But it also invokes the communist ideals and expectations of the first disciples, as described in Acts, and their re-creation in medieval monasticism, as well as in various medieval dream worlds: the Land of Cockaigne, the worlds of pastoral and the millenary imagination, the realm of Prester John. Above all, it speaks to the expectations raised by the discovery of the New World a quarter century earlier and specifically to the voyages of the Italian who gave America its name.

More's *Utopia* is, as its title in Greek indicates, "nowhere" (*u-topos*), but that nowhere is also perhaps the best place (*eu-topos*), or at least it offers us a vision of what such a place might be like.

Agriculturally self-sufficient, the utopians inhabit an almost impregnable island, which nonetheless (unlike most Greek islands!) has enough water and is easily negotiated by foot, everything being just the right distance apart (like Ireland). Food therefore is not a problem, and neither is crime. A carefully planned educational system produces model utopians who have no interest in gold or in amassing private property (since it is forbidden), and the aberrant deviant or protester is easily shipped off to the galleys.

More's society has what we would regard as sensible marriage and divorce laws, though the household and the paterfamilias are still regarded as the basic social unit. It is committed to religious tolerance within limits (though atheism and agnosticism are inconceivable). Its artistic life seems nonexistent, apart from hymnody, though utopians are encouraged to read, under supervision, serious books in their spare time (and here the rule of Saint Benedict seems to be the paradigm). The ethos is one of calm: stoic in adversity, chastely Epicurean in prosperity, always efficient, always economical. Opponents would see its life as intolerably drab, repetitive, and unexamined: as a kind of pious prison that housed neither Scholastic subtlety nor Renaissance "virtù."

In its exercise of foreign affairs, however, Utopia is relentlessly Machiavellian and fights to win by guile before force (like Venice), and here More shows none of the idealism that moved Rabelais to mock the blindness and savagery of predatory princes. Indeed, Utopia is in many ways the perfect Renaissance state in spite of itself, and the chasm separating its internal from its external politics points to the enduring dilemma of any leader who has to play by two often mutually destructive sets of rules.

Utopia has been enormously influential and is undoubtedly the most important book ever written by an Englishman in Latin. It inspired not only other literary and philosophical utopias (indeed gave us the very term) and eventually dystopias (such as Huxley's *Brave New World* and Orwell's *Animal Farm*) but also practical schemes. As early as the 1530s Vasco de Quiroga was recommending the establishment of utopias in the New World (since its golden world was not suited to European customs), and as late as the eighteenth century the Jesuits were trying to do the same in Paraguay. It was hailed by nineteenth-century liberals and by early communists as a revolutionary work; reviled by twentieth-century defenders of the open society as a reactionary work; and savored by literary humanists as a witty and elliptical work, "A truly golden handbook, no less beneficial than entertaining," in the words of the subtitle. It continues indeed to be interpreted as a wise and as a foolish book, though many of the superficial judgments are based upon a reading of the second book alone.

Thomas More took great care to protect himself from a simple reading, however, through an array of distancing devices. More tells the story of having been in Antwerp with Peter Giles, who had introduced him to a long-bearded, sunburned stranger who had sailed with Amerigo Vespucci on the last three of his four voyages. The stranger's name, Raphael Hytholday, suggests that his guardian angel has been peddling (*daien*) him a lot of nonsense (*huthlos*). More's learned contemporary readers immediately cottoned on to the game-playing, ludic features of the work, even to the point of inventing a Utopian philology! This combination of gaiety, cleverness, force, and vision continues to intrigue us, surely accounting for *Utopia*'s status as a literary and philosophical masterpiece, an equal to Plato's greatest dialogues.

The Huntington copy was acquired at the Herschel V. Jones sale in 1919, and it was previously in the collection of Mark Masterman Sykes, who noted in the book that it was given to him "by my worthy friend the Revd James Dalton of Copgrove 1809." *Michael J. B. Allen*

References
R. W. Gibson, *St. Thomas More: A Preliminary Bibliography of His Works and of Moreana to the Year 1750* (New Haven: Yale University Press, 1961), no. 1; M. A. Shaaber, *Check List of Sixteenth-Century Editions of Works of Sixteenth-Century Latin Authors* (New York: Renaissance Society of America, 1963), no. M220.

Bibliography
J. H. Hexter, *More's "Utopia": The Biography of an Idea* (Princeton: Princeton University Press, 1952); Edward Surtz, *The Praise of Pleasure: Philosophy, Education and Communism in More's "Utopia"* (Cambridge: Harvard University Press, 1957); George M. Logan, *The Meaning of More's "Utopia"* (Princeton: Princeton University Press, 1983); Dominic Baker-Smith, *More's "Utopia"* (New York: Harper Collins Academic, 1991); Peter Ackroyd, *The Life of Sir Thomas More* (London: Chatto & Windus, 1998).

323

MICHEL DE MONTAIGNE

Essais

Bordeaux: S. Millanges, 1580
6½ x 4½ in. (16.5 x 11.4 cm)
William Andrews Clark Memorial Library, UCLA
(*PQ 1641 A1)

324

RENÉ DESCARTES

Discours de la méthode

Leiden: Jan Maire, 1637
7¹⁵⁄₁₆ x 5¹⁵⁄₁₆ in. (20.2 x 15.1 cm)
Department of Special Collections, Young Research
Library, UCLA (G 000 030 186 1)

325

THOMAS HOBBES
Elementorum philosophiae
sectio tertia de cive

Paris, 1642
8 9/16 x 6 9/16 in. (21.7 x 16.7 cm)
William Andrews Clark Memorial Library,
UCLA (*B1241)

The English philosopher Thomas Hobbes (1588–1679) was born in what is now Malmesbury, in Wiltshire. He lived to be ninety-one—an extraordinarily long life for the time—and it was a life full of both incident and remarkable achievement. He was a late bloomer as far as philosophy was concerned: not until he was roughly forty years old did he chance on a copy of Euclid's *Elements of Geometry* and find himself at once wanting to apply its deductive logic to the study of human nature and human institutions. His first published book was a translation of Thucydides' history of the Peloponnesian War (1629), and among his last was a translation of the *Odyssey* and the *Iliad* (1674–75), which he undertook in his eighties. Hobbes wrote two autobiographies (one in prose and one in verse) and was also the subject of one of John Aubrey's lives (composed during the last third of the seventeenth century), with the result that a good number of charming and revealing anecdotes about him are known. For example, his preferred form of exercise was tennis, which he played into his seventy-fifth year, and he calculated the exact number of times—it was a hundred—that he had been inebriated during his lifetime.

Hobbes was supported during much of his career by the Cavendish family, whose sons he tutored and with whom he made trips to the Continent. It was during one of these tours that he met and became friendly with the philosophical circle in Paris that included René Descartes, Marin Mersenne, and Pierre Gassendi, and it was this group of men who took him in when he felt it prudent to flee England near the end of 1640 because of his royalist sympathies and anti-Puritan views. It was also in part for the Mersenne circle that the first edition of *De cive* (On the state) was intended.

The rarity of the first edition of 1642 (only eight copies are known: three in the United States, one in France, and four in England) has led Hobbes scholars to presume that it was issued in a very lim-ited number of copies, almost as a trial edition to be distributed to an inner circle for comment and criticism. The second, or first really widely available, edition was issued in 1647 by the Elzevier press in Amsterdam, and it included a new *praefatio ad lectores* (preface to readers) as well as important notes in which Hobbes dealt with certain objections that had been raised by readers of the 1642 edition. The third edition (also 1647) included congratulatory letters from Mersenne and Gassendi, and the text was later translated into French (1649; translated by Samuel Sorbière) and English (1651; translated by Hobbes himself).

Though published first because of its particular relevance to the events leading up to the outbreak of the Civil War in England, *De cive* is actually the third and last part of Hobbes's *Elements of Philosophy*, of which *De corpore* (On the body; 1655) and *De homine* (On humanity; 1657) are the other two. Many of Hobbes's views and theories on the construction of the state as expressed in his later and better-known *Leviathan* (1651) can be found in *De cive*, including the belief in the absolute power of the monarch in a commonwealth, the identification and importance of natural law and civic duties, and the relationship between the ecclesiastical and civil powers. Hobbes's hatred for any view that set the authority of the church above that of the state naturally did not win him any friends in religious circles. By 1654 *De cive* was on the index of books prohibited to Catholic readers, and in 1683, by which time Hobbes had been dead for four years, it and *Leviathan* were ordered by the authorities of Oxford University to be publicly burned. Hobbes had wanted to treat the theory of politics in the same experimental way that Galileo (whom he knew) had approached astronomy. His deeply held materialistic views about human behavior and social institutions made him controversial and even despised during his lifetime and for a long time after.

The Clark Library is one of only two libraries (the other is the Bodleian Library at Oxford) to own copies of the first editions of all three parts of Hobbes's *Elements of Philosophy*. The Clark copy of *De cive* was acquired in 1999. *Bruce Whiteman*

References
Thomas Hobbes, *Opera philosophica quae latine scripsit omnia*, ed. William Molesworth (London: Bohn, 1839), vol. 2, [133]–432; *Catalogue général des livres imprimés de la Bibliothèque nationale* (Paris: Imprimerie nationale, 1897–1981), vol. 72, 579; *Short-Title Catalogue of Books Printed in France and of French Books Printed in Other Countries from 1470 to 1600 in the British Museum* (1924; reprint, London: British Museum, 1966), no. H.21; Hugh Macdonald and Mary Hargreaves, *Thomas Hobbes: A Bibliography* (London: Bibliographical Society, 1952), no. 24.

Bibliography
F. C. Hood, *The Divine Politics of Thomas Hobbes: An Interpretation of "Leviathan"* (Oxford: Clarendon Press, 1964), 43–53; A. P. Martinich, *Hobbes: A Biography* (Cambridge: Cambridge University Press, 1999).

8 9/16 in.

RELIGIO

ELEMENTORVM
PHILOSOPHIÆ
SECTIO TERTIA
DE CIVE

Pro. 8. 15.

Per me Reges regnant et
legum conditores iusta
decernunt.

IMPERIVM

LIBERTAS

PARISIIS
1642.

Nath. f.

6 5/16 in.

Thomas Hobbes

**Elementorum philosophiae sectio tertia
de cive**, 1642

A very rare treatise on the relation
of the individual and the state

326
JOHN MILTON
Areopagitica

London, 1644
7⅜ x 5¹³⁄₁₆ in. (18.7 x 14.8 cm)
William Andrews Clark Memorial Library, UCLA
(*PR 3570 A61)

John Milton's *Areopagitica*, in simplest terms, was a treatise on licensed printing. His view was that even if there is objectionable writing—whether it be seditious, morally corrupt, or even dangerous to its readers—people are able to defend themselves through their reason. He admits "that some restraint is necessary, but . . . the control should be rather an inner one, inside the personality itself, than an external one, dictated by some outside authority."[1]

Is it possible that this most important and influential treatise emanated obliquely from an upheaval in Milton's personal life? That may be part of the picture, but there is more to it than that. In 1642 Milton married Mary Powell, who was only seventeen (Milton being thirty-three at the time). Douglas Bush has pointed out that "success could hardly be predicted for the marriage of a scholar and a poet of thirty-three to an uneducated girl of half his age from a large, easygoing household."[2] In July 1643 Mary went to stay with her father, refusing to return to her husband. We do not know what precipitated this separation.[3] The immediate outcome of this marriage was a series of pamphlets on divorce: "Doctrine and Discipline of Divorce" (1643; enlarged in 1644, followed by three more pamphlets on the same subject in 1644 and 1645). As Herbert Read has noted: "The Order of Parliament requiring all publications to be licensed for press by an official censor, and to be registered in the books of the Stationers' Company, had already been in force for two months when Milton issued his pamphlet . . . uncensored and unregistered"—and, of course, unlicensed. It was a deliberate act of defiance.[4]

In arguing for the right to divorce, Milton "was attacked as a libertine by Royalists and Presbyterians alike," and his reply was, in part, that he had the right to voice his views. Other pressures bore on Milton at the time. On June 14, 1643, Parliament passed the Licensing Order "for suppressing the great late abuses and frequent disorders in printing many false, forged, scandalous, seditious, libelous and unlicensed papers, pamphlets, and books."[5]

Whether the Licensing Order was in direct response to Milton's divorce essay of earlier that year is debatable. We are told that "Milton, generalizing in his characteristic way on the private experience of his wife's desertion, published his tract *The Doctrine and Discipline of Divorce*. This so shocked clerical opinion that a complaint was laid against him under the new ordinance, to which Milton, again converting his own experience into a public protest, rejoined with *Areopagitica*."[6]

In passing the Licensing Order, Parliament seemed to be reintroducing the restraints on publishing put in place in 1637 by the Star Chamber, which had been abolished in 1641. But as K. M. Lea has pointed out, even though the prohibitions were no longer in force, between 1641 and the Licensing Order of 1643 there were still strong pressures on printers to be licensed before going to press and to submit their texts to censors.[7] Further, the stringency placed upon printers by the authorities was strongly backed by the influential Stationers, who saw a free press as not only challenging their primacy but also taking their business away. And this was a long-standing pressure, having emanated from the founding of the Stationers' Company in 1557. Only Stationers were licensed to print, and as Richard C. Jebb has explained: "All printing was . . . centralized in London under the immediate inspection of the Government. No one could legally print, with special license, who did not belong to the Stationers' Company. The Company had power to search for and to seize publications which infringed their privilege." The Order of Parliament of June 14, 1644, was what Read has called a "totalitarian edict," giving the Stationers' Company powers of censorship and control of printing throughout the country.[8]

Milton's tract has four main arguments. First, there is a basic, absolute truth in the world, even if it is not wholly revealed to humankind. Truth, moreover, continues to emerge and evolve, so it cannot be controlled. The second is that, according to the legal constraints imposed by the June 14 order, someone had to decide what was acceptable and what was not, and where does one draw the line between truth and falsehood, good and evil? The third issue is that it is impossible to find "individuals

competent to draw such a line, supposing it to exist." Such a law would be utterly impossible to enforce. Related to this third issue is the fact that only total lunatics would spend their lives reading masses and masses of texts just looking for objectionable content. Read says that Milton "found it difficult to imagine a body of men with either the patience or the competence to carry out such an enormous task."[9]

The final argument contains Milton's key point: that censorship of the press (or of any kind) is hurtful. He says, "I lastly proceed from the no good it can do, to the manifest hurt it causes, in being first the greatest discouragement and affront that can be offered to learning and to learned men." Learning is discouraged, and writers are reduced to little more than schoolboys under the control of a tutor. He also adds, almost parenthetically, that often an author who has gotten his text licensed wishes to change it before it finally goes to press, and "the printer dares not go beyond his licensed copy." The conclusion to this complication is that the author must trudge over to the original licensor, have him read the revised text, and get him to sign a new license. "Meanwhile either the press must stand still, which is no small damage, or the author lose his accuratest thoughts, and send the book forth worse than he had made it, which to a diligent writer is the greatest melancholy and vexation that can befall."[10] The delays caused by licensing are almost as objectionable as the infringements on freedom of expression.

Milton is afraid that granting licensors the power to censor will lead to their further corruption. As Read explained: "The control of the material is apt to give the controllers consequential powers whose abuse cannot be prevented. This is particularly the case in publishing."[11] Finally, Milton says that there is nothing wrong with punishing evil speech but that it should not be stifled. Only those who are enemies of books would try to prohibit freedom of the press. In this brilliant rhetorical document, Milton writes a defense for all people who are doing what he himself is doing: publishing.

Sidney Berger

References

John Carter and Percy H. Muir, eds., *Printing and the Mind of Man: A Descriptive Catalogue Illustrating the Impact of Print on the Evolution of Western Civilization during Five Centuries* (London: Cassell and Company, 1967), no. 133; Donald Wing, *Short-Title Catalogue of Books Printed in England, Scotland, Ireland, Wales, and British America, and of English Books Printed in Other Countries, 1641–1700* (New York: Index Committee of the Modern Language Association of America, 1972–98), no. M2092.

Notes

1. B. Ifor Evans, "Milton and the Modern Press," in *Freedom of Expression: A Symposium*, ed. Hermon Ould (London and New York: Hutchinson International Authors, [1944]), 27.
2. In *New Encyclopaedia Britannica: Macropaedia*, s.v. "Milton."
3. Richard C. Jebb, "Life of Milton," in John Milton, *Areopagitica* (Cambridge: University Press, 1928), xiv, n. 1.
4. Herbert Read, "On Milton's *Areopagitica*," in *Freedom of Expression*, 123.
5. The full text of this order is in John Milton, *Complete English Poems; Of Education; Areopagitica*, ed. Gordon Campbell (London: Dent; Vermont: Charles E. Tuttle, 1995), 619–20.

6. See *Printing and the Mind of Man*, 2d ed. (Munich: Karl Pressler, 1983), 79.
7. The text of the pertinent passages of the Star Chamber Decree of 1637 may be found in John Milton, *"Areopagitica" and "Of Education,"* ed. K. M. Lea (Oxford: Clarendon Press, 1973), 61–63.
8. Jebb, "Life of Milton," xxiii; Read, "On Milton's *Areopagitica*," 124.
9. Read, "On Milton's *Areopagitica*," 124, 125, 126.
10. Milton, *Areopagitica*, 33, 35.
11. Read, "On Milton's *Areopagitica*," 129.

(1)

For the Liberty of unlicenc'd Printing.

THey who to States and Governours of the Commonwealth direct their Speech, High Court of Parlament, or wanting such accesse in a private condition, write that which they foresee may advance the publick good; I suppose them as at the beginning of no meane endeavour, not a little alter'd and mov'd inwardly in their mindes: Some with doubt of what will be the successe, others with feare of what will be the censure; some with hope, others with confidence of what they have to speake. And me perhaps each of these dispositions, as the subject was whereon I enter'd, may have at other times variously affected; and likely might in these formost expressions now also disclose which of them sway'd most, but that the very attempt of this addresse thus made, and the thought of whom it hath recourse to, hath got the power within me to a passion, farre more welcome then incidentall to a Preface. Which though I stay not to confesse ere any aske, I shall be blamelesse, if it be no other, then the joy and gratulation which it brings to all who wish and promote their Countries liberty; whereof this whole Discourse propos'd will be a certaine testimony, if not a Trophey. For this is not the liberty which wee can hope, that no grievance ever should arise in the Commonwealth, that let no man in this World expect; but when complaints are freely heard, deeply consider'd, and speedily reform'd, then is the utmost bound of civill liberty attain'd, that wise men looke for. To which if I now manifest by the very sound of this which I shall utter, that wee are already in good part arriv'd, and yet from such a steepe disadvantage of tyranny and superstition grounded into our principles as was beyond the manhood of a *Roman* recovery, it will bee attributed first, as is most due, to the strong assistance of God our deliverer, next to your faithfull guidance and undaunted Wisdome, Lords and Commons of *England*. Neither is it in Gods esteeme the diminution of his glory, when honourable things are spoken of good men and worthy Magistrates; which if I now first should begin to

A 2 doe,

327

BENEDICT DE SPINOZA

Tractatus theologico-politicus

Hamburg (i.e., Amsterdam): Henricus Künraht, 1670
8³/₁₆ x 6⁷/₁₆ in. (20.8 x 16.4 cm)
Department of Special Collections,
Young Research Library, UCLA
(SRLF G 000 052 606 1/B3985 A3 1670b)

328

JOHN LOCKE

**An Essay Concerning
Humane Understanding**

London: Elizabeth Holt for Thomas Basset, 1690
12¾ x 8 in. (32.4 x 20.3 cm)
William Andrews Clark Memorial Library, UCLA
(*fPR 3541 L57 E7 1690a)

329

DAVID HUME

A Treatise of Human Nature

London: For J. Noon, 1739–40
8⁵/₁₆ x 5³/₈ in. (21.1 x 13.7 cm)
University of Southern California,
Archival Research Center,
Special Collections (192 H92t)

330

JEAN-JACQUES ROUSSEAU

**Du contrat social; ou,
Principes du droit politique**

Amsterdam: Marc Michel Rey, 1762
8½ x 5¼ in. (21.6 x 13.3 cm)
William Andrews Clark Memorial Library, UCLA
(*PQ 2036 D81)

331

ADAM SMITH

**An Inquiry into the Nature and Causes
of the Wealth of Nations**

London: For W. Strahan and T. Cadell, 1776
11³/₈ x 9⁷/₁₆ in. (28.9 x 24 cm)
University of Southern California, Archival
Research Center, Special Collections
(HB161 S6 1776)

Nowadays, conservative pundits love to wrap themselves in the jacket of Adam Smith's great work in political economy. He would be unimpressed. *The Wealth of Nations* grew out of the passionate interest that eighteenth-century thinkers, particularly in Scotland, possessed in the disparities of wealth plainly visible in their day. The highlands of Scotland alone offered a site of poverty and misery, and travel literature told of human beings so poor that they ate plants and berries. Smith wanted to know why some areas of the world, particularly in England and the Scottish lowlands, seemed to have developed work practices and power relations that made them more prosperous. He was a reformer who wanted to understand how markets work, not find excuses for oppressing those less able to cope within them. The book's great strength lies in Smith's ability to see most clearly what his contemporaries did not, that practices like the division of labor enhanced output and profit, and that markets, left to their own devices, could cope with intense competition without creating social chaos. Smith believed that the rise of commercial life brought with it the liberation of the human mind. He saw nothing romantic about feudalism or peasants toiling for mere subsistence.

Note that Smith (1723–90) was a professor of logic and moral philosophy at Glasgow, and he never shied away from making moral judgments and ethical pronouncements. The market might be blind and yet self-regulating; human beings needed to assess their actions even in the economic sphere. The moral instinct of humankind compelled his attention, and he sought to understand how human sympathy might lay the foundations for civil society and personal liberty. Scholars have identified "the Adam Smith problem" as the attempt to reconcile the moral thinker with the marketeer so visible in *The Wealth of Nations*.

The link between the moralist and the marketeer lies in Smith's belief that political institutions and sound jurisprudence must make both liberty and self-interest work in the interests of the whole.

The Wealth of Nations appeared, perhaps fatefully, in the same year as the American Declaration of Independence, 1776. Both works belong within a movement known then and now as the Enlightenment. What makes Smith enlightened are the same qualities that made him an early Newtonian. He wanted to see the economy as the natural philosopher would see the heavens, to find its underlying laws and to display the order imposed by the metaphor he employed in *The Wealth of Nations*, "the invisible hand." It works in the market rather like Newton's God, as an agent imposing order, because markets—like human self-interest—work to check and balance the whole. The gravitational pull of one sector against another, to continue the metaphor, held all in balance.

Like the American founders, Smith also believed that human beings could find happiness in society if justice and law prevailed and liberty allowed for self-expression. Judging from how he presents his thought in *The Wealth of Nations*, the form of self-expression that most fascinated Smith lay in the multiplicity of market transactions and in the process by which value is added to goods by human labor. He argued that labor must be highly organized and compartmentalized to maximize its efficiency, and he championed the division of labor. We know from the contemporary reports of French industrial spies that in Britain by the 1770s the division of labor was commonplace and more advanced than it was in France. The spies saw its value not in economic terms, as Smith argues in *The Wealth of Nations*, but in power terms. As long as the entrepreneur alone knew the whole process, he enhanced his power over individual workers assigned a single task. Smith did not want workers to be impoverished or exploited, but he did want industry to flourish. As a moralist, even Smith, who had seen the long and brutal hours that workers could put in, would be appalled at the potentially life-threatening working conditions of many factories in the developing world today. The purpose of labor, Smith argued, perhaps naïvely, should be the relative prosperity of workers and not their exploitation. While *The Wealth of Nations* has been used as the bible of the exploiter, Smith meant it as a rallying cry for prosperity unfettered by complex regulation intended to make the state, and not the people, richer. *Margaret C. Jacob*

References
T. E. Jessop, *A Bibliography of David Hume and of Scottish Philosophy* (London: A. Brown & Sons, 1938), 171; *The Rothschild Library: A Catalogue of the Collection of Eighteenth-Century Books and Manuscripts Formed by Lord Rothschild* (Cambridge: Privately printed at the University Press, 1954), no. 1897; John Carter and Percy H. Muir, eds., *Printing and the Mind of Man: A Descriptive Catalogue Illustrating the Impact of Print on the Evolution of Western Civilization during Five Centuries* (London: Cassell and Company, 1967), no. 221; ESTC t96668.

Bibliography
The Glasgow Edition of the Works and Correspondence of Adam Smith, 6 vols. (Oxford: Clarendon Press, 1976–83); R. H. Campbell and A. S. Skinner, *Adam Smith* (New York: St. Martin's Press, 1982); Fania Oz-Salzberger, *Translating the Enlightenment: Scottish Civic Discourse in Eighteenth-Century Germany* (Oxford: Clarendon Press, 1995); Margaret C. Jacob, *The Enlightenment: A Brief History with Documents* (Boston: Bedford Books, 2001); Emma Rothschild, *Economic Sentiments: Adam Smith, Condorcet, and the Enlightenment* (Cambridge: Harvard University Press, 2001).

AN

INQUIRY

INTO THE

Nature and Caufes

OF THE

WEALTH OF NATIONS.

By ADAM SMITH, LL. D. and F. R. S.

Formerly Profeffor of Moral Philofophy in the Univerfity of GLASGOW.

IN TWO VOLUMES.

VOL. I.

LONDON:

PRINTED FOR W. STRAHAN; AND T. CADELL, IN THE STRAND.

MDCCLXXVI.

Adam Smith
**An Inquiry into the Nature and Causes
of the Wealth of Nations**, 1776

The central text of mercantilism

332

Manuscript of the New Testament in Greek

11th or 12th century
6⅜ x 5½ in. (16.2 x 14 cm)
Department of Special Collections,
Young Research Library, UCLA
(170/347)

333

Speculum humanae salvationis

Augsburg: Günther Zainer, 1473
10⅝ x 7⅝ in. (27 x 19.4 cm)
Department of Special Collections,
Young Research Library, UCLA
(*A1 S74)

334

Biblia hebraica: Hagiographa: Tehillim

Brescia: Gershom Soncino, 1493
3¾ x 2¹¹⁄₁₆ in. (9.5 x 6.8 cm)
The Huntington Library, San Marino, California
(RB 101705)

335

Horae

France, late 15th or early 16th century
7¼ x 5⅛ in. (18.4 x 13 cm)
The Huntington Library, San Marino, California
(HM 1181)

336

Horae ad usum Romanum

Paris: Thielman Kerver, [1499?]
8¼ x 5¹¹⁄₁₆ in. (21 x 14.4 cm)
The Huntington Library, San Marino, California
(RB 55796)

337
Complutensian Polyglot Bible

Alcalá de Henares: Arnald Guillen de Brocar, 1514–17
[i.e., 1522]
14½ x 10¾ in. (36.8 x 27.3 cm)
The Huntington Library, San Marino,
California (RB 270873)

This is the first complete Bible in more than one language ever published, and it is the first attempt to prepare the full, original Hebrew and Aramaic texts of the Old and New Testament for study with the standard Christian translations.

It was organized and paid for by Cardinal Francisco Ximenes de Cisneros (1436–1517), archbishop of Toledo, primate of Spain, and the holder of some of the most powerful political offices in Spain under Ferdinand and Isabella. He persecuted Jews and heretics, but he was also a fervently religious mystic. He founded the Complutensian University of Alcalá and brought to it the printer Arnald Guillen de Brocar, at whose press he sponsored a program of devotional and intellectual publications. This was the vigorous environment in which the Complutensian Polyglot Bible was conceived and executed. Ximenes well knew the effect that publishing a book could have in the Renaissance, when the commerce of the book was a market of persuasion and ideas as well as of money and goods. Assembling the greatest Hebrew and Biblical scholars of Spain, he brought into being this massive work of detailed scholarship. Its six volumes, combining the knowledge made possible by the printed word with the basic faith of its culture, are an exemplar of the Renaissance.

In Spain two great civilizations, the Christian and the Islamic, loved fine and true books. The Islamic love of organized pattern, as well as the easy familiarity with Semitic languages it gave Spain, can be seen in the Old Testament page layout here. In it, the Hebrew root is printed in the column along the outermost edges (foredges) of the pages; from these roots the eye moves to the full Hebrew text and from this to the Chaldaic, Vulgate Latin, and Jerome Latin versions, which branch out like luxuriant leafage from its seeds. This book introduced a Greek typeface of stunning and unequaled beauty. Throughout all six volumes, the student is given texts rich in information, the meaning and value of which are declared by the loving organization of the pages. The volumes are dated 1514–17, but it does not appear that they were published before 1522, probably because of a privilege that was granted to Erasmus for his 1516 New Testament.

In the eighteenth century this copy came into the possession of Jeremiah Milles (1714–84), for whom it probably was bound. He was a dilettante who studied first Egyptian, then English antiquities; as this book had long been famous, he doubtless considered it valuable in his scholarly library. When this library was sold in 1843, long after his death, it soon passed into the hands of Samuel Prideaux Tregelles (1813–75), another amateur scholar. Tregelles was entirely self-taught—even in Hebrew, Greek, and Chaldaic—but he produced a lifetime of serious scholarly work. He wished to produce a text of the Greek New Testament based solely on his own study of all the manuscripts. This was a work of comparative philology as well as biblical scholarship, fully in line with the aims of the creators of the Complutensian Polyglot Bible.

Decades later, Estelle Doheny (1875–1958), a papal countess and the patron of numerous cultural institutions in Los Angeles, bought this copy, one of the great works of Catholic scholarship, and gave it as a gift to the center of Renaissance studies in Southern California, the Huntington Library.
Bennett Gilbert

References
T. H. Darlow and H. F. Moule, *Historical Catalogue of the Printed Editions of Holy Scripture in the Library of the British and Foreign Bible Society* (1903–11; reprint, New York: Kraus, 1963), no. 1412; Herbert M. Adams, *Catalogue of Books Printed on the Continent of Europe, 1501–1600, in Cambridge Libraries* (London: Cambridge University Press, 1967), no. B968; John Carter and Percy H. Muir, eds., *Printing and the Mind of Man: A Descriptive Catalogue Illustrating the Impact of Print on the Evolution of Western Civilization during Five Centuries* (London: Cassell and Company, 1967), no. 52; F. J. Norton, *A Descriptive Catalogue of Printing in Spain and Portugal, 1501–1520* (Cambridge and New York: Cambridge University Press, 1978), no. 27.

Bibliography
James P. R. Lyell, *Cardinal Ximenes, Statesman, Ecclesiastic, Soldier, and Man of Letters, with an Account of the Complutensian Polyglot Bible* (London: Grafton, 1917); Felipe Fernandez-Armesto, "Cardinal Cisneros as a Patron of Printing," in *God and Man in Medieval Spain: Essays in Honor of J. R. L. Highfield*, ed. Derek W. Lomax and David Mackenzie (Warminster: Aris & Phillips, 1989); Rosa Helena Chinchilla, "The 'Complutensian Polyglot Bible' (1520) and the Political Ramifications of Biblical Translation," in *La traducción en España, ss. XIV–XVI*, ed. Roxana Recio (León: Universidad de León, 1995), 169–90; Julian Martin Abad, "The Printing Press in Alcalá de Henares," in *The Bible as Book: The First Printed Editions*, ed. Paul Saenger and Kimberly Van Kampen (London: British Library; New Castle, Del.: Oak Knoll Press, 1999), 101–16.

Incipit prologus beati Hieronymi
presbyteri in psalterium.lxx.

SALTERIVM ROMAE dudum positus emendaram: & iuxta septuaginta interpretes(licet cursim) magna tamen ex parte correxeram. Quod quia rursum videtis o paula & eustochium scriptorum vitio deprauatu3: plusq antiquum errorem q̃ nouam emendationem valere: me cogitis vt veluti quodam nouali scissum iam aruum exerceam:& obliquis sulcis renascẽtes spinas erradicem: æquũ esse dicentes: vt quod crebro male pullulat crebrius succidatur. Vnde consueta prefatione commoneo tam vos quibus forte labor iste desudat:q̃ eos qui exemplaria istiusmodi habere voluerint: vt que diligenter emendaui:cũ cura & diligentia transcribantur. Notet sibi vnusquisq̃ vel iacentem lineam: vel radiantia signa.i.obelos vel asteriscos:& vbicuq̃ viderit virgulam p̃cedentem:ab ea vsq̃ ad duo punẽta que͛ impressimus: sciat in septuaginta trãslatoribus plus haberi:ubi autem perspexerit stelle similitudinem:de hebreis uoluminibus additum nouerit eque usq̃ ad duo punẽta iuxta theodotionis dumtaxat editio= nem:qui simplicitate sermonis a septuagita interp̃tibus non discordat.Hec ergo & uobis & studioso cuiq̃ fecisse me sciens:non ambigo multos fore qui uel inuidia uel supercilio malint contemnere uideri p̃clara q̃ discere:& de turbulento magis riuo q̃ de purissimo fonte potare.

Explicit p̃logus beati Hieronymi.

Incipit p̃logus B.Hieronymi p̃sbyteri
in psalterium quod transtulit in latinũ
iuxta Hebraicam ueritatem.

VSEBIVS HIERonymus Sophronio suo salutẽ dicit. Scio quosdam putare psalterium in quinq̃ libros esse diuisum: ut ubicunq̃ apud septuaginta interp̃tes scriptũ est ϑϵοίτο ϑϵοίτο.i.fiat fiat: finis librorum sit:p quo in hebreo legitur Amen amen. Nos autem Hebreorum auẽtoritatem sequuti: & maxime apostolorum qui semper in no͛no testamento psalmorum librum nominãt: unum

uolumen afferimus. Psalmos quoq̃ omne mur auẽtorum qui ponuntur in titulis:D Asaph: idithun : filiorum chore: heman e & Salomonis: & reliquorum quos esdras comprehendit. Si enim amen.i.fideliter transtulit ϖϵπιϛοιϑϕως: in fine tãtum libro & nõ interdũ aut in exordio aut in calce ser tentie:nunq̃ saluator i euãgelio loq̃retur: co uobis:nec pauli epistole in medio illud rent.Moyses quoq̃ & Hieremias & ceteri multos haberent libros: qui in medio uolu amen frequenter inserunt. Sed & numerus corum librorum & mysterium eiusdem nur tabitur. Nam & titulus ipse hebraicus sefer interp̃tatur uolumen hymnorum Apostoli congruens:non plures libros sed unum uo dit. Quia igitur cum hebreo nuper dispu p dñoñ saluatore de psalmis testimonia ptu ille te illudere p sermones pene singulos ita haberi in hebreo ut tu de.lxx.interp̃tibus studiosissime postulasti ut post aquilam syn theodotionem nouam editionem latino s ferrem. Aiebas enim te magis interp̃tum ri: & amore quo laberis:uel translatione ue esse contentum:unde impulsus a te: cui & q beo: & que non possum: rursum me obtre tratibus tradidi:maluiq̃ te uires potius me tatem in amicitia querere. Certe consider multos huius operis testes citabo: me nih scientem de hebraica ueritate mutasse. Sicut mea a ueteribus discrepauerit: interroga q breorum:& liquido p̃uidebis me ab emulis ri:qui malunt contemnere uideri p̃clara q̃ sissimi homines.Nam cum semp nouas exp tes:& gule eorum uicina maria non sufficians studio scripturarum ueteri sapore contenti dico quo p̃cessores meos mordeam:aut qu bitrer detrahendum quorum translationem me emendatam olim lingue mee hominib sed quod aliud sit in ecclesiis christo credent legere:aliud iudeis calumniãtibus p singula dere.Quod opusculum meum si in grecum transtuleris:& impitie mee doẽtissimos quo re uolueris: dicã tibi illud Horatianũ in syl ras:nisi q̃ hoc habebo solamen:si in labore telligam mihi uel laudem uel uituptaioné munem. Valere te cupio in dñoñ Iesu:& me

Explicit prologus. B.Hieronym.

PSALTERIVM.
ΨΑΛΤΗΡΙΟΝ.

dauid: sine titulo apud hebreos. 1.
τοῦ δαυίδ, ἀεπιγραφος παρ᾽ εβραίοις. ά.

Beatus vir q̄ nō abiit in cōsilio ipfo:
Ἀκάριος ἀνὴρ ὃς οὐκ ἐπορεύθη ἐν βουλῇ ἀσεβῶν,

et in via peccatorū nō stetit: & in cathedra
καὶ ἐν ὁδῷ ἁμαρτωλῶν οὐκ ἔστη, καὶ ἐπὶ καθέδραν

sedit. Sed in lege dñi volū
λοιμῶν οὐκ ἐκάθισεν. Ἀλλ᾽ ἐν τῷ νόμῳ κυρίου τὸ θέλη

in lege ei meditabit die ac nocte.
μα αὐτοῦ, καὶ ἐν τῷ νόμῳ αὐτοῦ μελετήσει ἡμέρας καὶ νυκτός.

lignū q plātatū est fecus
Καὶ ἔσται ὡς τὸ ξύλον τὸ πεφυτευμένον παρὰ τὰς διεξόδους

fructū suū dabit in tpe suo:
τῶν ὑδάτων, ὃ τὸν καρπὸν αὐτοῦ δώσει ἐν καιρῷ αὐτοῦ,

& eius nō defluet: & oīa q̄cūq;
καὶ τὸ φύλλον αὐτοῦ οὐκ ἀπορρυήσεται, καὶ πάντα ὅσα ἂν

facerabit. Nō sic ipi nō sic
ποιῇ κατευοδωθήσεται. Οὐχ οὕτως οἱ ἀσεβεῖς οὐχ οὕ

sed tanq̄ puluis quē puicit vētus a facie
τως, ἀλλ᾽ ἢ ὡς ὁ χνοῦς ὃν ἐκρίπτει ὁ ἄνεμος ἀπὸ προσώπου

ideo nō resurgēt ipii in iuditio:
τῆς γῆς. Διὰ τοῦτο οὐκ ἀναστήσονται ἀσεβεῖς ἐν κρίσει,

neq; in cōsilio iustoꝝ. Qm nouit dñs viā iu
οὐδὲ ἁμαρτωλοὶ ἐν βουλῇ δικαίων. Ὅτι γινώσκει κύριος ὁδὸν δι

iter ipiorum peribit. Psalmus dauid. 2.
καίων, καὶ ὁδὸς ἀσεβῶν ἀπολεῖται. Ψαλμὸς τῷ δαυίδ. β́.

fremuerūt gētes & meditati sūt inania:
Ἵνα τί ἐφρύαξαν ἔθνη καὶ λαοὶ, ἐμελέτησαν κενά;

reges terre: & pncipes cōuenerūt
παρέστησαν οἱ βασιλεῖς τῆς γῆς, καὶ οἱ ἄρχοντες συνήχθη

aduersus dñm & aduersū xρm
σαν ἐπὶ τὸ αὐτό, κατὰ τοῦ κυρίου καὶ κατὰ τοῦ Χριστοῦ

rūpamus vincula eos: & puciamus
αὐτοῦ. Διαρρήξωμεν τοὺς δεσμοὺς αὐτῶν, καὶ ἀπορρίψω

a nobis laqueos ipfoꝝ. Qui habitat in celis irride
μεν ἀφ᾽ ἡμῶν τὸν ζυγὸν αὐτῶν. Ὁ κατοικῶν ἐν οὐρανοῖς ἐκγελά

bit eos: & dñs subsannabit eos. Tūc lo
σεται αὐτούς, καὶ ὁ κύριος ἐκμυκτηριεῖ αὐτούς. Τότε λα

cos in ira sua: & in furore suo cō
λήσει πρὸς αὐτοὺς ἐν ὀργῇ αὐτοῦ, καὶ ἐν τῷ θυμῷ αὐτοῦ τα

Ego aūt cōstitut sū rex ab eo sup
ράξει αὐτούς. Ἐγὼ δὲ κατεστάθην βασιλεὺς ὑπ᾽ αὐτοῦ ἐπὶ

sanctū e: pdicās pceptū dñi. Dñs
σιὼν ὄρος τὸ ἅγιον αὐτοῦ, διαγγέλλων τὸ πρόσταγμα κυρίου. Κύριος

ne: fili meus es tu: ego hodie genui te. Po
με, υἱός μου εἶ σύ, ἐγὼ σήμερον γεγέννηκά σε. Αἴ

me: et dabo tibi gētes hereditate tuā: &
με, καὶ δώσω σοι ἔθνη τὴν κληρονομίαν σου, καὶ

terminos terre. Reges eos in
τὴν κατάσχεσίν σου τὰ πέρατα τῆς γῆς. Ποιμανεῖς αὐτοὺς ἐν

virga tanq̄ vasa figuli cōfringes eos. Et
ῥάβδῳ σιδηρᾷ, ὡς σκεύη κεραμέως συντρίψεις αὐτούς. Καὶ

itelligite:erudimini q̄s q̄ iudicatis
νῦν, βασιλεῖς, σύνετε, παιδεύθητε πάντες οἱ κρίνοντες τὴν

terrā. Seruite dño in timore: & exultate
γῆν. Δουλεύσατε τῷ κυρίῳ ἐν φόβῳ, καὶ ἀγαλλιᾶσθε αὐτῷ

Apphēdite disciplinā:nequādo irascaf dñs: pe
ἐν τρόμῳ. Δράξασθε παιδείας, μήποτε ὀργισθῇ κύριος, καὶ

via iusta. Cum exarferit in breui ira e
ἀπολεῖσθε ἐξ ὁδοῦ δικαίας. Ὅταν ἐκκαυθῇ ἐν τάχει ὁ θυμὸς αὐ

oēs q cōfidit in eo.
τοῦ, μακάριοι πάντες οἱ πεποιθότες ἐπ᾽ αὐτῷ.

lmus dauid: cū fugeret a fa
Ψαλμὸς τῷ δαυίδ, ὁπότε ἀπεδίδρασκεν ἀπὸ προσώπου

absalō filii sui. 3.
Αβεσσαλωμ τοῦ υἱοῦ αὐτοῦ. γ́.

quid multiplicati sūt q̄ tribulāt me? multi
Κύριε, τί ἐπληθύνθησαν οἱ θλίβοντές με; πολλοὶ

aduersū me: multi dicūt aie mee: nō
ἐπανίστανται ἐπ᾽ ἐμέ· πολλοὶ λέγουσιν τῇ ψυχῇ μου, οὐκ

salus ipi in deo eius. Dψ.
ἔστιν σωτηρία αὐτῷ ἐν τῷ θεῷ αὐτοῦ. Διάψαλμα.

Incipit liber psalmorum. 1.

Beatus vir qui non abiit in consilio impiorum: & in via peccatorum non stetit: & in cathedra derisorū non sedit. Sed in lege domini voluntas eius: & in lege eius meditabitur die ac nocte. Et erit tanq̄ lignum transplātatum iuxta riuos aq̄rum: quod fructū suū dabit in tpe suo: & folium eius non defluet: & omne quod fecerit prosperabitur. Nō sic impii: sed tanq̄ puluis quem proiicit ventus. Propterea non resurgent impii in iudicio: neq; peccatores in cōgregatione iustorum. Quoniam nouit dñs viam iustorum: & iter impiorum peribit.

2.

Quare congregauerunt gentes: & tribus meditabuntur inania. Consurgent reges terre: & principes tractabūt pariter: aduersus dñm & aduersus xρm eius. Dirumpamus vincula eorum: & proiiciamus a nobis laqueos eorum. Habitans in celis irridebit: & dominus subsannabit eos. Tūc loquetur ad eos in ira sua: & in furore suo cōturbabit eos. Ego autem ordinaui rege meum super sion mōte sctm meū. Annunciabo dei preceptū: dñs dixit ad me filius meus es tu: ego hodie genui te. Postula a me & dabo gentes hereditatem tuam: & possessionem tuam terminos terre. Franges eos in virga ferrea: vt vas figuli conteres eos. Et nunc reges intelligite: erudimini qui iudicatis terram. Seruite dño in timore: & exultate i tremore. Adorate pure: ne forte irascatur & pereatis de via: cum exarferit post paululū furor eius: bti oēs q cōfidit in eū.

Psalm dd cū fugeret a facie absalō filii sui. 3.

Domine qre multiplicati sunt hostes mei: mlti cōsurgūt aduersus me. Multi dicunt anime mee: nō est salus huic in deo. Sp.

אַשְׁרֵי־הָאִישׁ אֲשֶׁר לֹא הָלַךְ
בַּעֲצַת רְשָׁעִים וּבְדֶרֶךְ חַטָּאִים לֹא
עָמָד וּבְמוֹשַׁב לֵצִים לֹא יָשָׁב׃
כִּי אִם בְּתוֹרַת יְהוָה חֶפְצוֹ
וּבְתוֹרָתוֹ יֶהְגֶּה יוֹמָם וָלָיְלָה׃ וְהָיָה
כְּעֵץ שָׁתוּל עַל־פַּלְגֵי מָיִם אֲשֶׁר
פִּרְיוֹ יִתֵּן בְּעִתּוֹ וְעָלֵהוּ לֹא־יִבּוֹל
וְכֹל אֲשֶׁר־יַעֲשֶׂה יַצְלִיחַ׃ לֹא־כֵן
הָרְשָׁעִים כִּי אִם־כַּמֹּץ אֲשֶׁר
תִּדְּפֶנּוּ רוּחַ׃ עַל־כֵּן לֹא־יָקֻמוּ
רְשָׁעִים בַּמִּשְׁפָּט וְחַטָּאִים בַּעֲדַת
צַדִּיקִים׃ כִּי־יוֹדֵעַ יְהוָה דֶּרֶךְ
צַדִּיקִים וְדֶרֶךְ רְשָׁעִים תֹּאבֵד׃

ב׃
לָמָּה רָגְשׁוּ גוֹיִם וּלְאֻמִּים
יֶהְגּוּ־רִיק׃ יִתְיַצְּבוּ מַלְכֵי־
אֶרֶץ וְרוֹזְנִים נוֹסְדוּ־יָחַד עַל־יְהוָה
וְעַל־מְשִׁיחוֹ׃ נְנַתְּקָה אֶת־
מוֹסְרוֹתֵימוֹ וְנַשְׁלִיכָה מִמֶּנּוּ
עֲבֹתֵימוֹ׃ יוֹשֵׁב בַּשָּׁמַיִם יִשְׂחָק
אֲדֹנָי יִלְעַג־לָמוֹ׃ אָז יְדַבֵּר אֵלֵימוֹ
בְאַפּוֹ וּבַחֲרוֹנוֹ יְבַהֲלֵמוֹ׃ וַאֲנִי
נָסַכְתִּי מַלְכִּי עַל־צִיּוֹן הַר־קָדְשִׁי׃
אֲסַפְּרָה אֶל־חֹק יְהוָה אָמַר אֵלַי
בְּנִי אַתָּה אֲנִי הַיּוֹם יְלִדְתִּיךָ׃
שְׁאַל מִמֶּנִּי וְאֶתְּנָה גוֹיִם נַחֲלָתֶךָ
וַאֲחֻזָּתְךָ אַפְסֵי־אָרֶץ׃ תְּרֹעֵם
בְּשֵׁבֶט בַּרְזֶל כִּכְלִי יוֹצֵר תְּנַפְּצֵם׃
וְעַתָּה מְלָכִים הַשְׂכִּילוּ הִוָּסְרוּ
שֹׁפְטֵי אָרֶץ׃ עִבְדוּ אֶת־יְהוָה
בְּיִרְאָה וְגִילוּ בִּרְעָדָה׃ נַשְּׁקוּ־בַר
פֶּן־יֶאֱנַף וְתֹאבְדוּ דֶרֶךְ כִּי־יִבְעַר
כִּמְעַט אַפּוֹ אַשְׁרֵי כָּל־חוֹסֵי בוֹ׃ iij

מִזְמוֹר לְדָוִד בְּבָרְחוֹ מִפְּנֵי אַבְשָׁלוֹם
בְּנוֹ׃ יְהוָה מָה־רַבּוּ צָרָי רַבִּים
קָמִים עָלָי׃ רַבִּים אֹמְרִים לְנַפְשִׁי
אֵין יְשׁוּעָתָה לּוֹ בֵאלֹהִים סֶלָה׃

עצץ
ישב לין
ירה
יגה
פרה
עשה
צלח
מוץ
נדף קום
שפט עד
צדק ידע
אבד
צב תה
ריק
יסד
משח פתח
יסר שלך
ישב שחת
לעג דבר
בחל בחר
קדש
חמק ספר
בנה
נתן
ירש
שכל כלה
נפץ שבל
יסר
גבר בר
אנף אבד
חסה מעט
זמר פנה
צנן רבה
נצב רבב
קום
ישע

338

JUAN DE ZUMÁRRAGA

Dotrina breve muy provechosa

Mexico City: Juan Pablos, 1543
7¹³⁄₁₆ x 5¹³⁄₁₆ in. (19.8 x 14.8 cm)
The Huntington Library, San Marino, California
(RB 83701)

Before you is a copy of the first book printed in the New World of which complete copies survive. It came off the press sixty-two years before the founding of the Jamestown colony in English America and ninety-six years before the first book was printed in the English colonies of North America. Fray Juan de Zumárraga (1468–1548), the first bishop of Mexico, and the man with the connections (the *enchufe* in modern Mexican parlance) at court and the clout to bring about the establishment of a press in the New World, wrote it.

Following the completion of the conquest of the Aztecs and other indigenous peoples of Mexico, there followed the need to establish Spanish culture, society, and government. This book embodies many aspects of the culture that Spain sought to sow and which are now integral to the heritage of Los Angeles and other areas of the United States where Spain established cities and towns: a culture of the written word, orthodox Catholicism, supremacy of Spanish as the preeminent language, and new technology.

It was the Spanish reverence for the written word and the desire to ensure that Old World orthodox Catholic practices were exercised in the New World that pushed Father Zumárraga to see to the bringing of the new technology of printing from old Spain to New Spain. In order to inaugurate the new press, he wrote a new doctrinal work for the New Spaniards. By the time this work was printed, in 1544, the first generation of Spaniards born in New Spain—that is, Spaniards who had never been in Spain—was reaching maturity.

As much of Spanish culture planted in the New World is a blend of the old and the new, so too this volume exemplifies that melding. Catholic doctrinal concepts, beliefs, and dicta fill this book. The bishop builds his *doctrina* on the Fourteen Articles of Faith, the Seven Sacraments, the Ten Commandments, the Seven Deadly Sins, the Four Commandments of the Roman Catholic Church, the Fourteen Works of Mercy, and other old and long-established elements of Roman Catholicism. Despite being surrounded by hundreds of thousands of speakers of Nahuatl, Otomi, Purepurchea, and the other indigenous languages, the New Spaniards rarely learned to speak any of those tongues. Spanish was the de facto imperial language, and so Zumárraga chose to produce his new work in the Old World language and not in one of the New World ones. But rather than merely reprinting an already existing work, he chose to present the old faith in a new work using his own words, organized into a new presentation for the new audience.

Similarly, old and new characterize the typography of Bishop Zumárraga's *doctrina*. The type that Juan Pablos used to print this work in New Spain is old, from the old Spanish printing establishment of Juan Cromberger, with whom America's prototypographer contracted to work in Mexico City under the Cromberger monopoly to print. The elements of the woodcut border of the title page are old, cut down, and reused in a new way, a way related to but different from the manner in which they appeared on the title page of the 1513 printing of Petrarch's *De los remedies contra prospera y adversa fortuna*. Despite the borrowings, the typographical composition is new, and it speaks well of the printer's ability to work with limited resources.

As much as Father Zumárraga would have liked to prevent the spread of Reformation-era Protestant theological concepts, he knew that books are easily portable and that volumes containing the new theology could and would find their way across the Atlantic. What he failed to conceive was that his own work might fall afoul of later censors. And this epoch-making work did, but only in a minor way. There is a passage on the reverse side of folio 5 that says that after his crucifixion and resurrection, Christ recovered sufficient blood to sustain life. In several copies of this work, that passage has been inked over by subsequent Church officials.

David Szewczyk

339

The Booke of the Common Prayer and Administration of the Sacramentes

London: Edouard Whitechurche, 1549
10¼ x 7⁷⁄₁₆ in. (26 x 18.9 cm)
The Huntington Library, San Marino, California
(RB 62273)

References
Joaquín García Icazbalceta, *Bibliografía mexicana del siglo XVI:
Catálogo razonado de libros impresos en México de 1539 a 1600*
(1886; reprint, Mexico City: Fondo de Cultura Económica, 1954),
no. 4; José Toribio Medina, *La imprenta en México (1539–1821)*
(1907–12; reprint, Amsterdam: Israel, 1965), no. 8.

Bibliography
Joaquín García Icazbalceta, *Don fray Juan de Zumárraga, primer
Obispo y arzobispo de México* (Mexico City: Andrade y Morales,
1881).

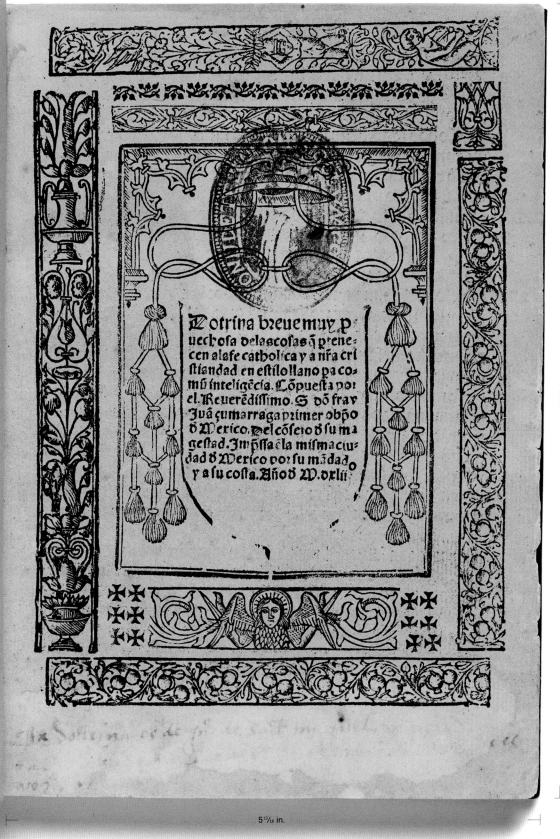

7¹³/₁₆ in.

5¹⁵/₁₆ in.

Juan de Zumárraga
Dotrina breve muy provechosa, 1543

The earliest surviving book printed in the New World

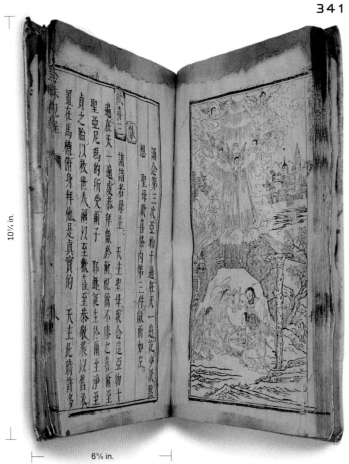

10¼ in.

6⅝ in.

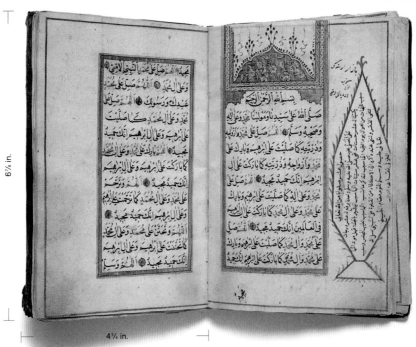

6⅞ in.

4¾ in.

João da Rocha
Sung nien chu kuei ch'eng, c. 1619–23

Manuscript of the Delailü-l-Hayrat, 1620

A Portuguese missionary's Chinese translation
of instructions for saying the Rosary

A handbook of prayers to the prophet Mohammed

340

JOHN ELIOT

The Holy Bible: Containing the Old Testament and the New, Translated into the Indian Language

Cambridge: Samuel Green
and Marmaduke Johnson, 1661–63
7⁵⁄₁₆ x 6⅛ in. (18.6 x 15.6 cm)
The Huntington Library, San Marino, California
(RB 18656)

341

[JOÃO DA ROCHA]

Sung nien chu kuei ch'eng

[Beijing: Society of Jesus, c. 1619–23]
10¼ x 6⅝ in. (26 x 16.8 cm)
Library, Getty Research Institute
(1365-379)

342

Manuscript of the Delailü-l-Hayrat (a handbook of prayers for the Prophet),

dated (Rabi'al-Akhir) 1029 A.H. / A.D. 1620
6⅞ x 4¾ in. (17.5 x 12.1 cm)
University of Southern California,
Archival Research Center,
Special Collections

343

King James Bible

London: Robert Barker, 1611
16¾ x 11½ in. (42.5 x 29.2 cm)
Libraries of the Claremont Colleges,
Honnold/Mudd Library
(BS 170 1611X)

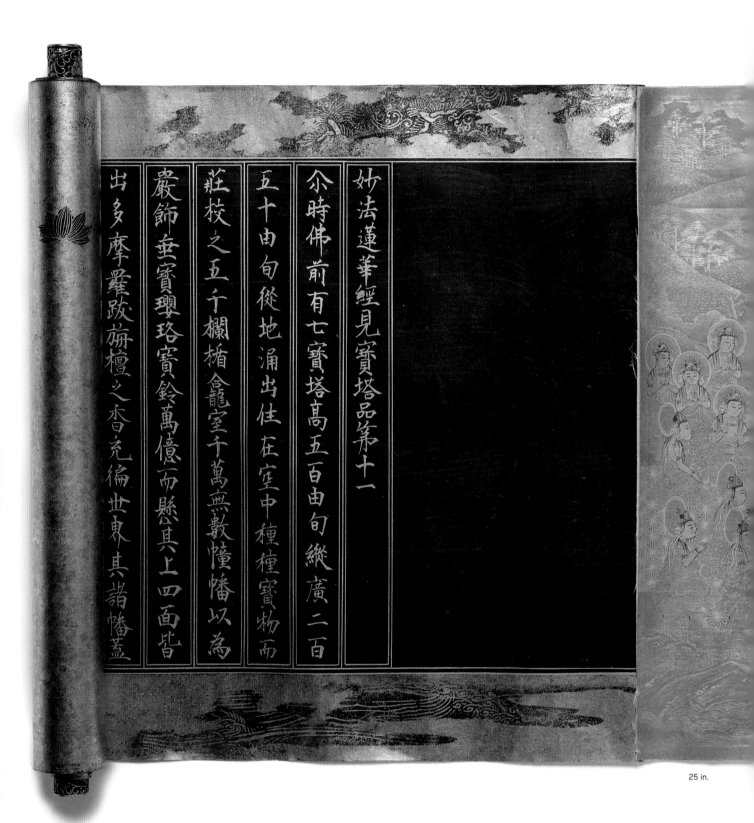

妙法蓮華經見寶塔品第十一

尓時佛前有七寶塔高五百由旬縱廣二百

五十由旬從地涌出住在空中種種寶物而

莊校之五千欄楯龕室千萬無數幢幡以為

嚴飾垂寶瓔珞寶鈴萬億而懸其上四面皆

出多摩羅跋旃檀之香充徧世界其諸幡蓋

"Myōhō renge kyō, Kenpōtō bon daijūichi," 1667 An illustrated manuscript sūtra scroll

25 in.

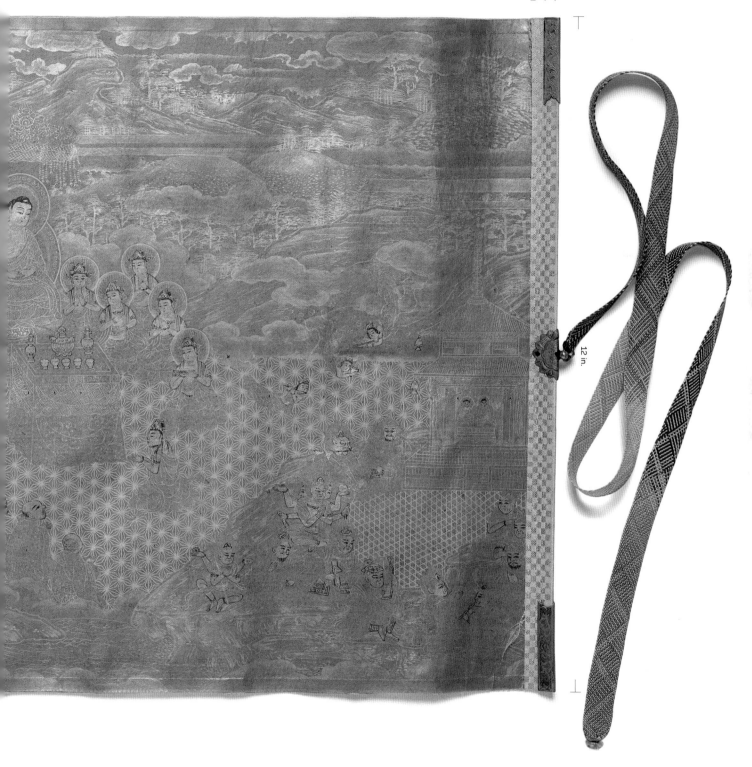

12 in.

344

"Myōhō renge kyō, Kenpōtō bon daijūichi,"
chapter 11 of **Saddharma puṇḍarika sūtra**,

Japan, 1667
Scroll; 12 x 288 in. (30.5 x 731.5 cm)
Department of Special Collections, Young Research
Library, UCLA (*170/213)

"At that time in front of the buddha there appeared a stūpa adorned with the seven precious treasures." Thus begins the chapter "Myōhō renge kyō, Kenpōtō bon daijūichi" (Beholding the Precious Stūpa [i.e., pagoda]), one of the most famous miracles in the Saddharma puṇḍarika sūtra (Lotus of the marvelous Dharma Sūtra, or Lotus Sūtra). This exquisite copy of the chapter, handwritten in gold on indigo paper, illustrates this wondrous event in a frontispiece (11 x 12 in. [27.9 x 30.5 cm]) of inlaid cut gold leaf supported by a brocade woven in gold, red, blue, green, and yellow threads on a cream background.

The left side of the gold frontispiece depicts the buddha Sākyamuni (a.k.a. Gotama) preaching the Lotus doctrine (dharma) of universal salvation to his disciples and to the great bodhisattvas (saviors). What the buddha promised, however, was so marvelous that his audience could scarcely believe it. At that moment, according to the story in the Lotus Sūtra, a precious stūpa appeared in the sky, and a loud voice announced, "What the Lord Sākyamuni has preached is true!" This voice belonged to Prabhūtaratna (Abundant Treasures; Tahōbutsu), the buddha who resides in the precious stūpa and who vowed to testify every time and every place throughout the infinite universe whenever any buddha preaches the Lotus Sūtra.

The right side of the illustration depicts the Precious Stūpa at a subsequent moment in this chapter, when Prabhūtaratna invited Sākyamuni to sit beside him. This scene of the two buddhas sitting side by side in the Precious Stūpa, one of the most celebrated motifs in Asian religious art, symbolically unites our existential lives (limited in life span, geography, and history, just like that of Sākyamuni, who appeared so long ago in India) with the universal truth of the Lotus Sūtra, which is valid for all people in all times and all places.

The Lotus Sūtra is arguably the single most important and most popular Buddhist scripture in East Asia. Composed in India (the original title is Saddharma puṇḍarika sūtra) and translated into Chinese in 406 C.E. by Kumārajīva, it recounts a series of easily understood parables and miracles that illustrate the Mahāyāna (Great Vehicle) Buddhist doctrine of universal deliverance from suffering through faith. According to the scripture, one should express this faith by preaching the Lotus Sūtra, by copying it, by illustrating it, and by offering it to others. Thus, illustrated copies of the Lotus Sūtra constitute a major form of East Asian religious art.

The scroll seen here is a masterpiece of Tokugawa period (1603–1868) Buddhist art, which carefully combines into a balanced composition its aristocratic calligraphy, its fine gold brocade, and its outstanding cut gold leaf (kirikane)—a unique Japanese painting technique that is now practically extinct. The illustration conveys a delicacy and subtlety of line that would have been unachievable with traditional brushwork. This scroll once formed part of the complete twenty-eight-chapter text of the Lotus Sūtra that was handwritten by high-level members of the imperial court. Hino Hirosuke, the calligrapher for this scroll, had served as a chancellor (dainagon). Emperor Gomizunoo (1596–1680) presented it in 1667 as one of the so-called Tuizen hōsho shakyō (scriptures copied and offered for salvation of the deceased) on the occasion of the seventeenth memorial service for the third shogun, Tokugawa Iemitsu (1604–51). The gift of this scroll was as much a political act as a religious one, since it helped to restore amiable relations between the imperial court and the shoguns who ruled in its name.

The scroll was acquired by Richard C. Rudolph, Emeritus, for the UCLA Library in 1962 for an undisclosed sum. Only five other scrolls from the original set of Tuizen hōsho shakyō are known to exist, and all of them are in Japan. In 1997 the five scrolls in Japan were placed on the market as a single set for a price of 75 million Japanese yen (approximately $700,000). *William M. Bodiford*

345

The Book of Mormon

Palmyra: E. B. Grandin for the author, 1830
7½ x 4⅛ in. (19 x 10.5 cm)
William Andrews Clark Memorial Library, UCLA
(*BX 8623 1830)

346

The English Bible

Hammersmith: Doves Press, 1903
13¹⁵⁄₁₆ x 9⁵⁄₁₆ in. (35.4 x 23.7 cm)
William Andrews Clark Memorial Library, UCLA
(Press Coll. Doves)

References
"No. 6. Daiyūin Dono jūshichi kaiki: Tsuizen hōsho shakyō," in Shibunkaku kosho shiryō mokuroku, no. 155 (Kyoto: Shibunkaku, 1997), 8–11; Mihoko Miki and Jun Suzuki, Kariforunia daigaku Rosanzerusukō shozō Nihon kotenseki mokuroku (Tokyo: Tōsui Shobō, 2000), 241.

Bibliography
Bunsaku Kurata and Yoshiro Tamura, Art of the Lotus Sūtra: Japanese Masterpieces (Tokyo: Kōsei, 1987); Willa Jane Tanabe, Paintings of the Lotus Sūtra (New York: Weatherhill, 1988); George J. Tanabe and Willa Jane Tanabe, The Lotus Sūtra in Japanese Culture (Honolulu: University of Hawai'i Press, 1989).

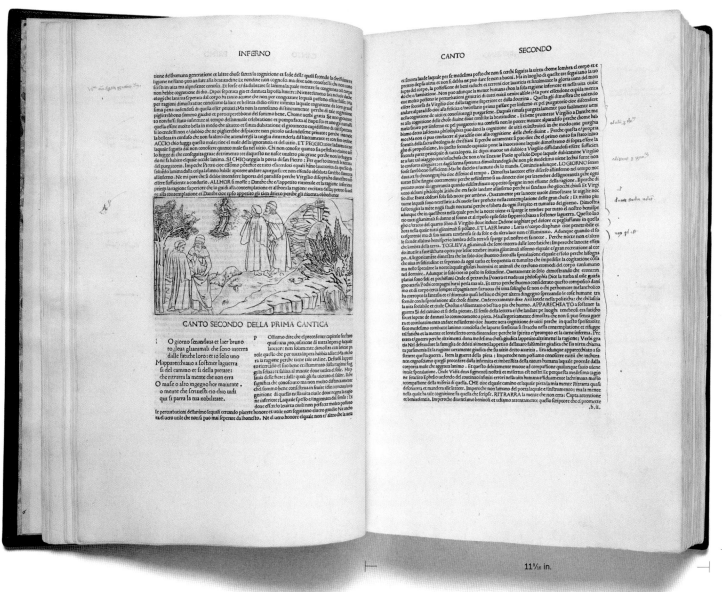

17⁹⁄₁₆ in.

11⁵⁄₁₆ in.

Dante Alighieri

**Comento di Christophoro Landino fiorentino
sopra la Comedia di Danthe Alighieri poeta
fiorentino**, 1481

The first illustrated edition of Dante's *Divine Comedy*

347

DANTE ALIGHIERI

Comento di Christophoro Landino fiorentino sopra la Comedia di Danthe Alighieri poeta fiorentino

Florence: Nicholo di Lorenzo della Magna, 1481
Illustrated with etchings by Baccio Baldini,
based on drawings by Sandro Botticelli
17³⁄₁₆ x 11⁹⁄₁₆ in. (43.7 x 29.4 cm)
Loyola Marymount University, Charles Von der
Ahe Library (PQ4302.A81)

The first printed editions of the *Commedia* (Comedy) of Dante Alighieri (1265–1321) are dated after 1470 (the word *Divina* was not added to the title until 1555, when it appeared on the title page of Lodovico Dolce's edition of the poem). The fact that the first eight editions were printed outside Florence, the birthplace of the poet, did not escape the attention of the Florentine intelligentsia. It suddenly realized that the primacy of Tuscan culture, which relied so much on Dante, was in jeopardy. It became necessary to produce a "Florentine" edition of the *Commedia*, one that would be extraordinary enough to eclipse all previous editions of the poem. After all, the eight early printed editions did little more than reproduce the mise-en-page of contemporary manuscripts. Dante was printed as a "classical" author, together with the great authors of the Latin tradition. The commentary of Iacopo della Lana, written twenty years after the poet's death, accompanied these early printed editions. Della Lana's text was totally anachronistic, being steeped in a language and a culture that were 150 years old.

For a "new," more contemporary Dante, a new idea of the world was required. This would be found in the Neoplatonic philosophy developed in Florence at the court of Lorenzo de' Medici by Marsilio Ficino, Pico della Mirandola, Angelo Poliziano, and

Cristoforo Landino. On August 30, 1481, the first Florentine edition of Dante's *Commedia* was published by Niccolò di Lorenzo *tedesco* (the German), who was the foremost printer in Florence at the time. In its formal and compositional elegance, and in the beauty of the Roman font selected by the printer, the 1481 edition surpassed all previous editions. This was also the first edition in print that included both a set of etchings and a new commentary, written by Cristoforo Landino, one of the most renowned humanists teaching in Florence. In a public ceremony Landino himself presented the Medici with a copy of the poem printed on vellum; in this special copy, however, the etchings had been replaced by a set of illuminations.

Landino interpreted Dante according to the Neoplatonic humanism developed in the most advanced center of culture in Italy. By becoming the bearer of that ideal world created at the Medici court under the influence of Ficino, the Florentine *Commedia* became the standard text for the next seventy years.

The decoration of the book consists of nineteen copperplate etchings. Most etchings are in the incipit of the first cantos of the *Inferno*, with the exception of those in cantos 1, 3, 5, and 6, which are placed in the lower margin of the page. In the remaining cantos an empty space indicates that the printer and the artist intended to illustrate all one hundred cantos. It is probable that the printer abandoned his plan for practical reasons. Each page had to be passed through the press twice in order to print first the text and then the illustrations, and such labor would have added significantly to the cost of the book. Because of these difficulties most

copies of the book were published with only the first two plates printed in the text. Only a few copies had the third plate printed on the incipit of canto 3. The remaining plates were printed on separate pieces of paper, which were then pasted into the book. Only about twenty copies are known to have the full set of nineteen plates. According to Giorgio Vasari, the drawings were done specifically by Sandro Botticelli for this edition of the poem, and the etchings were executed by Baccio Baldini. It is also possible that Baldini worked from the magnificent illustrations that Botticelli was preparing for the entire *Commedia*. The etchings are done in the so-called *maniera fine*, in which the image is created by thin etched lines that cross one another, creating a vibrant chiaroscuro effect.

It is estimated that approximately two hundred copies of the book were printed. The copy in the exhibition consists of 370 leaves, folio, and is in exceptional condition. The first two plates are printed in the text and two of the other original plates, number 15 and number 19, are pasted in. It is one of the few with the first plate intact, owing to the larger dimensions of the copy. In copies of a smaller dimension the lower part of the plate was cut away when the edges of the book were trimmed. The remaining fifteen plates are facsimile reproductions laid in the text.

This copy was previously owned by the "Monasterio Sancte Marie Coronate." It was purchased in the late 1960s by T. Marie Chilton for the purpose of donating it to the Loyola Marymount University's Von der Ahe Library, where it is presently preserved.
Massimo Ciavolella

References
Catalogue of Books Printed in the Fifteenth Century Now in the British Museum (London: British Museum, 1908–), vol. 6, nos. 628–29; *Gesamtkatalog der Wiegendrucke*, 10 vols. (Leipzig and Stuttgart: Hiersemann, 1925–), no. 7966; Frederick R. Goff, *Incunabula in American Libraries: A Third Census* (New York: Bibliographical Society of America, 1964), no. D-29.

Bibliography
Peter H. Brieger, Millard Meiss, and Charles Singleton, *Illuminated Manuscripts of the Divine Comedy* (Princeton: Princeton University Press, 1969); Kenneth Clark, *The Drawings by Sandro Botticelli for Dante's "Divine Comedy"* (New York: Harper & Row, 1976); Modesto Fiaschini, ed., *Pagine di Dante: Le edizioni della "Divina Commedia" dal torchio al computer* (Perugia: Electa, 1989); Hein-Th. Schulze Altcappenberg et al., *Sandro Botticelli: The Drawings for Dante's "Divine Comedy"* (London: Royal Academy of Arts, 2000).

348

(Everyman) Here begynneth a treatyse how ye hye fader of heven sendeth dethe to somon every creature

London: J. Skot, (1528?)
6⅞ x 5³⁄₁₆ in. (17.5 x 13.2 cm)
The Huntington Library, San Marino, California
(RB 14195)

Everyman is the most famous example of the morality play, a late medieval literary genre that has been called "a sermon in dramatic form." Unlike the mystery plays about biblical characters or the miracle plays about saints, morality plays dramatized the battle between good and evil in the human soul, with speaking parts distributed among the virtues, the vices, and other personified abstractions. *Everyman* takes its title from its main character, who represents both the abstract individual and collective humanity. Although a generalized human without specific personal traits and thus a distinctly medieval "type," Everyman also represents the individual coming to terms with his fate, a quintessentially modern theme. Something of Everyman survives in familiar characters from King Lear to Willy Loman.

As the play begins, Everyman receives a summons from God's messenger, Death, announcing that he must at once prepare to die by presenting his moral "account book" for a divine audit that will decide his fate in the afterlife. After some protest, Everyman readies himself for this last journey, a process during which he is successively abandoned by Fellowship, Kindred, Cousin, Strength, Beauty, and even his Five Wits. But Knowledge and Confession come to his assistance, guiding him through the sacraments, and Good Deeds accompanies him into the grave and to salvation.

Whether the play is taken to represent life's journey as a whole, the aging process in particular, or simply the final preparation for death, clearly it was intended to teach doctrine to a Christian (and specifically Catholic) audience and to assure their conformity with Church sacraments. The play's vernacular style, exemplified by Everyman's outspoken dismay at the arrival of Death; its resonant imagery, as in the individual book of reckoning used throughout as a stage prop; and even its occasional comic touches, such as Cousin's refusal to accompany Everyman to his final reckoning because of a sudden attack of cramp in his toe, all help to turn inward mental processes and abstract moral truths into vivid and memorable, if somewhat didactic, stage action.

The English play, probably adapted from a slightly older Flemish original, reflects the preoccupation with death and dying in late medieval Europe, which had suffered repeated outbreaks of pestilence after the Great Plague of 1348, besides war, famine, and other apocalyptic disasters. The dramatic "Summons of Death," a stock scene of the morality genre, is an animated stage version of the memento mori that appears as a menacing shrouded skeleton in late medieval artworks such as illustrations of the Danse Macabre. The title page of the Huntington Library copy of *Everyman* shows a woodcut of Death admonishing a well-dressed and worldly Everyman. (A similarly ominous figure of Death plays chess with the Knight—a kind of Everyman—in Ingmar Bergman's film *The Seventh Seal*.)

The Huntington *Everyman* is one of only four surviving early printed copies of the play, and the older of the two complete versions. According to a printer's mark on the last page, it was produced in London by one John Skot, probably in 1528, although no date is specified. The pamphlet-sized play is set in small (quarto) format, and its slightly under one thousand lines occupy only thirty-two black-letter pages. Speaking parts are indicated both in the body of the text and by marginal cues. With some doubling of parts, a performance would have required about ten actors. The staging was simple and probably took place indoors. The Huntington copy, previously in the Lincoln Cathedral library and later at Britwell Court, was purchased by Henry E. Huntington in 1919, the year in which he established the library.

Everyman was not reprinted until 1773, as far as is known, and was not performed again until 1901, when the English director William Poel began a successful stage revival that toured England and America. A notable Los Angeles performance took place in 1936 at the Hollywood Bowl, directed by Johannes Poulsen and with an English text translated from Hugo von Hofmannsthal's German edition.
Eric Jager

References
W. W. Greg, *A Bibliography of the English Printed Drama to the Restoration* (London: Bibliographical Society, 1939–59), vol. 1, no. 4c; Carl J. Stratman, *Bibliography of Medieval Drama*, 2d ed. (New York: Ungar, 1972), vol. 1, no. 5503; A. W. Pollard and G. R. Redgrave, *A Short-Title Catalogue of Books Printed in England, Scotland, and Ireland and of English Books Printed Abroad (1475–1640)*, 2d ed. (London: Bibliographical Society, 1976–91), no. 10606.

Bibliography
A. C. Cawley, ed. *Everyman* (Manchester: Manchester University Press, 1961); V. A. Kolve, "Everyman and the Parable of the Talents," in *The Medieval Drama*, ed. Sandro Sticca (Albany: State University of New York Press, 1971).

6⅞ in.

5³/₁₆ in.

[Everyman] Here begynneth a treatyse how ye hye fader of heven sendeth dethe to somon every creature, [1528?]

The only known copy of the sixteenth-century English morality play

349

WILLIAM SHAKESPEARE

A Midsommer Nights Dreame

London: R. Bradock for T. Fisher, 1600
7⁹⁄₁₆ x 5⁵⁄₁₆ in. (19.2 x 13.5 cm)
The Huntington Library, San Marino, California
(RB 69334)

350

WILLIAM SHAKESPEARE

Mr. William Shakespeare's Comedies, Histories, and Tragedies

London: W. Jaggard, Ed. Blount, J. Smithweeke,
and W. Aspley, 1623
12⁹⁄₁₆ x 8⁹⁄₁₆ in. (31.9 x 21.7 cm)
Loyola Marymount University, Charles Von der Ahe
Library (PR2751 .A1 1623)

How many ages hence
Shall this our lofty scene be acted over
In states unborn and accents yet unknown!

Julius Caesar (3.1.113–15)

With some thirty-eight plays, 154 sonnets, and several longer poems to his credit, William Shakespeare (1564–1616) constitutes the most important fact of British literature in its twelve-hundred-year history, and the worldwide acclaim for his dramatic tragedies, histories, and comedies has made him the most loved, produced, and influential playwright who ever lived. This school-leaver from a middle-of-England market town has been celebrated from the beginning of his career to our own time as, in the words of poet John Milton, "our wonder and astonishment." To his friend and rival playwright Ben Jonson, Shakespeare was the unquenchable "Soul of the Age! The applause, delight, the wonder of our stage!"

Shakespeare experienced the theater from three perspectives—as actor, playwright, and share-holder-manager—and although his fame rests on his dramatic and nondramatic writing, his considerable fortune derived from his share in London's most attended and lucrative theater company, originally licensed as the Lord Chamberlain's Men and then as the King's Men. His astonishingly productive theatrical career spanned two decades—the last ten years of the sixteenth century and the first decade of the seventeenth—under two theatrically engaged (though very different) monarchs, Elizabeth I Tudor

(until 1603) and James I Stuart. Indeed, theater historians often divide Shakespeare's career into a sixteenth-century, or Elizabethan, first half and a seventeenth-century, or Jacobean, second movement.

The two Shakespeare volumes in the exhibition—*A Midsummer Night's Dream* (in a quarto edition of 1600 from the collection of the Huntington Library), and a larger, collected volume (the 1623 folio edition from Loyola Marymount University)—represent the two printed formats in which Shakespeare's plays have been transmitted from his raucous London stage to posterity. The smaller of the two volumes represents the first publication of Shakespeare's best-loved comedy and was printed some four years after its first production, perhaps to mark a return engagement before London's notoriously fickle, variety-demanding audience. So voracious and theater-addicted was this London audience that Shakespeare's company, performing six afternoons a week nearly year-round, might stage some thirty to thirty-five different plays in a season, with probably half of these being brand-new plays! No wonder so much contemporary satire focused on actors not knowing their lines. This first quarto edition, derived from Shakespeare's own manuscript draft, or "foul papers," provides an unusually reliable text for *Dream* and serves as the sound basis for all later editions, including a second quarto edition of 1619, which in turn served as the immediate principal source for the monumental collected edition of 1623.

The 1623 collected edition—titled *Comedies, Histories, and Tragedies* to indicate the disposition of its contents, and popularly revered as the "First Folio"—presents thirty-six plays by Shakespeare as prepared by his longtime fellow actors John Heminge and Henry Condell, working with the help of the publisher William Jaggard, and with the approval of Shakespeare's old acting company. The First Folio was published more than a decade after Shakespeare's retirement from the London stage and some seven years after his death in his hometown of Stratford-upon-Avon. The importance of the First Folio does not derive from the distinction of its

typography, which is rather crude even by the relatively low standards of English Renaissance printing, but from the fact that among its thirty-six plays, half had never before been published. Without this edition almost half of Shakespeare's plays would be lost. The plays not previously printed include *Julius Caesar*, *As You Like It*, *Twelfth Night*, *Macbeth*, *Antony and Cleopatra*, *Coriolanus*, *The Winter's Tale*, and *The Tempest*. *Henry V* and *Romeo and Juliet* had been published previously in corrupt, probably pirated versions; both *Hamlet* and *King Lear* had earlier quarto editions that presented significant differences from the reliable texts provided in the First Folio. So we owe Heminge and Condell an immense debt of gratitude and should give these actor-editors the final word on the greatness of their friend and take to heart their advice to all future readers of this magnificent compendium: "It is not our province who only gather his works and give them you to praise him. It is yours that read him. And there we hope, to your divers capacities, you will find enough both to draw and hold you: For his wit can no more be hid, than it could be lost. Read him, therefore, again and again. And if then you do not like him, surely you are in some manifest danger not to understand him." *David Stuart Rodes*

351

JOHN CLELAND

Memoirs of a Woman of Pleasure

London: For G. Fenton, 1749
6⁵⁄₈ x 4¹³⁄₁₆ in. (16.8 x 10.6 cm)
The Huntington Library, San Marino, California
(RB 430000)

References
A. W. Pollard and G. R. Redgrave, *A Short-Title Catalogue of Books Printed in England, Scotland, and Ireland and of English Books Printed Abroad (1475–1640)*, 2d ed. (London: Bibliographical Society, 1976–91), nos. 22302, 22273.

Bibliography
W. W. Greg, *The Shakespeare First Folio: Its Bibliographical and Textual History* (Oxford: Clarendon Press, 1955); Charlton Hinman, *The Printing and Proof-Reading of the First Folio of Shakespeare*, 2 vols. (Oxford: Clarendon Press, 1963); R. A. Foakes, *Illustrations of the English Stage, 1580–1642* (London: Scolar Press, 1985).

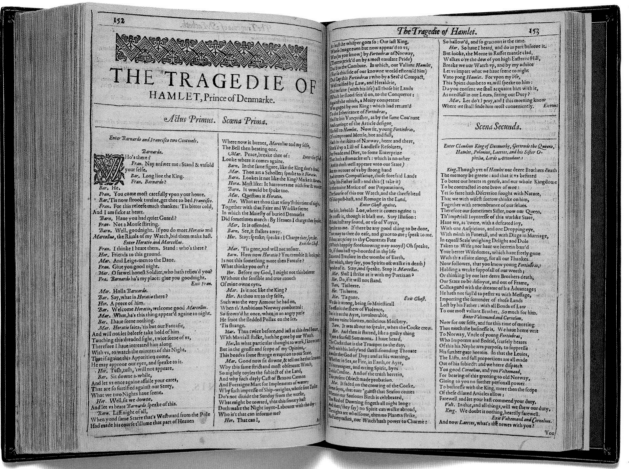

12⁹/₁₆ in.

8⁹/₁₆ in.

William Shakespeare
**Mr. William Shakespeare's Comedies,
Histories, and Tragedies**, 1623

This first collection of Shakespeare's
plays includes many that had never
been published before

352

PHILLIS WHEATLEY

Poems on Various Subjects, Religious and Moral

London: For A. Bell, 1773
6¹³⁄₁₆ x 4⁹⁄₁₆ in. (17.3 x 11.6 cm)
Western States Black Research
and Educational Center

This first edition of *Poems on Various Subjects* is a rare copy signed by Phillis Wheatley herself. Peculiar to this edition is a penciled marking on the flyleaf, which reads "Phillis Wheatley Negro Servant to Mr. John Wheatley" and encircles a list of more than a dozen names, possibly subscribers to the book. An engraved likeness of Wheatley at her desk with quill and book faces the title page.

The first African American to publish a book of poems and the first American woman who attempted to earn a living from her writing, Phillis Wheatley (1753–84) was named for the slave ship *Phillis*, which transported her from Gambia to Boston, and for the family that bought her. As a frail child of seven, she was taken as a domestic slave into the home of John Wheatley, a merchant, to care for his newborn twins. Wheatley learned to read the King James Version of the Bible under the tutelage of her mistress, Susanna Wheatley, and her daughter Mary. Her first poem was published when she was merely fourteen years old in the *Newport Mercury*, on December 21, 1767, with the likely encouragement of Obour Tanner, a close African American friend who may have been a fellow slave on the *Phillis*. Wheatley also proved herself sufficiently adept in Latin to translate the short epic "Niobe in Distress," from Ovid's *Metamorphoses*.

When Wheatley first attempted to publish her volume of poetry in Boston in 1772, racist attitudes prevailed in spite of her superior intellectual achievement. Even in England a statement attesting to the authenticity of the volume—"by PHILLIS, a young Negro Girl, who was but a few years since, brought an uncultivated barbarian from Africa," signed by councilmen and her master—appeared in several London newspapers before publication. Subsequent editions carried the verification as a printed preface to the volume. Within a year after its first printing in autumn 1773, more than eighteen hundred copies of the book had been printed in London. Still, the first American edition was not published until two years after Wheatley died. Henry Louis Gates Jr. has argued that her poetry makes her "the progenitor of the black literary tradition."[1] Born in West Africa, transported on a slave ship to America, published and admired in England, she is also the embodiment of the black Atlantic and transnational cultures—incorporating African, American, Caribbean, and European influences—engendered by the African diaspora.

The favorable reviews of Wheatley's book very likely hastened her emancipation, though legally she should have been freed simply for traveling to England, where, according to the Somerset decision, a slave could not be returned to slavery. She voiced her own antislavery sentiments in a letter to Samson Occom, a Mohegan Indian: "In every human Breast, God has implanted a Principle, which we call Love of Freedom; it is impatient of Oppression, and pants for Deliverance."[2]

Critics have disagreed over the extent of her originality. Some have argued that her use of traditional verse forms and classical topics was imitative of British poets such as John Milton and Alexander Pope, and that she is primarily assimilationist. Recent discoveries, however, indicate her strong abolitionist tendencies, her pride in her African origins, and the breadth of the influences upon her. Of the thirty-eight poems in the collection, fourteen are elegies that may be formally derivative of African oral songs composed for the dead. Wheatley also incorporated sun worship, a ritual of offering "water before the sun at his rising," which she recalled her mother performing. Joseph Seall (pastor of the Old South Church of Boston, where political meetings related to the Boston Massacre and the Boston Tea Party occurred) and her spiritual adviser Samuel Cooper receive personal tributes in her poetry. Her most famous elegy is "On the Death of the Rev. Mr. George Whitefield, 1770." Whitefield was a Methodist minister and chaplain to Selina Hastings, countess of Huntingdon, who supported Wheatley's writing. Wheatley attracted considerable attention from statesmen and literati, including George Washington, Granville Sharp, Brook Watson (Lord Mayor of London), Benjamin Franklin, and the earl of Dartmouth, who gave her five guineas to purchase Pope's complete poems.

Wheatley married a free black, John Peters, a man of many trades and an advocate for his fellow blacks, in 1778. Her projected second volume of poetry along with her letters failed to attract a publisher, and most of the manuscript has been lost. She died at the age of thirty-one, shortly after the birth of her third child.

This copy of *Poems on Various Subjects* is part of the African American Rare Book Collection of the Western States Black Research and Education Center. The book was purchased in the 1980s from a private collector in Pennsylvania by Mayme Agnew Clayton, founder and archivist of the collection, for about two hundred dollars, a tiny fraction of its current value. *Felicity A. Nussbaum*

References

Joseph Sabin, *Bibliotheca Americana: A Dictionary of Books Relating to America*, 29 vols. (1868–92, 1928–36; reprint, Amsterdam: N. Israel; New York: Barnes & Noble, 1961–62), no. 103136; ESTC t153734.

Bibliography

William H. Robinson, *Phillis Wheatley and Her Writings* (Garland: New York, 1984); Henry Louis Gates Jr., *Figures in Black: Words, Signs, and the "Racial" Self* (New York: Oxford University Press, 1987); John C. Shields, *African American Writers*, ed. Valerie Smith (New York: Charles Scribner's Sons, 1991); John C. Shields, *Notable Black American Women*, ed. Jessie Carney Smith (Detroit: Gale Research Co., 1992), vol. 1, 1243–48; John C. Shields, in *American National Biography*, ed. John A. Garraty and Mark C. Carnes (New York: Oxford University Press, 1999), vol. 3, 121–22.

Notes

1. Gates, *Figures in Black*, 73.
2. Phillis Wheatley, *Complete Writings*, ed. Vincent Carretta (New York: Penguin Books, 2001), 153.

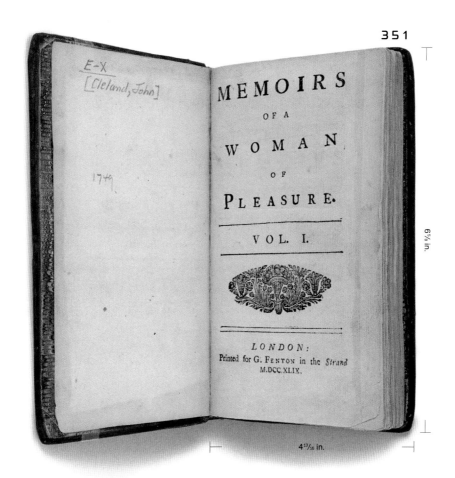

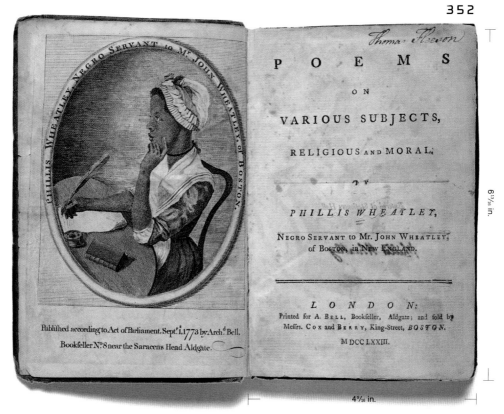

John Cleland
Memoirs of a Woman of Pleasure, 1749

The rare first edition of *Fanny Hill*

Phillis Wheatley
Poems on Various Subjects, Religious and Moral, 1773

The first published book by an African American

353

WILLIAM BLAKE
Poetical Sketches

London, 1782
8½ x 5⅜ in. (21.6 x 13.7 cm)
The Huntington Library, San Marino, California
(RB 57432)

In the early 1780s the Reverend A. S. Mathew and his wife, Harriet, began to give dinner parties for artists and poets. Among the lesser-known members of the coterie was the young engraver William Blake (1757–1827). His recitations of his poems so delighted the audience that the Mathews, with the help of Blake's friend the sculptor John Flaxman, provided the financial backing for the publication of a selection of these verses under the title *Poetical Sketches*, "By W. B." The press run for this slim volume of seventy pages must have been small, perhaps no more than fifty copies. The book was not offered commercially but given or sold to acquaintances. Only twenty-two copies are now traceable; five of these lack leaves, now supplied in facsimile.

An unsigned "Advertisement" on the book's second leaf states that "the following Sketches were the production of untutored youth, commenced in his twelfth, and occasionally resumed by the author till his twentieth year." Thus the composition of these apprentice poems corresponds roughly to Blake's actual apprenticeship in engraving, 1772–79. The collection reveals the young poet trying his hand at several genres, including poems on the four seasons, sonnets ("To the Evening Star"), song lyrics, allegorical prose ("The Couch of Death"), and the opening scenes of a play, "King Edward the Third." Blake was also essaying a variety of styles and moods, ranging from the picturesque to the gothic, from pathos to sublimity. He was clearly indebted to eighteenth-century predecessors, such as James Thompson and Thomas Chatterton, but he also reached back to earlier models, particularly Spenser, Shakespeare, and the supposedly ancient works of Ossian. Yet, while practicing the conventions of his time, Blake sometimes reveals dissatisfaction with an attenuated poetic tradition; as he writes in "To the Muses,"

How have you left the antient love
That bards of old enjoy'd in you!
The languid strings do scarcely move!
The sound is forc'd, the notes are few!

When viewed in the light of Blake's later poetry, we can see in *Poetical Sketches* the nascent form of the genius that would, in our time, make the author of *Songs of Innocence and of Experience* and *Jerusalem* one of England's most highly regarded poets. His intensification of personification, a dominant eighteenth-century mode, foreshadows his development of such figures into the characters of his mythic poetry. Unease with conventions would give birth to the experiments in language and versification that made Blake's mature poetry virtually inaccessible to his contemporaries. Tensions between energy and restriction, hinted at by some of the *Sketches*, became a fundamental dynamic in Blake's visions of both mind and cosmos.

The Huntington Library copy included in *The World from Here* is the only one extant that bears a presentation inscription from the author—"to Charles Tulke Esq^re / from William Blake"—which appears on the title page. Like most copies, this one includes several of Blake's manuscript emendations. For example, the printed line "And the rustling beds of dawn" in "Mad Song" is corrected to "And the rustling birds of dawn." The volume was later in the possession of the renowned bibliophile Robert Hoe, from whose collection Henry E. Huntington acquired it at auction in April 1911. Three years later Huntington obtained a second complete copy as part of the duke of Devonshire's library, adding it to what was rapidly becoming one of the world's greatest collections of Blake's art and writings.
Robert N. Essick

354

JANE AUSTEN
Sense and Sensibility

London: T. Egerton, 1811
7½ x 4⁵⁄₁₆ in. (19.1 x 11.6 cm)
Loyola Marymount University,
Charles Von der Ahe Library
(PR4034 .S4 1811)

References
G. E. Bentley Jr., *Blake Books* (Oxford: Clarendon Press, 1977), 343–54 (copy C); Robert N. Essick, *The Works of William Blake in the Huntington Collections: A Complete Catalogue* (San Marino, Calif.: Huntington Library, Art Collections, Botanical Gardens, 1985), 176–78.

Bibliography
Margaret Ruth Lowery, *Windows of the Morning: A Critical Study of William Blake's "Poetical Sketches," 1783* (New Haven: Yale University Press, 1940); Geoffrey Keynes, *Blake Studies: Essays on His Life and Work*, 2d ed. (Oxford: Clarendon Press, 1971), 31–45; Michael Phillips, "Blake's Earliest Poetry," in *William Blake: Essays in Honour of Sir Geoffrey Keynes*, ed. Morton D. Paley and Michael Phillips (Oxford: Clarendon Press, 1973), 1–28; idem, "William Blake and the 'Unincreasable Club': The Printing of *Poetical Sketches*," *Bulletin of the New York Public Library* 80 (1976): 6–18; Robert F. Gleckner, *Blake's Prelude: Poetical Sketches* (Baltimore: Johns Hopkins University Press, 1982); William Blake, *The Complete Poetry and Prose of William Blake*, ed. David V. Erdman (New York: Anchor Press, 1988), 408–45; Mark L. Greenberg, ed., *Speak Silence: Rhetoric and Culture in Blake's "Poetical Sketches"* (Detroit: Wayne State University Press, 1996).

355

JOHN KEATS

Poems

London: C. & J. Ollier, 1817
7⅛ x 4¾ in. (18.1 x 12.1 cm)
William Andrews Clark Memorial Library, UCLA
(*PR 4834 P71)

Published on March 3, 1817, John Keats's *Poems* was a commercial and critical disappointment. Only six reviews appeared—three written by friends of the poet—and the few people who bought copies of the volume evidently soon repented of having done so. Less than two months after the book's release, Keats's brother George wrote the publishers, complaining of its sluggish performance and urging them to bestir themselves on its behalf. The reply he received from them is famous: "We regret that your brother ever requested us to publish his book, or that our opinion of its talent should have led us to acquiesce in undertaking it. . . . By far the greater number of persons who have purchased it from us have found fault with it in such plain terms, that we have in many cases offered to take the book back rather than be annoyed with the ridicule which has, time after time, been showered upon it." Even individuals who might have been expected to take a special interest in the *Poems* seem to have given the collection a tepid reception. The most poignant case involves William Wordsworth, whom Keats venerated and to whom he sent an inscribed copy. When Wordsworth died in 1850, the book was found in his library, most of its pages unopened.

Nor have the *Poems* fared better with subsequent generations of readers. Though posterity elevated Keats (1795–1821) into the pantheon of English poetry on the basis of his later work— mainly the stunning odes he wrote in 1819—even his most fervent admirers have tended to regard the book as prentice work composed largely under the unfortunate influence of Leigh Hunt, and with the exception of its vigorous sonnet "On First Looking into Chapman's Homer," they have found little in the collection to excite enthusiasm.

Nevertheless, the volume is a landmark. It is the inaugural collection of a very great poet, and one of only three books he produced in his short life. (The second is *Endymion*, which appeared in 1817 and which was the object of the notorious attacks by *Blackwood's*, the *Quarterly Review*, and the *British Critic*. The third and final book is *Lamia, Isabella, The Eve of St. Agnes, and Other Poems*, which was issued in 1820 and which remains one of the finest collections of verse ever published in English.) Further, the poems in the collection are remarkable in ways that have never been fully appreciated. Even the weakest poems have wonderful descriptive details, such as the minnows that in "I stood tip-toe upon a little hill" face upstream and hold themselves steady against the current, or the flames that play over the coals in the sonnet "To My Brothers." Most important, we see Keats developing, in "Sleep and Poetry" and in the collection's three verse epistles, his singular talent for moving fluidly between description and meditation—a talent that would enable him to create, in his odes, a new kind of middle-length poem, one that fused image with argument and featured both lyric concentration and discursive breadth. And so far as such modern poets as W. B. Yeats, Robert Frost, Wallace Stevens, Yvor Winters, W. H. Auden, Richard Wilbur, and Philip Larkin have all at times adopted, varied, and extended this lyrical-essayistic form, its flickering emergence in the *Poems* is the dawning of a long and fruitful tradition.

The copy of Keats's *Poems* in the current exhibition was presented by the author to John Byng Gattie, who was the brother-in-law of the publishers, Charles and James Ollier. (It was apparently James, the more business-oriented of the brothers, who wrote the harsh letter to George Keats; Charles, the more literary of the brothers, retained his faith in Keats's work and continued his friendship with the poet even after the failure of the *Poems* and the firm's repudiation of the collection.) The volume stayed in the Gattie family for some decades but was eventually acquired by the noted collector Winston H. Haggen. In 1918 William Andrews Clark purchased it from the rare book and manuscript dealer George Smith, at a cost of several thousand dollars more than the original price of six shillings.
Timothy Steele

356

PERCY BYSSHE SHELLEY

Adonais

Pisa: With the types of Didot, 1821
9¾ x 7⅜₆ in. (24.8 x 18.3 cm)
William Andrews Clark Memorial Library, UCLA
(*PR 5406 A1)

357

EDGAR ALLAN POE

Tamerlane and Other Poems

Boston: Calvin F. S. Thomas, 1827
7 x 4¼ in. (17.8 x 10.8 cm)
William Andrews Clark Memorial Library, UCLA
(*PS 2611 T11)

358

NATHANIEL HAWTHORNE

The Scarlet Letter

Boston: Ticknor, Reed, and Fields, 1850
7¹⁵⁄₁₆ x 4¾ in. (20.2 x 12.1 cm)
William Andrews Clark Memorial Library, UCLA
(PS 1868 A1)

359

HERMAN MELVILLE

The Whale

London: R. Bentley, 1851
8⅛₆ x 5⁵⁄₁₆ in. (20.5 x 13.5 cm)
Department of Special Collections,
Young Research Library, UCLA
(Sadleir 1685)

References

J. R. MacGillivray, *Keats: A Bibliography and Reference Guide* (Toronto: University of Toronto Press, 1949), no. A1; John Hayward, *English Poetry: An Illustrated Catalogue of First and Early Editions* ([London]: Published for the National Book League by the Cambridge University Press, 1950), no. 231.

Bibliography

W. Jackson Bate, *John Keats* (Cambridge: Harvard University Press, 1963); Ian Jack, *Keats and the Mirror of Art* (Oxford: Oxford University Press, 1967); Robert Gittings, *John Keats* (London: Heinemann, 1968); G. M. Matthews, ed., *John Keats: The Critical Heritage* (London: Routledge and Kegan Paul, 1971); John Keats, *Complete Poems*, ed. Jack Stillinger (Cambridge: Harvard University Press, 1978).

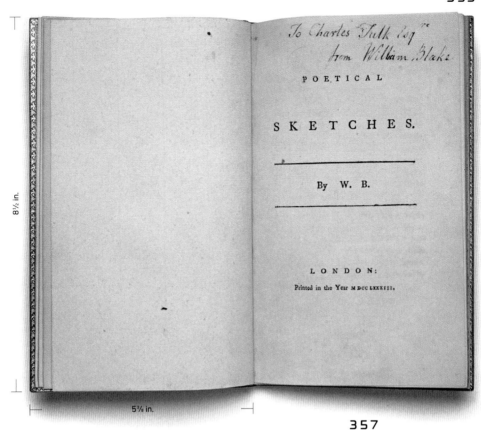

William Blake
Poetical Sketches, 1782

A presentation copy of Blake's rare first book

Edgar Allan Poe
Tamerlane and Other Poems, 1827

Poe's very rare first book

My dear Giovanni I hope your eyes will
soon be well enough to read this with plea-
sure and ease

Poems,

BY

JOHN KEATS.

" What more felicity can fall to creature,
" Than to enjoy delight with liberty."
Fate of the Butterfly.—SPENSER.

PRINTED BY C. RICHARDS,
No. 18, WARWICK STREET, GOLDEN SQUARE, LONDON.

LONDON:
PRINTED FOR
C. & J. OLLIER, 3, WELBECK STREET,
CAVENDISH SQUARE.

1817.

7⅛ in.

4¾ in.

John Keats
Poems, 1817

A presentation copy of Keats's
first collection of poems

360

HENRY DAVID THOREAU

**Leaf from the autograph manuscript
of "Walden,"** 1845–54

9¹⁵⁄₁₆ x 7⅞ in. (25.2 x 20 cm)
The Huntington Library, San Marino,
California (HM 924)

Near the end of March 1845 Henry David Thoreau (1817–62) went to live in the woods near Walden Pond, a short distance from Concord, Massachusetts. With a borrowed axe, and on land owned by Ralph Waldo Emerson, he built the simple cabin that would be his home for the next two years, two months, and two days. During that time Thoreau planted a bean field; observed the plants, birds, and animals through all the seasons; and wrote of his experiences in notes that would be published in 1854 as *Walden; or, Life in the Woods*.

The son of a pencil maker, Thoreau was a Harvard-educated teacher who became a day laborer in order to live more simply by the hard work of his own hands. He explained in *Walden* why he embraced an austere life:

I went to the woods because I wished to live deliberately, to front only the essential facts of life, and see if I could not learn what it had to teach, and not, when I came to die, discover that I had not lived. I did not wish to live what was not life, living is so dear; nor did I wish to practice resignation, unless it was quite necessary. I wanted to live deep and suck out all the marrow of life, to live so sturdily and Spartan-like as to put to rout all that was not life.

In this simple yet profound statement, Thoreau set forth a central theme of his book: the importance of nature as a constant in transitory human life, and the imperative of stripping away the nonessential trappings of life in order to embark on a journey of self-discovery. A closely related second theme of *Walden* is the importance of the individual. At its most basic, the book presents this theme in the story of one man, alone in a cabin and forced to be completely self-reliant. But, more deeply, Thoreau speaks of our need for a spirit of independence that eschews mindless conformity to convention. Addressing his book to those who "lead lives of quiet desperation," he wrote, in a famous passage that still resonates for his readers: "If a man does not keep pace with his companions, perhaps it is because he hears a different drummer. Let him step to the music which he hears, however measured or far away."

For two years Thoreau followed his own drummer in the woods near Concord, and for the next six years he honed and refined the notes and text in which he had recorded his observations and experiences, producing no fewer than seven drafts of *Walden* that cover almost twelve hundred heavily revised pages on paper of a befittingly frugal assortment of sizes, colors, and origins. These seven drafts now reside in the Huntington Library, together with the corrected proofs (revealing the author's textual changes, as well as the printer's great difficulty in deciphering Thoreau's handwriting), plus autograph drafts of other writings of Thoreau. Most of the library's Thoreau manuscripts and letters, including the drafts of *Walden*, were purchased by Henry E. Huntington in 1918, as part of the William K. Bixby library.

The *Walden* manuscripts are now among the most significant American literary treasures extant, but as he prepared his drafts for publication, Thoreau felt no confidence that the work would find favor with any publisher. Ticknor and Fields, perhaps the foremost publishing firm of the time, readily accepted the book, however, and even rewarded the unassuming author with a generous royalty arrangement. On the day in August 1854 when the book was published, Thoreau wrote in his journal: "To Boston. 'Walden' published. Elderberries. Waxwork yellowing." Characteristically for Thoreau, in his eyes the fruit and flora of the fields carried equal importance with the publication of the book on which he had labored for so long.

Despite Thoreau's modesty concerning the greatest of his works, *Walden* is rightly considered to be an American classic. But it is much more than a mere icon of our literary heritage, to be placed unread on a library shelf. Thoreau's timeless account of his own search for self-understanding has much to say to readers now and in any age—about the conservation of natural resources; about the constancy of nature in a distracting, ephemeral society; and about finding one's true self in the unadorned simplicity of the natural world. With Thoreau, we can all go to the woods of Walden and learn much about the worlds both outside and within ourselves. *Sara S. Hodson*

361

WALT WHITMAN

Leaves of Grass

Brooklyn: The author, 1855
11⁷⁄₁₆ x 8¹⁄₁₆ in. (29.1 x 20.5 cm)
Loyola Marymount University,
Charles Von der Ahe Library
(PS3201.1855)

Bibliography
J. Lyndon Shanley, *The Making of "Walden," with the Text of the First Version* (Chicago: University of Chicago Press, 1957); Philip Van Doren Stern, ed., *The Annotated "Walden"* (New York: Clarkson Potter, 1970); Henry David Thoreau, *A Week on the Concord and Merrimack Rivers; Walden, or, Life in the Woods; The Maine Woods; Cape Cod* (New York: Library of America, 1985); Joel Myerson, ed., *Critical Essays on Henry David Thoreau's "Walden"* (Boston: G. K. Hall, 1988).

p 202

This is a delicious evening, when the whole body seems to be one sense, and imbibes delight through every pore. I go and come with a strange liberty in nature, a part of herself. As I walk along the shore of the pond, though it is cool as well as cloudy and windy, and I see no peculiarity which I can describe, yet all things are very congenial to me. The frogs keep to celebrate the sacred hours of night, and the whippoorwill sings in the rippling wind. Though it is now night, the waves still dash, the wind still blows and roars in the wood, and some creatures lull the rest with their notes. The repose is never complete. The wildest animals seem not to repose but seek their prey now; the fox and skunk, and rabbit roam the fields and woods without fear. Nature has her watchmen, who are the links connecting the days of animated life.

p 203

When I return to my house

Henry David Thoreau
Leaf from the autograph manuscript of "Walden," 1845–54

9 15/16 in.

7 3/8 in.

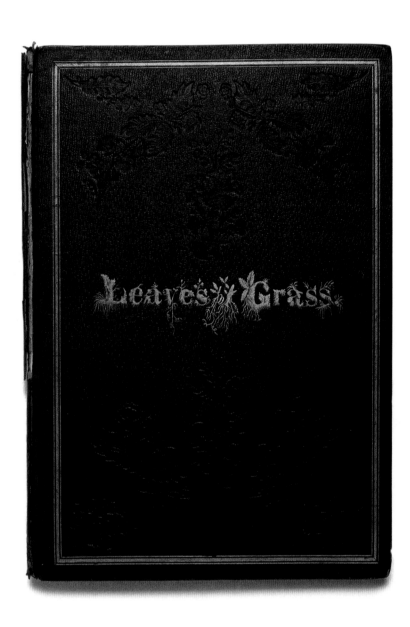

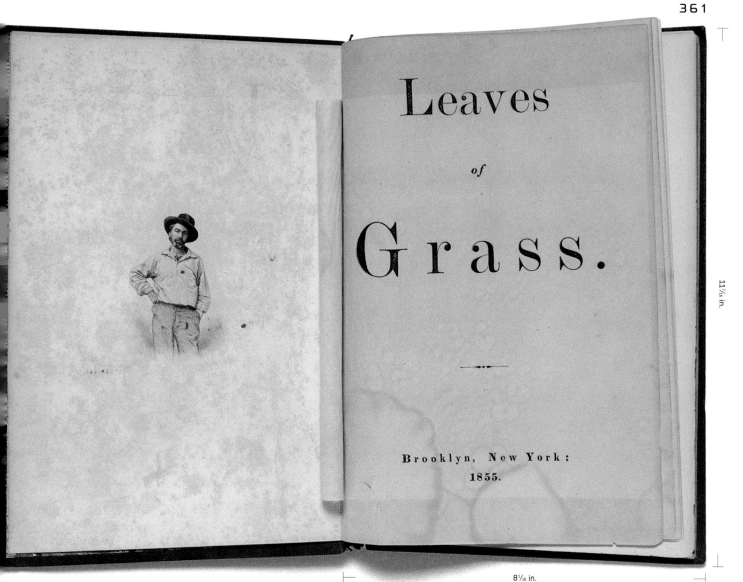

11⁷⁄₁₆ in.

8¹⁄₁₆ in.

Walt Whitman
Leaves of Grass, 1855

The first edition of *Leaves of Grass*,
printed by the author

362
LEWIS CARROLL
Alice's Adventures in Wonderland
London: Macmillan, 1865
Illustrated by John Tenniel
7 13/16 x 5 9/16 in. (19.8 x 14.1 cm)
The Huntington Library, San Marino, California
(RB 110219)

The tale of the collaboration between Lewis Carroll (1832–98) and John Tenniel (1820–1914) might not make a bad script for a film in the spirit of Mike Leigh's *Topsy-Turvy*. The unknown author Carroll—actually Charles Lutwidge Dodgson, an unassuming bachelor who was also an amateur artist, pioneering photographer, and mathematics don at Christ Church—had spun out a fairy tale for his underage muse and boss's daughter, Alice Liddell. Having presented her with an illustrated manuscript version, *Alice's Adventures Underground*, Carroll worked out an arrangement with Macmillan to publish the story at his own expense. Next, Carroll managed to land as *Alice*'s illustrator one of the best-known artists of the day, the one-eyed, self-taught political cartoonist John Tenniel.

While the patient and thoroughly professional Tenniel was at work on the pictures, Carroll, who was no expert on the reproductive processes of commercial book illustration, pestered him with polite, friendly letters that were "more than usually critical, both with the drawings and engravings," according to the Dalziel brothers, who read them during the woodblocks' preparation. When the time came to inspect the sheets printed by the Oxford University Press, however, Tenniel complained about the poor typography, layout, and presswork, and Carroll insisted that Macmillan find another printer to redo the job to his collaborator's satisfaction. Richard Clay in London reprinted the book, and Macmillan arranged to sell the rejected sheets with a canceled title page to D. Appleton for publication in America, where, Carroll reasoned, the children would be quite content with inferior work.

Eighteen months later, Carroll approached his collaborator to illustrate *Alice*'s projected sequel, but Tenniel declined. When Carroll finally finished *Through the Looking-Glass* early in 1871, he still had no illustrator, and somehow he managed to persuade an unenthusiastic Tenniel to draw the pictures for this new text. But after a second round of Carroll's helpful letters, Tenniel stoutly refused to have anything to do with "the conceited old don" again and eventually destroyed their correspondence about the two masterpieces' creation.

It is ironic that an author and an artist temperamentally unsuited to work with each other succeeded in laying down the law of nonsense for generations of modern readers. Of the three great Victorian fantasists—George MacDonald, Charles Kingsley, and Carroll—only Carroll's work has penetrated the wider culture to such an astonishing degree. *Alice in Wonderland* still inspires important book illustrators such as Anthony Browne, Barry Moser, Helen Oxenbury, and Lisbeth Zwerger to reimagine its landscape and characters. The story continues to be retold in all media. There are the dramatizations for the legitimate theater, such as that of Eva Le Gallienne, which has been revived at least twice on Broadway since its 1932 premiere; the musical adaptations, which include H. Savile Clark's 1886 operetta authorized by Carroll, and Vinette Carroll's disco spectacle, *But Never Jam Today* (1979); and the cinematic treatments, notable for the star turns in cameo roles, such as W. C. Fields as Humpty Dumpty in the 1934 Paramount film, or Whoopi Goldberg as the Cheshire Cat in the 1999 Hallmark Hall of Fame television production.

But perhaps even more interesting than the classic's reinterpretations are the surprising range of allusions to Wonderland in other original works. Individual scenes have inspired pieces for the concert hall, such as Liza Lehmann's song cycle for four voices, "Nonsense Songs" (1908), or David Del Tredici's "Lobster Quadrille" (1969), as well as numbers by Irving Berlin and Sammy Fain. Wonderland's inhabitants have been visited by Mickey Mouse and Betty Boop in animated short films and have made guest appearances on television series, such as "Shore Leave," a 1989 episode of *Star Trek*. The same characters have pitched products from player pianos to laundry detergent, or played the wide-eyed initiates into the mysteries of such subjects as stamp collecting, navigation, commercial radio broadcasting, and theoretical physics. The looking-glass world of Carroll and Tenniel has also offered satirists a means of exposing the irrationality of current events, including fiscal policy, Prohibition, and the Patty Hearst trial.

Carroll and Tenniel succeeded in creating a blueprint for turning the modern world upside down, although neither lived to see it. Perhaps it would have amused them that the first edition of 1865, which pleased neither of them, was the beginning of it all. Just twenty-three copies of the 1865 *Alice* are known to have survived Macmillan's recall of the sheets. Some of the dozen copies bound by Burns & Son in red cloth gilt and dark blue-green endpapers never came back, having been distributed to children's hospitals or presented by the author to friends, who, for some reason, kept the aborted first printing. Of this handful of books, just two are known to have been owned by people involved in the book's production: one of the two copies at the Berol Collection at New York University Library—a set of proofs retained by John Thomas, the book's printer at the Oxford University Press—and this mint copy at the Huntington Library, which was originally in the library of George Dalziel, of the celebrated Victorian wood-engraving firm Dalziel Brothers & Co., whose craftsmen engraved the woodblocks after Tenniel's drawings. The Huntington's copy is enhanced by three tipped-in letters, including two from Carroll (dated 1881 and 1883) concerning the illustrations for his book *Rhyme? and Reason?* Of even greater interest is the third letter, from Tenniel to Dalziel, which was probably written around November 1865, which explains that the artist's protests against the original sheets' "disgraceful" printing had convinced Macmillan to cancel the edition. *Andrea Immel*

References
John Carter and Percy H. Muir, eds., *Printing and the Mind of Man: A Descriptive Catalogue Illustrating the Impact of Print on the Evolution of Western Civilization during Five Centuries* (London: Cassell and Company, 1967), no. 354; Selwyn Goodacre, "Census of the Suppressed 1865 Alice," in Justin G. Schiller, *Alice's Adventures in Wonderland: An 1865 Printing Re-Described* (New York: Privately printed for the Jabberwock, 1990), no. 8.

Bibliography
Edward Guiliano, *Lewis Carroll: An Annotated International Bibliography, 1960–77* (Brighton, Sussex: Harvester Press, 1981); Charles C. Lovett and Stephanie B. Lovett, *Lewis Carroll's Alice: An Annotated Checklist of the Lovett Collection* (Westport, Conn.: Meckler, 1990).

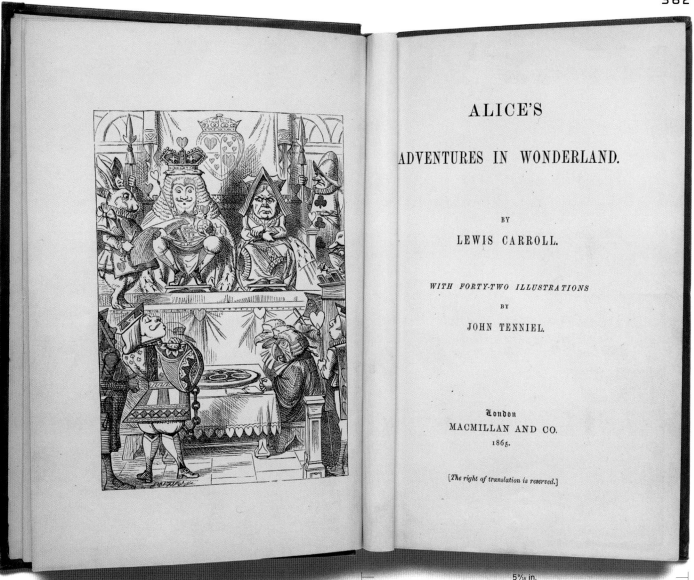

ALICE'S

ADVENTURES IN WONDERLAND.

BY

LEWIS CARROLL.

WITH FORTY-TWO ILLUSTRATIONS

BY

JOHN TENNIEL.

London

MACMILLAN AND CO.

1865.

[*The right of translation is reserved.*]

Lewis Carroll
Alice's Adventures in Wonderland, 1865

365

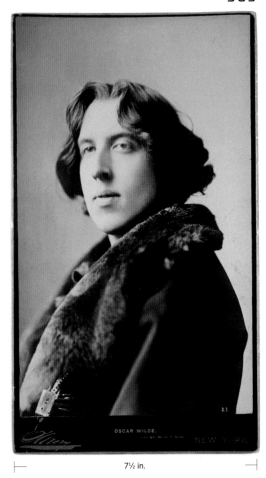

13⅛ in.

7½ in.

367

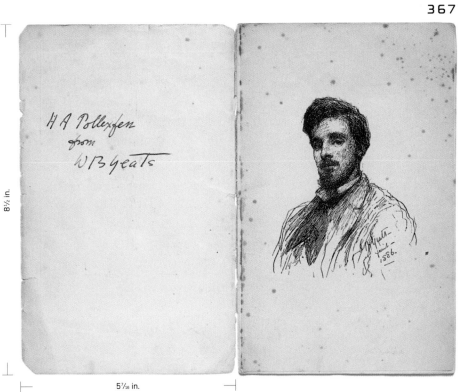

8½ in.

5⁷⁄₁₆ in.

Napoleon Sarony
Portrait of Oscar Wilde (#23), 1882

W. B. Yeats
Mosada, 1886

One of a series of photographs taken of Wilde
during his North American tour

A presentation copy of Yeats's rare first book

363

OSCAR WILDE

Vera; or, The Nihilists

London: Ranken & Co., 1880
7¹⁵/₁₆ x 4¼ in. (20.2 x 10.8 cm)
William Andrews Clark Memorial Library, UCLA
(*PR 5820 V471)

364

OSCAR WILDE

Manuscript of "The Sphinx," 1894

16⁷/₁₆ x 11⅛ in. (42.9 x 28.3 cm)
William Andrews Clark Memorial Library, UCLA
(Wilde Ms. W6721M1.S753 [1894] a)

365

NAPOLEON SARONY

Portrait of Oscar Wilde (#23),

January 1882
Albumen print; 13⅛ x 7½ in. (33.3 x 19.1 cm)
William Andrews Clark Memorial Library, UCLA
(Wilde Photo Box IN. 1)

366

RUDYARD KIPLING

Schoolboy Lyrics

Lahore: Printed at the "Civil and Military
Gazette" Press, 1881
6¾ x 4¼ in. (17.1 x 10.8 cm)
Loyola Marymount University,
Charles Von der Ahe Library
(PR4854.S37 1881)

367

W. B. YEATS

Mosada

Dublin: Printed by Sealy, Bryers,
and Walker, 1886
8½ x 5⁷/₁₆ in. (21.6 x 13.8 cm)
William Andrews Clark Memorial Library,
UCLA (*PR 5904 M891)

368

JAMES JOYCE

Ulysses

London: Egoist Press, 1922
9 x 7 in. (22.9 x 17.8 cm)
University of Southern California,
Archival Research Center,
Special Collections (820 J89 TU.3)

369

T. S. ELIOT

The Waste Land and Other Poems

Richmond: Leonard and Virginia Woolf
at the Hogarth Press, 1923
9¹/₁₆ x 5⅞ in. (23 x 14.9 cm)
The Huntington Library, San Marino,
California (RB 323753)

370

VIRGINIA WOOLF

Two letters to T. S. Eliot,

2 November 1930 and 15 January 1933
9 x 7 in. (22.9 x 17.8 cm);
10 x 8 in. (25.4 x 20.3 cm)
Libraries of the Claremont Colleges,
Denison Library, Scripps College

371

D. H. LAWRENCE

Lady Chatterley's Lover

Florence: Privately printed, 1928
9⅛ x 6⅞ in. (23.2 x 17.5 cm)
Department of Special Collections,
Young Research Library, UCLA
(PR 6023 L43l 1928 / SRLF G 000 024 649 6)

372

GERTRUDE STEIN

The Making of Americans: Being a History of a Family's Progress

Paris: Contact Editions, Three Mountains Press, 1925
12⅞ x 8 in. (32.7 x 20.3 cm)
Department of Special Collections, Young Research Library, UCLA
(H 000 003 839 8 / *PS 3537 S819m 1925a)

373

MAN RAY

Portrait of Gertrude Stein, c. 1930

Gelatin silver print; 9¹³⁄₁₆ x 7⅞ in. (24.9 x 20 cm)
Department of Special Collections, Young Research Library, UCLA (***98. Carl Van Vechten collection)

374

PABLO PICASSO

Homage à Gertrude, 1909

Tempera on wood; 8 x 10½ in. (20.3 x 26.7 cm)
Department of Special Collections,
Young Research Library, UCLA (*170/689)

Gertrude Stein (1874–1946) and Pablo Picasso (1881–1973) met soon after each began living in Paris at the turn of the last century. Stein moved there from the United States in late 1903, joining her brother Leo. After brief prior visits, Picasso returned to Paris in 1904, and like Gertrude Stein, he became a permanent resident of France.

Gertrude and Leo Stein—together with their brother Michael and his wife, Sarah—were among the first collectors to acquire works by the Cubists and other avant-garde artists of the period. Over the next decade or so, they were to amass among them a major collection of modern art that included works by Pierre Bonnard, Paul Cézanne, Paul Gauguin, Juan Gris, Edouard Manet, Henri Matisse, and Henri Toulouse-Lautrec, as well as Picasso. In addition to collecting art, they formed friendships with various artists. Later, during the 1920s, Gertrude would become a prominent literary figure, and her salon attracted both European artists and fellow American expatriate writers such as Ernest Hemingway and F. Scott Fitzgerald.

Picasso's well-known 1906 portrait of Stein, now in the Metropolitan Museum of Art in New York, reportedly required some ninety sittings— an extraordinary number for Picasso or any other artist—and the friendship between the two deepened over the course of their many meetings.[1] The UCLA painting has been dated 1909 on stylistic grounds, and its original provenance as the gift of the artist to Stein is documented in the writer's *Autobiography of Alice B. Toklas*: "It was about this time too that [Picasso] made for her the tiniest of ceiling decorations on a tiny wooden panel and it was an hommage à Gertrude with women and angels bringing fruits and trumpeting. For years she had this tacked to the ceiling over her bed. It was only after the war that it was put upon the wall."[2] The painting bears nail holes in each of its corners.

Picasso's painting was donated to the UCLA Library Department of Special Collections by Gilbert A. Harrison, in honor of the memory of Provost Ernest Carroll Moore and Kate Gordon Moore. Harrison (class of 1937) edited the *UCLA Daily Bruin* as a senior and served as founding editor of *The New Republic* magazine from 1954 to 1974. He first met Gertrude Stein at a lecture she gave in the Los Angeles area, and his ensuing friendship with her and her companion, Alice B. Toklas, continued throughout the lives of the two women. Their correspondence forms part of a Gertrude Stein collection established at UCLA by Harrison, which also includes manuscripts and more than three hundred books. *Anne Caiger*

References
Pierre Daix and Joan Rosselet, *Picasso, the Cubist Years, 1907–1916: A Catalogue Raisonné of the Paintings and Related Works*, trans. Dorothy S. Blair (Boston: New York Graphic Society, 1979), no. 248.

Bibliography
Gertrude Stein, *The Autobiography of Alice B. Toklas* (New York: Harcourt, Brace and Company, 1933), ill. facing 116; *Four Americans in Paris: The Collections of Gertrude Stein and Her Family* (New York: Museum of Modern Art, 1970), ill. 170.

Notes
1. Pierre Daix, "Portraiture in Picasso's Primitivism and Cubism," in *Picasso and Portraiture: Representation and Transformation*, ed. William Rubin (New York: Museum of Modern Art, 1996), 259–60.
2. Stein, *Autobiography of Alice B. Toklas*, 109.

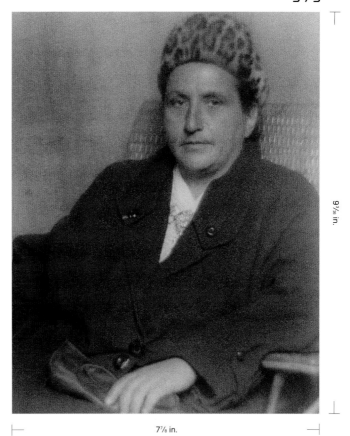

9³/₁₆ in.

7⅞ in.

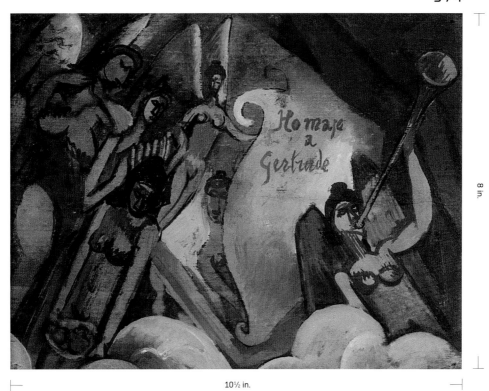

8 in.

10½ in.

Man Ray
Portrait of Gertrude Stein, c. 1930

Pablo Picasso
Homage à Gertrude, 1909

❧ VANA.

In vain have I striven
 to teach my heart to bow;
In vain have I said to him
« There be many singers greater than thou. »

But his answer cometh, as winds and as lutany,
As a vague crying upon the night
That leaveth me no rest, saying ever,
 « Song, a song »

Their echos play upon each other in the twilight
Seeking ever a song.
Lo, I am worn with travail
And the wandering of many roads hath made my eyes
As dark red circles filled with dust.
Yet there is a trembling upon me in the twilight,
 And little red elf words crying « A song »,
 Little grey elf words crying for a song,
 Little brown leaf words crying « A song »,
 Little green leaf words crying for a song.
The words are as leaves, old brown leaves in the
 [spring time
Blowing they know not whither, seeking a song.

— 30 —

❧ LI BEL CHASTEUS.

That castle stands the highest in the land
Far seen and mighty. Of the great hewn stones
What shall I say ? And deep foss way
That far beneath us bore of old
A swelling turbid sea
Hill-born and torrent wise
Unto the fields below, where
Staunch villein and wandered
Burger held the land and tilled
Long labouring for gold of wheat grain
And to see the beards come forth
For barley's even tide.

But circle-arched, above the hum of life
We dwelt amid the ancient boulders,
Gods had hewn and druids runed
Unto that birth most wondrous, that had grown
A mighty fortress while the world had slept
And we awaited in the shadows there
While mighty hands had labored sightlessly
And shaped this wonder 'bove the ways of men
Me seems we could not see the great green waves
Nor rocky shore by Tintagoel
From this our hold,
But came faint murmuring as undersong
E'en as the burgers hum arose
And died as faint wind melody
Beneath our gates.

— 31 —

Ezra Pound
A Lume Spento, 1908

Pound's rare first book

375

EZRA POUND
A Lume Spento
Venice: A. Antonini, 1908
8 ⅜ x 6 ⅛ in. (21.3 x 15.6 cm)
Department of Special Collections,
Young Research Library, UCLA
(PS 3531 P86a / SRLF G 000 033 907 7)

Collectors of modern literary first editions prize above all elusive and legendarily rare items, and the first books of famous writers almost always fall into that category. Sometimes self-published (especially poetry—even *Leaves of Grass* was published by the author), often issued in small print runs, and typically not well distributed, sold, or reviewed, first books often sink from sight until a later stage in a writer's life, when fame causes collectors, critics, and booksellers to seek out copies. Many authors, from the bibliographer Thomas Frognall Dibdin (1776–1847) to the poets John Gray (1866–1934) and William Carlos Williams (1883–1963), actively attempted in later life to suppress their first books by destroying copies that they found.

Ezra Pound was twenty-three when his first book was published. He was born in Hailey, Idaho, in 1885 and was destined to become one of the greatest poets of the twentieth century. But in the summer of 1908, when *A Lume Spento* was produced for him by A. Antonini, a Venetian job printer, he was at the very beginning of his literary career and was little more than just another American expatriate seeking the culture of the Old World. His exile would in fact last a lifetime. From Italy he moved first to England, subsequently to France, and then back to Italy, where he was arrested for treason in 1945 and forcibly returned to the United States and incarcerated in St. Elizabeth's Hospital in Washington, D.C., after he was judged mentally unfit to stand trial. He returned to Italy on his release in 1958 and died there in 1972.

Kultur with a capital *K* (to spell it in a Poundian way) would inform Pound's lifelong poem, *The Cantos*, to an extraordinary degree, and it is already a strong presence in *A Lume Spento*. (The title comes from the third canto of Dante's *Purgatorio*, and was given in English by Pound himself as "With Tapers Quenched.") Pound was trained as a scholar of romance languages and was deeply influenced by late nineteenth-century poets like Swinburne and Dowson. As a result the diction of his earliest poems is a sometimes curious amalgam of poetic archaisms, scholarly allusions, and cries from the (sometimes posturing) heart:

Prometheus

For we be the beaten wands
And the bearers of the flame.
Ourselves have died lang syne, and we
Go ever upward as the sparks of light
Enkindling all
'Gainst whom our shadows fall.

Weary to sink, yet ever upward borne,
Flame, flame that riseth ever
To the flame within the sun,
Tearing our casement ever,
For the way is one
That beareth upward
To the flame within the sun.

The archaisms and the allusiveness of Pound's poetry remained characteristic throughout his life, and *The Cantos* is certainly the most allusive poem of its age, if not of all time. This complexity of reference was imitated by later American poets in the Pound tradition—including Robert Duncan, Charles Olson, Robert Kelly, and others—who aspired, as Pound eventually did, to create large-scale poetic forms that would both reflect the complexity of the century and be flexible enough to carry the poet through a work that might be written over several decades. Pound himself would spend over half a century writing *The Cantos*, which was left unfinished at his death.

When Pound finally allowed *A Lume Spento* to be reprinted in 1965, he composed a brief foreword in which he grumpily dismissed the poems in the book as "stale creampuffs." They are clearly the work of a young poet; most of them were written before Pound left for Italy in February 1908, and although some were included in later books, only a handful remain in the editions of his selected poems published in 1949 and 1975. The printer produced 150 copies of the book, but many have disappeared, as slim pamphlets by fledgling poets predictably do. The bookseller Tom Goldwasser carried out a census of *A Lume Spento* that was published in 1989, and he was able to locate 33 copies. The copy at UCLA, acquired by the university in 1948 or 1949, was presented by Pound to the publisher Thomas Bird Mosher. UCLA owns a second, incomplete copy of *A Lume Spento* that purportedly belonged to D. H. Lawrence and had apparently been used by Pound as the copy text for part of his later book *Personae* (1909). *Bruce Whiteman*

References
Donald Gallup, *Ezra Pound: A Bibliography* (Charlottesville: University Press of Virginia, 1983), no. A1; Thomas A. Goldwasser, "Ezra Pound's *A Lume Spento*: A Preliminary Census," *Papers of the Bibliographical Society of America* 83 (March 1989): 17–42.

Bibliography
Ezra Pound, *A Lume Spento and Other Early Poems* (New York: New Directions, 1965); John Espey, "Ezra Pound," in *Sixteen Modern American Authors: A Survey of Research and Criticism* (New York: Norton, 1973); Ezra Pound, *Collected Early Poems*, ed. Michael John King (New York: New Directions, 1976).

376

Une saison en enfer

Brussels: Alliance Typographique, 1873
7 ³⁄₁₆ x 4 ¹⁵⁄₁₆ in. (18.3 x 12.5 cm)
Department of Special Collections,
Young Research Library, UCLA
(PQ2387.R5 S15 1873)

Among the work of all the great nineteenth-century poets, that of Arthur Rimbaud stands out in some ways as the most predictive of twentieth-century writerly obsessions. Rimbaud was a prodigy—*Une saison en enfer* (A season in hell) was written when he was only nineteen years of age—and his apparently deliberate abandonment both of literature and of European civilization shortly after the publication of this, the only work of his which he saw through the press, has challenged writers and readers ever since. During the years when most of his work was accomplished, from the age of fifteen to nineteen, his life was that of the classically rebellious adolescent. Indeed the choice of Leonardo DiCaprio to portray him in the sometimes dubious film *Total Eclipse* (1995) was inspired, and DiCaprio's foul-mouthed, loutish characterization is demonstrably close to the truth.

Rimbaud was born in the provincial city of Charleville, northeast of Paris, on October 20, 1854. His father was a military man and something of an autodidact. He had taught himself Arabic during a posting to Algeria, and he translated the Koran into French. His mother had all the traits of the petit bourgeois: she was deeply Catholic and raised her four children in an atmosphere of repression and discipline. Rimbaud was a brilliant student (he astounded his masters with his ability to write Latin hexameters), but his mother's strict regimen left him extremely self-conscious and socially awkward. His literary talent was obvious from the age of fifteen, when he began seriously to write poetry in French; the next four years, productive as they were of some of the most brilliant poetry in French ever written, were also for Rimbaud a period of extreme personal distress. His relationship with the poet Paul Verlaine (1844–96) led ultimately to the "Brussels drama," when Verlaine shot Rimbaud in the wrist and spent two years in prison as a result.

Une saison en enfer is now thought by most scholars to be Rimbaud's last work. It was begun on his mother's farm at Roche in April of 1873 and finished, after the disruption of his final break with Verlaine, in August. In this "notebook of a damned soul," as he provisionally entitled it, Rimbaud considered his life, his work, his intellectual and religious inheritances, the value of beauty and of poetry. All of this, and much more, he execrated as constituting the searing journey to hell through which he had come. Most of the book is in prose, but it is a prose that is everywhere inspissated with the concision and music of poetry. The moving "Adieu," with which the work concludes, begins thus: "Autumn already! But why rue a sun that never fades when discovering that the divine light is the goal we have set ourselves—far from those who live and die with the seasons." Further along in this section he says, in a now-famous admonishment, "You must be absolutely modern," and both the direct counsel and the detectably ironic edge of that sentence were to echo through a century of modernism.

Rimbaud wrote little after the age of twenty and spent the last years of his life as a trader in Africa, until a tumor on his knee forced him to return to France. There he died on November 10, 1891, after receiving the last rites, if the testimony of his sister is to be believed.

Rimbaud arranged for the publication of *Une saison en enfer* in Brussels, but most of the edition of five hundred copies sat unremembered in storage because the printer's bill was never paid. A bibliophile discovered the boxes in 1901, and although some copies were damaged (and were subsequently burned), most were salvaged. The legend that Rimbaud himself destroyed the edition when he burned his manuscripts is untrue. The copy on exhibition is part of a Rimbaud collection given to UCLA by Mr. Giles Greville Healey in 1954.
Bruce Whiteman

References
Arthur Rimbaud, *Oeuvres complètes*, ed. Rolland de Renéville and Jules Mouquet (Paris: Editions Gallimard, 1967); *En français dans le texte: Dix siècles de lumière par le livre* (Paris: Bibliothèque nationale, 1990), no. 299.

Bibliography
Henry Miller, *The Time of the Assassins: A Study of Arthur Rimbaud* (Norfolk: New Directions, 1956); Graham Robb, *Rimbaud* (London: Picador, 2000).

A. RIMBAUD

UNE

SAISON EN ENFER

PRIX : UN FRANC

BRUXELLES
ALLIANCE TYPOGRAPHIQUE (M.-J. POOT ET COMPAGNIE)
37, rue aux Choux, 37

1873

7³/₁₆ in.

4¹⁵/₁₆ in.

Arthur Rimbaud
Une saison en enfer, 1873

One of the foundational texts of European
modernism

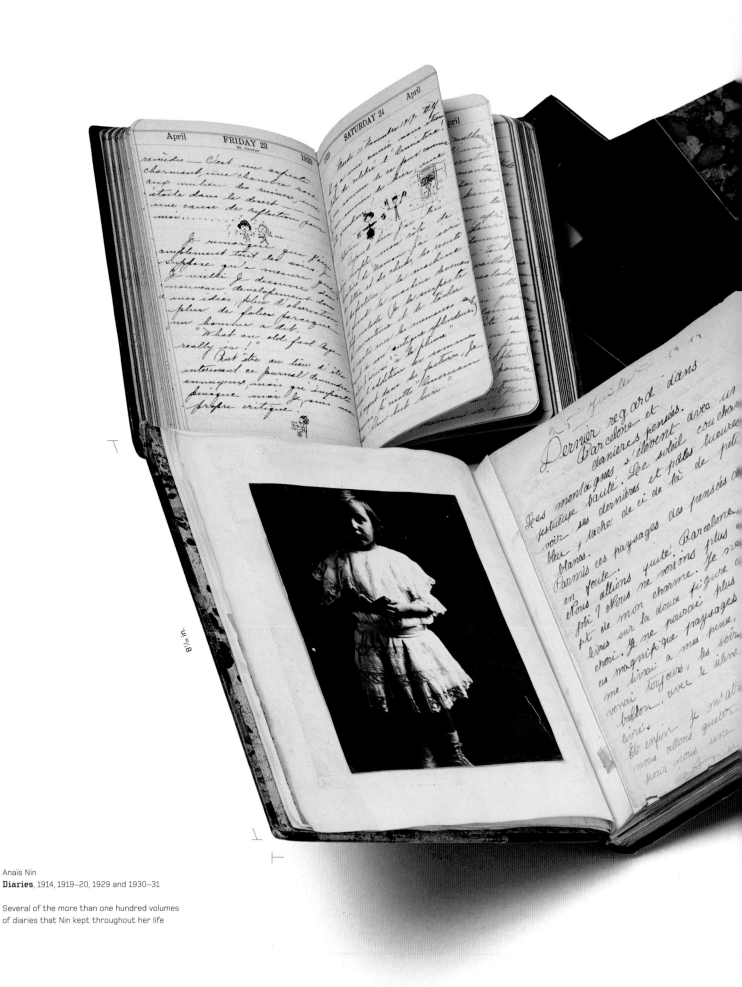

Anaïs Nin
Diaries, 1914, 1919–20, 1929 and 1930–31

Several of the more than one hundred volumes
of diaries that Nin kept throughout her life

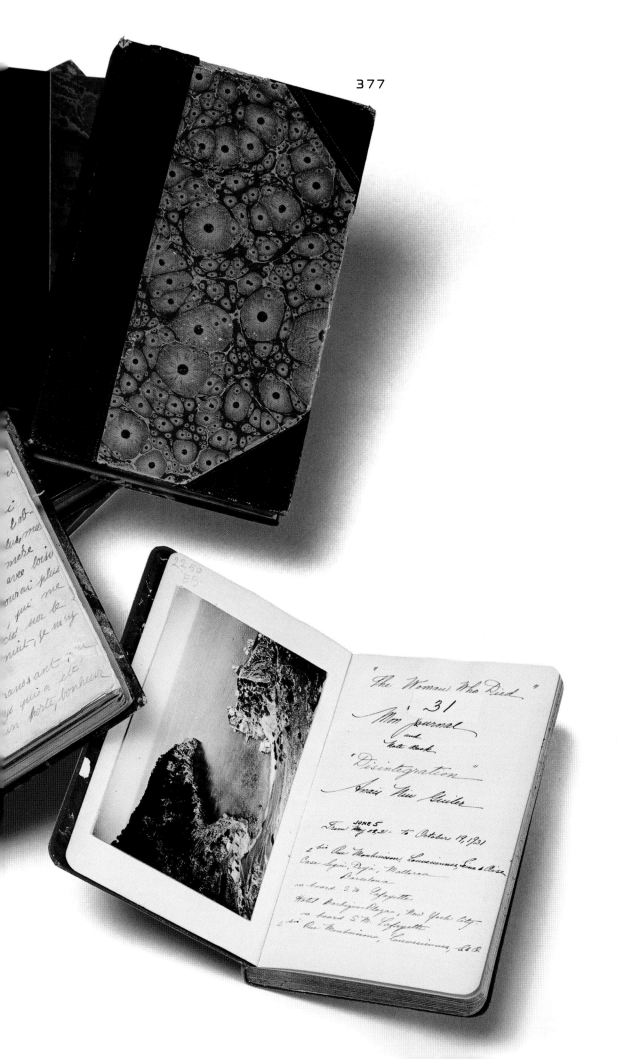

377

ANAÏS NIN

Diaries, 1914, 1919–20, 1929, and 1930–31

No. 1 (1914): 8 7/16 x 7 1/2 in. (21.4 x 19.1 cm);
no. 7 (1919–20): 6 5/8 x 4 5/8 in. (16.8 x 11.7 cm);
no. 27 (1929): 8 5/8 x 5 1/2 in. (21.9 x 13.9 cm);
no. 30 (1930–31): 6 7/8 x 4 13/16 in. (17.5 x 12.2 cm)
Department of Special Collections,
Young Research Library, UCLA
(Coll. 2066, Box 2 and Box 15)

Perhaps no writer in history has recorded her or his life at greater length or in more intimate detail than Anaïs Nin (1903–77), whose lifelong diary ultimately comprised more than one hundred volumes and filled fifteen thousand pages when typed. For decades the diary was enticingly alluded to as a great masterpiece by the few people who had read parts of it. Henry Miller, in 1937, classed it with the confessions of Saint Augustine and Rousseau and the novels of Petronius and Proust. Certainly Nin's own opinion, often expressed over the years, that the diary was more important than her many novels, now seems true. The style of Nin's fiction has dated, whereas the diary's endless narrative of self-examination and intimate revelation, particularly as it describes a woman's evolving inner life and the *vita sexualis*, grows more relevant to Western culture all the time.

Nin's father was the well-known pianist and composer Joaquin Nin (1879–1949), who had studied piano with Moritz Moskowski and composition with Vincent D'Indy. When Anaïs Nin was eleven years old, her father left his family, and she was taken by her mother to live in the United States. She began her diary (in French at that time) as a letter to her absent father; indeed he continued to dominate the text for many years, and the 1933 diary records her first meeting with him since the abandonment. Much of the first volume of the published diary, covering the years 1931–34, focuses on Joaquin Nin, either his actual presence or his force in Nin's psychic life, as described by her in sessions with her psychoanalysts, first René Allendy and later (and more famously) Otto Rank.

One of Nin's most famous friendships was with Henry Miller, and the early diaries record the relationship *à trois* with Miller and his second wife, June, who appears as the character Mona in *Tropic of Cancer*. Nin encouraged Miller enormously and helped to get his first novel published in 1934, and he in turn gave her the confidence to go on with her fiction when, apart from a critical study of D. H. Lawrence published in 1932, she was still an unpublished writer. Her extensive recording of her relations with Henry and June is as good an example as any of Nin's extraordinary sensitivity to the ebb and flow of human emotion, motivation, and drive. She reads Miller's and his wife's characters now with detachment, now with writerly comradeship, but always with stunning insight. "To be fully alive," she writes, "is to live unconsciously and instinctively in all directions, as Henry and June do. Idealism is the death of the body and of the imagination. All but freedom, utter freedom, is death."

Nin's lifelong self-analysis and its record in her diaries had an extraordinary impact on twentieth-century literature and on women's writing in particular. In the diary that covers the period from April to December of 1928, she describes herself as "I who work[,] live, think by explosion," and later she makes an extensive, compelling comparison of herself with Colette. She can be as acute as Jane Austen in her views on the sentimental life, but her observations are imbued with a characteristically modern sensibility composed of sexual honesty, angst about the future, and a kind of permanent self-absorption that leads to disquieting insights. "It is not in heaven that marriages are made," she wrote in the 1934 diary, for example. "Only when the dreams die do you get genuine copulation. It is the dreams which make fusion impossible. You marry the day you realize the human defects of your love."

At the end of her life, Nin published some of the pornographic stories that she had written for a collector in the 1940s, and the first of these collections, *Delta of Venus* (1977), transformed her cult status into fame. She herself wrote an introduction to the book in which she attempted to rescue the stories from potboilerdom by claiming that they represented a minor revolution—at least in the history of pornography—in describing sex from the woman's point of view. That is certainly true, but it seems unarguable that the diary goes much, much further in representing a woman's whole life, including sex but not at all limited to it. The novelist Lawrence Durrell, whom Nin befriended in the late 1930s, once said to her (we know, because she recorded it in January 1939): "My god, Anaïs, you're always opening new trap doors. Trap doors on the infinite."

The Nin papers, including her diaries, were acquired by UCLA in 1977 with the assistance of alumna Joan Palevsky. *Bruce Whiteman*

References
Anaïs Nin, *Diary of Anaïs Nin*, ed. Gunther Stuhlmann, 7 vols. (New York: Swallow Press, 1966–74); idem, *The Early Diary of Anaïs Nin*, 4 vols. (New York: Harcourt, Brace, Jovanovich, 1978–85); idem, *Henry and June: From the Unexpurgated Diary of Anaïs Nin* (San Diego: Harcourt, Brace, Jovanovich, 1986).

378

HENRY MILLER
**Draft translation of Rimbaud's
"Une saison en enfer,"** 1945
Manuscript with hand-painted wrapper; 12³/₁₆ x 9⁷/₁₆ in.
(31 x 24 cm); book: 11¾ x 9 in. (29.8 x 22.9 cm)
Department of Special Collections, Young Research
Library, UCLA (Coll. 110, Box 83)

In the Anglo-American literary criticism of the twentieth century, a handful of books stand out as so original and so personal in their approach to a writer's work or to a group of texts as to constitute a work of art in themselves. D. H. Lawrence's *Studies in Classical American Literature* (1923), Edward Dahlberg's *Do These Bones Live* (1941), and Charles Olson's study of Herman Melville, *Call Me Ishmael* (1947), all combine remarkably astute responses to literary texts with a degree of autobiography, variously articulated, that renders these books as much about their authors as they are about their ostensible subjects.

Henry Miller's study of Arthur Rimbaud (1854–91), *The Time of the Assassins*, is another of these highly personal works of so-called literary criticism. Miller tells us in the preface that the book resulted from his failure to translate Rimbaud's *Une saison en enfer* convincingly, and a draft of that translation, dated 1945 from Big Sur, California, bears witness to Miller's attempt. A later typescript, also in the Miller papers, contains a note in the writer's hand dismissively abandoning the translation: "(Which proves that I am not and never will be a translator!)." But, successful or not, that project remains of central importance in Miller's literary life if for no other reason than that it led to the publication of *The Time of the Assassins*.

A five-page manuscript that accompanies the material relating to Rimbaud in the Miller papers records his twenty-five-year engagement with the French poet. In 1927, when Miller was thirty-six, he first heard Rimbaud's name but remained willfully ignorant of his work *("Too young!")*. Five or six years later a second opportunity—he says in the preface to *Assassins* that it was at Anaïs Nin's home—was again resisted out of something approaching a self-defense mechanism. But when Miller did at last engage with Rimbaud in the mid-1940s, after he had left Europe and returned to the United States, the experience was clearly an extraordinary one for him.

Despite its subtitle, *The Time of the Assassins* is much more than a simple study of Rimbaud. Even as such it is curiously limited: few texts other than *Une saison en enfer* (cat. no. 376) are referred to, and the central question addressed vis-à-vis Rimbaud is that of his abandonment of poetry. This is, of course, the key issue in any study of the poet, but here it is investigated almost to the exclusion of everything else. Miller is anything but a systematic critic.

"In Rimbaud I see myself as in a mirror," Miller says in the course of his essay, and that quality of identification gives *Assassins* its fiery, imaginative cast. "Rimbaud restored literature to life; I have endeavored to restore life to literature," he writes in the short manuscript referred to earlier, but despite this apparently crucial difference, Miller's jeremiad (for it is that) against stale custom, the unexamined life, the rule of science and the Bomb, and the many other sources of evil on which he expatiates in this book, finds a ready parallel in Rimbaud's life and poetry. "No one had keener vision, truer aim, than the golden-haired boy of seventeen with the periwinkle blue eyes." However romantic that sentence may sound, Miller was able to show perfectly how Rimbaud's later life, bitter and empty as it was, signified a harsh criticism of Western society— a criticism in silence as devastating as his books had been.

Although Henry Miller (1891–1980) is best known as the author of a number of notorious novels that were long banned, he in fact produced many books and essays that attest to his very wide reading. Most of these, like the novels themselves, are intensely autobiographical, just as the fiction (if one stops to notice) is full of social and literary criticism. Rimbaud, above all writers, spoke to Miller with a direct and multidimensional power, and *The Time of the Assassins* records that literary relationship in a text that remains one of his most persuasive and provocative works. *Bruce Whiteman*

References
Laurence J. Shifreen and Roger Jackson, *Henry Miller: A Bibliography of Primary Sources* (Chelsea, Mich.: The authors, 1993), 250–54.

11¾ in.

9 in.

Henry Miller
Draft translation of Rimbaud's
"Une saison en enfer," 1945

379

W. H. AUDEN

Poems

London: Faber & Faber, 1930
8 ¼ x 6 ½ in. (21 x 16.5 cm)
The Huntington Library,
San Marino, California (RB 611019)

380

ROBINSON JEFFERS

Meditation on Saviors

San Francisco: Hermes Publications, 1951
10 x 8 ⅛ in. (25.4 x 20.5 cm)
California State University, Long Beach,
University Library, Jeffers Collection
(PS3519 E27 M45)

381

WILLIAM BURROUGHS

The Naked Lunch

Paris: Olympia Press, 1959
6 ¹³⁄₁₆ x 4 ¹⁵⁄₁₆ in. (17.3 x 12.5 cm)
Department of Special Collections,
Young Research Library, UCLA
(Z233 O5 B94n 1959)

382

ALLEN GINSBERG

Howl, and Other Poems

San Francisco: City Lights Bookshop, 1956
6 ³⁄₁₆ x 4 ¹³⁄₁₆ in. (15.7 x 12.2 cm)
Department of Special Collections,
Young Research Library, UCLA
(G0000643379)

383

THOMAS MORLEY

First Book of Balletts to Five Voices

London: T. Este, 1595
8 ½ x 6 ⅝ in. (21.6 x 16.8 cm)
William Andrews Clark Memorial Library,
UCLA (*M 1585 M866)

384

LUDWIG VAN BEETHOVEN

Grosse Sonate für das Hammer-Klavier

Vienna: Bey Artaria & Comp., [1819]
12⁵⁄₁₆ x 10¹⁄₁₆ in. (31.3 x 25.6 cm)
Music Library Special Collections, UCLA
(**M23.B39 s29 1819)

Among Beethoven's thirty-two sonatas for the piano, the "Hammerklavier," written in 1817–18, is the longest and most demanding, both of the player and of the listener. At 1,167 bars it is half again as long as Franz Liszt's B-minor Sonata of 1854, the work throughout the whole of the nineteenth century that most closely approaches the "Hammerklavier" in ambition as well as technical difficulty. Liszt himself programmed the "Hammerklavier" often and helped to establish it as one of the masterpieces of the piano literature. Beethoven fully recognized the difficulty of the piece, as a remark he made to his publisher, Mathias Artaria, attests: "Now there you have a sonata that will keep the pianists busy when it is played fifty years hence."

By the time Beethoven (1770–1827) began composing the sonata late in 1817, his personal circumstances were distressing to say the least. The fight with his sister-in-law over custody of his nephew Karl consumed much of his time and emotional energy, and he was now almost totally deaf. He had last played publicly in 1814, during the Congress of Vienna, and the series of conversation books in which he "talked" to friends and visitors began three years later. He had not produced a major composition in many months, although the catalogue of his works belies this fact. There the "Hammerklavier" finds its place in a long string of masterpieces, including the seventh and eighth symphonies and the song cycle An die ferne Geliebte

(To the distant beloved), op. 98; the A-major piano sonata, op. 101; the two sonatas for cello op. 102; and the last three piano sonatas, op. 109, 110, and 111. These and many other great works fall into the "third" or "late" period of Beethoven's creative life, when his compositional resources stretched further and further beyond the accepted norms of classical expression.

For all its colossal length and frequent extending of the rules of form and harmony, not to mention its extraordinary expressiveness, the "Hammerklavier" sonata stays within the plastic boundaries of sonata form for the most part. It is in four movements, and even its overwhelming emphasis on counterpoint and especially on fugal textures, one of the defining characteristics of Beethoven's late style, does not countermand the outward conventionalities of the work. The opening allegro ranges over the full six octaves then available to the composer on his new grand piano (sent to him as a gift by the English manufacturer Broadwood). The themes are reworked fugally in the development section, and the recapitulation contains a beautiful and effective modulation into G-flat major. The scherzo second movement uses a theme that is closely connected to the thematic material of the allegro, as Donald Francis Tovey and other commentators have pointed out. It concludes with a brief battle between the keys of B-flat major and B major, a striking dissonance that also occurs elsewhere in the piece.

The third movement, marked "Adagio sostenuto," is one of the most extraordinary pieces that Beethoven ever wrote. Its tragic urgency, its

harmonic richness (although in F-sharp minor, a remarkable modulation in bars 14 and 15 takes it temporarily to the remote key of G major), the unsettling filigree at the recapitulation, all combine to compose a deeply moving piece of music. Liszt's performance, one listener remarked in a Saint Petersburg paper, seemed like "an eyewitness to secrets of a world beyond the grave." A brief largo leads to the finale, a boisterous three-voice fugue that is wild and as unlike anything of Bach's before him as it is unlike anything of Brahms's after. The fugal writing is nevertheless quite strict, and it is Beethoven's remarkable achievement to have elaborated such strict writing in a context of heroism and pure poetry. Tovey, an Englishman and a schoolmasterish analyst who did not bestow praise lightly, collapsed prone (metaphorically speaking) before this fugal finale and described it simply as "holy ground."

Beethoven used "Hammerklavier" (the German word for pianoforte) at the head of his twenty-eighth piano sonata, op. 101, as well, but it is to the twenty-ninth sonata that the nickname has stuck. It was published in Vienna on October 1, 1819, and was dedicated to the composer's most important patron, Archduke Rudolph of Austria (1788–1831), to whom many other important works were also inscribed. Although a number of sketches for the sonata survive, the original manuscript is lost. This copy of the first edition of the score was purchased by the Music Library at UCLA in the early 1980s. It was slightly trimmed at some point, and an early ownership inscription cannot now be made out.
Bruce Whiteman

References
Ludwig van Beethoven, *Werke: Vollständige kritisch durchgesehene überall berichtete Ausgaben* (1864–90; reprint, Ann Arbor, Mich.: J. W. Edwards, 1949), vol. 16; Georg Kinsky and Hans Halm, *Das Werk Beethovens: Thematisch-bibliographisches Verzeichnis seiner sämtlichen vollendeten Kompositionen* (Munich: G. Henle, [1955]), nos. 290–96.

Bibliography
Donald Francis Tovey, *A Companion to Beethoven's Pianoforte Sonatas* (London: Associated Board of the Royal Schools of Music, 1951); Nicholas Marston, "Approaching the Sketches for Beethoven's Hammerklavier Sonata," *Journal of the American Musicological Society* 44 (fall 1991): 404–50; Charles Rosen, *The Classical Style: Haydn, Mozart, Beethoven*, expanded ed. (New York and London: W. W. Norton & Co., 1997); Maynard Solomon, *Beethoven*, 2d rev. ed. (New York: Schirmer Books, 1998).

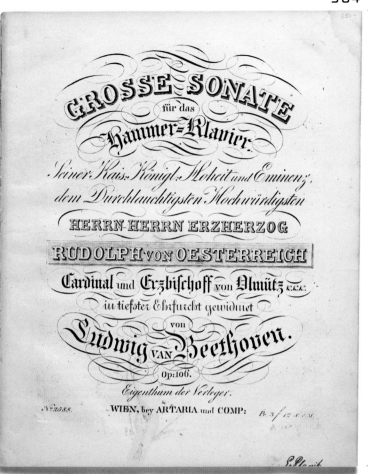

Ludwig van Beethoven
Grosse Sonate für das Hammer-Klavier, 1819

Beethoven's longest and most technically complex
piano sonata

385

FELIX MENDELSSOHN

Manuscript of "Songs without Words,"

[1832]
9⅝ x 12⅛ in. (24.4 x 30.8 cm)
The Huntington Library, San Marino,
California (HM 1019)

386

ERIK SATIE

Sports et divertissements

Paris: Lucien Vogel, 1914
Illustrated by Charles Martin
15⅜ x 17⁷⁄₁₆ in. (39.1 x 44.3 cm)
Music Library Special Collections,
UCLA (**M24.S25sp)

387

GEORGE ANTHEIL

Manuscript score for First Symphony,

(1922)
16⅜ x 13¹¹⁄₁₆ in. (41.6 x 34.8 cm)
University of Southern California,
Archival Research Center,
Special Collections (ML96 A5 S9 No.1)

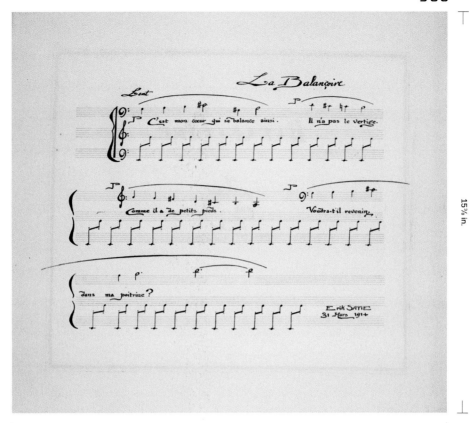

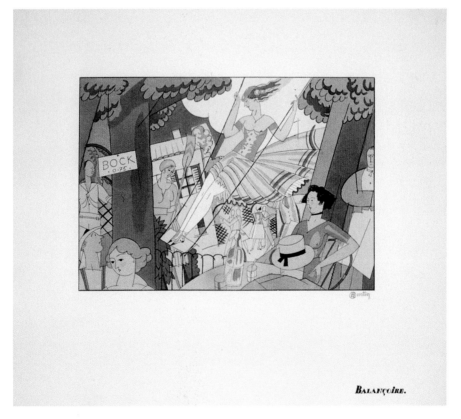

Erik Satie
Sports et divertissements, 1914

Short piano compositions accompanied
by Art Deco illustrations

Igor Stravinsky
**Score of "The Rake's Progress:
Opera in Three Acts,"** 1948–51

388

IGOR STRAVINSKY

Score of "The Rake's Progress: Opera in Three Acts," 1948–51

Libretto by W. H. Auden and Chester Kallman
Manuscript sheet; 17¹⁄₁₆ x 13¹⁄₁₆ in. (43.3 x 33.2 cm)
University of Southern California, Archival Research
Center, Special Collections (M780.7 S912r)

In September 1939, having recently lost several family members, and with war threatening his adopted homeland of France, Igor Stravinsky (1882–1971) moved to the United States, establishing his residence in Hollywood. The Mediterranean climate agreed with the composer, and his acclimatization was aided by the presence of many other European expatriates, although he remained aloof from Los Angeles's other musical giant-in-exile, Arnold Schoenberg. Soon after arriving in America, Stravinsky conceived a desire to write a large-scale vocal work in English, but specific inspiration did not strike until May 1947, in Chicago, where he saw an exhibition of the eighteenth-century artist William Hogarth's cycle of paintings *The Rake's Progress.* To Stravinsky, Hogarth's series depicting the Rake's downward spiral into debauchery, debt, and insanity suggested an old-fashioned "number opera," and accordingly (on his neighbor Aldous Huxley's recommendation) he invited W. H. Auden, a master of English versification, to be his librettist. The poet accepted, writing that "the chance of working with you is the greatest honor of my life."[1]

The Rake's Progress is an opera about the conventions of opera, including even harpsichord-accompanied recitative (the instrument appears in Hogarth's second picture). The composer aimed, as he put it, to "re-use the past and at the same time move in a forward direction."[2] In October 1947 Stravinsky invited Auden (then in New York) to California for consultations, and together they settled on a strict architectural scheme: three acts of three scenes each, plus a moralizing epilogue in the manner of Mozart's *Don Giovanni.* During Auden's visit the collaborators attended a performance of Mozart's *Così fan tutte*—"an omen, perhaps," Stravinsky later wrote, "for the *Rake* is deeply involved in *Così.*"[3] Baba's cleverly interrupted (and resumed) rage aria "Scorned! Abused!" indeed recalls Ferrando's "Tradito, schernito," but operatic history is in fact present throughout the *Rake.* Stravinsky's conspicuously labeled arias, finales, and cabalettas, and his evocations of their musical gestures, worked with Auden's archaic vocabulary to provide "period" dress, while reminiscences of specific operas spanning several centuries cast a web of associations that enriched both plot and characterizations.

In fleshing out Hogarth's parable, Stravinsky and Auden (and Chester Kallman, the latter's collaborator) gave it a more pastoral beginning—a sort of *Rite of Spring.* The country lass Anne Trulove (replacing Hogarth's urban heroine) commences by singing of how "All things keep this festival of May" (the composer dated his sketch of this section "Festival of May 8/48"), and Tom Rakewell responds that a swain's kiss can "restore the Age of Gold." Classical and pastoral references return with tragic poignancy toward the opera's end, after the city and its temptations have wrought havoc in Tom's life. The final Bedlam scene is also a return to Hogarth, after considerable divergence from his tableaux.

Stravinsky's English-language opera premiered at La Fenice in Venice on September 11, 1951, with mostly foreign soloists and a chorus whose English was often incomprehensible as such. Some critics (including Stravinsky's assistant Robert Craft) judged the composer's English text setting "inept," but Stravinsky scholar Richard Taruskin has demonstrated that (much as with Beethoven's quirky settings of Latin) there was musical method in it. And though conceived by two European émigrés and steeped in Europe's literary and musical culture, the *Rake*'s connections to Los Angeles are several. The composer gave the score to the University of Southern California in December 1959, ostensibly as a tax write-off, but the university's opera department had expressed early interest in staging the work, and Stravinsky chose its opera director, fellow refugee Carl Ebert (director of the famous 1934 revival of *Così* at Glyndebourne), to stage the premiere at La Fenice. Even Hollywood left its mark on the opera: Stravinsky's wife, Vera, remarked (according to Craft) that "in the Epilogue, the idea of pointing to the audience—'you and you'—was inspired by Walter Huston in *The Devil and Daniel Webster*, a film I.S. liked."[4]

The score exhibited here is the composer's fair copy. (USC also owns his "summary sketches," made before final orchestration.) The composer notated it in pencil on semitransparent sheets, from which he made Ozalid copies (a process akin to blueprinting), which he sent in installments to his publisher, Boosey and Hawkes in London. Each act (as also the first scene of act 2) is dated; the final sheet reads, "Finis / IStr / April 7/51 / Hollywood," then (in pen), "This is my original manuscript / Igor Stravinsky." *Bruce Whiteman*

Bibliography

Igor Stravinsky and Robert Craft, *Memories and Commentaries* (Garden City, N.Y.: Doubleday, 1960); Paul Griffiths, with Igor Stravinsky, Robert Craft, and Gabriel Josipovici, *Igor Stravinsky: The Rake's Progress* (Cambridge and New York: Cambridge University Press, 1982); Richard Taruskin, "Stravinsky's 'Rejoicing Discovery' and What It Meant: In Defense of His Notorious Text Setting," in *Stravinsky Retrospectives*, ed. Ethan Haimo and Paul Johnson (Lincoln: University of Nebraska Press, 1987), 162–99; Robert Craft, *Stravinsky: Chronicle of a Friendship*, rev. and exp. ed. (Nashville: Vanderbilt University Press, 1994).

Notes

1. Stravinsky and Craft, *Memories and Commentaries*, 145.
2. In Griffiths, *Igor Stravinsky*, 2.
3. Stravinsky and Craft, *Memories and Commentaries*, 148.
4. Craft, *Chronicle of a Friendship*, 62.

389

JOHN CAGE

Musical notation book, 1958

7 x 8⅛ in. (17.8 x 20.6 cm)
Library, Getty Research Institute
(970077)

Experimental composer John Cage (1912–92) challenged many conventional notions of the composition, performance, and reception of music. Born in Los Angeles, Cage studied with Arnold Schoenberg, who had recently immigrated to the United States and was teaching at the University of California, Los Angeles. Schoenberg was said to have stated, recalling his enthusiastic American student: "An inventor! An inventor of genius. Not a composer, no, not a composer, but an inventor. A great mind."[1]

In the early 1950s, after relocating to New York, Cage became closely associated with the composers Earle Brown, Morton Feldman, and Christian Wolff. The "New York School" of composers, as they came to be known, had a common interest in employing various elements of indeterminacy in their compositions, most of which were notated in an unconventional manner. Cage described the purpose of subjecting compositional determinates to chance: "One may give up the desire to control sound, clear his mind of music, and set about discovering means to let sounds be themselves rather than vehicles for man-made theories or expressions of human sentiments."[2]

During the 1950s Cage toured throughout the United States and Europe with pianist David Tudor, mainly performing works for two pianos written by the New York composers. The most significant of these performances were those that took place at the legendary summer courses for new music at Darmstadt, the center of the European avant-garde. Since the early 1950s the younger generation of composers in Europe, led by Karlheinz Stockhausen

and Pierre Boulez, had been concerned primarily with serial techniques. Somewhat of a polemic developed between the Darmstadt composers, who advocated the ultra-rational approach of serialism, and the New York composers, who experimented with indeterminacy. Thus, Cage's appearance at Darmstadt in 1958 was pivotal in the relationship between the American and European avant-gardes.

The notebook on display contains Cage's notations for the realization of his own part (Tudor separately realized his own) of two pieces that they performed at Darmstadt: Cage's *Music for Two Pianos* and three versions of Wolff's *Duo for Pianists I*. The compositional procedure for *Music for Two Pianos* (a two-piano version of his *Music for Piano*) was certainly unconventional. A sheet of transparent paper was placed atop a sheet of manuscript paper. Imperfections on the upper page were intensified with a pencil so as to leave marks on or around the staff lines of the lower page. These marks were then inked as pitches. The number of sounds per page, accidentals, clefs, and the manner in which the sounds were to be produced on the piano ("normal" or, inside the piano, "muted" or "plucked") were each determined according to chance operations. Cage described the function of such a compositional approach: "Analogous to the Rorschach tests of psychology, the interpretation of imperfections in the paper upon which one is writing may provide a music free from one's memory and imagination," things he considered to be limitations of perceptual experiences.[3]

In the score for *Duo for Pianists I*, Wolff instructs the performers to select a specific number of notes from a given pitch collection to execute

within a specific time frame. The exact pitches and rhythms, however, remain indeterminate. In such a composition, Cage suggests, "the composer resembles the maker of a camera who allows someone else to take the picture."[4]

In the realization of both pieces, Cage employed the technique of time-space notation: the carefully measured space on the page where an event is notated corresponds to its place in clock time, the passage of which is specifically indicated above the staff. "A rhythm results," Cage explains, "which is a far cry from horse's hoofs and other regular beats."[5] Also indicated in Cage's notations are internal piano techniques such as "prepared," whereby an object is lodged between strings to alter the timbre of a given pitch; "pizz," instructing the performer to pluck a given string; and "mute with fingernail."

In an article describing the process by which he composed *Music for Piano*, Cage anticipated a question that was certain to arise, although, with characteristic ambiguity, he left it unanswered in order to encourage deeper reflection: "All these [indeterminate] elements, evidently of paramount importance, point [to] the question: What has been composed?"[6] *Eric Smigel*

390

MORTON FELDMAN

Intersection #3 (with David Tudor's realization), 1953

Score (manuscript sheet); 8½ x 13½ in. (21.6 x 34.3 cm)
Library, Getty Research Institute (980039.B9.F26.S)

Bibliography
John Cage, *Silence* (Middletown, Conn.: Wesleyan University Press, 1961); James Pritchett, *The Music of John Cage* (Cambridge and New York: Cambridge University Press, 1993); John Holzaepfel, "David Tudor and the Performance of American Experimental Music, 1950–59" (Ph.D. diss., City University of New York, 1994).

Notes
1. Peter Yates to John Cage, 8 August 1953, John Cage Papers, Northwestern University.
2. Cage, *Silence*, 10.
3. Ibid.
4. Ibid., 11.
5. Ibid.
6. Ibid., 61.

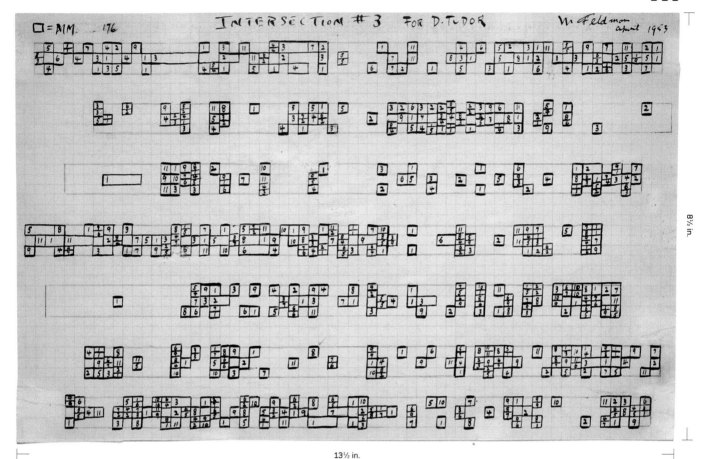

Morton Feldman
Intersection #3, 1953

David Tudor's realization of a piano composition
by Feldman

391

BILL VIOLA

Letter to David Tudor, 1973 or 1974

Four sheets, 11 x 8½ in. (27.9 x 21.6 cm) each
Library, Getty Research Institute
(980039.B60.F2.1)

Known primarily as the foremost pianist of American and European avant-garde music in the 1950s, David Tudor (1926–96) premiered dozens of new works by such composers as Sylvano Bussotti, John Cage, Morton Feldman, and Karlheinz Stockhausen. The virtuoso pianist dazzled audiences with his deftness at handling notoriously difficult compositions, many of which were notated unconventionally. Tirelessly exploring new sound worlds, Tudor increasingly turned his efforts toward the composition and perfor-mance of live electronic music, effectively abandoning his career as a pianist in the late 1960s.

In 1973 Tudor founded Composers inside Electronics, a group of musicians who designed and built electronic circuitry for the purpose of performing their own compositions. He explained the exploratory aesthetic of the group:

The realm of electronics, entered into in the spirit of discovery, can give the musician a new world. Electronic components and circuitry, observed as instrumentally individual and unique instruments rather than as servo-mechanisms, will more and more reveal their personalities, directly related to the particular musician involved with them. The deeper this process of observation, the more the components seem to require and suggest their own musical ideas, arriving at that point of discovery, always incredible, where music is revealed from "inside," rather than from "outside."[1]

Initially Composers inside Electronics was made up of musicians who had congregated specifically to produce *Rainforest IV*, the visionary electro-acoustic environment created by Tudor. The fundamental principle according to which *Rainforest IV* operates is that of amplification. By means of

special transducers, electronic signals are sent into various found objects of wood, metal, or plastic, causing the suspended objects to vibrate. The vibrations produce sounds that are peculiar to the resonant frequencies of each object. Truly revealing their musical idea from the "inside," the objects function as unique sculptural loudspeakers. These sounds are in turn amplified by conventional loudspeakers via contact microphones attached to each object, thereby creating a recycling effect or, as composer and electronics specialist Gordon Mumma has called it, "an ecologically balanced sound system." The resulting environment is one in which visitors are encouraged to walk freely and to come and go as they please. In the mid-1970s *Rainforest IV* was produced many times to enthusiastic acclaim. Reviewing a performance in 1976 at the Los Angeles County Museum of Art, William Weber referred to Tudor's "sonic ecology" as the "healthiest side of the experimental music scene."[2]

Bill Viola (b. 1951) was a founding member of Composers inside Electronics and collaborated with Tudor in several performances of *Rainforest IV*, including the Los Angeles production. A prominent artist who has worked extensively with video, Viola has asserted that his own work has been greatly influenced by his experience with Tudor's electro-acoustic project.

From a technical standpoint, video, which is electromagnetic and records in real time, is distinct from film, which is chemical and operates according to principles of photographic montage. As Viola has explained, "The video camera, as an electronic transducer of physical energy into electrical impulses, bears a closer original relation to the microphone than to the film camera." Indeed, the general evolution of electronic media (telegraph, telephone, radio, television) exhibits itself as a sound-derived technology. True to the medium, Viola claims that

the primary informant that dictates his camera movement is sound, a sensitivity to which he developed while working with Tudor: "One of the many things I learned from [Tudor] was the understanding of sound as a material thing, an entity. My ideas about the visual have been affected by this, in terms of something I call 'field perception,' as opposed to our more common mode of object perception. In many of my videotapes, I have used the camera according to perceptual or cognitive models based on sound rather than light."[3]

In 1997 the Whitney Museum of American Art organized a retrospective exhibition of Viola's work, which was presented first at the Los Angeles County Museum of Art, just over twenty years after Viola's participation in the *Rainforest IV* project at the same venue.

Recently acquired by the Getty Research Institute, the David Tudor Papers provide an invaluable account of the activities of the postwar avant-garde, particularly in regard to the development of electronic music. In May 2001 the institute sponsored an international symposium, "The Art of David Tudor: Indeterminacy and Performance in Postwar Culture," which featured the collection and, in collaboration with the California Institute for the Arts, included a realization of the electro-acoustic environment *Rainforest IV*. Bill Viola was among the participating artists.

The letter on display documents Viola's devotion to the recurring production of the *Rainforest IV* project. More significantly, Viola affectionately acknowledges the profound influence that Tudor had on his development as an artist: "being involved with this piece [*Rainforest IV*] and meeting you has redefined a lot of things for me. . . . You've completely changed my concept of sound, for one. That's something that's even carried into my video work. I've never been able to grasp the notion of sound as a substance before." *Eric Smigel*

Bibliography

Bill Viola, *Reasons for Knocking at an Empty House: Writings, 1973–1994* (Cambridge: MIT Press, 1995); *Bill Viola* (New York: Whitney Museum of American Art, 1997).

Notes

1. David Tudor Papers, Library, Getty Research Institute.
2. William Weber, "Rainforest: An Electronic Ecology," *Los Angeles Times*, 20 November 1975, in Tudor Papers.
3. Viola, *Reasons for Knocking*, 151.

DAVID,

ENCLOSED FIND SOME GOODIES AND OTHER STUFF. I DON'T THINK I EVER SENT YOU THE EXPENSES FOR BUFFALO. THEY WERE $14.00 GAS $1.00 TOLL $3.00 BACK RENTAL. TOTALING $18.00. LUF AND I WERE "BUZZING" ALL THE WAY DOWN THE THRUWAY AFTER THAT WEEKEND. I THINK WE ALL FELT IT — THE PIECE IS JUST GETTING MORE INTENSE EVERYTIME. AND AGAIN I GOT SO CHARGED UP WITH ENERGY AND NEW IDEAS FROM DOING THE PIECE AND SEEING EVERYONE, I DIDN'T KNOW WHAT TO DO FIRST WHEN I RETURNED. THE NEATEST THING ABOUT IT IS THAT THE ENTIRE WEEKEND WAS RAINFOREST — THE SOUNDS STARTED AS SOON AS WE GOT EVERYTHING HUNG AND CONTINUED UNTIL THE LAST POWER SWITCH WAS CUT OFF — GOING LONG BEFORE AND AFTER THE "PUBLIC" HAD COME AND GONE. AND THE FEELING WAS CARRIED OVER INTO THE TRADITIONAL RAINFOREST DINNER AND LATE NIGHT DRINKING. IF THINGS CONTINUE THIS WAY, NEXT YEAR AND BEYOND COULD BE TRULY AMAZING (BOY THAT'S NICE TO LOOK FORWARD TO.) I THINK I TOLD YOU THIS BEFORE BUT IT ALWAYS COMES UP, BEING INVOLVED WITH THIS PIECE AND MEETING YOU HAS REDEFINED A LOT OF THINGS FOR ME. (I DON'T WANT TO SOUND CORNY, BUT IT'S TRUE) YOU'VE COMPLETELY CHANGED MY CONCEPT OF SOUND, FOR ONE. THAT'S SOMETHING THAT'S EVEN CARRIED INTO MY VIDEO WORK. I'VE NEVER BEEN ABLE TO GRASP THE NOTION OF SOUND AS A SUBSTANCE BEFORE. ANYWAY, ALL I CAN SAY IS I CAN'T WAIT TILL THE NEXT RAINFOREST!

I'M SORRY I DIDN'T GET A CHANCE TO DROP BY AT STONEY POINT THAT TIME I WAS DOWN IN N.Y. IT'S HARD TO PULL OFF WITHOUT A CAR, BUT I DO WISH I COULD DROP IN FOR MORE THAN JUST AN ANNUAL VISIT.

I'VE ENCLOSED A COUPLE OF THINGS:
FIRST — THE REVIEW FROM THE HERALD JOURNAL ON THE EVERSON PERFORMANCE. THEY GOT A LITTLE MIXED UP, THINKING WE WERE THE NEW MUSIC ENSEMBLE, BUT IT'S NOT BAD FOR SYRACUSE LOCAL — (THE PAPERS ARE LIKE THE PLACES TO EAT AROUND HERE.)

ANOTHER PAPER DID AN ARTICLE WHICH I MISSED, BUT AM GETTING A COPY OF AND WILL SEND IT ON.

THE SECOND THING IS AN ESSAY FROM A REALLY UNIQUE BOOK I'M READING. THE LIVES OF A CELL BY LEWIS THOMAS. THOMAS IS A GUY WHOSE BEEN WATCHING CELLS FOR THE LAST 20 YEARS, AND AFTER AWHILE STARTED TO NOTICE SOME STUFF. NAMELY THAT THE THING WE CALL MUSIC IS BIOLOGICAL AT ITS SOURCE AND IS CONNECTED TO ACTIVITIES ON THE CELLULAR LEVEL — MANIFESTATION OF INTERNAL RHYTHMS. HE ALSO TALKS OF THE THEORIES OF SOCIETY AS ORGANISM — TECHNOLOGY IS DREAMICALLY MODELLED — BUT HE PRESENTS THEM IN A NOVEL WAY. HE HAS A GREAT SENSE OF HUMOR IN HIS WRITING — HERE'S A QUOTE HE'S TALKING ABOUT SYMBIOTIC BACTERIA — "... IT IS KNOWN THAT CERTAIN MICROBES

EKE OUT A LIVING, LIKE 18TH CENTURY MUSICIANS, PRODUCING CHEMICAL SIGNALS BY ORNAMENTING THE PRODUCTS OF THEIR HOSTS." IT'S A REAL GOOD BOOK — HE'S DEVELOPING SOME IMPORTANT IDEAS ABOUT US. I'VE ALWAYS LIKED BIOLOGY IN SCHOOL, ANYWAY.

HARITHAS SPOKE WITH ME ABOUT DOING A RAINFOREST IN HOUSTON WHEN HE GETS SETTLED THERE IN THE FALL. THE SPACE AS HE DESCRIBED IT'S FANTASTIC — A HUGE WAREHOUSE-LIKE AREA — OPEN — HIGH CEILING — WITH EXPOSED GIRDERS ALONG THE TOP! HE REALLY LIKED THE EVERSON EVENING A GREAT DEAL — HE SAYS HE HAS A SPECIAL IDEA FOR DOING IT AT THE CONTEMPORARY ARTS MUSEUM THERE — POSSIBLE DOING A PERFORMANCE OR TWO — THEN LEAVING THE STUFF UP AND RUNNING ON TAPE FOR A WEEKS INSTALLATION. WE'LL HAVE TO SEE HOW IT GOES AND DISCUSS IT WHEN THE TIME COMES — BUT IT MIGHT BE A REALLY FANTASTIC THING — AND PROBABLY QUITE PROFITABLE SINCE HARITHAS HAS A KNACK FOR MONEY. I AM GOING TO TELL HIM, THAT ON THAT SCALE THERE WILL BE 7 OF US — JOHN, LUF, RALPH, MARTY, PHIL E., AND ME. O.K? ANY OTHER THOUGHTS, LET ME KNOW.

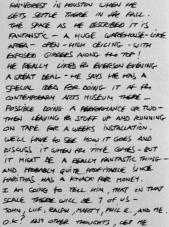

I AM ALSO GOING TO WRITE TO JANE LIVINGSTONE AT THE L.A. COUNTY MUSEUM TO SEE THE POSSIBILITIES THERE. THIS WEST STUFF WILL ALL BE PLUS EXPENSES OF COURSE.

WELL, THIS LETTER IS RAPIDLY BECOMING A MANUSCRIPT SO I WILL END IT SOON. (I SHOULD SEE YOU MORE OFTEN, IT WOULD SAVE ON INK.)

I GOT SOME NEW INSTRUMENTS — THE SONY 152SD — (FINALLY — SUPERB!) WITH TWO ECM 220 CONDENSERS (I'M HOOKING UP A BINAURAL RIG NOW) ALSO A SONY MX-14 SIX INPUT MIXER — A REALLY NICE UNIT — BUT I WISH IT WAS TWO YEARS AGO SO I COULD'VE GOTTEN THE OLDER MODEL FOR LESS $! AND I FINALLY SCROUNGED UP ENOUGH FOR TWO JBL 4311 CONTROL MONITOR SPEAKERS — BOY ARE THEM NICE — I'M WORKING ON A BUNCH OF NEW PIECES — SOUND INSTALLATIONS MOSTLY — INVOLVING RECORDINGS WITH MOVING MICS AND A LARGE SCALE PIECE I GOT THE IDEA FOR BY LISTENING TO THE SOUND OF A STEAM PILE DRIVER BOUNCE SOUND WAVES OFF BUILDINGS ON DOWNTOWN SYRACUSE. I WAS CAPTIVATED FOR HOURS. I'M GOING TO USE MICROPHONES IN A SITUATION LIKE THAT TO FEED THE SPATIALLY DELAYED SOUND BACK INTO SOURCE. I'M TRYING TO GET SOME $ TO DO IT HERE IN THE FALL, SINCE IT INVOLVES SPEAKERS AND LOTS OF AMPS ON BUILDINGS. I DON'T KNOW IF I CAN GET IT THOUGH.

— I'M OFF TO COLOGNE FOR THE ART FAIR IN ABOUT 3 WEEKS SO PLEASE SEND ME THOSE ADDRESSES YOU SAID YOU HAD.

WELL, I CAN'T THINK OF MORE THAN 20 OTHER THINGS, SO — UNTIL I SEE YOU NEXT, MAY YOUR EARS NEVER STOP RINGING.

A BIG HELLO TO DAVID AND CATHY TOO.

VERY BEST,
Bill

Bill Viola
Letter to David Tudor, 1973 or 1974

11 in.

8½ in.

CONTRIBUTORS

Romaine Ahlstrom
Head of Reader Services,
The Huntington Library

Michael J. B. Allen
Professor of English, UCLA

Susan M. Allen
Chief Librarian, Library,
Getty Research Institute

Blake Allmendinger
Professor of English, UCLA

Val Almendarez
Collections Archivist, Margaret Herrick Library,
Academy of Motion Picture Arts and Sciences

Nicolas Barker
Editor, *The Book Collector*

Timothy O. Benson
Curator, Rifkind Center for German
Expressionist Studies, Los Angeles County
Museum of Art

Sidney Berger
Director, California Center for the Book

John Bidwell
Astor Curator and Department Head,
Printed Books and Bindings,
The Pierpont Morgan Library

William M. Bodiford
Associate Professor, Department
of East Asian Languages and Cultures, UCLA

Kenneth A. Breisch
Director of Programs in Historic
Preservation, School of Architecture,
University of Southern California

Bruce Alan Brown
Professor, Thornton School of Music,
University of Southern California

Cynthia Burlingham
Senior Curator, Grunwald Center for
the Graphic Arts, UCLA, and Deputy Director
for Collections, Hammer Museum

Anne Caiger
Head, Manuscript Division, Department
of Special Collections, Young Research Library,
UCLA

Zeynep Çelik
Professor of Architecture,
New Jersey Institute of Technology

Massimo Ciavolella
Professor of Italian and Comparative
Literature, UCLA

Joseph Connors
Professor, Department of Art History
and Archaeology, Columbia University

Joseph A. Dane
Professor of English,
University of Southern California

Katharine E. S. Donahue
Head, History & Special Collections,
Louise M. Darling Biomedical Library, UCLA

Eduardo de Jesús Douglas
Assistant Professor, History of Art,
University of California, Riverside

Sören Edgren
Editorial Director, Chinese Rare Books Project,
Princeton University

Stephen F. Eisenman
Professor of Art History,
Northwestern University

Brent Elliott
Librarian, The Royal Horticultural Society,
London

Robert N. Essick
Professor of English,
University of California, Riverside

H. George Fletcher
Brooke Russell Astor Director for Special
Collections, The New York Public Library

Robert G. Frank Jr.
Professor of Medical History and History,
UCLA School of Medicine

Noriko Gamblin
Exhibition Consultant

Roger Gaskell
Roger Gaskell Rare Books

Bennett Gilbert
Proprietor, Bennett Gilbert Rare Books

Owen Gingerich
Research Professor of Astronomy
and History of Science,
Harvard-Smithsonian Center for Astrophysics

Anthony Grafton
Henry Putnam University Professor of History,
Princeton University

Karin Higa
Senior Curator of Art,
Japanese American National Museum

Thomas S. Hines
Professor of History and Architecture,
UCLA

Sara S. Hodson
Curator of Literary Manuscripts,
The Huntington Library

Andrea Immel
Curator, Cotsen Children's Library,
Princeton University Library

Margaret C. Jacob
Professor of History, UCLA

Eric Jager
Professor of English, UCLA

Alan H. Jutzi
Avery Chief Curator of Rare Books,
The Huntington Library

Roger S. Keyes
Director, Center for the Study
of Japanese Prints

Michael Laird
Bibliographer, Ursus Rare Books

Linda Harris Mehr
Director, Margaret Herrick Library,
Academy of Motion Picture Arts and Sciences

Felicity A. Nussbaum
Professor of English, UCLA

Ynez Violé O'Neill
Research Professor, UCLA
School of Medicine

Steven F. Ostrow
Associate Professor, History of Art,
University of California, Riverside

Roberta Panzanelli
Research Associate, Getty Research Institute

Robert McCracken Peck
Fellow of the Academy and Curator
of Art and Artifacts, The Academy
of Natural Sciences, Philadelphia

Carolyn Peter
Assistant Curator, Grunwald Center
for the Graphic Arts, UCLA

Theodore W. Pietsch
Professor, Aquatic and Fishery Sciences,
University of Washington

Robert Rainwater
Assistant Director and Curator, Spencer
Collection, The New York Public Library

Marcia Reed
Curator of Rare Books,
Getty Research Institute

Peter Hanns Reill
Professor / Director, UCLA Center
for 17th- and 18th-Century Studies /
William Andrews Clark Memorial Library

David Stuart Rodes
Director, Grunwald Center
for the Graphic Arts, UCLA

Michael S. Roth
President,
California College of Arts and Crafts

Kevin Salatino
Curator and Department Head,
Prints and Drawings,
Los Angeles County Museum of Art

Marje Schuetze-Coburn
Feuchtwanger Librarian, Co-Director,
Specialized Libraries and Archival Collections,
University of Southern California

Daniel J. Slive
Rare Books Librarian,
Department of Special Collections,
Young Research Library, UCLA

Eric Smigel
Graduate Student in Historical Musicology,
University of Southern California

Pamela H. Smith
Hahn Professor of the Social
Sciences in History,
Pomona College, Claremont, California

Robert A. Sobieszek
Deputy Director of Strategic Artistic
Initiatives, Curator of Photography,
Los Angeles County Museum of Art

Jonathan Spaulding
Associate Curator, Seaver Center for Western
History Research, Natural History Museum
of Los Angeles County

Timothy Steele
Professor of English, California State
University, Los Angeles

Dan Strehl
Branch Manager, Frances Howard Goldwyn
Hollywood Regional Library, Los Angeles
Public Library

David Szewczyk
Partner, The Philadelphia Rare Books
and Manuscripts Company

Stephen Tabor
Curator of Early Printed Books,
The Huntington Library

Norman J. W. Thrower
Professor Emeritus,
Department of Geography, UCLA

Bruce Whiteman
Head Librarian, William Andrews Clark
Memorial Library, UCLA

Wim de Wit
Head, Special Collections and Visual
Resources, Library, Getty Research Institute

Hossein Ziai
Professor of Islamic and Iranian Studies,
Director of Iranian Studies, UCLA

Most photographs are reproduced courtesy of the creators and lenders of the material depicted. For certain artwork and documentary photographs we have been unable to trace copyright holders. We would appreciate notification of additional credits for acknowledgment in future editions.

P. 37 Courtesy of the Pasadena Public Library; p. 38 Courtesy of the Santa Monica Public Library Image Archives; Courtesy of the Security Pacific National Bank Photograph Collection / Los Angeles Public Library; Courtesy of the Print Department, Boston Public Library; p. 41 Courtesy of the Library of Congress; Courtesy of the Photo Collection / Los Angeles Public Library; p. 42 Courtesy of the Photo Collection / Los Angeles Public Library; p. 45 Joseph L. Wheeler and Alfred Morton Githens, *The American Public Library Building: Its Planning and Design with Special Reference to Its Administration and Service* (New York: Scribner, 1941); p. 46 Courtesy of the Photo Collection/Los Angeles Public Library; Wheeler and Githens, *The American Public Library Building*; Courtesy of the University Archives, University of California, Los Angeles; p. 51 Courtesy of the University Archives, University of California, Los Angeles; Courtesy of the University Archives, University of Southern California; p. 52 Courtesy of the University Archives, University of California, Los Angeles; Courtesy of the Santa Monica Public Library Image Archives; p. 55 © The J. Paul Getty Trust. Photo: Scott Frances / Esto; pp. 88–89 Courtesy of the Paul Landacre Estate; p. 97 © Estate of Davíd Alfaro Siqueiros / Licensed by VAGA, New York, NY; p. 182 © 2001 Artists Rights Society (ARS), New York / ADAGP, Paris; p. 187 © 2001 Artists Rights Society (ARS), New York / SIAE, Rome; pp. 188–89 © 2001 Man Ray Trust / Artists Rights Society (ARS), NY / ADAGP, Paris; p. 195 © Jasper Johns and Petersburg Press/Licensed by VAGA, New York, NY; p. 324 Photograph by Ansel Adams. Used by permission of the Trustees of the Ansel Adams Publishing Rights Trust. All Rights Reserved; p. 340 Photograph reproduced with the permission of Santiago Calatrava S.A.; p. 356 Photos courtesy Dion Neutra, Architect and Neutra Papers—UCLA Special Collections; p. 358 © 2001 Artists Rights Society (ARS), New York / ADAGP, Paris / FLC; Photograph reproduced with the permission of Daniel Libeskind; p. 431 © 2001 Estate of Pablo Picasso / Artists Rights Society (ARS), New York; © 2001 Man Ray Trust / Artists Rights Society (ARS), NY / ADAGP, Paris; pp. 436–37 Photograph reproduced with the permission of the Anaïs Nin Trust.